THE HAIR MAKEUP & STYLING CAREER GUIDE

4th EDITION

by Crystal A. Wright

Artists of The Crystal Agency, Inc.

PHOTO BY CHARLES HOPKINS

SET THE PACE PUBLISHING GROUP

Fashion Stylists, Raven Kaufmann, Jason Griffin, & Leola Johnson; Makeup Artist, Robert Bolanos; Agent & Author **Crystal Wright**; Hair Stylist, Neeko; Makeup Artist, Aleish Pierce; Hair Stylist Justi Embree; and Fashion Stylist, Michael Rozales

96 95 94 93 92 10 9 8 7 6

Library of Congress Cataloging-in-Publication Data

Wright, Crystal A.
 Set The Pace Publishing Group

ISBN 0-9641572-3-3

Carly,

I hope you find this book helpful as you start out in your career.

Remember, the sky is only the limit for those who don't think they can reach the stars.

For you there is no limit.

Go for it, full speed!

Wish all my love,

Dad -

9/19/04

TABLE OF CONTENTS

INTRODUCTION

THE PATH OF NON-TRADITION

Choosing a career as a makeup, hair, or fashion stylist may be one of the boldest decisions you'll ever make.

While these careers may seem quite glamorous and exciting to you, the choice may not win you the "Decision-Maker of the Year Award" from your family or friends. "After all," your parents might say, "You could get a college degree and become an accountant. Better yet, the local post office is hiring". Now that's an exciting stable job you can really sink your teeth into. Choke, cough, choke!

While they mean well, your family and friends may never have had contact with or even heard of a '*Stylist to the Stars*'. They may endeavor to discourage you from pursuing a career that could, in their eyes, prove quite fruitless and a waste of time when you could be earning an hourly wage and bringing home a weekly paycheck.

Listen, if you've sunk $40 into this book, I'm betting that you have already decided to throw caution to the wind, ignore the family & friends who think you're making a mistake and like NIKE, "Just Do It" anyway.

So here's the good news, with a little experience and a well-developed portfolio, an artist's day rate (fee) for photo sessions, music videos and TV commercials can be quite hefty. Upwards of $500 per day is typical even in small markets like Cleveland, Dallas and Seattle, and in places like Los Angeles and New York, artists routinely make upwards of $1,500.

The cosmetology license or makeup academy certificate is just the beginning of your adventure. Doing makeup, hair, fashion styling, prop styling, or manicures for the fashion and entertainment industry is no easy task. But so what. It's great fun, it's exciting, and financially, it is very rewarding.

Working in makeup, hair or fashion styling is like jumping headlong into the entertainment industry. Television and film are entertainment. Music videos, magazines and even commercials, have become entertainment. Celebrities, recording artists and super models endorse everything from Pampers to Coca-Cola, and with more regularity, the commercials are more fun to watch than the TV shows. Of late, even fashion stylists are photographed on the Hollywood and New York party scene and featured in magazines like *InStyle*, *Movieline*, *Angeleno* and *Ocean Drive* along with and apart from the stars they style.

By now you're probably saying to yourself "So where do I sign up? I want to do Gwyneth Paltrow's hair and be singled out at a Hollywood party and recognized as the hair stylist who made her look so fabulous in her last film." Well, hopefully by the time you finish this book, you'll know more about how to do that than you do today.

The place to begin, regardless of where you are in the process, is to ask yourself what area of the

industry you want to focus on first. I say first because you have to start somewhere and focus. Once you've done that, you can begin the process of evaluation, deciding to stay with the area of the industry you started with or move on to another part of the business. There are several disciplines. Some of them overlap, while others don't at all.

You'll begin this introspection by asking yourself which part of the business excites you most. Is it the idea of doing a TV show? Perhaps the next generation *Sex in the City*, or are you more interested in working with magazines, celebrities and high profile photographers? For some of you, only working on full-length feature films will do. For others, only seeing their work immortalized on the covers of fashion and entertainment magazines will satisfy them, and for still others, the allure of a Paris Runway show and the opportunity to work with stars like Pat McGrath and Francois Nars is what drives them. All are dreams that can come true.

As an account executive at Xerox I sold several different products. It was there that I learned 'the product is different, the process (for getting the sale) is the same'. Makeup, hair & styling is no different. The steps for achieving success—i.e. getting booked on high-paying jobs—is the same, for a makeup artist, hair stylist or fashion stylist.

In this book, each of you will begin by creating a plan, and making a conscious choice about which part of the industry you want to work in.

Life is full of surprises. You may have your heart set on being a television & film makeup artist. Then, after working on a television show for several months, you discover that the long hours and pay scale just aren't what you expected. In contrast, you may decide after working on a CD cover that you like the fast pace, and the style of shooting for print assignments is more suited to your temperament and creative abilities. Whatever your aspirations, the *Career Guide* will show you the way.

SPECIAL THANKS

Giving thanks first to God who strengthens and empowers me and my staff daily.

To Germoney & Beth I give my undying gratitude for tirelessly working with me day in and day out to do the impossible. I could not have finished this book, or the *Portfolio Building* workshops without you. Thanks for keeping your feet planted firmly where they would do the most good. You are my dream team.

To my dear friend Kathy Blount who rescued me at the eleventh hour, I love you dearly, miss you very much and am thrilled that you have returned to the west coast where you belong.

To Noelle Sukow, Christina Jacobs and Vanessa Serrano for working NIGHT and DAY to help me complete one more edition. I appreciate all of you.

To my precious husband Bill, for being the best cheerleader a girl ever had.

THE HAIR, MAKEUP & STYLING CAREER GUIDE
4th EDITION

AUTHOR
Crystal A. Wright
Crystal@MakeupHairandStyling.com

WRITERS & CONTRIBUTORS
Reesa Mallen
Beth Carter & Germoney Scott

PUBLISHER
Set The Pace Publishing Group

INTERVIEWERS
Crystal A. Wright
Reesa L. Mallen

BOOK DESIGN
Crystal A. Wright

COVER PHOTO
Jayme Thornton
www.jaymethornton.com

Airbrush Makeup
Tobi Britton/The Makeup Shop
Hair
Jason P. Hayes/Mark Edward Inc./The Makeup Shop

AUTHOR PHOTO BACK COVER
Bonnie Holland

AUTHOR PHOTO'S INSIDE
Noel Federizo

GROUP PHOTO
Charles Hopkins

A WORD FROM THE AUTHOR

In 1986, a well-known makeup artist by the name of Tara Posey asked me to represent her. I had no clue what I was getting into. I didn't know what it meant to be an artist's representative. Fortunately, she knew more about being a makeup artist than I did about representing one. So, with her portfolio and a phone list in hand, I set out to gather contacts and get her booked on jobs. Tara changed the direction of my life.

This book is an anthology of our travels together and beyond. It's what I've learned these last seventeen years of representing makeup, hair, and fashion stylists, manicurists and photographers. This 4th edition of the _Career Guide_ as always, is a labor of love. It is my way of giving something back to a business and the artists that have given me so much.

I became inspired to write the first _Career Guide_ after receiving a phone call and letter from an aspiring makeup artist. Having recently graduated from a well known Los Angeles makeup academy, she was working hard to secure jobs. After six months of phone calls, and strings of unmeaningful interviews, she remained unemployed. In her letter, she asked that I offer her suggestions on creating a portfolio. I was astounded that even though she had spent several months learning makeup techniques and tens of thousands of dollars on her education, she had never been taught or informed of ways to <u>market</u> and <u>present</u> herself in the job market.

This 4th edition is a further opening of a door that will help to close a chapter of exclusion to a great number of young people who want so much to be a part of this exciting industry.

I hope to show each of you the best way to achieve your goals and dreams. Whatever your choice, print, TV, film or video, the _Career Guide_ will assist you in making informed decisions about which route to take from the start, so that your journey begins from a position of power and information. Together, we will create a plan, locate the best resources, and finally, point you in the right direction. Throughout the book I'll share with you the secrets of successful artists who have already done what you're about to do.

This edition has even more new information. A wholly expanded agency section, more stuff on fashion styling, new tools of the trade, new glossary terms, and updated magazine information to help you get tearsheets for your book. Reesa as always, brings a wealth of information about how to do business from her unique perspective as a booker. She spent two years meeting, greeting and changing the minds of clients who were used to working with agencies other than ours.

I intended the _Career Guide_ to be well used by you: the reader. I can only hope that by the time you reach the end of this book, you will have personalized your copy with lots of pen, pencil and highlighter marks, staples, and post-it notes. Treat it like a favorite homework assignment and it will serve you well.

Sincerely,

Crystal A. Wright

Crystal A. Wright
President
The Crystal Agency
www.CrystalAgency.com

REESA'S FYI

Hello Future Stars and Welcome!

It's such a pleasure to be a part of this publication, the only resource of it's kind for artists who are searching for a way to break into this exciting and growing field of freelance makeup, hair, and fashion styling.

For me, the opportunity is in sharing all the information and inside tips I acquired every day at the agency. There's so much useful information and advice given to me from the clients that hire freelance artists, and I feel honored to be able to pass along the knowledge to people who can really use it to their advantage.

I'm convinced that reading advice can be much more valuable than getting it face to face or over the phone because you can review it again later. Some of you may agree with what I have to say and some of you may not. I'm just passing on what I've learned, in an effort to enhance your career. Take it as you will. Just remember, what I'll say throughout the book is what I've heard over and over again from the folks who will be hiring you!

If I have one general comment for freelance artists it is "*be pleasant and positive*". In the beginning nothing is easy, but clients like to work with people who have good attitudes and are team players. Paying your dues is like changing the oil in your car: it's a pain in the butt, but it must be done in order for your car to run properly.

Once you have the technical skills down, it's important for photographers, producers, fashion and video directors or whomever is hiring you to like you. Nobody wants to spend eight to eighteen (depending on the type of project you are working on) hours a day with a whiner. This is, after all, show business folks, so put on your happy face, know your job, and no matter how negative the director, model, or other artist working next to you becomes hour after hour, don't let them get to you! The guy standing by the food table all day munching on the fat free pretzels and red vines may be the one who chose you for this job, and he may be watching you deciding if he wants to book you for Madonna's music video next week.

Best of Luck. Test. Test, and keep testing, and believe in yourself. Remember, if you don't have confidence in yourself no one else will!

Sincerely,

Reesa L. Mallen

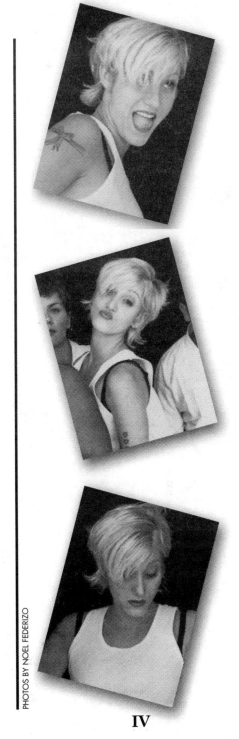

IV

1 GETTING STARTED

YOU ARE HERE

If you've ever been inside a shopping mall, which I'm sure you have, then you are well acquainted with the large free-standing information boards called directories. They are usually located close to the main entrances of the mall. The first thing most people look for when they approach one of these large directories is the brightly colored dot, and the words, "YOU ARE HERE."

From that bright spot on the board, you can locate the store or stores you want to find, determine the order in which to approach them, and then plot the best course for getting to each one in the time allotted. Quite simply, a PLAN!

A career as a freelance makeup, hair or fashion stylist should be approached in much the same way.

Throughout this book, your objective will be to formulate and finally implement your own plan for achieving your goals. I encourage you to think of the Career Guide as your workbook. View it as a challenging homework assignment.

While working through the remainder of this chapter, your objective will be to familiarize yourself with the career options such that you can find a starting place to achieve your goals.

CHOOSING A PATH

Like the challenge of making it to the top of corporate America, making it to the top echelons of a freelance styling career has a path depending upon which side of the business you want to work on. On one side there's print, video, commercials and runway. On the other side there's TV & Film. Why? Who knows, it was this way when I arrived and in 14 years little has changed. It's like politics, you're either a democrat or a republican. There are a few independents sprinkled about but for the most part you're on one side or the other.

At this juncture, choice serves an important purpose, to help you find a starting point and thus a path. You can mix it up later, but for now, you have to start somewhere or you'll end up all over the place with little to show for it and credentials that make you look like a jack of all trades and a master of NONE! A film here, a print ad there, a play, a TV commercial, and people (creative decision-makers) in a position to choose you for a job asking "So, what do you do anyway?"

ASIA GEIGER
MAKEUP & HAIR STYLIST

CREDITS

Tim McGraw • New Edition
Elysian Fields • Teddy Riley & Blackstreet
Tia Carrera • Tim Burton • Jim Belushi
Judd Nelson • Violent Femmes

CG: Tell me about the beginning of your career, Ms. Asia!

AG: I began to have an obsession with makeup, literally. I started buying tons of makeup and experimenting with textures and color and what's new in the market. I modeled, so I had no fear of experimenting. I find a lot of women are scared to play around with cosmetics. That's what's really exciting for me, playing with an image; especially when you work on editorial, you can create a whole fantasy with the makeup, hair and styling. The transfor-

CONT ON P 1.3

The most important element of where you are right now is the ability to stick with your choice long enough to determine whether you really like it or not.

In other words each of these choices have their peculiarities, personalities and lifestyles. I won't call them pros or cons because a PRO to one person is a CON to another. You know, kind of like a yard sale. My junk your treasure sort of thing.

FEATURES & BENEFITS

A career in TV and Film is attractive to some because it offers a sense of security. Many artists get jobs on television shows and work there for many years collecting a steady paycheck as if they worked a 9-5. A film while not quite as steady can go from a few weeks to several months, again a paycheck that you can plan on.

Print, Video, Commercials & Runway are quite different. The pace and life is more like that of a superstar athlete who plays a new team in a different city every few days. Artists who choose this path often have agents that represent them and while they don't get a steady paycheck the checks they do get for a days work can run into the thousands.

PRESENTATION

In TV & Film you build a resume, it's your calling card. It is bolstered by the positions and thus the amount of responsibility you hold on projects. There are two goals. First to gain enough experience working on projects so that you can apply for better positions and pay on subsequent films until you are the head of the department. Second, to get into the union so that along with your position and a certain amount of security, you get medical benefits, a pension and opportunities to work on better projects. The big budget films are all union.

In Print, Video, Commercials & Runway you build a portfolio that you will send around to agencies for representation and to clients for jobs. The better your book the higher the rate you can demand for what you do. Better in this case means published work (tearsheets) with national advertisers, magazines, celebrities, recording artists and high fashion and/or cutting edge tests that get the attention of the creative decision-makers in charge of hiring.

CHOICES

Regardless of the division (TV & Film or Print, Video & TV Commercials) artists typically start out in one of two ways; testing, assisting or both. Artists who choose TV & Film create books that

are very different from that of a Print & Video artist.

The TV & Film makeup artist must be able to prove their ability with artistry that includes cuts, bruises, bald caps, etc. The hair stylist must show proficiency with wigs, period styles, etc. . Many times these artists display before, during and after polaroids and movie stills in their books. The quality of the photographs is negligible. Technique and continuity are everything. Over time, the resume replaces the book and a successful makeup, hair or costume designer is known to say, "gee, no one's asked to see my book in years". Not so with Print.

Print is a whole different ball game. The picture, the whole picture and EVERYTHING including the picture matters! That's why the team is so important. The collaboration of people (makeup, hair, stylist, photographer and model) that produces the picture is part of the magic that makes a creative decision-maker say "Wow!" The objective of testing is the production of "Wow!" The Print makeup artists book is always being updated. They are always in pursuit of creating or collecting (from the photographer) the picture that could get them a great job or a great agent.

THE OBJECTIVE

The goals are different. In TV & Film the objective is to create a character. On the television show "All My Children" the CHARACTER "Erica Kane" played by Susan Lucci does not change from day to day. Each day when the television audience returns they find Erica. That is unless Erica has been hit across the head with a bat by one of her X-husbands, now has amnesia and for the remainder of the season will wander aimlessly [as another pre-defined CHARACTER, perhaps a hooker] until her mom or a neighbor spots her and drags her back to Port Charles. . .oh sorry, that's General Hospital. In film, Cate Blanchett, who won the Academy Award for Elizabeth in 1998, was Elizabeth from beginning to end. As a makeup, hair or fashion stylist on a film, you don't get to come in on Tuesday morning half way through the film and decide it's time for Elizabeth to chuck the white makeup on her face and go with a more interesting color. That kind of creativity is reserved for print jobs for magazines, music videos and runway work.

On print jobs, at least as it relates to fashion editorial and especially on music videos, there is a lot more spontaneous creativity in the air. Directors on music videos are usually working from a 1-2 page treatment that was written by them based upon a 2-3 minute song. The song is given to the director by the artists record label. While not always this loose, instructions to makeup, hair and styling talent can sound like, "We're going for a kind of edgy urban feeling". . .whatever that means. Similarly, creative direction on fashion editorial might sound like "Linda (Evangelista that is) is

ASIA GEIGER
MAKEUP & HAIR STYLIST

mation is really exciting to watch. When I moved to Los Angeles from Tokyo, I had to learn the business aspect: how to make the phone calls, etc. . Life in America is easier than where I come from (Poland). If you want to do something and you stick to it, it can be done. Soon after I arrived here, thank God I discovered Crystal's book and learned all about testing to build your book with photographers. She actually signed my book at a book store signing, and one year later I ended up signing with The Crystal Agency! Before you start doing the whole marketing yourself thing, you obviously need to be a skilled and talented makeup artist and have confidence that you will succeed.

CG: When starting out, what tips can you give to the new-comers?

AG: It's very easy to get discouraged if you don't know exactly what area of

CONT ON P 1.4

the business you would like to work in, whether it be print, film or television. You just have to find out by trying the different aspects and look into your self to see what you really are interested in. Stay focused and determined. If you need to get a part time job in order to survive at the beginning, don't let that discourage you. Always keep your goals in front of you.

**JENNIFER ELAINE CUNNINGHAM
MAKEUP & HAIR STYLIST**

CG: So how did you get started in freelancing Jennifer?

JC: "I started going to Beauty School in high school because I knew what I wanted to do. I knew that I wanted to work in fashion but I

CONT ON P 1.5

going to be our model, and we're doing a red story".

Both of those leave a lot up to interpretation and it's the kind of work that many print artists cut their creative teeth on while doing the not so creative–but well paying catalogue and advertising jobs.

Catalogue is the television work of the print industry. It's steady and shoots often go on for several days. It pays well, averaging $350-$750 per day, and is usually very consistent once you get on board with a photographer or the company that is producing the catalogues. Catalogue companies are famous for hiring the same team over and over again for years on end. Hiring the same people ensures the consistency they require to meet the needs of their customers.

Advertising, which includes print and commercials is the creme of the crop. It usually pays very well, usually $500-$5000 a day, is high profile and exposes you to some of the best photographers and commercial directors in the world.

So venture forward. The next few pages will help you to identify those areas of the business that interest you the most. Begin now by asking yourself: What areas of the business would I like to work in? Near the end of this section (page 1-5) you will be asked to rank your choices in order of importance, place check marks in the corresponding boxes and choose a starting place.

GET FAMILIAR

Following are brief descriptions of each career area and are designed to familiarize you with the subtle differences between print, video, commercials, film, television and live performance. By supplying you with some basic information on the type of work assignments you can expect in each venue, I hope to help you zero in on where you would like to begin your freelance career. Don't mark anything yet. You'll come back to these boxes later.

THE PRINT ARTIST

makeup, hair or fashion stylists who work within the print arena will find themselves working closely with photographers, art directors, designers, artist managers, fashion and photo editors. Print assignments include but are not limited to the following:

PRINT	EXAMPLES
____Magazines	Essence, Elle, Bazaar, US, Rolling Stone, Vibe
____Advertising	Nike, Coca-Cola, Clothestime, Wheaties, Coors

____Album Covers	Whitney Houston, Christina Aguilara, Macy Gray
____Catalogues	Victoria's Secret, J. Crew, Banana Republic, Talbots
____Movie Posters	The Patriot, Gladiator, Big Momma's House, The Clumps
____Corporate	Annual Reports (multi-page booklets of corporate earnings.

THE VIDEO ARTIST

The video stylist typically comes from a print background. Quite often an artist who works on music videos has developed a portfolio that showcases his/her work on fashion editorial assignments and album covers. Video assignments include the following:

VIDEO	**EXAMPLES**
____Music Videos	Brittany spears, Santana, Sting, Mark Anthony, Maxwell
____Industrial Videos	TRW, Hughes Aircraft, Boeing
____Educational Videos	Cancer Research Foundation, Aids Hospice

THE TV COMMERCIAL ARTIST

Artists that work primarily on television commercials often have a good deal of experience working on print and/music videos. In LA or New York, it's fairly easy to get a job on a low-budget music video to gain experience and learn what goes on, on the set. However, an artist who comes up in a market like Chicago where advertising is KING may work on some print jobs and go right into

Corporate: Up above in print examples, I list corporate and then use Annual reports as an example of the kind of work you might do. Here's why. Hollywood is known for celebrities and recording artists. New York is known for fashion and advertising. Chicago, for print advertising and television commercials. But what if you live in the silicon valley in northern California where there are no celebrities and there is no fashion, but there is plenty of business. What kind of work will you do? Well, companies still need pictures, they just won't be seen in Vogue. They will however hire a local photographer to take pictures of all the executives in their offices, foremen hauling crates of micro-chips and secretaries happily greeting customers who are walking through the door. Those kinds of images, populate thousands of corporate annual reports. These full color books are then mailed out to all of the stockholders, who can then marvel at how well the company is doing in business.

**JENNIFER ELAINE CUNNINGHAM
MAKEUP & HAIR STYLIST**

didn't know how to get involved in it. So I stared talking to people who owned modeling agencies in the area and they referred me to a couple of photographers to do tests with and build my book. I started getting pictures for my book with good makeup, hair, and styling and just O.K. models. Then once I had enough of those in my book I was told I could get better "girls" (models) by showing the work I had accumulated. I learned that my book and tests should look like they could be in the top fashion magazines. I learned that I needed to make the tests look like the real jobs that you would want to do, whether it be fashion, music or advertising.

CG: What advice would you give someone who was just starting out?

JC: Practice on everybody that you can. Try to get "girls" in your book, and the only way to do that is by going to the modeling agencies. Tell them this is what you want to do, and be prepared to work for free for a while. You can't expect to make a lot of

CONT ON P 1.6

JENNIFER ELAINE CUNNINGHAM MAKEUP & HAIR STYLIST

money off the bat, but you just got to stick with it.. it takes a while. Just stick with it, it's frustrating at the beginning, but you just can't expect to wake up one morning and be a makeup artist. It's like any other business, nobody knows who you are when you're just starting out.. it's up to you to pay your dues, get your name out there, and have something to show. **END**

Jennifer Cunningham
is a makeup artist
Her first tearsheet
was the December 9, 1996
cover of Newsweek Magazine
with Tiger Woods

Since then Jennifer has added the following
credits to her resume:

Fashion Editorials for Teen Magazine
Vondie Curtis Hall for Venice Magazine
Carmen Elektra for Access Magazine
Joe Sample for Warner Bros Records
Natalia Cigliuti for Vanidad Magazine
The California Mart "Look" Fashion Shows

working on TV commercials—because that's a lot of what they do in the windy city. I think it's safe to say that the artists who work on a lot of TV commercials in markets where there are few music videos, probably started in print working on advertising assignments and then moved into commercials. In Los Angeles, however, as music video directors make their way into television commercials, they often bring their video crews (makeup, hair & fashion stylists) with them. TV commercial projects include the following:

COMMERCIAL	EXAMPLES
____Commercials	Got Milk?, Miller Lite & Genuine Draft, Cover Girl, Revlon
____Infomercials	Jane Fonda's Workout, Ab Roller Plus, Tai Bo

LIVE PERFORMANCE ARTIST

Lets look at live performance on two sides of a fence. On one side, there are:

____Concerts	Back Street Boys, Mariah Carey, Boyz II Men, N'Sync
____Road Tours	Janet Jackson, Britney Spears, Faith Hill, Dixie Chicks
____Runway Fashion Shows	Donna Karan, Isaac Mizrahi, Anne Klein, Todd Oldham

and on the other side, there is:

____Theatre	Phantom of The Opera
____Dance	Goffrey Ballet, Dance Theatre of Harlem
____Musicals	Lion King, A Chorus Line, A Midsummer Nights Dream

An artist who has worked on live performances for 2 or 3 years emerges with a tremendous amount of experience and the preparation needed to step into the television or motion picture arena with greater ease than the artist who has been working only on print and/or music videos where most jobs are shot in a day or two and the artist is on to something else totally unrelated. The daily challenge of working on live shows prepares an artist for addressing issues of timing, the illusion of spontaneity, and the necessity for continuity. These skills are an asset for the rigors of a hectic, demanding and constant pace that is associated with working on episodic television and feature films which are usually shot out of sequence (last scene first and so on) and require an artist to keep track of what they did last week, or last month.

THE TELEVISION ARTIST

An artist who wants to work in television can expect to work on the following projects:

TELEVISION VEHICLES	EXAMPLES
____Sitcoms	Frasier, Friends, Will & Grace
____Movies Of The Week	The Monkeys, Growing Up Brady
____Miniseries	The 70's, Jesus
____Drama	Law & Order, ER, The Practice
____Action-Adventure	Zena, Hercules, Cleopatra 2520
____Day Time Soap Operas	Days Of Our Lives, One Life To Life, All My Children
____Science Fiction	Star Trek, Deep Space 9, The X-Files
____Awards Shows	Grammies, Emmies, Oscars, Soul Train Music, MTV, VHI

In television and film the makeup artist and hair stylist retain their titles, however the word fashion stylist that is associated with working in fashion and on music videos changes to wardrobe. From here on in, you will hear terms like wardrobe mistress, costumer and costume designer—the person in-charge of designing the look of the show as it relates to clothing. The feature film resume frequently includes work in the theatre. A theatre background is excellent training and preparation for working on feature films, which involves a lot more than shopping and having the occasional garment designed or built from scratch. The costume designer is brought into the project early, and is expected to do a great deal of research to authenticate the look of a film, especially for a period piece like Elizabeth, Lord of the Rings, or even A Beautiful Mind which meanders along from the 50's up through the year 2000. Film vehicles include:

FILM	EXAMPLES
____Features	Gladiator, The Perfect Storm, Shaft, The Patriot
____Short Films	In The Bag
____Student Films	Culture
____Documentaries	Three Little Girls

You may be surprised at the vast array of opportunities and exciting career choices. You'll find more information on what it takes to work in film and television in Chapter 6. It is here that you begin

ALEJANDRO PEREZA
FASHION STYLIST

CG: Alejandro, How did you get into this business?

AP: Well my mom was a sample sewer for years, my dad was a sewing contractor, and two of my uncles were tailors. I have just always loved clothes and was always around fashion so I just sort of fell into it.

CG: How did you find out about agencies, testing and this whole business of fashion styling?

AP: I worked in a restaurant on Melrose and I met and became friendly with a couple of models. They basically told me about the career of fashion styling and about calling modeling agencies to set up tests to get pictures to start building my book. So I went to the agencies and started to build my book by testing with their models.

CG: What were some of the ups and downs you experienced in the business?

AP: Let's see. Finding good photographers to test with, getting good clothes and models, and just hooking up with legitimate peo-

CONT. ON P 1.8

ALEJANDRO PEREZA
FASHION STYLIST

ple. Also, starting my book and just knowing what it should look like, and defining my own style.

CG: Do you have future goals other then freelance styling ?

AP: Yes. I would like to be a fashion editor at a magazine. One of the big New York or Paris publications; possibly Harper's Bazaar, Vogue, or "W".

CG: What warnings would you give to newcomers about testing?

AP: Basically, you have to go on your gut instinct when it comes to trusting photographers to keep their word. Many times they will disappear after promising you prints or tell you the shoot they are doing is a spec job for a magazine when it is really a paid test for a modeling agency. They are getting paid for the job and I am pulling all these great clothes and getting paid nothing. You've got to be careful. Ask around, most people in this business know each other.

CG: How did you create relationships with vendors and designers to get clothes for tests

CONT. ON P 1.9

the process of making an informed decision. Using the list below, number each area of interest from 1-6 in order of its importance to you, 1 being the most important and 6 the least.

AREAS OF INTEREST	TYPE OF WORK
____ **PRINT**	Magazines, Album Covers, Advertising, Movie Posters
____ **VIDEO**	Music, Industrial, Educational
____ **COMMERCIALS**	Commercials & Infomercials
____ **FILM**	Features, Shorts, Documentaries
____ **TELEVISION**	Sitcoms, Soap Operas, Dramas, Movies of the Week
____ **LIVE PERFORMANCE**	Concerts, Road Tours, Fashion Shows, Theatre

Now, **go back** through pages 1.4-1.7 and place check marks in up to 3 boxes that correspond to your number 1 and 2 choices for AREAS OF INTEREST.

From time to time we will call upon our fictitious makeup artist Mary Coletti (see below) to help us understand a concept or solve a problem. Here's an example: Mary Coletti wants to become a makeup artist. Her top two (2) areas of interest are:

1.	PRINT	Magazines, CD Covers, Ad Campaigns, Movie Posters
2.	COMMERCIALS	Commercials & Infomercials

On pages 1.4-1.7 Mary placed check marks in the following boxes for PRINT:

PRINT VEHICLES	**EXAMPLES**
☑ Magazines	InStyle, Essence, Elle, Bazaar, US, Rolling Stone, Jane
☑ Advertising Print Ads	Nike, Coca-Cola, Coors, Clothestime
☑ Album Covers	Macy Gray, Enrique Iglesias, Christina Aguilera
☑ Movie Posters	The Patriot, Gladiator, Big Momma's House, The Clumps
☑ Catalogues	J. Crew, Banana Republic, Victoria's Secret
☑ Corporate	Annual Reports

What do we know about our fictitious (aspiring) makeup artist, Mary? From reviewing the shaded area on the previous page, we know that her first choice is to work with magazines, on advertising campaigns, album covers and movie posters. That tells us that Mary should start her freelance journey in PRINT. If she decides later to move into film and television, she'll know exactly what she likes and dislikes about working in print, video and television commercials, since a print portfolio that includes fashion and celebrity editorial and recording artists usually provides the perfect entre into music videos. Why? Because many of the freelance [creative] production decision-makers (producers, production managers & production coordinators) who work on music videos often also work on TV commercials. I'm sure you're starting to get the picture.

THE PROCESS

Later in Chapter 3, MARKETING YOURSELF, there will be a more thorough discussion about choices, goals and how to assess and succeed in the marketplace you live in and/or intend to work in. At that point you'll be asked to fill in and personalize your book with a very specific personal statement about where you're going.

Now that you've identified your personal areas of interest and studied and checked off the corresponding vehicles, you can more clearly see the different kinds of work available to you in the marketplace. Every page of the Career Guide is designed to help you set and achieve your goals as a freelance artist. Hopefully you'll find yourself flipping back to these pages often as you begin to understand exactly how to accomplish your goals.

"GETTING STARTED" means preparing yourself, becoming aware, fine tuning your peripheral vision so you don't miss anything valuable that might help you now and in the future. It also means knowing what to look for, and how to use the information once you find it.

LOOKING THE PART: PERSONAL STYLE, HAIR & WEIGHT

I can think of only a few professions where personal imaging is as important as it is in our business. Whether you're a hair stylist, makeup artist, fashion stylist, or costume designer you should develop a personal style of your own. You must be current, creative, and coifed. Individual style is applauded and most people who have it also appear confident and self assured. It's the sort of thing that creative decision-makers like when they are considering hiring you.

Keep up with fashion trends. You don't have to adopt each and every one, however you should be aware of them as you may be called upon at any time for your opinion about the latest trend in

**ALEJANDRO PEREZA
FASHION STYLIST**

when you didn't have a stylist letter from a magazine or a clothing budget?

AP: I just would drive around to all the stores I liked or go spend a whole day at the California Mart introducing myself . I would say something like, "Hi, my name is Alejandro, you have beautiful clothes and I do styling. I have upcoming projects and I'd like to take your business card and your latest catalog. Your stuff is gorgeous etc.." Then I would take a look at all of the materials collected and go over everything examining the clothes. I would see if the clothes and designers appealed to me, and see if their stuff was current. When I say current I mean if that style of clothing is being featured in the Paris couture books or the fashion magazines. Then if I had a job I would be in touch with them, and then if I return all the clothes just as I had taken them they will usually be cool and trust me to borrow their clothes for a test. It's really all about building relationships and trust. Even if it's just a test they may let you take it out if they can put prints of each look for their books in their showroom books.

CONT. ON P 1.10

ALEJANDRO PEREZA
FASHION STYLIST

CG: O.K. What if the showroom or designer is not in L.A. and they only have their stuff at let's say like a Barneys. For instance if you want to pull Gucci?

AP: Well, they know and trust me now, so usually it's not a problem, but at the beginning I had to pull a bunch of stuff, let's say $1000.00 worth of clothes and buy maybe $200.00 worth of clothes that I could wear for myself. Then they were happy. As long as everything is returned in the exact condition you took it out in, all the tags are there; and you buy something once in a while, it's usually not a problem.

CG: Let's say you pull a shirt for a model and he has awful body odor, how do you return it?

AP: You own it. Sometimes you can get away with dry cleaning it, if they don't find out and it looks perfect.

CG: For insurance purposes do stores need a credit card or some sort of deposit?

AP: Yea. They keep a credit card slip on file, so at if anything happens to the clothes they can just charge it to your card.

CONT. ON P 1.11

beads, rocks or . . .who knows what.

I had been working for Los Angeles photographer, Bobby Holland as his rep for about six months when I resigned. (Actually, I got fired, but let's not quibble). During my hiatus, I started my own company and had the good fortune to meet an extraordinary woman Elka Kovac, a photographers rep who became my mentor and dear friend. We got to talking, and I showed her my promotional materials and the portfolios of the photographers I was hawking. She loved the package and presentation, but said that the photographers were not very good. Then she eyed me up and down and told me I could stand a little work myself. What was she talking about? My clothes. There I stood, in my navy blue suit, white blouse, and a big bow tie, wearing "Hanes my way (that is, with my Red Cross pumps)." 'There are no navy blue jackets and white shirts in this business, she informed me. Although I had left Corporate America, my presentation was still very Fortune 500, and inappropriate in my new work environment.

My response was (what yours should be) to look at what others in the business were wearing, pay attention to the trends and adopt [only] those trends that suited me personally and professionally.

Some of you will work and prosper in the small to medium towns you live in. Others will do the same in the big city. Let me tell you now that big city style and small town dress are two different things. So if you're coming to the big city (Los angeles, New York, Chicago, Miami, Dallas) then listen up.

If you're over 25 and still wearing the same hair cut that you had when you were 18 and the last boy [or girl] you really liked in high school told you was cute, you probably need to get a new one. Whenever I venture thirty miles outside of Los Angeles I always notice that most of the people, would look like they were living in the year 2000 if they would just got a new hair cut. Think contemporary. An up-to-date look helps in this business regardless of what city you're working in.

And for those of you who think you're over weight and need to fix it, here's what I have to say. One of the sexiest and most confident women I've ever known is a size 20. When she walks into a room every head turns. Why? Because she wears the weight it does not wear her.

Sharon Gault, aka "Mama Makeup" is one of the best makeup artists in the country. She is also a very big girl with the confidence and makeup artistry skills to match. She works with some of the top photographers in the world, including but not limited to David LaChapelle. I doubt that anyone cares about Sharon's size because ONLY when Sharon arrives does the show really begin. Sharon is talented, charismatic and friendly. It works!

PRESENCE

There's one other thing that usually goes hand-in-hand with personal style and that's presence. People tell me often that I have presence. Only recently did I figure out what they were talking about. I stand up very straight, hold my head up when I walk, project my voice into the next state, speak good english, have a firm [but not crushing] handshake, am very approachable and always assume that I'm going to get what I came for. I believe that is what people see when they say that I have presence.

At one of my "Packaging Your Portfolio" workshops in Miami I was fortunate to have Nicola Bowen, former artist rep at the Michelle Pommier Agency and new owner of her own agency, Nicola Bowen Artist Management, sit on my panel and speak to my class candidly about presenting themselves to agencies and clients. "There's nothing more offensive than an artist who comes to meet with me and they are sitting there in a chair with slumped shoulders and mumbling about why they came to see me" Nicola said. "I will not sign an artist like that. I can't imagine that they would go to an interview and present themselves to a client any differently than they are presenting themselves to me".

Your style will be important to the people who hire you. And you might be surprised to find out that every agency owner we interviewed had something to say about the importance of signing artists who had an understanding of fashion and personal style.

I'll end with this little story. Early in 2000 a makeup artist came to show me her book. It was very, very good. But she was totally outdated and couldn't understand why photographers in the LA market weren't responding to her. While she was an attractive girl, her hair was much too long for her age, her jacket sleeves were folded up and pushed up above her elbows exposing the lining, she was wearing flesh colored pantyhose and black pumps. I took a deep breath and said "we'll, since I assume you aren't paying me $150 an hour to look at your book and blow smoke in your eyes I'll tell you what I think. Let those darn sleeves down on your jacket. That show your lining thing is so 80's. Dump the pantyhose or wear pants if you're not comfortable with showing your legs, trade in the pumps for some clunky sandals and lose some of that hair or pull it up and let some of it fall down around your face in a sort of messy cool way. She started getting appointments right away.

ALEJANDRO PEREZA
FASHION STYLIST

CG: You always hear about stylists talking about how they are ordering new designer pieces from the New York showrooms. How does that work?

AP: It kind of works the same way. You call them, but you've got to make the job sound like the hottest shoot going on in L.A. that day. If you're asking to pull clothes for a hot celebrity who's getting a lot of press for a new movie and the publication will give credit, they will Fed-Ex the clothes to you. Be as nice as you can to the showroom people you're dealing with on the phone. That always helps. Call them when you have a budget for a commercial or music video as well as when it's just for editorial. That way you get to know them and they will send you stuff for almost anything. Once they trust you will call them for paying jobs, you can get people to help you.

CG: Oh! So that's how it works! How do the employees at studio services know that you are really a stylist?

AP: They really don't know when they first meet you. There is a great story about that a woman

CONT. ON P 1.12

ALEJANDRO PEREZA
FASHION STYLIST

who would come into Barney's and pull really expensive gowns saying she had all these major events to attend. She said she had no time to try the gowns on and would take out four or five saying that she would buy the one she chose to wear. Then she would wear the dress and return it saying that none of the dresses worked. One day Los Angeles Magazine ran a photo of the woman wearing a $10,000 dress she pulled from Barney's to the opera. She returned the dress two days before the photo ran. When a Barney's employee spotted it, they mailed the dress to her and charged it to her American Express card. They never did business with her again.

CG: What do you think about assisting other stylists when starting out?

AP: I think it's a good idea, even though I have only done it twice myself. Assisting can show you how styling works and how to behave once you're on the shoot. You can call agencies and tell them you would like to assist. It's always best to try and meet with the agencies, that way you have a better chance of them remembering you. Also, newcomers should hang out in places where you have a good chance of meeting photog-

CONT. ON P 1.13

THE FIRST YEAR

The first six to nine months of your new career can be the toughest. Many artists have full time jobs they work diligently to juggle, while testing for their books or work on student films during their off days and hours. Some try to do it with part time jobs, often taking on roommates or moving back home with parents to make up for the loss in income. Still others quit their day gigs all together and get jobs assisting or apprenticing with more experienced artists while they test with photographers to build their portfolios.

All three choices involve sacrifice. I offer this advice: get your business in order. Make some early sacrifices, cut spending on luxuries like clothes, restaurant outings, and entertainment. Put some money in the bank and save up enough to pay your rent, bills, food and entertainment expenses for at least six to nine months. You can do it!

Becoming a freelance artist is not an inexpensive venture. The least costly area of expertise is hair. Makeup is second. Fashion styling can send you to the poor house. In many instances, a hair stylist or makeup artist can strap kit supplies around their waist in a fanny pack and get away with leaving their wares in the van parked a block away from the photo shoot. The fashion stylist, on the other hand is in constant fear that the $500 Donna Karan handbag and the $2,500 Richard Tyler jacket that were charged on her Mom's American Express card, are going to be the only items the neighborhood thief wants out of the van.

In addition to the basic materials and requirements artists have in common, each discipline (makeup, hair and fashion styling) requires its own specific set of accoutrements (tools). Fashion styling however, is like college, once you pay the tuition, you still have to buy your books. In this case the books are clothing, accessories and props. Unlike a tube of lipstick which can be used over and over again and mixed with something else to make an entirely different color, much clothing is so trendy and specific that it cannot be worn over again until deemed retro in the next decade. Later on in chapter 7, I've included a chart (First Year Budget) that will give you a good idea of what you can anticipate spending during your first year as a freelance artist. If you plan ahead now, you'll be in a better position to have a second year.

GOOD HABITS

Now is the time to start developing good habits that will save you lots of time and money later on.

One of those is collecting and categorizing receipts. Almost everything you do as a freelance artist is write-offa-ble. Mileage, meals, parking, kit supplies, copies, phone calls, etc. The trick is to set up a system NOW that will help you keep track of all those tiny pieces of paper that you will accumulate throughout the year. Later on in chapter 7 (Freelancing, p7.23), you'll see an example of a 1st year budget and a simple system for keeping track of your business, and most importantly—your receipts.

WHAT TO DO FIRST

The most valuable activities you will participate in during your first year as a freelancer will be things like testing with photographers to build a strong portfolio, getting on with a local film school project as part of the crew on someone's first student film, or working your way up from gopher to makeup artist on a low budget music video. It doesn't really matter where you start, just as long as you do... start that is.

As your personal style emerges, you will find that the work of some photographers, or directors excites your senses while others don't do it for you at all. This narrowing down process is quite natural and will help you to focus in on the people you would like to work with and the kinds of projects you see in your future.

The most important advice we got from the artists we interviewed was that you shouldn't waste your time testing with photographers whose work you don't like. The expense of testing is too great to fool around with photographers whose work is not going to get you any closer to your goal. The same goes for directors. There are as many of them as there are photographers, and you will have to search until you find the ones who fit your sensibilities.

In closing this chapter, I encourage you to venture forward and get acquainted with your marketplace.

ALEJANDRO PEREZA
FASHION STYLIST

raphers and other people to test with. For instance, every time I go to make copies of my prints, I meet photographers or models. In fact every time I go to a photo lab, I meet photographers, models, hair and makeup people, at least two or three people. You don't even need to make up prints when you go into a lab, you can just go and ask questions. Don't be afraid to approach people if you see their work and it looks interesting. Make sure you have a business card or promo to give to the people you meet. Also, make sure you read all the fashion magazines from the inter-national ones to the local papers! Watch all the fashion television shows so you can learn who's designer what type of clothing. That will help you to define your own style. **END**

2 TOOLS OF THE TRADE

This chapter is about resources: The tools of your trade. While we can't possibly go into all the specific accoutrements that each discipline (makeup, hair & fashion styling) will require, what we can and will talk about, are the products and services available to the individual who wants to compete successfully as a freelance makeup, hair, or fashion stylist in the major and secondary metropolitan markets throughout the United States and in Canada.

The Career Guide ends with an extensive resource section. We have endeavored to provide you with names, addresses, phone numbers, hours of operation and more on the vendors we believe you can count on to provide you with superior products and services in a crowded and competitive marketplace.

Following are the list of tools we'll cover in the upcoming pages:

Tool #1	The Portfolio	Tool #7	Consumer Magazines
Tool #2	Self Promotion	Tool #8	Trade Magazines
	Print Promo Card	Tool #9	Production Services
	PDF Promo Card	Tool #10	STAPLES *Paper Cutter to Grease Pencil*
	Website	Tool #11	Your Credit Rating
Tool #3	The Internet	Tool #12	The Public Library
Tool #4	The Résumé	Tool #13	Continuing Education
Tool #5	The Reel		
Tool #6	Creative Directories		

TOOL #1: THE PORTFOLIO

A portfolio is probably your most valuable tool. You will take it with you to appointments, drop it off for others, and send it by messenger and overnight courier to clients and prospects throughout the country. Decision-makers are busier today than ever before. It is commonplace for them to select freelance artists by reviewing **only** their books. Everyday, makeup, hair and fashion stylists are chosen for job assignments through the portfolio review process.

Visit **MakeupHairandStyling** .com to stay informed of hot new developments, news, trends and tips. Get advice on career planning, self-promotion along with up-to-date product developments and feature stories on your favorite artists; People like Monifa Mortis, Phillip Bloch, Sam Fine,and Oribe. We recognize freelancers for the work they do behind-the-scenes in print, video, TV, film and fashion. (323) 913-3773. **www.MakeupHairandStyling.com.**

Every picture should not make it into your portfolio just because you worked on it. Artists sometimes make the mistake of putting every test or paid assignment that produces a tearsheet into their portfolios in an effort to fill it up. I've got news for you folks, great hair on a photograph with bad makeup is a bad picture. Bad photography and great fashion styling is simply—a bad picture. An art director isn't going to separate your fabulous hair from bad makeup, photography, or fashion styling, so be discriminating! Pick your best shots!

It's very important that you understand what makes a book stand out, and increases your chances for being singled out and booked for a job. In order of importance, the two factors are content & presentation.

A. CONTENT

By content, creative decision-makers consider these four things. Read and review the questions.

CONTENT	QUESTIONS
1. The quality of the prints, color copies and tearsheets that are shown in your portfolio.	1. Are they sharp & in focus, not over or under exposed and free of finger prints?
2. The choice of images (*photographs or tearsheets*) and stories that make it into your portfolio.	2. Do they feature a combination of good makeup, hair, fashion styling and photography? Are their stories (2+ pages) in your book, or just a bunch of single images with no relationship to one another.
3. The creativity, inventiveness, interest and enthusiasm with which the artist completed their assignments.	3. Are the subjects and environments interesting and well thought out, or is everything just thrown together with little or no thought to the stories that you are telling.
4. Layout. How well did you tell the story of who YOU ARE as an artist?	4. Is there a flow in your book that keeps the viewer with you til' the end? Have you included enough range to let them know you are capable of performing several looks or styles throughout the day—ALL day. Have you thought about the images that open and close your book and the impression that they leave?

Notes:

Over the years I have learned that what most creative decision-makers mean by range is variety within the context of what you do consistently as an artist. For example, if you are a hair stylist, and what you do best is hair that is simple, neat and clean, then show plenty of it. Different models, and variations of styles with lots of changes. That means short hair, medium length hair and long hair. Let me see it up, down and turned around. Let me see it on white girls, black girls, asian and hispanic girls. I want dark and light hair, so I don't think it's all the same model. Let me see it working with the wardrobe, and the environment the photographer is shooting in.

Courtesy of Los Angeles Times Magazine. ©1995. Photos by Troy House, Makeup by Troy Jensen/Celestine, Hair by Neeko/The Crystal Agency, Model: Tyra Banks

If you do a fashion spread with 4 changes of clothes, then let me see what you can do with the hair to insure that it works with the clothing changes. And then be smart enough to know when you **DON'T** need to make any changes at all. Remember that makeup and hair are NOT done in a vacume where you decide to apply makeup or start the hair without knowing what the photographer wants and what the fashion stylist is planning on putting on the model.

The fashion spread **above** is a good example of proper execution by the makeup and hair stylist according to the photographers background—simple and the stylists clothing choices. Neeko, a hair stylist at The Crystal Agency worked on this shoot for the Los Angeles Times Magazine. This was a one day shoot with several clothing, hair and makeup changes. The model is Tyra Banks.

What you see, is Neeko's ability to execute subtle changes in Tyra's hair styles according to what the fashion stylist is doing with the clothes.

Look at these photos. 4 looks. 1 day. Perfect. A story. If this were your test, the only thing missing would be the type and page numbers dropped in by the magazine.

Notes:

B. PRESENTATION

Presentation encompasses the inside, outside, and collateral (the things that go with; i.e., business card, comp card, résumé, etc.) elements of your book. Size, typeface (font), cleanliness, neatness, accessories, and **YOU** all come together to create an impressive presentation. These important elements are often overlooked by artists who don't get it. Remember, first impressions are non-refundable. I see pages ripped sloppily from magazines and photographic prints that bare the uneven scissor cuts of a six year old. Don't let your book be one of those inadequately produced and prepared portfolios that never make it to round two.

1. SIZE

The two popular portfolio sizes seen in the marketplace are 10x13 with 9x12 pages and 12x15 with 11x14 pages. They are referred to [by their page size] as 9x12 and 11x14. My personal preference, is 9x12, it fits perfectly inside a medium FedEx box and most store-bought carrying cases. It also weighs less than the larger books. But it's up to you. Just **DO NOT** pick an 8X10 book, it's unacceptable in this business and reminds everyone of headshots—Not cool.

2. STYLE & TYPE

There are custom (made-to-order) and off-the-shelf (cash-and-carry) portfolios. Custom portfolio makers offer books that can be built according to your taste and pocketbook, the others you can pick up at most art supply stores. Custom style choices include things like:

- **color,** which ranges from black to a bright shade of yellow and just about anything in between.
- **materials** which range from a faux leather-like fabric, better known as wax skin, to alluminum, plastic, real leather and more. If you can imagine it, then Jay Colvin at Advertisers Display Binder Company in New Jersey can make it for you.
- **embossing** which comes in a variety of colors from blind to black, red, gold, white, silver and.yup, just about anything.
- **page type** which can be plastic or acetate. Again up to you. The plastic is matte. The acetate has a more glassy appearance.

For a list of Portfolio Do's & Dont's, jump to page 3.9 in Chapter 3, Marketing Yourself.

Portfolio pages come in two different materials: plastic and acetate. Plastic seems to look better a little longer, but both of these surfaces will scratch and mar over time. Which one you like is a personal choice. The plastic pages have more of a matte quality to them and only open on one end. The acetate pages have more of a glossy quality and open on both ends so that you can put pictures in from the top or the bottom. Which one is better? Neither. It's personal preference.

3. APPEARANCE

Prints and tearsheets are most impressive when trimmed neatly and mounted so that they don't move around in your book.

3. MATERIALS

Portfolio pages come in two different materials: plastic and acetate. Plastic seems to look better a little longer, but both of these surfaces will scratch and mar over time. Which one you like is a personal choice. The plastic pages have more of a matte quality to them and only open on one end. The acetate pages have more of a glossy quality and open on both ends so that you can put pictures in from the top or the bottom. Which one is better? Neither. It's personal preference.

5. ACCESSORIES

Portfolios can be ordered with various sizes of pockets. The size most commonly found in books extend across the width of the inside front and/or back covers. In the past we ordered a pocket for each cover (back & front) since there always seemed to be something to put in them. However, in 1996 we decided that one pocket on the back cover was enough and didn't detract from the creative decision-maker focusing on the opening page. One or more pockets is essential for holding promotional cards, resumes, and things like brochures or catalogues that you want people to flip through. They are also great for business cards. Not everyone carries a promotional card around

PORTFOLIO FRONT

CAROLE TANBOOR

PORTFOLIO INSIDE

address label

comp cards

resume

business card holder

Carole Tanboor
555 W. 5th, Apt 7
Atlanta, GA 30351
(404) 555-1212

Carole Tanboor
FASHION STYLIST

pocket

Notes:

CAROLYN BAKER
FORMER VICE PRESIDENT
A & R DEVELOPMENT,
WARNER BROS RECORDS

Carolyn Baker no longer works at Warner Bros.
Records, however, her job title and responsibili-
ties still exist at many labels.
We thought you could still benefit
from what she had to say.

CG: What is your job at Warner Brothers Records?

CB: I am the vice president of A&R
Development. I work with our artists on
their imaging and marketing for photos
and music videos. For black artists in
particular, not a lot of attention has been
paid to their imaging. I get in-volved in
picking makeup, hair and fashion stylists
for my artists because I'm very con-
cerned that they have the proper imag-
ing.

CG: How do you go about it? Do you get involved with the art department as well?

in their wallet, but they do carry business cards. I recently discovered a way to make business cards available to clients without worrying about whether they were going to slide unnoticed into the big pockets of the portfolios. Cardinal or Smead makes a plastic pressure-sensitive business card pocket. They are available at most office supply stores. (try Staples and Office Depot) You apply them by simply peeling off the self-adhesive backing and pressing them into place on your portfolio. You can then slide two or three business cards into the pocket and clients can remove them at will.

TOOL #2: SELF PROMOTION

The second most important tool in your arsenal is your ability to create, implement, follow-up and follow-thru with a marketing plan to promote yourself. Your plan should include print and web-based promo (comp) cards, a web site, public relations as well as social and community involvement in the creative community with which you want to work. (For more specifics refer to How To Create Your Own Marketing Plan in chapter 3).

a. PRINT PROMO CARD

Every stylist should have one. A promotional card, that is. When I was a sales rep at Xerox, we called them "leave behinds". They are your own personal mini brochures. They show potential clients what you do, your style, and the way you approach your art.

The promotional card, often referred to as a promo piece, comp or zed card acts as your calling card and leave-behind all rolled into one. It will remind others of what your work is like long after you and your portfolio have left someone's office or studio.

Success can be an elusive promise without self-promotion. You may never know how many jobs you didn't get, because after reviewing your portfolio and liking it, the photographer or art director didn't have a promotional piece to hang on to when it was time to hire someone for an assignment. When it's time to call in portfolios for a project, most decision-makers open up their files or glance up at their walls lined with the promo cards they liked and kept. They call the individual artists or their agencies and request that specific books be sent over for upcoming projects. Like the American Express ad instructs, your book should "never leave home" without one.

It's not unusual to walk into the office of an art director or fashion editor for an appointment and find the walls and table tops covered with promotional cards of stylists, photographers and illustrators whose work they find particularly interesting or stimulating.

Basically what we're talking about here are postcards. As the demand for postcards grows as a means of marketing everything from movies to lingerie, the price of having cards printed has

become very reasonable. Companies like Modern Postcard and 1-800-GoPostcard, print 500 4x6 postcards for around $95 dollars. For 500 5-1/2x8-1/2 cards will run around $165 dollars. The cards are four color on one side and black & white on the other. In printer lingo it's called 4 over 1 (written: 4/1).

If for instance the printer was offering 4 colors on one side and 2 colors on the other (perhaps red & black), they would say, 4 over 2 and write it 4/2. Get it?

Without a card, it's hard for a decision-maker to remember what your work looked like when it's time to book talent (like you) for a job. If, on the other hand, there is a promotional card in your portfolio each time it goes out by messenger or you drop it off for review, the odds go way up that your book (if the work is good) will get called back and you will be selected for jobs.

b. PDF [electronic] PROMO CARD

Portable Document Format, better known as PDF is my new favorite thing. PDF is a new way to send documents across the world wide web. In this particular case the software used to create PDF documents is called Adobe Acrobat. Adobe Acrobat is a widely used FREE piece of software that you can download off almost any site, including ours (www.MakeupHairandStyling.com).

Unlike much of the stuff that is delivered to your email box with that disgusting Helvetica or Geneva type face that we all dread reading, PDF documents open up live and in living color. It's kind-of like when Captain Kirk would say, beam me Scotty, and there he'd be, live and in living color. PDF is very 3-D. Documents come to life. You can print them out on your black & white or color laser printer at home and you'll get something very close to what you might have gotten in the mail. It really depends on your printer.

How does that help you? An art director calls at 4pm and says "can you get your book to me by 10am tomorrow?" Do you panic because your book is at another clients office for review? Sure, if you don't have a PDF promo card.

Imagine for a second that you've already turned your four color promo card into a PDF file. It takes about 2 minutes or less. If you have, you very confidently say "Well Mr. Art Director, my book is out for a job, but I'm sure you have an Epson color printer in your office, how about I send you a PDF file of my most recent promo card and you can print it out?"

You see, unlike many freelance artists who are still going to Kinko's or a friends house to pick up their email because they don't have computers, let alone printers, most creative decision-makers have BIGG FATT Epson color printers in their offices and BIGG FATT 21 inch screens with which to display anything you might send them over the net. So, go ahead, send that email with an Adobe Acrobat PDF'd promo card to the art director and get that Job!

CAROLYN BAKER

CB: I look at books. I work with the art department, and the video department. Most of the time we agree. When we don't and I think that something really needs to be addressed, I figure out how to do what I want to do. Most of the time that's not necessary. We call the agencies and request books. Sometimes, agencies call me to tell me about somebody who's new and exciting. When I have a need, I'll consider their recommendation, or ask to see the person's portfolio. Sometimes I'll take chances on people. I'm always looking for somebody really good. People are good for different kinds of artists. Fashion stylists seem to work for a certain vibe. I'm always looking for people who are on the cutting edge of what's going on.

CG: How do you like to be contacted by artists?

CB: They should call me and drop off their portfolio. That's the only way I can have any indication of what their work is like. I don't get too upset about being called or being solicited by individuals. I'm looking for people. Sometimes people come up with really interesting ways to get to me and I like that. It shows something special about them. If their work reflects that and they've got a good creative thing going on then I'm really interested in trying them out.

CG: When do you like to look at books?

CB: Monday is the worst day ever. I don't want to hear from anybody on a Monday. I also think Friday afternoons are a bad time. Any other time in the week is cool.

CAROLYN BAKER

CG: What turns you off about a portfolio?

CB: A bad portfolio is one that's not put together well. It shows the person doesn't care about their work or presenting themselves in the best possible light. There's a difference between being sloppy and not having a lot of money to put together a great, glitzy book, and it's not the same thing. Somebody may not have a lot of money and still show their creativity by putting together an interesting book.

A book that shows a good range is what grabs me. It's hard to say off hand what will get my attention. There are just things that I like or things that I don't like. It's hard to say until I'm looking at it. **END**

Notes:

QUESTIONS ABOUT CARDS

WHAT SIZE SHOULD MY CARD BE?

Promotional cards come in a variety of types and sizes. The most common and least expensive ones range in size from 5-1/2 x 8-1/2 to 8-1/2 x 11 and are usually made of 80-100 pound card stock. In printer-ease you might say 10-12pt stock. They can be black and white or color, and are often two-sided. The more elaborate the card the more it costs. A card can be shaped like an accordion, fold out into the shape of a bird, or be printed on vellum paper. You can produce whatever your mind can conceive. Your only limitation is money.

BLACK & WHITE ONLY?

Artists often ask whether they can have an all black & white card. Fashion stylists and hair stylists can sometimes get away with using only black and white images on their cards. However, this technique rarely works for (unknown) makeup artists because black and white photography can easily hide the facts. A photographer looking for a great makeup artist won't be able to tell whether the makeup artist inappropriately applied blue eye shadow on a model wearing a brown tweed suit being photographed if he can't see the color. Very few photographers would take a chance on hiring someone they've never worked with or never heard about if all they've ever seen of the artists work is in black & white.

HOW MANY PICTURES SHOULD I PUT ON MY CARD?

Now there's the million dollar question. You could put 10 on a card. . .but I wouldn't advise it. Why? Because less is more and the purpose of a promo card is to give the decision-maker a taste of what they'll find in your portfolio, not the whole shabang! Personally, I don't want to see more than 4 pictures on a small card and 1-3 is better.

DO I NEED PERMISSION TO USE A PHOTOGRAPHERS PICTURES ON MY CARD?

Photographs are owned by the photographer who took them. They call it copyright. There are times when the photographer sells his copyright or grants certain usages to clients such as magazines or record companies. Because of this, it's very important that you ask

QUESTIONS ABOUT CARDS

the photographer for permission to use his/her photographs before having them printed on your promotional card. In most cases, the photographer will not withold permission unreasonably, however as a professional courtesy, you should ask. And whenever possible, get written permission. Always get the correct spelling of the photographers name and provide them with written credit on your card. Yes I know, they rarely reciprocate the credit for makeup, hair or styling on their own card but that's the world we live in.

Listen Up! Getting anything from a photographer after a shoot is almost impossible. Make it a habit to ask up front for permission to use the photographs from the shoot on your card and in your book (See chapter 4 for more information on working with photographers).

c. WEBSITE

Over the next few years your website will become as important as your portfolio and hopefully cost you a lot less to maintain. The trick to creating a website is not getting it built, but getting it seen. If you build it and don't promote it (by at the least submitting it to major search engines like Yahoo), it's like trying to sell a house without a real estate agent or a newspaper ad. The only people who will know that your house is for sale are the ones you tell and the people who drive down that street. Not very good marketing is it?

1. Hiring a Webmaster

The place to start creating a website is in a quiet room with a pencil and paper, a computer and a printer. (**see sidebar page 2.16 - Creating a Website Development Plan**) Why? You need the computer so that you can surf the web to find out what elements exist on other sites that you would like to incorporate into yours, a printer so you can print out copies of those pages to use for reference and a pencil and paper so you can formulate your plan in writing and keep a record of all the questions you need to get answered before you begin building, or having someone else build your site.

What's the problem with web builders? Everybody thinks they are one. Anyone with a copy of Microsoft Front Page web building software thinks they are a webmaster. They're not. Can you

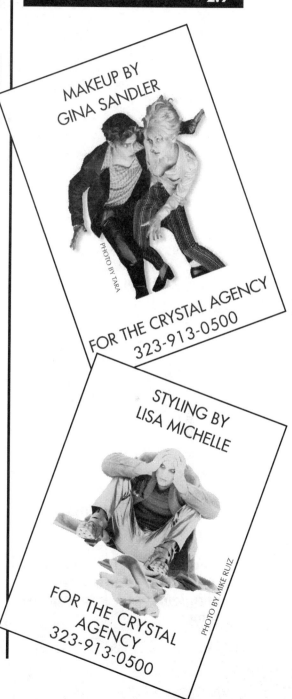

MAKEUP BY GINA SANDLER

PHOTO BY TARA

FOR THE CRYSTAL AGENCY
323-913-0500

STYLING BY LISA MICHELLE

PHOTO BY MIKE RUIZ

FOR THE CRYSTAL AGENCY
323-913-0500

ADOBE ACROBAT & THE FREELANCE STYLIST

Portable Document Format (PDF) is the standard for sending your attached email files around the world.

PDF is a universal file format that <u>preserves</u> all of the <u>fonts, formatting, colors, and graphics</u> of any source (original) document, <u>regardless</u> of the application (Word, Quark, Pagemaker, Works, etc.) and platform (MAC, Windows, Unix) used to create it. PDF files are <u>compact</u> (don't take up much space at all) and can be shared, viewed, navigated, and <u>printed exactly as intended</u> by anyone with a free Adobe Acrobat® Reader™. <u>You can convert any document to Adobe PDF</u>, even scanned paper, using Adobe Acrobat 4.0 software which you can purchase through Adobe at: **www.adobe.com**.

WHAT PROBLEMS WILL IT SOLVE

P: Recipients can't open files because they don't have the applications used to create the documents.

S: Anyone, anywhere can open a

tell that I've been through my share? Ugh! But you need a web presence so what do you do?

You can hire a webmaster to build a site from scratch, do it yourself or lease space on an existing site that offers you several pre-set templates to choose from. There are lots of these kinds of sites set up for other kinds of businesses, however, to date I haven't seen a great one for freelance makeup, hair and fashion stylists.

If you can find one it's a great option because it affords you the opportunity to submit the pictures you want scanned and uploaded onto your new site along with your résumé in many cases. These kinds of subscription based programs typically offer a specific number of times that you can update the pictures and the résumé on the site for a pre-set amount. Furthermore, and most importantly, is a site that caters to a specific industry will submit the website to search engines (Yahoo, Excite, Goto, etc.) for you. Ongoing and scheduled submissions to search engines is one of the ways to drive traffic to your site.

The scarriest thing about having a website built is not knowing anything about it. Like photographers who run away with your photos, web designers are even better at dissappearing since often you get into business with them without ever meeting them. Do yourself a favor, take a class or read a book. I have two very savvy business associates who run successful companies and didn't even know how to look up the dot com's they owned. They were at the mercy of the webmasters who were [supposed to be] working on their sites, and even though nothing was getting done, they didn't know how to take their real estate (dot com) back.

TOOL #3: THE INTERNET

The world wide web is here to stay. Everyone has got or is getting a web page and so should you. When you think "Internet", think information, research and access. The next time you need access to information or have to research a project, dial up one of the popular search engines and go for yours. Just about everyone in the world knows about Yahoo! However there are ton's of others like Dogpile, Goto and NorthernLight, which can open up doors that you've only imagined. It's the new portal to the world. You can access up-to-the-minute articles on the latest makeup maven or discover the web site of a small town designer you may have never heard of and whose clothes might be just right for a project you're working on. If you don't already have a computer - buy one, share one or rent one. Just don't get left behind on the information highway!

CONT. ON P. 2.12

HOW TO LOCATE, DOWNLOAD AND LAUNCH ADOBE ACROBAT 4.0 FOR USE ON <u>YOUR</u> COMPUTER

Here's the bottom line! If you share over the web, you should be doing it in Adobe PDF. Acrobat Reader is FREE and easy to download from **www.adobe.com**

MACINTOSH

- Apple Power Macintosh or compatible computer
- Mac OS software version 7.1.2 or later
- 4.5 MB of available RAM (6.5 MB recommended)
- 8 MB of available hard-disk space
- 50 MB of additional hard-disk space for Asian fonts (required for Acrobat Reader 4.0 CD-ROM, otherwise optional)

Choosing Either the .bin or .hqx File Format When Downloading So what's the deal?

When downloading Macintosh files from Adobe's Web site or FTP site, you <u>may</u> be given a choice of two different file formats: ".bin" or ".hqx."

The .bin file will download faster, but is less compatible with older systems. The .hqx file takes longer to download, but is more compatible with older systems.

WINDOWS

- i486™ or Pentium® processor-based personal computer
- Microsoft® Windows® 95, Windows 98, or Windows NT® 4.0 with Service Pack 3 or later
- 10 MB of available RAM on Windows 95 and Windows 98 (16 MB recommended)
- 16 MB of available RAM on Windows NT (24 MB recommended)
- 10 MB of available hard-disk space
- 50 MB of additional hard-disk space for Asian fonts (required for Acrobat Reader 4.0 CD-ROM, otherwise optional)

If you want to create your own PDF files: Adobe Acrobat 4.0 sells for about: $249.00

ADOBE ACROBAT & THE FREE-LANCE STYLIST

PDF file. All you need is the free Acrobat Reader.

P: Formatting, fonts, and graphics are lost due to platform, software, and version incompatibilities.

S: PDF files always display exactly as created, regardless of fonts, software, and operating systems.

P: Documents don't print correctly because of software or printer limitations.
S: PDF files always print correctly on any printing device.

WHAT BENEFITS DOES IT OFFER?

P: PDF files can be published and distributed anywhere. Attach your promo card and/or resume to an e-mail and send it to an art director. Post it on your web site or make it available on someone elses.

YOUR OWN .COM

Getting your own dot com is a lot easier and cheaper than you may think. One of the best resources around is a site titled: **www.namesecure.com**. At Name Secure you can register a Domain Name [online] for [two years] for $35 instead of $70, or you can call them on their Toll-Free number (800) 299-1288. Another good site is **www.register.com**. I usually go to register.com to search the name since it let's me search for multiple endings (.com, .net, .org) all at the same time and then go to namesecure.com to buy since it's cheaper.

WHAT DOES IT MEAN THAT I JUST GOT MY OWN .COM?

It's like buying a piece of property. You don't have to build a house on it right now but whenever you get ready to, it's just waiting. Like property you have to pay the taxes on it, but, heck, it's only about $35 a year after the first two.

CAN I SELL MY .COM?

Sure you can—sell your "dot com" real estate that is. I own several

TOOL #4: THE RÉSUMÉ

Résumés are viewed differently by various segments of the industry. When asked if they looked at résumés, and whether or not they were important as a means of hiring artists for jobs or signing an artist to an agency, here's what five industry decision-makers had to say:

Pat Harbron
Photographer

Carolyn Baker
Former VP Artist Dev.
Warner Bros Records

Joan Weidman
Freelance Producer
Film, Video, Commercials

Valerie Wagner
Art Director
Atlantic Records

Kevin Stewart
Fashion Director
Details Magazine

"A résumé doesn't mean anything to me by itself. I don't rely heavily on them."

"No, not at all, not for make-up, hair and styling."

"Yes. Because frankly, there are so many people out there, that I want to see their credits before I go so far as to speak to them."

"No, we never look at them, we never get any for the most part."

"Résumés are fine, but I can't hire a stylist from a résumé. I need to see their work."

The only thing worse than a poorly compiled portfolio is a sloppy résumé and cover letter. It's often said that a résumé won't get you the job, but it can lose the job for you. A résumé may not guarantee you the job assignment, but it can and will help you get your foot in the door of many television and film company decision-makers who won't entertain meeting with you until they review it.

The résumé for an artist who works in the film and television industry (Makeup Artist Marietta Carter Narcisse), is quite different from the résumé of an artist who works in the print arena (Hair Stylist, Neeko).

Mary Colletti's film résumé appears on p 2.16. A film and television résumé lists an enormous amount of information that includes the production company, director, producer, artists title and the project name. A film makeup artists résumé will give the creative decision-maker (in this case proba-

bly a producer or director) an opportunity to see the kind of responsibility the artists has had (by looking at his/her title) to determine whether or not the artist should be give the same position on an upcoming film or if the artist might be ready to assume more responsiblity and thus a better title.

Neeko's résumé (pg 2.18) on the other hand makes no mention of a particular position on a shoot. He is the hair stylist. This resume is designed to communicate something completely different about the artist. Creative decision-makers want to know who you've worked with, i.e. well known photographers, top-notch magazines, high-profile directors, cutting edge projects, etc. Most print résumés are like this, listing only categories, key individuals, projects and clients.

What can be wrong with a résumé?

Take a close look at and compare the grammar, spelling and clear, concise thoughts in the those artists résumés on pages 2.16 & 2.18 to the résumé on page 2.19. I received this letter from an artist who was interested in representation with the agency. I'm sure you'll agree that it leaves much to be desired.

TOOL #5: THE REEL

A reel, like a print portfolio, is a compilation of your work that has appeared on music videos, television commercials, television shows and/or in feature films. In my experience, artists who work in TV and film do not usually have reels. One reason might be because the cost to edit five feature films down to a few minutes can be quite prohibitive. The real reason is probably because most well known artists who work in film and TV are hired by their resumes and word-of-mouth. There are several components and steps involved in compiling a reel. They are:

1. Purchase of master tape stock
2. Collect music videos, commercials, TV shows, feature films and stills
3. Select an Editor
4. Schedule an editing session
5. Select the music
6. View existing videos to identify best pieces and sections for final tape
7. Select or "create" the opening & closing titles
8. Create video and case labels

A reel is a production. It is created by collecting the music videos, TV commercials, TV show episodes and feature films on one or more master tapes and then editing them down to a few fabulous minutes of an artist's best work and laying some music over the top for mood.

CONT. ON P 2.20

.com's from **"makeup, hair & Styling.com** to **Fashion Stylist.com"**. I'm not quite sure what I'm going to do with them, but I'm pretty sure they fit into the Set The Pace Publishing Group Plan somewhere and $35 was a small price to pay.

TOP 15 SEARCH ENGINES YOU SHOULD BE LISTED WITH

Alta Vista	HotBot
AOL	InfoSeek
Deja.com	Lycos
Direct Hit	Northern Light
dot com directory	Snap!
	WebCrawler
Excite	What-U-Seek
Google	Yahoo.com

Addme.com is one of the most popular website submission engine on the Internet. It's easy, free and remembers your information when you log back in.

Your website is only as good as the number of people who can find you on the web. Add Me! lets add your site to the top 30 most popular search engines for free.

Additionally it has tools to help you manage and grow your site.

www.addme.com

EMPOWERING YOURSELF ABOUT THE WORKINGS OF A WEBSITE

Knowing nothing about how to purchase and maintain your own dot com is courting disaster. Here are the basics of what you'll need to know to get into and out of your website.

1. Your password
2. How-to access your site using your own password.
3. How-to change the password you gave the webmaster [who has access to your site] when he/she begins to non-perform the agreed upon tasks.
4. How-to upload the site onto your computer and download the site back onto the hosting company's server.
5. How-to upload, resize and insert pictures
6. How-to create links to pictures
7. How-to insert basic html for:
 a. Pictures
 b. Links
 c. email addresses
8. How-to include an email address

10 Steps to Building a Freelance Friendly Website

There are no excuses for not a having Web site! Here is a simple 10-step check list to ensure you don't overlook anything.

1) Create a Website development plan that is integrated with your overall marketing. (See sidebar p. 2.16)

The content should be consistent with your promo card and portfolio. The graphics/images don't have to be identical to your book and card but should be consistent with your overall look, style, use of colors, etc.

2) Hire a Web designer that understands the freelance marketplace.

Not someone who is so in love with their own design capabilities, that your site gets bogged down with their idea of good graphics, etc. But, check your ego at the door when working with a designer. Many good website designs get ruined by artists who can't or won't listen to what the designer tells them about *how things work* in a web environment. It's not paper!

3) Load times

Remember that you're targeting creative decision-makers who are reaching your site via ISDN or DSL (high-speed modems). Because of this you can build a site that incorporates streaming audio or video, Shockwave or Flash capabilities (plug-ins: whistles & bells). Remember you're building this for business, not your family and friends.

4) Keep it simple

Make your site easy to move around in. Build a menu structure that is consistent with industry standards, local menus (for a page or section) on the left and global menus (overall site navigation) at the top and/or bottom of each page, keep as much information "above the fold" (above the cut off point at the bottom of a monitor), don't make people use horizontal scroll bars unless absolutely necessary.

5) Infuse "digital speed (mouse-clicks)" into your overall site design

Your prospective clients should be able to get to their desired area of your site within one or two mouse clicks. They will quickly get frustrated if they have to click through multiple menus to find information they are seeking.

10 Steps to Building a Freelance Friendly Website

6) Develop content that is Web enabled

People don't read Website content like they do magazines and newspapers. Keep your paragraphs short, no more than two to three sentences, build in white space with your content, include links in your pages (ex: when they click on a small picture it gets bigger) don't try to tell your whole marketing story on your site

Get people to call you (hello! the telephone still works!), email or fill out a profile form (guestbook). You can't follow-up with a potential client if you don't give them a way to let you know that they were there.

7) Make your site permission-based marketing ready

Ask a creative decision-maker for their permission to continue to market to them. It helps to build a long term relationship.

8) Make sure your site is optimized for Search Engines.

Identify 8-12 keywords that people will use to find your site. Incorporate them in your site content to drive relevancy with search engine spiders/bots). **Manually** submit your site to the top 10 search engines. Don't waste your money on the $19 spe-cials available. I use **www.addme.com**. It's free and easy.

9) Delve into your log server files.

Uncover "digital tracks" made through your Website (raw files that show how and from where (in most cases) people accessed your Website, where they went on your Website, how long they stayed, etc.). The hosting company you choose will give you access to these records.

10) Think global in your overall site design

The greatest Internet growth is occurring outside North America, so it is essential to build a site that can be accessed easily by people around the world.

What issues do you need to look at? Develop content that avoids colloquialisms (jargon) that may not be understood by others who don't speak the same language.

That's it... Follow these tips and your Website will be Freelance Friendly!

9. How-to create and resize tables
10. How-to make minor changes such as:
 a. fix typo's
 b. update your resume
 c. and/exchange outdated pictures.

Learning these basics is a CHOICE. Taking a four hour class at the local community college or taking the time to read and understand a book on website design is a way to empower yourself.

The web is here to stay. Using it is another tool in your arsenal for marketing yourself as a freelance artist. **END**

Notes:

WEBSITE DEVELOPMENT PLAN

Now is the time to go to that quiet room with your pencil & paper. Answer these questions before you start building a site or giving the assignment to a designer and you could save yourself weeks of pounding your head against the nearest wall. Begin by assessing your workflow environment:

Do you want more than one website?
__ Yes, How many? ____
__ No

If you have strong film & TV art (photos) and credits (resume) that you want to present as well as strong print art and credits you may want to consider 2 sites that can be marketed and submitted to search engines separately. Some artists have 2 distinctly different books for this very reason.

What is the primary purpose of the site(s)?

__ E-commerce (selling stuff)
__ Information (text)
__ Product Presentation & Info.
(Presenting your portfolio & resume)
Other _____

SAMPLE RESUME FOR FILM AND TELEVISION MAKEUP ARTIST

MARY COLLETTI
MAKE-UP & HAIR
LOCAL 555
marycolletti@filmfair.com
(555) 555-1212

FILM

PATCH ADAMS	MAKE-UP THIRD
Universal Pictures • Dir: Tom Shadyak	
CARRIE II	MAKE-UP THIRD
United Artists Productions • Dir: Bob Mandel	
ANIMALS	MAKE-UP
Magnolia Mae Films • Dir: Michael Di Jiacomo	
DECEIVER	MAKE-UP
MGM / MDP Worldwide • Dirs: The Pate Brothers (Joshua & Jonas)	
GREAT EXPECTATIONS	MAKE-UP
20th Century Fox • Dir: Alfonso Cuaron	
MY FELLOW AMERICAN	MAKE-UP
Warner Bros. • Dir: Peter Segal	
TO GILLIAN ON HER 37TH BIRTHDAY	1st.ASST.MAKE-UP
Sony/Albemarle Prods. • Dir: Michael Pressman	
MY TEACHER'S WIFE	MAKE-UP
Savoy Pictures • Dir: Bruce Leddy	
FALL TIME (c.1950's)	ASST.HAIR
Fall Time Inc. • Dir: Paul Warner	
RADIOLAND MURDERS (c.1938)	MAKE-UP
Universal • Dir: Mel Smith	

THE HUDSUCKER PROXY (c.1954)	HAIR
Hudsucker Pictures • Dir: Joel Coen	
AMOS & ANDREW	MAKE-UP
Castle Rock • Dir: Max Frye	
TEENAGE MUTANT NINJA TURTLES II	MAKE-UP
New line/Golden Harvest Prod.Dir: Michael Pressman	

TELEVISION

DAWSON'S CREEK	1st ASST.MAKE-UP
WB/Columbia-Tristar Prod: Greg Prange	
LEGACY(Pilot)	1st ASST.MAKE-UP
UPN/Atlantis Productions Dir: Stuart Gillard	
THE DAY LINCOLN WAS SHOT	MAKE-UP
TNT • Dir: John Gray	
WHAT THE DEAF MAN HEARD	1st.ASST.MAKE-UP
Hallmark Hall of Fame/CBS Dir: John Kent Harrison	
UNSOLVED MYSTERIES	KEY MAKE-UP
(episode: Picture Taking Fugitive) Cosgrove/Meurer Productions • Dir: Jim Lindsay	
THE STEPFORD HUSBANDS	ASST.MAKE-UP
CBS/Edgar J.Scherick Assoc. • Dir: Fred Walton,	
THE DAN JANSEN STORY (MOW)	KEY HAIR
CBS/Warner Bros. • Dir: Bill Corcoran	
BLUE RIVER (MOW)	1st.ASST.MAKE-UP
Signboard Hill Prod/Fox • Dir: Larry Elikann	

SAMPLE RESUME FOR FILM AND TELEVISION MAKEUP ARTIST

COMMERCIALS & MUSIC VIDEOS

RAYBESTOS BRAKES KEY MAKE-UP/HAIR
(4 spots,english and hispanic)
Manhattan Film & Tape/Maximum Marketing
Dir: Mark Sitley

GENERAL ELECTRIC KEY MAKE-UP/HAIR
Colelli Productions/Sheehy & Assoc.
Dir: Ralph Colelli

FIRST NATIONAL KEY MAKE-UP/HAIR
BANK OF PENNSYLVANIA
Jack O'Brien Agency • Dir: Jack O'Brien

OSCAR MAYER BOLOGNA KEY MAKE-
UP/HAIR
Michael Daniels Assoc. • Dir:Mark Piznarski

HARDEE'S FRIED CHICKEN KEY MAKE-
UP/HAIR
Brad Christian Films • Dir:Roger Tonry

McCOY'S CRISPS KEY MAKE-UP/HAIR
K.P.Foods U.K. • Dir: Syd Macartney

SUSIE BOGGUSS ASST.MAKE-UP/HAIR
"Drive South" (Music Video)
Deaton Flanigen Prods. • Dirs:Deaton & Flanigen

SPECIAL EFFECTS

BRAVEHEART, (U.K.)
ANIMATRONIC HORSE f/x crew
Paramount/Icon Productions. • Dir:Mel Gibson

IMPERIAL WAR MUSEUM EXHIBIT,(U.K.)
FINAL TOUCH-UP & LASHES

Lifelike Replicas Cazaly-Schoonrad

TEENAGE MUTANT NINJA TURTLES
CREATURE DRESSER
Golden Harvest Productions Dir: Steve Baron

References Available Upon Request

MARY COLLETTI
MAKE-UP & HAIR
LOCAL 555
marycolletti@filmfair.com
(555) 555-1212

WEBSITE DEVELOPMENT PLAN

In which formats are you interested in repurposing the content on your site?
__ CD-ROM __ DVD-ROM
__ PDA (hand-held device)
__ Other _____

In which languages would you like your site to serve content?
__ English __ Other_____

How many pages will your site be? ____
How many pictures will you display? __
How many times will you change them
per: __ month? __ quarter? __ year?

Who will add more pictures to your site? __ you? __ the webmaster?

How will you communicate with visitors?
__ Guestbook __ Database
__ Other _____

How will you present your resume on the site?
__ as a PDF file
__ can be printed directly from the site
__ both PDF & printing from the site

How will you present your promo card on the site?
__ as a PDF file
__ can be printed directly from the site
__ both PDF & printing from the site

How will people reach you?
__ a link to my email address
__ my address, __ phone, __ fax,
__ pager information will be present on the site.

we heard...

Crystal Wright proudly presents "Packaging Your Portfolio: Marketing Yourself as a Freelance Makeup, Hair or Fashion Stylist."

The 8-hour workshop covers building a portfolio, testing with photographers, signing with an agency, getting work from record labels, magazines, production companies, and more. The presentation includes a 1-hour Q&A session with a panel that includes art directors, editors, photographers, agency bookers or owners, etc., who hire or sign freelance stylists for work in the industry. Crystal brings artists portfolios from Los Angeles as well as portfolios from agencies in the area. Call (323) 913-0500. Or visit us at: www.MakeupHairandStyling.com.

you want to be famous...

NEEKO
HAIR STYLIST
PHOTOGRAPHERS

Jon Ragel	Isabel Snyder
Kate Garner	Troy House
Albert Sanchez	Ken Bank
Bob Sebree	Dewey Nicks
Alberto Tolor	George Lang
Dan Winters	Greg Hinsdale
Firooz Zahedi	Dorothy Low
Patrick Demarchelier	Bonnie Shiffman
Robert Erdman	Wayne Stambler
Larry Bartholomew	Richard Hume

EDITORIAL

Esquire	Elle
Vibe	Allure
Movieline	InStyle
Entertainment Weekly	US
GQ	Stuff
fitness	Maxim
Essence	LA Times Magazine
YM	Italian Max
Heart & Soul	Vanity Fair

RECORDING ARTISTS & CELEBRITIES

Halle Berry	Gena Lee Nolin
Nikki Taylor	India Davenport
Lil Kim	Holly Robinson
Elizabeth McGovern	Shara Nelson
Tyra Banks	Amanda Colville
Veronica Webb	Kellie Williams
Debra Cox	Lela Rachon

NEEKO
HAIR STYLIST
MUSIC VIDEOS

Neeko is a favorite hair stylist to all the major record labels. Music videos and/or CD packaging photo shoots for the following recording artists throughout the year include [but are not limited to]:

Tamia, Debra Cox, Keith Sweat, adriana Evans, Yolanda Adams, Athena Cage, Simone, Color Club, Lisa Taylor, Billie Lawrence, The Braxtons, Organized Noise & more.

ADVERTISING & COMMERCIALS

Cover Girl
Bill Blass
Schlitz
Dark & Lovely
McDonalds
Revlon
M&M's
Macy's

FEATURE FILM

Executive Decision starring Halle Berry

TELEVISION

Keenan Wayans Show
Vibe Television
Nickelodean

THE CRYSTAL AGENCY
(323) 906-9600

SAMPLE COVER LETTER AND RESUME

To Whom it may concern,

1A I am currently looking for employment as a stylist. Recently I've been working as a special effects artist in the film and television industry.

2 For the last ten years I've been involved with work as a freelance make-up artist, stylist & costumer, fabricator for creatures, props & minature fx and set decoration/construction.

1B **3** I am interest in pursuing my career as a stylist, and would like the opportunity to focus my talents working with you. Enclosed is an current **4A** résumé, I would appreciate and look forward to hearing from you on your upcoming and future projects. **4B**

5A Thank you, sincerely, **5B**

XXXXXXXXXXXX

```
                          XXXXXXX X. XXXXXX   7
                           P. O. BOX XXXXX
                         PASADENA, CALIF. XXXXX
                         PH: 714-XXX-XXXX
                                                        8A
Beauty Consultant/      Buffums Dept. Store - Glendale, Ca
Make-Up Artist          Part-Time Sales as an extra in cosmetic    8B
Sales  6A               dept.  1978 - 1979

Beauty Consultant/      May Co. Dept. Store - Eagle Rock Plaza, Ca
Make-Up Artist          Full-time line girl for Max Factor,
                 9A     Christian
Sales  6B               Dior lip & nails, Francis Denny, Germain
                        Montiel.  1979 - 1983              8C

Beauty Consultant/      Bullocks Dept. Store - Pasadena, Ca
Make-Up Artist          Part-Time line girl for Chanel Cosmetics
Sales  6C               1983 - 1985                        8D

Beauty Consultant/      Elite Nails Etc. Salon, Montebello, Ca
Make-Up Artist          Part-Time Make-Up Artist, Facilist, Waxing
Esthetician             Technician.  1985- 1986

Free Lance Make-Up      Independently working with salons, fashion
Artist/                 shows, and photographers.  1986-1988

Free Lance Make-Up      Stagelight Cosmetics - Make overs in
Artist              10B department
Sales/  6D              stores to promote sales.  1988-1989
```

Talents and Abilities **12A**
Esthetician, Make-Up, Waxing, Facials.
Make-Up Artistry in:
High Fashion, Photography, Special FX,
Fantasy, Corrective, and Salon Makeup

Education **12B** **11**
10A Elegance International, Inc, Academy of Professional School Of
Make-Up.
Wilshire Blvd. Los Angeles, Calif. 1982

Elegante Schools of Beauty College - Esthetician License. Pasadena,
Ca **8E**
1984

Awards **12C**
Wimba Fantasy Make-Up
Ball Masque 2nd Place student, competition produced by Marvin
Westmore.
1984 World International Championship

References available upon request

CORRECTIONS

The cover letter and résumé at left would be dismissed by most agencies & art directors for the following reasons:

1A-B *We don't know what is meant by the word "stylist"?*

2 *In this paragraph the artist appears to be a Jack of all trades; doesn't specialize in anything.*

3 *"interest" should have been "interested".*

4A *"an" should be "a"*
4B *"," should be a "."*

5A *"Thank You" should have been the beginning of a complete sentence.*
5B *"Sincerely" should be 2 spaces down from the "Thank You" sentence.*

6A-D *Sales has no relationship to the corresponding line.*

7 *California should be spelled out in the heading or abbreviated using capital letters "CA".*

8A-E *"Ca" should be "CA".*

9 *Dior & remainder of the line should be on the line with Christian.*

10A-B *Widow Line should be moved up to fit on previous line.*

11 *The address is not necessary.*

12A-C *Talents & Abilities, Education & Awards should all have a colon (:)*

TOOLS:

GETTIN' YOUR STUFF ON TAPE

1. Buy one or more of your own high quality 3/4" tape stock.

2. While negotiating your rate, negotiate your videotape deal with the producer the same way you would your print deal with a photographer.

3. Find out who the contact person is at the production company, their phone number and when the video is scheduled for release and/or compilation.

4. Include the videotape terms in the terms and conditions of your deal memo (confirmation form).

5. About the time the video is scheduled for completion, deliver or mail your high quality 3/4" tape to the appropriate contact at the video production or record label for transfer onto your tape.

For example, let's say that you are a makeup artist who has worked on five music videos totaling 20 minutes of tape. First you must begin the task of collecting each of your videos. You can do this any way you like. Most artists spend hours on the phone, calling production companies and record companies trying to get the company to put their work on VHS tapes and send them out. Usually, what happens is NOTHING. Why? Because production companies are in the business of making movies, videos and TV shows, not copies of those shows for everyone who worked on them.

So here are my suggestions for **GETTING YOUR STUFF ON TAPE** in the side bar to the right.

Make sure to enclose a memo-style letter that includes the following information on the single sheet of paper that accompanies your reel:

Video Title • Director • Producer • Job Name • Artist • Job No.

The memo should also include a sentence requesting that the video provider not erase anything already on the tape, and to leave 15 seconds of black after their entry.

Make sure your video is labeled with your name, address and phone number. Also hand write or type a self-adhesive label and include postage so the company will have no problem getting it back to you. Sound like a lot of work? It is. But in seven years it's the only sure fire way I've found to ensure you get what you need 80% of the time. I said "sure fire", not "fool proof". Repeat this process until you have collected each one of your videos, commercials, etc.

Make sure to label the tape with the name or title of work collected so you know what is on which tape and in what order it appears. If you are collecting videos and commercials, I suggest you invest in two (2) 3/4" high quality tapes. If you're wondering why I'm stressing the high quality tape thing it's simple. Everytime your video is copied, it looses a generation of quality. If you begin with a cheap low grade 3/4" or VHS tape, by the time you reach duplication stage, the final product will look like a gray day in Cleveland with low cloud cover. In order to end up with a product that is commensurate with your work and talent, you must begin with a high quality product.

Music Selection

Music selection is the part where you get to let your personality shine through. Pick a piece of music that represents you and your style. Beware, however, if you are building a universal career, pick something that a majority of decision-makers will respond to. 2Pac's "How Do You Want It" probably would not be a good choice.

THE ARTISTS AGENCY
PRESENTS
MAKEUP & HAIR
BY

MARY COLETTI

FOR BOOKING INFORMA-TION

CONTACT:

DENY POINTER

(216) 555-1234

www.artistsagency/mary.colleti
email: bookingsmary@artistsagency.com

*the sample **title** card pictured above serves as the lead in to a video or commercial reel*

In choosing your music, take into consideration the feeling and flow of the video and commercial clips that will appear on your new presentation reel.

Title

Your name, phone number, profession and any snazzy graphics make up what's known in the business as a Title. Hence, a title card (see example above). The editor usually has equipment that allows him/her to type in your vitals. However, most editors will have the ability to create something pretty sophisticated on a computer or use something you bring on a disk to serve as your opening and closing titles. Just make sure you ask the editor in advance, what format he/she is using so that the artwork will work on the editors system.

Planning

Your next step is to view all the videos, commercials, TV and film clips on your master reel and compile a list of the shots you desire in the finished product. It's also a good idea to think about your beginning (opening shot), ending (closing shot) and your middle. Planning your shot list in advance will save you time and money at the editing bay since the editor usually charges by the hour or has a set number of editing hours for a specific rate. Before scheduling your editing session, give yourself enough time to view your master reel and create your title card.

Ask the editor about his ability to create a title and/or shoot one. If you are creating or having an outside entity create your title card, make sure you ask the editor about the size of card (finished art) they like to work with. If you have a particular typeface you are using or you have a logo, then it should be incorporated into your title card.

Notes:

Notes:

Identification

Video and case labels are necessary for identification and the expeditious return of your finished VHS reels. But here's the catch: very few production companies return reels. So while you will spend a premium for your master tapes, the copies which you send out should be purchased in bulk and don't expect to see them again. Don't worry too much, 5 minute VHS tapes will only run you about $2-4 each. When you purchase your tape stock, make sure you ask about labels. You can write, type or have your logo imprinted on them. The most important elements other than the tape stock is your name, address and phone number.

TOOL #6: CREATIVE DIRECTORIES

Creative directories are resource guides. They provide you with names, addresses, phone numbers, email and web addresses as well as other important information that will help you reach out to photographers, artists, producers, art directors, production coordinators, directors, fashion editors, beauty editors, etc. Following are some of the best in the biz and detailed information that will help to determine which ones fit into your future marketing efforts.

ASSOCIATION OF FILM COMMISSIONERS INT'L.
www.afciweb.org
$Free
Published Annually
(323) 462-6092 Fax 462-6091

The AFCI Directory contains listings for more than 250 film commissions. Listings are organized according to regions around the world. Australia, New Zealand, Canada, Europe, the Caribbean, Mexico, South America, the UK and of course the United States is represented. This directory alone will lead you to just about every production directory for film and TV in the world and many can be obtained for free.

ALTERNATIVE PICK
www.altpick.com
$50
Published Annually in March or April
(212) 675-4176 Fax 675-4936

Alternative Pick is the definitive sourcebook for the music, video, film, and entertainment-related editorial industries. It's pages are filled with the names, addresses and promotional pages of photographers who shoot album covers for record companies and editorial features for entertainment publications like Rolling Stone, Vibe, Entertainment Weekly, Premiere, and US magazine. It also lists the names of music video directors and production companies. A few production companies even added listings of their directors and some of the music videos they worked on. Additional listings found in the Alternative Pick include: makeup, hair & Styling Agencies, Tattoo Artists, Magazines and Record Companies.

The Alternative Pick is well respected and used by art directors and photo editors, and is another good place to look for photographers to work and test with.

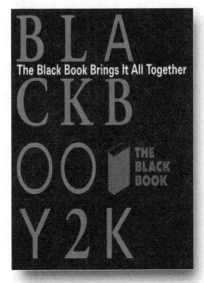

THE BLACK BOOK
www.blackbook.com
$72-$110
Published Annually in December
(800) 841-1246 (212) 539-9800 Fax (212) 539-9801

The Black Book is probably the most prestigious directory of advertising photography produced. It is certainly the most expensive to advertise in. The Black Book's photography section is strictly advertising related. When an art director in an advertising agency is looking for a photographer to shoot the new American Express ad campaign, they are more than likely going to turn to the Black Book first. So, if you have your heart set on doing those Miller Beer and Federal Express ads, the Black Book is a good place to find photographers to send your work to.

Notes:

FYI
Most Creative directories can be found in the reference section of your local public library.

CINEMA SECRETS
Beauty Supply for Film, TV, Video & Print

Established 10 years ago, this family owned & operated business has been a staple to film, television and print makeup artists since its beginning. Maurice Stein, the patriarch owner of Cinema Secrets, is a top makeup artist himself. Industry professionals consider Cinema Secrets a leader in the field.

www.cinemasecrets.com

PHONE: (818) 846 - 0579
FAX: (818) 846 - 0431

4400 Riverside Drive
Burbank, CA 91505
Between Cahuenga & Pass Ave.

Store Hours:
M - F 8:00am - 6:00pm
Saturday 10:00am - 5:00pm
Sunday Closed

Services Offered:
Worldwide Mail Order Service

Classes Offered:
Makeup Instruction

Credit Cards Accepted:
VISA • MC • AMEX • DISCOVER

The Black Book comes in separate volumes: Photography 2000 & Student Edition, Illustration and an Annual Report Award Book for best of show. Black Book Photography is the incomparable and original sourcebook for the creative industry. The directory focuses on leading commercial photographers, displaying their best work in high-quality, full-color print. A new feature of the Black Book 2000 is an editorial section covering industry news and trends.

CREATIVE INDUSTRY HANDBOOKS
www.creativehandbook.com
$ Free for the asking
Published in January and June of each year
(323) 874-4181 Fax 969-9130

The Creative Industry Handbook serves the needs of the creative, entertainment, and marketing professional throughout the United States. They produce two editions; California and North America. What you'll find: Costumes, everything from designers to Studio Services, hair and make-up supplies, jewelry, resale and vintage apparel, shoes, boots, props, fabrics, editing and title facilities, photographers, photo labs, studios for testing, color & laser output and promo cards.

To receive a free copy, write to them on your business or personal stationary and provide the following information: **Your job title, three projects you have or are working on and a list of 5 products or services you might be looking for in a source book.** Be sure to include a street address for UPS delivery, they don't deliver to P.O. Boxes.

LA 411
www.la411.com
$69.00
Published Annually in January
(323) 460-6304 Fax 460-6314
CD ROM available

Touted as the production bible, the 411 is considered a "must have" by people who produce television, video and film projects in Los Angeles. It is used to hire everything from hair stylists to zebra painters.

LA 411 can be of great assistance to you if you are interested in working on music videos and television commercials. It lists the names and phone numbers of working professionals who can hire you as an apprentice or assistant if you are just starting out. Got your book together and you're ready to take on the world of production? LA 411 is the directory for you, it lists the names and phone numbers of production coordinators and producers. And, for those of you who feel you are ready to show your books to agencies, LA 411 updates its listings of makeup, hair & styling agencies annually. The LA 411 has rate tables to compute overtime on 8 and 10 hour days, as well as specific information regarding crew (that's you) and union rules.

FASHION & PRINT
www.pgdirect.com
$ 59.95
Published Annually in July
(888) 332-6700 • (561) 999-8930 Fax 999-8931

Formerly the Madison Avenue Handbook, Fashion & Print 2003 is a comprehensive, detailed listing for image making professionals who need resources in the New York area. Although it covers over 20 separate categories, the listings that will be of interest to most makeup, hair and styling professionals include photographers, advertising agencies, production companies, and producers. If you're a hair stylist looking for wigs, a prop stylist looking for a piano, or a body makeup artist looking for temporary tattoos, you'll find it here. While its main focus is the New York area, there are listings that cover resources from Little Rock, Arkansas to Miami, Florida. Individual listings are available.

LEBOOK
www.lebook.com
$ 150-$180 (depends on where you buy)
Published Annually
(212) 334-5252 Fax (212) 941-4150
info@lebook.com

LeBook is an annual, international reference to the fashion world. A guide to more than 10,000 fashion professionals, including the best designers, stylists, photographers, modeling agencies, cata-

we heard...

Crystal Wright proudly presents "Packaging Your Portfolio: Marketing Yourself as a Freelance Makeup, Hair or Fashion Stylist."

The 8-hour workshop covers portfolio building, testing with photographers, signing with an agency, getting work from record labels, magazines, production companies, and more. The presentation includes a 1-Hour Q&A session with a panel that includes art directors, fashion/beauty editors, photographers, agency bookers, etc., who hire or sign freelancers for work in the industry. Crystal brings artists portfolios from Los Angeles as well as portfolios from agencies in the area. Call (877) 913-0500, Fax (323) 913-0900. www.MakeupHairandStyling.com.

you want to be famous...

Notes:

logue companies and studios. It's one of my favorite resource books and a source of today's and tomorrow's great photographic talent in fashion, beauty and luxury photography. We've been waiting for the launch of the site forever. However, if you go to the site, you can type in your email address and be notified when the site becomes active.

MIAMI PRODUCTION GUIDE
www.miamiproductionguide.com
$ 50.00
Published Annually in December
(800) 223-1254 • (212) 869-2020 Fax 869-3287

The Miami Production guide focuses on film and television production resources in the Miami area. The directory includes listings for directors, producers, photographers, video duplication, libraries as well as makeup, hair and styling agencies. An artist travelling to Miami for a shoot can find a list of accommodations or costume shops in South Beach. Submissions for a listing in the guide are accepted throughout the year.

MINNESOTA PRODUCTION GUIDE
www.mnfilm.org
$ 50
Published Annually in January
(612) 332-6493 Fax 332-3735

The Minnesota Production Guide is published annually by the Minnesota Film Board. While the book has a price, those with an interest in producing a feature, commercial or video in Minneapolis can get a copy sent to them for free. The guide supports the states efforts to bring Hollywood to Minnesota. This guide is full of valuable information for makeup, hair, fashion and prop stylists along with costume designers who are looking for potential clients. The guide provides info on producers, production coordinators, line producers, production companies and still photographers who hire for television commercials, music videos, and print shoots. Pick

this one up or search their online listings. Phone numbers for the film commissions throughout the country, directors with e-mail addresses, and phone numbers of the television stations in the Twin Cities, Duluth, Rochester, Fargo and Moorhead are included. The production guide staff offers this information to newcomers:

If you're new, you might want to start with an internship or check our hotline for jobs that can help you gain experience. There are also classes you can take. All levels of crew people can look at our calendar to see if we have any workshops, meetings or seminars that would be helpful to you. Make sure you're listed in our production guide so people who do the hiring will know where to find you. If you'd like to have your name in the guide, visit us online. Listings are free for the remainder of 2000! Also check with the local unions about work in town. Feel free to contact Eric Mueller at eric@mnfilm.org or 612-332-6493 if you want to find out what's happening production-wise. We are a non-profit organization with many opportunities for volunteering, funding and sponsorship. If you'd like to volunteer at the Board, contact Ben Nelson at bnelson@mnfilm.org or 612-332-6493.

RECORDING INDUSTRY SOURCEBOOK
(Final Edition)
www.mixonline.com
$ 79.95
Published Annually in January
(800) 344-5478 (510) 653-3307 Fax 653-3609

The Recording Industry Sourcebook 2000 is an attractively put together resource guide. It contains a selection of short but valuable lists of photographers, design firms, artist management groups and music video production companies that can benefit the artist who wants to pursue work on album covers and music videos. It also carries a complete list of names, addresses and phone numbers of record companies throughout the US and Canada.

Notes:

**GREG GILMER
FREELANCE ART DIRECTOR**

CG: How did you become an art director?

GG: I started out in high school. I was always into design, but the "fine art" part of it. I remember spending so much time with it that I had to ask myself what am I going to do with my life? I made an obvious choice to go into commercial art.

CG: Was you family supportive?

GG: They didn't really understand how I could make money. My family is from Mississippi and they didn't go to college so they didn't really know what a commercial artist or a graphic designer was. They weren't familiar with it but they were supportive.

CG: What was your first job as an art director?

GG: The yearbook in high school. I creat-

THE REEL DIRECTORY
**www.reeldirectory.com
$ 30.00
Published Annually in July
(707) 584-8083**

The Reel Directory is dedicated to the film, video and multi-image makers of Northern California. Of particular interest to makeup, hair and fashion stylists, The Reel Directory includes listings for photographers, directors, line producers, production companies, and art directors in San Francisco and surrounding areas. Each listing is accompanied by a short description.

SELECT
**www.selectonline.com
$ 90.00USD
Published six times a year
(212) 929-9473 Fax 675-3905**

Select touts its website as "the who, what and where..." of photographic and other related talent. Well, I don't know about all that, however, Select is a valuable source for finding photographers who work on catalogues and in entertainment.

Each issue focuses on a city and provides you with details, from which clubs to go to, to the modeling, photo and styling agencies, to information about transportation

Select America	Select U.K.	Select Worldwide	Select Germany
153 West 18th Street,	32a Alkham Road,	Duisburger Str. 44,	Duisburger Str. 44,
New York NY 10011, USA	London N16 7AA, England	40477 Düsseldorf, Germany	40477 Düsseldorf, Germany
fon: +1 - 212 - 929 94 73	fon: +44 - 181 - 880 01 87	fon: +49 - 211 - 498 20 68	fon: +49 - 211 - 498 20 68
fax: +1 - 212 - 675 39 05	fax: +44 - 181 - 806 67 39	fax: +49 - 211 - 498 34 24	fax: +49 - 211 - 498 34 24
america@selectonline.com	uk@selectonline.com	europe@selectonline.com	europe@selectonline.com

and getting around. While the Workbook leans toward the advertising marketplace and appears more serious in its approach, Select is avant garde, fun, and full of fashion and art. The book is produced in Germany and distributed worldwide through the following offices. Can't seem to find the magazine at your local news stand or Barnes and Noble, try calling their distributor: Eastern News Distributors, Inc. • 250 West 55th Street, New York, NY, 10019 • (800) 221 3148 Fax: (212) 265 6239

SHOPPING LA
The Insider's Sourcebook for Film & Fashion
$ 50
Published Annually

Three very smart LA costume designers decided to combine their rolodex cards and guess what they came up with? Right, "Shopping LA" an invaluable resource. Their introduction tells us that they got together at a party in Venice one night and conceived this great new costume sourcebook. If you're a wardrobe stylist, prop stylist or a costume designer don't let this one get by. It's got over 532 pages of must have resources. It will help you find anything you may need in a quick and organized way. From movie dirt, fake blood, authentic bellbottoms, anything you can think of, you can find listed in this book with the store address and phone numbers where the products are sold. They also have a listing of studio services for almost every major department and many specialty stores that work with stylists and costumers.

WHO'S WHO IN FASHION

I found this book while flipping through an issue of Women's Wear Daily. "What a great resource," I thought, especially for those of us with no formal fashion education. The book gives a brief history of where looks came from. For instance, did you know that Mary Quant is credited with having started the Mod Look of the mid 1950's and the miniskirts of the late 60's? I enjoyed reading about the diverse paths that many of the designers took before entering into fashion. Giorgio Armani tried medicine and photography, Christian

ed art for the basketball and volleyball teams, logos for people, design work for neighbors, whatever I could get. I got a scholarship to Art Center, and attended while I was still in high school. When I graduated, I couldn't afford Art Center so I went to Cal State Los Angeles for three years, put a portfolio together and got a partial scholarship to Art Center. I studied Two-Dimensional Design, Communication Design.

CG: What is Two-Dimensional Design?

GG: Anything that's printed. Brochures, logos, advertising, all that stuff.

CG: What was your first job?

GG: I worked in a small agency in the artist loft area of down-town Los Angeles. I got my start doing music stuff there. It was a lucky break because if you haven't done music stuff everyone is reluctant to give you that kind of job. I was being paid peanuts, but I used the opportunity to build my portfolio. I did a BB King album cover and a couple of movie sound tracks for License To Kill and Hunt For Red October.

CG: How long were you at Warner Bros.?

GG: About four years. It's the best job I've ever had. Jeri Heiden was the best boss I've ever had. It's was a very nurturing atmosphere, very artist oriented. You get to travel. I do a lot of Rap

GREG GILMER

and R&B acts and they just happen to be out in New York. I went there five to six times a year. Warner Bros. treated me very well.

CG: Did anyone special help you throughout your career, or did you do it on your own?

GG: I think I motivated myself. When your doing something creative, it sort of moves you. In high school my favorite art teacher, Mrs. Cook, really helped me and gave me that extra push. Sometimes that's all you need and its your own passion that drives you.

CG: What are your responsibilities as an art director?

GG: My key responsibilities are to be a resource to the recording artist that I'm working with. I talk with them and their manager and get an idea of what their look is or how they want to be portrayed. I have to know what makeup, hair, styling and photographers are going to help me bring that to life. That image. That's my place in that scheme of things.

CG: How involved do you get in terms of selecting makeup, hair and fashion stylists?

GG: A lot of times artists don't really know about it, and are new to the whole game. In that instance, I'm pretty instrumental. I become an important resource. I present the artist with the people that I think they're asking for.

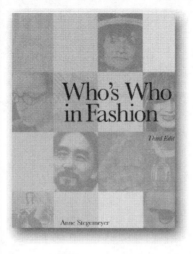

Dior wanted to become an architect but studied political science to please his family. Todd Oldham barely made it through high school, never went to design school and taught himself pattern making before becoming the star that he is.

THE WORKBOOK
www.workbook.com
$25.00
Published Annually in January
(800) 547-2688 (323) 856-0008 Fax 856-4368

A well respected sourcebook in the PRINT arena, The Workbook is an up-to-date resource for the graphic arts industry and best used to find photographers who are working in advertising. Listings are arranged alphabetically by category, making it easy to find photographers, photo labs, photo agencies, costumers, couriers, hair & makeup artists, props, retouchers, stylists and more. You can single out those photographers who are doing the kinds of work assignments you dream of and the clients you envision yourself working with. Additionally, and this is a biggie, the Workbook sells mailing labels. You can tell them who you are prospecting for and they can give you a count of those photographers, art directors, or editors who meet your criteria. Label prices range from about $.14 - $.21 each. A great buy. Or, you could hand write everything.

There are lots more creative directories and while we couldn't list them all here in the Career Guide most can be obtained easily once you have a copy of the Association of Film Commissioners International Handbook on **P2.22**. Check out **P2.33** for a few more creative resources.

Listings. Every directory has them and in many cases, getting one is free. If you are an artist out there on your own, doing your own marketing and legwork, these free listings are marketing tools that you don't want to pass up. Just call, and ask for the deadlines and requirements for submission.

Celestine

1666 20th Street, Suite 200B

Santa Monica, CA 90404

(Reps: makeup, hair & Fashion Stylists)

PH: (310) 998-1977	Email: info@celestine.com
FAX: (310) 998-1978	Web: www.celestine.com

The agency information above is considered a business listing. With only slight variation, they all give the same basic information to the reader and the potential client/consumer:

1. Company Name	2.	Address	3.	Phone Number	
4. Fax Number	5.	Agency Specialty	6.	E-Mail Address	

In addition to these business listings, many creative directories have individual listings for directors, producers, and yes, makeup, hair, & fashion stylists.

Individual listings, while not as extensive as the one listed above for Celestine, can be just as valuable, and are FREE. You merely request one, fill out a standard listing form and beat the deadline for the following year's directory. A typical artist listing follows.

Denise Suthermore	PH:	(213) 555-1212
Makeup Artist	FAX:	(213) 555-1313

The listing can be of even greater benefit to you if you provide the directory with a phone number that remains stable even when you're not. A pager or voice mail box number is best. Since these numbers are not attached to a residence or business, you can move around as much as you like and people will still be able to get in touch with you. This is especially important if you change agencies. Take it from an agency owner. As great and wonderful as we are, we're in business to make money. When someone leaves the agency and a client calls and asks for that person, most agency owners are not going to give out your forwarding phone number when a booking is at stake. A stable phone number is very important. So many people are unlisted that most creative decision-makers don't think to call information anymore, especially with so many area codes to choose from. Do yourself a favor. Get those free listings and stay in touch.

GREG GILMER

CG: Do you have a process for looking at books? Do you make the calls? Do you look at unsolicited books?

GG: I look at whatever I can because I'm supposed to be a resource. I take in all the information I can get. I don't care if it's an unsolicited book. If I have time, I'm going to see it, because it's going to make my job easier. Part of being on top of the game, being fresh and having the best looking stuff is knowing what's out there. So I don't have any qualms about people calling me up and wanting to sell their stuff. I may not always be able to meet with them but they can drop off their book. I'll be glad to look at it.

CG: What are you looking for in a book?

GG: Creativity. A professional presentation. Even if they don't have tearsheets, as long as it looks like they're taking pride in their presentation, I'm into it. You wonder about an artist's professionalism when they don't take pride in how their portfolio looks. You want someone who can do the job, that you can depend on, rather than someone who's a crazy, creative genius but is going to be late and not able to get enough hair styles in or takes a whole day to do one hair style.

CG: Have you ever hired a makeup, hair or fashion stylist that didn't have a book?

GG: Once. It was in New York and I was working with a group that wanted to use their own hair stylist. We had to ask ourselves, do we get a hair stylist we think is going to be better and have to deal with this group's attitudes throughout the day and ruin the pictures, or let them have their own hair stylist. It turned out well, but it was a gamble. It's sometimes difficult to take that chance when you're working within a budget. You want to know you're getting the best.

CG: **What makes you want to hire an artist over and over again?**

GG: Their creativity. Bringing something to the shoot that you would never have thought of or that no one has been doing. And their enthusiasm, because it makes the artist more comfortable. The artist likes to know that they're working with people who want to make them look good. Someone that's personable, and can get along with the whole creative team.

CG: **Will you hire somebody who has a book full of tests?**

GG: Yes, I will. If their book is professional, and the work is good and the book is professional, I'll give that person a break. And they're probably not as expensive as the big guys so I'll try them.

CG: **Do you keep promo pieces?**

GG: I only keep them if I like their book. There are some books that are good but the artist doesn't have a promo-

TOOL #7: CONSUMER MAGAZINES

While you may not want to subscribe to every fashion or trade magazine known to man, subscribing to the publications that will serve as your resource materials is smart and much less expensive than buying magazines off the news stand each month. I suggest making a list, pricing the magazines out, and purchasing your subscriptions all at once the same time each year. If you've ever subscribed to magazines, then you know what a drag it can be trying to remember the exact month you paid for your subscription to a specific publication. It seems as though publishing houses begin sending you renewal notices as soon as they get your check. This can become pretty unnerving if you have more than two or three magazines arriving each month. I've paid for Vogue so many times that I probably won't need to subscribe again until 2010.

TOOL #8: TRADE MAGAZINES

Two publications have emerged in the last couple of years to service and fulfill the needs of the freelance styling community; *1stHOLD* and *Makeup Artist* magazine. Makeup Artists magazine focuses on the needs of makeup artists who work on union film projects throughout the US. They cover current events, feature makeup artists who work behind-the-scenes and produce the annual International Makeup Artist Convention in Pasadena California. *Makeup Artist* magazine is published bi-monthly, sells for $6.95 and is available at many news stands in the US. You can also visit them at www. makeupmag.com.

1stHOLD magazine is published by guess who? Me! The *1stHOLD* staff of writers and editors endeavors to meet the needs of freelance makeup, hair and fashion stylists who work behind-the-scenes in print, video, film and television. It is our belief that these three disciplines are interdependent and thus should be spoken to with one voice. *1stHOLD* is a business publication for freelance artists, covering makeup from the perspective of how it can help the artist solve problems on the set. A popular feature in *1stHOLD* is the "HookUp" section. It's a listing of cosmetics companies who help makeup artists and hair stylists stock their kit inexpensively by offering steep discounts to professionals. Additionally, *1stHOLD* includes articles to help you get work if you're an assistant or get into the biggest ad agency as a seasoned professional. Artists turn to *1stHOLD* for news, information and trends in the industry.

TOOL #9: PRODUCTION SERVICES

Production services companies are firms that gather the crew and shoot particulars (details) of upcoming movie or television projects, create lists and provide them to anyone for a price.

PHOTOGRAPHERS	DIRECTORY	WEBSITE	GEOGRAPHY
Advertising	The Workbook	www.workbook.com	USA
	The Black Book	www.blackbook.com	USA
	Gold	No website available	New York
	Photo District News	www.pdn-pix.com	New York
Entertainment	Alternative Pick	www.altpick.com	USA
	Recording Industry Sourcebook	www.mixonline.com	USA
Catalogue	Select	www.selectonline.com	Int'l & Miami
Cutting Edge	LeBook	www.lebook.com	Paris
		www.lebookny.com	New York

VIDEO, FILM & TV PRODUCTION - USA

	LA411	www.la411.com	California
	Hollywood Creative Directory Online	www.hcdonline.com	California
	Northern California Film	www.microweb.com/ncfilm	Northern California
	NY411	www.ny411.com	New York
	New Jersey Production Guide	www.nj.com/njfilm	New Jersey
	New England Film	www.newenglandfilm.com	New England
	Miami Production Guide	www.filmflorida.com	Miami
	Metro Orlando Film & TV Commiss.	www.film-orlando.org	Orlando
	Minnesota Production Guide	www.mnfilm.org	Minnesota
	The Reel Directory	www.reeldirectory.com	Cotati (Northern California)
	New York Film & Video Web	www.nyfilm-video.com	New York
	Portland OR Film & Video Resource	www.teleport.com/~mhatter/pdx.html	
	San Diego Production Web	http://sd.znet.com/~qsystems/sdpw/	
	Production Resource Guide	www.nmia.com/PRG/	New Mexico
	Media Place	www.mediaplace.com	Houston, TX
	Idahoe Film Bureau	www.filmidaho.org/	Idaho

VIDEO, FILM & TV PRODUCTION - INT'L

	Filmnet	www.filmnet.ie/	Ireland
	Film New Zealand	www.filmnz.org.nz/	New Zealand

COSTUME & WARDROBE

	Debbies Book	www.debbiesbook.com	Los Angeles
	Shopping LA	www.shoppingla.com	Los Angeles

PRODUCTION: VARIOUS

	Creative Industry Handbook	www.creativehandbook.com	California & North America
	Fashion & Print 2000	www.pgdirect.com	Connecticut
	(formerly the Madison Avenue Handbook)		

GREG GILMER

tion piece. That makes it very difficult because once the book is gone I won't think of them again. There are so many books that come through, you need that promo as a reminder. I keep a file. When a job comes up, I look in my file and those are the books I'm going to call in.

CG: Do you prefer working with agencies or with freelancers?

GG: I prefer agencies because they handle all the paperwork. Freelancers get caught up in the paperwork and that's where they lack professionalism. They may be a great artist, but when you need their tax information or something else from them, they fall short. And an agent is always there when you call. They can provide you with the information you need about an artist.

CG: What draws you to an agency?

GG: The relationship I've made with the agency. If you have a good relationship with an agency, you're going to call and use their people all the time.

CG: What advice do you have for young artists?

GG: See what other people are doing. Have aspirations, and look to the top people because that is where you want to be. Learn their keys to success and emulate them. Nothing happens by chance. It's all hard work: a good goal, and a good plan. **END**

Notes:

They are offered daily, weekly and monthly and are best suited to artists who are interested in or are working in film and television. While they do list production companies who are producing television commercials and music videos, these are not their focus and you will be disappointed if you intend to find a list of 100 television commercials that are crewing up at any given time.

TOOL #10: STAPLES

The Survival Kit, as I like to call it, is a collection of things that when used together can make a big difference in the way you present yourself and respond to potential and existing clients. Being properly equipped makes you more professional and can set you apart from the pack during your first year as a makeup, hair or fashion stylist.

A. PAPER CUTTER. All paper cutters are not created equal. What you use to cut construction paper should not be the same tool you use to cut the edges off of your $15.00+ original photographic prints, $3.50 color copies, or expensive magazine tearsheets.

Photographs and color copies require a precise cutting device. We suggest you invest in a Dahle cutter by Eberhard Faber. It will give you many good years of service. With just the right blade and tension, a Dahle professional trimmer will cut the slightest edge off of a magazine or newspaper tearsheet cleaner and smoother than you've ever experienced.

Now some of you are not going to listen. You will go to the local office supply store and purchase one of those $12.99 jobbies and forever wonder why your pictures are always crooked, and never seem to fit squarely in your portfolio. Well, don't say I didn't warn you!

B. EXACTO KNIFE. An exacto knife is God's gift to the artist. It has many uses. You may find yourself using it to cut slits in a piece of construction paper to hold your business card or to cut through the packing tape an art director has used on the box that houses your portfolio . I have used it many times to peel the thick cardboard layer off of an album cover (tearsheet) so it would fit nicely in an artist's portfolio. Just get one. You can even use it to slice open all those envelopes containing the big checks you'll eventually be collecting.

C. CONSTRUCTION PAPER. All the portfolios I've ever seen came with black paper inside the plastic pages. From time to time, however, you may find the need to mount a photograph on a

different color paper so that a particular tearsheet or photograph pops off the page.

Don't misunderstand. I'm not recommending that you go out and buy chartreuse colored construction paper. Most colored papers will make your book look cheesy and unsophisticated. But having a few sheets of black, grey, white and creme paper in stock can give you just the variation or punch you need, at the right time.

D. ROLODEX. A Rolodex is a necessity. It's the phone book at home that never gets left at the photo session, stolen out of your car, or left at the bank teller window. Keeping up with your Day Runner or electronic organizer is more than a notion. If it's ever lost or stolen, you can feel out of touch and disoriented. Do yourself a favor and pick up a Rolodex for your home. You can write, staple, and tack other little reminders on to those 2x4 or 3x5 cards. The paperless office is not for those of us with a great deal to loose by loosing our organizers.

E. FAX MACHINE. What's more important than an answering service that pages you? A fax machine. If you don't have one, and can't afford to purchase one, I suggest you locate the nearest Kinkos and set up an account ASAP. Clients fax just about everything from directions and maps, to call times and model sizes. Many copy centers are open 24 hours a day, 7 days a week, so it's never too late to pick up a fax transmission.

F. PAGER. When you reach the resource section of this book you may wonder why smaller, local paging companies have been omitted. Many pager companies are unregulated operations that are here today and gone tomorrow. As a result, we decided to stick with the big boys. Verizon, SkyPage, PageNet & Metromedia who, like Xerox and Big Blue (IBM), always seem to be around.

My word on pagers is this: if decision-makers aren't able to get in touch with you, they can't give you work. When ordering a pager, remember to take possible travel assignments into consideration. If you live in Los Angeles, get a job assignment that takes you to Phoenix, and your pager signal doesn't extend past the San Bernadino mountains, you're in big trouble. At the very least your pager should reach to those areas you will most likely be working.

G. ANSWERING MACHINES. A reliable answering machine or voice mail system is a must-have. If you are using a machine or service for business that also doubles as your home answering machine I strongly suggest that you modify the greeting to something more professional than personal. I know producers and photographers who have hung up the phone in disgust before the beep sounded because the recorded music, poem, or silliness seemed to go on forever. While your child's playfullness may be cute and amusing to you, it is not to business people who have a finite amount of time to book an artist for a job.

TOBI BRITTON
MAKEUP ARTIST
ENTREPRENEUR
THE MAKEUP SHOP, NY.

CG: **How do you determine which products you will carry at The Makeup Shop?**

TB:　Well, the shop is really a giant extension of my kit for sale. It's a reflection of how successful the products have been for me.

When I started out in business I didn't have the money to stock every single line of professional and special FX cosmetics so I had to be selective. It was easy because I knew what was working for me. I was using the products on the set regularly.

The professional lines that I carry are Kryolan, Joe Blasco and Mehron. Kryolan is really the most comprehensive line, they have everything from body and face paint to glitter and special FX materials. Joe Blasco founda-

TOBI BRITTON

tions are very versatile, and the company also has many specialized products as well as the best brush cleaner.

Mehron's products are wonderful for practicing with because their prices are very reasonable.

CG: What about regular beauty products?

TB: I carry Aveda makeup and hair care products, as well as two aromatherapy skin care lines - Yonka and Bioelements. I believe that I am the only place to carry Bioelements in New York. I also have some private label products of my own, and great brushes. I work very hard to choose products that have no animal ingredients, only plants and other natural products.

CG: Tobi, tell me a little about the makeup classes you offer at the shop. How do they differ from what you learned at "The Beauty School of Middletown", and "Christine Valmay"?

TB: Well, the education you get at these schools helps you to pass the state board exams.

Students in beauty school should concentrate on one thing. . .passing the state board exam. After being licensed, they can then move on and take more specialized classes. There is no need to spend extra money at beauty school.

At Christine Valmay I took the esthet-

H. VOICE MAIL. Voice mail is the latest in answering machine technology, and is substituted for the old answering machine in most cases. It answers your phone, and allows the caller to review, change, or discard their message before they put down the receiver. Many voice mail services can be set up to page you for a nominal fee.

H. BUSINESS CARDS. I'm a fan of the simple yet elegant business card. Too much curly type on a card is a turn-off to me and many other people, while anything too straight is considered "corporate" and not representative of the creative nature of the makeup, hair & styling industry. Try to find something in the middle. Most companies who print business cards have samples you can choose from. It's not necessary to reinvent the wheel. Find something creative and reasonably priced. You can get something FABULOUS, customized and expensive later.

I. MOBILE PHONE. Mobile phones have become a necessary expense in our business. A busy stylist with two or three assistants working on an assignment doesn't have time to pull over to the side of the road, or get out of a cab on 5th Avenue in rush hour to return phone calls.

J. MAPS. It's 1:30 in the afternoon and you have no idea how to get where you need to be at 3:00. What do you do? Buy yourself a Thomas Guide, or the city map that is most popular in your area.

As a West Coast stylist, you'll be called on to travel all over the LA basin, throughout the valleys, and even to out-of-town locations like San Diego, Long Beach, and Santa Barbara for job assignments. You're a young professional now, and as such, you cannot afford the catastrophic consequences of not arriving at your "gigs" on time, or simply not arriving at all.

Save the speech about how you can't read maps. I didn't understand algebra either, until it became "Crystal" clear that I would not be admitted to business school without a passing grade. I enlisted a tutor, spent some time at the tutorial center, got with the program, and got myself a "B".

You will have to do the same if you are map-a-phobic. I suggest that you invest in a Thomas Guide. These invaluable books can be purchased at most office supply and book stores. The best prices are found at office supply super stores like Office Depot and Staples. Every city has its own set of maps to help you navigate the city streets and highways. We searched high and low for a condensed book-style map that would assist you in getting around each city covered in this book. Ideally, we had

hoped to find something similar to the Thomas Guides by Thomas Brothers Maps which covers each city in all of the western states. It's 11x8.5 inches and will fit into a backpack with ease. Best of all, it doesn't take up two or three seats worth of space on a bus or subway, and it won't obscure your view while riding in a cab. I have to report that we weren't very lucky. While we did find visually interesting and colorful maps, they were all somewhat large and cumbersome. However, not wanting to disappoint you or have you lost at the New York Port Authority, our recommendation follows.

Map Easy, Inc. It's innovative, useful and attractive to look at. It's color coded and has helpful hints for navigating the city and transportation options. By the way, it also has restaurant suggestions if you get hungry en-route. We found ours at a local Rand McNally Map Store. To locate a vendor, call Map Easy, Inc. at (516) 324-1804.

K. MESSENGER SERVICE

A reliable messenger service that can move your portfolio and other supplies and materials from one place to another safely is a must. If you plan on working bi-coastally, I suggest you establish a second messenger service on the opposite coast. Setting up the service usually requires filling out a one page application and possibly checking your credit references. Having it will allow you to move your portfolio around from place to place even when you are thousands of miles away. You are only charged when you use the service, there are no monthly or weekly service fees.

L. THE CROPPING TOOL

This is an instrument used by photographers and art directors to mark the boundaries of a photograph, transparency or slide. The picture is then printed to show only the area inside the markings.

M. GREASE PENCIL

A grease pencil is made of wax. It's used to crop a photograph without damaging it. It comes in various colors such as white, yellow or burgundy. If you make a crop mistake, it is easily wiped away with your finger or a cloth and you just start over.

N. VOUCHERS

Vouchers are usually three-part forms that are given to the client or someone in authority for signa-

ics course because I wanted to be an esthetician. It was great. I learned how to do facials, and found that I have a really good touch, and a good pair of hands for massage and things like that. So that was really quite useful since we offer those services at the shop.

However, at The Makeup Shop I teach more than just theory. I teach real world stuff. I tell my students, this is what happens in the books, and this is what happens when you have this woman and she's supposed to have this kind of coloring, and the stylist has put her in the completely wrong color, and you have to make due and still make her look pretty. It's common sense, 'learn by my mistakes' knowledge. It's very valuable. I save people from making their own mistakes.

Most schools teach, this is a square face, oval face, round face, and this is what you do for each one. In real life, people rarely fit into those molds, they're in-between. The problem is there are some set rules but there are also no makeup police who come around and arrest you for taking charge and being creative.

At the Makeup Shop we teach people how to think instead of just implementing certain learned responses. If you teach only specifics your students run into problems down the line because everybody is different. We don't want our students to panic at the first sign of something that wasn't in a textbook.

CG: You teach them how to make adjustments based upon who and what they're working with?

TOBI BRITTON

TB: Yes. There are a few formulas in this business, like you don't use lip liner as eye liner or the person will look sick. For the most part I teach a system that gives the artist alot of support. We teach a concentrated amount of knowledge in a short amount of time, and the students can practice on their own time without having to pay for practice time at the shop. And I will give the same class several times during the year so the student can come back for free for an entire year [depending upon enrollment] and review any subsequent class. **END**

Notes:

ture at the end of a job. They are used to verify and confirm your presence, as well as the actual amount of time you worked. Upon completion of a job, the client signs the voucher. You give them the pink copy, keep the canary copy, and mail the white copy to the accounting department for payment. This simplifies the process of billing, because you don't need to create a separate invoice. However, if you do have separate invoices, it's a good idea to mail the white copy in with the original invoice. For an example of a voucher, turn to page 8.12.

TOOL #11: YOUR CREDIT RATING

My best advice to you: Pay your bills on time! Unfortunately, not many of us (myself included) learned a lot about credit while we were growing up. Consequently, there are a good number of people struggling without the necessary resources, like a Visa, Mastercard, or American Express. In this business, there will be times you will need to rent a car for an out-of-town trip, purchase an airline ticket by phone, cover expenses for moving into a new apartment, or take a client to lunch. All of these things have one thing in common, access to a credit card, thus Good Credit. It's awfully hard to get your job done without it.

Many people find themselves getting serious about their career choices in their mid-to-late twenties only to realize they've demolished their credit rating and resources between the age of eighteen and twenty-three. Cleaning up your credit will take seven years. Don't let that be the case with you. If you have credit issues, now is the time to make a change. There is a great book called The Wall Street Journal Guide To Understanding Personal Finance. I've found it to be an invaluable tool.

Those of you with a long, tough, credit repair road ahead, should contact a bank that offers a secured credit card. The premise behind these cards is simple; if you don't have good credit, the bank will allow you to put money into an interest bearing savings account and provide you with a credit line equal to the account balance on deposit with them.

In other words, if you deposit $500.00 into the account, you will have a $500.00 credit limit. The more you put in, the higher your limit. Some banks even offer a credit limit equal to 1-1/2 times your savings deposit. A few banks who offer secure credit cards are listed below:

1.	Citibank	(800) 756-7047	2.	Capitol Bank (800) 548-4593
3.	Bank of America	(888) 462-7696	4.	1st Premier (800) 352-7306

A great resource for getting your credit in order is Consumer Credit Counceling. The service is free and available nationwide. Contact them through their toll free number at (800) 249-2227. Phone counceling is available at (888) 257-6916.

TOOL #12: THE PUBLIC LIBRARY

The Public Library has got to be the most underrated resource in America. I have always thought that libraries were one of America's greatest natural resources, right up there with the Redwood Tree. However, I find that most people (when seeking out information) look everywhere but the Public Library. The main library branch in most cities offers a service called "Quick Information," or an equivalent. To take advantage of the service you simply call the library and ask for ... you guessed it ... "Quick Information." They can answer questions such as:

> Can I have a list of all the magazines being published in Los Angeles?
> How many record companies are there in Los Angeles & New York?
> How many design firms are there in Miami, Florida?

TOOL #13: CONTINUING EDUCATION

It goes without saying that there is always more to learn. Be one of those people who takes advantage of new offerings of makeup & hair classes and seminars that can make you an even better artist than you are today. If you do makeup, learn a little about hair so you can be booked to do grooming or accept assignments that call for one person who can do both makeup and light hair. Take advantage of extension classes at the local university or community college being given by professionals in your industry who can teach you something new. Every step in the right direction brings you a little closer to achieving your goals.

Be discerning about the classes you take. Don't sign up for expensive classes without thoroughly examining the offering. Know what your getting into. Ask lots of questions and be sure that you get what you are paying for. For more on education, let's move into CHAPTER 2E.

SECURED CREDIT CARDS

Check out your options in the secured credit card market. Each company has its own policies, procedures and fees. One of the banks asked for a $69.00 administration fee while others required no fee at all. The initial deposit varies from bank to bank. The lowest we found was $200. Ask plenty of questions, and read all the fine print in the application before sending in any money. Examples Follow:

REGULAR ACCOUNT

Deposit	Credit Limit
$500.00	$500.00

ONE & ONE HALF ACCOUNT

Deposit	Credit Limit
$500.00	$750.00

Notes:

TOBI BRITTON'S MAKEUP BOOTCAMP

SERIOUS TRAINING FOR SERIOUS ARTISTS

"Our **MAKEUP BOOTCAMP**™ classes are structured to give you the most knowledge in the least amount of time, and at an affordable price. We believe that the real world is the best classroom. The faster you get out there and start working—the sooner you will realize your dreams!" —Tobi

TOBI BRITTON

MAKEUP BOOTCAMP PART 1 takes all of your current makeup skills and reorganizes them so you will have the required knowledge for Tobi's techniques utilized in BOOTCAMP 2. If you have no previous makeup experience, this class will put you on a level to understand the more advanced material. You will learn basic corrective makeup, (television, print, photography and video), and receive an evaluation of your current makeup skills.

MAKEUP BOOTCAMP PART 2 teaches you the techniques for becoming a professional makeup artist. Our unique format let's you study without having to take a leave of absence from work. Choose either a Five-week format, (one full day a week for 5 weeks), or a One-week intensive format. Bootcamp teaches you how to break into the business and what to do when you get there. You'll learn makeup techniques for film and television, commercials, fashion, runway, headshots, and music videos. You'll also benefit from Tobi's 20+ years of on-set experience which can help you take years off the "entry level" phase of your career. This includes crucial "behind-the-scenes" info concerning professional conduct, and what's expected by directors and stars alike.

Other classes include: Drag Makeup; Wig Styling; Testing for Your Portfolio; Brows, Lashes & Liner; Cuts, Burns, Bruises and more. For class info, dates & prices, **visit our website www.themakeupshop.com**

CALL TODAY and SIGN UP • 212-807-0447
See how one day a week can change your life!
The Makeup Shop • 131 West 21st Street • NYC

The Airbrush Revolution
Are you ready?

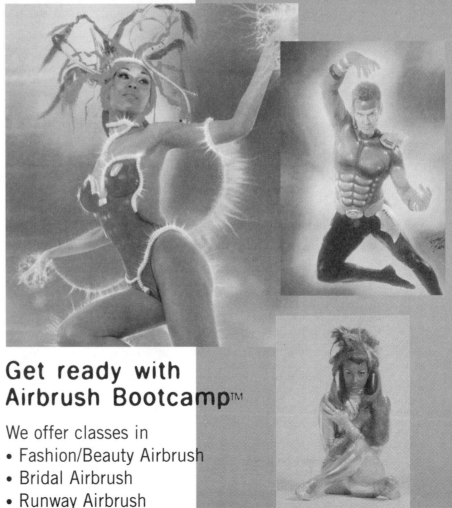

Get ready with Airbrush Bootcamp™

We offer classes in
• Fashion/Beauty Airbrush
• Bridal Airbrush
• Runway Airbrush

2EDUCATION

In a past issue (Fall/Winter 1999) of **1stHOLD** magazine I wrote an article titled "**Makeup Education: 10 Questions to Ask Before You Sign on the Dotted Line**". Questions from that article are reprinted in this chapter to help you make good decisions about schools.

What follows is our take on education. What you won't find are hair schools. There is an entire industry dedicated to educating hair stylists on their craft. The information that is currently available through cosmetology associations and magazines like Modern Salon, American Salon, and Salon News is much more thorough than we could ever include here. I do suggest however, that those of you who want to expand your hands-on knowledge of hair **STYLING** for print, video, TV, or commercials look into Bumble and Bumble in New York. They have some excellent short term styling classes that are worth every penny. For film and TV hair styling, call Susan Lipson's On Set Motion Picture Hair Academy in Santa Monica, California and Jason Hayes at the Makeup Shop in New York.

We have included information on selecting a good makeup school and information on licensing for hair stylists—just to keep you out of trouble with the state—any state. Some of the makeup schools do have hair styling programs, but I haven't looked into them enough to be able to say—go here or go there.

What's **NEW**? Well, makeup artist Tobi Britton has written a lengthy editorial on Special Makeup Effects to assist those of you who are thinking about venturing into that arena. She talks about the job opportunities in special makeup effects, the pros and cons of going to school, and what to expect from different markets.

When it comes to makeup artistry, there are many places throughout the country that call themselves makeup schools. You won't find all of them listed here because, what I call a makeup school and what they who call themselves makeup schools, offer their students may be two different things. From where I sit, a makeup school should be an institution with instructors who care about their students and are capable of teaching and preparing them with the necessary skills to work, succeed and feel challenged by the rigors of work behind-the-scenes in print, video, film or TV. Our discussion centers around the process of selecting an educational institution not the specific schools. However, we do not allow schools whose reputation is in question to advertise in this

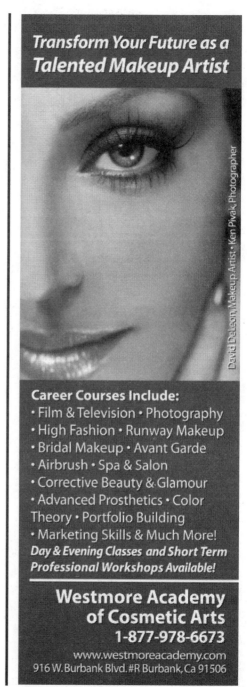

guide. Since writing the first Career Guide, people have come to count on me for advice on which schools will offer them the most value for their money. And since going to makeup school can be a very expensive proposition, I take that responsibility very seriously.

I receive lots of letters and tons of email from people who have spent thousands of dollars on makeup school only to be dissappointed by their lack of knowledge and preparedness when it came time to perform on the job. I hope what follows helps.

CHOOSING THE RIGHT SCHOOL

Which makeup school should I go to? is a question I get asked a lot. Of course I have my favorites, but I wanted to present you with information and options that would assist you and sharpen your decision-making skills. What is needed is a system for asking questions and compiling the information, hence the School Questionnaire at the end of this chapter. Unfortunately, most people don't approach makeup school the same way they do attending a four-year university even though there is usually quite a bit of money at stake.

Before I decided on Seattle University, my girlfriend and I combed through several books that helped us to compare the statistics, housing options, food plans, athletic facilities, faculty makeup (no pun intended) and financial aid packages of one school to another.

The key to picking a good makeup school is first knowing what aspect of makeup you want to pursue and second having a system that will allow you to compare apples to apples. Many students make the mistake of calling several different schools to gather information and request brochures, but never ask all of the schools the same questions. In the end many make an emotional decision or one that is based on the hard sell they get from the school admissions personnel on the day they stop by to "check it out".

Why shouldn't you ask for references? If you were applying to Harvard, they would certainly inundate you with the names of their most established, famous and successful graduates in an effort to get you to attend their university. Do you think that Michigan State University ever courts a high school basketball player without mentioning (amid the posters and newspaper clippings) that Magic Johnson played here?

You can begin by thinking of yourself as the first round draft pick. Imagine for a moment that you are being courted by five top makeup schools and in order to choose the one that will best fit your future plans to be a top film, TV or print makeup artist, they must meet certain requirements to get you to *Sign On the Dotted Line.*

Stephen McCallum, administrator at the Make-Up Designory in Burbank, California says, "The very first question anyone should ask when considering a training or vocational school is 'are

they licensed by the state in which they operate'. The state has become very aggressive about closing schools that are not licensed and thus operating outside of their guidelines. "If it isn't licensed to operate, the state will close it!" says Stephen. "When this happens, the students who are presently enrolled are out of luck. They lose everything."

Donna Mee, who owns Empire Academy of Makeup in Costa Mesa, California says that students should be concerned about who is REALLY teaching the course. She suggests finding out specifics about the schools' instructors and what they specialize in.

Loalynda Bird of Cinema Makeup School in Los Angeles says, "The first step to deciding on a school is considering what aspects of the makeup industry you want to pursue; print, video, commercials, film, television or even theatre perhaps. If you are interested in pursuing a career in TV or film, you will need to take most if not all of the courses offered at a school. Including but not limited to beauty, old age, character, hair work, bald cap and prosthetics. It goes without saying that you should have a passion for makeup."

Every student who wants to pursue a career in film and television should be concerned about whether the schools classes will cover at least the basic makeup techniques needed to one day pass the union exam.

What is clear is this, only practice makes perfect. The school will give you the basics, just like taking Accounting 101, 102 & 103 will give you the basics, enabling you to get your bachelors degree in accounting. However, whether you pass the CPA exam will depend on how much you studied, or in the case of a makeup artist, how much you practiced!

The questions we've assembled here when asked boldly and compared properly should help you make better decisions about your career.

QUESTIONS & CONSIDERATIONS

1. Is the school licensed by the state in which It operates?

A licensed school is held to much more rigorous standards than one which is left to its own devices in regards to what it offers, how the facilities are maintained, the length of its classes and the qualifications of its educators. When found out by the state, unlicensed schools are closed immediately and the students presently enrolled are just out of luck. They lose everything.

2. Who are the instructors? How much real world experience do they have as educators? What do they specialize in, as a makeup artist and instructor?

"No question is more important than the quality of instructors," says Stephen McCallum

of Make-up Designory in Burbank. "Remember, just because someone is outstanding in their field doesn't mean they will be able to educate others." Many excellent artists are terrible teachers. You don't want to take a beauty makeup course from someone who specializes in prosthetics...now do you?

3. What is the schools reputation (TODAY!) within the industry it professes to train students for? Can the school provide names of graduates, students, and employers who have used past students?

How great a school was ten years ago has nothing to do with the quality of education and/or students it is turning out today. Be careful of schools that can't give you a list of two or three students who have graduated within the last three years and are successful and working in the industry.

4. How many students are in each class? What is a reasonable amount of students per instructor in a class?

If there are 20 students and one instructor, will you get the kind of personal attention you feel like you need and deserve to be successful? "If the course is hands on, a student should expect to be watched, coached and critiqued," says Donna Mee of Empire Academy of Makeup (formerly Makeup Education Experts). Otherwise they could waste their time and money practicing many things incorrectly.

5. What does completion of the course or program provide? Certification? Diploma? License?

Certain fields of makeup artistry will respond to different credentials. If you choose to focus on print, video and television commercials, it is highly unlikely that anyone will ever ask what school you went to, or to see a diploma. However, if on the other hand you want to do extensive makeup FX work that requires meticulous attention to detail and experience with chemicals and other substances that must be applied to the skin, someone just may want to confirm that you know the difference between acid and foam. In this situation a certificate or license from a reputable school can be a big +.

6. How much time is spent in practical, hand-on applications? What percentage of that time is spent working on models and how much of the time will you spend sitting for another student?

"Intensive lectures and demonstrations are an extremely important part of every course," says

Donna Mee, "but they will never substitute for working with your hands." "Make sure that a high percentage of the course you take includes hands-on work and thus your opportunity to apply what you've learned" says Stephen McCallum of Make-Up Designory.

7. What is the cost per hour or credit breakdown for each course? What kind of training do you receive for the cost?

Cost per hour breakdown will allow you to compare apples with apples. If school "A" provides 40 hours for a beauty makeup course at $1,500 and school "B" provides 60 hours for a similar course (assuming you have compared what is offered) at $1,500. Then you should have questions about why the hours are so vastly different if you are considering the 40 hour course. I'm not suggesting that you shouldn't take the course with fewer hours. More is not always better. I'm suggesting that you **get answers**. "If the school does not list the number of hours for each course," says Loalynda Bird, an instructor at Cinema Makeup School, "then call and ask them".

8. What kind of information, training or business development is available to help you manage yourself as a freelance artist in a professional environment?

It helps to know the difference between a W-9 and a W-4 form when you get your first paying job. Calculating overtime and filling out a time card can be pretty important as well.

9. Does the school offer job placement assistance? Do they guarantee you work at the end of the class? Do they have an apprenticeship program? If so, how does it work?

Beware of schools that promise you work. Unless you can get it in writing, don't count on it. And think twice about a school that would make such a promise. Schools are there to train, educate and inspire. You will usually have to get the work on your own. Even students who graduate from Harvard still have to prepare résumé's and look for jobs. You will too!

Job placement assistance is quite another story and a welcome addition to any educational facility. A school with a good job placement assistance center usually means it's well connected and can provide you with leads for everything from non-paying student films to low-budget projects and modestly budgeted assignments. Stephen McCallum at Make-Up Designory (also known as MUD) says that MUD's services include help with resume writing, cover letters and one-on-one student meetings to discuss deal memo's, invoices, billing and how to use industry publications to look for work.

10. Am I required to purchase my makeup from the school?

"Some schools require the students to purchase their makeup line or prepackaged makeup kits. The danger exists once you get into the real world only to find out that you have missed the opportunity to work with various lines and thus finishes, coverages, consistencies and more," says Donna. Aspiring artists should discover and decide what works best with their own techniques. Yvonne Hawker, an instructor at Make-Up Designory for two years says "We give students a list of the items that they need. They can purchase a kit from us or pick up the things they like and may already be using and are comfortable with."

11. Do you offer night classes?

Find out if the night class hours and day class hours are the same. You don't want to get short-changed because you can't attend in the daytime. Loalynda says, "If you choose a night class, lighting, class hours and building security is important. Make sure that the building and parking are secure. Ask yourself what type of makeup artistry interests you before enrolling in a program. Beauty, fashion, bridal or special FX. "Otherwise," says Donna Mee, "you might end up spending a month (and a lot of money) learning to make zombies and oozing flesh wounds when your really just interested in making women beautiful!"

There are always more questions to ask. Some of them you will have to tailor to your specific situation. If you are moving from another state and need housing, remember to calculate how far away your new home will be from the school and consider how you are going to get there everyday. When considering taking a private course from an individual, all these questions and more become important. If the makeup professional whose name is on the door interviews you and signs you up, don't assume all of your classes are going to be taught by that individual. Ask! If the answer is yes, and particularly if the person is a successful working artist, get something in writing. You don't want to get the old switch-a-roni and end up taking lessons from the assistant if the makeup artist gets booked on a job. Request a class schedule complete with days, times and what you are supposed to cover on each day. If you're paying $6,000 for a week of makeup lessons and flying in to New York from Arizona, the last thing you want are class times being changed at the last minute and teachers being switched so your star instructor can run off and make $2,000 working on a celebrity when he or she is supposed to be instructing you [personally] from 9-5 on how to do the perfect eyebrow.

Make sure that your $100 per hour makeup instructor isn't running down the clock with several field trips that include you carrying their bags and watching them apply makeup on someone else for eight hours on a photo shoot.

A WORD FROM SOME STUDENTS

I got a great education from a small school I attended about six years ago. It was intense, but a very valuable education. I encounter other artists who have taken short workshops in beauty makeup and I find that I am a lot more versatile. If I'm at a fashion photo shoot and the art director wants to make the long haired model bald and silver, I can do that without calling in another artist to help out. Aspiring artists should ask:

1. Who are some of their former graduate successes?
2. Do they offer an after hours lab so that you can practice on your own using the schools equipment?
3. Is it a full service school? Will they teach you everything you need to know to work on film, print, FX, as well as character and beauty?
4. Will you graduate knowing everything you need to know to pass the union test?
6. Will the school try to get you some work during and after graduation, or will they just forget about you? --Sherrie Long, former student, Institute of Studio Makeup LTD

I vote for Makeup Designory. it is small and very personal. I could not take off an entire month to attend the beauty section and needed something more specialized than the basic course so Tate arranged for me to spend a week with John Bailey (head of education) in a one-on-one setting. It took my skills up several levels and allowed me to fill in the holes where I needed more training. I plan to go back this fall and do some private lessons with hair.

> --Terri, former student,
> Make-Up Designory, Burbank

Before taking a two week advance prosthetics class at Westmore Academy, I taught myself most of what I knew by reading EVERY book I could get my hands on and watching every video. I appreciated the teacher having me do things that were a little more advanced, because I already knew how to do some things like use old age stipple. Also, any time I met a make-up artist I tried to ask very intelligent and technical questions.
The best advice I received was to check out the credentials of the teacher and see if they had actually worked in the field.

> --Jen McCollom, former student
> Westmore Academy, Burbank

SCHOOLS

- **Westmore Academy of Cosmetic Arts**
 (818) 562-6808
 916 West Burbank Blvd.
 Burbank, CA 91506
 westmoreacademy.com

- **Award Studio**
 (for media makeup)
 (310) 395-2779
 1541 Westwood Blvd.
 Los Angeles, CA 90024
 www.MediaMakeupArtists.com

- **Complections**
 (416) 968-6739
 85 St. Nicholas Street
 Toronto, Ontario
 Canada M4Y 1W8
 www.complectionsmake-up.com

- **Vancouver Film School**
 (800) 661-4101
 400 W. Hastings St.
 Vancouver, BC Canada, V6B 1L2
 www.vfs.com

- **Art Institute of Pittsburgh**
 (800) 275-2470
 420 Boulevard of the Allies
 Pittsburgh, PA 15219
 www.aip.artinstitutes.edu

- **Academy of Art College**
 (800) 544-ARTS
 79 New Montgomery St.
 San Francisco, CA 94105
 www.academyart.edu

Tobi Britton on Makeup Artist VE NEILL

I never knew I had a 'makeup idol' until I read an article about Ve Neill several years ago.

As I read, I learned that Neill had meticulously executed every one of my favorite film makeup jobs: *Edward Scissorhands, Beetlejuice, Poison Ivey, Batman and Robin, Dick Tracy, Ed Wood,* and *Amistad.* The list goes on.

Neill is a master of applying and painting prosthetics. Although she spent many hours working in makeup labs, she learned early on that her talent was in applying and painting prosthetics. She decided to do just that! Neill has applied makeups designed by most of the biggest Makeup FX names in Hollywood: Rick Baker, Stan Winston, and Greg Cannom to

SPECIAL MAKEUP EFFECTS By Tobi Britton

"I don't want to do makeup FX, I just do beauty"

If you are thinking this way you may be cheating yourself out of potential work. If you work mainly in print and think makeup effects are just for movies—think again.

From runway to fashion shoots, in editorial and advertising, makeup effects are popping up to tease us with the question—is it real, or is it Photoshop? Body painted magazine covers and The Sports Illustrated Swimsuit calendar, full body tattoos in an Absolute ad, or that creepy "clown thing" in the Diesel ads are all SPECIAL makeup, and they have begun showing up more and more, in an industry that was traditionally just beauty and fashion.

Today we can see a crossover between fashion, music and film. It is common to see Madonna or Gwyneth Paltrow at a runway show where only fashion editors use to sit, and then to see the clothing designer's work in a music video, where at one time, they wouldn't be caught dead. Music videos are always pushing the envelope with cool makeup styles that incorporate the Special Makeup Effects that were once only seen in film. Great "makeup videos" of the past include Michael Jackson's, Thriller, and today just watch Tool's video, Schism, or Closer by Nine Inch Nails.

In this new addition to the 'Career Guide' I hope to help you understand another facet of makeup artistry—Special Makeup Effects. You may choose to simply "skim the surface" and learn a few new skills that will make you more marketable, or dive in and start creating fantastic makeups that you never thought possible! If you "just do beauty" please read on! You may surprise yourself.

WHAT ARE SPECIAL MAKEUP EFFECTS?

The term 'Special Makeup Effects' is used to describe a type of transformational makeup that is produced by using a variety of theatrical makeup products that include silicone, latex or gelatin appliances, medical adhesives, blood, creature suits, and animatronics, to create believable characters or creatures for film or TV. Makeup FX enables the artist to transform a character more completely than could be achieved by simply using one-dimensional or standard makeup products.

This type of makeup can be a delicate Old Age application using custom made appliances and painted realistically, or a complex, multi-piece appliance such as the Elephant Man or Mask. Today, makeups are sometimes digitally enhanced so the line between makeup effect and digital effect can be blurred.

Is Special Makeup FX right for you? If you compare your makeup education to the options available in a college degree program, you will see that there is room for some special skills or electives, in addition to your main focus. Perhaps you really enjoy fashion and beauty makeup for print, but love making cuts and bruises for fun. Think of your goal as a major in fashion/beauty with a minor in simple makeup FX. Now you can see how doing cuts and bruises won't compromise your fashion/beauty emphasis. However, when a makeup effect is needed on your next shoot, you will probably get the call before the photographer starts looking up serious effect people.

Having a wide variety of skills (or at least a working knowledge of them) will only help you become a more well-rounded and employable artist.

What are your options? Special makeup effects can be broken into two categories: Simple makeup effects and advanced special makeup effects. The first refers to effects that are called for on a fairly regular basis during filmed and videotaped productions. I believe, that a working knowledge of these skills should be maintained by anyone who calls him or herself a professional makeup artist. Simple skills such as cuts, burns, bruises, scars, sunburn, tears, tattoos, perspiration, stretch and stipple aging and bald caps can be the difference between getting the job or passing on it. Advanced Special Makeup Effects refers to the utilization of prosthetic appliances that are attached to the performer's face and/or body to become part of the finished makeup application. Animatronics—again advanced, add movement to lab created models of creatures, monsters and characters.

SIMPLE MAKEUP EFFECTS

In the film world where getting into the union means better pay, conditions, budgets and higher profile projects, knowing how to apply bald caps, cuts, burns, bruises, latex, gelatin or silicone

Tobi Britton on Ve Neill

name a few. Asked if she ever wanted to open her own lab, and the answer is a resounding "NO". She chose one aspect of makeup FX, application and painting. With these skills she has created an awesome career.

For years I never knew about her or the difference in disciplines, assuming that whoever designed the makeup also applied it! Neill did not go to makeup school. She sustains an awesome career in California, and makes the best darned brushes I've ever used—Ve's Favorite Brushes.

Her advice to new FX Makeup Artists, "Since there is a lot of competition out there now, take a class or two and go volunteer to sweep floors for free in a lab. Even if you may not want to do lab work, it is important to know how the appliances you are applying are made. It is also important to keep up with the latest products (like adhesives) and techniques that are out there so your applications will look better, last longer and perhaps take less time" ✍

appliances, age makeup and period makeup are basic skills that you are expected to master.

THE GOOD NEWS

Learning a few new skills can be as simple as a one or two day workshop. As you learn more, you may find that special makeup FX actually really appeals to you!

USEFUL [Film Quality] SIMPLE SKILLS:

Cuts, Burns and Bruises
Age Makeup: Both paint, Stretch and Stipple
Airbrush Beauty Makeup

USEFUL ADVANCED SKILLS:

Bald Cap, Prosthetic Application, Tooth Making

When thinking about what you should learn, think about how each skill can translate into $ or experience. For example: cuts, burns, bruises and age makeup can help you land more student and independent films, as well as specialized editorial (because most print artists can't do it!) Airbrush beauty makeup can make your bridal bookings hit the roof. Why, because you will have a skill that many of your competitors won't. Bald cap makeup can earn you big bucks because many artists rarely do them even though they know how. If you are good, word will travel fast! Prosthetic application will sure come in handy when there are a few makeup effects shows going on at the same time and good help is needed. Ditto for those of you who live in places where California and New York based production companies shoot in and hire local talent from such as 'the Carolina's', Georgia and Canada. Tooth making can make you a small fortune no matter where you live during Halloween!

FX PART 2

Advanced special makeup effects, like those described above, is not to be confused with Special FX—the art of blowing up cars, buildings, making smoke, and bullet hits.

The Studio Makeup Academy
1438 N. Gower Street
Mail Box 14, Studio 308
Hollywood, CA 90028
(888) 465-4002

The Studio Makeup Academy

The Sunset Gower Studios are used by shows like "Radio News," "In The House," "JAG," "Fresh Prince," & "Married with Children."

Classes for beginners & working industry professionals. Professional makeup artists attend brush-up or advanced courses to catch up on industry trends. Courses taught include, but are not limited to: Beauty, Old-Age, Bald Cap, Hairwork, Character & Special Effects, Prosthetics.

Day or Evening Programs available. Reasonable Tuition.

The Studio Makeup Academy
1438 N. Gower Street
Mail Box 14, Studio 308
Hollywood, CA 90028
(888) 465-4002

Well-known artists like Rick Baker (*The Grinch and Planet of the Apes*) and Stan Winston (*Terminator 2 and Jerassick Park*), and Nick Dudman (*Harry Potter and Mummy Returns*), etc. can do all aspects of special makeup from sculpting to application. However, they hire groups of specialized artists to get a film project done due to the sheer scale of the production.

Equally talented artists that can 'do it all', like Kenny Myers (AI and Out of Towners), Matthew Mungle (*The Score and Fast and Furious*), and Jeff Dawn (*Terminator 3 and The Scorpion King*) put out incredible work on a smaller scale while retaining a more hands-on role. Richard Snell (*Clock Stoppers and Brother*) is an awesome artist that also 'does it all' but chose several years ago to give up his shop and fly solo by giving up his shop. Having a shop, burdened him with paperwork and finances and took him away from the art of makeup. Today he is happy to work as a key or an assistant on film projects. It doesn't matter to Richard—he just loves the work.

Ve Neill (*Batman and Edward Scissorhands*) is the master of prosthetic application and an awesome beauty makeup artist as well. She spent time in the lab (the place where special makeup FX are typically created) early on, and soon realized that she loved working on the set and was great at application. Today she is one of the most well respected artists in Hollywood. These are just a few of the many incredibly talented makeup artists that make up the "A" list of special makeup effects.

Today, a career in special makeup effects does not require that you 'do it all'. You can find a specific area of effects to specialize in and "work it, gurl"—or guy, as the case may be!

Must I go to school? No. Many artists never went to makeup school. School for them was creating a basement lab, blowing up their garage, turning their dog into an Ewok, gaining 'on set' experience on low budget 'B' movies, making mistakes, and learning from them. I never went to school, but now I teach workshops, in guess what—film, TV and photography makeup. Fancy that! Ve Neill never went to school. Others did. Whether you go to school or not, is a personal choice with pro's and con's that we will explore.

SELF TAUGHT

Pros: Save money, learn at your own pace. **Cons:** It takes much longer to figure IT all out. Your mom or spouse may not understand the smell emanating from what used to be your kitchen. Your dog may never speak to you again after turning him into an Ewok and your friends suddenly become really busy whenever you ask them if they would like another bald cap.

ARTIST: JORDAN KEIT/MAKEUP DESIGNORY. MODEL: HEATHER HAUN

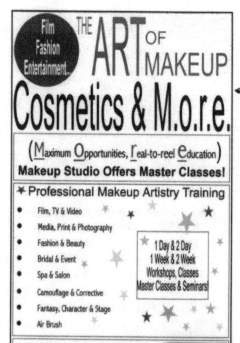
SCHOOL

Pros: Education can be a great jump-start to your effects career and can save you from some very costly and embarrassing mistakes. At school, you can find out what you need to know and practice it. This competitive edge will allow you to enter the work force sooner because you have [at least] a basic knowledge of what is expected of you.

Cons: Classes cost money. So do supplies. You will still have to work for free in the beginning, and your first job won't be perfect even though you did go to school. You will still need to practice to become a great makeup artist. Nobody becomes an experienced makeup artist upon graduation—it takes years!

Just attending school will not guarantee a successful career. Lastly, your mom or spouse may not understand the smell emanating from what used to be your kitchen. Your dog may never speak to you again after turning him into an Ewok. Your "friends" suddenly become really busy whenever you ask them if they would like another bald cap. Are we seeing a pattern yet?

TYPES OF COURSES:

Courses range from Dick Smith's home study course to workshops and all the way to full blown schools like the Makeup Designory, Studio Makeup Academy, Joe Blasco, and Empire Makeup Academy to name a few.

HOME STUDY

Dick Smith, one of our "Founding Fathers" of makeup effects teaches the only home-study course that I know about. He has spent his life creating the foundational techniques of what we know today as Special Makeup FX. It was he who transformed Linda Blair in The Exorcist, and created the character, Quentin in the Vampire laden daytime soap opera of the 70's, Dark Shadows. He has worked on hundreds of well-known productions. Dick is the man who invented PAX—a substance used to paint prosthetic appliances! Visit www.dicksmithmake-up.com to see examples of his work.

Dick has two courses to choose from. The first, which is brand new, is perfect if you would like to get your feet wet and see where you stand without investing a bundle. The course entitled "The Basic 3D Makeup Course" costs a mere $350! It walks the student through the basic steps of Special Makeup Effects: making a life mask, sculpting on the life mask, making the mold, molding the appliances and prosthetic application. The great thing about this course is that you can do it on

ARTIST: PATRICK MAGEE/EMPIRE ACADEMY OF MAKEUP

your own time and also have Dick's personal input as to your level of talent and what you would need to work on in order to have a successful career as an artist. He estimates materials to be around $200-$300. I think this is a great course to take before investing thousands on a long-term class.

MAKEUP FX WORKSHOPS

Quite often, you can find experienced special makeup FX people who give day to week long workshop in areas like cuts, burns and bruises, bald cap, prosthetic application, tooth making, sculpting, life casting, ventilating, wig making, airbrush and more. These classes are a great way to brush up on, perfect or learn a particular skill set and do not require a leave of absence from work.

FULL BLOWN SCHOOLS

These schools provide in depth study in special makeup effects and usually require daily attendance over a period of several weeks. Larger schools often offer free workshops and lectures taught by well-known, working, industry professionals with a wealth of experience and knowledge to pass along. Additionally, they make their labs available for students to practice in outside of regular hours and some even allow you to come back for refreshers, so do your homework, ask lots of questions, ask for references and write everything down.

Before you spend a small fortune on school or setting up a complete lab, you might want to investigate the various jobs in the industry. A little experimentation can go a long way toward finding out what you have an aptitude for and enjoy.

Two of the most useful skills are sculpting and painting. Here are a couple of cheap, simple ways to try them out.

NOTES

SCULPTING:

Do you love to sculpt? Then try this; buy a lump of clay, gather a few reference photos and start sculpting! View your sculpture with a critical eye: Are the features in proportion and do they have an "organic" flow?

Painting: How's your painting? Is it flat or can you create dimension. Richard Snell suggests taking a sheet of white paper and trying to paint it to look like a piece of skin.

As I stated before you don't have to be an expert in every aspect of special makeup effects in order to get work. Following is a list of skills that you can specialize in.

Casting: Every prosthetic starts out with a life cast of the actor. A life cast is a stone positive which is an exact replica of the part of the performer that the appliance will be made for: full head cast, face cast, body or body part cast. All of the sculpting will be done on the prosthetic, to create a perfectly fitting appliance.

Sculpting: The sculptor uses reference photographs, sketches or illustrations, to turn a lump of clay into a three dimensional replica which will later become a foam, silicone or gelatin appliance, body suit or model.

Mold Making: The success or failure of the appliance relies heavily on the mold made of the finished sculpture. A bad mold will render hours or days of meticulous sculpting useless. (Talk about pressure!!) Expert mold makers are always in demand.

Running Foam, Silicone or Gelatin is a process similar to baking a cake. This is where you create the actual prosthetic piece and put the foam, silicone or gelatin in the mold. It's an exact science that requires a "scientific mind". Recording and analyzing formulas and variables such as temperature, humidity and baking time are all part of the process. The final results are crucial, and used to duplicate a product or result consistently. Hold a foam prosthetic up to the light. Do you see air bubbles or pockets, or are the foam cells fine and even? These seemingly unimportant "pockets" can turn an application into a disaster when glued down! Is this the job for you?

Seaming: A noble task indeed, and very important! Without invisible seams, the illusion of reality and believability will be lost. Would you be frightened or just laugh out loud if you saw a seam on the T-Rex in Jurassic Park? Bad seams make an effect look like a B-Movie. Seaming is a good choice if are a detail person with patience to spare.

Painting: A perfectly created prosthetic looks like a piece of rubber until it is painted. Painters are very valuable to the makeup FX lab, and good ones work all the time. Painting is also the closest relative to makeup application; because that is basically what we do--paint faces for a living! Painting is also a crucial skill if you are more interested in application than lab work.

Hair Punching, Wigs & Hair Goods: Most characters are not complete without hair. From Planet Of The Apes to Austin Power's chest (Oh yeah, baby!), everybody looks better with hair. The makeup department is responsible for hair punching facial or body hair and hair goods. They work hand in hand with the hair dept. If you have the patience and talent to create pieces literally one hair at a time, you could have a great career!

Application: The perfect balance between lab and set is application. It makes all of the lab work believable—or not!

Animatronics: Not really makeup but part of the shop. This department makes things move, like models, puppets and dummies, or a combination thereof. And transformations too, like the guys in Werewolves of London.

WORKING WHERE YOU LIVE?

These days, you can live just about anywhere and work your craft. You could develop a very lucrative Halloween business doing awesome makeup applications or making custom fangs and teeth. Many theme parks hire makeup artists as well. How about a specialized children's birthday party service? Contact your state's Film Commission, they have access to information on what productions will be shooting nearby, and you may be able to get hired.

BEST BETS FOR MAKEUP WORK IN THE U.S.:

California: Los Angeles is probably still the best bet for makeup FX; I think they have more makeup artists per square mile than anywhere else in the world.

Florida: Many theme parks recreate FX film characters. Both Universal Studios and Disney have huge makeup effects labs. Seeing the need, Joe Blasco opened up a school there.

NOTES

New York: There is some work. However, most east coast artists who do special makeup work a lot in Los Angeles and maintain LA contact numbers. It gives production the feeling that the artist is always close at hand.

Canada: Many productions are shooting up in the hinterlands. US money spends well in Canada, but it's not easy for U.S. citizens to work there.

Anywhere Else: Sometimes, the best position to be in is that of a "Big Fish in a little pond"! Even if you do not live in or near an "Ideal Makeup Location," having specialized skills will put you ahead of the competition—especially when a big production comes to town.

WHAT TO EXPECT

Here is a quick rundown of a few opportunities and possible pay scenarios. Please bear in mind that pay is not always just money. Pay can also be experience, contacts, opportunity (to do something cool), or credit on your resume. NO PAY often pays off big later on!

Student films usually pay nothing but meals, transportation and a copy of the finished project. Some actually do have a makeup effects budget, and you can come close to breaking even on out of pocket expenses even though you may not receive pay for your services. Smart artists look at these projects as being paid to practice. The good news—they are usually short; you can have a lot of creative input, and a great opportunity to showcase your work.

A low budget [usually independent], "B-Movie" or Cult horror film can pay as little as $150 per day with no overtime [pay] and minimal supply money. The better 'B-Movies' pay around $250 per day with a little overtime. You will probably need a portfolio and a few student films under your belt to bag one of these babies, unless they are either really desperate or you are really lucky. But don't let your inexperience stop you from trying—it might be your lucky day.

Lab work often pays nothing but experience to start. Sometimes you can pick up minimum wage and then work up the scale—$10, 20, even $30 per hr. Pay is commensurate with experience, talent and as always—the production budget. Don't expect to walk in and start making $30 per hour. My advice is to expect nothing in the beginning, and then be grateful making anything at all! After more than twenty years as a makeup artist, I will still work for free if it is a cool job, or I see an opportunity to make a good contact, get an awesome piece for my portfolio or credit for my resume.

Your first few jobs may pay nothing at all. Heck, they may actually cost you money for lunch and transportation!

The most important part of this formula is dedication and LOVE for what you do. If you love

the process, the money will be an added benefit enabling you to keep you doing what makes you happy!

BREAKING IN

If you know of a makeup effects lab, volunteer to help out. Sweep floors if need be. Anything to get a foot in the door.

On Set Application: Basic union rates are around $38 per hour plus overtime. Well-known makeup artists often negotiate better rates and other perks like department budget control, special housing and travel arrangements, etc. See, you have a lot to look forward to. The hourly rate can fluctuate with different kinds of union contracts, but

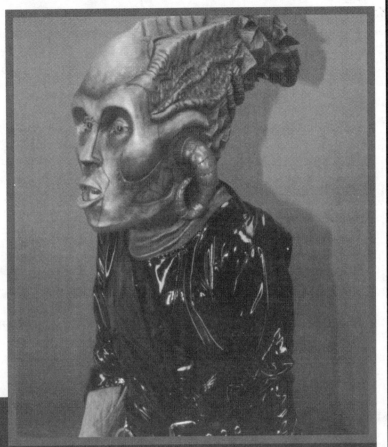

Artist: Pannipa Saekhow/Makeup Designory. Model: Sung Park

SCHOOLS TO CONSIDER FOR SPECIAL FX MAKEUP

Academy of Art College
www.academyart.edu

Art Institute of Pittsburgh
www.aip.artinstitutes.edu

Complexions International
www.complexions.com

Dick Smith
www.dicksmithmake-up.com

Empire Academy
www.makeupempire.com

Joe Blasco
www.joeblasco.com

Makeup Designory
www.makeupdesignory.com

New York University
www.scps.nyu.edu/summer

Studio Makeup Academy
www.studioacademy.com

Westmore Academy
www.westmoreacademy.com

The Makeup Shop
www.themakeupshop.com

Vancouver Film School
www.vfs.com

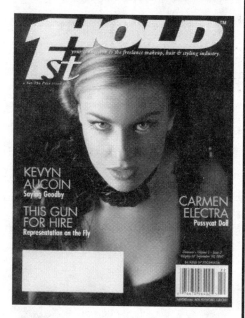

you'll know that going in. Non-union shows have no wage guidelines. And since they are not under union contract, they are not under any obligation to provide meals at regulation times, overtime or compensation for your kit (the supplies therein). This is where your savvy negotiation skills and written contracts become really important in securing a good working situation.

The applications involved in special effects makeup require the purchase of some pretty pricey products for your kit. A special makeup effects kit includes more than lipstick. A bottle of Silicone glue, thinner and remover can cost you almost $100. Keeping up with the latest products and techniques is an additional expense. Early on, your money will be spent on the materials you need for practice and getting good enough to build a portfolio of your work.

BOTTOM'S UP

As an artist, remember, growth takes time and patience is a virtue. Be humble, open and eager to learn. Knowledge comes with experience for which there is no substitute or short cut. Starting at the bottom can mean working at a shop sweeping floors enthusiastically until someone lets you mix hydro cal someday. Expect nothing, and be grateful for everything.

Choosing a school is personal. Do your own research and choose what is best for you! Full contact information for the schools listed below can be found in the resource section of this book.

SERIOUS ABOUT
A CAREER
IN MAKEUP?

If you're always late,
undependable, or have an ego the
size of Texas, don't bother calling.

*Empire is committed to improving the **quality** of makeup
artists, <u>not</u> the quantity, which is why we are so selective
about the students we choose to enroll. If you dream of
a career in makeup, aspire to be the best at your craft,
are dependable and willing to work hard, and you
desire a great reputation in the industry, the first step
towards making your dream a reality is to contact us. We
offer the most in-depth, advanced makeup training avail-
able to prepare you for the real world. Courses, work-
shops and private lessons are available in every aspect
of makeup application including Advanced Beauty, Print,
TV, Film, Effects and Airbrush.*

Call 714.438.2437
www.MakeupEmpire.com

EMPIRE
ACADEMY OF MAKEUP

CAREERS IN MEDIA MAKE-UP ARTISTRY

With specialized training in media make-up and a first class portfolio, we p[re]pare creative individuals to work for ads, television, films, CD covers, mu[sic] videos, runway shows and fashion magazines.

TRAINING AT AWARD STUDIO

In order to work for the media, specific training is required that is differe[nt] from salon make-up and what is taught at cosmetology and other make-[up] schools. It is essential for media artists to understand photography and le[arn] about all types of lighting and film. This enables them to apply the corr[ect] make-up for each media situation.

BUILDING A PORTFOLIO

Without a professional portfolio to show the quality of your work, clients w[ill] not even interview you for possible jobs. Award Studio offers the only trai[n]ing program that gives students the opportunity to work with actors a[nd] models, provided by us, on actual photo shoots. This "on camera" work co[m]prises more than 50% of the program and enables artists to build their po[rt]folio as they learn.

CLASS SCHEDULE

One Week Media Make-up Class - At our studio in Los Angel[es] Monday-Friday, day and evening (maximum of 9 students).
Two-Day Fashion Location Class - Saturday & Sunday following t[he] one-week Media class.

All classes are taught by international make-up artist and photographer A[nn] Ward. Her credits include many magazines such as a Vogue, Vanity Fair, Ma[rie] Claire, Brides and Cosmopolitan. She has worked as a makeup artist and photo[g]rapher for ads, films, TV commercials, CD covers, catalogs and runway shows.

For more information, visit us at
www.MediaMakeupArtists.com
(over 30 pages online)
If you have questions or would like an enrollment application you can
contact us at the number below.
310-364-0665

Award Studio is registered with the State of California Bureau of Postsecondary and
Vocational Education and is a member in good standing with the
Better Business Bureau.

3 MARKETING YOURSELF

Experts will tell you that the three most important elements of a successful retail establishment are location, location, and location. In the makeup, hair, fashion, prop, and costume industry, there are equally important rules to live by:

SHOW ME • LEAVE ME • CALL ME • FOLLOWUP

TRANSLATION:
Show Me Whatcha Got	(a portfolio and/or a resume)
Leave Me A Reminder	(a promotional piece)
Call Me	(follow up with a phone call)
Follow Up	(send a thank you card)

SHOW ME It is not enough just to tell people what you've done. You have to show them what you have to offer. That means presenting a portfolio for print and/or a résumé if your plans are to work in film and television.

LEAVE ME Once they've seen your work, you must give them something to remember you by. That's where your promotional card and/or résumé come in. It's the physical piece of evidence that stays behind and reminds people of the kind of work you do.

CALL ME You've presented your portfolio and left your promo card, now it's time to follow-up with a phone call. A good rule of thumb is to call back within 2-3 days of leaving or mailing your promo card or résumé. Remind them who you are, and ask if any work is coming up that you might be suited for. At worst, they can tell you no, at best, you just may be in the right place at the right time and get a job.

FOLLOW-UP Last but not least is the thank you card. It's the best way to say "I really appreciate you taking the time to look at my work, meet with me or give me advice. The beauty of a thank you card is that it too becomes a promotional piece. People really don't like to throw them

KEVIN STEWART
FASHION DIRECTOR
SAVOY MAGAZINE

Former Market Editor for Vibe

CG: What does a Market Editor do?

KS: Other magazines sometimes have more than one market editor to cover menswear. You have people who just do ties and shirts, or sportswear, or suits. I did it all. I had worked with clothes for so many years that it was natural to just pick what I thought was the best in certain collections. I did it for 2 1/2 years. I traveled to Europe and did the mens-wear shows in Paris and Milan. Then I decided I wanted to be a fashion director and here I am at Vibe.

CG: What are you looking for in the fashion stylist who works for Vibe?

KS: The problem I have with styl-

KEVIN STEWART

ists, is that they some-times forget to let the clothes speak for themselves. Many stylists are frustrated designers. They want to twist things, turn things upside down and hey, at the end of the day, people don't dress like that. They don't walk the streets with their sweaters turned inside out, wrapped around their heads. Don't strip it down and totally destroy the original intent of the clothes. In Italy they don't allow you to mix clothes. You don't mix designers at all. Stylists sometimes forget that people need to see the designers vision intact. Here, in America, you can do what you want. There are ways to mix designers, but I don't think it should be over the top. You don't put a big fur mohair jacket over a Ralph Lauren suit; those two elements aren't going to the same party. It's also important to work with stylists who understand editorial. Video styling does not work in editorial pages. Music videos are quick images that are supposed to be flash. When you go into editorial pages, and people try to apply those things to real life, they don't work. People shouldn't look like they're in a music video. Not all the time. Everybody can't be shiny. That's why you have to mix up the stylists

away and will often shuffle them around on their desks for weeks and months because it doesn't feel quite right to throw it in the trash. As Sam Fine said in the spring 2000 issue of 1stHold Magazine, it's "The gift that keeps on giving".

You can't win, I mean really win without committing these rules to memory and employing them each and every time you approach a potential client. You've got to show 'em, leave 'em, call 'em and follow-up. It may sound cliché, but the squeaky wheel gets the grease.

CREATING A MARKETING CAMPAIGN OF YOUR OWN: PLAN TO WORK & WORK THE PLAN.

The foundation of your marketing effort begins with a plan. Your goals. They and they alone should determine who you will work with, which pictures make it into your portfolio and onto your promo card, the kind of résumé you construct, whether or not you will need a reel, who you will send your promo cards to, which creative directories you will get listed in and those that you may even want to advertise in.

There are 3 things you must do before you can build a portfolio from a position of strength.

1. Make some choices
2. Set some goals
3. Get some knowledge about the market you're in and/or plan to work in.

Sound like a lot of work. Hey! Work now or work later. It's up to you. Spin your wheels without a thought about where you want to go or how you're going to get there, and you'll end up two years older with a portfolio that says little about the kind of artist you keep telling people you are. Choose a direction now and make a plan and you really could be working with Steven Spielberg on an upcoming feature or working on the cover of Vogue in 2002.

So how do we do it? By making some choices early in the game. You can't do everything. As much as you would like to. At least not in the beginning. You need to choose a place to start. Your choices don't have to be permanent but you will want to stick with them long enough to see the results of your efforts and know exactly what you like or don't like about Print, Video, TV Commercials and Runway or TV & Film.

Artists who are starting out often say to me, "but I want to do everything". Everything typically means one of two things.

1.　They want to specialize in print, video, film AND TV.
2.　They want to be a makeup, hair and fashion stylist.

For the sake of argument, lets all agree that it takes approximately two years to build a book or a résumé that can start to produce the kind of paying jobs that will sustain a lifestyle that is better than beans, rice and Lipton tea.

Remember what I said in Chapter 1: With Print, you build a book. In Film & TV, you build a résumé. So why is it so hard to do both at the same time?

Building a book means that you are searching for and setting up appointments with photographers, connecting with other makeup, hair, fashion stylists and models to set up test photo shoots that will net you good pictures for your book. You may also look for key artists to assist for experience.

Building a résumé means that you are seeking out student and independent film makers who are working on short and low-budget films to add to your résumé while searching for other key artists who work in film and TV to assist to gain experience.

A key element of building a book is the relationships that keep you connected to people who are constantly working on their books. If you step away from those relationships for the weeks that it takes to work on a film, the people you connected with move on to replace you because they, having committed to building a portfolio for print must continue the process and momentum required in building a portfolio.

Having taken several weeks off to work on a film, an artist can return to find that their connections have connected with someone else and the artist is then left to start the process all over again.

A year or two of this kind of leap frogging can leave you with a few pictures in your book, a couple of films to your credit and no real direction in your work.

Now let me paint the same picture for those of you who want to do makeup, hair & styling. I'll use EnVogue, the four girl group for a moment. Remember them? Four girls. Really popular

Test: A collaboration between a photographer, makeup artist, hair stylist and fashion stylist with the objective of creating something wonderful on film that they can each put in their portfolio's to show other creative professionals to secure more test opportunities and/or work.

Tearsheet: Published work. Any job (or test) that you do that results in work being published in a magazine, on a billboard, as a mobile [that hangs from the ceiling in a gas station], on a box or a book cover is considered a tearsheet. Even a television commercial, show or video is your tearsheet.

KEVIN STEWART

you use. So it doesn't become all the same.

CG: **In the past, Vibe had staff stylists.**

KS: We're not having any more contracts. I don't believe in them. I'm about spreading the wealth.

CG: **Since you are responsible for hiring makeup, hair & fash-ion stylists, what will be your process?**

KS: Because I'm a black man, and I have shown up to a television station and had to work with hair and makeup artists that didn't know what to do with my hair and skin, I am very aware of the needs of people of color. So now I have to be more conscious of that. It works in stages, first you get a pool of stylists, then you get a pool of hair and makeup artists. If you have to do a black man's hair, you need a barber. Regarding makeup, I don't like to see mens faces beat to the point that they look like they're wearing a mask.

CG: **How do you look at books? Will you set up hours, days and times to look at books?**

KS: People call. Sometimes I can't get

KEVIN STEWART

into it on the phone. But I will look at books. I don't always have time to sit down with you, but I will look at your book because I'm always looking for people. Setting up times is hard for me to do right now because my weeks aren't planned. Once I probably get through March (1995) that will be easier for me to do.

CG: What turns you off about the contents of a book?

KS: Finishing! Someone who doesn't know how to cuff a pair of pants the right way. Details...if you don't see a bit of cuff on the end of a jacket sleeve. If the jacket didn't fit, why did the stylist use it? I have a tailor, my clothes fit. I want to see that same thing in a photograph. If you are skilled, there are ways to fake it. Unless someone is running in the shot, you can pin and tuck. It's important that the stylist is equipped with the skills necessary to give an illusion. I don't want to retouch. But I will and that costs money. If things aren't ironed, I have a problem. If it's linen its understandable. Linen is at its best when it's wrinkled. If it's a cotton shirt and you didn't take the crease out of the sleeve of a shirt and I have to retouch it, you are costing me money.

for about 4 years from 1992 to 1996. Well I have represented several people over a period of years who worked with those girls from the photographer, David Roth to their first makeup artist Tara Posey, their second makeup artist Troy Jensen and two of their hair stylists, Roberto Leon and Erik Maziere. Their example presents a typical photo session and the reason you can't and would not want to try to do makeup, hair & styling on a photo shoot.

In fact, the only places that artists do everything is in smaller markets like Cincinatti, Ohio or Denver, Colorado and they would rather not. . .do everything that is. In smaller markets the clients really don't pay you any more money for doing all that extra work.

That said, here's the scenario:

You're the makeup artist. The photo shoot should take 8-10 hours. The (4) girls are going to have 4-5 clothing changes, 2-3 makeup changes and 2-3 hair changes. It's 7:00am and you have to be done between 3 and 5:00pm. It's February, cold! The shoot will take place in the studio and on location. As a matter of fact, the last shot of the day is on location at the beach. It's freezing cold even in Los Angeles and the sun sets at about 4:30pm. Let's go! 4 girls in 8-10 hours. You can do it all, Right? Impossible? Pretty much. Why?

It takes about an hour to an hour and fifteen minutes (at least) to do each girl. If you do the makeup for each girl by yourself you've just eaten up a minimum of 4 hours and you haven't taken a single shot nor have they had their hair done yet. Also, the girls that are done are sitting around waiting for you to do their hair, eating snacks, messing up their lipstick and wondering when they are going to get to try on some of the clothes. Now you'll need an additional 45 minutes to an hour per girl for hair. You've just used up another 3 hours. Its 2:00pm.

Each shot will take about 30-45 minutes, another 30 minutes for each clothing change and setting up for the next shot. Oh yes and don't forget changing the lipstick color to go along with each clothing change. And we haven't even left for the beach yet.

Why are we shooting at the beach in the dead of winter? Because the CD will be released in the Spring. It all makes perfect sense doesn't it. That's why you can't and wouldn't want to do everything. And if you cause the shoot to go overtime then you will be costing the record company no less than $1,000 per hour. Overtime means everyone gets paid extra. You, the photo assistants, the mobile home driver, the studio rental company. The list goes on.

For your information, EnVogue had 2 makeup artists, 2 hair stylists, one fashion stylist with 2 wardrobe assistants and a photographer with 3 assistants. All that and we finished at the beach at 5:30pm. Still think you can do everything?

EFFECTIVELY MARKETING

Marketing for print is different than marketing for TV & Film. In print, artists and/or their agencies use promo cards to market to creative decision-makers who review the images on those cards and call in portfolios. If they like the cards they keep them on file. Artists and/or their agencies, also place ads and list themselves in creative directories where art directors, editors and photographers look for talent. And now there's the Internet where both artists and agencies are putting up real estate to showcase their work and generate more bookings.

With TV & Film we are back to the résumé. Rarely do I get a promo card from an artist who is focused on or working in film & TV. The artists résumé informs a producer or director about the positions the artist has held and thus the amount of responsibility they assumed on each subsequent film. A producer, who likes what they see and has positions to fill might call the artist in for an interview to access which position they might be suited for.

If you decide to switch from print to film or film to print, you want to understand what you like and/or dislike about the choice you made or you may find yourself dissatisfied with both.

MAKING GOOD CHOICES: WHAT YOU HAVE TO KNOW

This is simpler than most people think. You have to know what you like. Really. Many of us are self-taught about a lot of things. The clothes we wear, the art we buy, etc. . . You walk into an art gallery, look at a painting and say "Wow!". The WOW comes from the inside. Sure, maybe a few of you took an art history class here or there, but many people just like something 'cause it feels good.

In 1985 when I started repping photographer, Bobby Holland, I didn't know anything about photography and I knew less about hair and makeup. In fact, how much I didn't know was proven after Bobby Holland fired me and my mentor, Elka Kovac, upon review of the new photographers I had chosen to represent, she informed me that my photographers were terrible. I was devastated.

So how did I learn? The same way you will, by paying attention to GOOD photography. Next question. How will you know good photography from bad? Here's a secret, only look at GOOD photography. There is no bad photography in *Vogue, Elle or Harper's Bazaar*. The photographers who shoot for these publications are world renowned and just plain fabulous. Two other great places to look for photographers are *American Photo* and *Photo District News*, better known as *PDN*.

Start to look at the pages of these magazines with a new eye. Forget the shoes, the dresses and the jewelry for a moment. Begin to look at the lighting the shadows or lack thereof. Look at

CG: Would you hire someone without a book?

KS: No. The one thing I think you can do is hook up with a photographer and test. I think you need to test your skills before you try them out on a magazine. I can't take a chance on doing a shoot that's going to cost thousands because I like you.

CG: As a display artist, how did you build a book?

KS: I did window displays and I would photograph my displays at night. I knew I was going to leave eventually, and I needed a body of work to show.

CG: How important are the aesthetics of the portfolio?

KS: Presentation is everything. If an artist comes in with coffee stains on their book, and torn pages and tearsheets, I'm just going to pick somebody else. Make an investment. People want to know that the artist is someone who cares about their work.

CG: Do you have a preference for artists who are represented by agencies?

KS: At this point, the better caliber of

KEVIN STEWART

people are with agencies. However, if someone comes by and they have something that makes me say 'boy there's a lot of talent here', I'm interested. I'm looking for someone who is raw and hungry. The hungry people are more willing to listen. The more established people think they know it all. Artists sometimes forget that the person paying the bill is the client. I want to work with artists who will take my reader and my opinion into consideration.

I've got 250,000 readers with incomes from $0 - 30,000. All of those people have to see something in the magazine that they can aspire to or readily go out and get. I can't have a shoot where everything on the model is unaffordable. Stylists have to take into consideration who is reading our magazine and what our readers can afford.

CG: Do you have an agency preference?

KS: No. I think it's the people, not the agency.

CG: Finally Kevin, what advice would you give someone wanting to get into or further their career in this business?

the way the lighting changes the lipstick. Look at the hair on one page and how different it might look on another. Not because they changed the style but because the photographer changed the lighting.

Here's an excercise. Get a piece of fabric or a dress. Silk or satin will do nicely. Take it outside and lay it in the grass about 15 minutes before the sun starts to set. Stand there and watch the way the shadows cascade over the fabric from moment to moment as the sun begins to recede. Makeup, hair and fabric color, texture and mood will react to a photographers lighting the same way the fabric reacts to the bright light of sun turning into the dark of night.

<u>You</u> will be asked and required [as a professional] to make all sorts of [artistry related] changes according to the photographer or directors choices of film and lighting, not the other way around.

Why all the fuss about good photography? Because bad photography makes bad pictures regardless of how fabulous your makeup, hair or styling is. Bad photography can make good makeup, hair or styling look hideous and good photography makes everything magical.

When you don't know what you like, you can't possibly make good choices about who to work with. You are easily fooled by imposters just because their portfolio is filled with pictures that you ASSUME are good because their are so many pages. It just doesn't work that way. What's supposed to happen? When you see good photography it should take your breath away.

GOALS

Goals give you single-minded focus. They act like a homing device, always bringing you back to your original purpose. There are two keys to having success with your goals. One is WRITING THEM DOWN, the other is knowing that you CAN'T tell them to everyone. BIG goals are Good. The goal is the thing that will order your choices. Here's what I mean.

If your goal is to do the cover of *Vogue* in December 2002, then the goal will order your career choices about who to work with, how long to work with them, which jobs to take, when to make your moves and everything in between. That's the beauty of a time line. You have somewhere to be in December don't you?

Pret-a-Porte: Ready-to-Wear.

Faux: Fake or similar to. In this case the faux material we are talking about is often called "Wax Skin" by the trade.

ADB: Advertisers Display Binder Company is a custom portfolio maker on the east coast. They can be reached at: (800) 489-3246. 10% discount to 1stHOLD subscribers and Career Guide owners.

If you've been doing your homework and paying attention to what you like, then you will identify the work of photographers and directors whose work turns you on. Why is this important? So that you'll recognize the work of a young photographer who's pictures remind you of Patrick Demarchelier, Steven Meisel or Annie Leibovitz when you look at their book or the handful of polaroids they're showing you. Your goals will order your choice to work with the person or not. Your goals will give you a new set of criteria by which to measure their work as it relates to your path. And there's nothing wrong with being picky. Especially since the bad work can't go in your book anyway.

The basics of your personal marketing campaign should include:

- Portfolio
- Promotional Card (comp)
- Telemarketing (phone calls)
- Résumé
- Direct Mail
- Website

- Networking (a.k.a. Partying with a Purpose)
- Business Cards
- Listings
- Logo or Personal Typeface
- Thank You Cards
- Personal Style

Optional elements of your personal marketing campaign might include:

- Reel
- CD ROM Portfolio

PORTFOLIO

As the most crucial part of your marketing effort, your portfolio should be flawless, whether it has five pictures in it or twenty-five. It should be neat, clean, labeled, have pages that are relatively free of too many scratches and contain work that showcases your ability, and work you are proud of.

Your portfolio is you. It should not contain work that you have to make excuses for. An art director is immediately turned off by the artist who shows his or her work and adds the proverbial disclaimer with every photo: "This photo would have been better if . . .", or "I keep intending to take this out of my book," and "This really isn't my best work," The typical art director response

★Drop-Off: Specific day(s) and/or time(s) that makeup, hair and styling [and modeling] agencies have set up for portfolio review and consideration.

KEVIN STEWART

KS: They need a foundation, to work on their skills. Take the time to understand how clothes are structured, not just how they're put together. You have to understand how to take something apart to make it work. If you're dealing with someone who's a size 38 pant and you have a size 34, then you need to know how to take it apart and make it work. Know how to give the illusion that it fits. Have some skills and be able to work the details. You can't have a book full of all this directional stuff that isn't going to get you any work. Remember that you're in a business and you don't always get to do what you want. Sometimes you just have to do a job and get paid. **END**

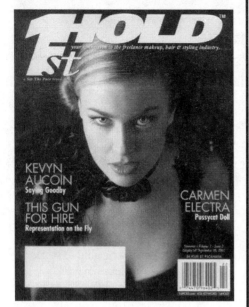

will be to thank you kindly and hire the artist (with a positive self image and attitude) coming in the door behind you. If the work is in your book, you should have only good things to say about it. If not, take it out!

BUILDING A STRONG PORTFOLIO

The process of building a portfolio is usually a long, arduous, yet rewarding task that will take at the least, several months and more than likely a couple of years to complete. Although complete isn't the right word to use for a work in progress, I will use it here to mean that your book is ready to show, and generate paid gigs and exceptional tests with hot photographers for you. Year after year newcomers approach me with the same questions about their portfolios:

1. HOW MANY PICTURES DO I NEED?

Most decision-makers we interviewed thought that an artist should have at least 10-15 great test shots in a book before they start showing it around to get work, and add 6-10 tearsheets before looking for an agency. There are of course exceptions to every rule. We suggest you use these as goals to aim for.

Everyone we spoke with was interested in seeing a range of work. Of key importance was that everything in the book be current. The biggest turn off was work that was dated.

Range is an interesting word. Some decision-makers like the term variety. Let me tell you what it means to me as an agency owner who has to secure work for you.

If you call yourself a hair stylist and I open up your portfolio and see 17 pictures of girls with shoulder length hair, all I know about you is that you're good with shoulder length hair. What I need to see is range. Girls with short hair, long hair, shoulder length hair, up do's, etc. You get my drift. Assume that the art director should know you do all those other things based on the shoulder length hair girls and you'll assume yourself right out of a lot of jobs.

Adobe Photoshop: Adobe Photoshop is a pixel-based, image editing, photo retouching and color painting software that produces professional quality results in the altering of images.

Retoucher: Someone who edits a photograph, in this case using a computer and software. The cost of a retoucher is usually $30 per hour and up.

PORTFOLIO

DO'S

- Remove a tearsheet from a magazine by bending the magazine at the seam (binding) and pulling the tearsheet out, being careful not to rip it.

- Trim the edge of each magazine or newspaper tearsheet with a paper cutter.

- Order a professionally custom-made portfolio with your name embossed on it.

- Place several promo cards, and a label in your book at all times.

- Purchase a nylon carrying case for your portfolio so it doesn't get damaged while being transported from one place to another.

- Own and maintain a minimum of at least two portfolios.

- Obtain renters or homeowners insurance that will cover the loss or theft of your portfolio.

- Put <u>COPIES</u> of originals and hard to come by tearsheets in your books (NOT ORIGINALS).

- Replace worn & torn pages in your book as soon as they become noticeably scratched or cloudy from wear & tear.

- Spend the extra few dollars to insure your portfolio when using an express mail carrier.

- Use FedEx, DHL or Airborne to transport your portfolio.

- Put a resume in your book for desicion makers to review.

- Update old work with fresh tests and tearsheets often.

DON'TS

- Rip a tearsheet from a magazine and put it in your portfolio without neatly trimming the torn edge.

- Use a pair of scissors to trim the edge of the tearsheet unevenly.

- Cut the heading off the top of a magazine and place it atop a tearsheet to prove it came from that magazine.

- Leave scratched portfolio pages in your portfolio.

- Use a three ring binder as a portfolio.

- Send your portfolio to a client without a business card and/or promotional piece.

- Send your portfolio to a client without proper labeling or identification.

- Send out a portfolio full of hard-to-replace original prints and hard-to-come-by tearsheets.

- Leave your portfolio in your car on hot days so that the pages get wrinkled from the heat.

- Use UPS to send your book anywhere if you can help it.

- Put work in your portfolio that is not yours.

- Put actor headshots, newspaper clippings or hair magazine submissions in your portfolio.

- Put Playboy or Playgirl nudie shots in your portfolio.

- Chop up your prints to create [what you think is] an artsy presentation.

**MARCIA COLE
FORMER EDITOR-IN-CHIEF
HYPE HAIR**

CG: How do you go about selecting hair makeup & fashion stylists for your magazine?

MC: Because Hype is a hair, fashion and beauty magazine we work with hair stylists all over the country. I have stylists who I'm not familiar with send me samples of their work in the form of snapshots, or a portfolio to show me what they can do. I look at the technique, the way they style hair in relation to what the subject is wearing. From a photograph I can tell how creative the stylist is in their thinking, and their ability to execute various styles at the drop of a hat. From there I choose who would be

CONTINUED ON PAGE 3-10

MARCIA COLE

best for the particular job assignment.

We work with a lot of hair stylists, and I find that there are several people whose work is appropriate for showcasing hairstyles, but they are not necessarily who I would book on a photo shoot. The range of creativity and flexibility just isn't there. They are pretty much settled in a specific thing that they do and the way they handle the hair.

We also consider makeup, hair artists and photographers through word of mouth. In any case I have to see what they've done. I request that the artist send in their portfolio, I look at it and contact them. If I like the book I move pretty quickly. On the next job that comes up, there is a pretty good chance that I will call that person for it. I'm always looking for new people to work with. I have a crew that I work with on a regular basis but I'm open to working with new talent.

CG: How many books do you look at each week?

MC: Not that many. I tend to get more phone calls about it, but most people don't follow through. That is also an indication whether or not they're serious about pursuing

CONTINUED ON PAGE 3-11

Neeko is one of the top hair stylists in the country. His book is chok full of celebrities, recording artists, fashion editorial and advertising. Sometimes when artists come by the agency to drop off their books, if Neeko's book is in the office we'll let them take a look at it so that they can get an idea of what the portfolio of an artist who makes $3,000+ per day looks like. Neeko's book is a good example because it also has wonderful fashion styling and makeup artistry in it as he usually works with artists that are as successful if not more than himself.

Often, what I'll hear is, "well I can do that" or "that's nothing, I do that kind of work with my eyes closed". My response, well then close your eyes and put it in your book because our clients are only interested in what they can see with their eyes.

2. WHAT'S WRONG WITH THE PICTURES IN MY BOOK?

We found that the two universal wrongs were bad photography and bad models. While mediocre work in any of the disciplines, (makeup, hair, props, styling or costume) can present a problem, photography and wanna-be models were the most common errors noticed by book reviewers such as art directors, photographers, and fashion editors.

3. CAN I USE MY SALON CLIENTS AS MODELS?

Sure, if their names are Linda Evangelista or Naomi Campbell. Ladies and gentleman your clients, unless they are real models, are really not capable of projecting on film what you will need to get work from most (not all) paying clients. While they are pretty to you and the average person walking on the street, most women and men who are considered beautiful by the general public would not past muster at even the smallest [reputable] modeling agency.

4. WHAT SIZE BOOK SHOULD I BUY?

Most agencies preferred 9x12 or 11x14. At The Crystal Agency, 9x12 is the size of choice for large portfolios. They fit neatly inside a FedEx box for shipping, and can be carried around in most oversized shoulder bags if a stylist needs to lug one around to a meeting. Most magazine tearsheets fit perfectly without any trimming. Also, when 9x12 prints are copied and reduced down to 6x8 for mini books, there is no noticeable loss of definition.

5. WHERE SHOULD I PURCHASE MY PORTFOLIO?

There are several manufacturers of quality portfolios. Choose one that suits your style and budget. Almost everyone in the industry uses one of the three companies listed below and in our resources section. All of the firms are located on the East Coast and are happy to provide you with brochures and order forms for mail order. The portfolio companies are: Advertisers Display Binder Co., Inc., House of Portfolios and Brewer Cantelmo. Most of the top agencies (Celestine, Zenobia, Crystal, etc) use them and so does Bobbi Brown. ADB also turns their high quality portfolios around in less than a week in most cases and they have a wonderful selection to boot.

6. HOW MANY BOOKS SHOULD I HAVE?

No less than two, and the goal should be three to four.

7. WHY DO I NEED SO MANY BOOKS?

You have only to ask the artist who had one book and left it in her car, where it was promptly stolen by someone who probably didn't even know what it was for, to get an answer to that question. Or the artist who lost a job with a photographer because the ONE book they did have was OUT for another job with a different client. Or the artist who sent a messenger over to the "W" Hotel to pick up their portfolio only to find that the concierge had accidentally given it to the wrong messenger company. The list goes on. If you have one book you can expect to get one job at a time.

In a perfect world you would have one book (perhaps slightly smaller than 9x12) that you can carry with you in case an opportunity (you meet Queen Latifah or Christina Applegate at the grocery store) presents itself, a second and third book that is available at home or a friends place of business so that it can be picked up and messengered anywhere at a moments notice.

8. SHOULD I HAVE ORIGINALS OR COPIES IN MY BOOK?

Everyone will have at least one book with originals in it because it's the first print that you collect from the photographer. Your other books should be good quality color copies. You can expect to pay anywhere from $.89 - $3.50 each depending on the market you live in. If you live in Los Angeles, New York or Chicago where reproduction is king, then copies are relatively cheap. However, if you reside in a small market like Idaho, where Kinko's is not on every corner, then you

MARCIA COLE

what it is they say they want to do. I probably see 10 to 15 books per month.

CG: If you get a book in that isn't quite right, but you think the person has the potential, what do you do?

MC: After I look at the book, I speak to the person about it. I discuss exactly what I like and don't like about the book. That goes for everyone I will or will not work with. I feel like I owe that to the artist who takes the time to send their materials to me. I don't believe in putting a note in someones book and sending it back to them.

If their book is not up to par, I can tell whether or not the artist will be able to meet my expectations with instruction on a set.

I did that with a makeup artist. He was new. We went over his book and I told him exactly what I liked and didn't like, what he should take out and keep in the book. A few weeks later a couple of jobs came up for the same day, and the makeup artist I usually book was not available, so I called him to do the job.

During the shoot I was on set and could give him direction which he took very well. Not

CONTINUED ON PAGE 3-12

MARCIA COLE

breathing over his shoulder, but instructing him on where things were and were not working. These particular shoots were with two recording artists; Brandy in the morning, and Changing Faces in the afternoon. The record company liked the photography from the Brandy session so much that they bought the photograph for her album cover. Two things I liked about him, he worked quickly and he could take direction. He ended up with an album cover from the Brandy session, and a magazine cover from the Changing Faces session.

CG: Is there a region of the country that most of your calls come from?

MC: I get calls from Los Angeles, but most are from the Tri State areas of New York. We also get quite a few calls from Philadelphia and Washington, DC. I also get calls from salons and stylists in other cities such as Milwaukee, but I don't have people in those cities that I have worked with before so I can't take a chance on doing photo sessions there because I wouldn't be present, and people in smaller cities typically have a totally different fashion sense.

CONTINUED ON PAGE 3-13

can expect to pay a little more. They call it supply and demand.

Tearsheets (published work) should always be originals when you can get them, particularly from magazines. Besides, it's cheaper than making copies in most cases. If you have two portfolios and you did work on a magazine that nets 4 usable pages, remember that those pages will probably be front and back. You'll have to purchase three to four magazines to get the front and back of all four pages. But most consumer magazines only cost about 2.95 each. Do the math. $2.95x3=\$9.00$ +tax. About \$9.72 divided by 8 pages is \$1.22 per page and no hassle or waiting in line at the copy store or being unhappy with the quality. Yeah, I thought you'd get it.

9. HOW LONG WILL IT TAKE BEFORE I HAVE A BOOK TO SHOW?

That depends on who you want to show it to. The process of building a portfolio is ongoing and everchanging. While there are always exceptions, (I know, I've signed a few of them to the agency) typically it will take no less than six months to a year before you are ready to show your book to most **clients** for work. The same goes for getting on the assistants lists at most agencies and more like 1 - 2.5 years before you get signed. However—and I can't stress this enough—you must show

The promo card above displays the work of renowned fashion & celebrity hair stylist, Neeko. This was his 3rd promotional card.

your portfolio to people.

All to often, artists are afraid to show their work to anyone because they are perfectionists and/or for fear of rejection. Not everyone is going to like your work. Do you like everyone's potatoe salad. NO! Only by showing your work will you know where you need to focus your energies to improve. **Show it** to photographers. **Show it** to art directors. **Show it** to producers. **Show it** to other key artists that you are or want to assist. Ask for constructive criticism, and then don't be pissed off because you didn't get the answer that you wanted.

You must show your book to photographers at every stage of the game and often. If you have one or two pictures then show them. It's the only way to get more photographers to work with.

10. WHERE DO I FIND GOOD PHOTOGRAPHERS TO TEST WITH?

Go back to Chapter 2 where we discuss this subject in depth. Good photographers are found in art schools, magazines, at labs, in photo programs at universities, community colleges, vocational schools, through word of mouth and so forth.

THE PORTFOLIO CHOICE: JUST A PURCHASE. . . . OR AN INVESTMENT?

Most newcomers start out purchasing a basic black portfolio manufactured by Prat and purchased from a local art supply store such as Sam Flax, World Supply, Art World, etc. The styles vary slightly in size, page design and surface materials. These are considered off-the-shelf, non-customizable portfolios. Sort of like Pret-a-porte (ready-to-wear) in the clothing business. They range in price from $45 to $150 each. Some come with pages permanently inset, while others have page sections that can be purchased separately and replaced when the pages become dirty or scratched. Carrying cases for these books are also available, and come with zippers, snaps, or velcro closures for page protection and ease in handling. Stylists often overlook the value of a carrying case. Don't. You can lengthen the life of your portfolio substantially by keeping it inside a case. A case will reduce the number of scratches, kicks, bruises, and coffee stains a book sustains while being moved around from place to place.

The second option for acquiring a portfolio is making the investment in the custom book. Many artists are surprised to find that a basic customized portfolio in faux leather fabric (often referred to as wax skin) with their name embossed on the front cover, costs only a few dollars more

MARCIA COLE

CG: Would you say that there was a common thread that runs through the books of the artists you have to say no to?

MC: Bad makeup, bad photography, bad lighting, no life to what they're doing, no creativity, no signature. Dated makeup and application. Eyebrows not current. Sloppiness.

CG: Where are you going with the magazine?

MC: My goal is to get my hair photos to line up with the quality of my fashion photography so that the book is complete. I am looking for photographers who can bring the same fashion beauty feel to my hair photos. The kink in working that out is that when you are working with hair photographers outside of the state, you talk to them and you think they understand until you get your photos back. They just don't get it.

CG: How would you describe the difference between the level of artistic talent you get from Los Angeles and New York versus other cities, and is there any advice that you can offer.

MC: Oh definitely. The difference is that the work is dated. NY differs

CONTINUED ON PAGE 3-14

MARCIA COLE

from Los Angeles in that there is so much cultural diversity that's easily seen in every area of the city, and people draw on that creatively. The locations, the colors, the people. And because it's the mecca of talent, an artist has an opportunity to move in circles with people who are involved in fashion, music, and art. They feed off of each other. LA is very spread out. You have Hollywood in LA, so visually, new things are coming at you constantly. In both of these cities you are able to move in these circles and get your creative juices flowing and everyone is moving forward.

In New York creative people are always going through all the fashion magazines, or attending to a fashion show, or working on their look, or visiting an exhibit, or even a street fair, or looking at what the trends are in the realm of fashion and beauty.

People who do not live in large metropolitan areas don't have the same people, or events to draw from. The pool that they do have access to is a little more confined. They don't have the talent, or models, etc. . I'm not saying that the creativity is not there, it is. But in terms of them tapping into other people who are doing those same things, and moving forward,

CONTINUED ON PAGE 3-15

than the off-the-shelf variety at the local art supply store.

At the basic level, the custom portfolio maker (such as ADB) can offer you a variety of book sizes, several different typefaces to choose from, and a choice of one or two pockets on the inside front and/or back cover to hold your promotional materials. At the truly customizable level, the options are endless. A custom portfolio can be anything you want. . . for the right price. Options include but are not limited to:

- Any typeface you can provide to the portfolio maker
- Using your own handwriting (or someone else's) as a typeface
- Pockets for business cards
- Writing on the inside of your portfolio covers
- Your title as a makeup, hair or fashion stylist on the portfolio
 - A variety of colors to choose from
 - Leather, leatherlike fabric, wood, metal, etc. . .
 - Providing the portfolio maker with fabric or some other material that you found
 - Personalizing your carrying case

Greg Gilmer pictured 2nd from Right on panel at Los Angeles Packaging Your Portfolio workshop.

If you can imagine it, one of New York's custom portfolio houses can make it for you and deliver it to you [usually] within three days to six weeks depending on the vendor, their backlog, and the availability of the materials requested.

Prestige in many social and professional circles is defined by the car you drive or the watch you wear. In this business it's a high quality portfolio, great tests and high profile tearsheets from fashion and entertainment magazines, ad campaigns and catalogues.

After many years of representing stylists, I am still surprised at how many poorly maintained portfolios we receive at the agency for review from stylists who are making the book drop-off rounds to seek representation. These shabbily kept portfolios always show up with stylists who have a bevy of excuses for why the books are in such bad shape.

I have one rule for you to remember, NOBODY CARES. A sloppy portfolio is the sign of a sloppy artist. PERIOD! Most decision-makers will assume that if you don't have time to put together and maintain the tool that produces your livelihood, then you will have little or no regard for the details involved in the successful completion of an important job assignment. Rather than

take a chance, most people who are in a position to choose will choose someone else.

Greg Gilmer, a freelance art director (formerly on staff at Warner Bros. Records) in California says, "I wonder about an artist's professionalism when they don't take pride in how their portfolio looks."

If the pages in your book are scratched or torn, take them out and replace them. They cost about $2.00 each. If the label with your name, address and phone number on it is dirty, remove it and type up a new one. It's also a good idea to purchase a few extra pages when ordering your portfolio. That way you can replace your pages at a moments notice when the unsightlies start to show. Unless you are an established stylist with a book full of Vogue, Elle, Essence, Bazaar and Rolling Stone tearsheets, it won't bode well for you to send out a less-than-perfect portfolio.

CONTENTS: WHAT'S INSIDE THE PORTFOLIO

Give a great deal of thought to the quality of the color and/or laser copies and tearsheets that go into your portfolio. Notice, I said copies. Do not work with the ONE book you have that has ALL originals in it if you can help it, and you can be spending the extra $50.00 to get the color or laser copies made. The artist full of regret is the one that lost a portfolio full of original prints.

Take advantage of the hottest technological developments of the last decade, them being, the color copier, the laser copier and the color laser printer.

- The laser copier produces color images on regular bond or laser paper.
- The color copier produces color images on lightweight photographic paper. The images are almost identical to photographic prints. Many photographers use them instead of original prints for their own books.
- The color laser printer produces near photo quality images on just about any surface; paper, photo paper or vinyl. It's truly amazing. If you have a computer, a photo editing program like Adobe Photoshop or Adobe Photo Delux and an Epson printer, you can make your own prints. Just remember that you'll need a color printer that can print on paper up to 11X17 in order to create 9x12 or 11x14 prints.

These three technologies have revolutionized and simplified the process of duplicating artists and photographers portfolios while substantially reducing the price of each print. Several years ago the cost to duplicate a single page from a standard size magazine was $7.50. An oversized album cover was $10.00. Now-a-days, a stylist can duplicate a magazine page anywhere from a low of $.89 at Office Depot or Staples to a high of $3.50 at smaller print shops. Naturally, the quality of the $.89 prints will be somewhat less than that of the $3.50 print, but at either end of the pricing spectrum

MARCIA COLE

it just isn't there. All of these things provide an opportunity to grow and many of your peers are taking advantage of them.

I suggest that they get their hands on every type of information that is out there. Pick up the magazine and pull out all the pages they like and throw the rest of the magazine out. Make a book that is your own creative well. Pull pages because you like the makeup, the hair, the lighting on the model, or the clothing. Pull it together in your spare time and use it as a reference point for yourself.

This business is about keeping up with trends and what's going on. The last thing I want to hear from an artist, whether it be a photographer, makeup, hair or styling is that they didn't see the latest issue of Bazaar, or Elle. My response is "what do you mean you didn't see it, you should have seen it."

CG: **What advice do you have for someone who isn't exposed to the things we're exposed to, but they are reading the magazines, and they do want to get involved, how can they take advantage of what's going on in their own communities?**

CONTINUED ON PAGE 3-16

MC: If there are fashion shows that are occurring, then try to find how they can participate by working behind the scenes. Don't get carried away with wanting to be a front person. Look into local television stations, fashion, cultural or lifestyle magazines, and newspapers. Inquire about apprenticeships. Find out how things are done. Get the trade magazines for the industry you are interested in. Go to the library and do research.

For instance if you want to be a makeup artist. Sit down and think about those aspects makeup touches in peoples lives. Makeup is used in everyday life, it's sold to people at makeup counters, makeup is used on television, for movies, in magazines, for theatre. Look at old movies, and compare them to the way makeup is worn today. Make every part of your life a study for your future. Be observant. Stay on top of what's going on.

CG: What advice would you give to someone who thinks they are ready to pack up their belongings and move to Los Angeles or New York?

MC: Do a reality check. Write down the specifics of what they expect to gain from moving. How much money do they have, and how far do they think it will take them if

there is a substantial savings over the prices paid just a few years ago.

PERFECTION

Forget Webster's definition of perfection. In our business, perfection is whatever the Adobe Photoshop expert can re-create on a personal computer. Today what many old style retouchers did with a paint brush by hand, computer retouchers do with a software program called Adobe Photoshop. Computer retouching is the art of editing a photograph by altering a single dot (commonly known as a pixel) on a computer display. This method of retouching can be used on less than perfect images as a way to insure that more of the photographs from a test photo session are usable and don't have to be tossed into the round file.

How does it work? Here's an example:

Let's say you're a hair stylist. The photograph you want in your portfolio is almost perfect, with the exception of a big pimple in the middle of the models forehead. The makeup artist tried her best to cover it up, but it still showed up on the photograph and is ruining an otherwise great shot for your book.

What do you do? If the image in question has already been printed then the retoucher will scan it, work his/her magic on the computer file and then print it out for you at the desired size you want for your portfolio.

If on the other hand you are looking at the photographs on a contact sheet, slides or transparancies and you notice that you're going to have a big problem once the image is blown up for your book, ask to have the image scanned onto a CD or ZIP without having it printed. Take it to the retoucher and have it printed out, post magic.

A good retoucher can remove a facial blemish with ease. Afterwards, your beautiful shot is just that. BEAUTIFUL. How much? Retouchers typically charge an hourly rate between $25-100/hour and they have minimums. It may only take the retoucher 15 minutes to get rid of that unsightly pimple but you will probably still pay for an hour of their time.

OBJECTIVITY

One of the toughest things for an up-and-coming artist to learn, is how to accept constructive criticism regarding the contents, and therefore the quality of the work in his or her portfolio. Inevitable and sometimes painful decisions must be made regarding what to keep in, or remove

from a book. Artists must be careful not to perceive the advice of professionals as a personal attack on their creativity or talent.

> **MARY COLETTI**
> **MAKEUP ARTIST**
>
> **HM: 212 • 555 • 1234**
> **PGR: 212 • 555 • 1235**
>
> **2125 W. 55TH ST, APT 7**
> **NEW YORK, NY 10019**

The suggestion to remove one or more pictures from your book due to obvious flaws may have nothing to do with the quality of your work. Fortunately or unfortunately, making people look good is a team effort. The beauty business of photography, film, television, and video requires the involvement of several people to pull off the miracles we love to behold in each of these media.

The obvious players on any variety of shoots (still and moving) include the following:

hair stylist	makeup artist	photographer
fashion stylist	actor	director of photography
prop stylist	manicurist	wig maker
director	model	special fx makeup artist

This is a list of key people. These are the individuals you can least afford to have show up on the set having a bad hair day. However, it can and does happen. The results vary from mediocre still photography that doesn't quite cut it, to moving film that has to be tossed and re-shot.

The emotional toll of having put so much work into a day or days that produce nothing can be frustrating to the young artist building his or her book. The longing to include something new in a portfolio often causes the new artist to compromise a portfolio with photographs that are less than perfect.

While you are vacillating on whether or not to include a so-so photo in your portfolio, remember this: **a busy art director will not separate your great hair styling from bad makeup, photography or fashion styling to conclude that you should be hired to work on an upcoming project**. On the contrary, the art director will look at your portfolio and decide against hiring you, convinced that the one unflattering photograph in your book [that you couldn't part with] is the very same one you will produce at his photo session.

In most instances, you will not be present during the portfolio review. Who is going to say to the art director, "Don't pay any attention to the bad makeup, just look at my wonderful hair?" One bad

they don't get work for a while. Do they have contacts. Just knowing people in the city does not guarantee you a job. You have to have a lot of courage, and confidence in yourself. You have to be ready to work. You can make it in New York. You need tenacity, and you have to be creatively up on your craft. Make the time work for you. Don't be idle, invest in your career by getting a good portfolio together, put a good promotional piece together, and sell yourself.

If I were moving to New York, I would do my research beforehand. I would promote myself like a record company promotes an artist. I would flood the market with promotion things saying who I am, or just a post card with my name on it for a month before I made the first phone call. They would get something from me for four weeks in a row. Maybe the first card would just have my name on it, and the second one would have a pair of beautiful red lips that I had done, and the third something else and the fourth something else still. Get a little mystery going. By the time I hit them up with a phone call to set up an appointment their response is "oh yeah, I've seen those cards, who are you, what do you want

from me." Planned spontaneity is always best.

It's also important to update your promotional pieces. What you used as a leave behind (promo card) in '92 should not be the same card you're leaving behind in '95 because things change and your work should reflect what's current and new. Invest in self promotion. I've seen people who came to New York and were aggressive about their approach to marketing themselves, turn a situation inside out.

This can be a very closed industry but once you get your foot in the door, you're in. And it can be just one job that does it for you. Doing makeup for an actor, actress or recording artist that blows up, or working with a photographer who likes you and they blow up. It can happen so fast. One small stepping stone...

CG: Can take you from obscurity to stardom.

MC: Very, very easily. There is no greater promotion than word of mouth. **END**

photograph can mean one lost job assignment. Most decision-makers prefer to see eight great photographs in your book rather than five great shots and three okay ones just to fill up space. Be selective.

TELEPHONE: INCOMING/OUTGOING

OUTGOING: The most effective phone calls are planned in advance and scripted if necessary. Early on in my career at Xerox, one of my primary activities as a sales representative was "cold calling." Cold calling is a term used often in sales to describe the act of contacting someone on the telephone or in person who isn't expecting you. For me, the experience was almost paralyzing. I would find a thousand things that needed to be done just as long as it didn't include calling a perfect stranger on the phone, having a door closed in my face, or having an unhappy former Xerox customer screaming at me because the last rep sold them the worst Xerox copier ever made. Fortunately I could only clean out my briefcase, straighten my desk, or refill my stock of Xerox copier and typewriter brochures so many times before I uncovered the telephone on my desk.

So what do you think happened? You guessed it. I got very good on the phone, stopped taking the perceived rejection personally, learned to close the deal and remained in the top ten percent of my region for the remainder of my four year tenure at Xerox. You see, we all have to overcome something. For me it was fear of the phone.

INCOMING: Hold on just one minute! Is that your three year old answering the phone? Nah, couldn't be, because freelancing is your business. If you owned a clothing store in Manhattan would you let your child answer the phone? If not, then don't do it from your home office. We don't think it's cute. By we, I mean agents, bookers and clients. That laughter you hear is nervous anxious [I don't have time for this nonsense in the middle of my business day] laughter.

And when your answering machine picks up, the outgoing message should be professional, succinct and informative. I want to know, where you are (unavailable or on a job), how I can reach you (pager or mobile phone) and when you're going to call me back (within an hour) what to do if it's an emergency (pager or mobile phone) and where I can leave you instructions (email or fax). What we don't want, children gurgling in the background, nicknames for your sweetie or 15+ seconds of your favorite musical selection. REALLY!

PROMO CARD AKA COMP CARD

A promotional card, a.k.a comp card, is to a freelance artist is what a magazine cover is to Condé Nast. Would you buy Vogue magazine if it didn't have an interesting or captivating image on the cover? I think not. Publishing companies put beautiful and interesting people on the covers of

their magazines because we the public buy pretty pictures of recognizable people or striking images that we cannot turn away from. The same is true of how you market yourself. A resume, though valuable and quite necessary for film and television, is rarely enough to get you a job in the print marketplace of magazines, CD covers, advertising layouts, and catalogues. A resume usually doesn't work with most video directors since many of them were once photographers who are accustomed to looking at portfolios. Flat art. Pictures.

ARTIST MANAGEMENT

Mylah
Makeup

4237 LOS NIETOS DRIVE • LOS ANGELES, CA 90027
323/913-0700 FAX 913-0900
WEBSITE: THECRYSTALAGENCY.COM
E-MAIL:MaleezaKorley@TheCrystalAgency.com

ARTIST MANAGEMENT

Neeko
Hair

4237 LOS NIETOS DRIVE • LOS ANGELES, CA 90027
323/913-0700 FAX 913-0900
WEBSITE: THECRYSTALAGENCY.COM
E-MAIL:MaleezaKorley@TheCrystalAgency.com

The promo cards above are the latest offering by 2 artists at The Crystal Agency, Los Angeles.

Visit us Online to stay informed of hot new developments, news, trends and tips. Get advice on career planning, self-promotion along with up-to-date product developments and feature stories on your favorite artists; People like Kevyn Aucoin, Sam Fine, Phillip Bloch and Oribe. We recognize freelancers for the work they do behind-the-scenes in print, video, television, film and fashion. (323) 913-3773. Visit us at: **MakeupHairand Styling.com.**

we heard...

Crystal Wright proudly presents "Packaging Your Portfolio: Marketing Yourself as a Freelance Makeup, Hair or Fashion Stylist."

The 8-hour workshop covers portfolio building, testing with photographers, signing with an agency, getting work from record labels, magazines, production companies, and more. The presentation includes a 1-Hour Q&A session with a panel that includes art directors, fashion/beauty editors, photographers, agency bookers, etc., who hire or sign freelancers for work in the industry. Crystal brings artists portfolios from Los Angeles as well as portfolios from agencies in the area. Call (877) 913-0500, Fax (323) 913-0900. www.MakeupHairandStyling.com.

you want to be famous...

A promo card is a meaningful and necessary means of promoting your work. It can be as small as a business card or as large as a movie poster. The most commonly found card dimensions are from 5-1/2 X 8-1/2 to 8-1/2 X 11 finished. By finished, I mean that a card created from an 11X17 sheet of paper, when folded twice, becomes 5-1/2 X 8-1/2. The same 11X17 in sheet of paper folded once is 8-1/2 X 11. A couple of samples follow:

Many a makeup, hair or fashion stylist is perpetually too broke to invest in a promo card that will showcase their skills and bring them more and better quality work on a regular basis. That same stylist, however, is rarely too broke to buy the latest Dolce & Gabbana dress or Manolo Blahnik shoes. The operative words here are INVEST & BUY. INVEST in a card that will bring you higher fees and steady work, or BUY a new dress to wear to the unemployment office.

COLOR vs BLACK & WHITE

Every artist wants to know whether or not they can have black & white photos on their promo cards. Well as you can imagine, the person who can have the most black & white pictures is the hair stylist. Hair styling is about styling not color, and the art director doesn't assume that you colored the hair. However, with makeup and fashion styling, the color choices are an integral

part of the shot. It's impossible for an art director to know whether you put purple, green or silver eye shadow on a model if everything is in B&W. And since that just would not work for a Breakfast at Tiffany's kind of shot, I suggest that you don't create a promo card or a portfolio with more black & white pictures in it than color. Following are samples of a few agency promo cards.

RÉSUMÉ

A résumés worth is dependent on the kind of work you are trying to get. Most producers and directors who work in television and film want to see résumés before portfolios or reels. As a matter of fact, many of them will hire you based on your résumé. In film and television, a résumé gives the producer information about the amount of responsibility you have been given [and might be ready to assume] on the set. Film and TV artists will always list whether they were the KEY, the Department Head, the 2nd Makeup or Assistant Makeup.

　In the business of print, video or television commercials, art directors, photographers and fashion editors usually couldn't care less about your title. If they can't see it in a portfolio, it doesn't exist. A film or television résumé is quite different from a print résumé, because the objectives are

different. Print, video and commercial decision-makers are more impressed with whom you've worked for.

REEL

Not enough artists who do videos and television commercials have reels. They are a great way to showcase the work in those venues.

The cost of producing a reel can seem a bit prohibitive at first (on-line editing prices range from $30.00 - $80.00 per hour), but if you are interested in doing a variety of commercials and music videos, a reel will enable you to market yourself more effectively to production companies than will a portfolio. A reel can be duplicated relatively inexpensively and sent, along with a resume and promo card, to a variety of people at various production companies.

Now this doesn't mean you shouldn't have a portfolio, because you should. It just means that the marketing approaches are different for commercials and music videos. It would cost thousands of dollars to put together enough books to mount a successful marketing campaign with portfolios, and only a few hundred to create two master reels and copies which can then be sent regular mail to various production companies.

The next step is to follow up with phone calls, ask for the business and if the work is good someone will bite. You're on your way.

NETWORKING

Networking applies to everyone you will meet, have met, and the activities that follow after you have met them. I once joked about networking being the buzz word for the 90's. The truth is, networking has always existed. The term is somewhat over-used, but the practice is alive and well on golf courses, at country clubs and just about every other place people join socially, or for business.

Networking is practically a social science. Lots of books have been written on the subject. Simply put, networking is about contact management and exploitation. Effective, successful networking, like most things, begins at home and requires preparation and follow up. Your initial meeting with a decision-maker or vendor will happen in a variety of different situations, so you need to be prepared.

1. Phone Conversation
2. Direct Mail Encounter (sending out promo materials)
3. In Person Interview/Meeting

4. Chance Marketplace Encounter (job assignment)

5. Social Gathering

Take the initiative to make each meeting purposeful. Before you pick up the phone and attempt to secure that all important appointment, it helps to know the who, what, where, how, why and when objectives of your call.

WHO: You're Calling The Decision Maker

WHAT: You Expect to Accomplish The Goal

WHERE: You Expect This Meeting To Lead The Result

HOW: You Expect to Accomplish It The Plan

WHY: You're Calling The Reason

WHEN: You Would Like To Meet The Date & Time

Armed with these facts and a purpose before you pick up the phone or head out the door, you will be better prepared for success in any situation.

THE BUSINESS CARD

Not everyone carries a promotional card around in their wallet, but they do carry business cards. The business card is the cheapest way to let people know what you do, who you are, and how to contact you. Since it does not list your credits, or have photographs of your work, it cannot be counted on to bring you the influx of work you need to establish yourself. A business card should be thought of as just one tool in an arsenal of tools that will bring you jobs. It will help to solidify your position in the marketplace as a legitimate and professional business person.

I recently discovered a way to make business cards available to clients without worrying whether they were going to slide unnoticed into the big pockets on our artists portfolios: Plastic pressure-sensitive business card pockets. They are available at most office supply stores. You apply them by simply peeling off the backing and pressing them into place on your book. You can then slide two or three business cards into the pocket and clients can remove them at will.

LISTINGS

Listings, as I mentioned in Chapter 2, are often free. They give a short description of who you are and what you do. A few come with a nominal charge that is just that when you consider the poten-

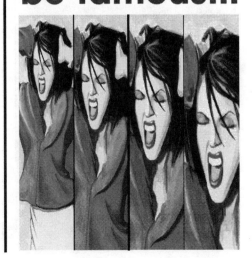

tial benefit of receiving even one phone call that could land you a job. Alone, they don't mean much. But in conjunction with the other vehicles and effort mentioned in this chapter, they make for a total marketing effort.

LOGO: A PERSONAL TYPEFACE

Like the fonts that Xerox, IBM or Apple use to distinguish themselves from their competitors you can do the same. Early in 1994 one of my stylists decided she wanted a typeface that was strictly hers. Something that would be used on her portfolio, résumé, promo cards, labels, etc. . . "Fine" I said. "But you'll have to pay for it." And so she did. . . . pay for it, that is. She brought me the typeface, I installed it on my Macintosh, and replaced everything in her arsenal with her new typeface.

In the midst of making all of these changes, I realized what a novel idea my young stylist had come up with. A new way to separate herself from the pack. Another way for decision-makers to distinguish her book and work from the hundreds of books and promos they review each month.

I now encourage my stylists to INVEST in their own personal typeface (font). A type style that they, as individuals, feel best represents them as artists. Once chosen, that typeface becomes part of their marketing campaign and is used on each and every piece of written material that

Joseph Neeko Abriol

Desiree Diggs

Kristine Kellogg

SUZANNE PATTERSON

MARIE BOYSENBERRY

Beth Carter

enters the marketplace on their behalf. In addition, once chosen and purchased, that typeface may not be used by any other stylist in the agency. In effect it becomes their logo. Their IMAGE!

The fonts pictured above are a sampling of the typefaces chosen by various makeup, hair and fashion stylists for their portfolios and other promotional materials.

IDENTIFICATION

There should always be a label on your portfolio. It lets people know the following information about you:

- Where the book should be returned
- A phone number where you can be reached for booking
- The correct spelling of your first and last name
- The title of your professional specialty (makeup, hair or fashion styling)
- The name, address, and phone number of your agency, if you have one

Trust me, without proper labeling, like the sample pictured at right, your book may end up in Timbuktu. It's not unusual for a book to end up at a competitive agency, someone's home, a hotel, or some other place you didn't send it while you are waiting for it to be returned to you. The flip side, is that you may receive someone else's book by accident as well. Sound strange? It's not. An art director may call several different agencies and artists in an effort to find just the right person for a project. When the art director has made a selection, everyone receives a phone call to come and pick up their book(s). A messenger shows up. Sometimes he knows which books he's to pick up, sometimes not. Sometimes the receptionist knows which books to give him, sometimes not. Just be aware. There can and will be several people handling your portfolio between the time it is picked up at your home or office and returned to you several days later. Without a label, you may NEVER see it again.

Notes:

Notes:

A LOOK BACK

Back in Chapter 1 (Getting Started) we looked at the various areas and opportunities for a freelance makeup, hair or fashion stylist. We used makeup artist Mary Colletti to help us get a handle on where we'd like to begin our freelance career.

As an Account Executive with Xerox my first sales manager, Tom Alire, used a phrase that has stuck with me throughout my years as a rep for photographers, makeup, hair and fashion stylists, and now as an author. He would say: **"PLAN TO WORK AND WORK THE PLAN"**

By taking this quote to heart and employing the same techniques, you will begin the process of creating success for yourself and propelling your own career forward.

While your first job may not be key makeup artist on the next Alanis Morrisette music video, you can get to that level by employing the techniques of goal setting and planning. A motivational speaker once told me to set high and lofty goals. "Better to aim high and miss, than to aim low and make it." I'm doing it, and you can too.

Committing your goals to paper makes them real. It's easy to say you want to be a high fashion makeup artist like Kevin Aucoin, Sam Fine, or Bobbie Brown, and work with famous photographers like Herb Ritts and Patrick Demarchelier on the covers of America's top fashion and entertainment magazines like Vogue, Elle, Vibe, Entertainment Weekly and Rolling Stone. But, how are you going to get there? Do you have a plan? Do you have a portfolio? Do you know what these photographers are looking for in a makeup artist? Do you know what makeup, hair or fashion stylists they are currently working with? Do you know what city they live in? How will you get your portfolio to them? Will they only hire talent from agencies, or do the magazines they work for do the hiring for them?

Lots of questions, huh? Well, I'm going to give you some of the answers and teach you how to find the rest.

Let's move ahead with our fictitious makeup artist Mary Coletti. By looking back and reviewing some of her choices on page 1.5-1.7, we know that Mary wants to work as a print makeup artist on magazines, album covers, and advertising campaigns. Since photographers are key decision-

Notes:

makers for each of those vehicles, Mary begins her goal-setting exercise by writing an affirming statement. Hers reads like this:

"The list of photographers that follows are doing the kind of work that interests and excites me and I look forward to working with them throughout my career as a makeup artist."

Following are the names of a few photographers on her list.

PHOTOGRAPHERS	RECENT EDITORIAL & COMMERCIAL CITINGS
Isabelle Snyder	Entertainment Weekly, Italian Elle, Buzz, Movieline
Danielle Federici	American Vogue, German Vogue, American Photo
Nigel Perry	Vanity Fair, Entertainment Weekly, US, "W"
Matthew Rolston	RollingStone, Armani Catalogue, In Style, Detour

This list tells us that Mary has given thought to the photographers she wants to work with, and has taken the time to research (by skimming through fashion, entertainment and photographic [trade] magazines, and frequenting record stores) the kind of work they've done recently. She can gather even more information if she digs a little deeper.

Magazines contain a wealth of information. From the editorial pages of most magazines, Mary and YOU can find out:

- Who photographed the cover and feature stories
- Who the makeup, hair, fashion or prop stylist was on a job
- Who the assistants were on the job
- What agencies the makeup, hair, & fashion stylists are signed to. . .or not
- What store(s), or designer(s) loaned out clothing
- What makeup and/or hair products were used
- Where the location of the shoot took place
- The name of the model and his or her agency

While all of this information is not included on every single editorial page, variations of it are included in most fashion and entertainment magazines.

Notes:

From a commercial project like an album cover, (now called CD packaging) you can find out some of the same information and other facts as well. On the inside of most CD jackets you can learn:

- Who photographed the cover and inside photos (different photographers are sometimes used)
- Who "art directed" the photo shoot
- Who did makeup, hair, fashion and prop styling
- Who manages the artist
- What record label the artist is signed to

Armed with these facts, you can utilize any number of directory resources in "Tools of the Trade" to obtain the addresses and phone numbers of the people (decision-makers) who should receive your promotional card, review your portfolio, or become one of your own resources if you are a fashion or prop stylist looking for new vendors to pull clothing and props from for photo shoots.

PERSONAL STATEMENT

Now it's time for you to make your own personal statement. If you've made up your mind about the type of makeup, hair or fashion stylist you want to be and the kind of work you want to do, take a moment to solidify your commitment by filling in the blanks below. If you can, do it now! If not, that's okay too. Keep reading The Career Guide, and exploring its contents until you find your own perfect and personal beginning.

My name is _____. I am _____
 BEGINNING OR CONTINUING
a(n) / established career as a _____.
 HAIR STYLIST • MAKEUP ARTIST • FASHION STYLIST • PROP STYLIST • COSTUME DESIGNER

Within my chosen field of expertise, I plan to work in the following areas
_____.
 PRINT • MUSIC VIDEOS • COMMERCIALS • LIVE PERFORMANCE • TELEVISION • FEATURE FILM

I will begin my new career by first establishing myself in the
_____ field and then venturing on to
PRINT • MUSIC VIDEOS • COMMERCIALS • LIVE PERFORMANCE • TELEVISION • FEATURE FILM

The pages at the end of this chapter (3.31-3.37) provide an excellent opportunity for you to zero in on the who's and what's you will incorporate into your personal marketing plan and your future. Filling in the blanks will help you to determine what you know, challenge you to find out what you don't and give you the fuel to complete your own personal statement.

The terms, strengths and weaknesses are often used to describe a person's knowledge or lack thereof. I prefer strengths and challenges. The American Heritage Dictionary defines the word strength as, "the power or capability to generate a reaction or effect" and a challenge as, "the quality of requiring full use of one's abilities, energy, and resources". A challenge summons you to action and effort. It stimulates. Becoming a successful makeup, hair, fashion or prop stylist is the challenge, and "The Career Guide" is one of your best tools. The written exercises at the end of this chapter offers you an opportunity to:

1. Familiarize yourself with the names of the real players and language of the business.
2. Focus in on, and be specific about your goals and aspirations.
3. Begin a process of thinking about the "hows" of your career.
4. Learn the basics of research, gathering and cross-referencing information that will benefit and assist you in meeting your goals.
5. Keep your eyes on the prize.

Do yourself a favor, don't rush through these pages. Linger over magazines, get to know them. Check out the fashion layouts. Compare them to the celebrity features and notice the differences in how they are laid out. Browse through the calendar sections and highlight the upcoming events that you should attend and possibly participate in on some level (i.e. fashion & trunk shows, photo exhibits, etc. . .). Become part of the fashion and entertainment scene. Get involved, be visible and by all means, look the part!

By 200__ I will have accomplished the following goals:_____

COVER(S) OF: VOGUE, ELLE, ESSENCE, ALLURE, DETAILS, FLAUNT, ETC. . .

MUSIC VIDEO(S) FOR: U2, PRINCE, JANET JACKSON, ETC . . .

CATALOGUE FOR: J. CREW, VICTORIA'S SECRET, THE BROADWAY, MACY'S, ETC. . .

TV SHOWS: ER, SIX FEET UNDER, LAW & ORDER, SPARKS, ETC. . .

MUSIC TOURS: BRITTANY SPEARS, MARIAH CAREY, ETC. . .

CD COVER(S): FOR MADONNA, KD LANG, USHER, ETC. . .

AD CAMPAIGN(S) FOR: COCA COLA, GAP, MANOLO BLANIK, ETC. . .

PHOTOGRAPHERS: MATTHEW ROLSTON, FIROOZ ZAHEDI, ETC. .

FEATURE FILMS: JERRY MCGUIRE, MISSION IMPOSSIBLE, SEVEN, ETC. .

THEATRE: THE LION KING. .

Notes:

Completing all of the pages could take you days or even weeks. You'll probably get more out of it, if it takes you weeks. Becoming a success in this business doesn't happen overnight, and neither will completing these exercises.

For some, these exercises will require purchasing the latest fashion, entertainment and trade publications or visiting your local public library. Others will invest in trade publications like *Daily Variety, The Hollywood Reporter, Shoot, Chicago Screen, or Film & Video*. Still others will spend time in front of a television set watching MTV, VH1 and BET with a pad and pencil recording the names of directors who are creating the kinds of music videos they see themselves working on.

By now you may have flipped through the next few pages, sighed, and asked yourself "what good is all this writing going to do?" Well, it's an excellent way to learn who is doing what, who is using whom, who is getting the good jobs, what agencies are involved, etc. . . It's like crashing a party. You weren't invited. . .but you had to be there.

The makeup, hair, styling and photography business loves to talk about itself. It talks about itself at parties and photo sessions, in coffee shops, print shops and anywhere else that the hippest of the hip gather to discuss the newest of the new. The topics of conversation move from who photographed the cover, to what supermodel was on the cover, to who did makeup, hair & styling for the cover, to why so and so didn't get the cover.

In the business of makeup, hair & fashion styling, nobody talks about "the" shoes they talk about the "Manolo Blahnik" shoes. Do you know who Manolo Blahnik is? How about Donna Karan? What's the difference between DKNY and Donna Karan? And who is Kevyn Aucoin? And who is doing Whitney Houston's makeup these days anyway?

Well, that's what this homework is all about, being in the know. In March 1993, Entertainment Weekly's cover featured a picture of actress Debi Mazar from the now defunct television show, Civil Wars, The headline read:

"HOW STYLE BECAME THE STAR"

The story opens on page 14 with a paragraph by Glenn O'Brien that begins: Models, designers, and photographers are the latest breed of media darlings--the new Hollywood, if you will. Heck, even hairdressers and makeup artists are celebrity timber now.

Not knowing the names of the players, their community, and activities translates to a lack of knowledge about the business, and therefore the language of it.

It is like being in a crowd of people at a party who are talking about a subject you know nothing about, or a book you didn't read. It's the sense of being on the outside looking in. I know, I've

CONT. ON P 3.38

LIST PHOTOGRAPHERS WHO ARE DOING EDITORIAL WORK THAT EXCITES YOU	LIST 2 MAGAZINES THAT FEATURE THE WORK OF THOSE SAME PHOTOGRAPHERS	LIST THE TEAM OF PEOPLE WHO WORKED ON BOTH MAGAZINE PHOTO SHOOTS	
Dah Len NOTES:	Esquire Magazine	HAIR	Joseph Neeko Abriol
		M/U	Sharon Gault
		STYL	Debra Waknin
(Find out what other magazines he works for.)	_____	HAIR	_____
		M/U	_____
		STYL	_____
1. _____ NOTES: _____ _____ _____	1.1 _____	HAIR	_____
		M/U	
		STYL	
	1.2 _____	HAIR	_____
		M/U	
		STYL	
2. _____ NOTES: _____ _____ _____	2.1 _____	HAIR	_____
		M/U	
		STYL	
	2.2 _____	HAIR	_____
		M/U	
		STYL	
3. _____ NOTES: _____ _____ _____	3.1 _____	HAIR	_____
		M/U	
		STYL	
	3.2 _____	HAIR	_____
		M/U	
		STYL	
4. _____ NOTES: _____ _____ _____	4.1 _____	HAIR	_____
		M/U	
		STYL	
	4.2 _____	HAIR	_____
		M/U	
		STYL	

Notes:

PRINT: EDITORIAL

Notes:

LIST 5 MAGAZINES THAT YOU WANT TO WORK WITH	LIST 2 PEOPLE AT EACH MAGAZINE WHOM YOU WANT TO REVIEW YOUR PORTFOLIO	LIST 2 PHOTOGRAPHERS WHOSE NAMES YOU'VE SEEN IN THE MAGAZINE
1. _____ NOTES: _____ _____ _____	1.1 _____ Title: _____ 1.2 _____ Title: _____	1.1 _____ PH: _____ 1.2 _____ PH: _____
2. _____ NOTES: _____ _____ _____	2.1 _____ Title: _____ 2.2 _____ Title: _____	2.1 _____ PH: _____ 2.2 _____ PH: _____
3. _____ NOTES: _____ _____ _____	3.1 _____ Title: _____ 3.2 _____ Title: _____	3.1 _____ PH: _____ 3.2 _____ PH: _____
4. _____ NOTES: _____ _____ _____	4.1 _____ Title: _____ 4.2 _____ Title: _____	4.1 _____ PH: _____ 4.2 _____ PH: _____
5. _____ NOTES: _____ _____ _____	5.1 _____ Title: _____ 5.2 _____ Title: _____	5.1 _____ PH: _____ 5.2 _____ PH: _____

PRINT: EDITORIAL

LIST 5 RECORDING ARTISTS WHO'S CD & MUSIC VIDEOS YOU WANT TO WORK ON	LIST THE RECORD LABEL, ART DIRECTOR AND PUBLICIST THAT WORK ON THAT ARTIST	LIST THE MANAGEMENT COMPANY AND MANAGER WHO REPRESENT THAT ARTIST
1. _____ NOTES: _____ _____ _____ _____	LABEL _____ Art Dir _____ Phone _____ Publicist _____ Phone _____	Mgt Co _____ Phone _____ Mgr _____ Ext _____ Asst _____
2. _____ NOTES: _____ _____ _____ _____	LABEL _____ Art Dir _____ Phone _____ Publicist _____ Phone _____	Mgt Co _____ Phone _____ Mgr _____ Ext _____ Asst _____
3. _____ NOTES: _____ _____ _____ _____	LABEL _____ Art Dir _____ Phone _____ Publicist _____ Phone _____	Mgt Co _____ Phone _____ Mgr _____ Ext _____ Asst _____
4. _____ NOTES: _____ _____ _____ _____	LABEL _____ Art Dir _____ Phone _____ Publicist _____ Phone _____	Mgt Co _____ Phone _____ Mgr _____ Ext _____ Asst _____
5. _____ NOTES: _____ _____ _____ _____	LABEL _____ Art Dir _____ Phone _____ Publicist _____ Phone _____	Mgt Co _____ Phone _____ Mgr _____ Ext _____ Asst _____

PRINT: MUSIC

JOAN WEIDMAN
PRODUCER
MUSIC VIDEO'S, COMMERCIALS &
FEATURE FILM

CG: How long have you been a producer?

JW: Twelve years.

CG: What criteria do you use in making your makeup, hair & styling decisions?

JW: I review resumes to determine whether an artist's experience and background are appro-priate for the project I am working on. Usually I will narrow my search to two or three candidates and call them in for interviews. During the interview, I review their book, reel or both. Generally artists have books.

A really important job criteria for me is personality and manner, because the hair and makeup people are the ones

JOAN WEIDMAN - PRODUCER

who relate most closely to talent. They are the ones touching them, and spending the most time with them.

It's very important that the artist be gentle, non-abrasive, warm and friendly.

In the case of a music video or feature film where a makeup or hair person spends most of the time with the actor or recording artist, the hair and make-up people are really the ones who most closely represent the production and the company.

CG: Are others involved in the final decisions?

JW: Sometimes it's just my decision. When a director wants to get involved, that is totally up to them. Sometimes the director is very busy and says to me, "if you're happy, I'm happy." Other times the talent has a very strong voice in the decision mak-ing.

CG: Is there a certain kind of makeup artist or hair stylist you are looking for?

JW: With most jobs, I look for portfolios of makeup artists with very natural makeup. Especially where women are concerned. However, there are excep-tions. We might be looking for some-one to do really dramatic makeup, so in general, I have to go on the basis of what the job calls for.

CG: Do you use criteria other than

LIST 5 OF THE CELEBRITIES THAT YOU WOULD LIKE TO WORK WITH	LIST ALL THE INFORMATION YOU CAN FIND ABOUT 1 PHOTOGRA-PHER WHO HAS SHOT THE CELEB.	LIST THE TEAM OF ARTISTS WHO WORKED ON EACH SHOOT
1. _____ NOTES: _____ _____ _____	Photog _____ Phone _____ Studio Mgr _____ Photo Asst _____ Phone _____	HAIR _____ Agency _____ M/U _____ Agency _____ STYL _____ Agency _____
2. _____ NOTES: _____ _____ _____	Photog _____ Phone _____ Studio Mgr _____ Photo Asst _____ Phone _____	HAIR _____ Agency _____ M/U _____ Agency _____ STYL _____ Agency _____
3. _____ NOTES: _____ _____ _____	Photog _____ Phone _____ Studio Mgr _____ Photo Asst _____ Phone _____	HAIR _____ Agency _____ M/U _____ Agency _____ STYL _____ Agency _____
4. _____ NOTES: _____ _____ _____	Photog _____ Phone _____ Studio Mgr _____ Photo Asst _____ Phone _____	HAIR _____ Agency _____ M/U _____ Agency _____ STYL _____ Agency _____
5. _____ NOTES: _____ _____ _____	Photog _____ Phone _____ Studio Mgr _____ Photo Asst _____ Phone _____	HAIR _____ Agency _____ M/U _____ Agency _____ STYL _____ Agency _____

PRINT: CELEBRITY

LIST 5 ADVERTISING PRINT CAMPAIGNS YOU WOULD LIKE TO WORK ON	LIST THE AD AGENCIES THAT HANDLE THE ACCTS & THE ART DIR. WHO SPEARHEADS CREATIVE	LIST THE PHOTOGRAPHER WHO SHOT THE LAST AND/OR IS SHOOTING THE NEXT CAMPAIGN
1. _____ NOTES: _____ _____ _____	AGENCY _____ PHONE _____ ART DIR _____ EXT _____ _____	PHOTO 1 _____ PHONE _____ PHOTO 2 _____ PHONE _____
2. _____ NOTES: _____ _____ _____	AGENCY _____ PHONE _____ ART DIR _____ EXT _____ _____	PHOTO 1 _____ PHONE _____ PHOTO 2 _____ PHONE _____
3. _____ NOTES: _____ _____ _____	AGENCY _____ PHONE _____ ART DIR _____ EXT _____ _____	PHOTO 1 _____ PHONE _____ PHOTO 2 _____ PHONE _____
4. _____ NOTES: _____ _____ _____	AGENCY _____ PHONE _____ ART DIR _____ EXT _____ _____	PHOTO 1 _____ PHONE _____ PHOTO 2 _____ PHONE _____
5. _____ NOTES: _____ _____ _____	AGENCY _____ PHONE _____ ART DIR _____ EXT _____ _____	PHOTO 1 _____ PHONE _____ PHOTO 2 _____ PHONE _____

PRINT: ADVERTISING

JOAN WEIDMAN - PRODUCER

a portfolio, reel or resume to hire artists?

JW: References.

CG: Would you ever hire someone without a portfolio?

JW: No, not in most cases. I wouldn't have a sense of what their work looked like, however, there are times when talent wants a specific artist. In such a case, I will consider hiring them because it's a very personal matter for talent.

A portfolio is really important for movie work. You have to know that the person can do specific kinds of makeup. Often there are minor special effects involved like bruises, cuts or scars. I need to see samples of that kind of work.

The hair department is another good example. There can be some things that are a little trickier involved in terms of wigs and maintaining continuity throughout a shoot.

CG: Do you look at unsolicited tapes and books?

JW: No. Well, I might if I had time on a given day. But I think it's a mistake to send portfolios and video tapes that are unsolicited to production companies. These materials are very expensive and valuable to whomever they represent. Unsolicited materials often arrive at the wrong time when no one has an opportunity to review them, or

JOAN WEIDMAN - PRODUCER

when it's not germane to anything we're doing at the moment. It becomes a burden to get them returned and often if it's a burden they don't get returned at all.

Resumes are fine. Send them over. No problem. But I think the more expensive materials should be requested.

CG: Is a resume important to you?

JW: Yes. Because frankly there are so many people out there, that I want to see some of their credits and training before I go so far as to speak to them.

CG: Are most of your people hired through agencies, or are they freelancers?

JW: For movies I tend to use freelancers more. For video and commercials, we tend to rely more on agencies.

CG: Do you like working with agencies?

JW: For the most part it's good. Again, some agencies are better than others. Some are just a tremendous help. They provide you with a selection of materials, they make arrangements, and they're great facilitators. I have, of course, encountered the occasional bad one where they double-book the artist and tell you at the last minute that they are unavailable. So there are a couple of nightmare agents out there, but most of them are quite good

LIST 5 CATALOGUES YOU WOULD LIKE TO WORK ON	LIST THE AD AGENCY/DESIGN FIRM WHO HANDLES THE ACCOUNT & THE ART DIRECTOR	LIST THE PHOTOGRAPHER WHO SHOT THE LAST AND/OR IS SHOOTING THE NEXT CAMPAIGN
1. _____ NOTES: _____ _____ _____ _____	AGENCY _____ ART DIR _____ DSNFRM _____ ART DIR _____	PHOTO 1 _____ PHONE _____ PHOTO 2 _____ PHONE _____
2. _____ NOTES: _____ _____ _____ _____	AGENCY _____ ART DIR _____ DSNFRM _____ ART DIR _____	PHOTO 1 _____ PHONE _____ PHOTO 2 _____ PHONE _____
3. _____ NOTES: _____ _____ _____ _____	AGENCY _____ ART DIR _____ DSNFRM _____ ART DIR _____	PHOTO 1 _____ PHONE _____ PHOTO 2 _____ PHONE _____
4. _____ NOTES: _____ _____ _____ _____	AGENCY _____ ART DIR _____ DSNFRM _____ ART DIR _____	PHOTO 1 _____ PHONE _____ PHOTO 2 _____ PHONE _____
5. _____ NOTES: _____ _____ _____ _____	AGENCY _____ ART DIR _____ DSNFRM _____ ART DIR _____	PHOTO 1 _____ PHONE _____ PHOTO 2 _____ PHONE _____

PRINT: CATALOGUE

LIST 5 VIDEO OR COMMERCIAL PRODUCTION COMPANIES YOU WOULD LIKE TO WORK WITH	LIST 2 DIRECTORS WHO ARE SIGNED TO THE PRODUCTION COMPANY	LIST ONE PROJECT EACH DIRECTOR HAS WORKED ON
1. _____ PH: _____ ADDR: _____ _____ _____	DIR _____ PHONE _____ DIR _____ PHONE _____	PROJECT _____ PROJECT _____ PROJECT _____
2. _____ PH: _____ ADDR: _____ _____ _____	DIR _____ PHONE _____ DIR _____ PHONE _____	PROJECT _____ PROJECT _____ PROJECT _____
3. _____ PH: _____ ADDR: _____ _____ _____	DIR _____ PHONE _____ DIR _____ PHONE _____	PROJECT _____ PROJECT _____ PROJECT _____
4. _____ PH: _____ ADDR: _____ _____ _____	DIR _____ PHONE _____ DIR _____ PHONE _____	PROJECT _____ PROJECT _____ PROJECT _____
5. _____ PH: _____ ADDR: _____ _____ _____	DIR _____ PHONE _____ DIR _____ PHONE _____	PROJECT _____ PROJECT _____ PROJECT _____

TAPE: VIDEO & COMMERCIALS

JOAN WEIDMAN - PRODUCER

and helpful.

Agencies are great because while the artist is out working the agency is in the office. They have the calendar in front of them, and they are able to let you know immediately if the artist is available on the days you are inquiring about.

CG: What about pay scales? Can you give our readers an idea of what to expect?

JW: The average music video day rate averages from $300.00 to $600.00 per day. Commercials are the same. A film assistant day rate starts at about $600.00 per week, and a key person makes between $1,000.00 to $2,500.00 per week depending on the budget.

CG: Can you tell us about one of your bad crew experiences?

JW: I once hired a fashion stylist who had only done print. His work was beautiful but he didn't understand the time pressure of having to get a person ready and out on the set quickly. So, there were about sixty crew people standing around about to go into overtime and we couldn't get talent out of the dressing room. Because the artist had never done video, their estimate of when talent would be ready was way off, and they held up the shoot.
In another situation, the makeup artist became very friendly with the talent, which was great—but then started to steer the talent against the production

JOAN WEIDMAN - PRODUCER

by saying things like "Gee, these people aren't giving you enough rest." That I found very counter-productive.

CG: So it's very important that as a part of the production crew everyone does their part to create a successful production?

JW: Yes. While the makeup artists and hair stylists have to pay particular attention to pampering the talent and making them feel special and getting them to relax, it's important to remember that everyone is working for the production.**END**

been there. It's an uncomfortable feeling. And the only way to positively rid yourself of the sense of inadequacy is through education, formal or otherwise.

During the course of writing the first edition of the Career Guide, I had occasion to have a conversation with one of my makeup artists that fit right in with this theme of education and the validity of participating in the language of this business. I will call her Nancy.

Nancy was quite successful. In addition to doing print work she was the department head of makeup on a popular Fox Television show, as well as a day player on two soap operas. She had several feature films to her credit and was frequently assigned album cover and music video work as well.

Nancy and I would have conversations periodically about her desire to get more editorial assignments. She would say that she wanted to do the cover of Elle magazine. We would discuss her need to test with fashion photographers so we could add more high fashion print work to her portfolio. The months went on, the work came in, however, it was not editorial. The more album cover work she did, the more album cover work she got. After landing her an assignment to do a cover of Essence magazine with a well-known male celebrity, the coordinator, who was very pleased with her work, soon called to book her on another assignment featuring the female stars of a top rated television show. After completion of the two day shoot, I spoke with the coordinator. As usual, I asked her for feedback regarding the work. She willingly gave me some feedback about my makeup artists' work. "Very nice with men," she said. "However, her work with women left a little to be desired. It was nice, but it wasn't high fashion." She went on to give specifics about lipstick color choices, the lack of definition in the models' eyebrows, and a word of caution that anyone who had been reading Essence over the last few years should have been more familiar with the style of the publication.

I passed the information on to my artist who became defensive. In the middle of protecting her feelings with plenty of rationalizations about why the lips were this and the eyebrows were that, I asked her two simple questions:

1) Do you want to do Elle Magazine?
2) Who's on the September '94 Cover?

She thought for a moment, then said "I don't know." I reminded her that it was the biggest issue of the year. She stopped to think and then blurted out "it was a blonde". She was wrong. Cindy Crawford, with her glorious brunette mane, graced the cover of that September 1994 issue.

I asked her another question. Who shot the cover?

She didn't know that either. "It's Gilles Bensimon, the same photographer who has shot every cover of Elle for every month of 1994", I replied. It finally hit her. She couldn't possibly hope to do the cover of a magazine she was paying little or no attention to, with a photographer who's work she didn't know anything about.

Listen, if you want to work for a publication, you should know something about the look, the feel, the style, the audience, and the photographers who are called upon to shoot for the magazine regularly. Which brings me to another point that I did not discuss in the first edition; the importance of having a working knowledge and understanding of photography. Without it you will not know a good photographer from a bad one. We'll talk more about the value of having a working knowledge of photography in Chapter 4.

Notes:

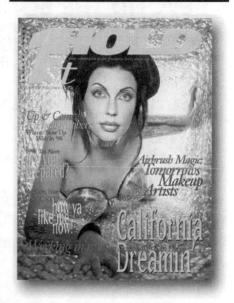

BEYOND THE BOOK

Crystal Wright's
Packaging Your Portfolio
Workshop

The best way we know of to get to the NEXT level.

Top-Bottom. LA Class Panel: Photographer David Roth, Teen Photo Editor Reesa Mallen, Celebrity Makeup Artist Sharon Gault, Makeup Artist Cindy Stinespring. • NY Class Panel: Celebrity Makeup Artist Sam Fine, TV & Film Makeup Artist/Educator Tobi Britton, Crystal, Sr. Booker Ashton Hundley & Makeup Artist Juanita Diaz. Crystal teaching • Washington DC Class talks with THE Agency owner Lynda Erkiletian.

we heard....

Crystal Wright, author of <u>The makeup, hair & Styling Career Guide</u>, publisher of *1stHold* magazine, and president of The Crystal Agency proudly presents her seminar series titled, "Packaging Your Portfolio: Marketing Yourself as a Freelance Makeup, Hair or Fashion Stylist."

The eight-hour workshop covers subjects such as building a portfolio, testing with photographers, signing with an agency, getting work from record labels, magazines, production companies, and more. The presentation includes an hour long Q&A session with a panel that typically includes art directors, editors, photographers, agency bookers or owners, etc., who hire freelancers as a function of their job in the industry. Crystal gets artists portfolios from local makeup, hair and styling agencies in the area. To register, call 323/913-3773, Fax 913-0900, or visit our website, **www.MakeupHairandStyling.com.**

you want to be famous...

CALL OR VISIT OUR WEBSITE FOR CITIES, DATES & TIMES
323/913-3773 ▸ www.MakeupHairandStyling.com

4 PHOTOGRAPHERS

Before we talk about photographers, let's talk about photography. Only in the last year or so have I come to understand that an artists understanding of and appreciation for good photography makes them a better artist.

Throughout this book we stress the importance of testing to build a strong portfolio. I talk about how an art director will not separate your great makeup, hair or fashion styling from bad photography. A few years ago I realized that I hadn't given artists any real direction or guidelines on how to distinguish good photography from bad photography.

A basic education in photography is crucial but it doesn't mean that you need to go out and take a class, though that's not a bad idea. You can educate yourself by reading and studying on your own, the same way you read and study what's coming up in fashion. There are great photography magazines around. American Photo is one of my favorites. The best trade magazine is Photo District News, better known as PDN. You can find them on the web at www.pdn-pix.com. Not only do they showcase the work of some of the greats, they often highlight the work of exceptional newcomers. For your purposes, these are the guys and girls that you want to align yourself with. Why? Because these are the new stars who are just forming their teams of makeup, hair and fashion stylists and thus will be more receptive to setting up appointments with you.

Throughout any given calendar year, PDN publishes two articles that highlight up-and-comers. One is titled 30 under 30 where they look to creative decision-makers to identify phototographers with promising futures and another article focuses on the assistants of top shooters.

"What's the big deal about photography" you ask? It's simple. If you don't know what's good, you can't possibly pick the right people to work with. And since the goals you set at the end of chapter 3, (i.e. to work on the covers of Vogue, Elle, Bazaar, Essence, etc. or Steven Spielberg, David Fincher, John Woo, etc.) are to keep you focused and order your CHOICES then it would help if you were CHOOSING the right people to work with.

HOW TO KNOW GOOD FROM BAD

Good photography should take your breath away, the same way a painting does in an art gallery or a dancer in the ballet. Yes, it can be the same feeling. Flipping through an old issue of PDN (April 96) I am awed by the 10th Annual Photo Design Awards winners. Photographers like Wayne Maser, Doug Menuez, RJ Muna,

PHOTOGRAPH BY NANCY SANTULLO

**MIKE RUIZ
PHOTOGRAPHER**

CG: How did you get started as a photographer & what led you to photography?

MR: My travels. Searching for myself through life. I modeled for a long time and being inquisitive, I would always ask photographers a lot of questions but I never really had an inclination or desire to be a photographer.

MIKE RUIZ

Two years ago somebody bought me a camera for Christmas. I've never studied photography but I've picked up bits and pieces asking questions on modeling jobs. I knew a little bit about photography but not much. I knew what I liked. The fact that most of my friends were models has helped. I would take their pictures which they would show to their agents and their agents would say "wow, who took these"? The agents started calling me to shoot models. This allowed me to become a little more creative. I was lucky because I had access; friends of mine were stylists or makeup and hair people so I was able to pull things together fairly easily. About a year and a half ago I decided to make a go of it. I started focusing and working like a dog and shooting everything in sight. At one point I was shooting seven days a week. I would go through magazines and try to copy the work but I spoke with some photography reps and they told me to find my own style, go in my own direction. I don't have any formal training but I guess I'm a student of life. So for the past couple of years it's just kind of snowballed.

CG: What jobs have you done so far?

MR: I've done

CONTINUED ON PAGE 4-3

Hans Neleman, Rodney Smith and Joshua McHugh stick out. I encourage you to study these books. Tear out the work that you like. Make up your own photography notebook or put the pictures on your walls at home. Review them often. Pay attention to the composition, the lighting, the placement of shadows. There are no accidental shadows in good photography.

My former booker, Reesa Mallen, had a great way of keeping up with the work of photographers she identified as prime candidates to work with the artists at The Crystal Agency. She kept a sort of scrap book/prospecting book all-in-one. She would cut the photographers picture out of the contributors section of magazines and glue them into her prospect notebook. It looked like a messy three ring binder [to me] but it worked GREAT for her. Over the next few months every time she saw their work in a magazine, she would tear out at least one page from the story or feature, add it to her binder and write down where she saw it next to their picture. When she made her cold (phone) calls she knew a heck-of-a-lot more about them than they knew about her. She found it much easier to get appointments with them because it felt [to them] that she really had taken the time to get to know their work.

The picture below is a scan of a page from Reesa's old prospect book which included everything she could find on a potential prospect; where he/she hailed from, whom they had assisted, when they got their first break, etc. . .

Let's say you meet a photographer who says he is testing for his book and would like to work with you. You ask to see his book. He shows you several pages of photos. Are they good? Are they bad? Are the subjects lit properly? Do random shadows appear all over the subject? Is the lighting flat? Are the pictures washed out? Are the photographs overexposed? Are they all black & white models head shots? Are they all shot in the studio? If you don't have the answers to all of these questions then you don't know enough about photography to make an informed choice about who to work with.

Artists have brought their portfolios to me for review and I have cringed. "How long have you been testing?" I've asked. Oh about a year or so. Where did you find the photographer? He has a studio on Hollywood Boulevard. Scary! Stereotypical maybe, but good photographers usually don't have studios in [traditional] Hollywood, and certainly not on Hollywood Boulevard.

At my workshops, artists often persist with questions about how they will know good photography. My advice, if you only read top fashion and entertainment magazines like Itallian Vogue, Elle, Glamour, RollingStone, Wall Paper, etc., you probably will never see any bad photography. Do this for 3 months. During that time pick out five photographers whose work you really admire. Look for their work in every magazine and creative directory that you can get your hands on. Soon you will recognize their work anywhere. From a distance on the cover of a magazine you will know the work of this photographer or that one. Your reality will change, and so will the photographers you choose to work with. I play a little game with myself. Every once in a while I go to the news stand, stand back and see if I can identify the photographers who have several covers. I'm right a good part of the time because I study.

As time passes, you will no longer be impressed just because a photographer has a book full of pictures. You will more than likely prefer to work with the guy who shows you five fabulous polaroids or has a few 9X12 prints that stir you from the inside out and remind you of some of the photographers whose work you have been collecting. When this happens you will be on your way to making some good choices about who to spend your valuable artistic time with.

Imagine the surprise of a young photographer when you mention to him or her that their work reminds you of Matthew Rolston, Annie Leibovitz or David LaChappelle. Everyone is impressed by people who do their homework and show genuine interest in what they do.

TESTING WITH PHOTOGRAPHERS

I once represented a well known celebrity photographer in Los Angeles who said, "If I could do the hair and makeup myself, I wouldn't even have these people around." Back in 1987 when I was getting him $5,000 per day to shoot a recording artist for Atlantic Records he was miffed as to why the makeup artist should get $850. This statement pretty much sums up the attitudes of those photographers who treat their makeup, hair and fashion stylists like second class citizens and in their testing days never seem to be available after the test photo session. The scenario usually goes something like this:

It's Wednesday afternoon, your telephone rings, and the voice on the other end of the phone is that of a photographer you've been dying to work with. He wants to do a test and claims to have a great girl from one of the local modeling agencies. He wants to know if you can test with him on Friday.

"Yes, of course", you reply. You speak with him/her several times during the week. The two of you brainstorm and come up with some great ideas for a shoot. You discuss, at length, the location, the time of day that is best, the lighting, and everything concerning the logistics of the shoot.

The photographer pulled together a great team to do makeup, hair and fashion styling, and you are looking forward to the opportunity to put new pictures in your portfolio.

The day of the shoot arrives. The model is two hours late. She overslept. She has bags under her eyes and her stomach is puffed out from all the pizza and beer she consumed the night before. But

MIKE RUIZ

work for Detour, Attitude, and a new magazine called Season. I was in Europe last summer and went to the news rack and looked for all the magazines I would like to shoot for. People told me that was bad practice, but it worked. I looked to see who the editor or fashion editor was and I called them up and made an appointment.

CG: How is NY treating you?

M: I'll be doing something for Interview, Detour and Paper soon. Interview is like the pinnacle; the day I do Interview is like the day I "arrive".

CG: In terms of makeup, hair and fashion styling, what are you looking for?

MR: The kind of stuff that I like to do is very dramatic. I usually go for hair and makeup people who have the ability to do "out of the ordinary" makeup and hair. I like people who have the ability to be very creative. I'll tell them the overall theme and leave it to them to do what they think is appropriate. I like people who are enthusiastic and like to collaborate. First and fore-most, I like working with people who are easy to work with.

CONTINUED ON PAGE 4-4

MIKE RUIZ

CG: Do you have an agency preference?

MR: Typically I just find people through word of mouth. I don't think the agency you're with reflects how talented you are. Although some agencies are more pleasant to work with than others. For the most part, I just book the talent. It doesn't matter who's representing them.

CG: What, if anything, totally turns you off about a portfolio?

MR: Presentation is really important. It's all a visual thing, so from beginning to end it must be visually appealing. Bad presentation reflects on their whole concern for the work. It shows disrespect for themselves and who they're showing their book to. I would rather see a book with three really incredible pictures than a book with cheesy headshots and a couple of good pictures. Bad stuff in a good book pollutes the whole book.

CG: When you're looking at a book, do you feel compelled to ask somebody what's wrong with their book?

MR: Having been a model and being subjected to a lot of negative reactions, I usually am very considerate

what does it matter? You're a great stylist, this is your chance to show off. The hair stylist has some fabulous styles he's been dying to try out and the makeup artist can't wait to do her signature "3-D" lips on this girl.

Six, eight, twelve hours of shooting. Mickey Dees for lunch, and a coke every hour. What the heck. The photographs will be worth it.

Back at the photographers' studio, hugs and kisses for everyone. All agree, "it was great." Goodbyes are exchanged and the photographer agrees that you can call him on Tuesday to view the pictures and choose those that are best for your portfolio. Ahh, what a great feeling. You can't wait for the weekend to end so you can get a look at the great photos everyone worked so hard on. Guess again.

Tuesday rolls around, you phone the photographer in the morning and leave a message on the answering machine. The end of the day draws near and no return call from the photographer. Wednesday comes and still no return call.

You check with the hair and makeup stylists. They, too have been getting no results. The hair stylist even claims to have overheard a conversation at a local copy center about the photographer leaving town to show his book around. With your pictures, no doubt!

And so the story goes. I'm sure that many of you who have been testing with photographers to build your portfolios have had this experience at least . . . once? There will be others. Some of you may meet the photographer who uses you to build his portfolio but doesn't hire you when he gets a real paying job.

I remember a photographer who used fashion stylist Lisa Michelle for some of the greatest things in his book when he was just starting out. I helped him secure Tyra Banks for a photo shoot with an Italian magazine that he had a relationship with and got him a fashion spread in one of the few hair magazines that produces pages that you can use in your book. The editor couldn't see it but I thought that he was brilliant and convinced her to use him for the shoot. The pictures were really special. Neeko, my top hair stylist went on to win the NAHA (North American Hair Awards) with pictures from both of those sessions. Lisa too got many jobs from those pictures but never once in the eight years since those pictures were taken did he ever hire either of them to work on paying jobs. He would go straight to one of the bigger agencies with bigger artists names and feel no shame about it. I asked him about it once and he blamed it on his rep, the convenient scapegoat.

These stories are not intended to paint so dismal a picture that you decide against a career in the business. On the contrary, I endeavor to educate you about the realities of working in the business, steer you clear of the potholes, and lead you to success without all the battle scars that those before you have already endured. You can't avoid all of the pitfalls, but you can learn where to look for them and how to succeed in spite of them.

THE DISAPPEARING PHOTOGRAPHER

Here are some things you can do to minimize, and hopefully avoid the disappearing photographer:

- Ask around. Talk to other artists. Find out what their experience was with the photographer. Photographers who exhibit this kind of behavior, usually have skeletons lurking around who still haven't gotten their photos, either. Their reputations precede them.

- Discuss getting the photographs prior to working with the photographer. Tactfully let him/her know that you are serious about testing for your book, and that the skills you bring to the session are valuable. Explain that you need to be able to select and have photos printed for your book immediately after the session.

- Always try to find out what labs the photographer uses to process and print film. They are often different for color and black & white.

- Tell the photographer in advance that you would like him/her to instruct the lab that you will be coming over to view the film, and pick out the prints for your book.

- Discuss the possibility of pictures getting picked up by a magazine. Negotiate an editorial credit up front. Following are examples of how your editorial credit might read:

Makeup by Mary Coletti or Makeup: Mary Coletti/The Bailey Group
(this shows how your credit would read if you were
represented by an agency)

WHAT TO EXPECT FROM TESTING

Understanding testing is knowing that twenty-five test photo shoots will probably yield fourteen to seventeen pictures for your book not twenty five to thirty. Twenty-five tests will rarely generate that same number of great portfolio pieces. Why not? Variables. There will always be unpredictable variables. Every photo shoot can potentially be affected by: MURPHY'S LAW. You know, what can go wrong, will go wrong. It's said, by Murphy of course, that if you drop a quarter outside your car door, that it will roll to the centermost point underneath the car, just outside your fingertips. Of course while you're laying facedown on the sidewalk trying to reach it. Photo shoots are like that. Here's what may happen:

MIKE RUIZ

of peoples feelings. I don't feel its my place to offer my opinions if it's only my opinion.

CG: Do you keep promo cards? Or do you just look at a portfolio and remember that person without a promo?

MR: Pretty much in LA, there are only a handful of people who really stick in my mind. If they're not available I usually go through my files. I prefer to stick with the same people. If it works out with somebody, I just stick with them. We can develop a rapport and we can understand what direction I'm going in.

CG: Ever hired somebody who didn't have a portfolio?

M: When I first started I had the attitude that "beggars can't be choosers" so hooked up with a makeup artist without a book. I didn't have much of a book either. It turns out that the [makeup artist] was incredible and has since gone on to do incredible things. I don't know how often that happens, but I was very lucky. He's an incredible makeup artist and I work with him all the time.

PAT HARBRON
PHOTOGRAPHER

Patrick Harbron is a photographer whose work is used mostly in editorial and advertising.

His portrait photography has appeared in Entertainment Weekly, Esquire, Rolling Stone, Premiere, Los Angeles Times Magazine, Newsweek, Saturday Night and Toronto Life to name a few publications.

He has worked for Columbia Pictures, Showtime, Disney, HBO, NBC and others on projects with stars ranging from Jim Carrey to Whitney Houston. He also has numerous album cover credits.

Through assignment and personal work he has been photographing a cross section of people living throughout the U.S. and Canada.

Current projects include an Apple Computer Power PC campaign and two books for Dell Publishing.

CONTINUED ON PAGE 4-7

The Model	Doesn't arrive.
The Photographer	Gets a paying job at the last minute
The Hair Stylist	Forgets the hot curlers
The Makeup Artist	Couldn't get to M.A.C. before it closed last night
The Fashion Stylist	Ran out of room on his/her Visa card
The Budget	There isn't one
The Transportation	Breaks down on the freeway in rush hour traffic
The Location	Wasn't scouted beforehand and is now a parking lot
The Electricity	Fails
The Weather	Is miserable
The Props	Don't arrive
The Food	Gets delivered to the wrong location

You name it, it can happen. Be prepared to improvise, and keep a good attitude regardless of the situation.

WHAT SHOULD MAKE IT INTO MY BOOK

I have a simple test for determining whether an artist has met their objectives when it comes to putting a new piece in their portfolio. Ask yourself this question. If I laid some type on this photograph, would it look like it could be a feature or fashion editorial in my favorite magazine? If the picture is a portrait, could it be a cover.

As a photographers rep, I worked with Essence Magazine often. The beauty and cover editor, Mikki Garth-Taylor would always bring a small piece of transparancy that was made to look like an Essence cover with her to the shoot. It fit perfectly over a polaroid. On a cover shoot, each time the photographer took a polaroid, Mikki would fold it neatly, and place the transparancy over the picture. She could then see how the set up, lighting, subjects look, clothes, hair and makeup were going to look on the cover of Essence Magazine.

You may not have a real piece of transparancy to put over your photographs but you should create one in your imagination and use it every chance you get. But don't rule out a real one either. A piece of transparancy film and a dry erase marker could work wonders for helping you to see how an art director, fashion editor or photographer might view your work.

PAID TESTS

Testing is done most often without compensation. There are, however, those instances with models, actors, and actresses, when small sums of money are given to the makeup, hair, fashion stylists and photographers for their participation in a photo shoot.

A paid test is usually orchestrated by a modeling agency for a new face, or a public relations firm for an actor who needs pictures. These sessions have not been commissioned by a commercial entity, (magazine or

advertising agency), and are being paid for by the actor or model. A day's compensation typically ranges from $50 to $150 for a session with a model, and from $50 to $500 for a session with a celebrity.

WORKING WITH MODELING AGENCIES

Modeling agencies are a good way to find new photographers. Reesa has established excellent working relationships with many of the Los Angeles modeling agencies, and you can too. Here's what Reesa has to say about working with modeling agencies.

GETTING THE PICTURES

Getting pictures from photographers after photo shoots necessitates that arrangements for acquiring the

CONT. ON P 4.8

REESA'S FYI

I have found that one of the best and most logical means of testing to get fabulous (you hope)! photos for your book, is to work with model-ing agencies.

Modeling agencies have what's called a New Faces department. The purpose of which is to, guess what? Find "New Faces". The chance of discovering a super model sucking on a Cherry Slurpy in front of the local 7-11 who happens to have a hot portfolio of herself sitting at home is about one in a million. Well okay, this is Los Angeles, so maybe the chances are more like one in twenty. This is where you come in. A "new model" who wants to get bookings (work) needs a good portfolio. What makes a good portfolio? Pretty much the same elements needed to make a makeup, hair & fashion stylist's book: good photography, great models, fabulous hair, a well beat face (makeup) and great threads.

It's a team effort. You, the model and the photographer who just graduated from the Art Center School of Design or Otis Parsons all need good models, makeup, hair and clothing. This is especially important if the photographer intends to focus on fashion.

Starting to get the picture? Each of you needs pictures in your book. In other words, you need each other. Modeling agencies set up tests for their new faces (models) all week long. They usually pay nothing because they know you need pictures for your book too!

So how do you do it? I'll tell you. Call the modeling agencies in your city and ask for the New Faces department. (If you're just starting out, the agencies will not give you their "Super Models" to test with until they see that you are a "Super Artist".) Ask the "New Faces" booker if you can come by and meet them. Explain that you want to test with their "Girls" (the word that refers to a model). The more you use their lingo the quicker you'll get in. Request that they call you for tests. When the agencies start to call you BEWARE! You will not want to test with every one of their girls! What is beauty to one eye may be boring and bland to another. Ask the booker if you can cruise by and pick up the models ZED card or have a messenger pick it up? Faxing is an alternative, but, you

CG: What do you look for in a makeup, hair or fashion stylist?

PH: First of all, the quality of their work. Their technical ability. A lot of people have wonderful books and do lousy on the job. Not a lot, but some. They have a great book and then they get there and add color on someone's face that shouldn't be there, or a texture of makeup that doesn't work.

The most important thing for them to understand is their function in the whole job.

CG: Do you like to meet with artists before you work with them?

PH: Yes. I met with a makeup artist in New York who was represented by an agent in Los Angeles. I looked at her book, liked her, hired her and she ruined the job.

I would never recommend this makeup artist to anybody. I would go so far as to tell anyone who asked me, what a terrible job she did. And it was a very responsible makeup artist; so was the agent. I couldn't believe how off the mark she was. So it's really important to meet people for that reason, but it's also important to meet them and see what kind of people they are, because I rarely shoot models. The artist's compatibility with the personalities on the set is very important. I shoot a lot of celebrities who do what they want when they want, unlike models who do what they're told. At the end of the

CONTINUED ON PAGE 4-8

PAT HARBRON

day, you sign their voucher and they go home.

So if you have a makeup person whose not friendly and up and positive and all that, then you're in trouble because the people you are photographing see them first and they can set the tone for what that talent is going to be like when they walk onto the set.

So, technical ability, attitude and knowledge of their job requirements on that day are the most important thing.

CG: Have you ever hired an artist without a portfolio?

PH: Yes, because I knew the agency, and they knew what kind of work I like done on my talent. It would not be in their best interest to send me somebody who wasn't exactly like the person I really wanted.

CG: So you put trust in the agency?

PH: To a point, yes. I don't let my guard down but you have to trust everybody who's working with you to some degree. You have to let them do their job whether they are the hair or makeup artist or your first assistant.

CG: Do you require that an artist have experience beyond testing?

PH: Oh, yes. This isn't testing I'm doing here, this is real life. I don't want to be training somebody on my set. No question there.

CONTINUED ON PAGE 4-9

can't always see the images! I suggest picking the card up from the agency in person, or having it messengered to you. If after reviewing the card(s) you decide to go ahead and test with the model, make sure you can speak with the photographer beforehand to get an understanding of the "Look" he/she is aiming for.

While building your book (through testing) it's important to keep the direction of your book in mind. You don't want to have to many pictures with the same exact "Look" in your book, or a decision-maker will assume that you have limited talent — or worse, that you are unimaginative!!

The assignment is not over until you get the pictures for your portfolio. Hence the question, who pays? It depends. If you need the photos just as desperately as the photographer, and he knows that, you may not be able to get him or her to give you a couple of free prints. You may have to fork out as much as $20.00 per print. And since, rarely do you want just one print from a photo session for your book, you may end up spending $40.00 to $80.00 to get the series of prints you need to complete a story. Remember, you are going for an editorial look in your book. Have you ever flipped through Vogue and seen a one-page editorial? Never!! A word of caution, always pick out your own prints. What a photographer thinks is right for his or her book, may not work in yours at all.

When you reach the point that you could take or leave another Model Test in your book and a photographer calls you on his own (instead of the modeling agency) you know you have a little leverage. He likes your work. Now is the time to try and negotiate some free prints for your book.

Have fun and remember you do not accept every test that the modeling agency or photographer calls you for! You may not like the model, the photographer or the rest of the makeup, hair and styling team. It takes a bit of luck to make a fabulous test fabulous. Good Luck and Happy Testing!!

CONT. FROM P 4.7

photos be made and understood prior to the day of the session. The onus is on you to confirm with the photographer or booking party (sometimes a studio manager) when the pictures will be ready for you to view, how soon after making your choices you can pick the photographs up from the lab, and how much the prints are going to cost. Here's what you will need:

1. A day and time to pick out and crop the photographs that will best suit your needs. (Remember, always pick out your own photos!)

2. The name, location, address and phone number of the lab where the pictures are being prined.

3. The cost of having the pictures printed in various sizes. The most popular sizes are 11X14, 9X12, and 6X8.

LAB TRICK: Here are some things you ought to know about labs, film, photographers & who can view

the film.

a. Labs have policies and procedures that include when you can get the film back without paying rush charges (i.e. 2 days, 3 days, etc.)

b. Photographers who don't have any more money than you do, and are testing to build their portfolio's aren't spending extra money to get their pictures back from the lab early (i.e. 100% rush charge for 24 hours, 50% rush charge for 48 hours).

c. If you call the lab and ask for a price list (which they will fax, mail or email to you), you can also find out what their policies and procedures are and it should help you to determine when the film will be ready.

d. If the film is ready at 4:00pm on Thursday and you are the least bit concerned whether or not you are going to be able to get your photos, I suggest you get to the lab when the film is ready to pick out, order and pay for your own prints.

e. Photographers often send assistants and studio managers to pick up their film. If you walk into the lab and confidently ask for the film of such-and-such, most lab operators will get it, bring it to the light table and hand you a loop.

f. At this point, you can pay for the prints that YOU want and exit quietly.

THE WRONG GUYS

No offense intended to the head shot photographers of the world, but these are not the guys to test with for your portfolio. If they were creating for themselves an opportunity to shoot for Bazaar, Elle or any of the other fashion and entertainment magazines, they would be anywhere but in a head shot studio.

WHERE TO FIND GOOD PHOTOGRAPHERS

There are hundreds of places to find photographers, but only a few of them are the right places.

A. SCHOOLS

Many different types of schools have photography departments. Art schools, universities, community colleges and vocational technical schools provide opportunities for you to meet photographers. Like makeup, hair and fashion styling people, photography is one of those fields of study that involves the use of other people to accomplish an assignment. So ask yourself, "where is the student photographer going to find a crew for his photo session?" makeup, hair and fashion styling that is. Well, many art schools like Art Center College of Design in Pasadena, California have student information boards where you can post a three by five (3X5) card with your name, phone number and a brief description about your specialty (makeup, hair or fashion styling).

PAT HARBRON

CG: Are resumes important to you?

PH: Well, I'd like to know where they've worked. I mean, a resume doesn't mean anything if they just show it to me by itself. If they say they spent a year in Milan, okay, so what? Drinking coffee, or working with Italian Vogue?

That's why I like to meet people. The resume could say, I did this, I did that. The person comes in here and they have an incredible attitude. The resume doesn't mean anything then.

So I don't rely very heavily on resumes, but I do think personal meetings and portfolios are important.

CG: Do you hire freelancers?

PH: Often. The fashion stylists I hire are freelancers. It just seems to have worked out that way. I find that if a stylist is really good, they're so busy from word of mouth that an agency really can't help them.

CG: Do you prefer using agencies?

PH: I don't mind because the agency I use in New York is just so personable and good to me. It's just easier. I would prefer working one-on-one with an artist. But for makeup especially, you have to go through agencies, for the most part.

CG: Are there disadvantages with working through agencies?

PH: Yes, if an agent doesn't understand

CONTINUED ON PAGE 4-10

PAT HARBRON

what you need for the job, or if they give the wrong information to the artist. It gets really expensive with the agency fee. I resent paying the fee if the job I ask them to do isn't done right.

CG: Do you have a horror story?

PH: I was photographing Jim Carrey on location in Los Angeles for a magazine cover. The makeup artist I hired was an artist signed to an agency in Los Angeles. I interviewed her and looked at her book in New York. She had a wonderful book. I like really clean natural stuff, and on men you hardly need any makeup.

This makeup artist put pancake or something on him. You would have thought he was doing Kabuki theater. He came out of the dressing room and he looked terrible. I asked [the makeup artist] to take if off and start over again. You know, you only have a couple of hours with a celebrity. When he came out the second time it still wasn't good. It was a very tough situation. The girl was dropped from the agency as a result of it. My client was really unhappy. Pieces of the film went back and forth to show what had been done and gone wrong. It was a terrible job by somebody who should have been great. It just shouldn't have happened. I almost lost the magazine as a client after that situation.

CG: Do you have old steadies that you use?

CONTINUED ON PAGE 4-11

In New York there's the Art Institute on West 21st street, somewhere in your town there's a school of photography. Finding them is relatively easy if you have a computer. Just go to a search engine like Yahoo or Goto, type in the key words: photography AND school AND Seattle and you'll get a list of schools that offer photography as a field of study.

The trick, as always is getting their attention. The 3X5 card is one way, the 3X5 card with a sample of your work is another, and still another is having the class schedule mailed to you and showing up on campus at the end of class and personally introducing yourself to the photographers and the professor is an even better bet for success. Last but not least, be PERSISTENT. Don't take NO for an answer, someone needs your services. When it becomes important enough, you'll do what it takes.

Year after year, the Art Center turns out some of the best photographers in the world. Photographers like Peggy Sirota, Everard Williams, and Melody McDaniel are all products of the Art Center. Not 20 miles away from Los Angeles, The Art Center sits in the hills of Pasadena.

B. PRINT SHOPS

Industry print shops are great places to meet photographers. Not just any print shop will do. It's highly unlikely that you will meet a photographer at a Kinko's in mid-town Manhattan, or downtown Los Angeles. However, you might just meet one while waiting for your print order at On-Line Colour Graphics in the Flatiron district of Manhattan, or Studio Laser Casting in Miami Beach. Every time you set foot in one of these places, you create an opportunity to meet great photographers and your peers, other makeup, hair & fashion stylists.

C. PHOTO LABS

Another opportunity. Don't be shy at the color lab. If you see a guy standing around with some great pictures seize the opportunity to introduce yourself and ask him if he took the fabulous pictures you see before you. Strike up a conversation, let him know who you are and what you do. Photographers and sometimes their assistants or studio managers often handle the pickup and delivery of film. Your new testing partner might be standing right next to you. Ask to see their books and show yours. Ask them if they are testing and let them know that you are available.

D. CREATIVE DIRECTORIES

It goes without saying that creative directories are a great place to find specifics like phone numbers, addresses, email and web addresses of photographers. If you can afford it, keep the Workbook, Select and the Alternative Pick close by. If you can't, never fear, the Internet will provide you with the same resources and most can be printed out on your laser or ink jet printer at home. (For more information on these directories, and others, see chapter 2, Tools of the Trade).

E. WORD OF MOUTH

Stop, Look & Listen. The actions prescribed by these words should become part of your daily routine. Stop what you're doing. Look around you, and listen to what people are saying about who's hot and who's not. Be aware of what your peers and more experienced stylists are saying about the photographers they work with.

F. PHOTO ORGANIZATIONS

There are nationally and internationally recognized photo organizations around the world. The APA is just one of those. It is national in scope, with local chapters in most large cities. Los Angeles is one. The organization maintains its own membership directory and lists each of the member makeup, hair and fashion stylists. If you decide to be a member, you'll become part of that directory. The cost is minimal and gains you access to all of the workshops, symposiums and talks that they host at a discount. The membership directory is updated annually and circulated to all members. The APA has monthly meetings that are attended by...guess who? Photographers. As a bonus, the workshops and gatherings often include art directors, reps, art buyers and more as part of the panel discussions. Certainly worth the price of admission. The APA also publishes a bi-monthly newsletter.

G. MAGAZINES

I am always surprised at the number of makeup, hair & fashion stylists who want to do fashion, but never bother to look up the names of photographers whose work they admire in their favorite magazines. The photo credit in most magazines can be found in one of four places:

- On the index or contents pages (cover credits are usually printed here).
- Next to the makeup, hair & styling credit in the seam of the magazine in the body of the story.
- At the back of the magazine, in the resources section (Ex: InStyle magazine).
- Centered somewhere on the first page of a story.

When a photographer's name is run in the credits of a magazine that is published locally, there is a good chance the photographer is listed with directory assistance. Why? Because photographers are business people and business people have their phone numbers listed....so should you!

H. COFFEE SHOPS

What better place to meet someone than the watering hole of the 90's, the coffee shop. Unlike the seedy

PAT HARBRON

PH: Mostly in New York, but there are a couple of people in Los Angeles I really like, and definitely people here I use a lot. Cloutier's good in LA, and Ivy Bernhard is the one I use mostly here.

CG: Describe an experience in your career as a photographer that has left an indelible mark in your memory.

PH: There's a lot. I'm really lucky, I'm able to do pretty much what I want. I don't shoot stuff and then go home and say I wish I was doing something else. I do the kind of photography that I want to do. So much so that a lot of it is also my personal work. Doing the kind of photography you want to do makes it all worth while.

CG: What works for you as a creative person in this business?

PH: Things always change. What worked for me a couple of years ago, I don't do now. The business and art are always growing, and you have to, as well. You have to let the people you're working for know where you are going, and have them come with you. And if they change you have to respond to their changes or you'll be a dinosaur.

Lets say you decide to move from magazines into advertising. That's more than complicated. It's a whole different procedure, people look at pictures differently. But once you're in there, you gotta swing with it because it keeps changing. You gotta keep growing.

CONTINUED ON PAGE 4-12

PAT HARBRON

END

www._____
UserName _____
Password: _____
Notes:

www._____
UserName _____
Password: _____
Notes:

www._____
UserName _____
Password: _____
Notes:

donut shops of yesteryear, todays coffee shop offers gourmet coffee, italian sorbets to cleanse the pallet, fancy european pastry (the names of which everyone except the Europeans mispronounce), comfy chairs, three-prong outlets for that all important laptop, magazines with names like Java and quite often, creative people sharing lots of great ideas. Photographers, video producers, fashion editors (if you live in New York), stylists, designers, and celebrities are all part of the new coffee shop scene.

I. PHOTO EXHIBITS

Photo exhibits and cocktail receptions are way up there on the list of "where to meet photographers". Some very hip industry people show up to meet, greet, eat and drink apple martini's while fawning and gossiping over Helmut Lang's latest muse. You can find listings for these kinds of gatherings in local newspapers, photo and fashion magazines, trade publications like PDN, and of course the Internet. Check out the calendar of events sections in each of the respective media, and you're sure to find a place to meet more of the people who can make a difference in your career.

Following are a few websites with email newsletters you may want to subscribe to. The additional spaces below and at left are included so that you can remember your user name and password and include your own discoveries.

GETTING APPOINTMENTS

Yes, there is a trick to getting appointments with photographers. You start by lifting the receiver on the

www.alternativepick.com
User Name _____ Password: _____
Notes: _____

www.pdn.pix.com
User Name _____ Password: _____
Notes: _____

www.workbook.com
User Name _____ Password: _____
Notes: _____

www._____
User Name _____ Password: _____
Notes: _____

telephone. If you are the kind of person that shies away from the phone, get over it. You gotta call people up. Be resourceful. Pick up the phone, call directory assistance and ask the question "Do you have a business listing for Mr. Photographer?" "How about a residential listing?" "Nothing in Hollywood, how about Los Angeles?" Calling photographers on the phone gets easier with practice, and lots of it. There are two kinds of phone calls you can make when prospecting. Let's examine them.

Phone Call Number 1: Hi Mr. Photographer, I'm Denise, a makeup artist, um and I was wondering if you were testing and um if I could come and show you my work?

Phone Call Number 2: Hi Mr. Photographer, this is Denise Kelso. I'm a makeup artist here in Dallas and I have been keeping up with your work for a very long time. I was admiring that 5 page piece that was featured in this months Allure Magazine and I noticed that you won an award for your Blankety Blank ad in Photo District News. Your stuff is amazing and I was wondering if you were doing any testing?

Now those are very different phone calls aren't they. And they will be to the photographer as well. Do your homework.

TWO KINDS OF PHOTOGRAPHERS

There are two kinds of photographers. The ones who are going somewhere, and the ones who are going nowhere.

PROFILE OF A PHOTOGRAPHER WHO'S GOING SOMEWHERE:

- Has established working relationships with modeling agencies
- Has a portfolio
- Uses the better labs to process and print film
- Shows respect for the work of his peers
- Is knowledgeable about the great photographers who came before him
- Is willing to collaborate with the makeup, hair and stylist on tests
- Returns phone calls
- Is creative

TESTING OR PERSONAL WORK: Recently at one of my workshops a very successful photographer came and sat on my panel. When one of the students asked him if he still tested, he said no. However later on he went on to say that he did do personal work. Folks, I'm here to tell you, it's the same thing. So, if and when a photographer tells you he/she doesn't test any more, ask them if they are working on any PERSONAL projects that you might be able to work on with them).

Photograph by Noel Federizo

Makeup & Hair by Cherie Combs, Styling by Alejandro Peraza
both for The Crystal Agency, LA

**NOEL FEDERIZO
PHOTOGRAPHER**

RM: **So Noel, as a fashion photographer, what kind of role does makeup, hair and fashion styling play in your work?**

NF:: Big. It creates the vibe and the mood of the shot. The mood pertains to the costume that the subject is wearing. Not just the styling but the hair and makeup too. It all has to match. Hair and makeup is essential because it creates the mood for the shoot itself. Fashion is like a costume party so you need to have the makeup flow. From the clothing to the hair and makeup, that's what you need to make the proper picture, basically.

When it comes to celebrity stuff, celebrities need to look not only the best they can, but they always need to keep up with the current trends in hair.

RM: **Do you think bad makeup, hair and styling can actually ruin a photo shoot?**

CONTINUED ON PAGE 4-14

NOEL FEDERIZO

NF: Of course. It has! I mean I've seen it before. I've seen pictures that look amazing technically and the models are great, but the one bad thing about it is the hair or makeup. An imperfect eyelash or imperfect eyebrows makes the subject look bad! And that in itself ruins the shot.

CG: Do you find that you have more problems with styling, hair or makeup?

NF: Makeup. A photo really looks awful if the makeup is bad, especially in fashion photography.

CG: Do a lot of the artists just come to the set and do what they want, or do photographers have a lot of say about the look they want.

NF: Photographers should have a lot of say because they are the ones photographing the scene and creating the mood. It's hard to find an artist that will click with the photographer. It's got to be a team effort. It can't be a solo gig. There has to be definite communication between all the artists involved, because they all are artists.

The model has to understand the idea behind the picture too. You can't just walk on the set without a clue. I've seen a diva come to the set and throw a tantrum because they want to see only what they see, versus what the group sees as the look for a shot or a story. It's either the photographer, or the makeup artist or the hair stylist.

CONTINUED ON PAGE 4-15

CHARACTERISTICS OF A PHOTOGRAPHER WHO'S GOING NOWHERE:

- Never gets girls from modeling agencies
- Always testing with someone they met on the street, or a neighbor
- Has been testing with modeling agencies for 5 or more years
- Doesn't have a book
- Constantly talks in technical terms you can't understand
- Criticizes the work of his peers often
- Takes days to return phone calls, or doesn't return them at all
- Is more interested in the kind of film being used rather than the picture being taken
- Thinks he's a better fashion stylist than you are
- Does wedding photography on the side

If a photographer exhibits these "nowhere" characteristics, run in the other direction.

THE PHOTOGRAPHER PSYCHE

Photographers who get large enough to have recognizable names like Herb Ritts, Matthew Rolston, and Annie Liebovitz (and those that appear regularly on Lifestyles of the Rich and Famous), also have teams of makeup, hair & fashion stylists they are comfortable working with. They demand that specific people work with them at all times, and have been known to reschedule shoots when their favorite artists are unavailable.

Seem unfair? Only when you're not on that list, huh? If you hope to work with famous photographers like the ones I mentioned, EARLY on in your career, it will more than likely NOT be his or her choice to book you the first time around. So if you get lucky enough to be shoved down some unsuspecting (and famous) photographer's throat, remember, THE BURDEN OF PROOF IS ON YOU to show that you are ALL THAT, and not on the photographer who has already paid his or her dues and is preparing to tape the next segment of Entertainment Tonight.

I've personally witnessed photographers be standoffish, even downright nasty to artists that were not part of their regular team on a photo shoot. It's not fair, but it does happen. Remember, this is your chance to excel, shine, and dispel any notion that you are any less of an artist than his regular stylist just because you don't have a Vogue or Elle cover in your portfolio.

The trick, in a situation where you have been summarily shoved down a photographer's throat, is to make it clear that you are coming to his party and you are on his team.

One of the things photographers dislike about working on photo shoots with artists who have been chosen by the celebrity is that [typically] when differences of opinion arise about the makeup, hair or styling direction of the photo shoot, the artist typically takes the side of the celebrity. This can handicap the photographer from creating that "something exciting and wonderful that he has planned and more importantly

that he has been hired by the art director, photo or fashion editor to create. (A feat he/she finds quite easy to do when using their TEAM).

A hypothetical scenario could go something like this: The photographer asks the hair stylist to "do this or that" with the hair. The stylist (who prides herself on how well acquainted she is with the celebrity) turns to the photographer and replies, "she doesn't like to wear her hair like that." STOP! WRONG ANSWER. Here's a better answer:

Oh, (Mr. Photographer) that sounds great. I've been dying to try some new things with her hair, and she's difficult but I think I can get her to do it for you. Do you think I could meet the stylist and take a look at the clothes? Then I can see where you really want to go with the hair and create something wonderful for you.

The moment of truth has arrived. The photographer now has an inkling that you may be on his side. Just remember, you will be tested all day throughout the photo shoot. All of your actions will answer questions in the photographer's mind. Questions like:

- Do you get along with the rest of his regular crew?
- Did you understand the concept, after speaking with the photographer and fashion stylist?
- Are you personable?
- Are you offering up creative suggestions and solutions?
- Are you assisting the photographer in his or her efforts to get the subject to buy into his ideas regarding how that person should be shot?
- Are you a team player?
- Are you attentive?
- Are you hip?
- Do you know fashion?
- Are you creative?

Take it all in stride and think of it as a right of passage. You're not being singled out. It happens to everyone. I'll share a story with you.

Many years ago while representing photographers, we had the good fortune to be working with Premiere Magazine. The Director of Photography back then was a woman by the name of Charlie Holland. We got along well right from the

NOEL FEDERIZO

CG: **When your looking for make-up, hair, and fashion stylists for your shoots, what do you look for in their books and in the person?**

NF: In the person I look for someone I can get along with and someone I can communicate with. As far as their book goes I look for technical proficiency in their work. I want to know how dependable they are and if their professional on the shoot. During a shoot there are a lot of variables that can change. A lot of things may not work out, the idea itself may not work out, but you've got to have some crafty people. I guess that's the word I like to use... crafty. That means you can do things with nothing, or do a lot of things with everything.

CG: **When looking at makeup books, do you like to see clean or wild and funky or mixed, and does an artist need tearsheets to appeal to you?**

NF: I will give everybody the benefit of the doubt, but, I also have to see some proof of what they say they can do. Tearsheets?... I guess it's a good thing because it shows that an artist has worked, but not necessarily. If some one is really into what they do and they can show a little bit of what they can do it's a good positive thing because someone should always get a chance. Not everybody starts off won-

CONTINUED ON PAGE 4-16

NOEL FEDERIZO

derful.

CG: **What is the most annoying thing a hair stylist or makeup artist can do on a shoot. Please give examples. Give me some, "DO NOT EVER'S. . ."**

NF: Do not ever question out loud. If you have a question you should pull the person your shooting with aside. Do not doubt too quickly with out thinking about the question. Don't doubt the idea. Don't sabotage an idea with out thinking about it or having a chat with the person who has the idea. Don't shoot an idea down before you've giving it a shot.

CG: **How do you feel about an artist who comes up and looks into your camera?**

NF: Well, that would be kind of difficult because I'm usually holding it. (laughs) I never really set it up on a tripod. I've seen artists do that, and I've seen photographers freak about that. It's like having a photographer pick up your makeup pencil and start drawing on the subject, or having the photographer mess up the hair with out even asking. Everybody's got their tools and everybody's got their place so they've got to work together instead of working against each other.

CG: **How do you feel about artists being "fashionably late" to a photo shoot?**

NF: It's inexcusable. It is just bad. It's not

CONTINUED ON PAGE 4-17

beginning. One of the photographers I was representing, David Roth, had already shot pictures of well known celebrities such as Willem Dafoe and Spike Lee for the cover of Movieline Magazine, and double page features of Billy Zane and Rachel Ward for Cable Guide.

The first job we got from Charlie, however, was an assignment to shoot a lesser-known actor for a small feature in the magazine. Another right of passage. Even though we were already shooting the caliber of people chosen for the cover of Premiere, it wasn't Premiere, and the circumstances surrounding our shoots may not have been the same. Charlie's message was clear. You perform well on this little assignment and I'll give you something a little bigger next time, and so on, and so on. The unspoken message was, "so let's see what-cha-got."

Many photographer's have choked after getting their big chance to shoot for a magazine like Premiere. There are not too many photo editors who can afford the expense of having a photographer flub a cover, any more than a photographer can afford to have a fashion stylist pull the wrong clothes, or the makeup artist put clumpy mascara on an actress like Geena Davis. Photographers will treat you the same way Charlie did us. If you do a good job under pressure, add a little follow-up and follow-thru, you will more than likely get another chance to work with them, and then another. If you do a bad job, it's good-bye Charlie!

Here are some things you can do before, during and after the photo session to insure yourself an opportunity to have a second one.

BEFORE THE SESSION

With a couple of days notice and the photographers name, you can do a little home work and familiarize yourself with some of the photographers work. This will be easy with all those new magazine subscriptions and the newly acquired research skills you have perfected since completing your homework in chapter 1. I'm sure you will have no problem rattling off two or three projects the photographer has worked on in the last three months and what freelance makeup, hair & fashion stylists he's been working with.

What if you can't find his/her name in those credits? That usually means that the artist is working on more commercial work than editorial. In this business we call advertising, catalogue and annual reports, commercial work. Magazines are editorial.

Unfortunately, most commercial work does not credit the photographer in writing. It's rare that you'll find a photographers name on a Budweiser ad or a Victoria's Secret catalogue so you'll have to be a bit more resourceful.

If you were hired by the celebrities manager or publicist, request the name of the creative person in

charge of the photo shoot. This might turn out to be the art director, photo editor or fashion editor. Call them and introduce yourself. Let them know that you've never worked with this photographer before and you were wondering if you could get a little background so you can familiarize yourself with his or her work. This knowledge will give you a little common ground and something to talk about at the photo session. I call it leveling the playing field. Remember, almost everyone is flattered when you know something about them and their work. At this point you know more about the photographer than he knows about you.

Another way to round out your research is by taking advantage of the information on the web based creative directories and photo websites. Enter the photographers name into the search box and you just might strike gold.

THE DAY OF THE SESSION

Arrive at the session early to set up. Introduce yourself to the photographer and find something to talk about before, during, or after you have set up. If it's going well, ask to see the photographers portfolio. Mention some of his recent work that you discovered in your research, what you liked about it. Feel free to discuss the kind of makeup, hair or styling he seems to like. Don't be afraid to ask him to show you what he wants.

DURING THE SESSION

During a photo session that lasts all day, there will be plenty of opportunity for you to assess how your work is being perceived by the photographer, and his crew. Don't be afraid to offer up suggestions when you think they are appropriate and will benefit the common goal. Be confident.

AFTER THE SESSION

Choose your move. There are several options. You can:

1. Ask about a good time to come back and show him your portfolio.
2. Whip out a book and throw it in his lap. (Though this rarely works well after a long day).
3. Ask him if he ever tests, and let him know that you are available.
4. Drop a promo card on him and ask about working together in the future.
5. Drop a promo card on him, and ask about coming back to show your book.

Think about it. Listen to your heart and go for it. Remember, if he says no today, there is always tomorrow. Call another day and ask again. Persistence is KING!

NOEL FEDERIZO

being professional. It happens all the time because you hear "oh, I am an artist" and this or that. Everybody plays that game, but it's still unprofessional. Basically time is of the essence to everybody. It comes off sometimes as "cute" and all that, but it's NOT! People are on hold for you. It is very unprofessional!

CG: **When you're testing, what is the deal? Do you pay them, do you offer them a free print? Or is everyone just doing it for free? Photog-raphers have different ideas about this.**

NF: True. Everyone does it differently. Generally people who test want prints out of it because that's the whole point. You're working on your portfolio. You're working on an idea that you had, so you got to throw in what you can. Not only your time, sometimes you got to throw in a little bit to help produce this thing to the utmost. Not only bring in what you have but sometimes a little extra. Generally they get a print. Not even a print usually from me they get the full editorial story cause that's what I shoot... editorial. My work has a tendency to fill up a book really fast.

CG: **Do you notice a big difference between makeup, hair and stylists who work in print, versus artists who do film or TV?**

NF: I don't think it's that easy to go back and forth. Motion is one escape for the

CONTINUED ON PAGE 4-18

NOEL FEDERIZO

people who do television. They have the tendency to cake on the make-up because the subject is moving. When you're working in print whoever is looking at the picture has a tendency to examine every little angle... The paint on the face. It's got to look as natural or as clean as possible without looking too made up, or not made up enough. The work is more open for criticism when it's print.

CG: **How do you feel about artists cold calling you to test with them?**

NF: That happens quite often actually because there is no way to be introduced without cold calling, unless your a total social butterfly and you can meet everybody. But even then you still have to introduce yourself. I am not opposed to it, as long as your not heckling everyone. Or you're not being so much of a pain that you end up looking like your stalking people.

CG: **Do you have advice or suggestions that you have always wanted to share with the artists of the makeup, hair and styling world?**

NF:. There's not much room for "divas" anymore. I mean, there use to be in the 80's, but being a hair diva or a makeup, or photographer diva is just not cool anymore. We're in a time where people are starting to work together. They should value the whole art form and not be such a prima donna. People get tired of that stuff.

REESA'S FYI: AN EDITORIAL LOOK

When I was working at the agency, I was often asked what was meant by an editorial look or editorial test. If you asked several people this question I'm sure you would get lots of different answers. Here's my definition: An editorial test is one that looks like a fashion story in a magazine. A series of pictures taken during a photo shoot that when strung together look like a story. Thinking in story form is a valuable skill you should work to develop. When you're testing, the objective should be to create a story. If you're not sure what I mean, go back to your fashion magazines and review the fashion editorials (stories) in the last third of the magazine.

Believe it or not, a model in a chair wearing the latest pair of CK Jeans, the same model leaning against an oak tree wearing a Norma Kamali dress, and the same girl again standing near the chair she was sitting in during the first shot except that she is now holding a bottle of coke and wearing a different shirt with those CK Jeans is a FASHION STORY! Hey, I just report the news. Happy testing!

NOEL FEDERIZO

Also there shouldn't be sexual tension on the set, especially if you're spending long periods of time with these people. Sometimes the sexual chase becomes the focus of the shoot instead of getting the job done. Being friendly is one thing, but the sexual stuff can jeopardize the job.

CG: **If you really believe in a hair or makeup artist and you've tested with them before and you get a big job are you going to call the big famous artists or would you call back the people you've tested with?**

NF: I'm pretty loyal. Generally, since I am also beginning in my career, I would feel uncomfortable using a major star stylist, unless they wanted me to work with them.

CG: **How do you feel about "partying on the set", as far as drinking and pot? I've heard a lot of mixed feelings about this.**

NF: I have nothing against it, but some people don't like it. You just have to feel out the vibe. If the artists are getting the job done, and are partying, that's cool with me. It all depends on the crew and client your working for.

CG: **Gotcha. Thanks for your time Mr. Federizo!**

5 AGENCIES...THE CATCH 22

MARYSA MASLANSKY
PRESIDENT
VISAGES

Finding the agency that is best suited to your needs, temperament, and personal style require some research, leg work, and being more than a little nosey.

The Career Guide provides you with an up-to-the minute listing of each agency, its owner or division head, hours of operation, interview and portfolio review policies, and more. You'll find complete agency listings at the end of this chapter.

My biggest surprise in compiling the agency list for this second edition was that there were agencies in cities that I would never have expected.

There are twelve agencies in the Los Angeles area. More than two and a half times that number exist in New York. Miami and San Francisco both have three, and we found five in Chicago. The agencies in the large markets of Los Angeles and New York stick to representing hair stylists, makeup artists, fashion stylists, manicurists and prop stylists. There are a few who also represent models, and a couple that represent photographers. However, in the secondary and even smaller markets of North Carolina, Pennsylvania, Dallas, Denver, Honolulu, Atlanta, Etc. . . they also handle models.

An agency's physical size is determined by the amount of talent it represents. Cloutier, the largest and oldest in Los Angeles, often keeps a roster of forty or more artists. A smaller boutique agency may represent only five to eight artists at any given time.

Size is one thing, prestige is another. Cloutier, Celestine and Visages are the largest and most prestigious agencies for makeup, hair & styling in Los Angeles. Between them, they garner the greatest number of high profile editorial and fashion advertising & catalogue assignments on the west coast. It is rare that you open magazines like InStyle, Esquire, Entertainment Weekly, Buzz or RollingStone and don't see at least one of those agency names. Their client lists read like a **Who's Who Behind The Scenes in Fashion and Entertainment.**

However, the face of Los Angeles is changing, and several new agencies have been giving the big C's a very serious run for the Gold. New entries include the now famous Smashbox Beauty, Heller Artist Managment, Rex and Bianca Blyth Beauty. Smashbox entered the market as a high profile full service photography rental studio, quickly added makeup, hair & styling talent and before you could say lipstick, had added a well publicized makeup line called Smashbox Beauty.

CG: How did you get started in the business?

MM: I started to represent photographers, fashion & celebrity photographers who worked with good makeup, hair and fashion stylists. And slowly I started to represent styling people.

CG: Did you know that this was what you wanted to do?

MM: I knew I wanted to have a business representing photographers. The style department came naturally after.

CG: Did you hold any jobs that led up to starting the agency?

MM: Well yes. Before Visages, I worked as a journalist for a European photo agency.

5.1

MARYSA MASLANSKY

CG: How long did you represent photographers before you added makeup, hair and fashion stylists?

MM: Very shortly. The hair people wanted me to handle them as well because we all had the same clients, obviously.

CG: Do you find the styling business easier than pho-togra-phy?

MM: I don't think it's any easier, I just think it's different. If you're an agent for photographers you can only handle four or five photographers, that's it. But one person can handle about twenty makeup, hair and fashion stylists.

CG: Visages is very diversified. What is your secret for making Visages the power-house agency that it is, and what is your next step?

MM: I have a good eye for talent, and I can spot a winner from afar. The next step was to open a video and commercial division to give a chance to our artists to grow in that direction. We have now already produced about 25 videos and a few commercials just in the last six months.

The agency has gotten obviously very big. I opened an office in New York seven years ago.
The agency is board-based. Apart from photographers, the style division and the electronic media division, we

CONTINUED ON PAGE 5-3

It's "ALL THAT!"

As Los Angeles restles with what will be the new agency hierarchy, the New York landscape is experiencing its ups and downs too.

Visages Style, once a powerhouse on both coasts closed its New York office and before we could gossip about it, Bianca Blyth, long time Visage, LA employee left the fold and started her own agency; Bianca Blyth Beauty now named Beauty & Photo. A major LA upset was the closing of Artist Group in Los Angeles. I personally viewed the reckage, a virtual ghost town. It is alleged that the owner left town with $250,000.00 of the artists money. What grew in it's place? Luxe.

In New York, the Ford Beauty Division, not a year old, was taken over by Debbie Walters, a woman we couldn't even squeeze work hours out of, and Achard & Associates has [obviously] decided that they prefer representing photographers to the likes of makeup, hair and fashion styling.

Suffice it to say, nothing has changed, because, everything is changing all the time.

HOW AGENCIES WORK

An agency is a firm whose job it is to secure work for the talent it represents. 2. a firm that secures work for you if you have a client list and a portfolio that shows experience, versatility, a personal style and range.

Agencies are responsible for providing a myriad of services for their artists. Following is a sample list of services a good agency should provide for you on a daily basis:

- Procure work for you
- Promote your talent
- Update your resume
- Provide vouchers
- Issue confirmations
- Issue invoices
- Give sound & honest advice regarding career
- Advise and counsel you regarding promotion materials
- Provide names resources for acquiring portfolios, creating reels, preparing & printing promo cards

- Verify credits
- Circulate and track your portfolio
- Book job assignments
- Negotiate fees & expenses
- Collect monies

Sounds great doesn't it? It is, when it works. For many a talented and lucky artist this is exactly the way it happens. Be forewarned, however, that agencies are in the business of getting work for

people who already have work. For many artists, the agency search becomes a frustrating Catch 22. You can't get an agency without a great portfolio, and many artists believe you can't get a great portfolio without an agency. You can, and you will have to, if you expect to be signed by an agency like Smashbox, Celestine, Crystal, Rex, Bryan Bantry, Zoli or Elizabeth Watson, Inc.

It's not callous, it's just business. The makeup, hair and styling industry is a multi- million dollar business. With that many decimal points and commas at stake, the big girls (most of the top agencies are owned and operated by women) are not playing around when it comes to their talent acquisitions (signings). They are looking for tearsheets, tearsheets, and more tearsheets.

THE BRASS RING

Competition is stiff among the top agencies, and every agency owner and division head is keeping an eye open for the next Kevin Aucoin. Sports teams aren't the only organizations looking for the first round draft pick. Owners are looking for the two or three stars who exude that mysterious "X" quality I talk about in chapter one. Representing artists who are liked and desired by the hottest photographers, models, clients, and celebrities can propel an agency into the stratosphere of **"HAPPENING"** and put the agency's name on the lips of every art director, fashion editor, photographer and video director within three thousand miles.

Many agency owners feel that the time they once had to groom an aspiring artist has gone the way of conducting business with a simple handshake. Agency life is filled with paperwork. Confirmations, invoices, contracts, liability insurance and issues of workers compensation for freelance artists can fill up many hours of an agency owner's work day.

It's a matter of economics. You are obligated to keep the workers working, and that leaves little time for pampering and grooming newcomers with potential.

THE AGENCY SEARCH: WHAT TO LOOK FOR

There are up and down sides to agency affiliation. When you start asking around about the various agencies, you'll get mixed reviews depending on whom you ask. I have heard horror stories from artists who claim to have been ripped off financially by an agency, while others swear that their books didn't get circulated enough. **BEWARE**. There are two sides to every story. For every artist who claims to have been duped, there are a lot of very happy and successful people at the same agency.

Artists blabber on and on about how their agency didn't pay them, all the while leaving out the

also syndicate images of celebrities worldwide.

CG: Are there certain requirements that you have for selecting talent?

MM: Well they have to have a reel and a book with a lot of editorial, otherwise it's really hard. I look for originality, a sense of style and taste. The personality of the person is very important. You have to be able to get along with people, you have to be flexible, and upbeat. You are around models, and actors or actresses, and they need to feel safe and that you are going to do the best for them, make them look their best, and they need to be reassured. They know that if they go to a reputable agency the person will have credentials.

CG: What turns you on or off about a portfolio?

MM: If it's sloppy, or the pictures are bad, or the portfolio is dirty. That is certainly a turn off.

CG: What makes a bad picture?

MM: Well, a bad picture is subjective. Some pictures I think are bad, others might think are fine. Obviously with my experience in this business, I can immediately zero in on the quality of a picture.

CG: What portfolio characteristics get your attention?

CONTINUED ON PAGE 5-4

MARYSA MASLANSKY

MM: Magazine covers get everyone's attention. But also for someone who is starting out, good tests, with a good photographer and model--a pretty model--are very important. Not something tacky.

CG: Do you implement formal agreements with your artists, and for how long must an artist sign with Visages?

MM: We do, yes. They have to be with us for a year, because it really takes at least a year to start a career for someone just starting out.

CG: Do you groom them for the agency, or set up tests for them?

MM: No, we don't do that. We can help them, but they really have to do that on their own first.

CG: Have you ever signed someone that didn't have a portfolio, but something in your gut told you that this person had it?

MM: Yes. In the past, I used to take chances with people. I did with photographers, and other artists.

CG: What advice would you give to artists just starting out?

MM: I would say to them that they should make friends with young fashion photographers who are just starting out, and do a lot of tests with them. They should pool their resources and connections

CONTINUED ON PAGE 5-5

important details. Many situations are out of the agency's control. One agency owner tells of a situation where, without paying its bill, a production company closed its doors and filed bankruptcy. The agency couldn't pay out what it didn't collect. The makeup artist was so angry after having worked on the television commercial for three days, she sent a messenger over to retrieve her portfolio. A year and a half later, the same makeup artist called and asked if the agency wanted to represent her.

In 1992, agency owners were caught completely off guard with the news that The Broadway department store chain had filed bankruptcy. Imagine for a moment that you own an agency. One half of all your annual billings come from catalogue, and thirty-five percent of those billings come from The Broadway. This is a real story:

> In 1992 The Broadway department stores (owned by Carter Hawley Hale) filed bankruptcy. A couple of Los Angeles-based agencies who did a large amount of catalogue and newspaper advertising work with The Broadway nearly lost their shirts. The settlement amounted to somewhere between 35 to 50 cents on the dollar, and even that money didn't come for several months after word of the Broadway's plight.

Here's a little business math. If you're owed $50,000.00, and only receive thirty-five cents on the dollar, what you'll receive in the final settlement is $17,500.00. Not a pretty picture. The situation with The Broadway is better than some. Not all bankruptcies end in reorganization. Some just end.

LOOKING FOR AN AGENCY, WHO'S CHOICE IS IT ANYWAY?

The search for an agency should be handled in much the same way you would look for a job. You've got to do your homework. Be nosey. Talk to artists who are happy with their agencies, and find out if there is any movement. Are they adding new talent to the roster? Have they heard talk of anyone leaving? Have they heard any rumblings that the agency might be looking for new artists?

The biggest mistake an artist can make while looking for an agency is to treat it like a crap shoot. Agents will respond better to artists who have taken the time to learn something about the agency. Following is a list of things you should do before approaching an agency for representation:

• Find out as much as you can about each of the agencies you are interested in signing with.

Learn something about their track record, their philosophy, the kind of work they do, and their specific requirements for signing an artist.

- Be ready to tell the owner or division head why you would be an asset to the agency, the contribution you can make, and how you are yourself fitting in.

- Be prepared to talk about the work in your portfolio, the creative choices you've made, and what you brought to the session in each photograph or assignment.

- Make a list of recent or upcoming job assignments that will soon produce new tearsheets for your portfolio. Know the names of the photographers, art directors or fashion editors that were present on the set.

- Create a resume. Make sure it lists all the photographers, directors, celebrities and recording artists you have worked with. It should also list magazines, record companies, catalogues, print ads and music videos you have worked on.

- Don't bother mentioning or showing work that has appeared in publications like the *Enquirer*, *Star*, *People* (in most cases), or *Soap Opera Digest*. These publications are not highly regarded by reputable agencies.

- Keep catalogue work separate from the rest of your portfolio unless you are showing your book to an agency whose work is primarily catalogue oriented. Mention that although you do, and have done catalogue, that is not your primary focus.

Interview **them** as well, and "assume the sale." That is, ask what you can expect professionally and financially from signing with the agency. You want to know what they can offer you, and how they would promote you. Find out who pays for what when it comes to advertising and expenses, and who is responsible for collecting your tearsheets and the work for your reel. Find out how many artists they represent and how many bookers are on staff. Be confident but not cocky. Be enthusiastic and let your personality show through. Look the part. If you're a hair stylist, I suggest you **not** go to an agency looking like Pippy Longstocking. As a makeup artist, Tammy Faye Baker is out. And fashion stylists, leave your Frankenstein getups for the next Halloween party. Yes, I'm

MARYSA MASLANSKY

to get some young models, and do tests. Out of those tests they will get pictures for their portfolio.

They obviously have to keep in touch with the fashion scene. They have to educate themselves by reading the fashion magazines. They should know who's doing what.

Of course, the ones who always make it big are the innovators, the ones who take chances and do what the others are not doing. But it takes a lot of experience to be able to be original. That is the paradox.

I think the English at the moment have a very high fashion profile, and there are a lot of good English makeup, hair, fashion stylists and photographers. Fashion comes in cycles. Before it was the French, and now it's the English. They have been very active on the fashion scene.

CG: Are there any warnings you would give an artist?

MM: Not to be temperamental and a prima donna. Just be nice to people. It's a great life. I mean, the top people make a good deal of money, they travel all over the world, they are around really interesting people. It's a great career. **END**

being a little facetious, but you get my point. If you want to be a part of this industry, learn your craft well and look like you belong. More on that subject in chapter eight (Freelancing).

WHEN YOU DON'T GET SIGNED

While shopping for an agency, keep in mind that it's a buyers market. There are ten times as many artists as there are agencies, and the competition is stiff. Put your best foot forward and keep it there.

Every agency has its own style and personality. Each one is looking for something different when it comes to signing artists to its roster. The ideal artist must possess a body of work that can be sold immediately within the agency's existing market. Next, the artist's personality, and personal style must mix well with the agency owner's vision of who the agency is, what the agency represents, and how it is perceived in the marketplace. Finally, the artist and their work must compliment the agency's existing cadre of talent and fill a void, or the looming potential for one. That void can be different things at different times. For instance, if an agency determines that it is missing opportunities in the catalogue market, it may process the information by taking the following actions:

1. Assessing its current roster to determine which of its artists can move into that area based on their experience and tearsheets.

2. Calling in the books of artists with those qualifications who showed past interest in joining the agency.

3. If your book had a catalogue in it, you may get a call back from an agency whose needs are changing, even though you didn't get signed on the first visit.

Getting signed to the agency of your choice isn't **just** about having a great book. The large agencies have tons of great people with fabulous portfolios. Don't be discouraged if you aren't signed to the agency on your first meeting. There can be several reasons why an agency may not take you on at that moment, the least of which is timing.

Ask for constructive criticism about your book, promo card, and yourself if you think it might be helpful and then be prepared to take it like an adult.. If the agency owner says she likes your work but the timing is bad, or that they are currently carrying another artist whose work is very similar to yours, then accept that at least for now.

Be encouraged that the agency shows interest in your work, and ask if it would be alright for you to follow up in a few months to show your new work and inquire about openings. If, on the other hand, they don't like your work, ask some open-ended questions. What do you like about my book? Where do you suggest I make changes? What specifically are you looking for? What about my work does not meet your agency needs? Can I look at some of your other artist's books? Answers to these questions will give you a better handle on what agencies are looking for and what the competition is really like. If in fact the agency seems genuinely interested in your work, but the timing may not be right and you are interested in assisting, ask to be put on their assistants roster.

Angelika, the president of Celestine, told us a great story of how an assistant fashion stylist performed so well on a shoot that the photographer called to book the stylist to a key job. There is always another day. Situations change, people come and go. If the owner or division head likes your work, the call could come sooner than you think. If you leave the bridge intact, you can always walk back over it.

COMPENSATION & EXPENSES

Agencies are paid twice. Once by the artist, and once by the client. They are paid fifteen to twenty percent by the artist for securing, negotiating, and collecting the funds for the job, and twenty percent by the client as an agency fee. Modeling agencies work the same way, the percentages are just a little different.

GETTING PAID OR WHEN DO I GET PAID?

Most agencies pay their artists upon receipt of payment from the client. There are a few who pay when the artist turns in a signed voucher, but they are few and far between. A "pay on voucher" system demands a hefty cash flow and can be extremely demanding of an agency's time and manpower depending on the size of the talent base the agency is maintaining. Most agencies we interviewed write checks once each week. If the agency receives a check for you on Tuesday, your check is written on Friday. A pay on voucher system can mean that you pay the artist while they are standing in your office, the phones are ringing off the hook, and you are trying to get portfolios out by 5:00 P.M.

These are just a few of the reasons most agencies pay once each week. Agencies who do pay upon receipt of a signed voucher also usually take an additional five percent commission for doing so.

BEATE CHELETTE
OWNER
BEATE WORKS

As president of Beaté Works, a full scale photo production agency, Beaté Chelette produces print advertising and video shoots for national and international clients in Southern California.

She represents photographers, illustrators, copywriters, art directors and a makeup artist.

Before moving to the United States, Beaté held the positions of photo editor at Wiener magazine and director of photography at German Elle.

CG: Before starting your own agency, you worked at Zenobia [Agency]. What was your policy for looking at books?

BC: I never had a drop off policy. I had a "drop by" policy. I didn't think the

CONTINUED ON PAGE 5-8

BEATÉ CHELETTE

person, or their personality could be separated from the portfolio. If an artist has a wonderful portfolio presentation but is sloppily dressed, or their nail polish is flaking off, I want to see that. I'm looking for a well groomed person.

At the same time, I'm evaluating the book. I'm looking to see if the book is customized. Is the artist's name on it, are the pages in proper condition, are the tearsheets neatly trimmed, or were they ripped carelessly out of a magazine and shoved into the book?

Overall, it's important that the portfolio have a neat look to it and that the front and back pages which sustain the most damage are exchanged frequently.

CG: Is there anything that turns you off about a book?

BC: Very much so. First, actor head shots have no place in a professional artist's portfolio.

Second, I'm not interested in seeing the unfolded, still creased and yellowed clipping from a small local newspaper where an artist did makeup, hair or styling just to prove to me that they are a working artist. I don't want to see newspaper or anything pornographic.

CG: What advice would you give

CONTINUED ON PAGE 5-9

BREAKDOWN OF ARTIST'S CHECK

DESCRIPTION	STYLIST	AGENCY
MAKEUP ARTISTS FEE	$ 850.00	
15% Agency Commission (Artist)	$-127.50	$ 127.50
20% Agency Commission (Client)		$ 170.00
SUB-TOTAL	**$ 722.50**	
Messenger Expense	$- 12.50	
TOTAL AMOUNT DUE	**$ 710.50**	**$ 297.50**

WHEN THE CLIENT PAYS

Each industry has its own pay schedule. The chart below details how most clients in the industry pay vendors. This list will assist you in creating your own personal receivables calendar.

ARTIST EXPENSES (OR WHAT HAPPENED TO MY CHECK?

Artists spend a lot of time complaining about the money that is deducted from their checks. They forget that while representing themselves, they shouldered those very same expenses. Over the years, I've concluded that there is something about having seventy five dollars subtracted from a check for messenger expense that makes an artist crazy. There are two ways to handle this. One, you can get used to it. Most agencies will not be liable for day to day expenses incurred as a result of endeavoring to secure work for you. The other option is to negotiate the agency taking a slightly higher commission (usually five percent) from your checks to cover your expenses. With this option, you will know exactly how much you are getting when your check arrives. Also, you won't have to worry about collecting receipts for every little expense to lower your taxable income, it will already be lower.

At The Crystal Agency, only one artist has opted for the twenty percent option. The additional five percent covers all day-to-day expenses. It does not cover portfolios, color and black & white prints, advertising expenses, or promotional cards. Following is a typical list of expenses you will incur on a monthly basis.

ACCOUNTS RECEIVABLE SCHEDULE

CLIENT	PAY SCHEDULE
Record Companies	30 - 45 days
Advertising Agencies	30 - 60 days
Magazine/National	30 - 60 days
Magazines/International	60 - 120 days
Catalogues	30 - 45 days
Department Stores	30 - 45 days
Production Companies/Commercials	15 - 30 days
Production Companies/Music Videos	15 - 45 days
Television	once per week
Feature Film	once per week

TAXES AND THE IRS

Ah yes, the Internal Revenue Service. Someone told the IRS that freelancers (self-employed individuals) don't pay their taxes, thus we have the W-9 and 1099 forms. As business entities, agencies are required to file form 1099-MISC for each person to whom it has paid at least $600.00 in income during a calendar year. Income is reported in Box #7 (non-employee compensation) of the 1099 form. Box #7 indicates to the IRS that the recipient (that's you) is subject to self-employment tax.

Most agencies will have you fill out a W-9 form the moment you sign with them. The W-9

LIST OF MONTHLY EXPENSES

1. Messengers
2. Color and/or Laser copies
3. Long Distance Phone Expense (for non-business related calls.
4. Postage
5. Express Mail: Fed Ex, DHL, Airborne
6. Magazines
7. Black & White and/or Color Prints
8. Promotional Cards
9. Portfolios, Plastic Pages
10. Advertising Expenses
11. Xerographic Copies
12. Faxes: Incoming & Outgoing

BEATÉ CHELETTE

an artist about how to choose the right pictures for their portfolio?

BC: This is one of my favorite topics and I talk to all my artists about it, you see because not all images are created equal, and one or two bad photos can bring the image of the book way down.

My general advice is that every artist should live with their own pictures. I tell them to take all the images out of their book and put them all over the house. In the bedroom, bathroom, kitchen, everywhere. I suggest that they live with their own images for a month and the ones that really start to bother them should be taken down. The photographs that are left hanging on the walls at the end of the month should go back into the book. I believe that ultimately, the artist will be the judge of what represents them the best.

CG: I'd love to hear some tips on how to get the best out of testing with photographers.

BC: I tell artists to give themselves fake assignments so that each time they test they are working towards a realistic goal.

If you are dying to do a cover f o r Vogue magazine, then create an editorial assignment for yourself and

CONTINUED ON PAGE 5-10

BEATÉ CHELETTE

then do your best to get as close as you can to the kind of clothing, hair, makeup and photography you would see in Vogue. You can also create a favorite ad campaign, perhaps Donna Karan, Anne Klein or Guess Jeans.

Once completed, the artist repeats the process of living with the new photos until they pick out those photographs that best represent who they are.

An artist should keep creating assignments until they are getting the assignments. Testing and evaluating your own work helps to clarify a style and signature. And just as we have come to recognize the lips of Kevyn Aucoin, the eyebrows of Sam Fine, or the photography of Helmut Newton, we may someday recognize the signature of some young artist who reads this book.

CG: How should an artist go about selecting an agency?

BC: I am blown away by the lack of knowledge of the artists who walk through my door looking for representation. They don't know anything about me or my business. I always ask them, "how did you hear about me?" The most common answer is that they found my number in a source book. I ask them why they want to join my agency and the typical answer is no answer at all.

CONTINUED ON PAGE 5-11

form is a request for your taxpayer identification number and certification. The tax identification number in the case of most artists is usually their social security number. The purpose of the W-9 form is to certify that (1) the tax I.D. number you are giving is correct (2) that you are not subject to backup withholding.

makeup, hair and fashion stylists are independent contractors, and not employees of the agencies who represent them. As independent contractors you are subject to the self employment tax and responsible for paying your own taxes.

THE BALANCING ACT: ARTIST-CLIENT RELATIONS

A common situation encountered by artists after signing with an agency is what I call the "Client Come On." Symptoms include, but are not limited to clients who subscribe to and initiate the following activities and conversations with artists:

- Insisting on calling you at home to find out your availability for a job after you've told them repeatedly to contact your agency directly.

- Suggesting that since they have a really small budget on this job, it would be helpful if they could bypass the agency just this once.

- Dragging artists into hallways during and after concept meetings insisting that your agency is going to ruin your career if they continue to charge these exorbitant day rates for your services.

- Suggesting that they could pay you more, and hire you more often if they didn't have to go through your agency.

The list goes on. Throughout your career you will be forced to listen to a host of decision-makers complain about paying the agencys twenty percent commission on top of your fee, even when they learned about and hired you through your agency.

Think of it as a test of wills. Young children try their parents in much the same way. They push and push to see just how much they can get away with. This can be a difficult aspect of agency life until you become skilled at dealing with the "Client Come-On."

The process often leads to uncertainty in the mind of the artist, internal upheaval (that's your

conscience), and short term memory, better known as the "what has my agency done for me lately" syndrome. Artists say to themselves:

- Well how bad can it be, I'm only going to do it this once.
- My agency will never miss the booking, It's only $300.00.
- They have fifteen other artists, they won't miss this little bit of money.
- Who's going to know?
- I give them all my other bookings anyway, what harm will it do?

The choice is, and always will be yours. Succumb, and you run the risk of getting caught, being in violation of a written or verbal agreement with your agency, and being summarily dismissed from the roster. Is it worth it? Probably not. Either way, you won't be the first or the last artist forced to take a stand with or against his/or agency. It is both a legal and moral decision. Consider this:

A couple of years ago I was introduced to a hair stylist. At the time, he was working in a trendy West Los Angeles hair salon and had never been with an agency, nor had he ever done any commercial work. He had begun to do a little testing with some model friends of his: most of the pictures he had taken himself.

We exchanged phone numbers and a couple of days later he visited me at the agency. I reviewed his portfolio which at that time had about eight test shots in it. His talent was apparent. We spent over an hour at the agency discussing how the agency worked, what was expected of him, and what I could do for him. We agreed to begin pursuing a professional artist/agency relationship.

On the day we first met, he was making $45.00 per head for a shampoo, and blow dry. Within three months I was getting him $700.00 - $850.00 per day. During this time he met another artist whom he allowed to influence him regarding his career. Sometime around the fourth and fifth months, his head started to grow so large, and he became so full of himself, that his behavior became unbearable to me and my staff. He became very mean -spirited and started ordering everyone at the agency around. Unfortunately, this transformation came along with his new stardom and the star company he began to keep.

At some point during this transformation, I received a long distance phone call from a well-

An artist needs to be clear about why they want to join an agency and what they think the agency is going to be able to do for them that they cannot do for themselves.

It's very important to gather information about the agency before you begin setting up appointments to show your book.

Talk to photographers and other people in the industry. Go through magazines and identify the photographers whose work you like and write their names down. Then locate their phone numbers in the Workbook Directory or the Black Book. Call them up and instead of saying, "I want to work with you," say "look, I'm a makeup artist and I'd like to find an agency -- who is it that you work with?" Use that opportunity to find out as much information as you can.

Then when you call or visit the agency and they ask why you want to sign with them, you can tell them that it's because they work with such and such, and so on and so forth and those are the caliber of photographers you see yourself working with and that is why you want to join their agency.

It will blow them away. **END**

Télestine

AGENCY FOR HAIR, MAKE-UP & STYLING
8278 Sunset Blvd., Los Angeles, CA 90046
(213) 650 7181 • FAX (213) 650 0997

**ANGELIKA SCHUBERT
PRESIDENT**

CG: Lets start at the beginning. How did you get started?

AS: I was born in Austria. I was involved in fashion all my life. From my early years when I was a child doing drawings, then I went to clothing design school. For a long time I had my own boutique in Vienna. I then went into freelance design, and was hired by a lace/fabric manufacturer as a freelance designer to do their shows. Everything was always fashion. For a while I traveled around the world modeling. Then eventually, somehow, I ended up in LA. I fell in love with LA. I feel you have so many more chances in America than you have in Europe. Americans are more open, much nicer, they're easier to deal with. They listen.
I started a clothing company here. To sell my clothes I had to call the shops and fashion boutiques to show my clothes. I think the European accent helped me to get in. Maxfields and

CONTINUED ON PAGE 5-13

known publicist who represented a well-known celebrity whose hair my artist had allegedly just done.

The publicist was outraged by the amount of the bill, $1,050.00 for three hours work. Since we had worked with his firm before and he had always known us to be fair and honest, he decided to call. Since I had no idea what the publicist was talking about, I asked him to fax me a copy of the bill. I was shocked to find that, not only had the artist circumvented the agency by accepting the booking without our knowledge, he had taken fraud to an entirely new level by tacking on a twenty percent billing fee.

When I found out, about it I contacted the artist immediately and requested his presence in my office. Soon after that I asked him to pick up his books.

COMMITMENT

The decision to join an agency is the first step towards commitment with a business entity that will represent you, and handle your money. Once an artist says "I do" so to speak, they have made a conscious choice to put in their time, tough out the rough spots, and work out the inevitable disagreements with the agency, no matter what, at least for the term of the agreement.

Most agency owners or division heads are very good about sitting down with an artist and explaining how the agency works, what is expected of you upon joining the agency, and all the terms and conditions that apply once you sign on. In turn, this kind of meeting provides the artist with the same opportunity to get their questions answered.

FINANCIAL CONSIDERATIONS

The financial commitment for an artist can be the most difficult aspect of joining an agency. This of course depends on where you are in your career. A new artist usually has little or no concern about handing over the fifteen percent commission to his or her new agency because fifteen percent of their jobs seems a small price to pay for the benefits of joining an agency that will also get them work. On the other hand, the established artist with a portfolio full of Vogue and Elle tearsheets, and a bevy of existing clients has some very different issues.
Artists often wonder how much work the agency will generate for them, whether or not the agency will give their established clients to other artists, if the agency will take fifteen percent of their existing clients and bring nothing more to their bottom line, and how their existing clients will respond

to working the the agency booker? All are genuine concerns that must be weighed carefully against the benefits of agency affiliation.

With a well established artist, there may be discussions surrounding what should and should not go through the agency. The artists' arguments usually include topics such as:

- People the artist knew and clients they had before joining the agency
- Whether or not jobs that pay small amounts should go through the agency
- A possible reduction in agency commission for clients they are bringing to the agency
- Commission schedules for different segments of the industry

When you join an agency, you enter into a partnership. Like any partnership there is give and take, and rules governing the relationship. In return for bringing your existing clients and relationships to the agency, you will receive a manager, negotiator, career advisor, collection agency, more work, better work, the prestige of being signed to a reputable agency, and in many instances, more money from your existing clients.

SPECIAL SERVICES

While most agencies don't publicize this fact, some create, keep and make available to their artists, lists of possible assistants. The key to getting on the list is first not to bug the agency. If you do you will end up on the black list instead of the "assistants available for work" list. Initiate contact in the following manner:

1. Contact the agency by phone.
2. Identify yourself and state your purpose.
3. Ask what their policy is for furnishing the names of possible assistants to their artists.
4. Ask to whom you should forward a list of your credits to.
5. Ask if you can bring the list in with your portfolio.
 If yes, schedule an appointment for the earliest possible date: if no, send your list of credits to the appropriate person and follow up with a phone call in two to three days.

The key to making it in this or any business is perseverance. You will hear NO from time to time. Remember that NO spelled backwards in ON. So keep ON keeping ON. Besides, NO is not personal, and usually has nothing to with you. If a booker is having a particularly hectic day, NO can sound like NO! It just means call back tomorrow.

ANGELIKA SCHUBERT

Macy's became my clients. I did this for three years and put out five collections a year. It was a lot of work.

CG: Where did the makeup come in?

AS: As a model in Europe I had to do my own makeup and hair. Eventually the other models asked me to do it for them. I had photographs of myself as a model, one thing led to the next. I got a book together and started doing hair & makeup. I signed with Cloutier and worked on many great celebrities with photographers like Matthew Rolston, Peggy Sirota, Philip Dixon.

Then it was time to move on. I wanted to do something else. I wanted to open my own agency. It was very hard work but I think that my experiences living and working in Europe and America and my ability to be professional helped a lot.

CG: What are the qualities of the right people?

AS: An artist has to be easygoing, excited, proud of what you're doing. No attitude whatso-ever. You have to have ideas and be interested in art, fashion and style. Know what will happen next season. Be in touch with current fashion. Look at old art books. Go to old movies. I know artists who go to the movies and make sketches.

CG: Do you look at the portfolios?

AS: I look at every book. Every artist's book in the agency is done by me. I have to take time.

CONTINUED ON PAGE 5-14

ANGELIKA SCHUBERT

CG: How may artists do you have?

AS: I have about forty-five. You never have them all here. Some are assistants, some are bi-coastal, some are in New York, others are on pregnancy leave.

CG: Are some of those in Seattle?

AS: We have another twenty artists there. I see all the books there, too. They send me all the books with tearsheets. I want for every artist to have at least three books.

CG: When you're looking at portfolios, what are you looking for?

AS: If the book is interesting, then I meet the artist. It's very important to see their face, their talent, their attitude, how they present themselves. Sometimes people can't tell the difference in makeup from one artist to the next, but they always remember their personality. The artist with the right personality has a better chance of being re-booked than the one with the better book.

CG: Is most of your work print?

AS: We do a lot of commercials, and videos. We have some stylists who have done film. For makeup & hair stylists, unless it's special effects or something of that nature, they're not very interested in film. We do mostly celebrities, print, editorial, album covers, commercials and videos.

CG: What should an artist never

CONTINUED ON PAGE 5-15

Acknowledge that you understand that today may not be such a good day, verbalize that you will call again, and when you do, open your conversation with a little light fare such as:

"You sounded very busy the other day, have things calmed down a bit for you?

Angelika Shubert, president of Celestine, mentioned occasions where stylists who started out on their assistants list performed so well on shoots, that the photographers asked them back to key jobs.

NEW YORK SALON CULTURE: THE NEWEST KIND OF AGENCY

So powerful and respected are some of the New York salons that we nearly mistook them for high powered agencies. These salons are mentioned over and over in top fashion magazines like *Allure*, *Mademoiselle*, *Vogue*, *Elle*, *Details*, and *GQ*. Their artists are interviewed and questioned about everything from current trends in nail color to the proper skirt length for fall. Well, I'm exaggerating a little on the skirt length thing, but really, hair stylists at these top New York salons are almost as famous as the celebrities and supermodels whose hair they coif and faces they create. Housed in everything from a four story walk-up to Trump Tower in midtown Manhattan, these salons are known for being pricey and turning out the creme of the crop in hair stylists and makeup artists. Many of these salon stylists go on to become beauty gurus to the stars, creating their own cosmetic lines, hair care products, and skin care lines.

Once again, competition is stiff at the top. Here's a list of top New York Salons.

- Oribe
- Frederick Fekkai
- Bumble+Bumble
- Pierre Michel
- Stephen Knoll
- Girl Loves Boy
- The Spot
- Jean Owen
- NuBest & Co.

CREDITS FOR SALE

Within the unique salon structure exists another uniquely New York experience: the selling of an artists' credit. I found out about this phenomenon quite by accident. About two years ago I was representing a makeup artist who was also represented by an agency in New York. My New York representative was secured an assignment with *Lears* magazine. Our makeup artist was to do Diane Von Furstenburg. After the shoot, the makeup artist called to let me know how his credit should read. Example: Mary Coletti for The Place. I was shocked. His request was that we

should credit him with neither his Los Angeles or New York agency, but the name of his hair salon. He went on to explain that the salon paid him a fee each time his name appeared in a magazine with the salon's name. The arrangement also included that any bookings that came in would be turned over to the artist, who could then turn it over to his agency to handle. The salon business is very competitive in New York, so you can imagine how much additional foot traffic a credit line in the right magazine can bring into a salon. If you're out their on your own, and you begin picking up some good editorial work as a hair or makeup artist, you might want to investigate this kind of relationship. Remember the makeup artist who worked on the *Lears* magazine assignment? His request was denied and the credit line in the magazine read clearly XXX/The Crystal Agency.

CONTINUED ON PAGE 5.16

Getting together with an agency will not come without its up and downs. Like any other relationship, there are stages.

STAGES OF A PROFESSIONAL RELATIONSHIP

1 DATING I like you
To meet

2 COMMITMENT I am bound
A pledge, engagement or contract

3 CONVERSATION We are speaking to each other
To talk; exchange thoughts and feelings

4 MISCOMMUNICATION . I thought I expressed myself clearly
To misunderstand

5 DISAPPOINTMENT I don't feel satisfied
To frustrate; fail to satisfy

6 COMMUNICATION I feel connected
Readily and clearly understood

7 UNDERSTANDING I know what you mean
Perceive; comprehend; know; grasp

8 PARTNERSHIP We're in this thing together
A contract

ANGELIKA SCHUBERT

put in their portfolio?

AS: Head shots, dated makeup and hair, awful models. Even an artist who has not had the chance to work with great photographers should at least be able to present their work artistically.

CG: Do you have a drop off policy?

AS: Yes, because I just can't sit down with everyone that comes in.

CG: Have you ever signed a make-up, hair or fashion stylist without a portfolio?

AS: No. We can't do it. We see stylists who have done commercials or videos and all they have is a reel. Companies still like to see portfolios. We can't send them out with a reel only. We need a portfolio, something to show and prove their work.

CG: Do you require that the artist has experience beyond tests in their portfolio?

AS: Yes I would like it if they did because it is so much easier to work with them. Without the experience they're almost like a baby. It's quite difficult.

CG: What about resumes?

AS: In each artist's portfolio is a copy of their resume. Not the kind of resume you use when you're applying for a job but a resume that lists all the things they've done, the celebrities they worked with and the photographers.

CONTINUED ON PAGE 5-16

ANGELIKA SCHUBERT

CG: Are artists in print able to get jobs with only a resume?

AS: No. With just a resume you don't know how they accomplished their work. Maybe they were just the assistant. You can't tell until you see the portfolio. Sometimes we have artists with work in their book that does not belong to them. That's why I prefer someone who's been around, who has some experience, that way you can check into their work and references. Once an artist came to me saying he did the hair and makeup and it was work that I had done myself.

CG: Do you have formal contracts with your artists?

AS: If I take someone new on, I give it about two to three months before we decide to have a contract. We both have to be aware and agree on all the work involved before signing a contract. When you take on someone new you always have to groom them, whether they are experienced or not. If we reach that point then we have a two year contract.

CG: How long does it takes to build a good portfolio?

AS: Realistically, about two or three years. If you get the exceptionally talented artist who is also friendly, punctual and reliable, they will do it faster than others. If, as an agent, you see the artist is really hungry, they really want to be successful, you'll go out of your way to get a booking for them.

CONTINUED ON PAGE 5-17

In the Fall 99 issue of 1stHOLD. New York based makeup artist David Maderich wrote an article he titled "Hair & Makeup Sponsorships: Nice Work if you can get it". We have reprinted it here for you.

And finally, the agency you are signed to can either help or hinder your progress and advancement in the business. Being with the right agency can get you in a door that appears locked to many of your peers. Make a wise and informed choice about representation, and in most cases, you will find yourself up to bat more often and with more work than you can handle. The phrase

MAKEUP & HAIR SPONSORSHIPS
NICE WORK IF YOU CAN GET IT

by David Maderich

Have you ever seen your favorite makeup artist or hair stylists name attached to a cosmetics company or hair salon and wondered what that meant? You know, Diane Kendal for Aveda or Ward for Bumble and Bumble. I know I did.

I first became aware of this practice six years ago when I was hunting for an agency in New York City. I was baffled by the many artists listing companies in editorial credits–not agencies. Did these artists work for these companies instead of agencies? I had to find out.

After calling the various cosmetic companies and salons, I was shocked to learn that most of the artists had nothing to do with the company other than getting paid to attach the company's name on editorial pages. Hair stylists, on the other hand, usually had some affiliation with the salon they were advertising–the stylists cut or colored hair on specific days, but not always. "We pay several hair stylists hundreds of dollars a month for sponsorships," (some-times referred to as credit sales) says a manager at a top Manhattan salon. "And I haven't seen any of them in the salon in over a year. But having their names in the big magazines month after month brings in big business."

So that's the bottom line–money! Susie Smith in Salt Lake City may never look like Kate Moss, but she can use the products these artists' claim to use on Kate Moss or get her hair cut in the salons mentioned. It's also about prestige. "Having our name in the big magazines allows us to charge a lot more for services," says one salon manager. "It's good advertising for us."

So how much money are these companies paying artists? Here's where it all gets tricky. All the companies and makeup artists or hair stylists I talked to refused to go on record about the amount of money being exchanged. "I don't think it's kosher to tell you what we pay our artists," says a public relations professional at a leading cosmetic company. "We pay every artist a little different and I don't want to start a war."

Elle Magazine: October 1999
Troi Ollivierre for Club Monaco Cosmetics/Trilise, Inc.

Sobeit. What I have been able to uncover is that makeup artists and hair stylists get paid with free products, money or both. Dollar amounts begin at about $100 per page of editorial and go up to about a high of $350 (on the average).

But it doesn't stop there. The big money is in being a spokesperson for a company.

My deep-throat at the cosmetic company told me a spokesperson gets paid an annual salary–sometimes in the high five to six figures–plus editorial credit dollars. What does a spokesperson do? Sally Hirshberger said in numerous magazine articles that she helped develop the new Sheer Blonde products by John Frieda. And when makeup artist Sonia Koshak was involved with Aveda, she taught classes at company functions and helped develop new colors. Unfortunately for Koshak, company loyalty is premium. Rumor has it that Aveda let her go when she co-wrote Cindy Crawford's Revlon endorsed beauty book. Don't pity Koshak though, she has her own signature line available at Target stores.

So, my fellow artists and hair stylists, it all sounds pretty good, huh? Good money coupled with good editorial can't be beat. But those are the key words–good editorial. You must have top, top, tippy top editorial pages to even be considered for a sponsorship. Vogue, Harper's Baazar, even Glamour will do nicely, thank you. "Good magazines are everything," says another cosmetics public relations specialist. "And it must be consistant."

These people mean business. I know one makeup artist who has done every platinum plugging hip-hop artist on the charts today, but cannot get a sponsorship because her work appears in magazines deemed less than tippy top. "I've done Vibe, Spin and Rolling Stone," she says with a sigh. "But I can't get a makeup [sponsorship] deal."

So there you have it. Sponsorships are great, but getting one is not easy. If you think you have what it takes, send your book crammed with tear sheets to cosmetic companies or hair salons and see what happens–and good luck.

David Maderich is a freelance makeup artist represented by Halley Resources, Inc. in New York City.

"What's in a Name" was never more true than with the selection of an agency.

AGENCY LISTINGS

The agency listings that appear throughout the remainder of this chapter will provide you with information never before compiled by a single source.

Let it serve as the foundation of your agency search.

ANGELIKA SCHUBERT

CG: Do you set up tests for your artists?

AS: We get calls from photographers who want to test with our talent. I never let my artists test with a photographer until I see their portfolio. You want your artists to work with good photographers. If they're good, you want to suggest a team of makeup, hair & styling for them. Sometimes I arrange the test and other times I contact my talent and have them contact the photographer to arrange the test. Each situation is different.

CG: What advice do you have for an artist who is starting out?

AS: As I said before, to be enthusiastic about their work. To be cheerful, friendly, punctual, reliable; all these things along with an artistic ability is a great combination.

Notes:

The photographer **forgot** the film.

The model was **late.**

The clothes didn't **arrive.**

And to top it off,

It **rained** in the desert, **but**

my **portfolio** arrived from **ADB.**

AGENCY WATCH

REPRESENTATION IN THE USA

California
Colorado
Florida
Georgia
Hawaii
Illinois
Maryland
Massachusettes
Minnesota
Missouri
New Jersey
New York
North Carolina
Ohio
Oregon
Pennsylvania
Tennessee
Texas
Washington
Washington, DC
Wisconsin
Austria
Australia
Canada
France
Germany
Great Britain
Greece
Italy
Japan
Portugal
South Africa
Spain

AGENCY LISTINGS
TABLE OF CONTENTS

CANADA

INTERNATIONAL

The Agency Listing is part of The Hair Makeup & Styling Career Guide. Copyright © 2004, 2003, 2002, 2001, 2000, 1999, 1998, 1997, 1996, 1995 by Crystal A. Wright. Printed and bound in the United States of America. All rights reserved. **No part of this book may be reproduced in any form or by any electronic or mechanical means including information storage and retrieval systems without permission in writing from the publisher**, except by a reviewer, who may quote brief passages in a review. Published by Set The Pace Publishing Group, 4237 Los Nietos Drive, Los Angeles, California 90027; (323) 913-3773. Third edition. 96 95 94 93 92 10 9 8 7 6 Library of Congress Cataloging-in-Publication Data Wright, Crystal A. • Set The Pace Publishing Group • ISBN 0-9641572-3-3

	ARTISTS UNTIED www.ARTISTUNTIED.com Cynthia@artistuntied.com	**CREW CALL, INC.** www.crewcall-jobs.com corporate@crewcall-jobs.com	**KOKO REPRESENTS** www.koko-represents.com kerri@koko-represents.com
CALIFORNIA **Northern**			
Address	35 Stillman Street, Ste. 104	61535 South Hwy 97, Ste 9-314	**166 GEARY STREET, STE. 1007**
City, State, Zip+4	San Francisco, CA 94107	Bend, Oregon 97702	SanFrancisco, CA 94108
Country	USA	USA	USA
Phone & Fax	415-957-0500 FAX 415-957-0555	310-673-2700 Fax 800-770-6595	415-434-9007 Fax 415-434-8882
Owner	Rene Narducci	Frank James	Kerri Kokszka
Department Head			
Roster	25 Artists	3500+(US Wide)	Open
Policy & Procedures			
Office Hours	9am-6pm M-F	24 Hour Referral Service	9am-6pm M-F
Drop Off Days/Times	Drop off Monday Pick up Friday	N/A	Wed.10:00am d/o, 5pm p/u
Preferred Presentation	3/4 reel and or Portfolio > 11x14	N/A	Portfolios 10x13, 11x14
Agency Commission	20%	Monthly Subscription Fee	20%
Expenses	Messenfer and Fed Ex		Negotiated with talent
Requirements For Consideration	Professtional attitude and the ability to do both makeup and hair.	All Film or Video Experience	Artistmust be creative, enthusiastic and personable. We look for a balanced portfolio with good tearsheets and tests
Market(s)	Print, Fim And Editorial	All Entertainment Markets	Print, Video, Commercials, Advertising, Catalogue, TV, Film
Words of Advice	"Understand that SanFransisco is not a fashion capitol, it's mainly advertising. So be prepared to meet the demands of this market."	"Crew Call is a job referral service that has been successfully placing it's subscribers in crew position since 1982."	"Be flexible and stay motivated. Respect this it is a buisness and value client relationships. Keep your book current, ten year old photos don't work."
Talent Pool	Hair Stylists, Makeup Artists, Fashion & Prop Stylists	Hair Stylists & Makeup Artists	Hair Stylists, Makeup Artists, Fashion Stylists, Prop Stylists and Phototgraphers.
Notes	_____	_____	_____

CALIFORNIA Northern	Workgroup www.workgroup-ltd.com info@workgroup-ltd.com	Zenobia Agency www.zenobia.com rikke@zenobia.com	Action Agency www.agtionagencyla.com model@actionagency.com
Address	956 Ellis Street	1796 18th Street, Ste. E	8424 Santa Monica Blvd. Suite H
City, State, Zip+4	San Francisco, CA 94103	San Francisco, CA 94107	West Hollywood, CA 90069
Country	USA	USA	USA
Phone & Fax	415-346-0539	415-621-7410 FAX 415-777-3020	323-654-5104 FAX 323-654-8059
Owner	Heather Brown	Keith Zenobia	Scott A. Tugel
Department Head		Lori McGovern	
Roster	No Information provided	9 Artists	12 Artists
Policy & Procedures			
Office Hours	Monday-Friday: 9:00AM - 5:00PM	Monday-Friday: 9:00AM - 5:00PM	Monday-Friday: 10:00AM-4:00PM
Drop Off Days/Times	By Appointment Only	M-F During Dusiness Hours	Wed. & Thurs. Between 2-4PM
Preferred Presentation	Portfolio > 11x14	Portfolio > 9x12, Reels >3/4"	Portflio > 91/2x12
Agency Commission	20%	20% (Paid by Artist)	20% (Paid by Artists)
Expenses	Messenger, FedEx, Promo Materials, Travel, Portfolio Maintenance	Varies	All expenses incured as a result of pro-motion & marketing
Requirements For Consideration	Developed Portfolio, Editorial and Conceptual Projects a must.	Artists must be creative, technically skilled, professional, personable and team players who set high standard.	Previous print experience and portfolio
Market(s)	Fashion, International Editorial, Advertising, Music Videos, Commercial	Print Advertising, Catalogue, Editorial, Fashion, TV, Videos, Special Events	National & International Advertising & Editorials
Words of Advice		"Study this source book. It's loaded with valuable pointers and insight"	"Keep makeuo and hair clean. Don't go overboard unless askes you to something wild. Work Quickly & efficiently. Time is money."
Talent Pool	Hair Stylists, Makeup Artists, Fashion Stylists, Photographers	Hair Stylists, Makeup Artists, Fashion, Prop & Food Stylists, Manicurists	Hair Stylists, Makeup Artists, Photographers
Notes	_____	_____	_____

	Beauty & Photo www.beautyandphoto.com monica@beautyandphoto.com	**Celestine Agency** www.celestineagency.com anita@celestineagency.com	**Cloutier** www.cloutieragency.com laposte@cloutieragency.com
Address	5225 Wilshire Blvd., Ste 620	1666 20th Street, Ste 200B	1026 Montana Avenue
City, State, Zip+4	Los Angeles, CA 90036	Santa Monica, CA 90404	Santa Monica, CA 90403
Country	USA	USA	USA
Phone & Fax	323-549-3100 FAX 323-549-9881	310-998-1977 FAX 310-998-1978	310-394-8813 FAX 310-394-8863
Owner	Bianca Blyth	Frank Moore	Chantal Cloutier
Department Head			
Roster	Open	Open	30 Artists
Policy & Procedures			
Office Hours	Monday-Friday: 9:30AM-5:00PM	Monday-Friday: 9:00AM-5:30PM	Monday-Friday: 9:00AM-6:00PM
Drop Off Days/Times	Anytime	By Appointment Only	Wednesday morning only
Preferred Presentation	Portfolio > 11x14	Portfilio > 11x14	Portolio > 11x14
Agency Commission	20% (Paid by Artist)	15% (Paid by Artist)	15% (Paid by Artist)
Expenses	Messenger, Fed-Ex	Messengers, FedEx	Confidential
Requirements For Consideration	Strong portfolio and/or reel. Personality counts too.	Strong Portfolio with updated editorial tearsheets. Established career	Lots of evperience. A strong portfolio that includes editorial, celbrities and fantastic tests. Good education.
Market(s)	Album Covers, Video, Commercials, Advertising, Catalogue, Fashion, Print	Print, Video, Commercials, Advertising, Catalogue, TV, Fashion, CD Covers	Print, Video, Commercials, CD Covers, Catalogue, TV, Film
Words of Advice	"Be creative. Keep pushing the boundaries."	"Be punctual and patient. Have a great style and look. Be sociable and intereste in the photographers & directors wook. Dress accordingly.	"Get a great education. Test, meet photographers. Build a great presentation to show your potintial agency. Get involved."
Talent Pool	Hair Stylists, Makeup Artists, Fashion Stylists	Hair Stylists, Makeup Artists, Fashion & Prop Stylists	Hair Stylists, Makeup Artists, Fashion Stylists
Notes	_____	_____	_____

	Crystal Agency www.CrystalAgency.com bookings@crystalagency.com	**Dion Peronneau** www.dionperonneau.com jennatdpla@aol.com	**Empire Agency** www.makeupempire.com mee4makeup@aol.com
CALIFORNIA Southern			
Address	4237 Los Nietos Drive	1680 North Vine Street, Ste. 814	801 Baker Street, Ste. D
City, State, Zip+4	Los Angeles, CA 90027	Los Angeles, CA 90028	Costa Mesa, CA 92626
Country	USA	USA	USA
Phone & Fax	323-906-9600	323-299-4043 FAX 323-462-3142	714-438-2437 FAX 714-438-2438
Owner	Crystal A. Wright	Dion Peronneau	Donna Mee
Department Head	Crystal A. Wright		
Roster	15 Artists	15 Artists	8 Artists
Policy & Procedures			
Office Hours	Monday-Friday: 9:00AM-6:00PM	Monday-Friday: 9:30AM-6:00PM	Monday-Friday: 9:30AM-6:00PM
Drop Off Days/Times	M-F During business hours	M-F During business hours	M-F During business hours
Preferred Presentation	Portfolio > 9x12, 11x14, Promo Cards	Portfolio > 9x12, 11x14, Promo Cards	Portfolio > 9x12, 11x14, Promo Cards
Agency Commission	20% (Paid by Artist)	20% (Paid by Artist)	20% (Paid by Artist)
Expenses	Paid by Artist	Paid by Agency	All expenses associated with promotion
Requirements For Consideration	Prefers that you send a jpeg or comp card for review & consideration, prior to an appointment will be scheduled.	Prefers that you send a resume for review & consideration. If sufficient interest is generated, an appointment will be scheduled.	Upon review of promo card and resume artist will be considered based on individual talent.
Market(s)	CD Covers, Music Videos, Editorial, Commericial, Print Ads	CD Covers, Music Videos, Editorial, Commericial, Print Ads	Bridal, Editorial, Commercials, Print, Video, Pageant
Words of Advice	Stay ready, and you won't have to get ready. Be able to tell me the story of who you are as an artist. Be passionate and persistent.	"If you have the passion to succeed you can do anything. Desire accompanied by professionalism are a winning combination."	"Have passion for what you do, respect for your clients and committment to a good reputation."
Talent Pool	Hair Stylists, Makeup Artists, Fashion Stylists & Photographers	Hair Stylists, Makeup Artists, Fashion Stylists	Makeup Artists
Notes	_____ _____ _____ _____	_____ _____ _____ _____	_____ _____ _____ _____

	Exclusive Artists www.eamgmt.com info@www.eamgmt.com	Fred Segal Agency www.fredsegalbeauty.com jdayco@fredsegalbeauty.com	Innovative Artists _____ _____
CALIFORNIA **Southern**			
Address	7700 Sunset Boulevard, Ste 205	9250 Wilshire Blvd. Ste. 210	1505 10th Street
City, State, Zip+4	Los Angeles, CA 90046	Beverly Hills, CA 90212	Santa Monica, CA 90401
Country	USA	USA	USA
Phone & Fax	323-436-7766 FAX 323-436-7799	310-550-1800 FAX 310-550-1501	310-656-0400 FAX 310-656-0456
Owner	LA Models	Micheal Baruch	Heather Parker
Department Head	Darrin Barnes & Crosby Carter	Alyssa & Martin	
Roster	45 Artists	21 Artists	13 Artists
Policy & Procedures			
Office Hours	Monday-Friday: 9:00AM-6:00PM	Monday-Friday: 9:00AM-6:00PM	Monday-Friday: 9:00AM-7:00PM
Drop Off Days/Times	By Appointment or Tues. 9-12PM	By Appointment or Tues. 9-12PM	By Appointment Only
Preferred Presentation	Portfolio > 9x12, 11x14, Promo Cards,	Portfolio > 9x12, 11x14, Promo Cards	Upon Approval of Resume
Agency Commission	15-20% (Paid by Artists)	10-20% (Paid by Artists)	Confidential
Expenses	Paid by Agency	Paid by Agency	No Information provided
Requirements For Consideration	Upon review of resume, portfolio, and or reels an artist will be considered for representation	Upon review of resume, portfolio, and or reels an artist will be considered for representation	Experience working in TV & Film
Market(s)	Print Advertising, Editorial, Film & TV	Print Advertising, Editorial, Film & TV	Commercials, TV, Film
Words of Advice	Have passion for what you do.	No Comment	
Talent Pool	Hair Stylists, Makeup Artists, Fashion & Prop Stylists, Manicurists, Photographers	Hair Stylists, Makeup Artists, Fashion & Wardrobe Stylists, Manicurists	Wardrobe Stylists & Costume Designers
Notes	_____ _____ _____ _____	_____ _____ _____ _____	_____ _____ _____ _____

	Magnet www.magnetla.com lisa@magnetla.com	**Mercury Artist Group** www.mercuryartistgroup.com jances@mercuryartistgroup.com	**Profile** www.profileartists.com info@profileartists.com
Address	1531 N. Cahuenga Blvd.	8460 Higuera St., 2nd floor	6100 Wilshire Blvd., Ste. 710
City, State, Zip+4	Hollywood, CA 90028	Culver City, CA 90232	Los Angeles, CA 90048
Country	USA	USA	USA
Phone & Fax	323-463-0100 FAX 323-463-0040	310-280-7471 FAX 310-558-1486	213-747-3525
Owner	Lisa	Ben Ahern	Patty Kassover
Department Head		Ron Ceballos	
Roster	25 Artists	15-20 Artists	25 Artists
Policy & Procedures			
Office Hours	Monday-Friday: 9:00AM-6:00PM	Monday-Friday: 9:00AM-6:00PM	Monday-Friday: 9:00AM-6:00PM
Drop Off Days/Times	By Appointment Only	By Appointment Only	By Appointment Only
Preferred Presentation	Portfolio > 9x12	Portfolio & Resume	Portfolio > 9x12
Agency Commission	20% (Paid by Artist)	20% (Paid by Artist)	20% (Paid by Artist)
Expenses	Varies	Kit Fee, Advances, Travel	Varies
Requirements For Consideration	We Prefer not to respond	Strong, organized portfolio	We Prefer not to respond
Market(s)	We prefer not to respond	Print, Video, Commercials, Editorial	We prefer not to respond
Words of Advice	"I am not interested in being listed"	"Be on time and ready to work."	
Talent Pool	Hair Stylists, Makeup Artists, Fashion Stylists	Hair Stylists, Makeup Artists, Fashion Stylists	Hair Stylists, Makeup Artists, Fashion Stylists
Notes		—*formerly Smashbox Agency*—	

CALIFORNIA Southern

	San Diego Model Mgmt.	Sandra Marsh Mgmt.	The Lyons*Sheldon*Prosnit Agency
CALIFORNIA Southern	www.sdmodel.com lcomer@sdmodel.com	smarshmgmt@earthlink.com	lsagency@aol.com
Address	438 Camino Del Rio South, Ste. 116	9150 Wilshire Blvd., Ste 220	800 S. Robertson Blvd., Ste 6
City, State, Zip+4	San Diego, CA 92108	Beverly HIlls, CA 90212	Los Angeles, CA 90035
Country	USA	USA	USA
Phone & Fax	619-296-1018 FAX 619-296-3422	310-285-0303 FAX 310-285-0218	310-652-8778 FAX 310-652-8772
Owner	Fred Sweet	Sandra Marsh	Jane Prosnit
Department Head	Linda Comer, Director		
Roster	10 Artists		10 Artists
Policy & Procedures			
Office Hours	Monday-Friday: 9:00AM-5:30PM	Monday-Friday: 9:00AM-6:00PM	M-F 9:00AM-7:00PM
Drop Off Days/Times	Mon. 12-2 and Wed. 2-4 w/ Appt.	By Appointment Only	By Appointment Only
Preferred Presentation	Portfolio > 11x14		3/4 Reel or 1/2 Reel
Agency Commission	20% (Paid by Artist)		10% (Paid by Artist)
Expenses	Messenger, FedEx		Messegers, FedEx
Requirements For Consideration	Strong portfolio	Feature Film work experience	Serious Artists Only.
Market(s)	Print, Video, Commercials, Advertising, Catalogue, TV, Film,	Commercials, TV, Film	Commercials, TV, Film, Music Videoss
Words of Advice	"Look good and be on time."		No information provided.
Talent Pool	Hair Stylists, Makeup Artists	Costume Designers, Production Designers	Costume Designers, Production Designers
Notes	_____	_____	_____

we heard...

Crystal Wright's
PORTFOLIO BUILDING WORKSHOP
LEARN TO MARKET YOURSELF

Crystal Wright, author of The makeup, hair & Styling Career Guide, publisher of *1stHold* magazine, and president of The Crystal Agency proudly presents her seminar series titled, "Packaging Your Portfolio: Marketing Yourself as a Freelance Makeup, Hair or Fashion Stylist."

The eight-hour workshop covers subjects such as building a portfolio, testing with photographers, signing with an agency, getting work from record labels, magazines, production companies, and more. The presentation includes a 45-minute Q&A session with a panel that typically includes art directors, editors, photographers, agency bookers or owners, etc., who hire freelancers as a function of their job in the industry. Crystal gets artists portfolios from local makeup, hair and styling agencies in the area. To register, call 323/913-3773, Fax 913-0900, or visit our website, **www.MakeupHairandStyling.com.**

you want to be famous...

Top-Bottom. Washington DC Class talks Lynda Erkiletian, owner of with THE Agency. • NY Class Panel: Celebrity Makeup Artist Sam Fine, TV & Film Makeup Artist/Educator Tobi Britton, Crystal, Sr. Booker Ashton Hundley & Makeup Artist Juanita Diaz. LA Class Panel: Sharon Gault with Students Looking on • Crystal shows artists how to lay out a portfolio and choose the right images for their books.

CALL OR VISIT OUR WEBSITE FOR CITIES, DATES & TIMES
323/913-3773 • www.MakeupHairandStyling.com

	Luxe Management www.luxemgmt.com annie@luxemgmt.com	[The] Mirisch Agency www.mirisch.com michael@mirisch.com	[The] Partos Company www.partos.com contact@partos.com
CALIFORNIA Southern			
Address City, State, Zip+4 Country Phone & Fax Owner Department Head	6442 Santa Monica Blvd., Ste B Los Angeles, CA 90038 USA 323-856-8540 FAX 323-856-8541	1801 Century Park East, Ste. 1801 Los Angeles, CA 90067 USA 310-282-9940 FAX 310-282-0702	227 Broadway, Ste 204 Santa Monica, CA 90401 USA 310-458-7800 FAX 310-587-2250 Walter
Roster Policy & Procedures	25-30 Artists	6 Artists	25 Artists
Office Hours Drop Off Days/Times Preferred Presentation Agency Commission Expenses	9:00AM-6:00PM By Appointment Only Resume 15% Messengers, FedEx, Promo [Comp] Cards, etc.	9:30AM-6:30PM By Appointment Only Resume Confidential Confidential	9AM-6PM Fax resume 9X10 or 11x14 Portfolio To be Discussed To be discussed
Requirements For Consideration	Edgy books catch our eye.	Experience in commercial television and feature films.	Looking for people in the commercial and video area
Market(s)	Editorial, Fashion, Celebrity, Music	Commercials, TV, Film	Commercial & Music Video
Words of Advice			
Talent Pool	Makeup, Hair, Fashion Stylists	Costume Designers	Hair Stylists, Makeup Artists, Fashion Stylists
Notes	_____ _____ _____ _____	_____ _____ _____ _____	_____ _____ _____ _____

	Rex Agency	**Timothy Priano**	**Zenobia Angency**
	www.therexagency.com	www.next-artists.com	www.zenobia.com
	kimberly@therexagency.com	calen@nextmodelmanagement.com	heidi@zenobia.com
Address	4446 Ambrose Ave.	8447 Wilshire Blvd. Suite 301	130 South Highland Avenue
City, State, Zip+4	Los Angeles, CA 90027	Beverly Hills, CA 90211	Los Angeles, CA 90036
Country	USA	USA	USA
Phone & Fax	(323) 664-6494 FAX(323) 871-9143	323-782-0021 FAX 323-782-1763	323-937-1010 FAX 323-937-1133
Owner	Charmaine Breitengros	Timothy Priano	Keith Zenobia
Department Head		Tracy	Heidi Rauen
Roster	32 Artists	20 Artists	Varies with city & Industry demand
Policy & Procedures			
Office Hours	9AM-6PM	9-5pm	9AM-6PM
Drop Off Days/Times	By Appointment Only	By Appointment only	By Appointment Only
Preferred Presentation	11x14 Portfolio, reel		9X12 Portfolio, Reels
Agency Commission	15%	20% (Paid by Artists)	20%
Expenses	Varies	Messengers, Website, Promo Cards	Varies
Requirements For Consideration	Must have talent. We like an artist with a definite style, personal taste, potential and personality.	A strong portfolio with editorial and celebrity tearsheets. Your book must be strong.	We want what all clients want: creative, technically skilled, professional, personable team players who set high standards standards for themselves.
Market(s)	Editorial, Music Videoss, Commercials Advertising, CD, film	Print, Video, Commercials, Advertising, Catalogue, TV, Film	Print, Video, Commercials, Advertising, Catalogue, TV, Film, Special Events
Words of Advice	"Have patience, this business is tough. 50 percent of your success depends on your personality and good character. Always be professional and positive, your hard work will pay off."	"Push yourself. test with photographers and accumulate a substantial amount of editorial work Presentation is extremely important. Develop your own personal Style."	"Study this source book. It's loaded with valuable pointers and insights."
Talent Pool	Hair Stylists, Makeup Artists, Fashion Stylists	Hair Stylists, Makeup Artists	Hair Stylists, Makeup Artists, Fashion & Prop, Food Stylists Manicurists
Notes	_____ _____ _____	_____ _____ _____	_____ _____ _____

CALIFORNIA Southern

	Donna Baldwin Talent www.donnabaldwin.com info@donnabaldwin.com	**Maximum Talent** www.maxtalent.com info@maxtalent.com	**Model Millennium Inc.** www.modelmillennium.com info@modelmillennium.com
Address	2237 West 30th Ave.	1660 Rob Albion St., Ste. 1004	2321 Hollywood Blvd.
City, State, Zip+4	Denver, CO 80211	Denver, CO 80222	Hollywood, FL 33020
Country	USA	USA	USA
Phone & Fax	303-561-1199 FAX 303-561-1337	303-691-2344 FAX 303-691-2488	954-757-7074 FAX 954-340-2080
Owner	Donna Baldwin	Rob Lail	Madeline Andrews
Department Head			
Roster	8 Artists	5-10 Artists	Open
Policy & Procedures			
Office Hours	9AM-6PM	9AM-6PM	Monday-Friday: 9:00AM-5:00PM
Drop Off Days/Times	By Appointment Only	By Appointment Only	Tues 2-4PM
Preferred Presentation	9X12 Portfolio	9X12 Portfolio	Portilio > 11x14 & 9x12
Agency Commission	20%	15%	20% (Paid by Artists)
Expenses	All expenses occured as a result of promotion and marketing.	Agency handles expenses	$150.00 to get onling portfolio
Requirements For Consideration	Serious Artists Only.	An established career	Look at Promotional Pieces
Market(s)	Commercials, Advertising, Catalogue	Print, Video, Commercials, Advertising, Catalogue, TV, Film	Print, Video, Commercials, Advertising, Catalogue, TV, Film
Words of Advice	"Be patient but persistent. A positive attitude on jobs along with being professional will have the clients calling you back."	"The Agency where talent works."	
Talent Pool	Hair Stylists, Makeup Artists, Fashion & Prop Stylists	Hair Stylists, Makeup Artists, Fashion Stylists	Hair Stylists, Makeup Artists, Fashion Stylists
Notes	_____	_____	_____

	3 Arts, Inc.	**Blink Management** www.blinkmanagement.com	**Exposure Talent Mgmt.**
	threeartsinc@aol.com	sabrina@blinkmanagement.com	

	3 Arts, Inc.	**Blink Management**	**Exposure Talent Mgmt.**
Address	3176 Prairie Avenue	421 Washington Avenue, Ste 202	90 Alton Road, Ste. 3304
City, State, Zip+4	Miami Beach, FL 33140	Miami Beach, FL 33139	Miami Beach, FL 33139
Country	USA	USA	USA
Phone & Fax	305-534-2787 FAX 305-531-8583	305-532-7511 FAX 305-532-3318	305-592-8353 FAX 305-436-1137
Owner	Katharina Rieck Allison	Sabrina Crews	Zachary Schifman
Department Head		Carol Ann	
Roster	10-15 Artists	30 Artists	10-15 Artists
Policy & Procedures			
Office Hours	9AM-6PM	9AM-5PM	9AM-5PM
Drop Off Days/Times	By Appointment Only	By Appointment Only	By Appointment Only
Preferred Presentation	9X12 Portfolio	9X12 Portfolio	9X12 Portfolio
Agency Commission	20%	20%	Varies. Messengers, FedEx
Expenses	Varies with each individual	Messengers, FedEx	
Requirements For Consideration	Some tearsheets and good test shots in the portfolio.	A great portfolio and attitude.	A good portfolio speaks volumes.
Market(s)	Catalogue, Advertising, Editorial, Commercials, Televison	All	All
Words of Advice	Be persistent. Let your personality show through."	We like to see people. Give us a call and come to show us your book.	"Experience in not as important as the work itself.
Talent Pool	Hair Stylists, Makeup Artists, Fashion Stylists	Hair Stylists, Makeup Artists, Wardrobe Stylists, Photographers	Hair Stylists, Makeup Artists, Wardrobe Stylists
Notes	_____	_____	_____

FLORIDA	Model Millennium Inc. www.modelmillennium.com info@modelmillennium.com	Nicola Bowen Artist Mgmt. www.irenmarie.com mail@irenemarie.com	Page Parkes Models rep www.pageparkes.com mail@page305.com
Address	2321 Hollywood Blvd.	728 Ocean Drive	1775 Collins Avenue, 2nd floor
City, State, Zip+4	Hollywood, FL 33020	Miami Beach, FL 33139	Miami Beach, FL 33139
Country	USA	USA	USA
Phone & Fax	954-757-7074 FAX 954-340-2080	305-672-2929 FAX 305-674-1342	305-534-7200
Owner	Madeline Andrews	Nicola Bowen	Page Parkes
Department Head			
Roster	Open	20 Artists	10 Artists
Policy & Procedures			
Office Hours	Monday-Friday: 9:00AM-5:00PM	9AM-6PM	9AM-6PM
Drop Off Days/Times	Tues 2-4PM	By Appointment only	By Appointment Only
Preferred Presentation	Portilio > 11x14 & 9x12	9 1/2x11 Portfolio	9-1/2X12 Portfolio
Agency Commission	20% (Paid by Artists)	20%	20%
Expenses	$150.00 to get onling portfolio	Composite Cards, Agency Promotional Books, Portfolios, FedEx, Messengers	Varies
Requirements For Consideration	Look at Promotional Pieces	Experience in Fashion, Print and or Film and TV	A portfolio with current editorial tearsheets. A resume and comp card. Strength of book should reflect great hair and lean natural makeup
Market(s)	Print, Video, Commercials, Advertising, Catalogue, TV, Film	US: TV, Commercials, Editorial, Catalogue, Film Europs: Catalogue, Editorial	Retail, Catalogue, advertising
Words of Advice			"Be patient and easy to work with."
Talent Pool	Hair Stylists, Makeup Artists, Fashion Stylists	Hair Stylists, Makeup Artists, Fashion Stylists, Models	Hair Stylists, Makeup Artists, Fashion Stylists
Notes	_____ _____ _____ _____	_____ _____ _____ _____	_____ _____ _____ _____

	Select Network Mgmt.	The Hurt Agency	Timothy Priano
	selectmdles@msn.com	www.thehurtagency.com	www.next-artists.com
		thehurtagency@mindspring.com	SarahB@nextmodelmanagement.com
FLORIDA			
Address	420 Lincoln Rd. # 356	400 N. New York Ave., Ste. 207	1688 Meridian Avenue Suite 800
City, State, Zip+4	Miami Beach, FL 33139	Winter Park, FL 32789	Miami Beach FL, 33139
Country	USA	USA	USA
Phone & Fax	305-672-5566 FAX 323-913-0900	(407) 740-5700 FAX (407) 740-0929	305-531-5100 FAX 305-531-7870
Owner	Joe Starzec	Jackie O'Leary	Timothy Priano
Department Head		12 Artists	
Roster	Open		6 Artists
Policy & Procedures			
		9AM-5PM	
Office Hours	10AM-5PM	By Appointment Only	9AM-5PM
Drop Off Days/Times	By Appointment Only	9-1/2X11 Portfolio	By Appointment Only
Preferred Presentation	9X12 Portfolio	Confidential	9X12 Portfolio
Agency Commission	20%	Agency covers expenses	20%
Expenses	none		Messaging, web site, promo cards
Requirements For Consideration	Strong Book	Sample Sheet, Comp Card or Portfolio	Serious Artists Only.
Market(s)	Editorial, Catalouge	All	All
Words of Advice		"Be professional and have a good attitude."	
Talent Pool	Hair Stylists, Makeup Artists, Fashion Stylists	Hair Stylists, Makeup Artists, Fashion Stylists	Hair Stylists, Makeup Artists
Notes			

	Arlene Wilson Management www.arlenewilson.com atlanta@arlenewilson.com	Crews http://crews.home.mindspring.com info@crewsinc.net	Elite Model Agency www.eliteatlanta.com
GEORGIA			
Address	887 W. Marietta St., Ste N-101	828 Clemont Drive	1708 Peachtree Street NW, Ste 210
City, State, Zip+4	Atlanta, GA 30318	Atlanta, GA 30306	Atlanta, GA 30309
Country	USA	USA	USA
Phone & Fax	404-876-8555 Fax 404-876-9043	404-876-6880 Fax 404-874-1350	404-872-7444 FAX 404-874-1526
Owner	Trish Owen	Shirlene Brooks	Dan
Department Head			
Roster	6 Artists	50+ Artists	10 Artists
Policy & Procedures			
Office Hours	9AM-5:30PM	9AM-5:30PM	9AM-5:30PM
Drop Off Days/Times	By Appointment Only	By Appointment Only	By Appointment Only
Preferred Presentation	Portfolio or Resume	Portfolio or Resume	9X12 Portfolio
Agency Commission	15%	20%	20%
Expenses	Messenger, FedEx	Messenger, FedEx	Messenger, FedEx
Requirements For Consideration	Minimum 5 years experience in comparable market	Experience & Good Tears	Did Not Want To Participate
Market(s)	Commercials, Catalogue, Advertising	Editorial, Catalogue, TV, Film	Print, Video, Commercials, Advertising, Catalogue
Words of Advice	"Be as pleasant as possible. Please remember to have a good attitude".		Did Not Want To Participate
Talent Pool	Hair Stylists, Makeup Artists, Wardrobe Stylists	Hair Stylists, Makeup Artists, Wardrobe Stylists	Hair Stylists, Makeup Artists, Wardrobe Stylists
Notes	_____	_____	_____

GEORGIA

	Gwynnis Innovative Looks	Help Me Rhonda	L'Agence
	phillipmosby@aol.com	www.helpmerhonda.com info@helpmerhonda.com	www.LagenceModels.com marklagence@aol.com
Address	1860 Farris Drive	1070 Hemphill Avenue NW	5901-C Peachtree Dunwoody Rd., #60
City, State, Zip+4	Decatur, GA 30032	Atlanta, GA 30318	Atlanta, GA 30328
Country	USA	USA	USA
Phone & Fax	404-284-0095 Fax 404-284-3813	888-231-4121 Fax 877-874-2505	770-396-9015 Fax 770-391-0927
Owner	Phil & Gwynnis Mosby	Rhonda Barrymore	
Department Head			
Roster	No Information provided	Open	15 Artists
Policy & Procedures			
Office Hours	10AM-7PM	10AM-8PM	9AM-5:30PM
Drop Off Days/Times	By Appointment Only	By Appointment Only	By Appointment Only
Preferred Presentation	Portfolio	9X12 or 11X14 Portfolio	9X12 Portfolio
Agency Commission	15-20%	20%	20%
Expenses	Messengers, FedEx	None	Messengers, FedEx
Requirements For Consideration	Strong Portfolio	Visionary Talent	
Market(s)	Music, TV & Film, Commercials	Fashion Editorial, Theatre, Film, TV, Video	Fashion, Print, Runway, Commercials, TV & Film
Words of Advice		Healty attitude about busines. Good appearance. Image is everything!	
Talent Pool	Hair Stylists, Makeup Artists, Fashion Stylists	Hair Stylists, Makeup Artists, Fashion & Prop Stylists, Set Design	Hair Stylists, Makeup Artists, Fashion Stylists
Notes			

Kathy Muller Agency

kma@panworld.net

Address	619 Kapahulu Aven., Penthouse
City, State, Zip+4	Honolulu, HI 96815
Country	USA
Phone & Fax	808-737-7917 FAX 808-734-3026
Owner	Ann Mata
Department Head	
Roster	Open
Policy & Procedures	
Office Hours	9AM-5PM
Drop Off Days/Times	By Appointment Only
Preferred Presentation	Portfolio and/or Comp Card
Agency Commission	20%
Expenses	Messengers, FedEx

Requirements For Consideration	A clean, creative and versatile portfolio
Market(s)	International, Print, Video, Commercials, Film
Words of Advice	None Given
Talent Pool	Hair Stylists, Makeup Artists,
Notes	_____ _____ _____ _____

Aria

www.fordmodels.com
info@fordmodels.com

Address	1017 W. Washington Stl., Ste 2-C
City, State, Zip+4	Chicago, IL 60607
Country	USA
Phone & Fax	312-243-9400 FAX 312-243-9020
Owner	David Kronfeld, Mary Boncher
Department Head	xMarie Anderson
Roster	16 Artists
Policy & Procedures	
Office Hours	9AM-5:30PM
Drop Off Days/Times	By Appointment Only
Preferred Presentation	Portfolio, Reel, Resume, Comp Card
Agency Commission	20%
Expenses	Varies

Requirements For Consideration	A portfolio that contains a good selection of tearsheets and or great test shots. The prospective stylist must have a resume, promotional card, and experience in their chosen field. This is especially important with hair and make-up.
Market(s)	Catalog, Commercials, Television Advertising, Film
Words of Advice	"Create your own style and identity, and go with it. Don't copy others. Chicago is very commercial & homogenized! There's no editorial to build a career on. Be prepared to work and pay your dues. Know your area of interest! Don't assume everyone will do your job for you. You have to have a head for business."
Talent Pool	Hair Stylists, Makeup Artists, Fashion Stylists
Notes	_____ _____ _____ _____

	Arlene Wilson Management www.arlenewilson.com info@arlenewilson.com	Ford Models www.fordmodels.com info@fordmodels.com	Stewart Beauty www.elitechicago.com shill@elitechicago.com
Address	430 West Erie, Ste. 210	641 W. Lake Street, Ste. 402	58 W. Huron Street
City, State, Zip+4	Chicago, IL 60610	Chicago, IL 60661	Chicago, IL 60610
Country	USA	USA	USA
Phone & Fax	312-573-0200 FAX 312-573-0046	312-707-9000 FAX 312-707-8515	312-943-3226 FAX 312-943-2590
Owner	Dan Deely	Mark W. Walker	Alice Gordon
Department Head			
Roster	15 Artists	30 Artists	20 Artists
Policy & Procedures			
Office Hours	9AM-5:30PM	9AM-5:30PM	9AM-5:30PM
Drop Off Days/Times	By Appointment Only	By Appointment Only	By Appointment Only
Preferred Presentation	9X12 Portfolio	Portfolio: All sizes qualify	9X12 or 11X14 Portfolio
Agency Commission	20%	20%	20%
Expenses	All expenses occured as a result of promotion and marketing.	Confidential	Messenger, FedEx, Promo Cards, Etc.
Requirements For Consideration	Portfolio of photographs	Good Tearsheets and experience	Competitive portfolio with tearsheets and or great tests.
Market(s)	Catalog, Commercials, Advertising, TV, Film	Catalog, TV, Film, Editorials, Commercials, Print	Catalog, Fashion Editorial, Advertising Television, Commercials, Film
Words of Advice	"Assist other stylists. Test with photographers until your book is developed."	"Keep portfolios fresh and up to current trends. Be able to translate trends."	"Follow through. Be persistent and thorough. Exhibit professionalism at all times, and let your personality shine through."
Talent Pool	Hair Stylists, Makeup Artists, Fashion Stylists, Models, Actors & Actresses	Hair Stylists, Makeup Artists, Fashion Stylists	Hair Stylists, Makeup Artists, Fashion & Prop Stylists
Notes			

Marlene Kurland

www.marlenekurland.com
info@marlenekurland.com

Address	PO Box 732
City, State, Zip+4	Owings Mills, MD 21117
Country	USA
Phone & Fax	410-356-5999/888-818-5995 FAX 410-356-4259
Owner	Marlene Kurland
Department Head	
Roster	50 Artists
Policy & Procedures	
Office Hours	9AM-5PM
Drop Off Days/Times	By Appointment Only
Preferred Presentation	Portfolio
Agency Commission	50%
Expenses	No information provided

Requirements For Consideration	Beautiful work and a great upbeat attitude.
Market(s)	Film, Special Events, Corporate Imaging, Fashion Shows, Beauty Pageants, Cosmetic Surgery, Professional Photo Sessions
Words of Advice	"Know your craft. Get continual education and always be energetic with a positive attitude."
Talent Pool	Hair Stylists & Makeup Artists
Notes	_____ _____ _____

Ennis, Inc.

www.ennisinc.com
info@ennisinc.com

Address	271 Lincoln St., Ste 5
City, State, Zip+4	Lexington, MA 02421
Country	USA
Phone & Fax	617-782-7103 FAX 781-863-1554
Owner	Barbe Ennis
Department Head	
Roster	26 Artists
Policy & Procedures	
Office Hours	9AM-5PM
Drop Off Days/Times	By Appointment Only
Preferred Presentation	11X14 Portfolio
Agency Commission	15%
Expenses	Promotional Materials

Requirements For Consideration	Good interview and strong portfolio.
Market(s)	Print, Editorial, TV, Commercials, Catalog
Words of Advice	"Beautiful, clean, simple pictures that represents the artist. Along with an attractive portfolio presentation."
Talent Pool	Hair Stylists, Makeup Artists, Fashion Stylists, Wardrobe Stylists, Prop Stylists
Notes	_____ _____ _____ _____

Team The Agency

www.teamtheagency.com
biz@teamtheagency.com

MASSACHUSETTS

Address	423 W. Broadway, 4th Floor
City, State, Zip+4	Boston, MA 02127
Country	USA
Phone & Fax	617-268-3600 FAX 617-268-3434
Owner	Maven Rossman
Department Head	
Roster	70 Artists
Policy & Procedures	
Office Hours	9AM-6PM
Drop Off Days/Times	Mon 3-5 Pick up Tues 3-5
Preferred Presentation	9X12 Portfolio
Agency Commission	15%
Expenses	Agency pays 50% of advertising and promo cards

Requirements For Consideration	Portfolio, great tests, tear sheets are optional and review of recent work.
Market(s)	Print, Editorial, Advertising, Catalog, Commercial
Words of Advice	"Be willing to keep your work updated and adjust to all situations. Be able to listen!"
Talent Pool	Hair Stylists, Makeup Artists, Fashion Stylists
Notes	_____

Moore Creative Talent

www.mooretalent.com
print@mooretalent.com

MINNESOTA

Address	1610 W. Lake Street
City, State, Zip+4	Minneapolis, MN 55408
Country	USA
Phone & Fax	612-827-3823 FAX 612-824-9353
Owner	Andrea
Department Head	
Roster	Open
Policy & Procedures	
Office Hours	9AM-5:30PM
Drop Off Days/Times	9AM-5:30PM
Preferred Presentation	9X12 or 11X14 Portfolio
Agency Commission	20%
Expenses	None

Requirements For Consideration	Beautiful book.
Market(s)	Print, Video, Commercials, Advertising, Catalogue, TV, Film
Words of Advice	Test often to build a great book. Network with photographers and other in the business.
Talent Pool	Hair Stylists & Makeup Artists
Notes	_____

	Terra Productions	**Wehmann Models & Talent**	
	www.terraproductions.net	www.wehmann.com	
	whenlyn@terraproductions.net	lhaver@wehmann.com	
MINNESOTA			
Address	1005 W. Franklin Ave. Suite 7	1128 Harmon Place, Ste 202	
City, State, Zip+4	Minneapolis, MN 55405	Minneapolis, MN 55403	
Country	USA	USA	
Phone & Fax	612-813-5635 FAX 612-813-5638	612-333-6393 FAX 612-344-1444	
Owner	Terra Andrews	Stacey Terwey	
Department Head	Lyn Terria		
Roster	12 Artists	5 Artists	
Policy & Procedures			
Office Hours	8:30AM-5:30PM	8AM-6PM	
Drop Off Days/Times	By Appointment Only	By Appointment Only	
Preferred Presentation	9X12, 8x10 Portfolio	9X12 Portfolio	
Agency Commission	15%	20%Confidential	
Expenses	Varies		
Requirements For Consideration	Experience, and a client base	Industry esperience	
Market(s)	Print, Broadcasting	Editorial, Advertising, TV	
Words of Advice	"Test, test, test, be a professional at all times."		
Talent Pool	Makeup Artists, Prop & Fashion Stylists, Synic, Large refferal list	Hair Stylists, Makeup Artists, Models	
Notes	_____ _____ _____ _____	_____ _____ _____ _____	

Talent Plus
www.talent-plus.com
info@talent-plus.com

Address	1222 Lucas Ave., Ste 300
City, State, Zip+4	St. Louis, MO 63108
Country	USA
Phone & Fax	314-421-9400 FAX 314-421-9440
Owner	Joan Robinson & Sharon Tucci
Department Head	
Roster	13 Artists
Policy & Procedures	
Office Hours	9AM-5:30PM
Drop Off Days/Times	By Appointment Only
Preferred Presentation	Portfolio
Agency Commission	20%
Expenses	Messengers, FedEx
Requirements For Consideration	A high level of ability, an up-to-date portfolio and on-set experience.
Market(s)	All
Words of Advice	"On-set presence and etiquette is very important."
Talent Pool	Hair Stylists, Makeup Artists, Wardrobe Stylists
Notes	_____

AXIS Models & Talent
None
melissa@axismodels&talent.com

Address	46 Church Street
City, State, Zip+4	Montclair, NJ 07042
Country	USA
Phone & Fax	973-783-4900 FAX 973-783-8081
Owner	Dwight Brown & Sharon Norell
Department Head	Sharon Norell
Roster	12-15 Artists
Policy & Procedures	
Office Hours	9AM-5PM
Drop Off Days/Times	By Appointment Only
Preferred Presentation	9X12 Portfolio
Agency Commission	15%
Expenses	All promotional materials
Requirements For Consideration	Experience, strong tearsheets, and a well rounded ability
Market(s)	Print, Advertising, Catalogue, TV, Film
Words of Advice	"Test with photographers and be able to work with all people."
Talent Pool	Hair Stylists, Makeup Artists, Fashion Stylists
Notes	_____

NEW YORK

Anyway Productions
www.anywayproductions.com
info@anywayproductions.com

Arends
www.frankarends.com
info@frankarends.com

Art & Commerce
www.artandcommerce.com
agents@artandcommerce.com

	Anyway Productions	Arends	Art & Commerce
Address	870 6th Ave	216 W. 18th St., Ste 703 B	755 Washington Strees
City, State, Zip+4	New York, N.Y. 10001	New York, NY 10011	New York, NY 10014
Country	USA	USA	USA
Phone & Fax	212-685-7475 FAX 212-898-1144	212-229-1423 FAX 212-604-0216	212-206-0737 FAX 212-463-7267
Owner	Gina	Frank Arends	Leslie Sweeney
Department Head		Suzanne Heflin / Emily Dunn	
Roster	Open	5	No information provided
Policy & Procedures			
Office Hours	9AM-6PM	9AM-6:30PM	9:30AM-6PM
Drop Off Days/Times	Anytime, ask for Alex or Matt	By Appointment Only	Wednesday 9:30-6PM
Preferred Presentation	9X12 Portfolio	9X12 or 11X14 Portfolio	11x14 Portfolio
Agency Commission	20%	20%	20%
Expenses	No	All expenses occured as a result of promotion and marketing.	Portfolio updates, Messengers, FedEx
Requirements For Consideration	Strong Portfolio	Strong portfolio. Artists who are compatible with our exhisting cadre of photographers.	Strong portfolio and established chientele
Market(s)	Editorial and Print	Print, Video, Commercials, Advertising, Catalogue, Music	All
Words of Advice			
Talent Pool	Hair Stylists, Makeup Artists, Fashion Stylists	Hair Stylists, Makeup Artists, Fashion Stylists	Hair Stylists, Makeup Artists, Fashion Stylists, Photographers
Notes			

	Art Department www.art-dept.com info@art-dept.com	Art House Management www.arthousemanagement.com info@arthousemanagement.com	Artists by Timothy Priano www.next-artists.com info@next-artists.com
NEW YORK			
Address	48 Greene St., 4th Floor	81 Greene Street, 4th Floor	15 Watts St., 6th floor
City, State, Zip+4	New York, NY 10013	New York, NY 10012	New York, NY 10013
Country	USA	USA	USA
Phone & Fax	212-925-4222 FAX 212-925-4422	212-343-2331 FAX 212-343-8841	212-925-5996 FAX 212-941-8483
Owner	Annie	Angelika Schuebert	Timothy Priano
Department Head			
Roster	10 Artists	OPEN	No Information Provided
Policy & Procedures			
Office Hours	10AM-6PM	9AM-6PM	9AM-6PM
Drop Off Days/Times	By Appointment Only	By Appointment Only	Any Time
Preferred Presentation	9X12 Portfolio	9X12 and 11x14 Portfolio	11x14 Portfolio
Agency Commission	15%	20%	20%
Expenses	Messengers, FedEx	Messengers, FedEx	All expenses occured as a result of promotion and marketing.
Requirements For Consideration	Established, high level portfolio	Bio, Tearsheets, Book and/or Reel	A portfolio with personality.
Market(s)	International, Editorial, Videos, Print Advertising	Print, Video, Commercials, Advertising, Catalogue, TV, Film	Print, Video, Commercials, Advertising, Catalogue, TV, Film
Words of Advice	"Know all the magazines and keep abreast of the latsted trends."		
Talent Pool	Fashion & Prop Stylists	Hair Stylists, Makeup Artists, Fashion Stylists andPhotographers	Hair Stylists, Makeup Artists, Fashion Stylists and Manicurists
Notes			

	Bradley Curry Management	Bryan Bantry	
	www.bradleycurry.com	www.fashionbook.com	
	hmu2000@aol.com	emailiano@fashionbook.com	
NEW YORK			
Address	611 Broadway, Ste. 101	4 West 58th Street, Penthouse	
City, State, Zip+4	New York, NY 10012	New York, NY 10019	
Country	USA	USA	
Phone & Fax	212-674-2500 FAX 212-226-7178	212-935-0200 Fax 212-935-2698	
Owner	Ellen Brain	Bryan Bantry	
Department Head			
Roster	No Information Provided	15-20 Artists	
Policy & Procedures			
Office Hours	10AM-6:30PM	9AM-6PM	
Drop Off Days/Times	By Appointment Only	By Appointment Only	
Preferred Presentation	11x14 Portfolio	11x14 Portfolio	
Agency Commission	Confidential	Confidential	
Expenses	No Information Provided	Negoiated with Stylist	
Requirements For Consideration	Strong Portfolio and Established Career	A strong book that shows creative experience. Must demonstrate the ability to execute ideas. The portfolio must clearly reflect talent.	
Market(s)	Print, Video, Commercials, Advertising, Catalogue, TV, Film	Editorial, Advertising Television, Celebrity	
Words of Advice		"Always say "yes" to everything in the beginning. Don't feel that you're better than the job. You never know how great the job can be or how it might launch your career."	
Talent Pool	Hair Stylists, Makeup Artists,Prop Stylists, Manicurists & Photographers	Hair Stylists, Makeup Artists, Fashion Stylists & Photographers	
Notes	_____	_____	_____

	CLM/Camilla Lowthar Mgmt. www.clmus.com clm@clmus.com	Chris Boals Artists www.thecrystalagency.com bookings@thecrystalagency.com	CMI www.cminy.com joyce@cminy.com
Address	17 Little West 12th St., Ste 202	17 W 12th Street, Ste 319	225 Lafayette, Ste 1105
City, State, Zip+4	New York, NY 10014	New York, NY 10014	New York, NY 10012
Country	USA	USA	USA
Phone & Fax	212-924-6565 FAX 212-242-5493	212-924-8810 FAX 212-924-8997	212-219-2226 FAX 212-219-9854
Owner	Brian		No information provided
Department Head		Michelle	
Roster	No information provided	No information provided	No information provided
Policy & Procedures			
Office Hours	9AM-6PM	9AM-6PM	9AM-6PM
Drop Off Days/Times	By Appointment Only	By Appointment Only	Tuesday & Wednesday
Preferred Presentation	Refused to disclose details	Portfolio	11X14 Portfolio
Agency Commission	Refused to disclose details	15-20%	20%
Expenses	Refused to disclose details	Messengers, FedEx	All promotion and marketing items.
Requirements For Consideration	Claims not to be interested in signing new artists.	An impressive and creative portfolio.	Agency Discretion
Market(s)	Refused to disclose details	All	Fashion, Editorial, Advertising, Catalog, CD Covers
Words of Advice	Refused to disclose details	No information provided	Clean presentation
Talent Pool	Fashion Stylists	Fashion Stylists & Photographers	Hair Stylists, Makeup Artists, Fashion & Prop Stylists, Photographers
Notes			

	Daniele Forsythe	De Facto	Elizabeth Watson
	www.danieleforsythe.com	www.defactoinc.com	
	daniele@danieleforsythe.com	info@defactoinc.com	
Address	116 W. 23rd St., Ste 500	41 Union Square West, Ste 1001	777 Washington Street
City, State, Zip+4	New York, NY 10010	New York, NY 10003	New York, NY 10014
Country	USA	USA	USA
Phone & Fax	212-949-9494 FAX 516-677-1920	212-627-4700 FAX 212-627-4732	212-627-0077 FAX 212-627-0348
Owner	Daniele Forsythe	Kristian Hanif	Elizabeth Watson
Department Head			Diana
Roster	Open	13 Artists	10 Artists
Policy & Procedures			
Office Hours	9AM-6PM	9AM-6PM	9AM-6PM
Drop Off Days/Times	By Appointment Only	Anytime	Anytime
Preferred Presentation	11X14 Portfolio	Portfolio	11X14 Portfolio
Agency Commission	15%	15%	15%
Expenses	Messenger, FedEx	Messenger, FedEx	Messenger, FedEx
Requirements For Consideration	Established career with a very strong portfolio and editorial advertising.	A strong portfolio and established clients.	Strength of portfolio.
Market(s)	Editorial, Fashion, Advertisting, Celebrities, Music Videoss, CD Covers, Catalog	All	All
Words of Advice	No information provided.	"Be patient...things don't happen overnight. "	No information provided.
Talent Pool	Fashion & Prop Stylists	Hair Stylists, Makeup Artists, Photographers, Fashion Stylists	Hair Stylists & Makeup Artists
Notes	_____	_____	_____

Frame Representatives, Inc.
framerepresentatives.com
framerep@earthlink.net

Gabler/Noonan, Inc.
www.gabler-noonan.com
n.gabler@gabler-noonan.com

Garren Artistic Division
www.garrenyagency.com
paul@paul.verizon.com

	Frame Representatives, Inc.	Gabler/Noonan, Inc.	Garren Artistic Division
Address	500 Greenwich Street, Ste. 602A	853 Broadway, Ste 1116	167 Madison Avenue, Ste 603
City, State, Zip+4	New York, NY 10013	New York, NY 10003	New York, NY 10016
Country	USA	USA	USA
Phone & Fax	212-431-1470 FAX 212-431-1057	212-674-9797 FAX 212-674-9747	212-684-5062 FAX 212-684-2580
Owner		Melina Gabler	
Department Head	Adriana		Jim Indorato
Roster	No information provided.	No information provided.	No information provided
Policy & Procedures			
Office Hours	9AM-5:30PM	9AM-6PM	9AM-6PM
Drop Off Days/Times	By Appointment Only	Anytime	By Appointment Only
Preferred Presentation	11X14 Portfolio	Portfolio & Comp Card	11X14 Portfolio
Agency Commission	By Appointment Only	20%	15%
Expenses	Messengers, DHL	All expenses occured as a result of promotion and marketing.	Messenger, FedEx.
Requirements For Consideration	Strong Portfolio	Good, clean, sharp appearance with a somewhat established career in editorial and or catalog.	Strong EDITORIAL portfolio
Market(s)	All	Fashion, Beauty, Editorial, Catalog	All
Words of Advice	"Punctuality is very important. You must have good energy when meeting with photographers and clients. Great personality a must!"	No information provided.	No information provided
Talent Pool	Photographers, Hair Stylists, Makeup Artists, Fashion Stylists	Photographers, Hair Stylists, Makeup Artists, Fashion Stylists	Hair Stylists & Makeup Artists
Notes	_____	_____	_____

	Halley Resources www.halleyresources.com info@halleyresources.com	**I Group** www.igroupnyc.com robin@igroupnyc.com	**[Zoli] Illusions & Style at Click** www.illusions-click.com info@illusions-click.com
NEW YORK			
Address	37 West 20th Street, Ste. 603	315 W. 39th Street, Ste 908	129 W. 27th Street
City, State, Zip+4	New York, NY 10011	New York, NY 10018	New York, NY 10001
Country	USA	USA	USA
Phone & Fax	212-206-0901 FAX 212-206-0904	212-564-3970 FAX 212-643-9748	212-242-7294 FAX 212-206-6228
Owner	Russell Halley		
Department Head		Robin	Leila Raiburn & Susan Branagan
Roster	25 Artists	10 Artists	Open
Policy & Procedures			
Office Hours	9AM-5PM	9AM-5PM	8:30AM-5:30PM
Drop Off Days/Times	By Appointment Only	10-5 the following day	Tues & Wed from 10-11AM
Preferred Presentation	Portfolio	9X12 or 11X14 Portfolio	11X14 Portfolio
Agency Commission	15%	15%	20%
Expenses	Messenger.	Messenger	All expenses occured as a result of promotion and marketing.
Requirements For Consideration	Strong Portfolio	No Information Provided.	Strong tearsheets and an established career.
Market(s)	Print, Video, Commercials, Advertising, Catalogue	Print, Video, Commercials, Advertising, Catalogue, TV, Film	Editorial, Advertising, Commercials, Music Videoss, Catalog, Fashion Shows, Celebrities
Words of Advice	"This is a business and it should be treated as such. The business portion should be just as important as the creative side. Be organized!"	Success is 25% inspiration and 75% perspiration. Keep working towards your goals.	"Be on time. Show interest in the shoot. Smile and look as professional as the work you create."
Talent Pool	Hair Stylists, Makeup Artists, Fashion Stylists, Prop & Food Stylists	Hair Stylists, Makeup Artists, Fashion Stylists & Photographers	Hair Stylists, Makeup Artists, Fashion & Prop Stylists, Manicurists
Notes	_____ _____ _____ _____	_____ _____ _____ _____	_____ _____ _____ _____

	Jam Arts	Jean Gabriel Kauss, Inc.	Jean Owen
	www.jamarts.com	www.jgkinc.net	www.jeanoweninc.com
	info@jamarts.com	jgk@dti.net	jeanowenagent@aol.com
Address	154 W. 57th St., Studio 817	161 Ave. of the Americas, 13th Floor	532 Laguardia Pl., Ste 488
City, State, Zip+4	New York, NY 10019	New York, NY 10013	New York, NY 10012
Country	USA	USA	USA
Phone & Fax	212-246-0448 FAX 212-262-1704	212-243-5454 FAX 212-243-5315	212-334-4433 FAX 212-965-0675
Owner	Maria Cutrona	Edward Kauss	Jean Owen
Department Head		Darrell Sam	
Roster	13 Artists	8 Artists	14 Artists
Policy & Procedures			
Office Hours	9AM-6PM	9AM-6PM	9:30AM-6PM
Drop Off Days/Times	By Appointment Only	Anytime	Tues & Thurs 11AM-12PM
Preferred Presentation	11X14 Portfolio	9X12 or 11X14 Portfolio	11X14 Portfolio
Agency Commission	15%	20%	15%
Expenses	Messengers, FedEx, Portfolio Maintenance	Messengers, FedEx	Lasers, Tearsheets, FedEx, Messengers
Requirements For Consideration	A strong portfolio	Quality portfolio content.	An established portfolio of tearsheets and an established clientele
Market(s)	All	Fashion & Beauty	All
Words of Advice	No information provided.	"Keep working hard."	"No one can work harder for you than you. Never dump your career into anyone else's lap."
Talent Pool	Hair Stylists, Makeup Artists, Fashion & Prop Stylists, Manicurists	Hair Stylists, Makeup Artists, Photographers, Set Design & Prop Stylists	Hair Stylists, Makeup Artists, Photographers
Notes	**Mailing address is:** 154 W. 57th Street New York, NY 10019		

	Jed Root, Inc. www.jedroot.com hmu@jedroot.com / stylists@jedroot.com	Judy Casey, Inc. www.judycasey.com info@judycasey.com	Jump Management, Inc. www.jumpmanagement.com nyjump@ren.com
NEW YORK			
Address	61A Walker St., 2nd floor	114 E 13th St.	17 Little West 12th St., unit 205C
City, State, Zip+4	New York, NY 10013	New York, NY 10003	New York, NY 10014
Country	USA	USA	USA
Phone & Fax	212-226-6600 FAX 212-274-0258	212-228-7500 FAX 212-228-9339	212-229-2134 FAX 212-633-9506
Owner	Jed Root	Judy Casey	Deadra Sullivan
Department Head	Kelly or Danielle		
Roster	13 Artists	44 Artists	Open
Policy & Procedures			
Office Hours	9AM-6PM	9:30AM-6PM	10AM-6PM
Drop Off Days/Times	Anytime	By Appointment Only	Anytime
Preferred Presentation	11X14 Portfolio	11X14 Portfolio	Portfolio
Agency Commission	15%	No information provided	15%
Expenses	Messengers & FedEx	Messengers, Portfolio Updates.	None
Requirements For Consideration	No information provided.	Established clientele	Fashion, Beauty, Editorial
Market(s)	Advertisting, Editorial, and Fashion Shows	Fashion and Beauty	Fashion, Beauty, Editorial
Words of Advice	"Start assisting if you're new to the business."	"Keep your book clean."	No information provided
Talent Pool	Makeup Artists, Hair Stylists, Fashion Stylists, Manicurists, Photographers	Hair Stylists, Makeup Artists, Prop & Fashion Stylists, Manicurists	Hair Stylists, Makeup Artists, Photographers
Notes	_____ _____ _____ _____	_____ _____ _____ _____	_____ _____ _____ _____

	Katy Barker Agency www.katybarker.com info@katybarker.com	**Ken Barboza & Associates** none available kbarboza@aol.com	**Kramer + Kramer** www.kramerkramer.com gabrielle.feldman@verizon.net
NEW YORK			
Address	208 West 11th Street	853 Broadway, Ste 1603	156 5th Ave.
City, State, Zip+4	New York, NY 10014	New York, NY 10003	New York, NY 10010
Country	USA	USA	USA
Phone & Fax	212-627-2558 FAX 212-627-2919	212-505-8635 FAX 212-260-3064	212-645-8787 FAX 212-645-9591
Owner	Katy Barker	Ken Barboza	Gay Feldman and Jay Sternberg
Department Head	Justinian		
Roster	6 Artists	20 Artists	No Information Provided
Policy & Procedures			
Office Hours	10AM-6PM	9AM-5:30PM	10AM-5PM
Drop Off Days/Times	M-W 10AM-6PM	By Appointment Only	Anytime
Preferred Presentation	Portfolio	11X14 Portfolio	Portfolio
Agency Commission	Confidential	20%	No Information Provided
Expenses	Confidential	Messengers, FedEx.	Messengers, FedEx.
Requirements For Consideration	Portfolio	A strong portfolio and a good attitude.	No Information Provided
Market(s)	Fashion	Fashion, Advertising, Commercial, Celebrity, Video, Editorial, Film	Fashion, Beauty & Entertainment
Words of Advice	No information provided.	"Yes, makeup, hair & fashion styling is an art, but it's also a business. As a stylist you must endeavor to give the client what they want. Profess a will to give at all cost."	No Information Provided
Talent Pool	Fashion Stylists	Hair Stylists, Makeup Artists, Fashion Stylists, Photographers	Hair Stylists, Makeup Artists, Fashion Stylists & Photographers
Notes	_____	_____	_____

	L'Atelier www.lateliernyc.com info@lateliernyc.com	**Lachapelle Representation** www.lachapellereps.com linda@lachapellereps.com	**LK&R Management** www.lkrmgmt.com info@lkrmgmt.com
Address	10 Hubert Street, 3rd Floor	420 E 54th St., Ste 14F	185 Varick Street, 5th Floor
City, State, Zip+4	New York, NY 10013	New York, NY 10022	New York, NY 10014
Country	USA	USA	USA
Phone & Fax	212-274-8282 FAX 212-274-0452	212-838-3170 FAX 212-758-6199	212-243-7879 FAX 212-243-6604
Owner	Francoise LeRoy	Linda Lachapelle	Stephanie
Department Head			
Roster	20 Artists	15 Artists	No information provided
Policy & Procedures			
Office Hours	9AM-6:30PM	9:30AM-6PM	9AM-6PM
Drop Off Days/Times	By Appointment Only	By Appointment Only	By Appointment Only
Preferred Presentation	Portfolio	11X14 Portfolio	Portfolio
Agency Commission	20%	20%	Confidential
Expenses	Messenger, FedEx	All expenses occured as a result of promotion and marketing.	Messengers, FedEx
Requirements For Consideration	Portfolio	An updated and professional portfolio and presentation.	Strong impressive portfolio.
Market(s)	Advertising, Catalogue, Fashion	Fashion, Editorial, Commercials, Film, TV	All
Words of Advice	No information provided.	No information provided.	No information provided
Talent Pool	Hair Stylists, Makeup Artists, Fashion Stylists & Photographers	Hair Stylists, Makeup Artists, Fashion & Prop Stylists, Photographers	Hair Stylists, Makeup Artists, Fashion Stylists
Notes	_____ _____ _____ _____	_____ _____ _____ _____	_____ _____ _____ _____

NEW YORK

	Loox Agency www.looxnyc.com johann@looxnyc.com	Mark Edward, Inc. www.markedwardinc.com mark@MarkEdwardInc.com	Mel Bryant Management www.melbryantmanagement.com info@melbryantmanagement.com
Address City, State, Zip+4 Country	100 Chambers Street, Ste 2 New York, NY 10007 USA	325 W 38th Street, Loft 1011 New York, NY 10018 USA	270 Lafayette, Ste 1001 New York, NY 10012 USA
Phone & Fax	212-406-8092 FAX 212-732-4149	212-279-1999 FAX 212-279-6661	212-274-8947 FAX 212-226-7178
Owner	Johanna	Julie	Mel Bryant
Department Head	Ren		
Roster	Open	No information provided.	5 Artists
Policy & Procedures			
Office Hours	9AM-6PM	9AM-6PM	10AM-6:30PM
Drop Off Days/Times	Afternoons. P/U the next day	Anytime	By Appointment Only
Preferred Presentation	Portfolio	11X14 Portfolio	Portfolio
Agency Commission	20%	15-20%	15%
Expenses	Messengers, FedEx	Messengers, FedEx.	Messengers, FedEx
Requirements For Consideration	Good portfolio.	The strength of your work will determine our interest.	A really good attitude and a creative sense of style.
Market(s)	No information provided.	No information provided.	Print, Video, Commercials, Advertising, Catalogue, TV, Film
Words of Advice	No information provided.	No information provided.	No information provided.
Talent Pool	Hair Stylists, Makeup Artists, Fashion Stylists, Photographers	Hair Stylists, Makeup Artists, Fashion Stylists	Fashion Stylists
Notes			

	Montgomery Group www.montgomerygroup.tv Ernest@montgomerygroup.tv	O'Gorman-Schramm www.ogorman-schramm.com ogormnschram@earthlink.com	Oliver-Piro www.oliverpiro.com natalie@oliverpiro.com
NEW YORK			
Address	350 7th Avenue, Suite 1606	642 Washington Street, Ste 1A	225 Layfayette St., Ste 1212
City, State, Zip+4	New York, NY 10001	New York, NY 10014	New York, NY 10012
Country	USA	USA	USA
Phone & Fax	212-643-6692 FAX 212-643-6693	212-620-0284 FAX 212-620-0731	212-925-2112 FAX 212-343-1923
Owner	Ernest Montgomery	Susan/Emily	Sydney Oliver, Charlene Piro
Department Head	Jose Borrero		
Roster	10 Artists	15 Artists	17 Artists
Policy & Procedures			
Office Hours	10AM-6:30PM	9AM-5PM	10AM-6PM
Drop Off Days/Times	By Appointment Only	By Appointment Only	Call for information
Preferred Presentation	Portfolio	11X14 Portfolio	Portfolio
Agency Commission	20%	20%	15%
Expenses	Messengers, FedEx	Messengers, FedEx	Messengers, Copies, FedEx
Requirements For Consideration	A really good attitude and a creative sense of style.	A working portfolio not a testing portfolio is necessary to be considered. The portfolio is judged on creativity.	Editorial, Advertising, Music, Catalog
Market(s)	Print, Video, Commercials, Advertising, Catalogue, TV, Film	All	Print, Video, Commercials, Advertising, Catalogue, TV, Film
Words of Advice	Stay on top of your game. Read magazines, go to the shows.	No information provided.	"Don't be negative or complain around clients. Keep good personal hygene. In other words...smell good!"
Talent Pool	Hair Stylists, Makeup Artists, Fashion Stylists, Photographers	Hair Stylists, Makeup Artists, Photographers	Fashion Stylists Photographers
Notes	_____ _____ _____ _____	_____ _____ _____ _____	_____ _____ _____ _____

	One www.onenakedegg.com onenakedegg@erols.com	Pat Bates & Associates _____ pbates@nyc.rr.com	Perrella Management www.perrellamanagement.com info@perrellamanagement.com
NEW YORK			
Address	675 Hudson Street, Ste. 4N	300 W. 12th Street, Ste 3-I	143 W. 29th Street, Penthouse
City, State, Zip+4	New York, NY 10014	New York, NY 10014	New York, NY 10001
Country	USA	USA	USA
Phone & Fax	212-925-1111 FAX 212-925-1531	212-807-8420 FAX 212-741-2640	212-465-9800 FAX 212-465-8004
Owner	Ivy Bernhard	Pat Bates	Jani Perez
Department Head			
Roster	No information provided.	7 Artists	20 Artists
Policy & Procedures			
Office Hours	9:30AM-5:30PM	9AM-5PM	10AM-5:30PM
Drop Off Days/Times	By Appointment Only	By Appointment Only	By Appointment Only
Preferred Presentation	11X14 Portfolio	Portfolio	9X12 or 11X14 Portfolio
Agency Commission	No information provided.	Varies	No information provided
Expenses	No information provided.	All expenses occured as a result of promotion and marketing.	Comp Cards, Mailings, Messengers, FedEx
Requirements For Consideration	"The most intriguing language with pictures."	A strong portfolio.	A strong portfolio with current tearsheets, recognizable clients, and an established client list.
Market(s)	All	Fashion Only	Editorial, Advertising, Celebrity, Catalog, Internet
Words of Advice	"Be distinctive!"	"Always present an organized presentation."	No information provided.
Talent Pool	Hair Stylists, Makeup Artists, Fashion & Prop Stylists, Photograhers	Hair Stylists, Makeup Artists, Fashion Stylists	Hair Stylists, Makeup Artists, Fashion & Prop Stylists, Manicurists,
Notes	_____	_____	_____

	R.J. Bennett www.rjbennettrepresents.com info@rjbennettrepresents.com.com	**Roseanne Renfrow** ———————————— ————————————	**Sally Harlor** ———————————— slugoh@aol.com
NEW YORK			
Address	274 1st Avenue, Ste 8E	240 East 76th Street, Ste 6K	232 Madison Avenue, Ste 804
City, State, Zip+4	New York, NY 10009	New York, NY 10021	New York, NY 10016
Country	USA	USA	USA
Phone & Fax	212-673-5509 FAX 212-677-5273	212-737-7188 FAX 212-517-3674	212-213-4282 FAX 212-213-6039
Owner	Rose	Roseanne Renfrow	Sally Harlor
Department Head			
Roster	No information provided.	Open	10 Artists
Policy & Procedures			
Office Hours	9:30AM-5:30PM	9AM-5:30PM	9:30AM-6PM
Drop Off Days/Times	By Appointment Only	By Appointment Only	By Appointment Only
Preferred Presentation	11X14 Portfolio	11X14 Portfolio	11X14 Portfolio
Agency Commission	20%	15%	15%
Expenses	Messengers, FedEx, Composite Cards.	Messengers, FedEx.	Messengers, FedEx, Special Promos
Requirements For Consideration	Strong porfolio and estasblished clientele.	No information provided.	Ability, personality, experience...in that order.
Market(s)	Fashion, Advertising, TV, Video, Catalog, Editorial	Editorial, Advertising, Beauty and Fashion Shows, Commercials, Catalog	All
Words of Advice	No information provided.	No information provided.	"First and foremost, be on time! Be acco-modating, not too talkative, don't over-dress and keep a spotless kit."
Talent Pool	Hair Stylists, Makeup Aritist, Fashion & Prop Stylists	Hair Stylists & Makeup Artists	Hair Stylists & Makeup Artists
Notes	—————————— —————————— —————————— ——————————	—————————— —————————— —————————— ——————————	—————————— —————————— —————————— ——————————

	Sarah Laird www.sarahlaird.com saralairdreps@aol.com	Stockland Martel www.stocklandmartel.com info@stocklandmartel.com	Streeters USA www.streeters.com liz@streeters.com
NEW YORK			
Address	12 charles Lane	5 Union Square West	568 Broadway, Ste 504A
City, State, Zip+4	New York, NY 10014	New York, NY 10003	New York, NY 10012
Country	USA	USA	USA
Phone & Fax	212-989-9666 FAX 212-229-1866	212-727-1400 FAX 212-727-9459	212-219-9566 FAX 219-9844
Owner	Sarah Laird	Simon Horobin	Jerre Morrone
Department Head			Elizabeth McKiver, Robin Jaffee
Roster	21 Artists	Open	28 Artists
Policy & Procedures			
Office Hours	9AM-6PM	9:30AM-6:30PM	9:30AM-6PM
Drop Off Days/Times	By Appointment Only	By Appointment Only	Drop off on Thur betw 9:30-6PM
Preferred Presentation	11X14 Portfolio	11X14 Portfolio	Portfolio
Agency Commission	20%	15%	15%
Expenses	Messengers, FedEx	Promotional Materials, Portfolios, Messengers	Magazines, Messengers, FedEx, Portfolio Updates.
Requirements For Consideration	Strong up-to-date portfolio.	Strong Editorial Portfolio	An established career including strong editorial experience.
Market(s)	Editorial, Advertising, Fashion, Celebrity, Catalog, Travel	All	Fashion, Music, Editorial
Words of Advice	No information provided.	No information provided.	"Get ready to be patient and persistent. Good Luck."
Talent Pool	Hair Stylists, Makeup Artists, Fashion Stylists, Photographers	Hair Stylists, Makeup Artists, Fashion & Prop Stylists	Hair Stylists, Makeup Artists Fashion Stylists, Photographers
Notes	_____	_____	_____

	Stylists & Company www.stylistsandcompany.com info@stylistsandcompany.com	**Susan Price, Inc.** —————— **scnylg@hotmail.com**	**Tapestry Creative Management** www.tapestryinc.com info@tapestryinc.com
NEW YORK			
Address	260 Madison Ave.	333 Hudson St., Ste 1002	274 W. 132nd St., 3rd Fl
City, State, Zip+4	New York, NY 10001	New York, NY 10013	New York, NY 10027
Country	USA	USA	USA
Phone & Fax	212-503-1574 FAX 212-268-0444	212-206-7671 FAX 212-206-8057	212-926-0477 FAX 212-368-9872
Owner	Laurie Schecter	Susan Price	Mahalia Watson
Department Head			
Roster	1500 Artists	15 Artists	5 Artists
Policy & Procedures			
Office Hours	24/7. Network of Stylists	9:30AM-6PM	9AM-6PM
Drop Off Days/Times	By Appointment Only	By Appointment Only	By Appointment Only
Preferred Presentation	Portfolio	11X14 Portfolio	Portfolio
Agency Commission	No information provided.	15%	20%
Expenses	No information provided..	Messengers, FedEx	All expenses occured as a result of promotion and marketing.
Requirements For Consideration	Professional industry experience necessary to be a part of network referral.	Prints, Tearsheets and a Creative Portfolio.	An established career with a strong portfolio.
Market(s)	All	Catalog, Editorial, Commercials, Music	All
Words of Advice	"It's not about what you think you know it's about what is."	No information provided.	"Keep a really good attitude at all times and leave the ego at the door."
Talent Pool	Photographers, Hair Stylists, Makeup Artists, Fashion and Prop Stylists	Hair Stylists, Makeup Artists Fashion Stylists	Photographers, Stylists, Hair Stylists, Makeup Artists
Notes	_____	_____	_____

	The Agency www.theagencyreps.com sfarnstrom@theagencyreps.com	**The Boho Studio** www.bohostudio.com info@bohostudio.com	**The Dream Group**
Address	580 Broadway, Ste 500	254 Elizabeth Street, Ste 5A	45 W. 21st Street
City, State, Zip+4	New York, NY 10013	New York, NY 10011	New York, NY 10010
Country	USA	USA	USA
Phone & Fax	212-965-9080 FAX 212-965-9087	212-431-4304 FAX 212-219-9145	212-807-0055 FAX 212 0836
Owner	Sarah Seyfried	Rania Abbassi	Ann Marie
Department Head	Shannon Farnstrom		
Roster	No information provided	7 Artists	3 Artists
Policy & Procedures			
Office Hours	9AM-6PM	9AM-6PM	9AM-6PM
Drop Off Days/Times	M-F after 12NOON	By Appointment Only	By Appointment Only
Preferred Presentation	Portfolio	Portfolio or Reel	Portfolio
Agency Commission	20%	20%	15%
Expenses	Messengers, FedEx	Agency splits cost of expenses with artist.	Messengers, FedEx
Requirements For Consideration	Strong portfolio and experience in the industry.	Portfolio	At least 3 year...rience in industry and a...g portfolio.
Market(s)	All	All	Editori...hion, Advertising
Words of Advice	No information provided.	"Presentation and Perseverance."	...test...test!!!! Don't be...ove with your own work that y...n't take constructive criticism."
Talent Pool	Hair Stylists, Makeup Artists, Fashion Stylists	Hair Stylists, Makeup Artists, Photographers, Fashion Stylists	...Stylists & Makeup Artists
Notes			

OUT OF BUSINESS

	Therese Ryan Mahar www.theresemahar.com trmbooker@aol.com	Tiffany Whitford www.tiffanywhitford.com tiffany@twi-nyc.com	Tricia Joyce, Inc. www.triciajoyce.com triciajoyce@triciajoyce.com
Address	167 Lexington Ave., Ste 200	210 E. 68th St., Ste 4G	79 Chambers Street, 2nd Floor
City, State, Zip+4	New York, NY 10016	New York, NY 10012	New York, NY 10007
Country	USA	USA	USA
Phone & Fax	212-679-8585 FAX 212-689-0567	212-706-9191 FAX 212-777-3214	212-962-0728 FAX 212-227-8471
Owner	Therese Mahar	Tiffany Whitford	Tricia Joyce
Department Head			
Roster	8 Artists	16 Artists	Open
Policy & Procedures			
Office Hours	9AM-5:30PM	9AM-6PM	9AM-5:30PM
Drop Off Days/Times	By Appointment Only	By Appointment Only	By Appointment Only
Preferred Presentation	11X14 Portfolio	Portfolio	11X14 Portfolio
Agency Commission	Confidential	Confidential	Confidential
Expenses	Messengers, FedEx	All expenses occured as a result of promotion and marketing.	Messengers, FedEx, Promo Materials
Requirements For Consideration	Strong portfolio.	Strong portfolio.	An established career with a strong portfolio and updated editorial tearsheets.
Market(s)	All	All	Fashion, Advertising, Catalog, Music Industry, Editorial
Words of Advice	"Be on time"	"Profesionalism and punctuality are of the essence."	Fashion, Advertising, Catalog, Music Industry, Editorial
Talent Pool	Fashion Stylists & Photographers	Hair Stylists, Makeup Artists, Fashion Stylists, Photographers	Fashion Stylists, Hair Stylists, Makeup Artists, Photographers
Notes			

	Utopia www.utopianyc.com carolyn@utopia.com	**Vernon Jolly, Inc.** www.vernonjolly.com vjolly@vernonjolly.com	**Vue Represents** www.vuerepresents.com gina@vuerepresents.com
NEW YORK			
Address City, State, Zip+4 Country Phone & Fax Owner Department Head Roster Policy & Procedures	12 West End Avenue, 2nd Floor New York, NY 10023 USA 212-634-9280 FAX 212-634-9288 Carolyn Bodner Michelle Bartlett Open	180 Varick Street, Ste 912 New York, NY 10014 USA 212-989-0800 FAX 212-989-0002 VJ 12 Artists	580 Broadway, 7th FL., Ste 715 New York, NY 10012 USA 212-431-5780 FAX 212-431-8312 Gina Lengyl 6 Artists
Office Hours Drop Off Days/Times Preferred Presentation Agency Commission Expenses	9AM-6PM Anytime 11X14 Portfolio 15% Messengers, FedEx	9AM-6PM Call first 11X14 Portfolio 20% Some expenses are split between agency and artists.	9AM-6PM By Appointment Only 11X14 Portfolio 20% Messengers,FedEx
Requirements For Consideration	Strong Portfolio, Tearsheets, Catalog	Tearsheets, editorial work and up-to-date portfolio	Strong and creative portfolio.
Market(s)	Strong Portfolio, Tearsheets, Catalog	All	Music, Fashion, Editorial
Words of Advice	"Personality and attitude make a big difference especially if you want to work with the same people more than once."	"Be personable, patient and understanding of the client."	No information provided.
Talent Pool	Hair Stylists, Makeup Artists Fashion & Prop Stylists, Photographers	Hair Stylist, Makeup Artists Photographers, Fashion Stylists, Manicurists	Hair Stylist, Makeup Artists Photographers
Notes	_____ _____ _____ _____	_____ _____ _____ _____	_____ _____ _____ _____

	Wall Group www.thewallgroup.com ali@thewallgroup.com	**Walter Schupfer** www.wschupfer.com wschupfer@aol.com	**Warren-Tricomi Agency** www.warrentricomi.com
NEW YORK			
Address	421 W. 14th Street, 2nd Floor	413 W. 14th St., 4th Floor	16 W. 57th Street, 4th Floor
City, State, Zip+4	New York, NY 10014	New York, NY 10014	New York, NY 10019
Country	USA	USA	USA
Phone & Fax	212-352-0777 FAX 212-462-2778	212-366-4675 FAX 212-255-9726	516-470-2493
Owner		Natasha	Joel Warren & Edward Tricomi
Department Head	Sophie		Ann Lawlor - X211
Roster	19 Artists	16 Artists	8 Artists
Policy & Procedures			
Office Hours	9AM-6PM	9AM-6PM	8AM-6PM
Drop Off Days/Times	Between 9-6. P/U following day	By Appointment Only	By Appointment Only
Preferred Presentation	11X14 Portfolio	Portfolio	11X14 Portfolio
Agency Commission	Refused to participate	Confidential	20%
Expenses	Refused to participate.	All expenses occured as a result of promotion and marketing.	Messengers, FedEx
Requirements For Consideration	Refused to participate	Research our agency and see if you fit with our profile.	A variation of looks and a strong portfolio.
Market(s)	Beauty, Fashion & Film	All	All
Words of Advice	Refused to participate	"Make sure you present what you want and not what you think I want to see. Never conform, you lose the magic which makes you unique."	No information provided.
Talent Pool	Hair & Makeup	Makeup Artists, Wardrobe, Fashion & Prop Stylists, Photographers	Hair Stylists, Makeup Artists, Manicurists
Notes	represents ttalent in fashion and film for freelance bookings and **long-term** contractual arrangements.		

	Wenzel Wilson	Williams Image Group	Z Photographic
	www.wilsonwenzel.com	www.williamsimagegroup.com	www.zphotographic.com
	portfolios@wilsonwenzel.com	info@williamsimagegroup.com	zny@zphotographic.com
Address	149 Wooster St., 4th Fl	240 W. 35th St., Ste 304	476 Broome St., 3rd Floor
City, State, Zip+4	New York, NY 10012	New York, NY 10001	New York, NY 10013
Country	USA	USA	USA
Phone & Fax	212-614-9500 FAX 212-614-0175	212-279-8574 FAX 212-279-8578	212-431-9222 FAX 212-941-1320
Owner	Amy	Charles Williams	Randal
Department Head			
Roster	3 Artists	10 Artists	12 Artists
Policy & Procedures			
Office Hours	10AM-5PM	10AM-6PM	9AM-6PM
Drop Off Days/Times	During business hours	1PM-4PM Daily	Tue-Fri During business hours
Preferred Presentation	11X14 Portfolio	11X14 Portfolio	Portfolio
Agency Commission	Confidential	20%	Confidential
Expenses	Messengers, FedEx.	Messengers, FedEx	Confidential.
Requirements For Consideration	Strong portfolio.	Strong portfolio.	Light, natural material contained in portfolio and a flexible attitude needed for work with our wide range photographers .
Market(s)	Editorial, Advertisting	Fashion, Editorial, Advertisting, Catalog, CD Packaging	Editorial, Advertisting, Fashion
Words of Advice	No information provided.	"A strong portfolio and agreeable disposition is a must in this industry."	"Show up on time and be nice not pushy. Attitude is everything."
Talent Pool	Hair Stylists, Makeup Artists, Fashion Stylists, Photographers	Hair Stylists, Makeup Artists, Wardrobe Stylists, Photographers	Wardrobe and Fashion Stylists, Photographers
Notes	_____	_____	_____

	Directions USA www.directionsusa.com newfaces@directionsusa.com	**Marilyn's, Inc.** www.marilyn-s.com models@marilyn-s.com	**The Talent Connection**
NORTH CAROLINA			
Address	3717-C West Market Street	601 Norwalk St.	338 N. Elm Street, Ste 204
City, State, Zip+4	Greensboro, NC 27403	Greensboro, NC 27407	Greensboro, NC 27401
Country	USA	USA	USA
Phone & Fax	336-292-2800 FAX 336-292-2855	336-292-5950 FAX 336-294-9178	336-274-2499 FAX 336-274-9202
Owner	Jill Joyce	Marilyn Green	Anne Swindell
Department Head	Jean Catlett	Kathie Moore, Freda Snyder	
Roster	15 Artists	8 Artists	Open
Policy & Procedures			
Office Hours	8:30AM-5:30PM	8:30AM-5:30PM	8:30AM-5:30PM
Drop Off Days/Times	Tuesdays from 2:30-4:30PM w/appt.	By Appointment Only	By Appointment Only
Preferred Presentation	9X12 Portfolio	Portfolio and/or Comp Card	9X12 Portfolio
Agency Commission	20%	20%	20%
Expenses	Messengers, FedEx.	Agency covers most expenses.	Messengers, FedEx, Promo (Comp) Cards, Etc.
Requirements For Consideration	Must have a portfolio.	Résumé and strong test shots.	A lot of experience and a Good Book.
Market(s)	Film, TV, Print, Editorial	Film, TV, Industrial, Editorial, Commercial	Film, TV, Music & Industrial Videos, Commercials, Print
Words of Advice	No information provided.	"Patience with the understanding of the business as well as punctuality is crucial to this industry."	
Talent Pool	Hair Stylists, Makeup Artists, Wardrobe & Product Stylists	Hair Stylists, Makeup Artists, Wardrobe Stylists	Hair Stylists, Makeup Artists, Wardrobe Stylists
Notes			

	Docherty www.dochertyagency.com	**Creative Talent**	NOTES
		creative-talent@columbus.rr.com	
OHIO			
Address	109 Euclid Ave., Ste 500	5864 Nike Drive	
City, State, Zip+4	Cleveland, OH 44115	Hilliard, OH 43026	
Country	USA	USA	
Phone & Fax	216-522-1300 FAX 216-522-0520	614-294-7827	
Owner	Deb Docherty	Donna Gonzales	
Department Head		Amber	
Roster	6 Artists	6 Artists	
Policy & Procedures			
Office Hours	9AM-5:30PM	9AM-5PM	
Drop Off Days/Times	Mon-Fri	Send Comp Card by Mail First	
Preferred Presentation	Portfolio	Portfolio and/or Comp Card	
Agency Commission	20%	20%	
Expenses	Messengers, FedEx	All expenses occured as a result of promotion and marketing.	
Requirements For Consideration	Must see your work.	Serious Artists Only.	
Market(s)	Commercial Print, Corporate and Industrials.	Print, Video, Commercials, Advertising, Catalogue, TV, Film	
Words of Advice			
Talent Pool	Hair Stylists, Makeup Artists, Wardrobe Stylists	Hair Stylists, Makeup Artists, Wardrobe Stylists	
Notes			

	Cusicks' Talent Agency, Inc. www.Q6talent.com justin@Q6talent.com	**Chartruse Artists Management** www.chartreusetalent.com kseidel@surflinx.com	**Reinhard Model & Talent Agency** www.reinhardagency.com info@reinhardagency.com
Address	1009 NW Hoyt St., Ste 100	801 N. 12th Street	2021 Arch St., Ste 400
City, State, Zip+4	Portland, OR 97209	Allentown, PA 18102	Philadelphia, PA 19103
Country	USA	USA	USA
Phone & Fax	503-274-8555 FAX 503-274-4615	610-433-5448 FAX 610-837-4938	215-567-2000 FAX 215-567-6322
Owner	Justin Habel	Charlene Mateus	Virginia Drake
Department Head	Bradley Kruger		
Roster	15 Artists	30 Artists	Open
Policy & Procedures			
Office Hours	9AM-5PM	9AM-5:30PM	9:30AM-6:30PM
Drop Off Days/Times	By Appointment Only	By Appointment Only	By Appointment Only
Preferred Presentation	9X12 or 11X14 Portfolio	9X12 Portfolio	Portfolio and Comp Card
Agency Commission	20%	Confidential	Confidential
Expenses	All expenses occured as a result of promotion and marketing.	All expenses occurred as a result of promotion & marketing	Messengers, FedEx
Requirements For Consideration	A good portfolio.	A portfolio that shows balance, creative experience & a clear reflection of talent. We want artists with fresh ideas & personality.	Must have 3-5 years catalog and print experience.
Market(s)	Catalog, Commercials, Film TV & Print	Bridal, Pageants, Industrial Video, Corporate, Theatre, Special Occasion	Fashion, Editorial, Catalog, Commercials, Fashion Shows
Words of Advice	"Invest in a great comp card. They are requested more than books, and we can book a job from a good one."	"Go for it! Get involved in every aspect of your craft. There's no free ride. Work. Build a great portfolio. Don't be afraid to ask questions. Establish good working relationships."	No information provided.
Talent Pool	Hair Stylists, Makeup Artists, Wardrobe Stylists	Hair Stylists, Makeup Artists, Fashion & Prop Stylists, Photographers	Hair Stylists, Makeup Artists, Wardrobe Stylists
Notes	_____	_____	_____

Penelope Hester Artist Image Group
www.penelopehester.com
penelopehester@comcast.net

Independent Artists
www.iagency.com
tracy@iagency.com

	TENNESSEE		TEXAS	
Address	1300 Division Street, Ste 200	Address	3107 Cole Avenue	
City, State, Zip+4	Nashville, TN 37203-4090	City, State, Zip+4	Dallas, TX 75204	
Country	USA	Country	USA	
Phone & Fax	615-793-4440 FAX 615-463-8484	Phone & Fax	214-720-4496 FAX 214-720-0702	
Owner	Penelope Hester	Owner	Siobhan Westphaer	
Department Head		Department Head	Tracey Keimer	
Roster	Open	Roster	18 Artists	
Policy & Procedures		Policy & Procedures		
Office Hours	9AM-5:30PM	Office Hours	9AM-5:30PM	
Drop Off Days/Times	Send resume first. Then call for appt.	Drop Off Days/Times	By Appointment Only	
Preferred Presentation	Portfolio	Preferred Presentation	9X12 or 11X14 Portfolio	
Agency Commission	20%	Agency Commission	20%	
Expenses	Messengers, FedEx	Expenses	Messengers, FedEx, Promotional Pieces	
Requirements For Consideration	Good Book and Resume with Experience.	Requirements For Consideration	Strong portfolio.	
Market(s)	Commercials, TV, Film, Print, Catalogue, Video	Market(s)	Catalog, Advertising, Editorial, Film, TV	
Words of Advice	"If you can't stand to hurry up and wait then you can't do the job. Patience is key."	Words of Advice	No information provided.	
Talent Pool	Makeup Artists	Talent Pool	Hair Stylists, Makeup Artists, Fashion & Prop Stylists	
Notes	_____	Notes	_____	

	Kim Dawson Agency www.kimdawson.com ldawson@kimdawson.com	Page Parkes Dallas www.pageparkes.com modelcenter@pageparkes.com	Page Parkes Houston www.pageparkes.com modelcenter@pageparkes.com
TEXAS			
Address	2300 Stemmons Fwy, Ste 1643	3303 Lee Parkway, Ste 205	332727 Kirby Drive, 8th Floor
City, State, Zip+4	Dallas, TX 75258	Dallas, TX 75219	Houston, TX 77098
Country	USA	USA	USA
Phone & Fax	214-638-2414 Kim Dawson	214-526-4434	713-807-8200 FAX 713-807-0055
Owner	Lisa Dawson	Page Parkes	Page Parkes
Department Head	Open	Peter Anthony	Vickie Snow
Roster		5 Artists	10 Artists
Policy & Procedures			
Office Hours	9AM-5:30PM	9AM-6PM	9AM-6PM
Drop Off Days/Times	By Appointment Only	By Appointment Only	By Appointment Only
Preferred Presentation	9X12 or 11X14 Portfolio	9X12 Portfolio	9X12 Portfolio
Agency Commission	20%	20%	20%
Expenses	Messengers, DHL, Promotional Pieces.	Messengers, FedEx, Comp Cards	Messengers, FedEx, Comp Cards
Requirements For Consideration	Strong portfolios with updated fashion tearsheets and updated test shots. Established career preferred.	Strong porfolio with updated hair and makeup a must!	Strong porfolio with updated hair and makeup a must!
Market(s)	Fashion, Advertising, Commercials, Print, Celebrities, Music Videos, Catologue, Fashion Shows	Print, Catalogue, Fashion, Advertising, TV	Print, Video, Commercials, Advertising, Catalogue, TV, Film
Words of Advice		"Patient and professionalism and ENDURANCE...says it all"	"Patient and professionalism and ENDURANCE...says it all"
Talent Pool	Hair Stylists, Makeup Artists, Fashion Stylists	Hair Stylists, Makeup Artists, Wardrobe Stylists	Hair Stylists, Makeup Artists, Wardrobe Stylists
Notes		Busy 10 months out of the year. Slow typically Jan & Feb.	Busy 10 months out of the year. Slow typically Jan & Feb.

The Clutts Agency
www.thecluttsagency.com
christopher@thecluttsagency.com

TEXAS

Address	1400 Turtle Creek Blvd., Ste 171
City, State, Zip+4	Dallas, TX 75207
Country	USA
Phone & Fax	214-761-1400 FAX 214-761-1402
Owner	Sheree Ross
Department Head	
Roster	25 Artists
Policy & Procedures	
Office Hours	9AM-5:30PM
Drop Off Days/Times	By Appointment Only
Preferred Presentation	9X12 Portfolio
Agency Commission	20%
Expenses	Messengers, FedEx, Promotional Piesces

Requirements For Consideration	One year experience as an assistant or key stylist and a strong, current portfolio.
Market(s)	Catalog, Film Advertising, TV
Words of Advice	"Out of 200 artists, 5 will show up on time. Out of 5, one will correctly fill out the voucher. We're always looking to find that one."
Talent Pool	Hair Stylists, Makeup Artists, Fashion Stylists
Notes	_____ _____ _____ _____

Celestine
www.celestineseattle.com
info@celestineseattle.com

WASHINGTON

Address	1201 1st St. South, Ste 323
City, State, Zip+4	Seattle, WA 98134
Country	USA
Phone & Fax	206-903-6661 FAX 206-903-6662
Owner	Mary Goodman
Department Head	
Roster	Open
Policy & Procedures	
Office Hours	9AM-5:30PM
Drop Off Days/Times	By Appointment Only
Preferred Presentation	11x14 Portfolio
Agency Commission	15%
Expenses	Messengers, FedEx

Requirements For Consideration	Established career. Professional attitude, strong book, willingness to test and update book often.
Market(s)	Catalog, Editorial, Commercial, Music Videos, Advertising
Words of Advice	"Be professional and positive. Be punctual. Look "put-together", try to be an asset on jobs. Have talent and personality.""Be professional and positive. Look "put-together", try to be an asset on jobs. Have talent and personality."
Talent Pool	Hair Stylists, Makeup Artists, Fashion Stylists
Notes	_____ _____ _____ _____

Zenobia

www.zenobia.com
coleen@zenobia.com

Address	1818 20th Ave. Ste 306
City, State, Zip+4	Seattle WA, 98122
Country	USA
Phone & Fax	206-340-0600 FAX 206-340-1500
Owner	Keith Zenobia
Department Head	Coleen Stupp
Roster	11 Artists
Policy & Procedures	
Office Hours	9AM-6PM
Drop Off Days/Times	By Appointment Only
Preferred Presentation	9X12 Portfolio
Agency Commission	20%
Expenses	Messengers, FedEx

Requirements For Consideration	We want what all clients want: creative, technically skilled, professional, personable team players who set high standards for themselves.
Market(s)	Print Advertising, Catalog, Editorial, Fashion Shows, TV Commercials, Music Videoss, Special Events
Words of Advice	"Study this source book. It's loaded with valuable pointers and insight."
Talent Pool	Hair Stylists, Makeup Artists, Fashion & Prop Stylists, Manicurists, Food Stylists
Notes	_____ _____ _____ _____

Anne Makeup & Styling

www.annemakeup.com
crmgtser@toad.net

Address	906 D Street N.E
City, State, Zip+4	Washington, DC 20002
Country	USA
Phone & Fax	202-333-3560
Owner	Anne Schwab
Department Head	
Roster	12 Artists
Policy & Procedures	
Office Hours	9AM-6PM
Drop Off Days/Times	By Appointment Only
Preferred Presentation	Promo Card
Agency Commission	20%
Expenses	Messengers, FedEx

Requirements For Consideration	Must be a working professional with an established career.
Market(s)	All
Words of Advice	"Be punctual, professional, polished and prepared. Avoid garlic and onions prior to working with a client. Be friendly but not overly familiar."
Talent Pool	Hair Stylists, Makeup Artists, Fashion, Prop & Food Stylists
Notes	_____ _____ _____ _____

T.H.E. Artist Agency, Inc.
www.theartistagency.com

Address	3333 K Street, NW
City, State, Zip+4	Georgetown, DC 20007
Country	USA
Phone & Fax	202-342-0933 FAX 202-342-6471
Owner	Lynda Lager-Erkiletian
Department Head	Elizabeth McDavitt-Centenari
Roster	20 Artists
Policy & Procedures	
Office Hours	9AM-6PM
Drop Off Days/Times	By Appointment Only
Preferred Presentation	9X12 Portfolio
Agency Commission	15%
Expenses	FedEx, Messengers, Promo Cards, Advertising
Requirements For Consideration	
Market(s)	Catalogue, TV, Film
Words of Advice	
Talent Pool	Hair Stylists, Makeup Artists, Fashion Stylists
Notes	

Arlene Wilson Management
www.arlenewilson.com
info.milwaukee@arlenewilson.com

Address	807 North Jefferson Street, Ste 200
City, State, Zip+4	Milwaukee, WI 53202
Country	USA
Phone & Fax	414-283-5600 FAX 414-283-5610
Owner	Arlene Wilson
Department Head	Catherine Hagen
Roster	20 Artists
Policy & Procedures	
Office Hours	9AM-5:50PM
Drop Off Days/Times	By Appointment Only
Preferred Presentation	11x14 Portfolio
Agency Commission	20%
Expenses	Messengers, FedEx
Requirements For Consideration	Strong portolio
Market(s)	Fashion, Commercials, Editorial, Advertising, Catalog, Fashion Shows
Words of Advice	
Talent Pool	Hair Stylists, Makeup Artists, Wardrobe Stylists
Notes	

Lori Lins, Ltd. Talent Mgmt.
www.lorilins.com
info@lorilins.com

WISCONSIN

Address	7611 West Holmes Avenue
City, State, Zip+4	Milwaukee, WI 53220
Country	USA
Phone & Fax	414-282-3500 FAX 414-282-3404
Owner	Lori Lin
Department Head	
Roster	Refused to provide information
Policy & Procedures	
Office Hours	9:00am - 5:00pm
Drop Off Days/Times	Refused to provide information
Preferred Presentation	Refused to provide information
Agency Commission	Refused to provide information
Expenses	Refused to provide information
Requirements For Consideration	Submit a letter of interest and resume. Include a promo (comp) card if you have one.
Market(s)	Refused to provide information
Words of Advice	Refused to provide information
Talent Pool	Refused to provide information
Notes	They will respond by mail within 4-6 weeks. Materials will not be returned.

NOTES

NOTES

INTERNATIONAL AGENCIES

REPRESENTATION IN CANADA AND ABROAD

	Ford www.fordmodels.com info@fordmodels.com	**Giovanni Artist Management** www.giovannimodels.com alan@giovannimodels.com	**Judy Inc.** www.judyinc.com info@judyinc.com
CANADA			
Address	385 Adelaide Street West	1 Yorkville Ave.	1 Yorkville Ave.
City, State, Zip+4	Toronto, Ontario M5V-IS4	Toronto, Ontario M4W 1/1	Toronto, Ontario M4W 1L1
Country	CANADA	CANADA	CANADA
Phone & Fax	416-362-9208 FAX 416-362-9604	416-962-5839 FAX 416-962-5849	416-962-5839 FAX 416-962-5849
Owner		Alan Thomas	David Clemmer, Janet White, Charles Pavia
Department Head	Cynthia Cully		
Roster	5 Artists	10Artists	30 Artists
Policy & Procedures			
Office Hours	9AM-6PM	9AM-6PM	9AM-5PM
Drop Off Days/Times	Wednesday 2-4PM	Anytime	Anytime
Preferred Presentation	9X12 Portfolio	9X12 Portfolio	9X12, 8 1/2x11 Portfolio
Agency Commission	15%	15%	15%
Expenses	Messengers, FedEx	All expenses occured as a result of promotion and marketing.	Messengers, FedEx
Requirements For Consideration	Established artists are preferred.	Artists with direction and a sense of style	Portolio
Market(s)	All	Print, Editorial, Fashion	All
Words of Advice	"Work Hard and keep chasing your dreams."	"Keep developing your technique. Work as much as possible even if it's for free."	"Treat being a freelance artist as you would a full time job. On your days off don't sit around waiting for the work to find you, continue promoting your craft."
Talent Pool	Hair Stylists, Makeup Artists	Hair Stylists, Makeup Artists, Fashion Stylists, Photographers	Hair Stylists, Makeup Artists, Fashion, Prop & Food Stylists
Notes	_____	_____	_____

	Redd Artist Management www.reddhairstudio.ca reddhairstudio@aol.com	The Artists Group, LTD. www.artistgrouplimited.com agency@artistgrouplimited.com	The Plutino Group www.plutinogroup.com info@plutinogroup.com
Address	1187 King Street West	847 Adelaide Street West	525 Adelaide Street West
City, State, Zip+4	Toronto, Ontario M6K 3C5	Toronto, Ontario M5V 1Y6	Toronto, Ontario M5V 1T6
Country	CANADA	CANADA	CANADA
Phone & Fax	416-530-7717 FAX 416-530-7718	416-703-5059 FAX 416-703-5060	888-758-8466 FAX 416-920-4563
Owner	Lisa Carnevale	Julie Miller & Jennifer Hodge	Roseanne Plutino
Department Head			
Roster	12 Artists	60 + Artists	35 Artists
Policy & Procedures			
Office Hours	10AM-8PM, Sat 9AM-6PM	9AM-5:30PM	9AM-5PM
Drop Off Days/Times	By Appointment Only	Anytime	Tuesday 10:00 AM - 12:00 PM
Preferred Presentation	9X12 Portfolio	9X12 Portfolio	9X12 Portfolio
Agency Commission	20%	20%	20%
Expenses	Messengers, FedEx	Messengers, FedEx	Messengers, FedEx
Requirements For Consideration	Portfolio with clean tearsheets and updated shots.	As many visuals as possible. We look for talent and we're happy to help develop someone with potential.	An established career and strong portfolio.
Market(s)	TV, Film, Editorial, Fashion, Wedding	All	Print, Commercials, Advertising,
Words of Advice	"Be creative, passionate and confident. Educate yourself as often as possible."	"It really mades a difference to have a passion for your work. Your portfolio is everything. Keeping your book current is so important because it is your agents selling tool to better market you."	"Be professional at all times."
Talent Pool	Hair Stylists, Makeup Artists	Hair Stylists, Makeup Artists, Fashion & Prop Stylists	Hair Stylists, Makeup Artists, Fashion & Prop Stylists
Notes	_____	_____	_____

AUSTRALIA	ANITA LOWE	THE ARTIST GROUP PTY LTD	CAMERONS MANAGEMENT MELBOURNE
Address	P.O. Box 202	15-19 Boundary Street	Suite 3402, Chapel Street
City, State, Zip	Bellingen NSW 2454 Australia	Rushcutters Bay, Sydney, NSW 2011 Ausrailia	South Yarra, Melbourne VIC 3141 Australia
Phone	61-15-007-093	61-2-9361-6966	61-3-9827-1687
Fax		61-2-9361-6434	61-3-9827-6401
Owner	Anita Lowe	Darren	
Roster			
Talent Pool	Makeup Artists & Hair Stylists	Hair Stylists, Makeup Artists, Fashion Stylists, Photographers	Hair Stylists, Makeup Artists, Fashion Stylists
Notes			

AUSTRALIA	CAMERONS MANAGEMENT SYDNEY	CREATURE DESIGN + MANUFACTURER	DOLORES LAVIIN MANAGEMENT
Address	Suite 52, New McLean Street	Unit 1532, Ereton Drive	Apt 177-17 Cook Road
City, State, Zip	Edgecliff, Sydney NSW 2027 Australia	Labrador, Gold Coast Q 4215 Australia	Centennial Park, Sydney NSW 2021 Australia
Phone	61-2-9632-0100	61-755-289-300	61-293-607-165
Fax	61-2-9363-3317		
Owner	Marie Massengale	Sharron Walters / Bentley O'Toole	Dolores Lavin
Roster			
Talent Pool	Hair Stylists, Makeup Artists, Fashion Stylists	Makeup, Hair & Prop Stylists	Makeup Artists, Hair Stylists, Photographers
Notes			

AUSTRALIA	GOLD COAST FREELANCERS	KIT CAMPBELL	NEW FACES TALENT www.newfaces.com
Address	P.O. Box 7602	P.O. Box 320	Suite 32, 217 Chalmers Street
City, State, Zip	Gold Coast Mail Centre Q 4217 Australia	Paddington, Brisbane Q 4064 Australia	Redfern 2016 Sydney, Australia
Phone	61-755-922-434	61-411-181-833	61-296-991-848
Fax	61-755-920-142	61-733-022-358	61-296-988-435
Owner	Janis Sheen	Kit Campbell	Brigitte
Roster			
Talent Pool	Makeup Artists, Hair Stylists, Costume Designers	Makeup Artists, Hair Stylists	Makeup Artists, Fashion Stylists, Photographers
Notes			

AUSTRALIA	THE NAMES AGENCY	THE PLATINUM AGENCY	NOTES
Address	4/1 24 Warners Avenue	1 O'Briens Lane	
City, State, Zip	Bondi Beach, Sydney NSW 2026 Australia	Darlinghurst, Sydney NSW 2010 Australia	
Phone	61-291-304-400	61-293-601-677	
Fax	61-291-307-296	61-293-601-685	
Owner	Annabel Blackett	Emily Szabo or Niki Sang	
Roster			
Talent Pool	Makeup Artists, Hair Stylists, Photographers	Makeup Artists, Hair Stylists, Fashion Stylists, Photographers	
Notes			

FRANCE	JED ROOT EUROPE www.jedroot.com	PECLERS PARIS www.peclers.com	NOTES
Address	2, Rue Caffarelli	23, Rue du Mail	
City, State, Zip	75003 Paris, France	75002 Paris, France	
Phone	33 (0) 1 44 54 30 80	33 (0) 1 40 41 06 06	
Fax	33 (0) 1 44 54 93 92	33 (0) 1 42 36 12 76	
Owner			
Roster			
Talent Pool	Hair Stylists, Makeup Artists, Fashion Stylists, Photographers		
Notes			

GERMANY	BIGOUDI www.bigoudi.de	CLOSE UP www.closeup-agency.de	FAME www.fame-agency.de
Address	Jungfernstieg 40	Winterhuder Weg 138	Oettingenstrasse 30
City, State, Zip	20354 Hamburg	22085 Hamburg	Munich 80538 Germany
Phone	0049-40-357-4680	t49-040-229-47-93	49-0-89-295-952
Fax	0049-40-357-46810	040-229-47-959	49-0-89-295-954
Owner	Agentur Bigoudi	Dagmar Ropke	Katja Reichardt
Roster			30 Artists
Talent Pool	Hair Stylists, Makeup Artists, Fashion Stylists	Hair Stylists & Makeup Artists	Hair Stylists, Makeup Artists, Fashion Stylists
Notes			

GERMANY	GISELA MAYER GMBH	LAURA BREUER AGENCY www.laurabreueragency.de	OPTIX AGENCY www.optixagency.de
Address	Schwabenstr. 4	Karlplatz 3	Oelkersallee 11b
City, State, Zip	Memmingen 87700 Germany	40213 Dusseldorf, Germany	22769 Hamburg
Phone	49-8331-95-400	49-211-32-80-21	040-44-44-95
Fax	49-8331-47-091	49-211-32-05-00	040-44-54-34
Owner	Gisela Mayer	Laura Breuer	Kathrin Bredereke
Roster			
Talent Pool	Hair Stylists & Makeup Artists	Hair Stylists, Makeup Artists, Fashion Stylists	Hair Stylists & Makeup Artists
Notes			

GERMANY	PHOENIX AGENTUR	TOP AGENCE www.top-agence.de	NOTES
Address	Marienstrasse 4	Prinz Georgstr. 81	
City, State, Zip	D-80331 Munchen	40479 Dusseldorf	
Phone	089-21-63-31-0	02-11-46-30-55	
Fax	089-21-63-31-21	02-11-46-45-32	
Owner	Gabriele Greiter		
Roster			
Talent Pool	Hair Stylists, Makeup Artists, Fashion Stylists	Hair Stylists, Makeup Artists, Fashion Stylists, Food Stylists	
Notes			

GREAT BRITAIN	SCREENFACE	TERRIE TANAKA www.terrietanaka.com
Address	24 Powis Terrace	101 Talbot Road
City, State, Zip	London, W11 1JH Great Britain	London, W11 2AT
Phone	44-171-221-8289	44-207-792-3500
Fax	44-171-792-9357	44-207-792-2600
Owner	John Danvers	Terrie Tanaka
Roster		
Talent Pool	Hair Stylists & Makeup Artists	
Notes		

GREAT BRITAIN	UNTITLED www.untitled.uk.com	THE FLAT
Address	72 Wardour Street	3 White Hart Lane
City, State, Zip	London, W1V 3HP	London, SW13 0PX Great Britain
Phone	0171-434-3202	44-181-392-1718
Fax	0171-434-3201	
Owner		Yasmin Iqbal
Roster		
Talent Pool	Hair Stylists & Makeup Artists	Hair Stylists & Makeup Artists
Notes		

	AGENCE IMAGE MANAGEMENT www.agence.gr
GREECE	
Address	15 Karneadou Street
City, State, Zip	10675 Athens, Greece
Phone	301-729-2611
Fax	301-721-3354
Owner	Antigone Deliou
Roster	
Talent Pool	Hair Stylist, Makeup Artists, Fashion Stylists
Notes	

	TWA AGENCY S.R.L. www.twa-agency.com
ITALY	
Address	Via L. Muratori, 29
City, State, Zip	20135 Milano
Phone	(02) 541-20-505
Fax	(02) 550-12-605
Owner	
Roster	
Talent Pool	Hair Stylists & Makeup Artists
Notes	

	JED ROOT, INC. Chisato Hohno Management
JAPAN	
Address	902, Meguro Heights, 3-22-1 Aobadai
City, State, Zip	Meguro-Ku Tokyo 153-0042 Japan
Phone	81 (03) 37 93 70 30
Fax	81 (03) 37 93 72 86
Owner	
Roster	
Talent Pool	makeup, hair & Fashion Stylists, Photographers
Notes	

PORTUGAL	ARTISTS-THE CREATIVE NETWORK	L'AGENCE	STAND BY
Address	Rua de Santa Catarina, 34-3	Rua Coelho da Roch, 69 Pav. 12	Rue da Rosa 257-2o, Esq.
City, State, Zip	Lisbon, 1250 Portugal	Lisbon, 1350 Portugal	Lisbon, 1200 Portugal
Phone	351-1-342-8419	351-1-397-1719	351-1-343-0463
Fax	351-1-346-0489	351-1-395-2981	351-1-343-0464
Owner	Marilyn Alexander or James Dubec	Catherine Palmeiro	Margarida Miquel
Roster			
Talent Pool	makeup, hair & Fashion Stylists, Photographers, Full Production Service for Videos, Film + Print	makeup, hair & Fashion Stylists	Hair Stylists & Makeup Artists
Notes			

SOUTH AFRICA	MONOPOLE
Address	2 Camelot, 31 Exner Avenue
City, State, Zip	Vredehoek, Cape Town 8001 South Africa
Phone	27-21-461-0623
Fax	27-21-461-9137
Owner	June Sawyer
Roster	
Talent Pool	makeup, hair & Fashion Stylists
Notes	

SPAIN	PALM STUDIOS-AGENCIA DE MODELOS
Address	Calle Carlades, n 6, bajos
City, State, Zip	Palma de Mallorca, 07012 Spain
Phone	34-71-714-726
Fax	34-71-718-896
Owner	Maria Jablonski
Roster	
Talent Pool	Hair Stylists & Makeup Artists
Notes	

6 FILM & TELEVISION

by Tobi Britton

**TOBI BRITTON
MAKEUP ARTIST
THE MAKEUP SHOP
NEW YORK**

Everyone knows that I know more about print, video and television commercials than I do about working in film and television. So, instead of winging it with this 3rd edition of the Career Guide, I decided to enlist the services of 2 people who really know what's going on when it comes to what it takes to succeed in TV & film.

Please welcome Tobi Britton and Tate Holland. Tobi Britton is a very successful makeup artist in New York. For the past several years she has worked as department head on the Cosby show. Additionally she owns The Makeup Shop in New York where she retails wonderful makeup products and teaches classes and offers internships to aspiring makeup artists. The Makeup Shop is a wonderful place to learn and network and I use it as my home away from home whenever I am in New York.

As many things were changing with the union in Los Angeles, (the test has been sumarily dismissed) Tobi went to our other resident expert, Tate Holland, president of the Makeup Designory. The Makeup Designory fondly known as MUD, is an excellent school based in Burbank, California. They offer classes in makeup, hair and wardrobe styling. I personally visit there often when venturing into the valley and have become very used to impromptu talks with their students. It is a joy to see the students learning. At MUD they are challenged to do more, do it better, do it faster and with more precision than they did the day before.

Tobi Britton's Makeup Shop is a home away from home for the resident and visiting makeup artist in NYC. With a host of accolades from top fashion and beauty publications, The shop has become a thriving center of creativity for the art of Makeup and Hair. Whatever you need to get the job done, Tobi's got it. From makeup products to makeup classes that help you create the career of your dreams, you will find what you need (along with a smile) at The Makeup Shop.

Editorial Credits include Allure, Vogue, Cosmopolitan, Town & Country, Maxim, McCalls, Modern bride and Rolling Stone.

Tobi spent 3 seasons as key makeup artist on Cosby. Additional TV credits include David Copperfield, MTV Music Awards, Good Morning America and Inside Edition. Nike, Footlocker, Red Lobster, Chase, Tropicana, Polaroid, Seagrams, US Navy, Wendy's and Pizza Hut are some of the commercials on her reel.

THE SET

Concepts like continuity, script breakdown, bald cap, lace front wig and shooting in sequence don't mean anything to the print artist. Worrying about whether some guy's faux tattoo was on his right or left hand in a scene will rarely be the concern of a makeup artist, hair or fashion stylist whose primary work is in print, on videos and on TV commercials, but it will be yours if you've decided that film or television is for you. Furthermore, the majority of films made on American soil are done with union crews, and unions, like most fraternal organizations, are designed to keep you out, not let you in. However, with the help of Tobi Britton and Tate Holland the landmines that follow will be navigated with much more ease.

TOBI BRITTON
MAKEUP ARTIST · THE MAKEUP SHOP

CG: Tobi, tell me a little about the makeup classes that you offer at the shop. How do they differ from cosmetology and esthetic schools?

TB: I teach Accelerated Makeup Workshops. I do not run a traditional "School". My workshops cater to artists that do not have the time or finances to leave work for three months and attend school out of state. My classes are fast paced, packed with 100% useable information, and give the student practical information and help to get out there and work!!! After classes, many students take advantage of my intern program to help get their portfolios together. Cosmetology and Esthetic school's only function is to prepare the individual to pass a State Board Examination.

CG: Tell me more about this intern program.

TB: I started the intern program a few years ago to help students keep their brushes working after the classes had ended. The hardest part of starting up a career is doing a little bit every day toward your goal. It is really easy for "life" to take over and make you too busy to keep up with what you just learned

LIGHTS! CAMERA! ACTION! by Tobi Britton

If working on a film set or television show seems exciting to you, then read on! There are many opportunities in this category for you to create the career of your dreams, if you really want it badly enough. Please do not think that just "wanting" to work in Television and Film will be your one way ticket in, but it is the deciding factor as to whether or not you are cut out for this type of work.

As my Uncle Henry once told me at the tender age of thirteen- "There is nothing you can't do in life if you want it badly enough". "You see," he continued, "when you want something badly enough, you will be willing to do what it takes to see it through." At the time, I had no idea what a treasure Uncle Henry had given me. What he had actually done was to ignite within me the "POSSIBILITY" of someday succeeding- being a success. In a sense, he had given me permission to go for it, no holds barred.

From the outside looking into a career in the entertainment industry, everything seems fun and glamorous. Working on stars, traveling to distant locations, seeing your name in the credits- these are a few of the "perks" that go along with the job. But unless you have a driving desire to be a part of this industry, you will soon tire of the long hard hours, sometimes temperamental personalities, and of course, the endless "Hurry up and wait!".

On the other hand, if this is what you truly desire then your desire will keep you going, keep you motivated and most importantly- keep you smiling! You will be smiling because you are loving what you do and your smile is a by-product of that love. This will be true no matter what type of artist you become or in what medium you choose.

Why the pep talk? Well, the good news is that everything IS possible if you want it badly enough. The bad news is that getting a foot (or even a toe) in the door of this industry will not be easy. The great news is that this chapter will help you get you off to a promising start. Just remember- your career is up to you!

THE OL' UNION " CATCH 22"

You will probably first hear this phrase when asking someone how to get started in Film/TV. "Oh..." they will say "That's the ol' catch 22- to get a job you have to be in the union and you can't get in the union unless you have worked on a job." Well, cheer up. Ol' Mr. Catch 22 is only partly true. Yes it's true that to be accepted into the union you must have had a specific number of days worked on actual productions, but who ever said that the only productions on the planet were UNION?! In actuality, there are probably far more non-union productions than union pro-

ductions. Let's take a look at a bit of history.

IN THE BEGINNING...

In the beginning there were no unions. There also weren't many makeup artists. Most performers applied their own makeup as part of their craft. Lon Chaney did a heck of a job with his own makeup considering the non-existance of many professional makeup items we take for granted today.

As motion pictures began making more and more money, the performers and crews were being worked harder and longer, and in many cases under terribly unsafe conditions for rediculously low pay. We have all heard about the Little Rascal's kids and how they were given amphetamines to keep them lively and working long hours. When the unions were finally organized, their purpose was to create specific rules for the studios to follow in order to provide safety and fair wages for the folks that were making these pictures. As the unions became more powerful, they demanded more money. Eventually the studios found ways to cut corners and get around the union, and we find ourselves with the question-

UNION -VS- NON-UNION

There is no question that being a union member should be your goal, but don't start calling your local union office until you have an excellent working knowledge of your craft!!!. The reality is that you will have to play the system in order to achieve this goal. Playing the system means using non-union projects to reach your goal of finally becoming a union member. The union makes it difficult to get in so that the quality of work will always be high. If they let in just anybody, it would lower the level of professionalism. When a producer hires a union crew, he/she knows that a certain level of expertise will be guarenteed. When you are starting out you will be working on non-union projects, so let's take a closer look at them.

NON-UNION

These projects can range from very pleasant and professional, to horrible nightmares. However they turn out, they will become what's known as "paying your dues". Bad shoots can be very valuable if you learn from them. In the beginning you should take every job that comes your way in order to gain valuable experience. As time goes on, you will learn under what conditions you will or will not want to work. See, the reason that some projects choose to be non-union is because

TOBI BRITTON
MAKEUP ARTIST · THE MAKEUP SHOP

in class. By committing to intern only one day a week, the artist knows that at least one day every week is dedicated to career advancement. The intern program has become hugely successful and it is one of the things that I am really proud of. Every day photographers, producers and directors call the shop to use my interns. The word has gotten out!! In exchange for being sent out on shoots, the artist helps with the day to day workings of the shop. New interns are sent out with more experienced interns on shoots for a while, and then eventually- are sent out on their own shoots. Eventually, the day comes that "Mama Bird" (me) nudges the birdies out of the nest and watches them fly!

CG: Is the intern program open to only students of yours?

TB: In the past the answer was yes. I felt that I needed to send out artists that I had personally trained in order to insure the quality of work. Now I have begun accepting non-student interns into the program, but it takes them longer to actually be sent out on jobs because I have to become familiar with their skills first, and also get

CONT ON P 6.4

to know them as people.

CG: The Makeup Shop also sells professional products, how do you determine which products to carry?

TB: The Makeup Shop is actually a giant extension of my makeup kit. I sell only the products that I actually use on shoots- products that work well for me. I never liked "Selling" very much, so by carrying products that I love, it is easy to talk about them and sell them as well!

CG: What lines do you carry?

TB: I carry Kryolan, Ben Nye, Mehron, TIGI Hair Products, Yonka skin care, MD Formulations, Joe Blasco, Japonesque palettes and beautiful makeup boxes. I have a spectacular line of TB BRITTON brushes coming soon, and I just started carrying a few Reel Creations products as well as Thom Surprenant Creations Special FX makeup. He has awesome bald caps and pre-mixed pax colors for prosthetics. I also have my house line–Tb Britton Basics (shadows, blushes, lipsticks etc.) and I give nice makeup artist discounts on many products!

they either have a restricted budget, or the production company wants to make more profit from not paying you overtime or other union penalties. Think about it- if you make $300 for a 10 hour day, and overtime is $45/hr, the company can save $900/hr if they have a crew of 20 people that they don't have to pay overtime to! It's all part of the business. Although union jobs may be more desirable, the non-union jobs will help you qualify for the union someday. Still interested? Great! Lets explore what steps to take to get this career in gear!

GETTING STARTED: KNOWLEDGE

The first step to success is knowledge. Knowledge in this case is meant to mean that you have the skills, aptitude and experience to apply makeup in various settings. For instance; Beauty, Period, Fashion and Horror or Science Fiction. There are several paths that you can take. One is the path of gathering the knowledge you need through reading books and practicing on others and assisting those who can teach you. Another might be working at a makeup counter or salon and using your clients as your experimental canvas. And still another way is through a formal education with a school like mine or the Makeup Designory or the many other schools that exist throughout the US and abroad.

Like many successful makeup artists who work in film and television I went to school. The benefits of school are not just the skills that you gather but the opportunity to work with and meet other artists that share your interests and career choices. A school may also send work your way!

A good school can also open doors for you through their placement program. Most importantly, classes can teach you proper techniques and on-set etiquette that you won't learn from working at a counter or salon. TV and film sets are different environments than photo studios or runway shows. It is not enough to know how to do great makeup. You will need to know how to breakdown a script, put together a budget, negotiate rate and hours, etc. Whether you choose to do it on your own or get a formal education, here's what you'll need to know.

- Natural Beauty, Corrective Makeup and Blowstyling
 (these activities will represent the bulk of your work)
- Fashion Makeup, Hairstyling, updo's.
- Bald Caps, Wigs, Prosthetics, Blood Effects
 (These skills come up, but not that often. You will eventually have to know them. Check out skills required for the union exam.)

STUDY

If working on film is your passion, make sure you know the history of film; directors, actors, etc. Get a list of required textbooks for college film courses, or enroll in film school! You will definitely make connections there. Hey, you may wind up working for a future Steven Speilberg! Stage make-up books are very helpful in learning to breakdown a character. Richard Corson's STAGE MAKE-UP was the first book that I learned makeup from and is still known throughout the industry as "The Makeup Bible". Get to know your industry. Things like sitting in as a member of a TV studio audience is a great way to see first hand how a show is taped.

INVEST IN A KIT!

Whether you are a makeup artist, hair stylist or wardrobe stylist, in order to work (even for free) you must have a kit! I know that building a kit can be expensive, but you will find it awfully tough to complete a job if you don't have a kit?! So take a look at the following 4 pages. There you'll find a few lists of the things you'll need for your first makeup or hair kit.

LOOKING FOR WORK IN ALL THE RIGHT PLACES

Here's how to get work if you haven't already started! It's time to move yourself in the loop. These gigs are all free however, so don't quit your day job yet!

STUDENT FILM

Even if you do not live in NYC or LA, if you are near a college that has a film department you can see if there is any help needed on student films or for classes. Make sure to read the script first before agreeing to work since the material can sometimes be a bit wierd.

CABLE/NEWS STATION

If the college has a broadcast department, try volunteering for on air programming or classes.

LOCAL CABLE SHOWS/PUBLIC ACCESS

Most of these can surely benefit from properly applied makeup!

LOCAL CABLE COMMERCIAL PRODUCTION COMPANIES

Really corny, but it is experience and you may even get paid! (Probably better on your resume than on your reel)

CONTINUED ON P 6.11

TOBI BRITTON
MAKEUP ARTIST · THE MAKEUP SHOP

CG: Anything new to report?

TB: YES!!! of course Crystal, you know me! I am expanding my classes to be hosting other makeup artists to teach a variety of interesting classes. I recently hosted Thom Surprenant and the Last Looks Academy for a two day intensive special FX class (Incredible talent!), and of course there will be several "Packaging Your Portfolio Classes" coming up. I just added a Bridal Bootcamp class and a "Fashions in Drag" class that is a lot of fun! The Shop also now has a resident photographer who shoots digital headshots as well as film testings for my artists.

CG: Any advise to newcomers?

TB: Stay focused, crave knowledge, be responsible and professional and practice practice practice. **END**

**SUSAN LIPSON
HAIR STYLIST**

Susan Lipson has been a hair stylist in television and film for over 17 years. Her credits include "The Wonder Years", "Poor Little Rich Girl" with Farrah Fawcett, "Golden Girls" and "NYPD Blue" which stars my future ex-husband (just joking) Jimmy Smits.

In addition to her career as a hair stylist for film and TV, Susan recently founded On Set, a training academy for hair stylists who want to work in the motion picture and television industries. So here are Susan's tips for getting started in TV & Film.

CG: How did you get started?

SL: I sent my resume everywhere. You want people to see it. If it's there at the right time or if they've seen it enough times, they'll call you.

PROFESSIONAL MAKEUP KIT FOR FILM AND TELEVISION

1) Professional Makeup Case (a must for film, TV and print)
2) Range of Foundations
3) Neutralizers and Concealers
4) Range of Contour and Accent Colors
5) Dermablend Pallet
6) Translucent Face Powder
7) Setting Powder
8) Pancake Makeup
9) Dual Powder Foundation
10) Creme Rouge
11) Powder Blush
12) Lip Conditioner
13) Super Matte Antishine (dark and light)
14) Duo Waterproof Eyelash Adhesive
15) Eye Pencils
16) Lip Pencils
17) Brow Color
18) Rouge Stick
19) Scissors
20) New Skin
21) Breath Spray
22) Eyelash Curler
23) Brow and Lash Comb/Brush
24) Tweezers
25) Pencil Sharpeners
26) Variety Stipple Sponges
27) Visine
28) Mascara
29) Current Lip Colors
30) Current Eye Colors
31) Basic Manicure Supplies
32) Synthetic Mu Sponges
33) Sea Sponges (gradated)
34) Large Puffs
35) Natural 100% Cotton
36) Q-Tips
37) Disposable Mascara Brushes
38) Disposable Lip Brushes
39) Alcohol
40) Brush Cleaner
41) Pallet for Mixing
42) Hand Sanitizer
43) Kleenex (tissues)
44) Hand Mirror

Note: Your brushes are one of your most expensive and necessary investments. Purchase good brushes made of sable, squirrel, badger, camel or pony.

PROFESSIONAL HAIR KIT FOR FILM AND TELEVISION

1) Brushes — 3 different sized round brushes and flat brushes
2) Water Bottle
3) Combs — Rat tail, wide tooth, regular, teasing, cutting
4) Cape
5) Blow Dryer
6) Clips and Pins — Long clips, roller clips, hair pins, bobby pins (3-colors: golden brown, black and silver)
7) Clippers — Rechargeable
8) Trimmers — Rechargeable
9) Rollers: — Velcro, hot rollers
10) Products — Leave-in conditioner, gel, spray, pump and aerosol (laminate "cuticle smoother"), pomade
11) Scissors and/or Razor
12) Hair Accessories — Comb, clips, rubber bands (variety-leather, ribbon)
13) Curling Irons — Small, medium, large sizes
14) Marcel Irons — (3-4 sizes)
15) Heating Oven
16) Spray Gel
17) Laminates Spray

Options: Hair pieces, wigs, falls, extension hair, braids

Notes:

SUSAN LIPSON
HAIR STYLIST

They'll say, "Oh I've seen that resume before, let's call her." It's a constant thing that you have to keep up on and also showing up to places, and letting people see your face.

CG: What kind of "places"?

SL: Wherever you can find. When a production is shooting you show up. Walk in and say you want to see the hair and makeup people. Just go in and introduce yourself. Once people get to know who you are and that you're willing to come in and work, they'll call you. I did a lot of work for free. I went in for the experience just to learn.

CG: Really? Just go in to the pro-duc-tion office or walk in on the set?

SL: Yeah. Just introduce yourself to the hair and makeup people - NOT the producers. Because then you're undercutting someone. There's a certain etiquette that you have to maintain in this business. Never try and get above someone else that [is already in] . . . If you go in to see a producer and say, "I'm a hair or makeup person - call if you need someone for your next job" what you're actually saying is that you're available for work at a lower rate than the person they have right now.

SUSAN LIPSON
HAIR STYLIST

The producers are always looking for a way to lower costs. Fellow hair and makeup people are our friends, not the producers, we have to stand together. Producers have access to a lot more money than they tell us.

CG: It's the producer's job to get the most out of the money.

SL: At "On Set" we have a negotiating class. The people who teach these classes are incredible. I'm not good at negotiating. I get a phone call from a producer saying this is the show bla bla bla what is your rate? You have to know what to say at that point - you don't want to cut yourself short. I just get to a point and I say, "What are you offering?" And that's so stupid - because he could say $10 dollars an hour and then I'm stuck. You're putting it back in his lap.

CG: Who should an artist visit?

SL: If you're first starting out the "key" is the person you definitely want to talk to and make friends with. I went in and I was "day-checking" on a show.

CG: What's "day-checking"?

SL: It's when you are in a union, you're in between films or projects and you want to work a couple of days a week,

Additional supplies that you should have on hand and know how to use!

Acetone:	For blending bald cap edges and cleaning lace.
Adhesives:	Spirit Gum, Duo Surgical Adhesive, Water Soluble Spirit gum, Prosaide, Telesis Adhesive.
70%-99% Alcohol:	For cleaning, sanitizing, and removing spirit gum from utensils.
Baby Wipes:	For washing hands, cleaning counters and your kit and removing stains, etc. *Huggies Original is my favorite brand.*
Blood:	Liquid, squirt, dark and light, coagulated, dried, etc.
Castor Oil:	To mix with RMG to thin out.
Clown White:	Cake, grease or liquid, water soluble or oil based.
Collodion:	Flexible (sealer), Non-Flexible (Scar material)
Dermacolor:	Paramedical camouflage from Kryolan that comes in a great little palette. Used to conceal any kind of blemish, discoloration, undereye circles etc. Excellent for covering men's beard shadows when turning them into women. Waterproof and sweatproof when applied properly.
Naturo Plasto:	Mortician's wax used to fabricate quick injuries, cuts, and other fun stuff. Great for one time fast effects, but hard to maintain continuity for extended periods of time.
Hair:	Crepe wool, natural hair crepe
Yak:	Used to create beards, moustaches and other small hair pieces for the face and body. Yak may be ventilated onto lace or glued to the face. Crepe is applied directly to the face.
Eyedrops:	Sterile single use tubes are preferable.
Eyewash:	Sterile eyewash is important incase the eye has to be flushed out.
Eye Lashes:	Strip, clump and individual.
Nu Skin:	A spray-on bandage to seal cold sores or other "weeping or bleeding" things on actor's faces so you can conceal them properly.
Glycerine:	For tears, and sweat. (Do not get it in the eyes!!)
Hairdryer:	To dry adhesives, stipple and other things just in case.

Additional supplies that you should have on hand and know how to use!

Sunblock:	A 30SPF to put on actor's faces, necks, ears and other exposed areas when shooting outside. If you don't, you will have an actor who gets progressively redder as the day goes on and will never match in the edit.
PS:	It is the makeup dept's job to tend to all exposed areas of skin on the talent's body. Have a good one for the face that does not shine too much- try Yonka's Ultra- Protection SPF 25 or MD Formulations SPF 30. Make sure to have a cheaper version on hand for the crew!
Electric Razor:	Shaves actor's faces without water or nicking, and can be used over a finished makeup! Great for fixing that 5 o'clock shadow after lunch! Remember, cordless & rechargeable!
Lip Balm:	Used with a tissue to wipe away dead skin. Put it on the most horribly chapped lips before you start the makeup. By the time you are ready for lipstick, wipe away with the tissue and the rest will lie flat for you. Carmex is my favorite.
Hair Trimmer:	To clean up men's side burns and neck lines. (Fondly called, Buzzer)
Makeup Cape:	Don't leave home without it!
Moustach Wax:	You will probably never use it, but when you need it there is no substitute. You can also use it to help tame eyebrows.
Polaroid Camera:	A must for continuity. Even on commercials. Polaroid Spectra is a good one, move in really close and take the picture vertically. You can also use a digital camera, but always have a polaroid back up.
Removers:	You must have the proper removers for any adhesives that you carry.
Tooth enamel:	Black, stain, white.
Trauma Colors:	Bruise wheel, burn wheel, old age wheel.
Topstick:	Toupee tape.
Tuplast:	Scar material by Kryolan.
Latex	
Tweezers	
Water	

you put your name on a list with the union and someone who's on a show will call the union to ask for people who are day-checking.

CG: Who teaches the class?

SL: Mary Guerrero and Fay Woods. They work on a lot of sitcoms. Mary does "The Larry Sanders Show". She's one of the top hair stylists for sitcoms. Fay Woods is doing "The Nanny".

CG: What's the path for an artist who wants to get into the union?

SL: The union has changed a lot in the last seven years. They've opened up quite a bit. One advantage the union has, is that they set a minimum base work hour/day rate. Also the insurance is good. An artist has to prepare for this the union test. In the past if you failed the test you had to wait another year before you could take it again. Fortunately, that has changed, now you can take it as often as you like until you pass. It's good and bad. Some people complain that there is no rhyme or reason to what it takes to pass the test. The union wants you, but the union wants educated people.

SUSAN LIPSON
HAIR STYLIST

CG: I've heard that "On Set" is the only school that teaches you what you need to know to pass the union test the first time?

SL: Right. We have production and hairstyling classes. A lot of people don't know that in motion pictures and TV, you can do hair or makeup but you can't do both. In photography and non-union stuff you can do both hair and makeup.

CG: What about the actor request as a way to get into the union, does that still happen?

SL: Yes. It all the time. These are the people I'm encouraging to come to "On Set". It's really frustrating when you go through fifteen years of being in this business and knowing what to do and going on a set and having an actor's request come in and not know how to break down a script. They don't know that movies are not shot in sequence or the importance of continuity. Artists are coming into the union - and it's great. There's plenty of work. They just need to be educated about film versus print. If an actor watches their film and their hair has continuity, looks good and changes from period to period and scene to scene they're going to know

CONT ON P 6.11

BASIC SPECIAL EFFECTS KIT FOR FILM AND TELEVISION

1) Professional Makeup Case (small)
2) Prosthetic Makeup
3) Beard Block
4) Artificial Blood
5) Blood Capsules
6) Chinese Eyelids
7) Variety Crepe Hair
8) Plasto
9) Curling Iron
10) Duo Surgical Adhesive
11) Glycerine
12) Tubplast
13) RCMA Scar Material
14) Matte Adhesive
15) Eyebags
16) Assorted Appliance Pieces
17) Ben Nye Greases
18) Fresh Scab
19) Ben Nye Bruise Wheels
20) Fuller Earth
21) Clown White
22) Blasco Death Gray
23) AF Powder
24) Ben Nye Neutral Set
25) Various Liners
26) Lip Colors
27) Shading/Contour Shadows
28) Chopped Hair
29) Menthol Blower
30) Datex
31) Clear Sealer
32) Collodion
33) Prosaide (Prosthetic Adhesive B)
34) Allergy Relief Visine
35) Spirit Gum
36) Old Age Stipple
37) Latex
38) Mineral Oil
39) Medical Adhesive
40) Reel Creations Tattoo Colors
41) Hair Whitener
42) New Skin
43) Tooth Enamel
44) Assorted Black Stipple Sponges
45) Roux Mascara
46) Acgua Colors
47) Mascara

These are just a few great ways to get your makeup brushes working! You will gain valuable experience and may make a contact or two. Just remember, NEVER take a job that you do not want to do!! It will show on your face and in your attitude, and that is not the kind of impression you want to leave with people, no matter how seemingly small the job is!

I saved the union for last. You will have a long way to go before you are ready to think about it, or luck may shine apon you (typically regarded as a star [or celebrity] request) and you may be there in no time! My advise to all of you is to take your time, develope your skills, compete only against yourself, be open to help from others, give back along the way, enjoy the process and don't forget the sunscreen!

WHAT IT TAKES

Being a makeup artist for film and TV is much more involved than for print work. There are a lot of skills to master–even if you are only working on non-union shoots. All of the skills on the Union exam are commonly required from an artist while working on a film. The skills are also very valuable for print as well because you never know when you may be asked to do a bruise or a cut. The more you know, the more work you will have! Education is never wasted. Be a sponge and soak up as much as you can! In the mean time, here's what you need to know about membership, benefits and the test.

INSIDE SCOOP-IATSE NEW YORK

As I mentioned before, joining the Union should be a long term goal saved for when you have a lot of experience under your belt. Knowing what will be required of you is a priceless apriceless gift so you can start preparing and practicing. Here it is- the whole truth... the holy grail...the inside scoop
on the union testing procedure!

In order to be eligible to send in an application, you must submit verifiable proof (via pay stubs, 1099's etc.) that you have worked on professional sets for no less than 180 days within the last three years. Sorry, no exceptions. IATSE rules are that members may do either hair or makeup but not both. Keep that in mind when sending in your resume.

MEMBERSHIP

The makeup, hair and costumer's unions are controlled by I.A.T.S.E., (International Alliance of

CONTINUED ON P 6.14

SUSAN LIPSON
HAIR STYLIST

you're good. An actor might help you get in, but what about the next film you get because the producer calls you? You need to know what you're doing, how to break down a script and know what's being shot that day or next week and how to prepare.

There's so much production out there. Of our last offers, one came from a big studio, the rest were independent films - some weren't even union. There's a lot happening and changing. I want to raise the [level of] excellence in the profession of hair and makeup because I think that it is such an incredible craft.

CG: **And finally, can you tell me about some of the classes offered at "On Set".**

SL: We have; "Avenue of Interests" class, "Breaking into the Bus-iness, a "Portfolio" class, "Pro-duction Education" which teaches you continuity, how to break down a script and how to present yourself. Technical classes include; "Period Hairstyling", "Synthetic Wigs versus Human Hair Wigs", "Camera-Ready Hair and Fashion Styling", "Ventilating Wigs", etc. . **END**

TIPS FROM A PRO
SUSAN CABRAL
MAKEUP ARTIST

**ALIEN 3
WITH SIGOURNEY WEAVER**

Always come to work dressed and groomed as a professional. This is an industry, not a hobby. You will be given more respect. Leggings and a t-shirt or shorts are inappropriate for business, especially on a film lot. No actor or producerf wants to look at someone who doesn't even take 10 minutes to pull themselves together. You are a reflection of your work.

Be on time and always willing to help whoever is in charge. Whatever the task they assign you, remember that the camera sees everything and that it is all important. Never use the attitude "the camera will never see it."

Be sure your equipment is neat and clean and that your station looks organized. Learn a little self-discipline and it will go a long way.

Treat everyone with kindness and respect. From the craft service people and background artists to production assistants and teamsters, all of these people have very vital functions that are necessary to the project. We all use each other and we are **all** important.

Check your ego at the door. In the words of the director, Peter Weir, "The **film** is the ego." Learn to listen carefully and be able to translate as well as create.

Be willing to learn from others and never feel that your way must be the only way. Remember that there has been a

WHO'S WHO ON SET: Here is a list of people that you will be working with and what they do. It will help you avoid the embarrassment of asking the caterer if they know which scene is up!

Art Director: The person who designs or selects the sets and decor of a picture.

Agency: A collective term used on commercials to describe the group of people from the advertising agency hired for the commercial.

Client: A collective term for the person or group of people representing the company for which the commercial is being shot.

Best boy: Also first assistant electrician. The gaffer's principal assistant. The key grip's principal assistant is the best boy grip.

Cameraman: **(1)** The director of Photography, also called the "first cameraman"; see "cinematographer"; **(2)** a camera operator or camera assistant of either sex. The camera operator, who runs the camera, is the "second cameraman"; the focus puller is the "first assistant cameraman" or the "first camera assistant" first ac.; the clapper/loader is the "second assistant cameraman" or the "second camera assistant."

Cast: **(1)** All of the performers in a movie or show; (2) to select an actor for a role.

Caterer: The person/company responsible for preparing, setting up and serving the crew meals.

Craft Service: The food table that sits near the set all day long to keep us happy.

Cinematographer: Also Director of Photography, abbreviated D.P., and lighting cameraman. The head of the camera crew, responsible for supervising the lighting of the set and all details relating to the camera. The DP's job is to determine how the set is to be lit, and is responsible for maintaining the "Optimum photographic quality of the production."

Director: The captain and creative coordinator of the production team, responsible for the most effective use of production materials and personnel and often for the creative integration of camerawork, performance, and editing.

1st AD: First Assistant Director is directly responsible to the director, works in close cooperation with the UPM and is also responsible for maintaining coordination between the crew and actors so that the production stays on schedule.

2nd AD: Assists the 1st AD in production duties such as getting actors on set in a timely fashion, filling out contracts and releases, background action coordination.

Gaffer: Also key electrician. The chief electrician on the set.

Grip: A stagehand attached to the camera crew.

Independent producer: **(1)** One who produces a film and arranges for its distribution without studio support; **(2)** one who produces a film autonomously but has a financing or distribution deal with a studio;

Key: (1) Principal; (2) supervisory.

Key grip: The head of the grip category.

Line Producer: Is directly responsible for supervising a production; see "executive producer."

Principals: Actors who play the most significant speaking roles in a film.

Producer: The head and supervisor of a filmmaking enterprise; the person who hires and provides funds for the filmmaking team and who often owns and licenses the finished product; see "executive producer," "independent producer," and "line producer."

Production Designer: An art director who designs the overall look of a movie, coordinating and integrating its sets, costumes, props, and color schemes.

Production Assistant: "PA" entry level position which helps all departments and is directly responsible to the UPM or whoever he is assigned to.Production Associate (For TV &Video only): Directly responsible to producer and production manager, maintaining the efficient flow of communication as well as taking production notes,

Production Manager: The below:the:line producer, who approves production costs, handles the payroll, and reports to the line producer; sometimes an executive who delegates these responsibilities to one or more unit production managers.

Script Supervisor: Keeps track of what was actually shot and reconciles that with what was originally planned to be shot. She also times the takes to make sure they are not too long or short. Script is also in charge of the overall continuity and flow.

Still Photographer: Shoots still coverage of the production, crew, cast etc.

Set Decorator: Reports to the art director and supervises the property personnel.

Property Master: Is responsible for the care, storage and placement of props.

Set Dresser: Is the assistant to the Prop master.

Home Economist: Is responsible for the ordering, arranging and preparation of any food that may be served or consumed as part of the action in a scene.

Talent: The performers.

Teamsters: Men that are solely responsible for driving the trucks, campers, generators etc.

Wardrobe: The Costume designer designs and selects the outfits for the film. During the production, the Key Wardrobe person is responsible for the care, maintenance and storage of the costumes, as well as supervising the costumer or asst. wardrobe and the dressers.

Unit production manager: Also unit manager. An on:the:set production manager in charge of the day:to day functioning of a first, second, or insert unit and sometimes of an entire production.

**SUSAN CABRAL
MAKEUP ARTIST**

legacy of people before you and their knowledge of the craft is invaluable. The "old timers" have forgotten more than you'll ever know and the ability to learn from them will serve you in years to come. The new ways aren't always the best. Just look at "Hunchbank of Notre Dame" and remember when it was filmed.

Stay out of company politics and gossip as much as possible. It never really helps and you almost always get yourself in trouble. Listen but don't repeat.

Be prepared - sounds like a Scout's motto, but it's true. Do your homework and don't **assume** anything. If you have questions or are unsure of anything - ASK! People are always willing to help and it sure keeps you from being embarassed later on.

Remember that our department sets the tone for the day. Try to make everyon feel welcome and production will be that much easier. If someone is impeding the flow, graciously ask them to step out until you are finished - then they understand that we all need our time.

Be honest when dealing with your UPM or AD's. Give them honest answers when it comes to time or money. Actors are fickle, but UPM's and AD's never forget.

Be willing and thankful to be the second ("assistant" in the non-union field) person on a show. First of all, you're working. Second, you don't have the headaches and pressure of the department head. Third, you can probably have more fun, shorter hours and make decent

SUSAN CABRAL
MAKEUP ARTIST

money. Even if you're used to running your own shows, relax a little once in a while and help someone who needs and trusts your abilities.

Most of all, learn all the complexities of your craft. There are so many aspects, especially now. the industry changes daily and you have to be aware of those changes. Learn and practice all phases and don't pidgeon-hole yourself. The more abilities you have, the more valuable a commodity you become.

Learn protocol and manners on a film set. Don't assume that what was okay on one set will be okay on another. **END**

Theatrical Stage Employees). N.A.B.E.T., another union, stands for the National Association of Broadcast Employees and Technicians. Last but not least, the Costume Designers Guild represents, you guessed it costume designers.

I.A.T.S.E. PLEDGE, PURPOSE AND BENEFITS

The purpose of the union, as stated in the constitution and bylaws, is to achieve the improvement of the social and economic conditions of workers identified with the motion picture, television, theatrical and videotape industries of the United States and Canada. The union endeavors to insure the maintenance of a fair rate for all members in these industries, to secure benefits for its members, and pledges to manage the financial aspects of its members affairs as they relate to wages and working conditions.

This pledge, however, does not come without a price. How high, you ask? That depends on your personal and professional goals. A financial commitment is relative to the value of its desired result as compared to one's goals. For those of you who intend to dabble in film and television, the price may be too high. For those who see their future in feature film, television and movies like Dances With Wolves, the price may seem a small one to pay to fulfill a dream.

A big benefit of union membership is its influence and power over unscrupulous characters and companies who would have you working into the wee hours of the day and night for little or no remuneration. The watchful eye of the union forces production companies to strictly adhere to certain rules and regulations that govern an artists pay and working conditions. Those items include but are not limited to:

- How much and when you should be payed
- The timing and length of break periods
- The length of an appropriate time for meals
- Accrual and amount of overtime
- The distance you can drive to and from a location before the production company must begin compensating you for the wear and tear on you and your automobile
- Safe working conditions
- Reimbursement for expendables (known as kit supplies)

A recent development is the Television Commercial Roster, aka TCR. This branch of the Union which organizes television commercial is said to have sprung out of several production deaths that

occured in 1996 giving the Union the power it needed to organize TV commercial productions. Yes, union membership has its benefits, but there are two important things it does NOT do:

1. Get you work. 2. Recommend you for jobs.

These activities you must undertake on your own. Unlike the artist who has an agency that assists in securing and booking work for them, the union does not provide this service. Some movie and television lots are strictly union lots. Being in the union makes it possible for you to work on the projects produced on those lots. However, it is up to YOU to get the work. That means finding out which company is producing a show, who the decision-makers are, when the show goes into production, and other related information.

Once you become a union member, your name will be placed on the member roster. If a production company calls the union to request a list of its eligible members, your name will be on that list as long as you remain a member in good standing. That means you pay your dues on time, and don't violate any rules or regulations. The following pages will answer questions about:

1) Membership Classifications 2) Examination Requirements
3) Initiation Fees 4) Required Test Scores

I.A.T.S.E. covers three categories: 1. Makeup 2. Hair 3. Costuming

Within each of these categories, there are two types of membership in each of the three crafts: general and associate. A general member is an individual who has met all the requirements of the classification to which he or she is applying. An associate member is one who has applied for membership, but has not met the requirements of a general member as outlined. Upon meeting all other qualifications, each associate member shall take the appropriate examination for general membership.

MAKEUP & HAIR

The makeup & hair union covers all persons engaged in applying facial or body make-up, prosthetics or cosmetics of any description; as well as those involved in styling hair, both human and synthetic. They work in every phase of television, video, cable, film, and anywhere else the art of makeup and hairstyling is practiced. Membership in the makeup and hair locals is composed of four separate groupings:

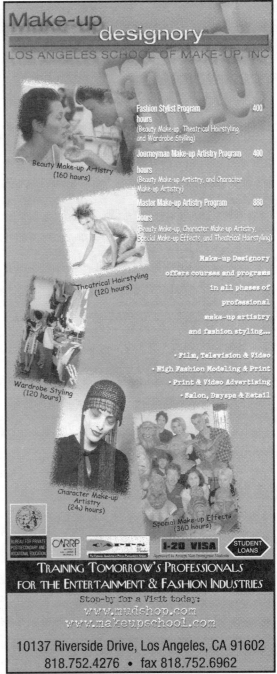

1) Facial Makeup Artists
2) Hairstylists
3) Body Makeup Artists
4) Wigmakers

The chart pictured on page 6-15 gives a breakdown of the makeup, hair and costume unions in some of the cities covered in this book. For more information about the unions, we suggest taking the initiative to call them yourself and request information. I.A.T.S.E. Local 798 in New York was the most helpful. They sent the information we requested right away, and suggested that each person interested in joining the union should call personally since everything including fees is handled on an individual basis.

In contrast to the familiar beautiful faces created by print makeup artists, a union makeup artist, whose skills must go far beyond beauty, may be called on to do that and more. Aging a 20-year-old girl thirty years through the use of prosthetics or special makeup effects is not an unusual request.

The term prosthetics is used to describe the act of changing or altering the structure of the body or face. If you saw the movie Mask that starred Eric Stoltz and Cher, or Batman Returns where they turned Danny Devito into the The Penguin, then you are aware of the impact that prosthetics accompanied with special makeup effects can have on turning an individual into a character. Simple examples of prosthetic makeup include a makeup artist creating a bulbous nose, scar or bruise. Wig makers, in addition to pulling together a simple wig hairstyle, may be called upon to create wigs for period films, such as Dangerous Liaisons or Gone With The Wind, or long, flowing tresses for rock stars.

Whatever your choice of crafts, the job of a makeup artist or hairstylist for film and television is as strenuous and rewarding as taking and passing any one of the list of exams that follow: There are five separate examinations:

1) Live television and motion picture makeup artists
2) Live television and motion picture hairstylists
3) Live theatre makeup artists
4) Live theatre hairstylists

PROCEDURES

The procedures and requirements for live television and motion picture makeup and hairstyling follow on pages 6.22-6.27. We hope that by having firsthand knowledge of what it takes to pass the rigorous exam, you can better prepare yourself for the task.

THE L.A. BUZZ - THE UNION by Tate Holland/The Makeup Designory

For a professional makeup artist developing a career in Los Angeles, the question of joining the

Makeup Artist & Hairstylist Union, Local 706, may become a major consideration. It is only necessary to join the union if you have an interest, the intention or the opportunity to work on productions that are under union contract. Membership is based on the level of experience and the types of work being sought.

Typically, union contracts are limited to the major broadcast networks for television, certain live theatrical productions, and to large multi-million dollar film productions. The majority of cable television, music videos, infomercials, and a vast majority of low-budget independent films are non-union productions. Practically all print advertising, editorial, and runway work is non-union. Many professional makeup artists make their careers in these areas, without needing to join the Union.

If you are determined that union membership is important to your career, then you will need to consider of the three primary avenues for qualification into Local 706. All considerations must go through Contract Services:

A.　Getting in the Union with Non-Union Experience:

The makeup artist must work 60 days per year, 3 years out of the past five (from date of application) on non-union film and television productions, which air on local or national television broadcast, cable television, or plays at a box office theater. All work must be "work-for-pay", contracted in the County of Los Angeles.

The make-up artist must present the proper records to Contract Services to support days works. These records include paystubs, 1099 records, W-2 forms, and photocopies of personal checks used to pay for work. Call sheets "may" be accepted by Contract Services, on an individual basis, to verify days works on specific productions.

When approved, Contract Services will notify Local 706. Once the Local is notified, the Local will send an invitation to the make-up artist to be considered for membership.

B.　Union Commercials:

Any 30 days of accrued work on Union Commercials qualifies for application for membership. All work on Union Commercials completed since November 1996 is eligible for consideration. Upon completion of 30 days, the individual makes application to Contract Services. When the application is accepted by Contract Services and Local 706, a Commercial Union Card will be issued, enabling the makeup artist to work under commercial contracts–not under film or television contracts.

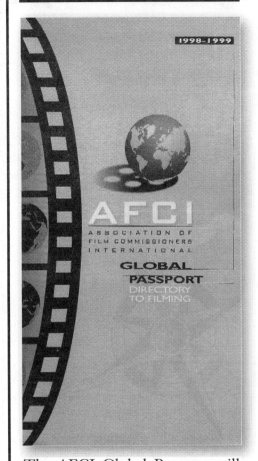

The AFCI Global Passport will connect you to every Film Commission in the world. It's a great way to get connected to the production community and find out what's going on in your area. You can also get the phone number and address to your local Union.

An Interview with
Monet Mansano
Makeup Artist

CG: Monet, tell me how makeup artistry differs in the United States versus Europe.

MM: When I came to Los Angeles 16 years ago I was already an established makeup artist doing print such as for Elle magazine. Then I moved to television and finally to film . . . I worked on many French movies. I worked for Carita - it was one of the biggest salons in Paris. When I came here I became the head of a studio department to hire makeup artists and to budget the movies and do some of the makeup . . . when I start hiring people I found that [makeup artists] here in the United States - it takes them two months, maybe going to UCLA to become a makeup artist. In Europe, it's a completely different system. You go to school for three years and then you become an assistant . . . In the United States, people

After an additional 90 days of Union Commercial work or non-union films, the individual is upgraded to "Trainee". Then, when available, the individual must attend continuing education classes provided by Contract Services for eligibility to Journeyman makeup artist status.

C. NON-UNION TO UNION PRODUCTION or A QUICK WAY TO GET IN IF YOU'RE LUCKY

If a makeup artist works on a Non-Union production which is upgraded to a Union production, the individual must complete 30 days with the production during the union period, to qualify for union membership, as a Trainee. Then, when available, the individual must attend continuing education classes provided by Contract Services for eligibility to Journeyman make-up artist status.

ELIGIBILITY

To determine your eligibility, you must send your resume to the screening committee at the local Union office.

Please do not waste the union's time by calling if you do not have the required days and/or skills yet that are outlined in this chapter. The union office is very busy, and my purpose in providing this hard to get info is so you may have an accurate guide in determining when you are really ready for them to consider you. Please respect this.

The Screening Committee reviews resumes every six months or so. They are looking for makeup artists and Hair Stylists with practical experience in film, commercials, television or theater. Although print work falls outside of Union jurisdiction, if you have this experience, it should be listed on your resume. IMPORTANT! Makeup in salons and department stores is NOT applicable!

If the screening committee is interested in your resume, they will call you for an interview. At that time you must bring with you proof of employment as a makeup artist for at least 180 days within the last three years. This proof may be in the form of paystubs, W-2 forms, call sheets with your name on them. This is a NON-NEGOTIABLE requirement. Letters from producers or production managers are not accepted.

SEMINAR AND EXAM

When you have received approval from the screening committee you are eligible to attend an Exam Seminar. You may not attend if you have not received approval. Please do not send a resume and then hound them with phone calls!

A description of the makeups to be demonstrated will be provided prior to the class. (Included in this chapter!) You may use this information to practice for your test. Attending the seminar is not a requirement for taking the Exam, but is highly recommended.

Note: While preparing to write this chapter, I spoke to Sharon Ilson about the pre-Exam Seminar. She had arranged for a class to be available to the applicants before an Exam. None of the applicants were interested, so the class was cancelled. When the Exam came about, Sharon couldn't believe the poor quality of work presented, and not one person thought that they needed a class! Needless to say, not one person passed that particular exam. Sharon told me that when she was preparing to take her own union exam, she let not one detail go unnoticed. She blended her own hair for the beard laying. She hand ventilated her moustache. She even made her own bald cap! As president of the union now, as well overseeing the the Screening Committee, she cannot understand why many makeup artists today just do not make the effort to practice, get educated and put in the time. Keep this in mind dear reader.

The Seminar will demonstrate the makeups and the quality of work that will be expected of you on the exam. After select sections are demonstrated, you will be applying these makeups to the models that you will provide. During the Seminar, Journeyman Makeup Artists will evaluate and discuss your work with you. This is your opportunity to fine tune your applications. The Seminar will help you decide if you are sufficiently prepared to take the actual exam. Keep in mind that doing well in the class will not guarantee passing the exam!

You will be notified by the Screening Committee of the dates for the Makeup Seminar and exam. There will be a fee for the testing process and the actual Exam. This exam is intended to ensure the highest standards of the Union, and to maintain our standards of professionalism. Keep this in mind as you practice and prepare for the exam, and first, and foremost, remember these standards are for your benefit. You will be the one learning

MONET MONSANO

go to [makeup] school for one or two months and come out believing they know everything. But when I was inter-viewing makeup artists - they would say yes I know this and yes I know that. But on closer examination, a lot was missing from their technique. This is the reason why I opened the Makeup Academy of Hollywood. I don't promote the school, people come to the school by word-of-mouth. I get 15 to 20 calls from people, I do do be-ginner's classes about once a year. I receive many calls from all over the US. From this I take 15 students and interview them. I don't tell them, "You could be rich and famous . . . " I am very honest with people. I tell them about the long hours, the smoke, about being upset when you can't create, and about not getting enough assign-ments - I tell them about every-thing . . . I tell them about the bad things and I tell them about the good things, and when I tell them about the bad things about two thirds of the interviewees leave.

I tell them that the movie business is like big circus wheels spinning very fast and if you learn your basics very well - you will be able to hang on to those wheels. If your work is weak, it will be a long time between movies. If I tell them that they will be rich and that they will work with the biggest actors - that would be a lie.

Hollywood is a small town and everyone knows who is a good make-up artist - everyone else is forgotten.

CONT ON P6.24

CG: Do you keep track of your students?

MM: It's very hard, but a lot of them call me and ask me for advice. Some of them today are doing excellent work. Plus, as a makeup artist myself, I was teaching some of the union people.

CG: Have you ever hired any of your students to work with you?

MM: When I myself am working on a movie, I'll take some of my students, or my wife takes some of the students - they can get their feet wet on small $3 or $4 million movies.

CG: What are some of the movies you've worked on?

MM: When I was young I did a lot of historical movies. I worked on "Jesus Christ Superstar", "Hook", "The Addams Family", "Mortal Kombat". I was nominated for the movie "Runaway Train".

CG: What else is going on in this fabulous Melrose location?

MM: I have the school and the shop and I have a makeup line . . . I've tried many many different kinds of makeup in my career as a makeup artist. I would go to the mall and buy more and more makeup even if I don't need it . . . I just love makeup. But over the course of years of trying so many different kinds of makeup, I would find that a makeup would have great color but poor tex-

CONT ON P6.25

from the experience of members whose credits and years of experience speak for themselves.

THE LOCAL 798 FULL SENIORITY EXAM SCORING SHEET

Here is a sneak preview of what is in store for you should you ever wish to take the Makeup Union Exam for New York. California has done away with their exam, and applicants must go thru a series of classes that at the time of this printing were not available! Union policies can change from month to month depending on the results of the meetings since each local is autonomous. For your reference, the following is a complete listing, by test section of each element to be graded by the judges. The makeups are to be judged as "camera ready" for the medium of Motion Picture.

Judging is on a 3 point scale as follows:

3 = Excellent
2 = Good
1 = Minimally acceptable
0 = Unacceptable

PROCEDURE FOR LIVE TELEVISION & MOTION PICTURE MAKEUP ARTIST'S EXAMINATION

THE EXAM

1. KIT INSPECTION

Your kit, materials, and equipment must have a professional appearance. Everything must be clean, look neat and orderly. You must bring all the equipment and materials necessary for complete application and removal of all the makeups. Remove or conceal all identifying marks.

2. CORRECTIVE BEAUTY • 30 Minutes limit-Female model

Applied over clean, makeup free skin, this must be a natural looking makeup worn by an actress appearing in feature film or TV soap opera. No high fashion model or runway looks. The colors should be natural. No single element of makeup must call attention to itself. All elements must be balanced and well blended.

Foundation: It must match the model's skin color and be appropriate for her complexion. An even and smooth amount necessary just to cover minor flaws. It should not look heavy. It should blend to cover the neck and ears as well. It should not end at the jaw line.

Corrective: Subtle and appropriate use of hilight and shadow for contouring. Discoloration and blemishes are covered and blended

Blush: Appropriate choice of color, placement and blending. It must compliment the rest of the makeup.

Eyes: Placement, blending, and choice of color appropriate to compliment the eyes. Application of mascara and eyeliner.

Brows: Shaping and application of color as needed.

Lipstick: Appropriate color, shape, and application. Minor flaws are corrected as well.

Overall Effect: The makeup should be harmonious, subtle and complimentary. The overall effectiveness will be graded.

3. PERIOD CHARACTER MAKEUP • 40 Minutes-Female Model

Removal of some or all corrective makeup may be required. This is a period makeup. The instructors at the seminar will discuss the periods and styles appropriate for the exam. Reference photographs and materials as examples of the makeups you will do will be required. Bear in mind that the application of false eyelashes-Strip not individual is required for this section. Plan your makeup accordingly. **You will be**

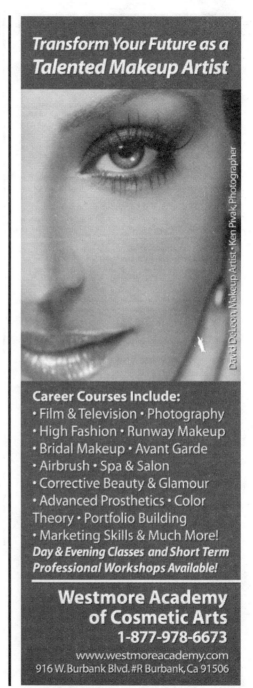

Come and visit our website **MakeupHairandStyling** .com to stay informed of hot new developments, news, trends and tips. Get advice on career planning, self-promotion along with up-to-date product developments and feature stories on your favorite artists; People like Monifa Mortis, Phillip Bloch, Sam Fine, and Oribe. We recognize free-lancers for the work they do behind-the-scenes in print, video, TV, film and fashion. (323) 913-3773. **www.MakeupHairandStyling.com.**

PROCEDURE FOR LIVE TELEVISION & MOTION PICTURE MAKEUP ARTIST'S EXAMINATION

graded on the following:

Foundation: It must match the model's skin color and be appropriate for her complexion. An even and smooth amount necessary just to cover minor flaws. It should not look heavy. It should blend to cover the neck and ears as well. It should not end at the jaw line.

Corrective: Subtle and appropriate use of high light and shadow for contouring. Discoloration and blemishes are covered and blended

Blush: Appropriate choice of color, placement and blending. It must compliment the rest of the makeup.

Eyes: Placement, blending, and choice of color appropriate to compliment the eyes. Application of mascara and eyeliner.

Brows: Shaping and application of color as needed.

Lipstick: Appropriate color, shape, and application. Minor flaws are corrected as well.

Overall Effect: The makeup should be harmonious, subtle and complimentary. Overall effectiveness will be graded.

Research: Accurate materials relevant to your character makeup.

4. OLD AGE STIPPLE APPLICATION & COLORATION • 60 Minutes-Female Model

Removal of some or all of the Period makeup may be required. You need to age your model only as much as you can without making her look unnatural or stagy. Only one side of the face needs to be aged. The effect must be from hairline to collarbone. Stipple should only be used in realistic amounts in the proper placement. Graying the hair may be necessary. You may not use theatrical wrinkling materials such as cotton and latex, collodion, or tissue paper and latex. No pre-made appliances allowed. **You will be graded on the following:**

Texture: Must have an appropriate and natural degree of texture according to the area of the face.

Tobi's Note: In addition to the above, you should also adhere to sanitary practices such as using brand new sponges, puffs & expendables. Work habits and the way your station looks during the exam can have an effect on your score. Wear comfortable, professionally conservative clothing. Don't be too trendy or look as if you are trying to call attention to yourself. Female artists should avoid low cut, high cut or overly revealing clothing. The test is about your makeup skills, not your dating skills! Men should look clean and neat. Watch your fingernails. Don't wear too much jewelry. A protective smock (the kind that hairdressers wear) is a good idea. Thoroughly prepare for this test. The current president of the union practiced for a full year before taking the exam. She is a good example to follow.

PROCEDURE FOR LIVE TELEVISION & MOTION PICTURE MAKEUP ARTIST'S EXAMINATION

Technique: Wrinkles must fall in the correct direction according to the areas of the face.
Coloration: Must be appropriate. Hilights and shadows placed correctly, and look natural according to the facial anatomy.
Character Coloration: Detailing- freckles, liver spots reddening blotches etc realistic.
Overall Effect: The degree of aging and natural appearance achieved.

5. MALE MODEL

1a. LACE SIDEBURNS APPLICATION • 15 Minutes-Male Model

This must be lace sideburns of reasonable quality. You may ventilate it your self if you wish. The quality, texture and color of the hair are important in relation to the model. A lighter hair color may adjust more easily than a darker one. The lace should be trimmed properly so that it lays flat and is easily glued. The sideburns may be styled prior to the exam, but must have a natural appearance to the model. **You will be graded on the following:**

Color: It must be appropriate to the model's hair and complexion.
Cut: The sideburns should be trimmed and cut to appear natural.
Styling: The hair should have the proper crimp and texture for sideburns. It must be curled and dressed realistically. A Marcelle iron heated in an oven is to be used. No Sterno or open flame allowed.
Edge: The lace edge must be concealed. The edge of the lace needs to be trimmed properly. You may have to lay hair to obscure the edge.
Adhesive: The adhesive must not be shiny. You may nor used toupee tape.
Overall Effect: The degree of realistic appearance achieved.

1b. OLD BROKEN NOSE 30 Minutes- Male Model

Use soft modeling materials. No pre-made prosthetic pieces. The material is to be sculpted, blended sealed and textured realistically. Skin color must blend to model's. Do not color as a bruise or injury, it is an OLD broken nose. **You will be graded on the following:**

Placement: Realistic shape and sculpting
Edges: Well blended. Unnoticeable.
Coloring: Must blend naturally to face. Subtle use of highlight and shadow.
Texture: Effective use of realistic texture.

GRADING

Excellent	100 - 95
Very Good	94 - 85
Good	84 - 80
Satisfactory	79 - 70
Unsatisfactory	69 <

PROCEDURE FOR LIVE TELEVISION & MOTION PICTURE BODY MAKEUP EXAMINATION

Overall Effect

1c. BLACK EYE, FRESH CUT & OLD SCAR • 45 Minutes- Male Model

Black Eye: The bruise is 2-4 days old. Does not have to be raised. Subtle use of color should suggest dimension. Reference photos extremely helpful. **You will be graded on: Placement, Coloration & Overall Effect**

1d. FRESH CUT

Use soft modeling material, prosthetic piece or a combination of materials. Prosthetics may be used for either the cut or scar but not both. Must have dimension, not just paint. It should be dressed with blood but not too much. It may be an incision or laceration 1-2 1/2 inches long. Either on the face or neck but not the forehead.**You will be graded on: Coloration, Edges, Blood & Overall Effect**

1e. OLD SCAR

Keloid type, naturally appearing like a healed injury, not a fresh one. You may use a prosthetic piece, collodion, soft modeling material or a combination. Use any part of face or neck.**You will be graded on: Coloration, Edges, Overall Effect**

2a. BALD CAP

The appearance of the result is the most important thing. If you can do a better job with latex than plastic caps, then use latex. Bring extra caps just in case. Repair any tears as you would in a real life situation on a shoot. Pax is the recommended material, but you may use any product of choice. Do not apply makeup to entire face. You may NOT airbrush. Cap is to be finished with a shaved head stipple.**You will be graded on the following:**

Application and Fit: Cap must be taut and smooth. Hair texture must not show through. No ridge showing at hairline. No wrinkles.Ccheck ears.
Edges: Glued all around, on the top, sides and back. Edges must blend and be invisible.
Texture: Stipple for realistic texture.
Coloration: Hair must not show through cap. Freckles, veins etc. must look natural.
Hair Stipple: Either chopped hair or stipple color. Even and smooth, not spotty.

PROCEDURE FOR LIVE TELEVISION & MOTION PICTURE BODY MAKEUP EXAMINATION

Overall Effect

2b. HAND LAID BEARD • 90 Minutes-Male Model

The beard will be on one half of face. Yack or Human hair only. No wool crepe in braids. No goatees. It should be a full beard that blends up to the sideburns. A Marcelle iron heated in an oven is to be used. No Sterno or open flame allowed. You will be graded on the following:

Color: Appropriate in relation to model's hair, skin and lace moustache. Color should be varied and blended. Different parts of the face may have subtle color differences.
Technique: Hairs laid in correct direction of growth according to face area and neck. Thickness should be natural, not sparse, thick or choppy.
Styling: Must be curled in sections with an iron for natural volume. No iron marks. Gently blend. (Your beard will often be yanked to test the strength.)
Cut: Neatly trimmed and shape balanced.
Adhesive: must not be shiny.

Overall Appearance.

2c. BEARD STUBBLE & FATIGUE

Your model must look as though he has not slept or shaved in at least 24 hours. The coloration should appear natural. Beard Stubble is of the chopped hair variety. No flocking guns. **You will be graded on the following:**

Beard stubble in proper amount for 24 hours. Realistic growth pattern. Must not be spotty or uneven.

Hair/Color: Correct color and length.
Signs of Fatigue: Circles under eyes etc., must look natural, not stagy.
Overall Effect.

There you have it! Being a makeup artist for film and TV is much more involved than for print work. There are lots of skills to master even if you are only working non-union shoots. All of the skills on the Union exam are commonly required from an artist while working on a film. The skills are also very valuable for print as well because you never know when you may be called to do a bruise. The more you know, the more work you will have! Education is never wasted... Be a sponge and soak up as much as you can!

ture. Or I would find a makeup with good texture but with poor color - something was lacking. So I created my own line of makeup. I didn't think it would be very expensive, but it turned out to be. I found two partners and con-vinced them, with me and my wife's long experience in makeup, that I could create something unique. I would create it for both the fashion industry and for every lady and young girl on the street. The first estimate I got was $300,000 to create it - but afterward it turned out to be over a million dollars to do it. It took a lot of testing and trial and error.

CG: What's it called, and is it available right now?

MM: Makeup by M. Monet, and yes you can get it right here at Image Exclusives, or in our West Hollywood store on Santa Monica Boulevard. It's also in other stores, in Europe and in Australia where it does very very well.

CG: Do you have many products in your makeup line?

MM: Yes, twenty-four.

CG: What services do you offer here at the store?

MM: Makeup artists can order and we will deliver to the studio. We ship everywhere. We give professional advice and we can also show people how to do specific things. We let them con-

CONT ON P6.26

MONET MONSANO

sult with us on exactly what it is they need to get. There is always someone here who can give professional advice. I also have a lot of ready-made prosthetic pieces. We can even create prosthetics for people at our lab, and we do aging. We have hand-made lace wigs - and a very big collection of wigs I acquired from Italy and France - we rent them out. We have ventilated Vanowen beards that look very very realistic and are made hair by hair. I am here personally two or three days a week.

CG: Monet, what would you like to share with someone who is just starting out?

MM: Being a makeup artist is the hardest thing. You get frustrated because you are given a small budget that makes it hard to do everything perfect. You can't take it personally. You have all the time in you life to reach perfection - take your time and don't give up. Don't let the producer influence you to compromise on quality by buying cheap products. If it turns out badly, you will be stuck with the blame. People will say you are a bad makeup artist. Everyone will remember that bad job. The studio will never call you back. Learn to walk away from projects that have the potential to create that kind of situation. ALWAYS use good products. **END**

PROCEDURE FOR LIVE TELEVISION & MOTION PICTURE HAIR STYLIST'S EXAMINATION

(a) The examinee shall furnish a suitable (non-shingled haircut) female subject approximately 30 years of age; however, he/she shall not work on said subject except under such conditions that only one (1) person is taking the examination. The Chairman of the Examination Committee and the Executive Board member present shall have the right to disqualify an examinee or require him/her to work on his/her furnished subject if, in their opinion, the examinee has not provided a suitable subject.

(b) The examinee shall provide own hairgoods necessary for the examination as designated below:
1. One-half or three quarter fall
2. Hair lace front wig

All hairgoods need not match model in size or color since models are switched. Please label hair pieces so that they can later be returned to you. Applicants shall also provide their own hairstyling kits, including croquinole iron. Please note, however, NO HOT ROLLERS, ELECTRIC IRONS OR WIG CAPS MAY BE USED. No hair goods to be previously combed out.

(c) The Chairman of the Examination Committee shall inform the examiners that no grade under fifty (50%) percent shall be permitted at any time.

(d) The Live Television Hairstylists examination shall consist of a session of practical applications where each examinee shall be required to perform the following:

DESCRIPTION	TIME
1. CASE & PERSONAL EQUIPMENT EXAMINATION	NO TIME LIMIT

At the beginning of the examination, the applicant shall submit his/her working case and lay out the equipment for examination.

2. WIG BAND	30 MIN.

The applicant shall prepare the subject's head for a wig band and apply the band.

3. HAIR LACE FRONT PERIOD WIG	60 MIN.

The applicant shall apply and comb out a lace front wig. (This must be done after wig is applied).

4. FALL APPLICATION	30 MIN.

The applicant shall apply a half or three-quarter fall on the subject and dress same.

5. CROQUINOLE	45 MIN.

The applicant shall croquinole one-half of subject's hair. NOTE: Do not comb out or style until after work is inspected.

6. PERIOD HAIRSTYLE	60 MIN.

The applicant will comb out the croquinole and create a period hairstyle designated by the Committee from the following list:
a) 1905 - 1912 b) 1920 - 1923
c) 1844 - 1850

7. CLEAN ENTIRE HAIR LACE BUT BLOCK ONLY ONE SIDE.	20 MIN.

PROCEDURE FOR LIVE TELEVISION & MOTION PICTURE HAIRSTYLIST'S EXAMINATION

COSTUME DESIGNERS GUILD

FUNCTION OF THE COSTUME DESIGNERS GUILD

The Guild is available to assist its members in anyway that it can. The Costume Designers Guild does not function as an employment agency. The Guild is not responsible for finding work for its members, nor can it recommend a member for a position over any other member.

The Guild maintains an availability list. The availability list is sent out upon request, with a copy of the directory.

The Guild negotiates the basic IATSE/Producer contract; i.e. minimum wage, health and welfare and other working conditions. The Guild polices the IATSE contract and acts as an arbitrator between its members and the employer, should the IATSE contract be violated.

A. The following are the requirements to apply for membership. You must qualify in one (1) of the three (3) areas listed below:

1. You must have at least three (3) verified screen credits (commercially released) as a Designer/Assistant Designer on film or television productions. (Commercials and Rock Videos not acceptable.)

2. Costumers from Local 705 must have completed at least three (3) verified productions in which you have solely supervised both men's and women's costumes. (Productions that did not have a costume designer.)

3. You must have at least three (3) verified program credits (commercially released) as a Designer/Assistant Designer on stage productions, and two (2) verified screen credits (commercially released) as a Designer/Assistant Designer on film or television productions. (Commercials and rock videos not acceptable.)

B. If you meet one of the requirements listed above, submit the following to the Guild office:

1. Completed Application.
2. One (1) copy of your resume.
3. Three (3) letters of recommendation for your claimed credits from directors, producers, unit production managers or costume designers (Assistants Only). The letters must:

MONET MONSANO

. Reference the production name
. Confirm your job classification
. Be signed, and on letterhead
. Be a commercially released production

4. Verification of screen and/or program credits, if not provided within the letters of recommendation. (Acceptable verification deal memos, crew list, and/or program).

5. Requirement qualification form.

6. A portfolio including no more than 20 examples of work. These examples must include designs for men and women, period, modern and character clothes. Sketches should be swatched and if possible, photographs included of the completed costumes. Please indicate if costume designs are yours or are designs by a costume designer. Indicate if you have used a sketch artist for work represented in your portfolio.

C. Please submit items from "B" by (date will be specified by Guild). The committee will review your information and if all requirements have been met, the project will be mailed to you on (date will be specified by Guild). After that date, contact the Guild office if you need to pick up your portfolio. You will have to bring it back for the interview. Interviews take place on (dates will be specified by Guild) and dates are subject to change.

(If you are applying as an Assistant Costume Designer you are not required to do the project if you do not wish to at this time. But if and when you want to upgrade to Costume Designer; you must complete the project requirements.)

LEADS

A good way to complement your prospecting efforts for television and film projects is by subscribing to one of a dozen or so pre-production leads service providers. These services provide from 35 to 50 weekly listings of pre-production leads complete with addresses, contacts and phone numbers. The information they provide includes: Shoot & Wrap Dates • Locations • Union • Affiliation • Genre • Budget Information

From time to time special services are offered free of charge to new subscribers. Ask if they have any special offers available at the time you subscribe. Following are 2 you might try:

PRE-PRODUCTION LEADS SERVICE PROVIDERS

SHOCAST PRODUCTION SERVICES
(310) 271 - 2153

WESTCOAST PRODUCTION NEWS
(310) 285 - 9756

PRODUCTION WEEKLY
(323) 860 - 8865
http: //users.aol.com/prodweek
E-MAIL: prodweek@aol.com

UNIONS	MAKEUP ARTISTS & HAIR STYLISTS	COSTUMERS	COSTUME DESIGNERS
LOS ANGELES, CALIFORNIA	I.A.T.S.E. LOCAL 706 (213) 877-2776	I.A.T.S.E. LOCAL 705 (213) 851-0220	THE COSTUME DESIGNERS GUILD (818) 905-1557
NEW YORK CITY, NEW YORK	I.A.T.S.E. LOCAL 798 (212) 627-0660	I.A.T.S.E. LOCAL 764 (212) 221-1717	THE COSTUME DESIGNERS GUILD (818) 905-1557
CHICAGO, ILLINOIS	I.A.T.S.E. LOCAL 476 (312) 775-5300	I.A.T.S.E. LOCAL 769 (312) 477-4952	THE COSTUME DESIGNERS GUILD (818) 905-1557
SEATTLE, WASHINGTON	I.A.T.S.E. LOCAL 488 (206) 448-0668	I.A.T.S.E. LOCAL 887 (206) 443-9354	THE COSTUME DESIGNERS GUILD (818) 905-1557
MINNEAPOLIS, MINNESOTA	I.A.T.S.E. LOCAL 13 (612) 379-7564	I.A.T.S.E. LOCAL 781 (612) 426-3968	THE COSTUME DESIGNERS GUILD (818) 905-1557
HONOLULU, HAWAII	I.A.T.S.E. LOCAL 665 (808) 596-0227	I.A.T.S.E. LOCAL 665 (808) 596-0227	THE COSTUME DESIGNERS GUILD (818) 905-1557
DENVER, COLORADO	I.A.T.S.E. LOCAL 229 (970) 962-1508	I.A.T.S.E. LOCAL ___ (___) _____	THE COSTUME DESIGNERS GUILD (818) 905-1557

MEMBERSHIP FEES AND DUES

The actual application for membership in the Costume Designers Guild is quite simple. It asks for very basic information: name, address, social security number, date of birth, present employer, design related education and any other union affiliation.

The Costume Designers Guild allows you to submit an application for one of three categories:

1. Costume Designer 2. Assistant Designer 3. Sketch Artist

The Guild has three cycles per year. Call the Guild Office when you are ready to join, and they will provide you with current cycle dates. If you are accepted by the membership committee, you will be required to pay the initiation fee in full within two weeks of acceptance.

NO EXCEPTIONS!

MEMBER	ONE TIME INITIATION FEES	QUARTERLY DUES
COSTUME DESIGNER	$4,040.00	$100.00
ASSISTANT DESIGNER	$2,020.00	$70.00
SKETCH ARTIST	$2,020.00	$62.50

7 FREELANCING

The word "freelance" is used to describe a lot of different folks doing a variety of different things. Webster's dictionary defines a "freelancer" as *any artist who sells his or her services to employers without a long-term commitment to any one of them, without the benefit of an agency.* Simply put, it means that YOU do everything to get your name out there, your book seen, and your money collected. And what does everything consist of? Read on.

PROSPECTING
- Contacting people by telephone and/or written correspondence.
- Scheduling appointments.
- Meeting with people to show your book.
- Sending—by messenger, or personally dropping off your book with potential & existing clients.
- Following up by telephone and/or written correspondence.

NEGOTIATING
- Discussing and handling all specifics and logistics regarding the terms, conditions and financial arrangements under which you will accept and proceed with the job assignment.

FACILITATING
- Scheduling, tracking and following up on the pick up, delivery and return of your portfolio and/or reel to and from potential and existing clients.
- Arranging for pick up, deposit, and verification of funds available on advance checks, money orders and/or cashier's checks.
- Collecting, copying & trimming tearsheets and/or prints for placement in your portfolio.
- Hiring assistants to work with you.
- Proper budgeting of your personal finances in the face of irregular income and the demands of updating your portfolios regularly.

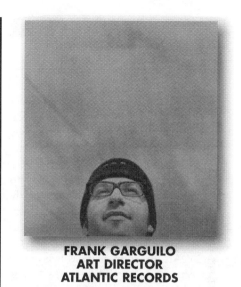

FRANK GARGUILO
ART DIRECTOR
ATLANTIC RECORDS

CG: How did you make your way to Atlantic?

FG: I've moved around a lot. I started working in the New York office of Whittle Communications. From there I went to a book publishing company. I made a short stop in a design studio that wasn't for me, and went from there to doing full time freelance for the art director of Metropolis Magazine. I freelanced on my own for a while before doing some work for Polygram and Atlantic. I then spent eight months in Japan as the art director of an in-flight magazine, and here I am at Atlantic.

CG: What do you do as an art director?

FG: In most places the term art director means coordinating the project,

FRANK GARGUILO

going to the photo session, articulating the overall look of the project and handing it over to a designer. That's very different from what we do here at Atlantic. Here we art direct and design the project. Very rarely do we hand anything over to a designer unless we are extremely busy, and records get bumped into other releases and things begin to overlap due to scheduling issues.

Art direction changes from project to project. The process begins with being assigned an artist or band, you have a meeting with them where you listen to what they have to say, hear their music, and try to get an understanding of what they're thinking about and their feelings about their own music. At that point I start pulling in photographers portfolios, and sometimes stylists and hair and makeup people at the same time, depending on the schedule. I like to try and pinpoint a photographer first, and move on to styling, hair and makeup.

Some artists feel that styling, hair and makeup removes some of their credibility. They think the whole process can seem very grand. Styling, hair and makeup really come more into play with the R&B groups. Especially women.

The entire process is very collaborative. I want everyone to have an opportunity to create. It starts with the selection of a photographer, the

CONTINUED ON PAGE 7-3

COLLECTIONS
- Following up on the payment of your invoices.

SCHMOOZING
- Remembering the birthdays, anniversaries, and other special occasions of clients by sending greeting cards, making phone calls, sending small gifts at times, and picking up the tab for meals and other entertainment related activities.

NETWORKING
- Showing up at social events properly attired with business and/or promotional cards, a firm—but not crushing handshake, a smile and the ability to listen more than you talk.
- Never leaving home unless you have a clear purpose for what you intend to achieve when you arrive at an event, job or meeting.

Sounds like a lot of work, right? It is. These are just a few of the reasons that artists seek out representation. The 20% an artist pays an agency is seen as a bargain when compared to the amount of time, legwork, and paperwork an artist can spend getting, negotiating and facilitating their own jobs. The process of landing those highly coveted fashion & entertainment job assignments should be put into motion long before you ever get that first job. It begins with a working knowledge and understanding of how fashion, photography, and the makeup, hair & styling industries work together to create images, each element dependent on the other to get to the next level.

ON THE JOB TRAINING

Success, in this business, is comprised of a few simple rules and activities. Follow them, and if you are talented, you will be successful. Don't follow them, and you can flounder around for years wondering why you never achieved the kind of professional and financial success you dreamed of.

ACTIVITIES: 3 Actions You Should Take Throughout Your Career

1. **Do your homework.** Keep up with what's going on in fashion, entertainment & photography by reading the fashion and entertainment magazines of New York, Los Angeles, and Europe. Scan magazine credits to keep abreast of who the hot photographers, fashion designers and stylists are. Learn to spot the sub-

tle differences between competing magazines and how changes in key staff members affect the look and feel of the magazine. Pay attention to the music video & fashion channels. Watch the latest fashion segments on television. Send or take your book and/or reel to the right people. Get to your interviews on time. Be positive. Meet and greet others with genuine enthusiasm and interest. Have good things to say about your peers, or say nothing at all.

2. **Meet and introduce yourself** to decision-makers and crew members. Mingle. Be seen. Be visible. Be a good listener. Hire skilled and reliable assistants who will follow your direction. Work with vendors you can depend on, and trust. Show up early to your jobs. Give 150%. Be a team player. Be a leader. Be firm.

3. **Always send thank you cards** to producers, photographers, directors, production coordinators, and art directors. Keep your promises to vendors. Follow up with new and existing decision-makers. Close the deal by asking for more work. Mail business and promo cards as reminders. Follow up on and collect your tearsheets and reels. Circulate your book and/or reel to decision-makers. Make the effort to follow up with peers that you got along well with on a job. Make time to take the first step towards forming new alliances and professional relationships.

In Chapter 3, I stressed the importance of networking and its significance as a cornerstone of a complete marketing campaign. With this in mind you should agree that every job provides the consummate networking opportunity.

Don't make the mistake of being invisible on the job. Too often an artist cloisters him or herself away in a location trailer or dressing room, only to be forgotten at the end of the day by the people who are giving out work tomorrow, next week, next month, and next year.

You need to BE SEEN! Let the producer, director, photographer, studio manager, production manager and production coordinator see your lovely face. If you don't, the next time a project comes up, and the discussions about who to use for makeup, hair or fashion styling ensues, your name will be absent. You **<u>don't want</u>** the conversation between a producer and director after they've been awarded a new job to sound like this:

PRODUCER: *Do you have anyone in particular you'd like to use on this video?*

DIRECTOR: *Um, let me think. The makeup was nice on that last video we did for Atlantic*

stylist next and the rest of the crew and that's how you begin preparing for a shoot. Hair and makeup is much more technique so I'm just looking for someone good. Unless it's something outrageous, then you are looking for something really special. Styling is really important, people notice clothing more than makeup, and that's the way it should be. You shouldn't notice someone's makeup unless makeup is the focus. With styling I look for creativity, even in the simplest things. The music starts the direction of what you are looking for and then the artist. I call in books of people I feel are in the same sort of mode. I show the artist three to five books, sometimes less.

It's really important for hair and makeup to work with good photographers. When the photography isn't good, or the lighting is all wrong it's hard to focus on the hair and makeup. Sometimes it's hard to get beyond the photography even though I've trained myself to be able to look beyond it at just the hair or makeup. The artist looks at the book and if the photography is bad it all looks bad to them, musicians are not trained to look at books the way we are.

I like really clean, non-existent makeup. But I like to see both extremes in a book. During a photo session I may want to go to both

CONTINUED ON PAGE 7-4

FRANK GARGUILO

extremes depending on the artist. I think a makeup artist should show a range in their book. A fashion stylist should show what they really like to do.

CG: If a portfolio doesn't work for you, how do you handle it?

FG: When I had more time, I used to write notes and leave them in the book. I would say what I did like about the book and what I didn't. I always try to leave one of my business cards in the book. If an artist calls, I will try to give them some feedback.

CG: What do you need from an artist on the set?

FG: Aside from their technique, I look for someone with a good attitude and spirit. I like a collaborative team of artists. If an artist has a suggestion, I want them to let me know. Sometimes people think they should just do what they do. I like my shoots to feel like a real team effort. I want it to be an experience for everyone. Those are the people I feel compelled to work with again. And no attitude.

I worked with a really great stylist that I may not ever hire again. We were doing CD on an artist who wasn't a thin person. We communicated this to the stylist, but when

CONTINUED ON PAGE 7-5

Records. Who did that?

PRODUCER: *Yeah, you're right. It was clean. Very high fashion. But I can't for the life of me remember who the makeup artist was. What was her name?*

DIRECTOR: *Denise. . . . Karen. . ., oh I don't know. Just call a few agencies and get some books for me to look at.*

No artist wants a conversation like this one to end without their name being mentioned and their phone number being dialed. If you did a great job on the video, commercial, or photo session, the key people should and must remember your name and have your promo card and/or business card close at hand. BE VISIBLE. Especially after you've left the job.

On a music video (at the production company level) there are several people who can create future work for you. The producer, director, production coordinator and production manager are key people you should get to know. Each of these people is a decision-maker. They can and do make and influence the choices of others when it comes to who is selected to work as part of the crew. Confused? Let me make it a little clearer.

Think about your own life for a moment. You make choices about your friendships and acquaintances. Try to think of the when's and if's that you and your immediate friends impose on others before you let them into your circle, or clique. Those same whens and ifs apply on a job. Everyone is sizing you up to see if you fit in.

Have you done your part? Are you friendly? Do you introduce yourself to others? Do you take the first step? Do you get involved and pitch in? Are you a team player?

A lot of your success is dependent upon how you fit in. How you mesh with the rest of the people (crew) on the set. Many of the crew people you will work with on your first jobs have been working together for years. They know each other and they know what to expect. You will be tested. You will be challenged. You may be snubbed. No matter what, you must do your best and maintain a positive attitude. It's the only thing that will be good enough.

THE BOOK REVIEW PROCESS

The book review process is what happens when your portfolio gets called in for a job. In the past, the book review process at record companies was a closed door session often held by one person, the art director. The art director would make his or her selections, inform the management of their choices for makeup, hair, fashion styling, and photography and the shoot was on. That kind of autonomy rarely exists any longer. The process has become much more democratic as key play-

ers (artists & managers) demand to be made a part of the process from the very beginning. This new trend is most often apparent in the entertainment industry. Recording artists, celebrities, and their management companies insist on calling in and reviewing portfolios personally. In a twist of events, management often invites the art director to messenger book preferences to their office or the artist's home for consideration. Once a decision is reached, the art director is notified, and asked to contact and book the celebrities choices for makeup, hair, fashion styling, and sometimes, photography. Powerful artists like Madonna, Whitney Houston, Britney Spears and Vanessa Williams will not tolerate being told who to use on a photo session, music video or feature film. Following is a true story.

ACTRESS & SINGER VANESSA WILLIAMS: THE LAST WORD

Several years ago I was representing a "very" french photographer. He was quite good, and upon referral from Vanessa's hair stylist, Roberto Leon, the photographer's book was called in for consideration as someone who might be right to shoot her upcoming CD. Prior to our meeting with Ms. Williams and her manager, I thought it wise to have a conversation with the photographer about the subtle differences between shooting fashion photography with models who are compensated to do whatever you tell them, and shooting fashion/commercial photography with multi-platinum recording artists with opinions, images and marketing plans that existed before the photographer arrived on the scene. He in his wonderful french-ness was not hearing of it. He was positive that he could persuade Ms. Williams to see it his way. He was determined to use 'this' person to do her makeup, 'that' person to do her hair (even though her hair stylist was the person who recommended him for the job--so much for loyalty in this business), and some other person to do her styling. No matter how I tried to convince him that she would get another photographer before she would abandon her hair stylist and makeup artist, he wouldn't listen. During the meeting in her manager's office he went into detail explaining why he needed these specific people to work with him on her project. She listened politely and said "no". He continued. Still polite, and a little more stern, she said "no". He was relentless and insistent with his argument. This time however, Ms. Williams raised her voice, glanced at her manager as if to say, someone is not hearing me, and said "NO!" one final time. The photographer finally got the message, gave up, and got the job.

As this new hierarchy in decision making takes hold, your opportunities as an artist increase. Now, in addition to sending your book and promo pieces to a single art director at a record label, you can forward those same materials to the appropriate people at management firms as well. The secret of

FRANK GARGUILO

she showed up at the meeting and saw the artist her mouth dropped open and she made the artist feel terrible. And that just cannot happen. After spending more than eight hours together at a photo session, I bumped into the stylist and she didn't even remember who I was. And we've been re-introduced a couple of times since then.

It's really important for makeup, hair and fashion stylists to know that we are not working with models, these are real people with real feelings. They are musicians, not models.

CG: How do you like to be contacted?

FG: If it's someone who has been recommended to me then I try to meet with them and look at their book. But it's best for people to take advantage of our drop off day, which is Thursday. The books are put in a conference room, and all the art directors know that they are there, so they go in during the day and look at them. Cards are good. If I get something really amazing, then I'll call the person or agency and ask to see the book. An artist should have some sort of card in their book. I usually take out the ones I like and write a note. When I'm looking for someone for a job, the first thing I do is go through my files.

CONTINUED ON PAGE 7-6

FRANK GARGUILO

CG: What do you want to see?

FG: Personal work. When someone brings me a lot of commercial stuff, I will ask to see their personal stuff.

CG: Which agencies have you used a lot?

FG: Merrick, they have really good people. Crystal in Los Angeles.

CG: What advice would you give an artist who's in the process of building his/her book?

FG: Like the work you are putting in your book. Gear your book towards something you like and feel strongly about. Find a few good photographers that you can collaborate with. I think it's also really good for a fashion stylist to be able to create things themselves or find people who can help them. Using young designers is a good idea. A really good stylist who can't find something will make it, or have it made. I think it's even great when a stylist can take a household item and make something out of it, or just find that extra something. I think good styling is all about putting things together in interesting flattering ways. What I look for most in a stylist's book is how they put things together, mix and match things, their sensibilities. It's really important for a stylist to make connections.

CONTINUED ON PAGE 7-7

success in this environment is to be upbeat, on time, professional and master your craft. All of these qualities will give decision-makers more than enough reasons to remember you and want you back on their next project.

WHO SAW MY BOOK

A touchy subject with artists in this business is dealing with the frustration they experience in getting the photographers they long to work for to look at their books. Artists spend countless hours on the phone cold calling to set up appointments to drop off their books at photographers studios. Many times when an artist returns to the scene of the crime to pick up their portfolio, they are sent away by a rude studio manager or photographer who may or may not have even looked at their work. Forget feedback.

The egos of some photographers, their reps, and their studio managers (who live vicariously through the stature of the photographers they work for) means that early on in your career you may find it difficult to get an opportunity to show the photographer of your dreams your portfolio. That is unless your credits can show that you just completed work on the latest GAP campaign with a photographer the caliber of Annie Liebovitz.

Guess what? There is a better way. A seemingly nobody photographer can be tomorrow's star just by being in the right place at the right time, and by being talented of course. I wasted the first couple of years as an agency owner trying to get huge photographers to notice my little artists and my little agency. Only after Reesa joined us in 1995 and surmised that it would be easier to get something going with young new photographers who were talented but not well known, (until we built up our artists books) did I realize the value of building relationships with photographers we could grow with, and we have.

A TIME AND A PLACE

My grandmother always said, "there's a time and a place for everything." This statement is true of workplace etiquette and ethics. As an artist, you may be privy to conversations and information involving well known persons in entertainment and industry. A word of caution--keep what you see and hear to yourself. Sharing private and sensitive information will get you canned, and quick! If you learn that a well known actor or actress is wearing a toupee or a weave, keep it to yourself.

If you are like the rest of America, and just dying to tell someone about your latest discovery,

I suggest you confide in your best high school buddy who lives and works in a small cave at least 2000 miles away. The hills of South Dakota, now there's a great place to keep old friends. Take my word for it on this one. I know a fashion stylist who got canned after working for Janet Jackson. She was overheard in Maxfield's (a trendy LA clothing store) discussing Ms. Jackson's weight, and her gig became history. Don't! Gossip, that is.

Be on time! A lot of people, places and things are affected negatively when a crew person (YOU) is tardy getting to the set. If you are 30 minutes late and the production goes 15 minutes overtime, the producer may have to pay 10 to 20 or more people time and one half. Think you'll ever get hired again? Think again, and don't be late!

Don't put a decision-maker on the spot by asking questions about your fees and expenses in the presence of other crew members. Everyone may not be making the same amount of money. If you have questions or concerns about your rate, overtime, or expenses, ask the person in charge for a private meeting to discuss the issues. Don't discuss your fees with peers. Everyone cuts a different deal. If you learn that you are making less money than someone who you feel is your equal, don't make a big fuss on the set. It's unprofessional. Cut a better deal the next time you negotiate with that producer.

MONEY MATTERS

1. SETTING A DAY RATE

As a freelancer, you will be setting your own day rate (fee). While you can and should charge whatever the market will bear, getting it is quite another matter and requires experience, skill, demand (for your services and expertise) and an impressive book or reel. Talk to others in and around your field. Makeup and hair stylists tend to get about the same day rate. A fashion stylists' day rate tends to be a bit less per day, but they generally work a minimum of three days at a time (prep, shoot, wrap). Remember to collect your tearsheets. The more tearsheets (published work) you add to your book, the more credibility you have, and the more money you can ask for.

2. GETTING PAID

What a concept. For many of you, this is the toughest part of the job. Most artists (and I've never known a makeup, hair or fashion stylist who wasn't one) dislike the part of being a freelancer that requires them to discuss, arrange for, pick up or collect money from clients. Paychecks are fine. It's just the discussion leading up to the paycheck that can be a little unnerving.

FRANK GARGUILO

CG: Do you look at resumes?

FG: Not really. What's in someone's book is more important to me. I don't think they are very important for a freelancer.

CG: Thanks Frank?

FG: No problem. **END**

NOTES

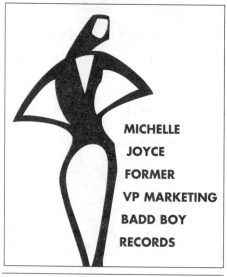

MICHELLE JOYCE FORMER VP MARKETING BADD BOY RECORDS

CG: What criteria do you use for selecting artists to work with your label?

MJ: I get a ton of books in regularly. I look for something that hasn't been done, an artist that's setting a new trend. When I look at someone who's been styled, I'm looking at everything: the clothes, accessories, how it's all been pulled together--a whole look.

CG: What turns you on or off about a book?

MJ: I just want to see work that can keep my attention throughout. The book is a person's way to get my attention. It's an artist's introduction. If I like it, I'll call them or their rep. If I see something and it's

CONTINUED ON PAGE 7-10

Unfortunately, while you are on your own (without an agency), you'll probably be doing what I call, the money dance: Negotiating your fees & expenses, preparing confirmations to ensure that the terms and conditions of your work assignment are met, invoicing for payment and Collecting the money that is owed to you.

If you were to talk to an established artist, I'm sure he or she would be able to recount the times they didn't get paid, or got paid less than the amount that was agreed upon over the telephone, because the terms and conditions of the job was not confirmed on paper. I wish I could tell you that a hand shake or a verbal ok is enough. IT ISN'T. Sometimes the paper work isn't even enough but it's better than nothing and will protect you and get you paid in the event that small claims becomes an option.

Want to invest in something that will save you from many sleepless nights of wondering if you're going to get paid? Purchase a fax machine, have some vouchers printed (see chapter 2), and order a set of StyleWise™ Business Forms (see page MO-3). A paper trail replete with signatures is the only way to insure you will get paid what was agreed upon. . . consistently.

Discussing money does get easier with practice. It's just the first two or three hundred conversations that make you sweat. The trick is not to panic. The phone call from an art director or fashion editor excites you but the negotiation makes you sick. With practice, it all gets easier.

3. PETTY CASH AND LARGER AMOUNTS OF MONEY

Petty cash has to be accounted for even when receipts aren't given. For instance when you use meters for parking. You can throw small amounts ($50-$100) in your purse, but it's not prudent to do that with several thousand, as many artists who have been robbed or have left their purses in studio services, or at the a professional beauty supply store will tell you.

A great way to handle large amounts of cash is to turn it into travellers checks. Once you sign them, they are protected, and can be replaced within 24 hours. Just remember to sign them or their no good. I once left my purse in a restaurant in Battery Park in New York, with $300 worth of unsigned travelers checks in them. American Express replaced them at first, but when the unsigned travelers checks turned up without my signature on them, they charged them back to my card.

A better way to handle cash, is to deposit it into your business, or personal [interest bearing] checking/savings account. Use your point drivin' credit cards to make purchases, and then pay off the balance in full when the bill comes in.

SHOW.. ME.. THE..MONEY**..	MAKEUP	HAIR	FASHION STYLING	MAKEUP & HAIR
MUSIC VIDEO				
Non-Union	$300-3,500	$300-3,500	$500-4,000	$500-4,000
Union	18-40/hr	18-40/hr	18-29.34/hr	N/A
CD COVERS	$500-4,500	$500-4,500	$500-4,500	$750-4,500
EDITORIAL: Magazines	$150- 350	$150- 350	$150- 350	$250- 350
ADVERTISING				
Print Ads	$500-6,500	$500-6,500	$500-6,500	$750-8,000
Commercials - Non-Union	$500-5,000	$500-5,000	$500-5,000	$750-6,500
Commercials - Union	18-40/hr	18-40/hr	N/A	
Catalogue	$450-1,250	$450-1,250	$450-1,250	$700-1,500
Movie Posters	$500-6,500	$500-6,500	$500-6,500	$750-8,000
PUBLICITY				
Press Junkets	$500-6,500	$500-6,500	$500-6,500	$750-8,000
Publicity	$500-6,500	$500-6,500	$500-6,500	$750-8,000
LOOKBOOKS	$300- 500	$300- 500	N/A	N/A
LIVE ACTION				
Runway	$250	$250	$250	$250
Award Shows	$500-3,500	$500-3500	$700-4,500	$700-4,500
TELEVISION				
Sitcom - Non-Union	$300- 500	$300- 500	$300- 500	$300- 500
Sitcom - Union	20-40/hr	20-40/hr	18-29.34	N/A
Drama - Non-Union	$300- 500	$300- 500	$300- 500	$300- 500
Drama - Union	35-40/hr	35-40/hr	18-29.34	N/A
Reality - Non-Union	$250- 400	$250- 400	$250- 400	$250- 400
Reality - Union	25-32/hr	25-32/hr	18-29.34	N/A
Mini-Series - Non-Union	$200- 400	$200- 400	$300- 500	$300- 500
Mini-Series - Union	20-32/hr	20-32/hr	14-29.34	N/A
FILM				
Non-Union	$200- 400	$200- 400	$200- 400	$200- 400
Union	20-40/hr	20-40/hr	18-29.34/hr	N/A
BRIDAL	$150-1,500	$150-1,500	N/A	$150-1,500
ASSISTANTS	$100- 500	$100- 500	$100- $500	$100- 500

INDUSTRY STANDARDS

Makeup, hair, and styling fees vary from project to project and from one market to another.

Makeup artist Noelle Sukow thought it would be a great idea to include a list of rates for artists—so thar' ya' go! It's here!

These are minimum's and maximum's. The lowest rates, to some of the highest in the industry, and yes, those are comma's. Rates in some markets get into the thousands regularly. People do make $5,000+ a day to do makeup, hair and fashion styling.

However, at $5,000 a day, you must add geography as a caveat. Those high rates are typically available only in LA where there are celebrities, and in New York where big advertisers, and top fashion houses do their advertising.

For instance, in 2000, when I represented one of the top hair stylists in the country, we got $2,500 a day for his work on Cover Girl. However, when I asked for that rate, which was $1,000 more than I had gotten for him in the past, and the art director agreed quickly, I knew I could have gotten more because she said yes too easily. Better to ask for too much than too little. You can't go back.

**These rates are ESTIMATES. They have been collected from a number of sources including Makeup & Hair Unions, and agencies.

MICHELLE JOYCE

not professionally presented, it tells me that this is not a person that really cares about my perception of them.

CG: What about promotional pieces? If you get a piece you really like, will you call in books from it?

MJ: I call in books if the promotional piece is outstanding. I don't discriminate against new people, either. It's okay that they don't have a book full of magazine and CD covers. If I get a card from someone who is right out of school and I like their work, I'm just as likely to give them a shot.

CG: Have you ever hired someone who didn't have a book?

MJ: Honestly? Yes. Case in point: we just completed a video in Jamaica. I was referred to a makeup artist who didn't have a book, but she had done all the makeup for the local television stations, and some video companies who shoot on location there. I went out on a limb, took the recommendation, and it worked out beautifully.

CG: Do you have a preference for freelancers or agencies?

MJ: I do both. It doesn't matter.

CONTINUED ON PAGE 7-11

This accomplishes 3 things:

⟶ First, you get the points for vacation travel, or jobs that you may want to accept, even though the client doesn't have enough of a budget to put you up in a hotel, and/or pay for your airfare. It's also great for other perks.

⟶ Second, you maintain a high balance with your credit card company, which you pay off at the end of every month. This causes the credit card company to raise your limit about every six months. The time will come when you need that extra room on your card.

⟶ Third, many credit card companies offer insurance for anything that is lost or stolen. Now you can stop worrying about all that latex in the trunk of your car.

4. COMMITMENTS

Here's a trick question. You accept a job for less money than you want as a fee, and less money than you need for expenses, what do you do now? **Answer: A great job!** Nothing is more dishonorable than someone who accepts a job that they don't want to do, and then they do less than their best. A minimum of 100% is what every client deserves once you have accepted the job. If you don't like the pay or the job conditions, don't accept the assignment.

5. NEGOTIATION

Whether you are with an agency or not, you will be responsible for negotiating with and asking your clients for large and small amounts of money to cover clothing, accessories, props, wigs & hair pieces, special FX makeup, per diem, mileage, kit fees, and more.

While the need for this kind of negotiation happens daily with fashion stylists, costume designers, and prop stylists who can't do their job without spending money, hair and makeup artists who become the heads of their departments in film and television will be responsible for managing the budgets of their departments, and that means money.

Your agency can and will negotiate your fees, per diem, travel expenses, assistant rates and overtime. However, as the artist, only you will be able to determine how many assistants you will need, and estimate the costs of the supplies necessary to successfully complete an assignment.

As an agency owner and negotiator, I often find myself redirecting a conversation that begins as a discussion about my artist's day rate and mysteriously leads into how much I think my stylist

will need for clothing. Here's my typical response to "Well, how much do you think your stylist will need for clothes":

"Mr. Art Director, without up-to-the-minute knowledge of what's in the marketplace (clothing stores) and a thorough understanding of the clothing needs for this job assignment, I couldn't possibly tell you how much my stylist is going to need for clothing. However, if you're going to be in your office for a little while, I'll have my stylist give you a call, and the two of you can hammer out the details and the numbers. After the two of you have spoken and agreed on a figure (for expenses), I will plug the numbers into my estimate and fax over a confirmation for your signature."

The keys to getting the budget you need as a stylist are:

→ Not to commit to a figure until you have gathered all the facts about the job.
→ Be ready, willing and able to justify (in writing if necessary) why you need the dollars you say you do to complete the assignment.
→ Be ready to walk away from a job when you can't complete it within budget.
→ Stand by your convictions, that's what they're paying you for.

An art director will throw out a figure that the company would like to spend on the clothing budget. You don't have to feel tied to that number. Later on in this chapter I provide a scenario so you can examine the dialogue between a stylist and an art director. By asking lots of questions and fine tuning your listening skills, you'll soon learn the important questions to ask an art director and how to buy yourself a little time before you blurt out a number that you have to live with.

Now, I haven't forgotten that in the beginning, artists sometimes have to work miracles and call in a lot of favors from vendors to get the job done. Just be very careful about where you spend your miracles and favors. Not everyone needs them, even when it looks that way on the surface. Become a detective when it comes to getting the facts. Don't be afraid to dig a little deeper. Listen very carefully to what people say and even closer to the details they leave out.

The Keys to Negotiation Are Simple:

1. Listen Carefully, and Read Between the Lines.	2. Ask Questions. 3. Take Notes. 4. Think Before You Speak.	5. Take Your Time, Don't Feel Pressured To Answer Right Away. 6. ABC. Always Be Closing.

MICHELLE JOYCE

CG: What kind of selection do you usually get from agencies?

M.J: They usually send two or three books of whatever I am looking for. Sometimes more or less, depending on how specific I get with my requirements.

CG: What agency do you like to use most?

MJ: I have to tell you, I'm biased. Crystal Wright--the Crystal Agency.

CG: And what about New York?

MJ: In New York I've worked with a lot of freelancers. I haven't really gone through agencies.

CG: Do you meet with stylists personally?

MJ: Yes. I have an open door policy in terms of people dropping off books to me. That can be done at any time. If I see something that catches my eye, I'll call for them to come in at some point.

CG: What are you looking to learn from that meeting?

MJ : I want to know what kind of connections they have for getting clothes. It's very important that

CONTINUED ON PAGE 7-12

MICHELLE JOYCE

they're connected to the designers, warehouses, and stores. Here at Bad Boy, our artists have various looks and images. A stylist has to be able to get Karl Kani as well as Chanel.

CG: **What pay scale can a beginning artist expect versus a more experienced stylist?**

MJ: It just depends. Many times I'm given a grand total to work with and everything has to fit in that budget: makeup, hair, fashion styling, photography, props, everything. So it's really negotiable and varies quite a bit. The high end is $750 - $1,000 per day. The low end is $150 - $500 per day.

CG: **How does a stylist's physical residency (in or out of state) enter into the equation?**

MJ: It really doesn't. If it's someone I'm really interested in working with, we'll bring them in to do the job. **END**

Remember, at some point, you have to ask for the order. The business. The job assignment. In sales, there are closing questions. For instance, if I thought I had answered all of a potential clients questions, or objections about purchasing a particular copier, I would say something like, "Mr. Customer, would you like us to install the copier on Monday or Tuesday?". That's called an either or close. You're giving the customer a choice. You might say "Would you like to meet with me to go over the makeup color choices on Monday or Tuesday? Or, after talking with a producer about the budget, [even though you may know that he is talking to other stylists], you could say "What's the best time for me to pick up a check for the clothes, 3 or 4 this afternoon?" ABC. Always be closing.

The following pages of dialogue illustrate a typical situation and conversation between an art director and an experienced fashion stylist. *You hear the phone ring.*

DENISE: *Hello.*
DON: *Hello, may I speak with Denise.*
DENISE: *This is Denise.*
DON: *Hi Denise, this is Don Drisdale from Artful Records. I looked at your portfolio today and I think you might be right for a job I've got coming up this Friday. It's a CD cover for a new group, so we don't have a big budget on this one. What's your availability on Friday?*

He's asked what appears to be one question, but it's really three.

1. *Do you want the job?*
2. *Are you available to prep Thursday, shoot Friday and wrap on Saturday?*
3. *Can you work within our budget?*

Here's the place most stylists get into trouble. They're so excited about getting the job, they forget to gather enough details about the job to determine whether it's worth their time, effort, resources, and sometimes, favors. This is also the place where the stylist commits to everything and anything, just to get the job. Be smart! Before you say yes, buy yourself about thirty seconds and a deep breath, then respond (notice I didn't say answer).

DENISE: *It sounds interesting, I'd like to hear more about it. Can you hold on a moment while I get a pen and my calendar.*
DON: *Sure, no problem.*

Locate a pencil, legal pad and calendar to confirm the dates. Sit poised in a comfortable chair, pick up the phone and ask lots of relevant (leading) questions that will help you to determine how much money, time and manpower it will take to complete the job successfully.

DENISE: *So, tell me a little bit about the group?*

DON: *Well, it's a three guy band. They're R&B. We're thinking along the lines of a Ralph Lauren sort of vibe. We plan on shooting in the studio and on location.*

Hold it! How much information you can glean from the AD's answer to the stylist's last question.

WHAT YOU HEARD	**WHAT IT MEANT**
1. There are 3 men in the group.	1. You are going to need an assistant. There is a lot of work involved in styling three people.
2. The music format is rhythm & blues.	2. The artists are probably African American.
3. The clothing direction is Ralph Lauren.	3. You will need plenty of cash. Ralph Lauren clothing is pricey.
4. There are at least two locations.	4. You will be moving clothing and bodies from one place to another.

Time to ask more questions.

DENISE: *What kind of locations have you selected, and how will we be moving from the studio to the location (and back).*

DON: *We're going to shoot the guys in three locations. One's an old warehouse downtown, the other is a museum in Pasadena, and we'll spend half a day in a rental studio downtown not far from the warehouse location. The photographer is renting a mobile home for transportation.*

**VALERIE WAGNER
ART DIRECTOR
ATLANTIC RECORDS**

CG: How did you become an art director?

VW: I went to the school of visual arts in New York. After graduation, a position was available at Atlantic. I dropped off my book, and Melanie Nissan the creative director liked my work and called me in. I got started immediately.

CG: Did you know you wanted to be an art director?

VW: I always knew somewhere in my heart, that I would end up doing something art related. Although for a while I thought about being a lawyer, When I decided to go to art school, I wasn't sure what I was going to do. I had a really great professor in my last year and decided to

CONTINUED ON PAGE 7-14

VALERIE WAGNER

go into design. My work dealt with very personal and political issues. I didn't gear it toward any area of the design industry I just followed my heart and believed that if I did what I loved, I would do it really well.

CG: What does an art director do?

VW: It's a weird job. It changes. I get handed a band to work with, and from there, I handle every aspect of the photo shoot. You find out what the artist is looking for, the kind of image you, the artist and the label feels is right. You hire a photographer, and stylist. After the shoot you edit the film and design the package while communicating with everyone about what is going on.

CG: How many books do you go through for a job?

VW: About five or six photographers. Then I narrow them down to four or five that I show to the artist. Sometimes you go through twenty, but I try not to. With fashion stylists, sometimes I can just say this is a great stylist, and this is who we think you should use. Other times we show two or three books and the artist makes the choice. Sometimes you just know the person you want to use and you can convince the band that it's right, it just depends.

CONTINUED ON PAGE 7-15

Whoa! I thought there was a small budget on this job. Somebody may be trying to save money on the stylist and the clothing budget because mobile homes, locations, permits and security are expensive. Now we're getting some really good information. The picture is coming together. However, there is one big question that hasn't been asked?

DENISE: *By the way, who is the photographer?*
DON: *Mark Holloway.*

The picture is rounding out. As an artist, you should be able to search your memory and call up the number of times you've seen the photographers work in the last six months. Is he well known? Is he doing editorial? Is he working a lot? Have you heard any of your peers talking about him. Is he hot, or is he not? Answers to these questions will help to determine whether you as the stylist will get your day rate or an argument when you ask for it. Here's what we know now.

WHAT YOU HEARD	WHAT IT MEANT
1. There are 3 locations, not 2 as mentioned. They are a warehouse downtown, a museum in Pasadena and a photo studio.	1. There's a budget for security, a mobile home, locations & studio rental.
2. The photographer is well known, working, accomplished.	2. He's probably getting a reasonable day rate, between $3,500 - $5,000 per day.

DENISE: *It sounds great Don. I really like Mark's work. I was working on a job for A&M last week, and got a chance to see some photos he took of a girl group. What's your clothing budget for this act?*
DON: *Well, I think we have about $2,000 - $3,000.00*

DENISE: *How many changes?*
DON: *Four.*

DENISE: *Oh, a rental budget. I'll need to speak with them about bringing their own shoes and accessories?*

DON: *You don't think we can get clothing and shoes for $3,000.00*

DENISE: *Not really, if you're talking about Ralph Lauren, it's kinda' pricey.*

DON: *We really wanted them to keep the clothes for their upcoming video shoot. How much more do you think we would have to spend if we wanted to keep the clothes and shoes?*

DENISE: *To keep the clothes and add shoes? Why don't you let me think about it and play around with some numbers. I would like to make a few phone calls and see what's out there. I can call you tomorrow. Would you like me to put together a budget that includes the clothing, my fee plus my assistant.*

DON: *Yeah, that sounds great.*

DENISE: *I'll call you in the morning and fax it over. Bye.*

DON: *Bye.*

Quite a few things went on during this conversation. For one, the Art Director, Don, asked a buying question. ("*How much more do you think we would have to spend*"). This is an indication that he has more money, and that he probably knew he was going to have to spend more to get the look he wants. Other issues that might need to be addressed in order for the stylist to complete this job successfully include:

— **Prep days:** *How many will you need for shopping, fittings, and meetings with the group.*
— **Assistant budget:** *You will probably need your assistant for each day. How much can you get for him/her?*
— **Increased clothing budget:** *You may need MORE money. If the look is contemporary, you won't be able to rent anything for them. You'll be shopping from department and specialty stores, and they DON'T rent clothes. Take the budget that the Art Director (AD) has offered ($3,000) and divide it by the number of guys in the group (3) and then divide that number by the number of looks that the AD wants. From there you can determine whether or not $3,000 will meet the goals of the AD for the kind of look he wants for this group.*

I hope this exercise helped to get you thinking about the realities of doing a job of this magnitude and each person's role in the success of the shoot. I can't stress enough the importance of understanding your industry, cultivating your resources, knowing your value and taking your time.

Now that you know what to say, let's take a look at the kind of fees you can expect for each segment of the market place, i.e. editorial, music videos, advertising, commercials, runway, etc.

CG: How do your needs as an art director at Atlantic differ from those of a fashion editor at a magazine?

VW: In some ways the needs are the same, especially if we're doing a package where there is a fashion feel. But it differs in that the fashion editor works with models, and here not everyone is a model. You have to be really sensitive to how the artist fits into the clothes to achieve certain looks and you have to know that they may not be comfortable where a model would be.

CG: What should a makeup, hair or fashion stylist know about working with recording artists.

VW: Sometimes they are really afraid of the styling and the hair and make-up. Every now and then you get someone who is really open to it. They tend to be a little sensitive to the idea of someone coming in with clothing to style them when they already have very specific ideas. The stylist has to be able to make the artist comfortable, and incorporate the artists ideas of how they should look into their plans. A skilled artist knows how to do that. Once the artist begins to trust the stylist, and feels like they are being

CONTINUED ON PAGE 7-16

VALERIE WAGNER

respected and listened to, they tend to let go a little more and let the stylist do their job.

CG: Do you have a policy for reviewing portfolios.

VW: Our drop off day is Thursday for makeup, hair, stylists, and photographers. We look at the books to get an overview of what's going on. But a lot of stylists and makeup artists just call me and say Hi, can I come by and show you my book. If I'm not to busy, I'll make an appointment with them. When I have time, I like to meet them and look at their book instead of just having them drop it off. Whatever art directors are available, we all share and say "c'mon in and take a look." It's pretty open and direct around here.

CG: At what point should an artist make an appointment?

VW: We don't necessarily require that people have done big jobs. We look at people who have tests in their books. We don't mind looking at the books of people who are starting out. I don't really think of it that way, like a tear sheet or a test, as long as the book is strong and there is direction and a sense of style. We sometimes get books in that are really specific versus kind of

CONTINUED ON PAGE 7-17

REESA'S FYI: PHOTOGRAPHERS

Okay, let's say you don't have an agency. How in the heck are you going to find and meet those young, new, hot, talented photographers that you, and everyone else is dying to work with? There are many ways to go about it, but I'll tell you how I met them. Let's go through some steps!

1. Know <u>WHO</u> you want to work with and <u>WHY</u>.

It may be a celebrity shooter because you want to work with the stars. It may be a fashion shooter because you love his lighting and concepts. Even if the reason you want to work with a photographer is as simple as: "They're cute or you like their "vibe", at least that's a REASON! What ever it may be, understand why you want to work with a particular photographer.

2. Look for an image you like in a magazine, newspaper, book or on a CD cover.

—Search in local or smaller circulation publications if you're just beginning.

Ex: Axcess vs Vogue

—Write down the name of the photographer and cut out the image. Start a file with tearsheets next to a piece of paper so you can make notes about the photographer and keep track of your phone call attempts.

—Locate information about the photographer by looking for makeup, hair, styling, and photography credits. The agencies names is usually right next to them.

Ex: Styling by Lisa Michelle/The Crystal Agency.

The credits will also give you a clue as to what city the assignment was shot in. Although that does not guarantee where the photographer resides, it's a start. Play detective. If you do not have a creative resource book start by dialing "411" (information). When looking for photographers, begin with the major cities; New York , L.A. Chicago, etc.

Reesa puts a face with the name by cutting a picture of the photographer out of the contributor's section of a magazine or from the feature section of Photo District News magazine.

Reesa takes the time to write what she learns about the photographer, i.e. background, past work assignments, etc. A little history to help you with your phone calls.

REESA'S PROSPECTING NOTES

Most photographers list their phone numbers in information, so prospective clients can find them. Once you have the phone number, go back to step 1—Remember **why you want to work with this person**. When you get them on the phone, be prepared, and follow these instructions:

a) **Have a reason in your head when you call them! If voice mail picks up, leave a message.**

b) **Tell them what you love about their work, why you want to meet them and mention some of their work you have seen recently.**

Now you know why it's so imperative to keep up with who's shooting what EVERY MONTH! **Warning:** Get used to leaving messages and calling back a couple times a week until you get a call back or a live person to speak with. I've called photographers for six months straight until they finally gave in and agreed to meet with me. Fortunately, this is not always the case, and many of those same photographers are still calling the agency today to book Crystal Agency artists. I have arranged meetings on the first call. It's a matter of *good timing and a bit of luck.*

3. **When your meeting has concluded with the photographer, make sure you leave him/her with a promo piece that has your name, and cell phone number on it.**

—Keep in touch with the photographer by sending a thank you card and dropping a cute post card whenever you see some of their work or a story about them that you like. Don't be afraid to call them again when you have a "new shot" in your book that you feel they will dig.

ONE MORE TIP: If the photographer or studio manager says to call back next Tuesday...always call back next Tuesday. That does not mean next Monday or next Wednesday. If you don't listen, and call back when you please, you've just given them an excuse to blow you off. Don't get discouraged if the photographer reschedules or doesn't call you back. You can't take it personally because they don't even know you! Never give up, but be smart about it. Don't call everyday, and listen to what the photographer says. For instance if she tells you she's leaving for Europe for two weeks, don't call everyday and leave her messages. She will think you're a loony!! But don't give up. Some of our most cherished clients today are the same ones I drove crazy with my persistent calling!

VALERIE WAGNER

general where a person can do a lot of things. I think it's always good when a person can do a variety of things. That person can be hired more often for different kinds of jobs. A person like that can get their head around a lot of problems. They think.

CG: What turns you off about a book?

VW: A lot of people try to gear their book towards something, and when they do that, they eliminate a lot of their personal work. Often that's the most uninhibited, really free work, and interesting. We tell people, please include everything, even the personal stuff you think we might not be interested in. I don't like books that are stacked up with celebrities. It's not impressive. Usually it's the most boring stuff.

If I feel someone hasn't had a lot of opportunities, but they have some tests, or a few jobs, and they're needing a break and I feel they are really capable and I can communicate really well with them and I feel that they have the same sensibilities as me, I'll definitely hire them. Personality is really important. **END.**

EDITORIAL

Magazines have what the industry calls an editorial rate. It's a fee schedule that usually ranges from $100.00 to $350.00 per day. Many of you will be surprised to find out that Allure pays a makeup artist $150.00 per day regardless of whether it's a cover, inside spread or a tiny 2X2 photo of an author in the new books section. Check out our **RESOURCES** section for a current list of the editorial rates paid by many magazines based in Los Angeles and New York. The editors of Vogue know (and so should you) that one of their pages in your portfolio can take you from obscurity to stardom as a makeup, hair or fashion stylist in the blink of an eye.

Donna Karan tells a story about her early days as a designer. In a TV interview, she tells of how no one was buying her dresses. One day she received a review from the fashion editor of Vogue and moved thousands of dresses in a single day.

The exception to the editorial rules is that 'the bigger the magazine, the smaller the rate'. They don't have to pay more that $150. Everyone wants to work for them. When small magazines do pay (often you work for credit only) they sometimes pay more to get good people—or they don't know the going rate.

RUNWAY

Aaah the lure of the glamorous runway shows with all that back stage action and fun in exciting cities like New York, Paris and Milan. The reality is more like $250 per show. Not bad actually. You can do more than one in a day and the hours—just a few—aren't bad either.

CATALOGUE

Catalogue is the assembly line of the fashion industry. The idea is to crank it out. It's not at all like editorial where you might do 4-6 looks, or less in a day. On a catalogue shoot, you may have 10-15 looks in one day. Of course there's the cool catalogue like Victoria's secret, J. Crew, and Banana Republic, but there's also the factory catalogues like Sears, Spiegel, and JC Penney. The beauty of catalogue is the number of days in a row that you typically work on a single project. The rates start at about $450 a day. Not bad when you're working for 5 days at a time.

CD COVERS

In the music business, day rates aren't set in stone like those in the editorial market. Getting well paid on a CD cover usually depends on 1) Whether the artist is new, or established, 2) Whether you are new or established, and 3) Whether the artist or their management has clout.

An artist with clout usually means that the powers at the record label from the president to the publicist believe the artist could be the next Clint Black or Whitney Houston. The company is pulling out all the stops and sparing no expense on the accoutrements necessary to propel the artist to STARDOM, they hope! I have witnessed makeup, hair and fashion stylists being flown in from faraway cities to coif the likes of a perceived new star. The artist without clout, on the other hand, can mean that even though the deal is signed, the record label is not expecting huge numbers of record sales, so they aren't coming out of pocket with big dollars for makeup, hair and fashion styling. The objective for the label in this scenario is to get the pictures taken and the record released with the least amount of expense possible.

After speaking with quite a few art directors in Los Angeles and New York where most of the music business is centered, we found that the rates listed in the chart below applied across the board. We also learned that most record companies were accustomed to paying an additional twenty (20) percent agency commission. Refer to the resource section at the back of the book for a partial list of record companies, and creative decision-makers to show your portfolio to.

PRINT ADVERTISING AND COMMERCIALS

The rates for print advertising depend upon who's being marketed to. "General Market" is the term used to describe the Caucasian percentage of the population, and the Ethnic Market is used to describe everyone else. General market advertising campaigns market to the wealthiest and most populous segment of the United States and therefore spend the greatest amounts of money producing print advertising and commercials for that segment.

Ethnic campaigns are broken down even further into African American, Asian, Latin American, Etc. Less money is expected to be returned from marketing to these groups and thus the rates paid for makeup, hair and styling is less.

Our research showed that an average day rate for an artist on a general market campaign was $750 per day and could go as high as $2,500 per day if a celebrity was involved. African American and Hispanic day rates started at around $450 per day and went as high as $1,500, again if a celebrity was included. Asian campaign day rates were stable at about $750 to $850 per day. I think it is safe to say that the latin market has become very important to American Industry, and you can

MUSIC INDUSTRY SIDE NOTE

I encourage you not to get too caught up in the marketing, product management and A&R departments of record companies. Young stylists who are personal friends with someone who works in product management or A&R, often get hung up on that person's ability to give them work. And they can. Just not as much work as an artist can get by aligning themselves with art directors, whose job it is to give them work.

While a person in one of those departments can get you an occasional job. The majority of work for freelancers is given out by the art directors and graphic designers who staff the creative departments where numerous assignments are given out to makeup, hair, fashion stylists and photographers daily.

A product manager may be assigned a few acts to work with during the course of a year, while an art director at a company the size of Warner Bros. works on more than a dozen projects each year. You figure it out. 12 or more CD covers is equal to twelve photographers, and at least thirty six makeup, hair and styling people. Sony, Atlantic, and Warner Bros. creative departments each have ten or more (Sony has about 20) art directors. How's that for odds?

GETTING ORGANIZED

Remember back in chapter 1, I briefly mentioned a budget, and keeping track of your receipts? Here's a suggestion: Purchase a letter-sized rolling cart, some hanging file folders, a box of manilla file folders with fasteners, some avery labels, a 2-Hole punch, a Brother or Dymo label maker, and a box of 6X9 envelopes.

STEP 1: Label each of the hanging file folders with 5 letters of the alphabet.

Ex: A-E, F-J, K-O, P-T, U-Z.

STEP 2: Put 1-2 manilla folders inside the hanging file folders.

STEP 3: Using the categories on page 7.23 (First Year Budget), do the following:

—Label each of the 6X9 envelopes with a category, and the current year.

(EX: Automobile Exp - 2003).

CONTINUED ON PAGE 7-21

expect to see those numbers rise over the next few years to the typical African American top of $2,500.

MUSIC VIDEOS: HOW THEY WORK

The record company queries 2-3 directors about working on a new or established recording artists upcoming music video. The music for the recording artists new song is given to the directors who then write what's called a treatment (1-3 page storyline for what they will do). The treatment is then turned into a record company staff person in the video department, who then reads each of the treatments. The director who wrote the best treatment gets the gig. At this point the production company, as well as the artist and his/her manager begin looking at makeup, hair and styling books—separately.

If the artist worked with people that he/she really liked on the CD cover, then they typically request those people for the music video—which is often not the same people that the director wants to work with on the project.

At this point, a few things can happen...and do.

1. The producer may request that the recording artists portfolio picks be sent over, so that they can be evaluated by the director.

2. The director may look through them, say they're fine and tell the producer to go ahead and book them.

3. The director may look at them, hate them, and communicate this to the recording artist, at which point the recording artist may defer to the director.

4. The director may look at them, hate them, and communicate this to the recording artist, at which point the recording artist does not defer, and a test of wills ensues. Or, in the most drastic of cases.

5. The director may hate the recording artists picks, and request that the producer pretend to book the requested makeup, hair and fashion stylists, tell the recording artist, and management that the those freelancers were unavailable, and book his choices anyway.

REESA'S FYI: ON THE JOB TIPS

PERSONAL HYGIENE: Remember how physically close you are to the people you are working on and make sure your breath is minty fresh. Mints are always a better idea than gum, which, if chewed like a farm animal or a cracking fool can make one loose one's mind. Check your teeth to make sure you don't have evidence of your last meal in your teeth. Be aware of your finger nails. Chipped polish, dirt under the nails, and six inch long neon green dragon lady claws with hoops through the tips won't get you far in this business. Deodorant Please! Nobody is going to tell you that you stink, they just won't ever hire you again.

SANITATION: Make sure your kit and brushes are squeaky clean. Sanitize your tools. Don't wear dirty clothes or wipe your makeup on the clean ones you are wearing, and take an extra ten minutes to iron the creases out of the shirt you wore last night if you are going to wear it to today's shoot. Never be late. The production can be four hours behind, you can't! If you get into an accident on the way to a shoot, and you're not dead, call the production to tell them what happened, and then call your mother.

DRAMA: Check your personal baggage (problems) at the door. Yes, it will be hard to have a sunny disposition If your boyfriend or girlfriend just walked out on you, but act, and act well. Never bring a friend or unconfirmed assistant to the shoot with you. If you feel like you need help with an assignment, tell your agent so they can negotiate it into the budget or tell the client if you are handling your business transactions.

PERSONAL SPACE: Never look through the director or photographers camera without asking permission first. I have heard many times from photographers how annoyed they became when an artist just walked up to the camera and started fussing around. It's like asking a stranger if you can hold their baby. As a makeup, hair or fashion stylist, wouldn't you be offended if the photographer came up to the model and started rearranging her hair, changing her lipstick color or rummaging through your racks of clothing? Think about it.

HUMAN RESOURCES: Having a problem with another artist who will not get out of your mix? Be subtle about you objections. DO NOT yell at them or throw a tantrum. Pull the person aside quietly and work diligently to have an adult and professional discussion. Remember, you are being paid to work. Even when the other person is wrong, it doesn't look good to be involved in a brawl. After speaking with the individual, if the situation in question cannot be resolved, take your issues to the next level. Quietly, of course.

GETTING ORGANIZED, cont.

—Alphabetize the envelopes, according to the budget item, i.e.

- **Automobile**
- **Travel & Entertainment**
- **Stationary**
- **Office Supplies**
- **Office Equipment, etc.**

Drop 2-3 of the envelopes into the manilla folders that are housed in hanging file folders and each time you purchase an item or a service;

a) **Write the purpose on the front or back of the receipt, and**

b) **stuff the receipt into the appropriate envelope.**

Your accountant will love you at tax time. Now this of course is a really simplistic way of keeping up with your receipts. A more sophisticated system can be devised and is recommended.

Those of you who have accountants, financial advisors or savvy parents will do well to ask them now to help you devise and maintain a simple yet workable system.

The one I suggest will at least keep you out of trouble. **END**

A Good Reason for GETTING & STAYING Organized...

Many years ago, one of my fashion stylists; Lisa Michelle, was doing work for a small record label in LA. Everything was going along nicely until' we sent in the invoice. Thirty days, 45 days, 90 days later, we still hadn't been paid. I called numerous times, and as a last resort, I resorted to small claims court.

The president of the company—who was named in my complaint didn't show up, and so the judge found in our favor.

The next day, I sent a letter stating that we had won, and that he was to send me a check for the balance due, plus the additional fees that the judge had added. Still I got no word.

Luckily—Now this is the '**Being Organized Part**'—since this was a styling job, we had collected a check from the record label for the clothing advance. I went to the folder, and there it was, a copy of the check. I promptly took a copy of the check to the sheriff's office, and they promptly took $5,000 dollars out of the record label's bank account.

If money is important to you...Get Organized!

MUSIC VIDEOS: HOW MUCH THEY PAY

Working on _most_ music videos is not going to make you rich. Tired—yes. Rich—no.

Here's my theory about music videos. No one thinks they are making enough money on a music video. Not the director, or the producer, and certainly not the crew. Music videos come with long hours. It's not uncommon for one to shoot for 17 hours. The record companies hold out on the money they pay the production companies, and the production companies hold out on what they pay the artists.

Additionally, music videos are stepping stones. Everyone really wishes that they were working on high paying TV commercials like Coca-Cola, and feature film projects like "The Matrix Reloaded". While the record companies need to produce music videos to promote their artists, the money expended on producing those videos appears to have gone down in the last five years instead of up, like the cost of everything else.

The music video director turns in a budget to produce that winning treatment, and the record company promptly cuts the budget in half and still wants the same video. And so, everyone is underpaid.

MUSIC VIDEOS: EXCEPTIONS

There are, of course, Super Star artists like Janet Jackson, Sting, Whitney Houston, Clint Black, Mariah Carey and Boyz II Men who get million dollar video budgets. Everyone else gets the $40,000 to $60,000 budget and a request for miracles, please!

Makeup artists and hair stylists on these low budget projects get between $350 to $500 per day unless an artist is demanding their presence on the video. The twenty percent agency commission is squeezed out of a nearby rock. The poor fashion stylist is lucky to get one prep day to style a four girl group and ten extras for $500 per day. Requesting overtime can get you the proverbial dial tone quicker than you can say "Hello, are you there?" Music video budgets have been slashed so much these days that producers think flat rate is a new line item on their budget sheet. Is it that bad? Yes.

TELEVISION AND FILM

Television and film rates depend on several variables.

1. Whether the project is union or non-union.
2. The budget.
3. What position classification you are hired for.
4. How much the producers want you.
5. Your level of experience and expertise.
6. Your resume credentials.
7. If you have special skills.

If you are just starting out, you will not be taking home the big paycheck. So chalk it up to paying your dues and getting all the experience you can. What we did discover in all our union snooping around is that the lowest printed hourly rate for an entry level hair stylist was about $20 per hour, and the highest printed hourly rate for a makeup department head was about $33 per hour. It's not much, but it's the best we could do under the secretive circumstances.

1. A contact sheet with the names, addresses, phone and fax numbers and email addresses of every creative decision-maker you come in contact with on the job.
2. An **ENVELOPE** for receipts.
3. Two **CREDIT SHEETS**:
 - one for clothing credits.
 - one for your editorial credit line (these two forms are often faxed to different people at a record company or magazine).
4. A copy of the **VOUCHER** that you got signed by a decision-maker on the job.
5. The **ADVANCE REQUEST** form that you submitted prior to the job for expenses (ie. clothing, props, accessories, etc. . .)
6. A copy of the **CHECK** you received for expenses.
7. The **INVOICE** you submitted upon completion of the job.
8. An **EXPENSE** Sheet which is used to record expenses for which you have no receipts. Things such as mileage, parking meter use, tipping valet's and sky caps at airports, pay phone usage would be written and kept track of.

REESA'S FYI: THIS & THAT

RESPONSE TIME:

Bookings come and go in a matter of minutes. If you're stuck on the freeway when you get a page, and you can access your cell phone without driving into a Mack truck, then call back as soon as possible.

When clients call to check availability, they usually put in more then one call to more than one artist or agency. If it's a last minute booking, the client will usually hire whomever returns the call first.

BE PREPARED: When a shoot you're on turns out to be a long one, you should have been prepared. Here are a few pointers, so that next time, you don't turn into a whiner.

—Wear shoes that are comfortable.

—Pack snacks that are high in protein for a boost of energy when your blood sugar slips. Power bars or protein shakes are always good.

—Pack and stash personal hygiene products in your car for "that time of the month". Leaving a shoot because you "forgot" something, is unacceptable; even when said with a cute little embarrassing giggle.

STEVEN QUINN COOPER
MAKEUP & HAIR
CLOUTIER

RM: Steve, tell me how you got into this business and became the star hair and makeup artist that you are today?

SQC: When I was a little kid, I worked in front of the camera as an actor. Eventually, I got frustrated with the actor's life. I knew I had to do something that would allow me to be physical, because I was a dancer and an Olympic athlete. I wanted something to fall back on besides my body. I would spaz my self out

CONTINUED ON PAGE 7-25

PAPERWORK

Handle your business! Once everything is agreed to over the phone, the paperwork mill starts to grind, and never more loudly than it does with freelance artists. Makeup and hair stylists generally use four simple forms; **Confirmation, Voucher, Invoice** and **Credit Sheet**, and occasionally the Request for Advance. However, for a fashion stylist, it's those forms and these too: **Stylists Letter, Request for Advance, Clothing Addendum, and Stylists Worksheet.** On the next pages, we'll share some of them with you (in the order that they are typically used, explain what they're for, and even fill some of them out for you, so you'll know how to do it yourself.

CONFIRMATION & AGREEMENT

The **CONFIRMATION** is first. It is sometimes called a Deal Memo, and spells out the terms and conditions, day and overtime rates under which the artist will work on a project. It can be adapted for use in all industries. At the Crystal Agency, we use it to confirm every job our artists work on, including those where only a written credit is given in lieu of payment. The confirmation provides the creative decision-maker with a clear and concise description of the deal. It is a legally binding document. Fulfill your part of the bargain as the artist and if a client refuses to pay you, a document like this one with signatures from the powers that be will assist you in your quest for payment in small claims court. Since this form is on computer at the agency, we can add and/or delete paragraphs as needed. The vital information contained in a confirmation includes:

a. A **JOB DESCRIPTION.** Spells out who you are, what you do, the job you are working on, who you are working on (celebrity/recording artist) and whether or not you will have people (assistants) working with you.

b. A **DAY RATE.** Spells out how much you are getting paid for the first "X" number of hours (Rate Base) in a specific day before overtime begins to accrue.

c. The **OVERTIME RATE.** The rate of pay for two hour increments of Time that begin to accrue over the rate base hours called time and one half, Double-Time and Golden Time (Triple Time).

d. A **FLAT RATE**. A flat dollar figure you agree to work for without overtime regardless of how many hours the shoot goes on.

e. The agreed upon number of days you will be on the job.

f. The number of approved assistants and their rates.

g. The clothing budget.

h. When the stylist is to be paid (No later than).

i. What happens if clothing is damaged.

j. When you are to be reimbursed for damaged clothing.

k. What should happen to the remaining clothing at the end of the shoot.

Items i. and k. are very important because you don't want to get strung out with several hundred or thousands of dollars sitting on your credit cards, while you wait for someone to approve reimbursements for clothing that was damaged on the shoot. This sometimes requires that an additional clause be added to the confirmation. At The Crystal Agency, we always added the clause after "Total Minimum Fees" and before "Cancellation & Postponements". Here's an example:

SAMPLE CLAUSE

Morning Productions agrees to accept financial responsibility for damage to clothing, accessories, shoes, etc. . . that occurs during the music video shoot as a result of wearing by the artists, extras and/or principals. Monies due for damage to clothing accessories, shoes, etc. . . that causes fashion stylist Denise Farrell to go over her $7,000.00 budget must be reimbursed to Denise Farrell within 12 hours of damage assessment given to Morning Productions by Denise Farrell. Upon verbal and/or written damage assessment, Morning Productions will provide Denise Farrell with a check for overages which she will use to pay her vendors.

This, will keep you out of trouble with your vendors (see P7.26 for example of a confirmation).

STEVEN QUINN COOPER

and go to the gym three times a day if I knew I had a Speedo audition. I had always used my body to make my living and it got really got to me.

RM: **What about porno's? Just kidding.**

SQC: HA HA. So my best friend got married and had a really expensive wedding at the Ritz Carlton and hired one of the top people from CLOUTIER to do makeup.

RM: **Did you know much about hair and makeup and how all the agencies worked before the wedding?**

SQC: I knew a little bit because of my experience working in theater. I learned a lot about makeup from the ballet company I was with. I used to always mess around with friend's hair. I used to cut my nephew's hair, and I always had a natural eye for some sort of fashion style. I was never a fashion victim, but I could tell what looked good on people.

At my best friend's wedding, I hooked up with the makeup artist, and she suggested we become a team; she doing makeup and I hair. I had just gotten a scholarship to go through the directors program at Robert Redford's Sundance Institute, and I was doing Circque De Soleil. After six months my

CONTINUED ON PAGE 7-32

If the potential for damage to clothing on a particular job is high, you can always add a clause regarding financial responsibility for clothing in the event of damage or loss.

The clause can be added after "Total Minimum Fees" and before "Cancellation & Postponements".

Make sure to get your confirmation signed by someone who matters, in this case the Art Director. If it were a video or TV commercial you should have it signed by the producer or production manager.

This number authorizes the accounting department to pay you once your invoice comes in. It's called a Purchase Order No.

CAROL O'CONNOR
FASHION STYLIST
CONFIRMATION & AGREEMENT

This letter will serve as confirmation for **CARRY STYLEWISE, MAKEUP ARTIST** listed below as "TALENT" to *CELINE DION CD COVER TITLED "BABY LET ME GO"*

TALENT: _CARRY STYLEWISE, MAKEUP ARTIST_
PROJECT: _CELINE DION CD COVER TITLED "BABY LET ME GO"_
ARTIST JOB NUMBER: JT# _CS1000_ CLIENT JOB# _ONV 177_ CLIENT PO# _8077128_
CLIENT NAME: _SONY MUSIC_
CT PERSON & TITLE: _JANINE OLSON, ART DIRECTOR_
PREP/SHOOT/WRAP DATES: _AUGUST 19 & 20, 2003_
TOTAL NUMBER OF DAYS: _2_

RATE & TERMS

RATE/FEE :	$ _1,000.00_	per full / half day for up to _8 HOURS_ hours	
OT RATE (1.5):	$ _187.50_	per hour for each hour in excess of	_10 HOURS_
OT RATE (2.0):	$ _200.00_	per hour for each hour in excess of	_12 HOURS_
PREP RATE:	$	_N/A_	
WRAP RATE:	$	_N/A_	
ASSISTANT RATE:	$ _150.00_	per full / half day for up to _FLAT_ hours	
EXPENSES:	$ _35.00_	_PER_	
TOTAL MINIMUM FEES & EXPENSES:	_$1,370.00_		

Add financial responsibility clause HERE if necessary. If the clause is long, instruct the person to go to the next page, and add your own.

To compute overtime. Do this:

Take the fee of $1,000 and divide by 8 (the number of hours) and then multiply that number ($125) by 1.5 for Time-and-a-Half.

For double time, multiply by 2.0.

CANCELLATIONS & POSTPONEMENTS
IF NOTICE OF CANCELLATION OR POSTPONEMENT IS GIVEN LESS THAN TWO BUSINESS DAYS BEFORE THE SCHEDULED SHOOT DATE, THE CLIENT WILL BE CHARGED 100% RATE.

INVOICE PAYMENT
Note: The invoice generated from this job assignment is due and payable no later than _Aug 30, 2003_.
If payment has not been received by that date, a new invoice will be generated with a 2% late fee per month on the unpaid balance.

Your signature is required in the spaces provided below and will serve as confirmation and agreement of the number of days and dates booked, as well as the agreed upon rate(s) and terms for payment of the invoice that follows.
Once signed, you have agreed to the terms and conditions as they are stated above.

NAME _____ TITLE _____ DATE _____

THE REQUEST FOR ADVANCE

This extremely valuable form is a special invoice that permits a client to release funds to an artist for expenses such as clothing, accessories, props, wigs, makeup, etc. It gives the client a record of your social security number, as well as a description of what and/or whom the funds will be used for.

A stylist was miffed about why a record company would send her a 1099 tax form at the end of the year, for monies they had given her. *"I spent all the money on their artist"* she said. True enough. She had spent all the money on the artist, and further, she had dutifully given the record label all of the receipts. But artists, here's the deal. **It is your responsibility to make copies of all receipts and keep them on file** to show your accountant at the end of the year. As a matter of fact, you should maintain a file draw with duplicate folders complete with your own set of job numbers for each assignment. In it, you should catalogue every piece of paper collected by you or you assistants in the execution and completion of a job assignment. A single manila folder with all of the paper you have gathered for a job will keep you from having a big IRS headache down the line. Following is a general list of contents you should keep in each of your job folders:

ADVANCE CHECK

The advance check is given to artists for the purpose of renting and/or purchasing clothing, accessories, and props if you're a fashion/wardrobe stylist, and supplies such as prosthetics, wigs or other makeups that may not be regular items in a kit, if you're a makeup or hair stylist.

Without that check, I have witnessed artists get burned by large and small companies alike. The client insists that the budget will be "X" amount and directs the artist to **GO AHEAD** and get started shopping on their own cash, and credit cards. The result is usually a clothing budget and stylists fee that are cut in half two days later, leaving the stylist hanging out to dry with a bunch of returns, restocking fees and an invoice from an assistant for two days of work.

THE RULE IS THIS: unless you are working with a longtime client you trust, have worked with before, OR you have a signed confirmation describing the terms, conditions, fees, and expenses connected with the job, STOP! Keep your credit cards in your pocket, your cash in the bank, save your contacts for the gig that has been confirmed on paper, and let your assistant work for another stylist today. You are about to get Screwed!

WHEN TO USE:

The REQUEST FOR ADVANCE is sent in before the job to get the funds you need to purchase whatever you require in order to execute the job.

CARRY STYLEWISE
MAKEUP & HAIR STYLIST
10000 ANYSTREET BLVD., STE 000
ANYCITY, XX 55555

REQUEST FOR ADVANCE
INVOICE

DATE	INVOICE NO.
	CS1000

BILL TO:

SONY MUSIC

ATTN: JANINE OLSON

555 MADISON AVENUE, 22ND FLOOR

NEW YORK, NY 10017

ARTIST JOB NO: *CS1000*

SOCIAL SECURITY NO: *55-55-5555*

CLIENT JOB NAME: *CELINE DION*

CLIENT JOB NUMBER: *SONY:CD4177*

KEY CONTACT PERSON: *PERSON WHO HIRED YOU*

PURPOSE FOR ADVANCE: *CLOTHING RENTAL/PURCHASE*

MEDIUM: *PRINT: CD COVER*

PO NO: *SBCD1273*

This invoice is for _____. The scheduled shoot date is: _____.
CLOTHING, PROPS, KIT EXPENSES, ETC.

It is imperative that I receive the advance by: *AUGUST 14, 2003*.

EXPENSES:

1. _____ $ _____
2. _____ $ _____
3. _____ $ _____
4. _____ $ _____
5. _____ $ _____

EXPENSES TOTAL: $ _____

NOTES:

PLEASE MAKE YOUR CHECK PAYABLE TO:

CARRY STYLEWISE
10000 ANYSTREET BLVD., STE 000
ANYCITY, TX 55555

© SET THE PACE PUBLISHING GROUP 2003

CS1000=Carry Stylewise 1000.
1000 is the first job number in your series. The next job will be CS1001, etc. You can also use the same number for your Invoice number.

Big companies ALWAYS assign some kind of number, and usually it's 2.

First there is a client Job # that follows the particular assignment around everywhere it goes. Everyone who is working on the Miller Ad campaign that happened in Hackensack, NJ on the 25th of March is given the same job #.

They almost ALWAYS have a second number which is the PO or Purchase Order number.

The Purchase Orders are numbered consecutively, and are assigned to the purchase of specific goods or services.

In other words, the makeup artist PO # may be SMCD1273, the hair stylist may be SMCD1274, and so on.

Ask them for it. That number on your invoice will make it much easier to get paid.

Include the date you require the advance here, or you'll never get it in time.

CLOTHING ADDENDUM:
Never Leave Home Without It.

A clothing addendum is a form that can be used to get additional purchases or rentals [over and above the original budget] approved by a decision-maker **on the spot**. Stylists use this form more than anyone.

A good stylist always over-pulls, however, that doesn't mean that the client can afford to use all of the clothes in the shoot. If the client has a $5,000 budget and wants 4 looks, a good stylist may pull $10,000 worth of clothes —enough for 7 or 8 looks (just in case).

CLOTHING ADDENDUM: When & Why

Here's what often happens: Somewhere on location, a shoot is taking place in the middle of Chicago. It begins to rain. A conversation between the Art Director and the stylist ensues:

Art Director: "I want the model to wear that silver metallic leather jacket."

Stylist: "Well, Sir, that's what I had planned for her to wear, but it's raining now and if the jacket gets wet, I can't return it."

Art Director: "So what?"

Stylist: "Well, Sir, this jacket is $1,600 and will put us $1,732 over budget. We're already $132 over."

Client: "I don't care, it's perfect for the shot."

Stylist: "Okay, if I can just get you to sign my addendum (guaranteeing payment within 24 hours) for the additional overages, then we're good to go."

CARRY STYLEWISE
MAKEUP & HAIR STYLIST
10000 ANYSTREET BLVD., STE 000
ANYCITY, XX 55555

ADDENDUM FOR OVERAGES

This Addendum is made part of the Confirmation Agreement dated _____ , (TODAY'S DATE) regarding Job No: _____, and Job Name: _____ by and between _____ (NAME OF AUTHORIZING PERSON) the _____ , and _____ , the _____ stylist. (TITLE) (FIRST & LAST NAME OF THE STYLIST)

Seeing as how the use of additional clothing, and/or accessories, and/or jewelry, and/or shoes on the following: __ photo shoot __ music video __ commercial __ tour __ personal appearance __ _____

will cause _____ (FIRST & LAST NAME OF THE STYLIST) the _____ (TITLE) stylist, to go over the official budget of $_____, it is necessary to get approval in overages, which will be:

__ billed to the client

__ charged to the _____, _____ credit card ending in __ __ __ __

__ paid with a reimbursement check, provided by _____ on _____, ___ 200__.

I, _____ HEREBY AUTHORIZE _____ TO: (NAME OF AUTHORIZING PERSON) (STYLISTS NAME)

__USE MY CREDIT CARD TO CHARGE THE ITEMS LISTED ON THE REVERSE SIDE OF THIS AGREEMENT SHOULD THEY BECOME DAMAGED AND/OR UNRETURNABLE TO THE CLOTHING/ACCESSORY/SHOE STORE IN ANY WAY.

__BILL _____ FOR THE ITEMS LISTED ON THE REVERSE SIDE OF THIS (RESPONSIBLE PARTY) AGREEMENT SHOULD THEY BECOME DAMAGED AND/OR UNRETURNABLE TO THE CLOTHING/ACCESSORY/SHOE STORE IN ANY WAY, AND THE STYLISTS _____ WILL BE REIMBURSED FOR THE AGREED UPON OVERAGES WITHIN 4 WORKING DAYS OR 96 HOURS.

_____ _____ _____
AUTHORIZED SIGNATURE TITLE DATE

A savvy stylist with an addendum helps an enthusiastic Art Director put creativity back into business perspective. Sure, that jacket Rocks! And the recording artist would look good in it, but unless the Art Director is willing to sign the addendum, the money isn't there, and you could end up trying to sell that jacket to one of your girl friends for a fraction of what it costs.

The decision-maker must put-up, shut-up, or wait until it stops raining. Don't get stuck with a $1,600 jacket that you cannot fit or afford because they were afraid to speak up. Remember what Cuba Gooding Jr. said to Tom Cruise in the film "Jerry McGuire;" "Show Me The Money".

VOUCHER

The voucher (pictured at right) comes in handy on music videos and TV commercials where producers get amnesia around the 2nd or 3rd hour of overtime. Once a voucher is signed by a person in charge, it is proof that you were on the job and the number of hours you worked. It matters when you are working on a video that was supposed to be a 12 hour day, and you're into the 17th hour. You don't mind the long hours because your paycheck is growing bigger by the moment.

However, the producer does mind. How is he going to get that money back? Perhaps by forgetting the hour lunch you didn't get because you worked through it. Your invoice shows 17 hours worked, but the producer subtracts an hour for lunch. How will you prove that you didn't eat

Make sure to get your VOUCHER signed by someone who matters.

FOR EXAMPLE

Music Videos, Commercials, TV, and Film:
- Producer
- Production Manager
- Director

CD Covers:
- Art Director
- Photographer

Editorial:
- Photo/Fashion/Beauty

Editor
- Art Director

Catalogue:
- Art Director
- Designer

Advertising:
- Art Director
- Photographer

Publicity:
- Get a confirmation signed beforehand for sure. Publicists hate to sign anything and are rarely responsible for payment. If you were contacted by the publicist, but you are billing a production company, or a film company, then try to find someone on the client side to sign your voucher at the shoot.

ANYONE'S NAME GOES HERE

CLIENT _____	ARTISTS JOB NO. **CS1000**
ARTIST / SUBJECT _____	CLIENT PO N. **8077128**
PROJECT TITLE _____	CLIENT JOB No. **SONY:CD4177**
X PHOTOGRAPHER ____ DIRECTOR _____	**DAVID ROTH**
X ART DIRECTOR ____ PRODUCER _____	**JANINE OLSON**

	DATES OF WORK	DAYS	HOURS	RATE	TOTALS
PREP	_____	/		$ ____	$ ____
SHOOT	AUGUST 18/19	2	N	$ 1,000.00	$ 2,000.00
WRAP	_____			$ ____	$ ____
TRAVEL	_____			$ ____	$ ____
WEATHER	_____			$ ____	$ ____
OT: 1.5	_____ /			$ ____	$ ____
OT: 2.0	_____ /			$ ____	$ ____
	_____ /			$ ____	$ ____
				SUB-TOTAL	$ 2,000.00

EXPENSES ____ KIT FEE ($35/DAY FOR 2 DAYS) ____ $ 70.00

TOTAL AMOUNT DUE $ 2,070.00

BILL TO SONY MUSIC
ADDRESS 555 MADISON AVENUE, 22ND FLOOR SUITE# ____
CITY/STATE/ZIP NEW YORK, NY 10017
ATTENTION JANINE OLSON PHONE (310) 555-1212
AUTHORIZED BY JANINE OLSON Janine Olson
 PRINT NAME SIGNATURE
TALENT SIGNATURE Carry Stylewise

PRINT CREDIT TO READ AS FOLLOWS
MAKEUP by CARRY STYLEWISE

LET'S MAKEUP

FED TAX ID NO: 215-46-6155
5430 LYNX LANE, STE 290 · COLUMBIA, MD 21044
PHONE 410-997-8757

White Copy: Agent Canary Copy: Talent Pink Copy: Client

lunch? By sending in the voucher that you got signed on the day of the job with your invoice.

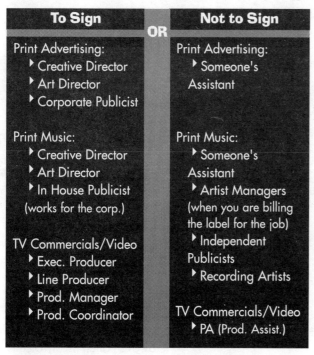

To Sign	OR	Not to Sign
Print Advertising:		Print Advertising:
▸ Creative Director		▸ Someone's Assistant
▸ Art Director		
▸ Corporate Publicist		
Print Music:		Print Music:
▸ Creative Director		▸ Someone's Assistant
▸ Art Director		▸ Artist Managers (when you are billing the label for the job)
▸ In House Publicist (works for the corp.)		▸ Independent Publicists
		▸ Recording Artists
TV Commercials/Video		
▸ Exec. Producer		TV Commercials/Video
▸ Line Producer		▸ PA (Prod. Assist.)
▸ Prod. Manager		
▸ Prod. Coordinator		

AUTHORIZATION: WHO CAN SIGN

If the person who hired you and whose company is paying the bill isn't around to sign the addendum, and/or they can't be tracked down so that you can fax it over for signature, then think again. A lesser person's signature might not be enough to get you reimbursed.

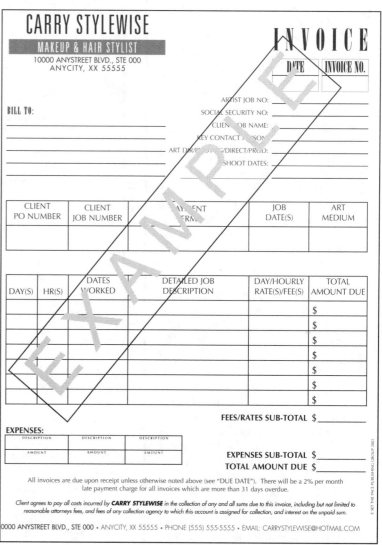

INVOICE

Professional people have professional invoices. Prepare one, at the end of the job, and send it in along with a signed voucher if you have one. ALWAYS include vitals such as: PO Numbers, Job Numbers, Job Dates, etc. on your invoice. It will expedite the processing of your invoice and make it easier for the accounting department to pay you on time (See P7.23 for an example).

CREDIT SHEET

There are two kinds of credit sheets. One is sent to the editorial department of a magazine to insure that the clothing is credit properly (see P7.28), and the other is used to ensure that you're credited properly in a magazine. Here are some examples:

STEVEN QUINN COOPER

agents tried to change my contract from one to three years without telling me. For a while I didn't know what I was going to do! But, I made a decision. A week later I left to go to cosmetology school, Redford's directing school and taught dance privately all at the same time up in Utah. I was going to school almost 75 hours a week. I hated the directing school at that time. It was too much of what I tried to get away from in LA. But I totally rocked at cosmetology. I loved it. After a year I moved back to Los Angeles, called the makeup artist that I met at the wedding and started looking for a place to live. I couldn't find anything for three weeks and I was just about to get my things out of storage and move back to Utah when she called and offered me a ten day booking. It was for a Cosmopolitan cover, a Levi's 501 commercial, a Lee Jeans Commercial and a shoot for Interview Magazine.

At the end of the Cosmo shoot when they were giving the credits, the makeup artist only gave me an assistant credit. I was pissed because I did ALL the hair and she did the makeup. I left the shoot an hour early because I was so mad about the credits. That same day I went to CLOUTIER. I showed them Polaroid's and totally sold myself. I explained my whole history and told them I was really serious and passionate about doing this. At

CONTINUED ON PAGE 7-33

ANYONE'S NAME GOES HERE
ANYONE'S TITLE GOES HERE

CREDIT SHEET

Client: SONY MUSIC
Job Name and/or Number: SONY: CD4177
Project: CELINE DION CD COVER "BABY LET ME GO"
Artist/Subject: CELINE DION
Editorial Section & Issue: N/A &
Art Director: JANINE OLSON
Photo Editor: N/A
Fashion Editor: N/A
Photographer: DAVID ROTH
Photo Session Date: AUGUST 19 & 20, 2003

CREDITS SHOULD READ AS FOLLOWS:

Makeup by CARRY STYLEWISE
Makeup & Hair by
Mens Grooming by
Hair by
Fashion Styling by
Set Decoration by

Should you have any questions regarding this information please call ANYONE'S NAME GOES HERE @ 555-555-5555.

ANYONE'S NAME GOES
ANYONE'S TITLE GOES HERE

ANYONE'S ADDRESS GOES HERE
PHONE: 555 - 555 - 5555 FAX: 555 - 555 - 5555

© SET THE PACE PUBLISHING GROUP 1995

Ask the person who hired you, whom you should send the **CREDIT SHEET** to. You need to ask because if you just worked for a magazine, the editor who hired you may not be responsible for insuring the accuracy of the credits.

It's okay to attach a copy of the credit sheet to your invoice when you send it in, —if the invoice is going to the creative person who hired you.

However, often the invoice is going to the ATTN: of the accounting department, and they could care less about your credits. So remember to ask the question, otherwise your name could be misspelled or omitted from the printed piece altogether.

By the way, credits do not appear on ALL printed pieces. You can expect to see your credits in magazines, and on CD covers, but not on Advertisements like Miller Beer or Tiffany jewelry.

Fashion Styling by Renee Howard/The Crystal Agency, or
Fashion Styling by Renee Howard for The Crystal Agency, or
Fashion Styling by Renee Howard/CrystalAgency.com

Makeup by Joanne Gair/Cloutier
Makeup by Joanne Gair for Cloutier

Hair by Jason Hayes for Mark Edward, Inc.
Hair by Jason Hayes of The Makeup Shop for Mark Edward, Inc.

(This listing is shared by "The Makeup Shop" where Jason rents space for his wig business, and his agency Mark Edward where he is booked out for commercial jobs)

Hair by Reeko of Elgin Charles/Crystal, or
Hair by Reeko of Elgin Charles for the Crystal Agency, or
Hair by Reeko of Elgin Charles in Beverly Hills/CrystalAgency.com

(These listings are shared by "Elgin Charles", the salon that Reeko works at when he is not booked out for commercial jobs, and his agency; Crystal.

If you are represented by an agency, they will take care of that little detail. However, if not, you will need to do it yourself. When faxing over your credit, it's important to remember that editors and art directors are working on lots of different projects, and while your one credit line in the magazine is important to you, you may have to provide them with a little more information than just the credit, as it is written above to insure that it is printed accurately in an upcoming issue. The credit sheet pictured on P7.28 will give you an idea of the kind of information a credits editor or art director will need to put your name with the right photo(s).

ASSISTING

Assisting is a great way to learn without being responsible for the outcome of a project. You can learn set etiquette, politics, tips, and techniques from the best in the business. All without getting in too much trouble if you make a mistake here and there. But there are some mistakes that can get you canned forever. Tobi Britton explains.

one point I even grabbed the arm of the woman I was meeting with. She said there wasn't much she could do for me without a book. All she could do was send me out on free or low paying jobs and tests to build my book. My Dad always told me never work for free, but in this business that's what you do to build relationships, show people what you're about and build your book! I worked for free seven days a week for six months for the first time in my life. I was lucky, I had saved $10,000 from my dance lessons in Utah. I did free jobs but I got some great gigs. I did JEWEL for Interview and gave her a whole new look by cutting her hair off. I was really lucky. I was at the right place at the right time and I had a good attitude.

RM: Wow! So, was it all easy street from that point on?

SQC: Well my second job was a show for Giorgio Armani. I was still dabbling in acting and broke my foot dancing at a commercial audition. The next day I was booked to do the Armani show. When I called CLOUTIER, they said they would take me off the job. I told them "No way! I'm an athlete, I need to work with my hands not my feet. They finally agreed and I did the show with a cast on my foot and crutches. There were sixty girls and I had never

CONTINUED ON PAGE 7-34

STEVEN QUINN COOPER

done a runway show in my life! When the show was over, Mr. Armani came up to me, kissed me on the forehead and said, "Kid, you're gonna be a star". After that I got booked for Calvin Klein, Versace, everybody. I am really the only one in L.A. who has done that caliber of show. I totally dig it!!

RM: Cool. So do you still test?

SQC: Oh yeah. I still test. I believe in working at your craft every day. Whether it's prepping for a job, working on a mannequin or a client, getting your pictures printed up, making your business cards, whatever. It's a never ending process. I think that's what moved my career so fast, my determination and my drive. On top of it I've learned to be a businessman.

RM: Are you dreaming about doing the cover of Vogue?

SQC: Yeah, definitely. I actually just did a bunch of work for German Vogue. I only want to work in the fashion industry. I don't like the hours on music videos or commercials. I only have a couple of those clients. I do editorial & fashion shows. It's not always about money for me. It's really about having a good time and doing fresh, creative work.

THE ART AND ETIQUETTE OF ASSISTING
by Tobi Britton

There is no doubt that assisting an established artist is a fabulous way to learn the craft of freelance hair, makeup or fashion styling. It is also the most difficult type of work to get, and being an assistant doesn't always guarantee that the diva artist you are working for will, in turn, share their pearls of wisdom thus making life easier for you. In fact, I would like to suggest that you should welcome the more difficult road, for in the long run, you will be a better prepared and more solid artist than those who found an easy way. It's called "paying your dues", and it will be your mantra until you can support yourself entirely by your art.

When I decided to become a makeup artist, I figured that as soon as someone important saw my natural talent they would hire me immediately. I looked at other artist's work in magazines and thought—I could do that, it's no big deal. Fortunately, I never said that to anyone. I was a bit obnoxious, but at the time, I just thought I was extremely motivated!

Let's take a look at the industry. Makeup, hair & fashion styling is the most unnerving of art forms. We are the only artists that have our canvases talk back to us and tell us whether they like IT or not!

If that isn't bad enough, we then have art directors, photographers, directors, editors (you get the picture) waiting to let us know if they like it too.

And then there are the times when the director loves it, and the actress hates it and vice versa.

Successful artists need a pretty strong sense-of-self, a heaping tablespoon of talent and a truckload of people skills to boot. Many find it easier to close down the vulnerable side and become defensive, haughty or just so damn driven that they don't care how many people they have to step on and use to get where they want to go. If you find yourself displaying that type of behavior (even a little!), remember this:

❖ The world owes you nothing.
❖ Be grateful for any help you receive on the way.

❖ Be loyal and give credit to those who help you.

❖ Stay open.

❖ Your time will come—be patient.

So what exactly is assisting? Assisting is a form of the old 'give and get'. And as a rule, it depends on the key artist's needs.

What You Give:

❖ Your time to help the key artist, and make them shine.

❖ Your time and diligence in keeping all of the makeup, hair supplies and tools organized.

❖ Setting up and packing the artist's kit.

❖ Cleaning and/or sanitizing the brushes and makeup.

❖ Keeping the makeup or hair table organized and clean.

❖ Running errands when needed.

❖ Watching the set like a hawk without gabbing.

❖ Doing whatever makeup applications or touchups that are asked for.

What You Get:

❖ A fabulous opportunity to see and experience a shoot.

❖ A chance to see how a pro handles a set, organizes and problem solves.

❖ A sense of comfort from having had the opportunity to be and learn on the set, while not having to assume responsibility for the way things turn out.

❖ An opportunity to learn new techniques that you may not have thought of.

What Assisting is Not:

❖ A networking frenzy for you and your career.

❖ A chance to get chummy with any of the people in charge so you can contact them later.

❖ A chance to let your fantastic talent shine so brightly it outshines the key.

❖ The place to make the key look bad.

❖ The time to ask tons of questions of the key while she is working.

❖ An opportunity to return all the phone calls you've been meaning to catch up on because it appears that there is a lull in the work flow.

Makeup Artist Tobi Britton by Jayme Thornton

Tobi Britton is an accomplished makeup artist, hair stylist and educator. She can be reached at her shop in Manhattan. The Makeup Shop, NY is located at 131 West 21st Street, NY 10011. (212) 807-0447

themakeupshop.com

STEVEN QUINN COOPER

RM: **What are some of the "No No's" of this business?**

SQC: I think the most important thing is that no matter what the job is, it should be thought of as the cover of Vogue. Why? Because the girls that you work with DO end up on the cover of Vogue. Not everybody, but some of them.

As far as attire goes; I work in t-shirts and surfer shorts or baggy clothes. **The thing is, my clothes are clean, my kit is clean, my hands are clean, and I am on time to all my jobs.** In fact, I am early because I need to set up, and express my views to the photographer. I am usually the first one there. I always believe in production meetings before the shoot, even for tests. It saves so much time when everybody is prepared and organized. I think organization is the key to success, not just on the job, but in your life in general.

RM: **That's good advice. Okay readers, everybody put this book down for an hour, and clean up your room! Anything you'd like to say before we call this a wrap?**

SQC: The whole idea of fashion for me is beauty. I believe there's a lot of makeup and hair people that do such freaky stuff that the beauty of the work never shines through. You can do wild and freaky but it still has

to be beautiful in some way shape or form. I mean, everybody has an imagination to make things really far out, but the trick is to make it appeal to 5 million people. Take as many classes as you can. I really believe you can never know enough. I still go and take color classes and skin classes. I collect samples of a lot of new different products and keep them in my kit to try out. I think everything you can learn can add to your career success.

Every month read all the fashion and entertainment magazines so you can keep abreast of what's happening. Rip out tearsheets of work you admire, or try keeping a sketch book around and jot down ideas or drawings of work you would like to experiment with, that's my new thing. Also, If you just do hair, learn makeup, and vis a versa. They really go hand in hand. And one last tip: Don't mix business with pleasure if you know what I mean. Just be careful, this is a business and you need to deal with 1,000 different personalities that you have to mold to.

RM: Groovy, Mr. Cooper. Thanks for your time. You tell a good story young man! END

❖ Your chance to be chatty with the crew or PR people during the shoot—especially when you are supposed to be watching the set!

❖ A chance to show your book to anyone, in fact, do not even bring it unless the key specifically requests it.

❖ A place to let those in charge know how YOU would have done the makeup if you had the chance.

So why all of the rules? What's the big deal if you hand out a few cards? Think of working as an assistant as being invited to your best friend, and her fiancee's home. Your best friend is the artist who hired you. Her fiancee is anyone you may feel like networking with. Would you approach her fiancee and tell him that you would make a better girlfriend than she, or that you would cost a lot less to live with?! Would you give him your number? What if he asked you for yours? Would you give it to him then?

Be worthy of another's trust. It will benefit you many times over, and much more than handing out your card inappropriately. Not only will it build character and good karma, the artist that you are assisting will probably recommend you for other jobs in the future. If your ego won't allow you to work for another artist, or you feel jealousy toward other artists, then DO NOT accept assisting jobs. If you are really interested in assisting, here are some things to remember.

❖ Don't give up because it appears that doors are being repeatedly slammed in your face. Sometimes, they just don't want to make it easy on you because they had to pay their dues the hard way.

❖ Don't give in because some artists are being down right rude to you when you ask to assist. Unfortunately, people sometimes mirror and then project (unwittingly) their own bad experiences onto others.

❖ If someone asks you for your card, refer them to your key and tell them they can get in touch with you through her. Many times, the key will tell you it is all right to give your card instead. This will say a lot about your character and professionalism, both to your key and others.

When you get an opportunity to assist, remember that your place is one of a support person. Make the person who hired you shine. Following these simple guidelines will help you tremendously with your career.

AGENCY ASSISTANTS LISTS

We receive calls from people daily asking if they can assist our artists. While we only have a small roster of artists who maintain a list of 1 or 2 assistants each, the bigger agencies, like Celestine, Zoli, Cloutier and Art & Commerce have much larger rosters of artists who need assistants.

Every agency has an assistants list whether they own up to it or not. The best way for an assistant to get on with an artist is by first doing their homework and having an idea of the artists they would like to assist and the kinds of projects those artists are working on. Before you contact an agency to get on their assistants list, do your homework. Find out which artists they represent, and identify one or two that you would like to work with. It's a lot more impressive than, "Hi, I'm a stylist and I want to work with your artists."

We receive résumés and cleverly put-together cover letters from aspiring freelancers wanting to work with our artists all the time. Our modus operandi is to photocopy the résumé and forward it to each of our artists. However, very few of our artists even bother to follow-up, they're just too busy. The need for an assistant materializes when there is a big job with lots of principals and extras that need dressing, grooming or making up. That's the moment when our artists begin frantically trying to find more assistants to help them out, and often it's the agency that fielded those calls in the first place, that does the searching and booking of assistants.

The person that needs to follow up is you. The squeaky wheel gets the grease. After you have made the initial introduction via phone, fax, letter, or email, take the time to call once every couple of weeks just to follow-up and touch bases with the booker or owner at the agency. You'll have a much better chance of getting work, because we remember those artists who continue to follow-up, and follow-thru...with a smile. Also, if you have even a single picture of your work—send it. It will give the agency something to keep on file and reference.

TV and film hair stylist Susan Lipson of On Set Motion Picture Hair Academy suggests that you go to the set and introduce yourself. Ask for the the makeup or wardrobe department if it's a TV show, or the costume department on a feature film. People bond with people and voices, rarely paper [résumés]. And remember what Reesa said about following up, "If you meet a person who says call me on Monday at 12PM, call on Monday at 12PM".

Mademoiselle's
Fashion Director, Evyan Metzer-Street
Shoots from the hip.
by Shelley Shepard

During March and April designers are busy showing their latest fashions to the press in Europe and New York. It is the time of year when magazines forecast the fashions we will be seeing on their pages for the next 6 months.

The woman holding the fashion reigns at Mademoiselle Magazine is the fashion director, Evyan Metzer-Street. Her creative hands are full, and still found time to share her experience with us.

Q: What is it like going to the shows? As fashion director, what is your role?

A: Well, I just returned from the shows in London, Paris, and Milan, and this week I'm attending the shows in New York. My job as fashion director is to look at it all, absorb, and try to figure how it will be seen through Mademoiselles eyes.

Q: How do YOU TRANSLATE what you see at the shows to the printed pages of your magazine?

A: It's a total process, you're involved with seeing the show, seeing an idea, putting the idea into a story, getting the photographer, hair, makeup, etc. After fashion week, I meet with my editors at my house and talk about the trends and then try to put the trends into story ideas. I then meet with my editor-in-chief, cre-

CONTINUED ON PAGE 7-38

EVYAN METZER-STREET

ative director and the photo editor and talk about some photographers we have worked with in the past and some new ones we want to try. We slot them into our schedule so that we not only have a balance in fashion but a balance in the photographic styling.

Q: What is your background, were you FASHION INSPIRED as a child?

A: As a child I loved clothes, shoes and interestingly enough, photography. I was and still am a total magazine junkie. My stepmother, who is a photographer, influenced me and gave me a very good background in photography. I went to a liberal arts college and was going to go into advertising, but changed my mind and majored in communication. During the summers, I worked in production and got more experience there. After I graduated in '86, I interviewed at Condé Nast Publications and got a job right away at Glamour magazine, assisting the new creative director. I learned so much there, Glamour is a huge magazine. After a year and a half, and a chance meeting with a friend who worked at Vogue, I got offered a job at Vogue. It was at Vogue that I was guided and taught to be a really good editor to photographers and to make the best picture. After that I got my first editor job at Harper's Bazaar. I was only there briefly then moved to Vanity Fair, where I also did celebrity styling. But *styling for celebrities and styling for*

CONTINUED ON PAGE 7-39

BUILDING THE FASHION STORY

In her book <u>Mastering Fashion Styling</u> former fashion stylist Jo Dingemans said "A fashion story begins with an editors choice of trends, direction and seasonal musts for that month". Following is a way to think about and include a fashion editors *thought process* into your own when building a story for a test.

In creating your own fashion stories for testing, take a moment to think beyond the pages of your favorite magazine for inspiration. Think, as the top editors must about world affairs, art, celebrity, politics and how they impact the designers work. What's big news? It it a particular color? Or is there a political or social theme that permeated the runways this season? Is there an artistic or cultural renaissance emerging?

Like a fashion editor, the team (makeup, hair, stylist, photograper) must decide what they will work on, and then how to interpret the story through fashion, photography and the environment that you choose to shoot in.

Perhaps the editor noticed that the designers showed a preponderance of gray on the runways in response to the worlds own military build up in a particular war. How would you interpret that build up in your own story?

How might you—your team, have interpreted the dot com demise through testing? The enormous excesses and internet gains of '99-2001 gave way to huge personal losses in 2002 right along with the waning of the fur stigma in 2000. The stark contrast of people loosing their fortunes in a single day on the internet when compared to a resurgence in American women's love of fur could make for an interesting story—don't you think?.

Think of it. A shot of a model laying on the floor in the kitchen of her fabulous home. Empty. She is dressed only in blackgama mink laying amongst broken DVD software in one shot. Next she lays poolside in another blackgama mink with a martini, but the pool is empty—save the leaves and a computer. What images come to mind? Let your imagination go wild. A story can be as elaborate and as staged as this, or as simple as a girl shopping for the seasons best strappy shoes in Beverly Hills. What would the story look like on paper—with pictures? Think of it like a storyboard, the way commercials are scripted out. Ask yourself these questions:

About Logistics: How many pages will the story have? 4? 6? 8? (Remember, 1 picture does not a story make). How many different locations will we shoot in?

About The Story: What would a girl who was going shopping all day do—from morning til' night? Where would she go? What would she eat? Where would she eat? How would

she get to Beverly Hills? On a bus? In Her Car? How would she get home? What if the car wouldn't start? Who would she interact with throughout the day? Would she window shop—or not? And in every shot, the shoes are the focal point.

About The Looks: What will she wear in each shot? What will you do with her hair, ...the makeup? Will there be drastic or subtle changes in makeup and hair? Here's a little exercise.

What you'll need:

1 Copy of this weeks Newsweek 1 Copy of the current issue of Vogue, W or Elle.
Post-It Notes Yellow Hi-liter

What to do with it:

First, flip through the copy of business week and use post-it notes to identify 3 world events that interest you. They can be anything. Business. Politics. News. Life. Death. Art. Sports. Hip-Hop.

Next, flip through a copy of one or more of those 3 fashion magazines. Use the post-it notes and hi-liter to identify 1 trend, 1 direction, and 1 season must-have.

Now, find the trend, direction or season must-have that inspires you and match it to one of the world events.

Then, work on the details. The who, what, where, why, and when.

And, using the storyboard squares provided, write in your storyline as if they were pages in a magazine. If you can draw, (which I can't) fill in the story with pictures, and write the storyline in the spaces provided below.

Lastly, go to the back 1/3rd of your favorite fashion magazines and look at the fashion STORIES. That's what they are—Stories. Ask yourself, "What is the story that they're telling in this editorial.

Now construct your own using from the magazines, post-it notes, and hi-liter. The storytelling is what pre-production meetings are all about.

EVYAN METZER-STREET

fashion are two very different things and after two years at Vanity Fair, I missed high fashion. Liz Tilberis was redoing Harper's Bazaar and wanted a young editor, and brought me over. After 2 years there I started feeling like I was the youngest person on the totem pole and wanted to find a place that was more like myself and what I was all about. Luckily I fell into Mademoiselle! I was Sr. Editor for 2 years, and then they made me Fashion Director.

Q: Do you STYLE yourself?

A: Yes, I style for photo shoots as well. My job is not just about coordinating and styling the big fashion pages, however, we have all sorts of style sites, fashion news pages and more.

Q: When it comes to booking hair, make up and stylists, does Mademoiselle book artists through agencies or do you use freelance?

A: We usually work through agencies, but we have used freelance people to do beauty stories. There are allot of magazines though that use more freelance people.

Q: So you think it is more important to be with an agency?

A: Yes, it is good to be with an agency, but it's also good to do some networking for yourself. I think agents are important,

CONTINUED ON PAGE 7-42

Use this ▾ and ▸ to formulate your story idea and the images that tell the story.

Like an actor. What's your motivation:

__Trend __Direction __Must-Have

__Business__Politics __News __Art
__Life __Death __Sports __Hip-Hop

The story:

Where will the shoot take place:

___ Studio___Location

If on location, then where:

Country: _____ City: _____

Type of location:

What time of year is it?

___Sum ___Fall ___Win ___Spr

How many pages will your story be: ___

Who's on your team?

Makeup: _____
Hair: _____
Stylist: _____
Prop stylist: _____
Photographer: _____

ARE YOU READING

PERIODICAL STUDIES FOR THE SAVVY FREELANCE ARTIST

FASHION

WOMEN
- Clear
- Cru
- Citizen K
- Elle
- Flare
- Flaunt
- Harper's Bazaar
- Marie Claire
- Mademoiselle
- Nylon
- Surface
- Vellum
- Vogue
 U.S./French/Ital/British
- W

MEN
- Details
- Esquire
- GQ

LIFESTYLE

URBAN
- Blackbook
- Detour
- Paper
- Wallpaper

WOMEN
- Cosmopolitan
- Jane
- "O" Oprah
- Self
- Shape
- Vanity Fair

YOUTH
- Seventeen
- YM
- Teen People
- Vogue Teen

MEN
- FHM
- Maxim
- Razor
- Smooth
- Stuff
- King
- Men's Health

ETHNIC
- Essence
- Heart & Soul
- Honey
- Latina
- OYE'
- Estylo

BEAUTY

BEAUTY
- Allure
- Glamour

ENTERTAINMENT

MUSIC
- Country Music
- Dazed & Confused
- Interview
- Rolling Stone
- Spin
- The Source
- Urb
- Vibe

CELEBRITY
- Biography
- Entertainment Weekly
- InStyle
- Interview
- Movieline
- People
- Premiere
- US

TRADE

MAKEUP
- 1stHOLD
- Makeup Artist

FASHION
- Women's Wear Daily
- Sportswear International

PHOTOGRAPHY
- Photo District News
- American Photo
- Picture

FILM & TV
- Daily Variety
- Hollywood Reporter
- Back Stage West

ADVERTISING
- Ad Week
- Ad Age

ARE YOU GOING

EVENTS TO CHECK OUT

MAKEUP

- Int'l Makeup Artists Trade Show
 June - Pasadena, CA
- Hollywood Makeup Artists and Hair Stylists Guild Awards
 February - Hollywood, CA

FASHION STYLING

- Olympus Fashion Week - NY
 7th on 6th - Men's and Women's
 Fall Collections.
 February - New York
- Mercedes Benz Fashion Week - LA
 7th on 6th - Men's and Women's
 Fall Collections.
 March - Los Angeles
- Paris Women's RTW Collections
 Fall - March - Paris
- Magic - Buyers and sellers of men's, women's and children's apparel and accessories
 August - Las Vegas
- Olympus Fashion Week - NY
 7th on 6th - Men's and Women's
 Spring Collections.
 Sept - New York
- Mercedes Benz Fashion Week - LA
 7th on 6th - Men's and Women's
 Spring Collections.

EVYAN METZER-STREET

but agents aren't the people who are going to brainstorm with the photographer on creative decisions. It's good for artists to also know what's going on and who is who at the magazines! I also think so much of this industry is word of mouth and sometimes someone will say to me "oh, have you seen this person or that person" and we will try someone new.

Q: SO WHAT ADVICE can you offer freelance people who don't have an agent and want to work with a magazine?

A: Make some phone calls to the photo or bookings editor and find out if they use freelance people. If they do use freelance people it could be worth your while to send a printed sample of your work or drop off your portfolio. But don't go spending a ton of money on elaborate promo cards, just do a beautiful or simple postcard, if someone is interested in it believe me they will call. If they're not looking for artists, it's sad to say, but your card will probably end up in the trash.

Q: What do you LIKE TO SEE in an artist's portfolio?

A: Well, I like to see a point of view. I also like to see how much range a person has. They need to be able to show more than one particular type of style and at the same time show a consistency in it. I look for not only how great a picture is but also if the artist paid attention to details. I mean, like is the shoe tied?

CONTINUED ON PAGE 7-43

BEST OF THE NET

Following is a short list of sites worth checking out. Some will help fashion stylists and costumers with pulling clothes from fashion houses around the world, or open doors for those of you who need contacts for that all important career change. Still others may find a new hairdo for an upcoming celebrity photo shoot. Lifestyle.uk listed over 175 sites that cater to fashion, hair and beauty in the UK and Europe. My favorite sites were Fashion Web and First View which together gave me the feeling that I was reading Colleczion Magazine.

BEST OF THE NET

FASHION WEB
www.fashionweb.co.uk

Lots on fashion & beauty in Europe and the U.S. is here. Fashion Web has several links to other helpful sites. If you're an artist looking for a way to keep abreast of what's going on fashion and beauty, Fashion Web is for you. There are showrooms, a chat room and a free directory that encourages you to register yourself and let the world know what you offer. I found a categories for hair & makeup as well as fashion styling & costume design. An "online" appointment book suggests it can help you find work in the industry.

FIRST VIEW
www.firstview.co.uk

This on-line publication offers thousands of photos of the latest collections from the designer shows in Paris, Milan, London and New York. Phone numbers and addresses of the fashion houses are listed. A real help to stylists searching for the latest garment for an upcoming project.

THE FASHION GROUP INT'L
www.fgi.org

Connect with The Women who move the fashion industries of Apparel, Accessories and beauty. FGI is a global non-profit professional organization with over 6,000 members.

InStyle.com
www.InStyle.com

Now only available to subscribers and news stand buyers, InStyle.com covers trends, celebrity fashions, and style advice. InStyle provides consumers with a unique mix of celebrity-driven stories and advice.

Makeup Hair & Fashion Styling
www.MakeupHairandStyling.com

Visit our online portal for freelance makeup, hair and fashion stylists who work behind-the-scenes in print, video, film and TV. Get news, information, agency updates and more. Our message boards are some of the best in the business. Find contacts, jobs and new people for an upcoming test.

BEST OF THE NET

CONDE NAST ON-LINE
www.condenast.co.uk

This sight features Vogue, and GQ. I found the Vogue archives and information service very valuable.

Style.com
www.Style.com

The online home of Vogue and W magazines. Fashion shows, news, trends, people, parties, shopping and beauty.

Fashion Wire Daily
www.FashionWireDaily.com

Syndicated wire service covering fashion, celebrity style, entertainment, fitness, beauty, lifestyle and home. Top industry professionals contribute features and photos daily.

Zoozoom
www.zoozoom.com

ZOOZOOM Fashion Magazine brings photography, art, and fashion to the web. Zoozoom offers a feast of original fashion and beauty photography produced by New York's artistic talent.

The Look Online
www.lookonline.com

Their subscriber only newsletter is a twice monthly report covering New York fashion news, issues, and events with links to relevant information and resources on the web. An events calendar offers a schedule of "A" list fashion related shows, parties, store openings, book signings, launches and charity events going on in New York City. They also offer a complete guide to New York's fashion public relations firms, a "Who's Who" list of 60 fashion public relations firms in New York. It's a great "insider" resource into one of the most important areas of fashion.

TV Clothes
www.tvclothes.com

It's A Wrap! Production Sales liquidates wardrobe for sale all off the sets of film and television shows. They claim to be the world's only retail store that sells wardrobe in volume directly off the sets of films, television shows, commercials and the fashion runway. They get everything from T-shirts to designer gowns! Items that are discounted up to 95% off retail price.

SoWear, Inc.
www.SoWear.com

So Wear promotes emerging talent in fashion. The site enables an exchange between artists, consumers and the fashion community. They offer a unique space for artists to experiment with new and innovative ideas, and a place for media and buyers to learn what's happening in the forward-thinking fashion community. 131 E 23rd St., Ste 6D, New York, NY 10010. (212) 677-7604. Info@sowear.com

EVYAN METZER-STREET

Q: Any advice for artists that are testing and trying to build their books?

A: It's hard because when you test, hair, makeup, and styling are usually also testing and everyone seems to want to make the story theirs instead of talking about it and making the best pictures. When you do an assignment for a magazine, it's like "let's talk about the overall feeling that we want from these pages ". For someone who is putting a book together and wants some consistency, it's a good idea to talk with the photographer about the overall idea so everything isn't extreme. Sometimes tests can be a little overstyled. See the whole picture.

Q: What qualities do you think an artist needs to be successful in this business?

A: You have to be a really good communicator. Be patient and have a good sense of humor. Articulate your ideas, and problem solve. A lot of times you'll work with people who aren't very good at communicating what they want. It's your job, as a stylist, to be able to bring it out of them.

Q: What's changing in this industry? What does the future look like?

A: There will be a lot more men styling. Also, the fine line between fashion styling and celebrity styling is getting thinner. I mean, just about every cover you see these days has a celebrity on it. **END**

REESA'S FYI: THIS & THAT

EDUCATION: Gain an extra skill and you can open yourself up to much more work. It increases your marketability. If you're a barber and you take a basic makeup course, you then become a men's groomer. If you're a makeup artist and you take a hair styling course, now you can offer yourself as a hair and makeup artist, which is often called for on jobs.

TESTING: You're never too hot to test. Testing should be a never ending activity. It keeps your work fresh and your mind ticking with creativity. It also gives you an opportunity to experiment with new ideas and trends without the risk of being thrown off a job for not doing what the client wants.

TOO MUCH FUN: Drugs and alcohol are a touchy subject. If the client who hired you is drinking wine near the end of the shoot, and offers you some, you should probably refuse—politely of course. If everybody is doing it and they keep asking you over and over to take a glass of wine, well, all I say is use your best judgement. Whatever you do, do not consume enough to make you drunk or high and then start acting foolish.

FREELANCE DO'S & DONT'S

DO'S

- Have a positive attitude.

- Be Persistent.

- Drop off your portfolio personally even if you don't get to stay long, or have an appointment.

- Look good at all times.

- Create at least two promotional pieces each year.

- Follow up (by phone) on your promotional piece within a week after mailing or dropping off.

- Record a brief, upbeat, professional outgoing message on your answering machine and give out your cell phone number, website, and email if you have them.

- Be accessible, and return calls PROMPTLY.

- Get a cell phone.

- Leave brief, well thought out upbeat messages for decision-makers when following up on your direct mail piece (promo) or portfolio.

- Listen to the opinions of decision-makers (whom you respect) about the removal and/or rearranging of the work in your book, if you get a consensus (2-3 people) about a specific image, or tears, then take action.

- Make appointments to revisit decision-makers you've already seen to show them the new work in your book.

DON'TS

- Give up

- Over spend on one promo piece so that you can't afford to do another during the year.

- Have an answering machine that runs on one tape

- Record a downer outgoing message on your answering machine

- Leave a downer message on anyone elses answering machine

- Record a lengthy unprofessional outgoing message on your answering machine with lots of music playing in the background or your children gurgling.

- Take your friends along with you to your job assignments. It's still work!

- Leave expensive wardrobe items in your car overnight.

- Carry large amounts of cash around with you when you can exchange the money for travellers checks thereby protecting you and your client from theft.

- Ask for autographs from celebrities.

- Get personal on set

- Gossip about anyone. It's a small world.

UPDATED & REVISED

FIRST YEAR BUDGET

DESCRIPTION	ESTIMATED CHARGES		MAKEUP & HAIR	FASHION STYLING	ACTUAL COSTS
1. PORTFOLIOS (2 Custom w/25 plastic or acetate pages & shipping)		$ 400.00	$400.00	$400.00	_____
2. STATIONARY: BUSINESS CARDS, THANK YOU CARDS, ETC.		275.00	275.00	275.00	_____
3. RESUME (TYPING & UPDATING)		100.00	100.00	100.00	_____
4. COMP (PROMOTIONAL) CARDS (4 Color: 1000 Pieces)		550.00	550.00	550.00	_____
5. FAX MACHINE & SUPPLIES (Consider All-in-One Fax/Copier)		300.00	300.00	300.00	_____
6. BUSINESS FORMS* (confirmation, invoice, voucher, etc.)		60.00	60.00	60.00	_____
7. MAGAZINES & SUBSCRIPTIONS					
—NATIONAL	75.00 -	100.00	75.00	100.00*	_____
—INTERNATIONAL	100.00 -	250.00	100.00	250.00*	_____
8. ORGANIZATIONAL SUPPLIES (Paper Cutter, Rolling Cart, Etc.)	250.00 -	400.00	_____.___	_____.___	_____
9. LONG DISTANCE & TOLL PHONE USAGE	250.00 -	400.00	250.00	400.00*	_____
10. CELL PHONE (phone & monthly service)	1,500.00 -	2,000.00	1,500.00	2,000.00*	_____
11. DELIVERY					
—LOCAL MESSENGER (Approx. 1 move/week for 1yr.)	400.00 -	650.00	400.00	650.00*	_____
—OVERNIGHT (Approx. 1 move/month for 12 mos)	350.00 -	500.00	350.00	500.00*	_____
12. COLOR & LASER COPIES (Approx. 71 pages in 1 year)		290.00	_____.___	_____.___	_____
13. PHOTOGRAPHIC PRINTS (Color & B&W: 40 prints in 1yr.)		1,000.00	1,000.00	1,000.00	_____
14. PARTYING WITH A PURPOSE (Entertainment)		1,200.00	1,200.00	1,200.00	_____
15. KIT & SUPPLIES	950.00 -	3,000.00	950.00	3,000.00*	_____
16. TRANSPORTATION EXPENSE					
—GAS, TAXI, SUBWAY, BUS		1,250.00	1,250.00	1,250.00	_____
—WEAR & TEAR, REPAIRS (Breaks, Muffler, Tires, etc)	1,350.00 -	1,700.00	1,350.00	1,700.00*	_____
17. WEBSITE (Build, Updates, Hosting, E-Mail, Internet Access)		1,800.00	1,800.00	1,800.00	_____
18. COMPUTER & SOFTWARE (Quicken, Graphics, Labeling, Etc.)		1,750.00	1,750.00	1,750.00	_____
19. RETOUCHING		250.00	250.00	250.00	_____
20. SCANS		250.00	250.00	250.00	_____
21. MAILING SUPPLIES: Stamps, Labels, Envelopes, etc.		550.00	550.00	550.00	_____
22. _____		_____.__	_____.__	_____.__	_____

TOTAL AMOUNT SPENT IN ONE YEAR

Remember, a stylist will always spend more on transportation, phone calls, messengers, etc. as a result of transporting clothing from one place to another, shopping, and getting clothing in from other cities like New York, Paris, Milan, Hong Kong, etc. And in the early part of a stylists career, there isn't always a client to charge the expense back to. Additionally, stylists with typically end up with some of the clothing from their testing shoots that cannot be returned due to damage and/or wear and tear.

StyleWise Quiz: For the Artist Who Thinks They Know Everything About Fashion

1. Mark Seliger is the contract photographer for what magazine?:

 a. Vanity Fair
 b. Marie Claire
 c. US
 d. Rolling Stone
 e. Detour

2. In Style Magazine features:

 a. Musicians b. Photographers
 c. Celebrities d. Hair Stylists

3. If You Want To Do Hair For Photo Shoots You Must:

 a. Have a state issued cosmetology license
 b. Have graduated from Vidal Sassoon Academy
 c. Know How To Cut & Color Hair
 d. Know How To Style Hair

4. Always look through the photographers camera to make sure your makeup, hair or wardrobe is okay:

 a. ___True ___b. False

5. Angeleno magazine is about Los Angeles but is based in which of these cities:

 a. Portland b. Miami
 c. Chicago d. New York

6. The rate to do the makeup for the cover of Vogue is closest to which of these figures:

 a. $890 b. $1,000
 c. $150 d. $5,000

7. Being fashionably late is very cool and an unspoken rule in this business:

 a. ___True b. ___False

8. Carol Shaw is a(n):

 a. Hair Colorist b. Salon Owner
 c. Art Director d. Makeup Artist

9. Ru Paul And k.d. Lang are poster girls for what line of makeup?

 a. Chanel b. M•A•C
 c. Makeup Forever d. Senna

10. Amber Valletta and Shalom Harlow are hosts for this fashion television show:

 a. Vh-I Fashion Television
 b. E! Fashion File
 c. MTV House Of Style
 d. CNN Style with Elsa Klensch

11. He wrote the book, "The Art Of Makeup":

 a. Dudley Moore
 b. Max Khalig
 c. Max Factor
 d. Kevyn Aucoin
 e. Francoise Nars

12. Orlando Pita does what for a living?

 a. Hair b. Makeup
 c. Fashion Designer d. Movie Producer

13. Frederic Fekkai's new salon is above what New York store?

 a. Barneys
 b. Henri Bendel
 c. The Nike Store
 d. Walmart

14. "W" Magazine caters primarily to what industry?

 a. Film b. Makeup
 c. Fashion d. Celebrity Lifestyles

15. Gilles Bensimon is the chief photographer and creative director for which magazine?:

 a. Vogue b. MAC User
 c. Elle d. Rolling Stone

16. Vivienne Westwood is a famous:

 a. Fashion Writer b. Hair Colorist
 c. Fashion Designer d. Art Director

17. M•A•C stands for:

 a. Modern Accent Cosmetics
 b. Miracle Application Cosmetics
 c. Most Awesome Company
 d. Make-Up Artist Cosmetics

18. Cloutier Agency reps what kind of artists?

 a. Painters
 b. Makeup, hair & fashion stylists
 c. Photographers

19. The term "dated" usually refers to?

 a. Someone you have gone out with.
 b. Work that appears out of step with what's current.
 c. The expiration date on the milk carton.

20. You only need to test until you build your book up.

 a. ___True b. ___False

21. These photographers have been shooting most of the "Diesel" advertising campaigns of late:

 a. Guy Aroche b. David Lachapelle
 c. Ellen Von Unwerth c. Nigel Parry

22. This model/actress endorses products from Estee Lauder:

 a. Isabella Rossellini b. Cindy Crawford
 c. Elizabeth Hurley d. Winona Ryder

23. This hair stylist made the "cornrow" hair-style popular once again by doing it for Madonna in her "Human Nature" music video:

 a. Neeko b. Orbie
 c. Orlando Pita d. Garren

24. John Galliano does what for a living?

 a. Sells At&T Long Distance
 b. Editor at Entertainment Weekly
 c. Limo Driver
 d. Commercial Director
 e. Fashion Designer
 f. Makeup Artist

25. The band the Sex Pistols inspired what kind of clothing style or look?

 a. Tailored
 b. Romantic
 c. Punk/ Grunge
 d. Death Rock

26. When sending your book out for review, you don't necessarily need a promo card because your work is so memorable that there is no way anyone could ever forget you.

 a. ___True, True, True, Honey!!!
 b. ___False, False, False, Sweetie!!!

27. Tearsheets are:

 a. Papers around your house that you tear up for therapeutic anger releasing reasons.

 b. Another name for the proof sheet given to you by a photographer you have tested with.

 c. Pages torn out of a magazine you've worked on to be placed in your book.

 d. A printed report of your spending on a shoot.

28. Isaac Mizrahi made a film about his career titled:

 a. Pret-A-Porte
 b. Shine
 c. Unzipped
 d. NY Style.
 e. The Man Behind The Designer

QUIZ ANSWERS

1	= D	Rolling Stone
2	= D	Celebrities
3	= D	Know how to style hair
4	= B	False
5	= C	Chicago
6	= F	$250
7	= B	False
8	= E	Makeup Artist
9	= B	M•A•C
10	= C	MTV House of Style
11	= D	Kevyn Aucoin
12	= A	Hair
13	= D	Chanel
14	= C	Fashion
15	= D	Elle
16	= D	Fashion Designer
17	= D	Makeup Artist Cosmetics
18	= C	makeup, hair & Stylists
19	= B	Work that looks out of style +
20	= B	False
21	= B	David Lachapelle
22	= C	Elizabeth Hurley
23	= D	Orlando Pita
24	= E	Fashion Designer
25	= C	Punk/Grunge
26	= B	False, False, False, Sweetie!!!
27	= C	Pages torn out of a magazine +
28	= C	Unzipped

Now take a moment to check your answers add up your score and see how well you did. Each right answer is worth 5 points. The highest score available is 140 points. Take a look at the rating (beneath the Quiz answers) to your left to see how much further you have to go to be in the know.

HOW DID YOU DO?

130-140 Good Going. Looks like you've been doing your homework, reading the requisite fashion and entertainment magazines on a regular basis.

100-129 Okay, but I think you better renew, Entertainment Weekly and "W" before that score slips any more.

70-99 Oops. Could there have been a family illness that kept you from your reading?

0-69 Climb out of that cave NOW!

BEYOND THE BOOK

Crystal Wright's
Packaging Your Portfolio
Workshop

The best way we know of
to get to the NEXT level.

Top-Bottom. LA Class Panel:
Photographer David Roth, Teen Photo
Editor Reesa Mallen, Celebrity Makeup
Artist Sharon Gault, Makeup Artist Cindy
Stinespring. • NY Class Panel: Celebrity
Makeup Artist Sam Fine, TV & Film
Makeup Artist/Educator Tobi Britton,
Crystal, Sr. Booker Ashton Hundley &
Makeup Artist Juanita Diaz. Crystal
teaching • Washington DC Class talks
with THE Agency owner Lynda Erkiletian.

we heard...

Crystal Wright, author of <u>The makeup, hair & Styling Career Guide</u>, publisher of *1stHold* magazine, and president of The Crystal Agency proudly presents her seminar series titled, "Packaging Your Portfolio: Marketing Yourself as a Freelance Makeup, Hair or Fashion Stylist."

The eight-hour workshop covers subjects such as building a portfolio, testing with photographers, signing with an agency, getting work from record labels, magazines, production companies, and more. The presentation includes an hour long Q&A session with a panel that typically includes art directors, editors, photographers, agency bookers or owners, etc., who hire freelancers as a function of their job in the industry. Crystal gets artists portfolios from local makeup, hair and styling agencies in the area. To register, call 323/913-3773, Fax 913-0900, or visit our website, **www.MakeupHairandStyling.com.**

you want to
be famous...

CALL OR VISIT OUR WEBSITE FOR CITIES, DATES & TIMES
323/913-3773 ▸ www.MakeupHairandStyling.com

8 FASHION / WARDROBE STYLING

ROSE CEFALU
FORMER PHOTO EDITOR
DETOUR MAGAZINE

There's a rumor going around that being a fashion stylist is a glamorous fabulous job replete with invitations to parties, lunch engagements with celebrities and first class round trip tickets to exotic locals where you shop endlessly with blank checks given to you by huge record and film companies for recording artists and actresses who can't live without you. Yeah right, says Atlanta based wardrobe stylist Camille Morrison, who as a stylist for the last 15 years working in Atlanta, Chicago, Bermuda, and New York, can tell you that styling is many things—but glamorous is rarely one of them.

We asked Camille to help us with the realities of freelance fashion styling, and she kindly devised a reality check. Why don't you check it out.

The Myths and Realities of Styling by Camille Morrison

MYTH: The job is very glamorous and after an assignment, you are invited to sip champagne with the beautiful people.

REALITY: The job is very physical, and you hardly have time to eat, let alone sip champagne. And judging by the way you look at the end of the day, you won't feel like going.

MYTH: Clients give you large sums of money and their credit cards so that you can shop as long as you like.

REALITY: You are expected to work miracles for very little money and do it by tomorrows deadline.

MYTH: You get to keep lots of fabulous clothes or at least wear them out at night for an event.

REALITY: You are the lucky person that gets to return the used clothes to the stores which may not take them back. So, on top of not getting to wear them, you may have to pay for them out of your own pocket. And if you do wear them for anything at all you will never work again.

Myth: You can hang out with your friends as long as you want, and then spend the day before the job preparing for a 6am call.

REALITY: Over-prepping is the rule of thumb. Even when you have all the time in the world, something will go wrong and you'll be glad that you prepared well, so as not to get caught too off-guard. You have to be <u>VERY</u> organized.

RM: **Can you tell me how you got into this business?**

RC: I went to art school in San Francisco and I took this class where one of our assignments was to put together a magazine. I really enjoyed it, and I thought it would be great to work for a magazine. I didn't want to move to New York to do it, I wanted to stay on the West Coast. Detour was the only magazine on the West Coast so I decided I wanted to work for them, and I moved down to Los Angeles. At that time Detour had been in L.A. for 2 years and I started an internship with them. Interning turned into a job, and now I am the Photo Editor. We have really grown; when I first started there were 4 people on staff and now we have about 25.

RM: **Wow. From an internship to Photography Editor. That's very impressive.**

ROSE CEFALU

RC: That's what I always had in mind, that's why I was interning. I knew what I wanted to do.

RM: **I heard you were a booker at the Profile agency for makeup, hair and styling at one point. Is this true?**

RC: Yes, actually, while I was interning at Detour I was working part-time at Profile.

RM: **So you must know a bit more about makeup, hair and styling than most photo editors. Who are the decision-makers concerning makeup, hair and fashion stylists on the Detour photo shoots?**

RC: The photographer ultimately chooses who he wants to work with, but myself, Luis Barajas who is the creative director and Long Nguyen who is the style director in New York, all have a say. Sometimes when we are shooting celebrities, publicists get involved in the decision, but I usually like to leave it up to the photographer. The photographer usually works with a crew of people who he/she trusts and they usually achieve a certain look by working with that team.

RM: **So when a photographer can't seem to find the right artist or the person they want is booked, do they ask you?**

RC: Yes, they often do. Even if the pho-

The Myths and Realities of Styling by Camille Morrison

Myth: The client is going to love everything you bring to the set, because after all—they told you what to shop for.

Reality: You have to make everyone happy and present the little that they do like as if it were their idea.

Myth: You drive a jazzed convertible car.

Reality: You drive a dirty pick up truck that you can use to store the millions of things you need.

Myth: The stylist is the one person that everybody becomes friends with.

Reality: Statistics show that if anything goes wrong at the shoot, it's the stylist that they are going to dump on.

Myth: Everybody helps each other and since you are the one with the most stuff, assistants and models will give you hand.

Reality: Each man for himself. You and you alone will carry your stuff from the car to the location, and it doesn't matter how far you have to walk or schlep.

Myth: You are often booked on jobs where you get to travel to exotic locations where you can really enjoy the weather and relax.

Reality: If you are lucky enough to get a booking that shoots in one of these locales, the only exotic looking thing you will see will be on the travel channel that night before you fall asleep, exhausted from lugging your clothing rack and steamer through the sand on the beach—in exotic hawaii.

Myth: Styling is a very easy job that anybody can do.

Reality: Styling carries a huge responsibility, an enormous amount of risk, and an extreme attention to detail. Very few people can do it right.

Myth: You get reimbursed for all expenses incurred during the job assignment.

Reality: The stylist can put hundreds of miles on a car; spend thousands on meals while entertaining, metered parking and huge cell phone bills that the client is not aware of, or responsible for.

Myth: You get paid for the actual time spent preparing the job.

Reality: The client has no idea how much time you really spend on the job, and wants to pay you less for the prep and wrap days, as well as the 2 or 3 meetings and fittings you attended prior to the shoot. Oh, the hours you spent the night before untagging, bagging for transportation, polaroiding, and packaging in preparation, and retagging for returns, forget about it.

Camille Morrison is a lecturer, educator, working stylist, and pioneer of the first developed wardrobe styling courses at Bauder College and AIU in Atlanta, GA. She has travelled the globe working on print, video, film, TV commercials and on tour with well known recording artists. Her contribution to this 4th edition of the "Guide" is invaluable. She can be reached via email at Only1Style@aol.com.

One of my favorite stylists, Ca-Trece Mas-Sey (who by the way just finished her first film with B2K) called me on the phone a few months ago while finishing up a job in New York, and said "I've come up with a name for my company". "Oh yeah, and what's that" I replied. "Blue Collar" she said proudly, "because styling is hard labor".

It's gotta' be one of the coolest names I've ever heard. At the end of every two-way pager message from Ca-Trece, or her assistant Chesney, it says "Blue Collar Squad: Styling is Hard Labor! They wear overalls to all their jobs, because as Ca-Trece says, "We get paid white collar money to do a blue collar job".

Why hard labor? Because styling is just one big multiple priority. It requires a tremendous amount of concentration, creativity, an eye for detail, tact, diplomacy, discipline, the ability to delegate, manage money and think on your feet. A good fashion stylist is a joy to watch. I have had the pleasure of representing some extremely talented stylists. Some were geniuses who rarely got a call back because besides being talented visionairies they couldn't get anything else done right. And beyond the pulling of the clothes, there is a lot of other stuff that you have to get right in order to get booked repeatedly.

I've represented some other stylists who were not visionairies, but they were dependable, and could be counted on to see every project they worked on through to its natural conclusion—i.e. down to the paperwork and petty cash envelopes balancing. They worked all the time because they were consistent. I will try to articulate their qualities, and responsibilities to you throughout this chapter.

STORYTELLING: WHO RISES TO THE TOP

Really good stylists think in story form. The thought process is similar to the way an illustrator sketches (storyboards) out a scene in a movie or a television commercial. There's a beginning, a middle and an end. Remember, we discussed it in **Chapter 7, Freelancing: Building a Fashion Story**.

The average stylist shops for an outfit. A really good stylist shops the story in all its complexity, variations and possibilities, keeping in mind the location that the story is being shot in, and the time of year that the story will appear or the ad will be released into the market. A good stylist is like an actor, always needing to know his motivation—the who, what, where, why and when.

A good stylist can be a great help to a photographer who is searching for an idea or a new twist on an old subject. On jobs they are looked at as an integral part of a production, and within the recording industry, are often called upon to suggest photographers for photo shoots.

ROSE CEFALU

tographer or celebrity doesn't want hair or makeup on the shoot, I always like to have hair and makeup people on the set to do little touchups. Maybe it's just powdering or something light. That is another opportunity where photographers have a chance to check out new artists.

RM: **What do you like to see when in a makeup, hair or styling book?**

RC: A really good book, one that is well put together. It doesn't have to be all tear sheets, but if a fashion stylist comes in and wants to do styling for fashion editorials, I want to see full fashion editorials in their portfolio. It's not necessary that they have pictures of celebrities in their book, but it helps; especially if a publicist wants to see their book. I just like to see a well thought out portfolio, a good representation of the artist; great clothes and great photographs.

RM: **So, you have no objections to one kind of look in a book. For example if the whole thing is way out there funky?**

RC: No, it's cool. With photography, we hire different photographers for different jobs, and different reasons. The same goes for fashion stylists; someone might have more of a fashion edge, or an editorial New York feel, or a European flair. People are remembered for certain things. Some stylists I know are great for

ROSE CEFALU

music and I'll hire them for music related shoots. That's how they start creating a name for themselves; doing the music editorial assignments, then music videos and CD covers. From there some artists progress to film.

RM: **When looking for stylists, do you always rely on agencies, or will you try out someone that you just met at a coffee shop?**

RC: Both. If I am looking for people, I'll call up an agent and ask them to bring in portfolios of the artists that they feel are really strong who lean toward the Detour look. Editorial. I look for hair and makeup people that are really dedicated. I love to meet them too, because at times there we have no representative from the magazine on the shoot, and you have to be able to trust those people.

RM: **What determines which agencies you call?**

RC: Los Angeles is a small community. You kind of know everyone at all the agencies, and who represents who. Of course they get new artists in, and books grow, but it takes a while.

RM: **Do you make time to meet with artists that phone you up cold?**

RC: Of course. My assistant Sal makes appointments for me like that all the time. Even if their book is not that great, if the person has potential or a

While hair and makeup artists are often booked as late as 2-3 days before the shoot, a fashion stylist can be invited to participate weeks or months ahead if there are imaging challenges, or a full makeover is required. At the least they are invited to sit in on meetings to discuss concept and begin prepping four to five days prior to the actual shoot.

Stylists are sometimes asked to offer suggestions for hair and makeup direction since those elements have to work with the clothes, and make recommendations for the hair and makeup artists who are ultimately selected to work on the shoot. It's a big job, with a lot of pressure, responsibility and an enormous amount of risk. It seems simple, doesn't it? The stylist's job is to Shop! How hard can it be? Let me tell you.

I field a lot of calls from young people who want to be fashion stylists. But ask any successful stylist, and they'll recount a story about someone who begged to be their assistant, and when they finally got the chance, they were completely overwhelmed with ALL the work involved in making a shoot happen. None of which had anything to do with being glamorous. Lets see.

There are prep meetings with the art director, the artists manager, the publicist and the artist. There are fittings with the artists, and sometimes shopping with them as well, not to mention all the shopping you have to do after you've wasted a full day with an artist who wants to stop and potty every 2 hours, and have lunch and snacks in-between. And then there's getting up 3 hours before the shoot so you can pack up your car, and showing up to the shoot an hour before everyone else so you can set up and steam all the stuff that got wrinkled on the way to the shoot. And 2 hours of deliberation about what the artist is going to wear for the first shot, and sending your assistant back to the stores to get the stuff that the art director and photographer said they didn't want—just yesterday. And of course you're the last person out because they wouldn't give you an assistant, and you could only afford one for half-a-day, because you had to pay for it out of your own pocket. And now that you're exhausted after a full days work, you have to pack up everything yourself and get it out to your car. And lastly you'll be up until' 2AM retagging all the stuff you need to drop off at the cleaners by 7AM so you can pick it back up by 2PM and take it back to the store with the rest of your returns, praying all the way that they don't notice it has been dry cleaned. And now that that's all done, there are 4 more hours of handling the receipts and balancing the budget that you were given, so you can get it to production before they wrap.

Sound like fun? If so, read on. If you've been watching Philip Bloch and Derek Kahn on the Style Channel, you are probably one of those people who think that ALL stylists get large sums of money and unlimited budgets every time they head out to Fifth Avenue to shop for their adoring celebrity clientele. But the truth is that not everyone styles celebrities and recording artists. Some people work on catalogues, others do boring print ads for Pampers that really aren't so boring if you're doing what you love.

You see, being fabulous on the Style Channel is the thing you get to do after you've hired all the assistants, stayed up all night pinning and packing, had numerous meetings with the production staff about the direction of the project, and spent hours at the all night tailor trying to make sure that those pants will fit your artist who [you just found out] gained 35lbs. while on an extended vacation.

A stylist is saddled with the a good deal of responsibility just pulling together the look for a single model on a Crest ad, let alone a 3 guy group for a one day CD cover shoot. So I thought we'd just start at the beginning. Like—how many different kinds of styling jobs are there anyway?

STYLING DEFINED

There are different kinds of stylists. Wardrobe stylists, fashion stylists, prop stylists, set stylists, and food stylists. There's even a person called a fashion editor who is really a fashion stylist in disguise. Within the styling world, the way a stylist is referred to tells you what kind of styling he/she is doing. For example. . .

EDITORIAL STYLING refers to work done on magazines, and newspapers. Big magazines like *Vogue*, *Elle*, and *Glamour* have lots of stylists on staff that pull the clothes and accessories for photo shoots. They have titles like Fashion Editor, Associate Fashion Editor, and Assistant Fashion Editor. They are employees. The fashion editor reports to the fashion director, who sets direction for the department. The fashion editor often has a staff of associate and assistant fashion editors that report to her.

Smaller magazines rarely have staff stylists—it's too expensive. Instead, they book freelance fashion stylists to pull the clothes and accessories for shoots, and pay them a day rate (**See P7.9 Freelancing**).

Big newspapers like the New York Times, the LA Times, and the Chicago Tribune have fashion editors and other staffers as well, but you won't find those big staffs on smaller regional papers. They too will hire freelancers.

ROSE CEFALU

drive, and wants my opinion about their portfolio and what they need to do, I am more than happy to give it to them.

RM: **As Photography Editor at Detour, what do you do?**

RC: I get an editorial calendar from the Editor. We go over who's going to be in the next issue, and we try to match celebrities and recording artists with the right photographers. Luis and Long do most of the fashion, but we all work together as a team.

RM: **Do you take risks and use new photographers and their makeup, hair and styling team?**

RC: Totally. All the time. It's a matter of having a really good book, a ton of drive and ambition, and knowing what you want to do. You don't need tear sheets from *Vogue* or *Harper's Bazaar*. If I look at your book and it's obvious that you are an artist, you know what you want to do, you want to do it for us, and we're into it, then yeah, there's definitely reason to try someone new. We've used people that are still in school.

RM: **Do you have a portfolio drop off policy?**

RC: Yes, drop off on Monday, and pick up on Wednesday.

RM: **What suggestions can you give**

ROSE CEFALU

new artists regarding set etiquette and behavior?

RC: Be professional. Be on time, and respect the photographer's requests. He is the person driving the whole team.

RM: Does Detour pay a re-stocking fee for clothing that has to be pulled and then returned to the store?

RC: No. We usually pay fed-ex and other shipping expenses. I never want anything to come out of anyone's pocket. We also provide a stylist letter, which I send out from here as opposed to giving it to the stylist directly, so we can keep track of which designers are being pulled for that month.

RM: So let's say that Brad Pitt got tomato juice on an Armani jacket, during one of your photo shoots, would you guys take care of the bill?

RC: Definitely, yeah, we would have it cleaned and call the designer and tell him or her what happened, like Brad rolled around in the mud (laughs). Usually designers understand, it hasn't really been a problem.

RM: What I am about to ask you is a rumor. I feel like I am a writer for the Washington Post (laughs). Is it true that magazines usually call the agencies that pay for advertising in their publication before

When styling for magazines, one has to remember that magazines work 3-4 months in advance. Stylists must pull from designer showrooms instead of department stores because the clothing won't still be in the store when the issue hits the news stand. Luckily, designers present their collections months in advance, so when the magazine comes out, the goods are in the stores.

With a newspaper however, you can pull from department and specialty retail stores, PR offices, and showrooms because you may only be working a couple of weeks in advance of the publication date. Either way, no one wants to have to tell a consumer that an item is not available in the store.

FASHION STYLING refers to work done on magazines, fashion and beauty ads, assignments with celebrities and recording artists, music videos, and catwalk work. They all want fashion stylists, not wardrobe stylists, because a fah'-shun stylist sounds much cooler, don't cha' think?

WARDROBE STYLING is thought of as more commercial, and refers to work done on television commercials, and lifestyle print ads—things that are considered more serious in nature than fashion. It just wouldn't do to have a fah'-shun stylist for something as serious as a Tide commercial—now would it? Styling for this genre is marketing driven, and the stylists job is to insure that the looks they pull represent the audience (consumer) that the advertiser is trying to reach.

CATALOGUE STYLING refers to work done on mail-order and other catalogues. Like lifestyle advertising, it offers very little creative license, as the goal is to sell clothes. The shots are not fancy—save Victoria's Secret. Clothing must be shown clearly so that the consumer can see and purchase items they see themselves in. Quite often, a single catalogue is broken into sections and shot by several different creative teams (photographer, makeup, hair and stylist) of people at the same time.

Spring and Summer catalogues are shot in the first months of winter (Jan/Feb).

Fall and Winter catalogues are shot in the heat of summer (July/Aug).

PROP STYLING refers to the person who pulls portable objects such as dishes, lamps, chairs, etc., for a variety of shoots. On shoots that require an abundance of prop styling, the client will hire a prop stylist. However, in many cases when there are just a few things to pick up, and particularly in smaller markets, like Cincinnati—even when there is a lot to pick up, the wardrobe stylist is asked to do the prop styling as well, and often for NO extra money.

SET STYLING a.k.a set decorating refers to the person who is responsible for dressing the set with furniture, draperies, carpet, etc.

[RUNWAY] SHOW STYLING is probably not the sort of thing that you want to do for long periods of time, because it's really a dressing job. The designers bring all the clothes, and what's involved is more a function of arranging and preparation than pulling, and styling. But, I hear the shows are an awful lot of fun to do—at least a few times, if for nothing else but the rush.

GETTING PREPARED: WHAT YOU'LL NEED

1. AN OVERALL PLAN

- The plan should describe the clothing you plan to dress the artists in. It doesn't have to written out, though a few bullet points on a sheet of paper wouldn't hurt as a reminder, and so you don't leave anything out.
- The approximate cost to dress the artists in three looks.
 The approximate cost to dress the artists in two looks
 (This will come in handy when the art director says "Well what if we only do 2 looks?").
 (Always estimate a little OVER, or you'll have know where to go)
- How much of the clothing has to be kept (bought).
- Which items of clothing the artist will and won't be able to keep.
- What can [more than likely] be returned to the stores.
- The items of clothing the artists will have to bring with them from their closets to the photo or video shoot if the budget cannot be adjusted (i.e. shoes, jewelry, etc.)
- What they will have to give up (perhaps a look) if the budget cannot be adjusted.
- Why you are the right person for the job.

2. A STRATEGY

a. Approach

 1. Opening statement. (Always positive).
 2. How you will proceed.
 3. Closing statement.

b. Body

 1. The points you will bring up.
 2. Answers to the client's objections about:

Money	Assistants	Rates.	Budget.
Time	Designers.	Days required to prep & wrap.	

calling the agencies that don't advertise?

RC: No, that's not true at all. We do not do that. Of course, if people are advertising we like to support their products if we like them, but that is not true at all in regards to makeup, hair and styling agencies. There's no sucking up to advertisers here. We or the stylists use the products we really like. If it's a good product that happens to be advertised in our magazine, obviously people are going to use it anyway.

RM: **How do you feel about artists bringing unannounced assistants to your shoots, specifically celebrity shoots?**

RC: No, that's fine. If it's a big shoot, and they've got an assistant there, it's usually because they are doing something. If someone is just there to hang out, then that's obviously not cool. You need a purpose to be on the shoot.

RM: **Do you ever have conflicts with the celebrity's publicist as far as makeup, hair and styling decisions go?**

RC: All the time. You want to respect the celebrities request, but sometimes you don't know whether it's the celebrity's request or the publicist's request. You just have to feel everything out. We, of course prefer the photographer to decide, because they

ROSE CEFALU

usually have a team that they've been working with that produces the results that they want. A result we have witnessed over and over again in their portfolio, which is why we booked them in the first place.

RM: How long after a shoot do you need the credits faxed to you, and what is the best way for you to receive them?

RC: We have a style form that consists of a Polaroid given to the stylist by the photographer, it lists the information to follow beneath it, like what store a garment came from, the designer, agency credits, etc... I like those as soon as possible.

RM: Does a resume inside a portfolio influence you in any way? If the list of photographers the artist has worked with has some big names on it, would that mean anything to you?

RC: Sure. I mean it doesn't influence me, but it's nice to know what they have done before. Resumes are a good idea.

RM: Case scenario: let's say you use two artists from the same agency and they both mess up one way or another, whether they are late or rude, or whatever. Will that affect your opinion of the entire agency that they are with, or just the artists themselves?

RC: Usually, I'll call the agent and tell the

c. Close
 1. Reasons (benefits) why the group should have the clothing you are suggesting.
 2. Spending justifications for your clothing suggestions.
 3. Why you versus someone else for the job.

3. A PENCIL & PAPER

To jot down notes and the clients' comments. To keep your thoughts in order. To order and record the way that you will attack the clients objections (that you have naturally anticipated in advance), should they come up.

4. RESOLVE

You are good at what you do, and you are the best person for the job. You know your craft, and you are bringing a wealth of information, experience, taste and expertise with you to this job assignment.

5. BOTTOM LINE

a. The lowest amount you'll accept for your fee, and as a budget for clothing.
b. The number of days you need to do the job *(figure out why—the justification for the days because the Art Director may ask)*.
c. The number of assistants you need to do the job *(figure out why—the Art Director may ask)*.

Having an agency doesn't spare the fashion stylist from conversations about money, something a hair or makeup artist rarely has to do once they get signed. Only the fashion stylist knows what it will take to do the job based upon his or her creative conversation with the client, and their knowledge of what's in the marketplace at that particular time. Your agent will not know the price of the wheat Armani jacket at Barney's on 59th. So, you'll just have be the one to discuss money with the client as it relates to your shopping and assistant needs.

CHRONOLOGY

In every styling job there is a way and an order in which things happen. From the moment you pick up the phone and hear the decision-maker or your agent offering you a job, all the way through to handing in that last bunch of receipts, there are a series of things that will most cer-

tainly occur (for the most part) each time you do a job.

You can and must plan for them in order to be successful—long term. Planning ahead will help you to meet objections and challenges along the way. Not planning—well. . . Following is a list, and a discussion of each subject:

Creative Conversation

Negotiation: Clothing, Accessories, Props

Negotiation: You and Your Assistants

Paperwork: Request for Advance, Purchase Order, Stylists Pull Letter, Petty Cash

Pre-Production: Meetings with Creatives, Managers, Artists, and Models

Shopping: Boutiques, Studio Services & Designer Showrooms

Fittings & Alterations

Shoot

More Paperwork: Addendums, Wardrobe & Credit Worksheets

Returns & Reconciliation

Paperwork: Invoicing

Creative Conversation

In the first conversation between the client and you the stylist, (If you have an agency, the client should have already spoken with them and discussed your day rate) the client, usually an art director (on CD covers) or a production manager (on music videos and TV commercials) describes the artist or group, spells out the budget, and answers any other questions you might have about the group, logistics, crew (photographer, makeup artist, hair stylist, manicurist, prop stylist), etc.

Some of the information you'll need to gather in order to do your job can be seen on **P8.11**.

Whether or not this assignment progresses to the next level can hinge on many factors:

1. Is the budget is adequate to accomplish the styling goals the client has set?

 EXAMPLE: If the client tells you that the clothing budget is $3,500.00 and you don't think this amount is sufficient to meet the clients goals for four looks on three guys, you have several options:

ROSE CEFALU

agent what the stylists did and then I'll call the stylist and tell them what they did wrong, and tell them that what they did was not cool.

RM: Would you ever use them again?

RC: It depends on their attitude and their response to the problem. There have been situations where I'll never use a person again, but I don't let that one artist affect my view of an entire agency.

RM: As photo editor, do you make a decision to keep a session or reshoot based on the hair and makeup? Is it politically correct to express your feelings about it?

RC: Sometimes an artist will do one crazy hair style and the subject will get stuck with it for an entire fashion story, and you kind of wonder why they did that. There have been times when we have gone back to re-shoot a story that we felt was not strong enough, or didn't have enough material. It's only happened about three or four times in the past couple of years.

RM: Why do most magazines pay stylists an editorial rate, and how come Detour does not?

RC: Most of our revenue use is projected toward the printing of the book. There are not many people that print on the quality of paper that we print on. We are not a big, huge corporation; we're actually pretty small, but

CONT. ON P 8.23

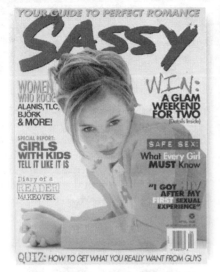

**CAROLINE LETTER
FORMER STYLE DIRECTOR
SASSY MAGAZINE**

RM: What's the difference between a fashion director and a fashion editor.

CL: A fashion editor is the one that goes out in the market and takes what the fashion director has dictated and translates it into the market. The fashion director comes up with the ideas. The fashion director dictates, the fashion editor produces.

RM: As Style Director what do you do?

CL: For Teen I create a look for the pages. It's not necessarily just fashion. It's the models we're putting in the book and the photographers we're using to create the overall

◎ NEGOTIATE FOR MORE MONEY

◎ LET THE JOB GO

◎ DO A MEDIOCRE JOB (because there was not enough money in the first place)

◎ DO A GREAT JOB & RUIN YOUR VENDOR RESOURCES IN THE PROCESS

2. Are you interested in the assignment? Does it sound like something you can sink your teeth into, or do you just need the money? Are you bored and weren't doing anything that week anyway? Do you have exotic vacation plans that could be helped along by the check you'll get from this assignment?

At this point, if you are somewhat interested, share your interest with the art director, and tell him/her that you need a little time to think about the project. If the budget seems adequate, cool. However, if you're feeling that the job will require more cash, then express a little concern about the budget, and request a good time to get back to the art director. The purpose of this strategy is to:

1. Keep you from agreeing to a situation or an amount without giving it the proper thought.

2. Give you some time to do a little number crunching and compare the clients goals with the clothing budget.

Wondering what I mean by clients' goals? Simply this. If the client says "We want the group in cutting edge, upscale designer threads," to you that might mean, Dolce & Gabbana, Donna Karan and Missoni. The client has said that his budget is $3,500, and that he wants three looks for the band. Ask yourself if that is realistic based upon the kind of look that the client has requested. Your conversation with the art director may be that he needs to revisit his goals, or come up with more money. Here's a simple way to break down an uncomplicated budget:

$$\textbf{\$3,500 / 3 guys = \$1167 ea.}$$
$$\textbf{\$1,167 / 3 looks = \$ 389 ea.}$$

Now ask yourself? "Can I do Dolce, shoes, accessories and dry cleaning for $389.00 per person?" I think not! Maybe you can do *Donna. . . .Johnson*, but you'll be hard pressed to do Donna Karan anything for $389. Unless she makes cufflinks. Cause' that's about all the DKNY you'll be able to pick up

Gather This Kind of Information in Order To Do Your Job

1. What's the name of the group?

2. How many members are in the group?

3. Are they men, women or both?

4. Do you have pictures of the group?

5. How old are each of the members?

6. Are they similar in weight and height?

7. What's the music like? *(Is it Rock, R&B, Jazz, Alternative, Pop, etc.)*

8. What is the shoot date(s)?

9. What kind of look do you have in mind for the group?

10. Do you have music that I can listen to?

11. What is the budget for clothing?

12. How many looks do you want?

13. Do you have all of their sizes?

14. Who is the shooter? *(Someone you've worked with before, or will you need to do research to understand his/her style, who they've shot before?)*

15. Are we shooting in studio or on location?

16. Are we traveling out of town? Are we staying overnight? *(Pack-ing for travel?).*

17. Can I meet with the group? *(Get to know their personalities, likes and dislikes, maybe one of the members hates blue?)*

18. What's their demographic? *(Who's buying this artist's records: adults, kids, teenagers, etc. . .?)*

19. What's the title of the CD?

20. When will the CD or video be released? *(Summer, Fall, Winter. We don't want an artist in a parka on a summer release, do we?)*

21. Can I see the music video treatment. *(The storyline the director has put together.)*

CAROLINE LETTERI

visual look. But, I do dictate what clothes I'd like to see in the magazine.

Here's an example of what I do at Teen: right now I am getting ready for the May issue. I sit down and plan what shoots to do on what dates. Two weeks in advance I'll have a meeting with the fashion editors and I'll tell them I'm looking for a certain kind of clothing, and ask what kind of accessories they think will work. We'll talk about what I see visually for the editorial. For instance, I might see a story on a beach with surfers hanging around, and shot on grainy film etc. The editors will either add to it, or say that's not working, we haven't seen that in the market. We start over from there.

My daily routine consists of coming in and having four cups of coffee, sitting down and making sure the models are booked, the hair and makeup is booked, and that the fashion editors are pulling in the right clothes. I look at Polaroids. I'm like a producer, creating the entire visual effect. The trick to this job is being able to communicate to the photographer and hair and makeup team exactly what you're visualizing. Many times I'll go to magazine stands and pull tear sheets. Then I bring in the tears to show the team. Hopefully they can see what I'm seeing.

CAROLINE LETTERI

RM: You don't really need fashion stylists do you?

CL: That's correct, I style everything. I used to go pull the clothes myself, but now with this new position I rely on the fashion and market editors to pull everything. They do that at least two days in advance. I'll sift through everything and decide what I love or hate. Then I'll put everything together. After I've done that, I call the photographer up a day in advance, we'll plan the locations and he'll take a look at the clothes to get a feeling for them. Then he can figure out what kinds of shots we need for which outfits. Almost every shot is planned out. There are no questions when we get to the shoot.

RM: How did you become a director?

CL: I went to PARSONS School of Design in New York. I studied design for four years. My first job was an internship at "Seventeen". I haven't left magazine publishing since. I worked my way up at "Seventeen," first as an editorial assistant, then fashion editor, next, senior fashion editor, and finally, fashion director. Later I worked for a start up magazine in the teen market called "Teenage Magazine". I was there for two years, they went out of business. After that, I went to "Sportswear International" and started "In Fashion" magazine.

for under $400? Well, I'm kidding—sort of!

But honestly, asking the art director if you can crunch some numbers is an opportunity for you to figure out what you'll really need.

A good stylist should know what's in the stores (at all times), how much [these] clothes and accessories will cost to purchase, the restocking fees on items that will be returned, and the estimated charges for items that typically have to be dry cleaned, re-tagged and returned.

Negotiation: Clothing/Accessories/Props

Good negotiating is what happens when preparation meets opportunity. Many people never get comfortable with negotiating because they don't do their homework. Once you figure out that most clients object and complain about the same thing—money, it gets easy. You can practice your answers, and be prepared to meet each of their objections. After a few encounters, when a client says, "Do you really need two assistants on the shoot days?" you'll know that he means "Why do I have to spend another $150.00 for an assistant?" A little fact-finding and preparation before the call back goes a long way towards alleviating the gnawing feeling in the pit of your stomach that reminds you of how you dislike talking about money. Here's a list of things that clients like to complain about:

Money for clothes:	Why do you need so much?
Money for assistants:	Why do you need so many?
Money for prep days:	Why does it take you so long to do the job?
Money for wrap days:	Why can't you get it all done on the day of the shoot?
Money for prep days:	Why can't you prep for 1/2 your day rate?
Money for wrap days:	Why can't you wrap for 1/2 your day rate?
Money for prep days:	Why can't your assistant do it?
Money for wrap days:	Why can't your assistant do it?
Money for YOU to do returns:	Why can't your $150/day assistant do it?
Money for overages:	Why can't we just have it dry-cleaned?
Money for travel:	Why can't you drive?
Money for you:	Why is your rate so high?
Money for your agent:	Why can't we just call you at home to book you?
Money for messengers:	Why can't you drop it off?
Money for FedEx:	Why can't we use UPS?
The time it takes you to prep:	Why do you need 3 days, can't you do it in two?

The time it takes you to wrap:	Why do you need a 2 days, can't you do it in one?
Hiring you again:	We would hire you more often if we didn't have to pay an agency fee.
Money for clothes:	Can't we get them cheaper?
Money for clothes:	Where can we get them cheaper?
Money for clothes:	Why can't we get them cheaper?

Negotiation: You & Your Assistants

Every negotiation should begin with you knowing your top—the rate you believe you deserve, and your bottom—the rate, below which you will not go.

Now, a certain amount of realism must be injected. Everybody wants to get $3,500 a day. But just like the asking price for a house that has been renovated, and over-built for the neighborhood, asking for an amount that isn't realistic for your market, won't get you anywhere.

Take a look at our rate chart (SHOW ME THE MONEY) on **P7.9**. These are pretty standard for the industry as a starting point. For example, CD cover fees start at around $500, and go as high as $4,500. Here's how those numbers roll out regionally:

	Atlanta	Chicago	Los Angeles	New York
CD Covers	$500	$500	$ 850	$1,000
Commercials	$500	$600	$ 750	$ 900
Press Junket	$850	$850	$1,500	$1,500

Certain variables that can affect these base numbers upward or downward include:

1. **Your relationship with the decision-maker.**

 –Has he already paid you more money on a previous job? If so, you can begin by asking for the last amount you received for an assignment, as you have established a precedent with that client.

 –Has he paid you less and wants to keep you there? If so, you'll probably have to fight for every penny you get. Just keep asking for more. You may be able to inch him along.

 –Is this a long time client? If so, he may feel like he gave you your start, and you ought to be grateful. It's unlikely that you'll be able to get this client to step up to too much more money until' the tears in your book show him that you really are a star.

CAROLINE LETTERI

After that, I went back to "Seventeen" who was bought out by Murdoch who also owned Sportswear and In Fashion. They asked me if I wouldn't mind going back to "Seventeen" to help create a new fashion department with a new feel. So I went back and did just that for a couple of years. Then sportswear called me back [laughs] and asked me to create a fashion department on the West Coast, since the West Coast was building up. I moved out here temporarily and I've been here for six years. Within that time I did my own little magazine for two years, called "Pipeline".

I'm a believer in West Coast trends: it has it's own environment. It's so spectacular and so strong. That's why I started a little trend report with "Pipeline". It began as a section in sportswear, and the buyers and retailers had such a great reaction to it that I developed a newsletter. From there it became a zine, and then a mag-azine. It worked out great. I put it on hold because the publishers here (Teen/Sassy) saw the magazine and asked me if I would come here and create a department for them! So I guess I'm the editor that gets brought in to create new fashion departments.

RM:　Who chooses hair & makeup artists for the shoots?

CL: Most magazines have a booking editor. If not, they have a sittings editor. I would be the one to say, "call in these four artists, I love them, I want to see their books," then the **sittings editor would arrange all the details regarding the shoot... Call times etc.... A bookings editor would be the one to handle all the models, hair and makeup** at a larger magazine. They do not choose the artists or models but there opinions are respected and trusted.

RM: **What inspires you to try an artist you've never used before?**

CL: Word of mouth. A photographer tells me about someone he just worked with that he really liked. I call in their book. I have a thing about meeting the artist prior to a shoot. You never know what can happen when you get to the shoot. The person may have a great book, but a lot of that may have come from the photographer, or fashion stylist. Or I may be on a photo shoot and say "I don't like that hair style, can you rearrange it? "I don't want to have a snap back. I want to hear, "Yes, no problem, but..." or your opinion is. . . I like someone who's easy to work with. Nobody likes a clash of personalities.

RM: **What are some of your "pet peeves" with hair and makeup?**

CL: They can scare me [laughs]!

2. **Tearsheets.**
 –If you have several tears in your book that establish you as a player, the decision-maker will already **expect** you to ask for more money. Do it!

3. **Your relationship with the artist/celebrity/management/publicist.**
 –This is where you're really in the cat bird seat, and it matters little what production says they have in their budget, if the celebrity or their management are insisting that you are the only one who can work on one of their clients ask for the moon!

3. **Budget**
 –They really can't afford to go any higher.

Quite often when you start out, you're not getting the rates you want, but because you want to work, you except less than you think you should get. This is okay, everyone does it in the beginning. You have to start somewhere. But remember, it's hard to get a $500 a day client to pay you $1,000 once they've gotten used to paying you $500. And what's worse, is that if you accept too low a rate for the promise of future jobs with better pay, when the client gets more money and can spend a couple thousand dollars a day, they often won't hire you, because you're the $500 a day artist. With them you've established your rate. But not with a new client. Ask for the money.

Sometimes you just have to accept it, or stop working for that client. Pick whom you lower your rate for carefully, because some people are short-sighted, and will never see you as more than that. Also, it's important to be able to read people. Some people just like to argue, and if your rate is $850, and you're dealing with someone who always wants a deal, then you'll have to start at $1,000 and back down to $850 so they feel like they got a deal, and you'll feel like you're being paid what you're worth.

YOUR ASSISTANTS

You will have to ask for assistants when you need them. Better yet, you'll need to make it known that you have an assistant (or two), and that you require their assistance on whatever job you are being booked for. When discussing your rate with a potential client, talk about your assistant very matter-of-factly. Assume that you will be given a budget for an assistant and talk as though it has already been done. **Examples:**

—Well Don, I think my assistant and I can knock this out in about 3 days, let me fax over a confirmation for your signature.

InStyle

Time, Inc

InStyle
Time & Life Building
Rockefeller Center
New York, NY 10020-1383

212-522-1212

April 25, 2003

To Whom It May Concern:

This is to confirm that Denise Davenport is working as a stylist for a photo session with actress Gloria Reuben that Jerry Avenaim is shooting for InStyle on April 29. InStyle will be responsible for all items borrowed, and will credit those items used in published photos.

Sincerely,

Carolyn Swindell
Deputy Photo Editor

xxx-xxx-xxxx phone
xxx-xxx-xxxx fax

It should be filled out immediately, and unless you have worked with a client several times, I wouldn't start shopping without the check in hand. The Request for Advance is simply an invoice that gets you money up front instead of after the job. Que-Pasa?

THE STYLISTS [PULL] LETTER

A stylists letter is just about the most valuable editorial tool there is when it comes to working with magazines. It's a letter given to the stylist by a magazine that allows the stylist to pull clothes from stores with little or no risk to the stylist, because the client assumes financial responsibility for any clothing that is damaged during the execution of the shoot.

—Well honestly Cliff, my assistant will actually save you money. With her help I can prep this job in 2 days instead of 3. Without her, it will take me 3, and she's only $150 a day.

PAPERWORK

REQUEST FOR ADVANCE

Naturally you wouldn't begin working without getting a confirmation signed (**see P7.26**) right? It's important. It spells out the terms and conditions under which you, and your assistant will work. We're talking overtime and all. Don't even start the job without one.

The Request for Advance (**see P7.28**) is how you get the money to shop.

Purchase Order: A purchase order is often referred to as a PO. Pronounced Pee-Oh. Seriously! Most large companies issue PO's. It's a formal request to sell to the purchaser (production company, record company, etc.) the items (your services as a freelance stylist) at agreed upon prices (your day rate and those of your assistants for a specific amount and the hours therein). Other important information on a purchase order can include how the merchandise (clothing) is to be returned to the client and how and when the invoice is going to be paid (15 days, 30 days, whenever they get ready) Get it!

CAROLINE LETTERI

Sometimes they get so set on a particular hair do! This is Hollywood, and a lot of hair and makeup artists are groomed for actors and actresses. We're a young, fresh teen magazine. I want to generate what I've seen in Europe, what's coming off the runways; and a lot of times the artists are very set in their way on how an actress likes to wear her hair. So, they'll bring that Hollywood idea to my "Teen" shoot, and it's just not working. The clothes are very sporty, young and fresh, and here's this big "do".

RM: **How do you feel about artists cold calling you and saying,"Hi, I'd like to work for teen!"?**

CL: I've found in the past that when you ignore calls you might be missing a tremendous talent that's just ready to start out. I think for young magazines it's really important to generate the fresh new talent that's just coming up. I have a really strong feeling about finding fresh, new young talent. Whenever somebody gives me a call, I always ask them to either drop off their book or come by. Even if they have tests in their book, as an experienced eye you know what they're capable of. I'd like to see some editorial, I'm sure most editors would but tests for me are fine. We have these small little pages in the front of the magazine; it's a great way

CAROLINE LETTERI

of testing out new artists. If we like them, we always give them a big editorial. Everybody wants to be first to showcase a new talent.

RM: **What do you like to see in an artists book? Clean stuff or funky?**

CL: I like to see a good mix of what the person is capable of doing. I don't really love a book when the whole thing is extreme; very out there. Something that you would never be able to bring down and relate to in an editorial, or real life. I like a good mix: some pictures fashion oriented, others more basic, some "Do's", some simple hair. I find some times that if a book is filled with very decorated hair, the artist isn't capable of doing really simple hair. That's the first indication to me.

RM: **Do you always go through agencies for hair and makeup?**

CL: Always, I feel safe. I feel like the agency that's repping them feels as strongly as I do, so that gives me some confidence.

RM: **So an artist calls you and they don't have an agency repping them, what do you do?**

CL: First I would ask them if they have seen any of the agencies. If they said "no", I would give them a list of

Once you've been given an assignment by a photographer or the magazine, call the contact person at the magazine and ask for a stylists letter. It's that simple. Also, if the magazine's editorial department doesn't have one, you can read them the verbage in this one, or type it up and email it to them. They can just drop it onto a sheet of letterhead. Just make sure you get it or you could be stuck with some very expensive clothing [that doesn't fit your or any of your friends] if anything goes wrong.

PETTY CASH ENVELOPE/VOUCHER

A petty cash envelope/voucher is used for the reimbursement of expenses of $300 or less. It enables you to track how production monies were spent. Petty cash vouchers bypass the reporting mechanism to the IRS. As a result, accounts payable does not send a report to IRS. If a production is audited however, and these services are not reported, the production can be heavily fined, or at least in trouble, which is why it's so important to keep every receipt, and turn your paperwork in on time.

Always write the job particulars on the envelope. If you're a smart stylist you'll write the job number, and the PO# (Purchase Order Number given to you by the client) on each receipt. Petty cash envelopes really help when you are working on more than one job at a time and have more than one assistant on board. Without them, and a system for keeping track of which receipts go with what job, production will NOT reimburse you for monies that you have spent.

Pre-Production Meetings with Creatives & Other Decision Makers

The most important part of a pre-production meeting is being prepared. You should be prepared to ask questions that will enable you to carry out your part of the assignment, and to take notes on those aspects of production that will impact your job. Typical subjects that are covered include: wardrobe, casting, locations, set design, theme, crew, etc.

Meeting with the Artist/Celebrity/Model

It's quite normal for the stylist to meet with a recording artist prior to a shoot. Everyone wants you to get a look at the person that you're shopping for. Production, management, and creative are pretty good about facilitating that kind of encounter.

If the person is not available for a meeting, because they are out of town or busy with show dates, then you should request a phone meeting wherein you will both have an opportunity to get to

know one another, and you can ascertain if they are being forthright about their size and weight, among other things.

It's important to remember that only women who are a size 6-8 don't lie about their size—they're proud of it. Everyone else wants to be a size 6-8, so you should shop accordingly. Better too big than to small. Clothes pins can fix too big. Only scissors can fix too small.

Celebrities are just too busy for meetings with stylists, at least in the beginning of the relationship. Once they get to know you, you'll find yourself shopping for them for all kinds of events.

Meetings with models are rare. You may request to be at the casting for a look-see, but most of the time, you will shop based upon a comp card and a phone meeting when necessary.

Shopping: Boutiques, Studio Services & Designer Showrooms

Artists ask me about shopping all the time, especially about testing and how the heck they are supposed to get clothes. There are three types of shopping.

1. Shopping with a commercial budget and thus cash in your pocket.
2. Shopping for an editorial assignment with a stylists letter in your day planner.
3. Shopping for a test with hope, and a prayer.

Testing is the thing stylists cut their teeth on. The question I hear time and time again; "But how do I get clothes, Crystal". My response, "Any which way you can".

Getting clothes for testing separates the men from the boys. The ones who couldn't figure it out—aren't styling anymore. Stylists need clothes. To get them, begin by assessing the available resources. I left a space, in case you come up with another ingenious place to get clothes from. Let's see:

1. Department Stores	6. PR Departments for Designer Showrooms
2. Studio Services in Department Stores	7. Thrift Shops
3. Boutiques	8. Costume Shops
4. Studio Services in Boutiques	9. Your Own Closet, & Those of Your Friends
5. Merchandise Mart Designers	10. _____

Shopping for tests requires a combination of these resources. People do not have to give you clothes so that you can get pictures for your book. You won't be able to borrow from boutiques all the time, but when you do, it will be because you have developed a reciprocal relationship of mutual respect, trust and benefit. i.e. you return the clothes when you say you will in saleable condition, and the store gets something from having loaned you clothing for your shoots. The most basic

agencies to go to. Then I would follow up with a call to the agency and ask the reps what they thought about the artist, and their book.

RM: Do you have an agency preference?

CL: Left up to some agencies, [and this is the truth..] they will give me their newest people who haven't done much editorial. That's tough for me because I am an experienced professional, and when you have 1.7 million readers buying your magazine-you know, I don't want try out someone new to editorial work! I get a list of who the agency represents and I spend three or four days calling in books that I haven't already seen. I make notes of who's work I like, and then I call them in again for specific shoots. I really go on what I see in their book, their reputation and what photographers say who have worked with them. I don't go to an agency and say, "who do you have available?".

RM: How do you handle artists who are tardy, using drugs or alcohol or have a bad attitude?

CL: I never ever use them again. I work much too hard to have to deal with stuff like that, and risk messing up a shoot.

RM: Thanks Caroline!

**TINA SIBULKIN
DIRECTOR OF FASHION PROGRAMS
THE CALIFORNIA MART**

RM: **Tina, tell me exactly what you do and how you started your career.**

TS: I am the Manager of Fashion Programs at the California Mart. I put together all the fashion shows, press releases and photo shoots for everything that has to do with the Mart. I graduated from UCLA with a degree in design and communications and I wasn't really sure what I wanted to do. I loved art and fashion. I got a job working as an advertising assistant at Bugle Boy and worked there for two years. Then I got hired as the photo shoot coordinator and marketing manager for all the Contempo stores across the nation.

expectation is that when you have clients, and a budget you will come back and shop at their store, and insure the appropriate credit is given in magazines, and on television.

However, from time-to-time, you will have to purchase things from department and thrift stores, as well as pick up items from rental shops. This is why good credit is so important. Before you know it, those pantyhose, shoes, and vintage earrings that couldn't be returned, start to add up, and they do so way before you begin to make a living from styling.

STUDIO SERVICES

Barney's New York	Macy's	American Rag	Banana Republic
Neiman Marcus	Nordstrom	Maxfield	The Gap
Politix	H. Lorenzo	Bloomingdales	Saks Fifth Avenue & MORE.

Studio Services is a fashion, prop and costume design tool of the trade. This particular resource is used by fashion stylists, and individuals in the wardrobe and costuming fields such as costumers, costume supervisors, wardrobe stylists and costume designers.

Studio services departments permit the removal of clothing from their stores for review, use, exposure, and ultimately sale of the merchandise. Each department varies slightly in its policies and procedures, but the basic premise is that by loaning the working stylist clothing for a day or

BARNEY'S NEW YORK STUDIO SERVICES
BEVERLY HILLS

POLICIES AND PROCEDURES
FOR STYLISTS

All stylists or clients who wish to work with Studio Service on an approval basis must provide a current phone number, address, driver's license, and credit card.

When using a client's card, the stylist must provide a letter of responsibility stating that the client understands the policies of Barney's New York Studio Services, and accepts full responsibility for all merchandise pulled by the stylist. When merchandise is being charged to an outside client, the stylist must provide the client's credit card number, as well as written permission for the stylist to use the card. With a production agency full agency letterhead will be required on permission letter.

There are a maximum number of pieces that may be pulled for any given job. The maximum number of pieces is determined by the specific job, as well as the capacity of Barney's New York Studio Services

BARNEY'S NEW YORK STUDIO SERVICES BEVERLY HILLS - POLICIES AND PROCEDURES

to process and prepare orders. No more than 40 pieces may be taken out of the store at once.

Stylists are expected to keep a minimum of 20% of the merchandise pulled (i.e. if the pull totals $10,000, the amount kept must total at least $2,000.) If over 50 items are pulled, 30% of the merchandise must be kept. 50% of the merchandise must be kept if the majority of the pull is sale merchandise.

Stylists are responsible for all merchandise taken out of the store. Any merchandise worn, including merchandise used for a photo shoot, must be purchased. Any merchandise returned to the store worn or damaged will be charged to the stylist or client's credit card. All merchandise must be returned to Barney's in its original condition, with the original hangers with tags. All merchandise must be returned in the same order that it went out per the memo.

Merchandise should be returned to the store within five business days unless special arrangements are made. If the return of the merchandise is delayed for any reason, a courtesy phone call is expected. If we are not notified, merchandise will be charged to the appropriate account.

Stylists are expected to communicate their billing needs. If cash or check will be used for payment, Studio Services must be informed at the time of the pull. Payment is always expected on the same day as the return, no exceptions.

Wrap time for pulls and returns is 5:30 p.m. If the pull isn't complete or the return isn't checked in by this time, the order will be completed the following morning by noon.

Leathers must be returned within 48 hours. If pulled on Thursdays, they must be returned before the weekend.

Any merchandise taken out of the country will automatically be charged at 30%, no exceptions.

Multiply pulls at once must be pre-approved by a manager. In the event that an assistant is pulling on behalf of the stylist, a courtesy call must be initiated by the stylist to Barneys New York Studio Services prior to the assistant beginning the pull. No exceptions.

All merchandise dropped off for return without pulling party present is subject to BNY Studio Services review and billing. We encourage all clients to wait and review drop offs in partnership with Barneys New York Studio Services staff.

_____ _____
Signature **date**

TINA SIBULKIN

I was there for four years until I came here. I never planned on being here, it kind of fell into my lap through contacts and past jobs. If you keep focused on what you want to do, and you're ambitious, you will get there. You've got to have patience and a little faith too. Just go with the flow. If it's something that excites you, just do it, because if you're bored as hell at your job, your not going to be good at what your attempting to do.

RM: **Do you choose the models and makeup, hair and styling for all the fashion shows at The California Mart?**

TS: I hire and work with freelance fashion show producers. I usually find them through word of mouth. That's the thing about L.A., even though we are one of the largest fashion manufacturers in the world, the talent is made up of a small pool, and most people in the field know each other. I hire a fashion coordinator who will help me pull clothes, hair and makeup artists, photographers, all the models, dressers, gofers, and display people. It's usually through word of mouth, but I do often call the agencies.

RM: **Do you ever struggle with the producers about the makeup, hair and stylists?**

TINA SIBULKIN

TS: Oh, yes. Compromise, or my word is final! [laughs]. I pay your bill. No, seriously, someone has to be ultimately responsible for the direction that we're presenting to the buyers and the press; and that has to be me. So I have to feel good and believe in what I am showing. I give creative people space to express their ideas. I don't say no right away, I listen, but someone has to have the final word or we get nowhere.

RM: Let's say I am a fashion stylist and I feel it's time for a change. Let's say I dream about being a fashion show coordinator at The Mart and I want to work my way up to a position like yours. What do you suggest I do?

TS: The most important thing is getting into the right company you want to work for. It can be on a full or part time basis. Once you're in, you can work your way up. . . if your good. There are a lot of skills you need to learn too. I mean you can be creative and have a wonderful fashion sense but somewhere along the way you have to learn business skills, how to budget and deal with money, how to manage people, and communicate. That's what these companies are looking for too. There are a lot of creative

BARNEYS
NEWYORK

BARNEY'S NEW YORK STUDIO SERVICES
CREDIT AUTHORIZATION INSTRUCTIONS

The following information is required for third party credit card authorization through the Barney's New York Studio Services department. Your letter must be on your company's letterhead and addressed to Barney's New York.

Please include the following information in your letter.

I, _____ hereby authorize _____ to secure merchandise from Barney's New York Studio Services on the following Barney's New York, Visa, MasterCard, or American Express credit card.

CLIENT NAME: _____

TYPES OF CREDIT CARD: _____

NAME AS IT APPEARS ON CARD: _____

CREDIT CARD NUMBER: _____

EXPIRATION DATE: _____

CID NUMBER: _____

BILLING ADDRESS: _____

CARD HOLDERS PHONE NUMBER: _____

I understand that any merchandise that is kept, worn, damaged, unsalable, photographed, or lost will be charged to this credit card, unless another form of payment has been agreed upon.

I also understand that Barney's New York shall have no liability for any purchases by the above authorized party which are purportedly made pursuant to the above authorization nor shall Barney's New York have any duty to inquire as to whether any purchases by the individual authorized above is pursuant to the above authorization. Where purchases are made by phone, e-mail, fax, or in writing, Barney's shall have no obligation to verify that the party making the purchase is the above authorized party. Until receipt of termination in writing of the above authorization, Barney's New York shall have the right to rely on such determination.

Please include a copy of your credit card (front and back) and a copy of your photo I.D. card (the I.D. must have the card holders signature.)

The credit card holder must sign and date the letter.

The letter can be faxed to 310-777-5746 or hand carried to the Barney's New York Studio Services offices

two at little or no charge, something will be purchased, possibly seen in the media, and with any luck credited in writing for consumers everywhere to see.

The expectation is that you, the fashion stylist, while working on various projects, will borrow items from the stores, and that out of those items you will purchase some. Check out the grid on **P8.18** for a listing of some stores that provide this service. There are plenty more. Do your homework.

Anyone with good credit and/or one to two existing credit cards in good standing can open up a studio services account. You simply go to the studio services department, request an application, and in some cases, you can be approved in 48 hours or less. Your credit limit will depend upon your credit report, so if you have not been a good boy or girl in regards to how you manage your credit, NOW is an excellent time to get it in order. It's fairly difficult to be a good fashion stylist without a decent credit rating or established credit cards. One more thing. Studio services is a west coast thing. There are very few stores on the east coast that offer it.

STUDIO SERVICES: TERMS, CONDITIONS & WORKSHEET

The studio services worksheet and contract (**See P8-20**) is given to stylists who want to pull clothes for review and use for projects. It's the means by which the store keeps track of what you have pulled and will take out on loan. It will also help you keep track of the items you have pulled from stores. The contract on **P8.20** is the type you will enter into when you take clothing from stores **like** Barney's, Saks, Nordstrom, Neiman Marcus, Banana Republic, etc. They are all just about the same.

RENTAL

Rental. Now there's a misnomer. Aside from costume houses that rent clothing, there is no such thing as renting clothes. The term is much overused in the fashion styling business. Department stores, boutiques, and shoe stores do not rent anything. However, as this was a word that clients understood, stylists began substituting it for its true term, restocking fee. Most decision-makers outside of the editorial world use the word rental, and assume that fashion stylists can take any garment or accessory out of a department or specialty store and return it for little more than a thank you. Not true at all. In fact, any clothing that is photographed, put on video tape or filmed, is considered owned.

RESTOCKING FEE

The restocking fee is an amount that stores charge the fashion stylist for the privilege of taking the clothing out for approval. The fee usually ranges from fifteen to twenty five percent of the cloth-

TINA SIBULKIN

people out there, you have to have something beyond that.

RM: **So if a stylist was sending you a resume for a full time job here in the corporate office, would you recommend they only put their office related skills down or should they give you their fashion styling resume?**

TS: Experience is the key. If the person didn't finish high school but they came across as very intelligent, and had worked at a great place or had great experience, that is what matters. They could have a B.A. and be totally wrong for the position. As long as they come across well, that's okay. A lot of people don't have degrees, or they just say they do. My degree did help me get through doors in the beginning, to get interviews; but it's definitely not the only way or answer. Unless it's a really specific skill that you need, I think experience is more important.

RM: **You worked at Contempo booking shoots. Did you often choose an artist who had tearsheets over one who had tests in their book?**

TS: It helps to have really professional tear sheets. Especially editorial. And I want to know who the artist has worked for. Unfortunately, it does go by name. For instance

when hair and makeup artist Steve Cooper came to see me and there was a Cosmopolitan cover opening his book, I immediately took him seriously. I'm probably going to pay a bit more attention to a book like that. I would encourage people to test, it's really the only way to start connecting with people and creating work that you can show. Ultimately, It would be great if you could always test with really talented photographers! If someone had a book full of tests I might bring them in at a lower rate. Perhaps they wouldn't get the top position first, or they would start an assistant and I'd see how they were. I would not be comfortable giving them a top level job.

RM: You have worked on photo shoots and fashion shows, would you say there was a difference in the way hair and makeup artists perform on one versus the other?

TS: Definitely. To work successfully on fashion shows, an artist needs to be extremely quick and resourceful. Things are chaotic backstage at a show. The designers are worrying about their clothing, the dressers are making quick but careful changes, you've got models left and right who don't always know where they need to be. There are constant

ing or the stylist is required to purchase a certain percentage of the entire pull.

SHOES

Shoes, the curse of the stylist. While clothing can usually be dry cleaned and retagged to look like new, this is not ordinarily the case with shoes. So delicate and easily marred are the soles of shoes, that most experienced stylists warn their clients in advance "if the shoes are damaged, or unacceptable to the stores in any way, you will have to pay for them." PERIOD!

A ruined Manolo Blahnik shoe can cost between $350 and $1,000. This sometimes equals half of a fashion stylist's clothing budget on a small job. And know this, the department stores have heard it all. They are not the least bit interested in why or how the shoes got that tiny little scratch. If the shoes are ruined, you or the client must buy them! Murphys Law. What can go wrong will go wrong, and it always does with shoes. Do yourself a favor and ask the models, celebrities and anyone else you know to bring their own shoes.

DESIGNER SHOWROOMS

Designer showrooms are an east cost phenomenon while studio services is a west coast thing. There are a few designer showrooms in the merchandise marts throughout the country in places like Los Angeles, Dallas and Miami, but nothing like the showrooms of New York, Milan, London and Japan.

Designer showrooms and magazines are inexplicably tied to one another. Showrooms loan clothing to fashion stylists who are doing work for high profile fashion or entertainment magazines. The magazines include: *Vogue, Elle, Bazaar, Marie Claire, Vogue L'Uomo, GQ, Details, Vibe, Entertainment Weekly, Movieline, Buzz, Essence* and *InStyle* to name a few.

The secret to working with designer showrooms is knowing that the only good reason for them to loan you a $2,000 dress is that there is a high probability that the dress will be seen by hundreds of thousands of consumers, some of which can and will buy the darn thing. The fact that only a small percentage of the world population can afford a two thousand dollar dress, tells you something else you should know about the kind of exposure a designer is seeking. Okay, let me spell it out for you. Isaac Mizrahi is not going to loan you his $2,000 dress to put on some unknown model for a magazine that neither he nor anyone else has ever heard of. In other words, Right-On is out! Here are a few rules of thumb to employ when working with designer showrooms.

1. **Don't waste their time.** Have your facts together, and know who you want to speak with before you pick up the telephone. Sometimes, that means going on a fishing expedition the

day before the real sock-it-to-me phone call to get the scoop on who you need to talk to.

2. **Know the collection.** It's best not to call Dolce and Gabbana about sending you all of their brights if they didn't do any for the collection you are requesting clothes from. I once called the ad agency that represented Absolute Vodka to try and secure an ad for 1stHOLD. When the account executive asked me what our demographic was, I said "18-34". He then said, "We don't sell alcohol to minors". That was the end of that. From then on, I made sure I did my homework ahead of time so I didn't look like an idiot. I had one chance, and I blew it.

3. **Be nice to everyone.** The receptionist can be just as important as the showroom supervisor. The receptionist may be the only person who knows where he or she is at a given point in time.

4. **Be ready to fax, email or hand over a copy of the stylists letter** from the magazine that names and authorizes you to pull clothing for a particular story.

5. **Always include the magazine's express mail carrier** (usually Federal Express) number on all correspondence to the showroom. Most showrooms will want an account number before they send you clothes.

6. **Make sure that there will be someone available to accept the clothing** at the location where you are having the merchandise shipped.

7. Be aware that some designers will want to know what other designers you are using in your story before they will lend out clothing.

Stylists spend countless hours on the phone attempting to convince the New York showrooms that they have the next great photo session going on day after tomorrow, and must have some items in their newest collections. For the right magazine, editorial spread, model or celebrity, you can get just about anything if it's available, and if the clothing used will be credited to the design house.

GETTING IT DONE

Fittings & Alterations

The purpose of a fitting is to see how things look on an artist as much as how they fit. Fittings work best when they occur 2-3 days prior to a shoot day, giving the stylist time to return items that don't fit or work for some other reason. It is usually attended by more than just the stylist and sub-

TINA SIBULKIN

changes in hair and makeup. You need to be a good communicator & under control, especially if something goes wrong, that's where the resourceful part plays a role. You need to get along with others because there are a ton of creative people all in the same area with ten billion opinions. It is very fast paced and exciting. For all the craziness, it's still a wonderful business **END**

ROSE CEFALU

we have a really large audience which is really nice. Basically, I don't have a budget to pay an editorial rate, which is unfortunate, I wish we did.

RM: **You do an excellent job of making sure everyone who worked on the shoot is given credit!**

RC: I credit everyone from the labs that help us out, to locations and of course the artists. The tear sheets are really beautiful. I do really wish we could pay a rate. Maybe in a year or so, but we really can't afford it now.

RM: **Well, it's definitely worth it, your tear sheets are exquisite. No doubt about that ! Hey, do you guys have a web site in the works?**

RC: Yes, we do, but it is being redesigned right now.

RM: **Cool. Well, thanks so much for your time, Rose!**

BARNEYS NEWYORK

MICHAEL SHARKEY

MICHAEL SHARKEY
MANAGER, STUDIO SERVICES

CG: Who does Barney's consider the ideal studio services client (stylist)?

MS: Barney's business encompasses all aspects of the styling marketplace; editorial, commercial styling such as a Coca-Cola or Maybelline, definitely TV, and of course feature film.

CG: What are your specific requirements for opening a studio account?

MS: We require that the person desiring an account have a major credit card. Visa, MasterCard, or American Express. And I encourage them to open a Barney's account for convenience.

CG: Do your other stores have studio services departments?

MS: There is one at the New York store on Madison Avenue.

CG: If someone is set up with a studio services account at the Beverly Hills store, can they use it in New York?

ject. Quite often, the manager, creative decision-maker, publicist, boy or girlfriend shows up. As you can imagine, that's way too many chiefs and not enough indians.

Once a decision has been made about what to keep, the stylist can drop clothing off at the tailor for final alterations while she continues to shop for last minute items and make returns.

Shoot

Today the stylist should be prepared for anything, including being sent back out to shop because everyone has changed their minds about what they want. There was never a better case for the additional expense of an assistant than the shoot day, when inevitably some piece of clothing gets left behind, or the actor decides that he does like those pants that he told you to take back just days ago. Cool heads must prevail. It's all in a days work.

Addendum for Overages

CARRY STYLEWISE
MAKEUP & HAIR STYLIST
10000 ANYSTREET BLVD., STE 000
ANYCITY, XX 55555

ADDENDUM FOR OVERAGES

This Addendum is made part of the Confirmation Agreement dated _____ ,
regarding Job No: _____, and Job Name: _____by and between _____
the _____, and _____, the _____ stylist.

Seeing as how the use of additional clothing, and/or accessories, and/or jewelry, and/or shoes on the
following: __ photo shoot __ music video __ commercial
 __ tour __ personal appearance __ _____

will cause _____, the _____ stylist, to go over the official budget of
$_____, it is necessary to get approval for overages, which will be:
 __ billed to the client
 __ charged to the _____, _____ credit card ending in __ __ __ __
 __ paid with a reimbursement check, provided by _____ on _____, 200__.

I, _____ HEREBY AUTHORIZE _____ TO:
 __USE MY CREDIT CARD TO CHARGE THE ITEMS LISTED ON THE REVERSE SIDE OF THIS AGREEMENT
SHOULD THEY BECOME DAMAGED AND/OR UNRETURNABLE TO THE CLOTHING/ACCESSORY/SHOE STORE
IN ANY WAY.
 __ BILL _____ FOR THE ITEMS LISTED ON THE REVERSE SIDE OF THIS
AGREEMENT SHOULD THEY BECOME DAMAGED AND/OR UNRETURNABLE TO THE CLOTHING/ACCESSO-
RY/SHOE STORE IN ANY WAY, AND THE STYLISTS _____ WILL BE REIMBURSED FOR THE
AGREED UPON OVERAGES WITHIN 4 WORKING DAYS OR 96 HOURS.

_____ _____ _____
AUTHORIZED SIGNATURE TITLE DATE

10000 ANYSTREET BLVD., STE 000 • ANYCITY, XX 55555 • PHONE (555) 555-5555 • EMAIL: CARRYSTYLEWISE@HOTMAIL.COM

A clothing addendum is a form that can be used during a shoot to get additional purchases or rentals [over and above the original budget] approved by a decision-maker **on the spot**. Stylists use this form more than anyone.

A good stylist always over-pulls, however, that doesn't mean that the client can afford to use all of the clothes the stylist brought to the shoot. They sometimes forget that the extras are for selection. If the client has a $5,000 budget and wants 4 looks, a good stylist may pull $10,000 worth of clothes—enough for 7 or 8 looks (just in case).

CLOTHING ADDENDUM: When & Why

Here's what often happens: Somewhere on location, a shoot is taking place in the middle of Chicago. It begins to rain. A conversation between the art director and the stylist ensues:

Art Director: "I want the model to wear

that silver metallic leather jacket."

Stylist: "Well, Sir, that's what I had planned for her to wear, but it's raining now and if the jacket gets wet, I can't return it."

Art Director: "So what?"

Stylist: "Well, Sir, this jacket is $1,600 and will put us $1,732 over budget. We're already $132 over."

Client: "I don't care, it's perfect for the shot."

Stylist: "Okay, if I can just get you to sign my addendum (guaranteeing payment within 24 hours) for the additional overages, then we're good to go."

A savvy stylist with an addendum helps an enthusiastic art director put creativity back into business perspective. Sure, that jacket Rocks! And the recording artist would look good in it, but unless the art director is willing to sign the addendum, the money isn't there, and you could end up trying to sell that jacket to one of your girl friends for a fraction of what it costs.

The decision-maker must put-up, shut-up, or wait until it stops raining. Don't get stuck with a $1,600 jacket that you cannot fit or afford because they were afraid to speak up. Remember what Cuba Gooding Jr. said to Tom Cruise in the film *Jerry McGuire*; "Show Me The Money".

Stylists Credit Sheet

NAME	DESCRIPTION OF CLOTHING	ACCESSORIES	QUOTE
Simmone (1)	Skirt. Poleci halter. Poleci	Barrettes - Gerrard Yosea Handbag - Temma Dahan Shoes - Charles David	Color/Blk & White Pictures
Simmone (2)	Sweater Vest - Urchin Knickers - Besty J.	Shoes - Charles David Bracelet - Darell Vass Ludcar	Color/Blk & White Pictures
Rebecca (1)	Knichers - Renee & Company Shirt - Lola	Tights - Hue Shoes - Charles David Bracelet - Paselle / Roxanne Assoulin	Blk/White Picture
Simmone (3)	Sweater - Betsy Johnson Halter - Dollhouse	Shoes - Charles David	Color Pictures

MS: Absolutely. And I always make a courtesy call for them to make sure that the New York store has all the up-to-date information on the stylist's account. When the stylist arrives in the store, they are not foreign to the people in New York. I do that so my client feels comfortable.

CG: **What are your procedures for removing clothing from the store?**

MS: All the paperwork is done on a memo form. We check the credit card being used to confirm that it can handle the amount of merchandise being removed from the store. Basically, it's all written on a memo. One copy is given to the artist and one is kept in our file. We give a stylist up to 48 hours to keep the merchandise out. If they need an extra day they can call me, and I may approve upon further consideration.

CG: **What are your expectations regarding the condition of the clothing that is returned to the store?**

MS: That's very, very important to me. I expect the clothes to be returned in exactly the same condition that

**BARNEY'S NEW YORK
MICHAEL SHARKEY**

they were removed.

CG: Are you expecting that a certain percentage of the stylist's clothing budget will be spent at the store?

MS: Not really. Barney's understands what the business is about, and that while a stylist is very enthusiastic when they walk in and find exactly what they want, the producer, director, photographer, or advertising agency may look at the merchandise and have a completely different opinion. So I don't have unrealistic expectations when the clothing goes out.

CG: Do you have credit limits?

MS: Yes we do keep between a $5000 to $7000 credit limit.

CG: So, lets say a stylist comes in with a $5,000 budget, can they return everything?

MS: Well, we have a 20% restocking fee for stylists. If a stylist takes $3,500 in merchandise out on approval and brings it all back, the restocking fee is $700.

CG: Do you rent clothing?

The stylists credit sheet—*not to be confused with the credit sheet in chapter 7*—is turned into the magazine at the end of a shoot so that the editor can properly credit the clothing for the vendors who loaned you the clothes. Page **8.27** has an example of what the editor should get. You may make up your own, or ask the editor at the magazine for their internal form.

Wardrobe Worksheet

The stylists worksheet is a post-production form that I designed for our stylists at The Crystal Agency to help them organize their receipts and balance their budget prior to turning them in to clients. The worksheet is usually stapled to the top of the pile of receipts, fastened inside a manila folder or taped to the front of the receipt envelope. (See Example on **P8.29**). This form is one of 7 in the StyleWise™ Business Forms package of customized forms for makeup, hair, and fashion stylists.

Returns & Reconciliation

Returns should be handled quickly, and immediately following the shoot. Without the final tally, production finds it difficult to close out a job and move on. It's important to remember that the photographer, producer, and director that you will be working with are freelancers just like you. They cannot get paid and move on to the next gig until' everything is wrapped up, and neither can you.

Invoicing

An invoice is required at the end of every single job, regardless of whether you are the key on the job or an assistant to someone else. Including the job numbers, and PO numbers I've talked about in this chapter on your invoice will make the difference between getting paid in 10 days or 10 months. No one will be able to pay your invoice in a timely manner if your job name is: Shoot in Las Vegas in the Desert. That is not recognizable to the accounting department. If you're assisting, you should ask the person who booked you, who you should submit your invoice to. Send it in, and follow up!

CARRY STYLEWISE
MAKEUP & HAIR STYLIST
10000 ANYSTREET BLVD., STE 000
ANYCITY, XX 55555

WARDROBE WORKSHEET

Client Name:	SONY MUSIC
Phone Number:	(310) 555-1212
Project:	CELINE DION: BABY LET ME GO
Artist/Subject:	CELINE DION
Editorial Section & Issue:	N/A
Art Director:	JANINE OLSON
Photo Editor:	N/A
Fashion Editor:	N/A
Photographer:	DAVID ROTH
Photo Session Date:	AUGUST 19 & 20, 2003

Item	Garment Description	Clothing Designer	Price
	Amount if any carried forward from previous page		$
Jacket	Brown Glen Plaid	Armani	$ 952.00
Pants	Wheat Colored Bell Botm.	Dolce	$ 627.00
Shoes	Matte Gold Sandals	Costume National	$ 330.00
Bracelets	Faux Silver Bangels	Rhonda Stewart	$ 270.00
			$
			$
			$
			$
			$
			$
			$
			$
			$
			$
			$
	Sub-Total Clothing Purchase and/or Rental		$ 2,169.00
	Monies Advanced to Stylist by Client		$ 2,500.00
	Sub-Total		$ -330.00
	Other Expenses: _____		$
	Monies Due X Client or ___ Stylist		$ 330.00
			$
	___ Please Make a Check Payable to _____ in the Amount of		$
	X Enclosed Please Find a Check Made Payable to _____ in the Amount of		$ 330.00

WARDROBE WORKSHEET

Use this Form as the basis for the accounting of what you purchased or rented.

You can include it along with your invoice to show how you spent the clothing budget that you were given.

You can also send it in with an invoice if you are owed money for overages.

It should also go in the job folder along with your receipts for tax time.

BARNEY'S NEW YORK
MICHAEL SHARKEY

MS: NO! We do not rent.

CG: What are your specific procedures for checking merchandise in and out.

MS: We have an ID badge that stylists wear. Stylists sign in with my office and I verify that their name, or their assistants name is on file with our office. The project they are working on is recorded, and they are ready to go. If it's a first time visitor, I greet them, let them know a little about the store, take them to each floor, guide them throughout the store, collect all the merchandise for them and bring it back to the office. I write it all up in a timely manner, and I help them to their car, or whatever means they have arranged to get the merchandise safely out of the store.

CG: What is the procedure you follow when a key stylist sends an assistant to pull merchandise for them?

MS: Our office must receive written authorization (by fax) from the stylist who maintains the Barney's studio account, giving permission to their assistant to use the account. This policy protects the stylist from having an unautho-

rized person use their account.

CG: What common problems do you encounter as a result of working with stylists, and what can they do to help you help them?

MS: They can limit their pull. Plan ahead so they work within the 48 hour deadline for approval. Stylists sometimes pull too early. When the merchandise is taken off the floor too early, it interrupts the flow of the general public who shop at Barney's. We are the studio department, but my job includes working with the store managers who have rules of their own to follow. I must be aware of their needs and not keep the merchandise out more than 48 hours. We work to give equal time to the stylists, however, we must also be sympathetic to the needs of our everyday client.

CG: How can stylists work more efficiently with Barney's?

MS: Stylists can help us and themselves in several ways:

1. Return the merchandise in its original condition

CONT ON P8.30

WHAT'S TOUGH ABOUT BEING A FASHION STYLIST

A fashion stylist's job is the most physically demanding and financially risky. It has several levels of difficulty, less room for error, and less of an opportunity to fix a mistake if one is made. It's also easier to pay a makeup artist or hair stylist an $850 fee for one day, than it is to pay a fashion stylist that same fee for three or four days (prep, shoot, wrap/returns). Consequently, it's always the fashion stylist's fee that has to be justified to the client, and elaborate means taken to show the specifics of how and where money is going to be spent and the stylists time used. Here are some of the obstacles you can expect to encounter as a stylist:

1. **Getting paid for the actual time spent preparing for the job.**
 The stylist is usually required to attend two or three meetings with the client and/or artist, celebrity or model prior to the shoot. The agenda may include fittings, concept discussions, etc. . . The stylist often spends numerous hours the night before the shoot, untagging, bagging for transportation, polaroiding, and packing in preparation for the next day's shoot.

2. **Getting reimbursed for actual expenses incurred during the shoot.**
 - The stylist can put hundreds of miles on an automobiles odometer for each job assignment.
 - The stylist who works with recording artists, often takes them out shopping and incurs meal expense.
 - The stylist can incur substantial miscellaneous non-receipt bearing expenses such as metered parking, and cell phones.

3. **An Assistant.**
 - The stylist almost always requires the help of an assistant.
 - Assistants range in price from about $150 to $250 per day.

4. **Client resistance.**
 - The client rarely wants to pay the stylist for attending meetings that can take up a substantial portion of an assistants day.
 - The client usually wants to pay less for the prep and wrap days which are perceived as less work than the shoot days.

5. **Budget Restrictions.**
 - The client expects the stylist to work miracles for very little money.
 - The client expects the stylist to return used clothing to the stores.

6. Every job averages three and one half days (3-1/2).

- On an average 3.5 day job, the client typically wants the following arrangement regardless of the actual time it takes to do the job. 1 prep, 1 shoot, 1/2 wrap. No assistant.
- The stylist works more days than they are paid for.

Still wanna' be a fashion stylist? Well, in spite of the ups and downs, it is a very exciting field. If you're very good at it, and you stay ahead of what's going on in the fashion world, you will probably spend only a single year dealing with low budget jobs. Great stylists are few and far between and word travels very fast. Once you catch on fire, so does your career and your day rate. From there, you will get the opportunity to pick and choose the jobs you want at the rate you desire, and bring the right number of assistants along with you.

TIMES TABLES

A savvy fashion stylist shops and sources for vendors all over the world. You'll need to know what time to set your alarm clock if you want to get those clothes shipped in from that hot Paris design house. So here's a chart to help you get up in the middle of the night:

LOS ANGELES SEATTLE PORTLAND	DENVER PHOENIX IDAHO	CHICAGO MISSORI TEXAS	NEW YORK BOSTON WASH., DC	LONDON	PARIS	FRANKFURT MILAN	HONG KONG	HO OLULU
5 AM	6 AM	7 AM	8 AM	1 PM	2 PM	3 PM	9 PM	3 AM
6 AM	7 AM	8 AM	9 AM	2 PM	3 PM	4 PM	10 PM	4 AM
7 AM	8 AM	9 AM	10 AM	3 PM	4 PM	5 PM	11 PM	5 AM
8 AM	9 AM	10 AM	11 AM	4 PM	5 PM	6 PM	12 AM	6 AM
9 AM	10 AM	11 AM	12 NN	5 PM	6 PM	7 PM	1 AM	7 AM
10 AM	11 AM	12 NN	1 PM	6 PM	7 PM	8 PM	2 AM	8 AM
11 AM	12 NN	1 PM	2 PM	7 PM	8 PM	9 PM	3 AM_	9 AM
12 NN	1 PM	2 PM	3 PM	8 PM	9 PM	10 PM	4 AM	10 AM
1 PM	2 PM	3 PM	4 PM	9 PM	10 PM	11 PM	5 AM	11 AM
2 PM	3 PM	4 PM	5 PM	10 PM	11 PM	12 AM	6 AM	12 NN
3 PM	4 PM	5 PM	6 PM	11 PM	12 AM	1 AM	7 AM	1 PM
4 PM	5 PM	6 PM	7 PM	12 AM	1 AM	2 AM	8 AM	2 PM
5 PM	6 PM	7 PM	8 PM	1 AM	2 AM	3 AM_	9 AM	3 PM
6 PM	7 PM	8 PM	9 PM	2 AM	3 AM	4 AM	10 AM	4 PM

★Stylewise Business Forms Package: A 6-7 piece set of customizable business forms available through Set The Pace Publishing Group. Included are a Confirmation, Request for Advance, Voucher, Invoice, Credit Sheet, Stylists Worksheet and a Tearsheet Collection Form. The forms are delivered to you with your name, address, phone numbers, email address, website and logo [if you have one]. $55 plus tax (California residents) and shipping ($5). See p8.40-8.41.

BARNEY'S NEW YORK
MICHAEL SHARKEY

2. Bring the merchandise back on time
3. Don't do partial returns.

By following these rules of thumb, the studio department and the stylist work together to insure that the system runs smoothly.

CG: What other services does your department offer to stylists?

MS: Barney's has a wonderful restaurant here in the Beverly Hills store. It's called Barney Greengrass. Private dressing rooms are available as well, and we want to accommodate them any way we can. We will book before and after store hours to help them with their business, and we encourage them to bring their celebrity clients into the store where we have private fitting rooms, and can fit and alter the clothing promptly.

CG: What do you want a new stylist to know about Barney's?

MS: I want to show them how unique Barney's really is and have an opportunity to demonstrate the range of products and services Barney's has to offer. We carry a

CONT ON P8.31

YOUR CREDIT RATING

My best piece of advice to you is: Pay your bills on time. Unfortunately, not many of us (myself included) learned a lot about credit while we were growing up. Consequently, there are a good number of people struggling without the necessary resources, like a Visa, Mastercard, or American Express (don't leave home without it). Listen, in this business, there may be times you will need to rent a car for an out-of-town trip, purchase an airline ticket by phone, or cover expenses for moving into a new apartment, or to pull clothes for a job. All of these things have one thing in common, Good Credit. It's awfully hard to get your styling job done without credit.

If your credit is in shambles, or heading in that direction, now is the time to take charge. There is a great book called "The Wall Street Journal Guide To Understanding Personal Finance." I find it to be an invaluable tool. And for those of you with a long, tough, credit repair road ahead, I suggest contacting a bank that offers a secured credit card. The premise behind these cards is simple; if you don't have good credit, the bank will allow you to put money into an interest bearing savings account and provide you with a credit line equal to the account balance on deposit with them.

Deposit $500 into the account, and you'll have a $500 credit limit; the more you put in, the higher your limit. Some banks even offer a credit limit equal to 1-1/2 times your savings deposit. Two national banks who offer this service are listed below: Citibank & Capitol One. For a list of companies that offer secured cards, just Google It!. Put the words "SECURE CREDIT CARD" in the search box, and click away. For more serious credit issues, call Consumer Credit Counceling. They can put you on a plan to help you pay off your debts and get back on the right road to fiscal health.

VENDORS

Vendors are like water—you can't live without them, so treat them well. Fashion stylists have been known to promise a vendor the world in order to get the store to loan them the clothing, accessories and jewelry they need to complete a test or a job.

The promises usually take the form of pictures the stylist swears they will give the vendor, credits that are supposed to appear in this or that magazine, the CD cover the stylist vows to bring the vendor once it's released, or the merchandise that will be returned by a specific date and time. Unfortunately, the favors extended by vendors are usually long forgotten by the time the pictures are available or the tearsheets run in a magazine. And while many stylists have forgotten the small boutiques that came through for them in the beginning, the vendor has not forgotten the stylist who didn't keep his or her word.

Los Angeles and New York are full of stylists who promised vendors the sun and the moon until they got what they wanted. The stylist didn't follow through, and thus, the next stylist may find that

vendors want his/her first-born child before so much as a sock can be removed from the premises. Keep your commitments and all will be well. A little honesty goes a long way toward building and sustaining a relationship with a vendor.

Back in April ('03) I booked a stylist [who shall go nameless] for the cover of *1stHOLD* magazine. It was our *When Style Becomes The Star* issue. This was terribly important, as it would be our last issue—a *Vanity Fair* style fold-out cover like the one we had done years ago with Sam Fine, Philip Bloch, Sharon Gault, Debra McGuire and Nonja McKenzie on the cover.

I must tell you, I loved this stylists work. All she had were tests in her book, but I saw something special in her, and in fact, I had helped her to organize her book during a portfolio review several months earlier. Additionally, since I was planning to reopen The Crystal Agency, I had her in mind for our roster, believing that she would one day be a real force in the industry. So here's what happened.

I offered up Ursula Rodriguez, and Lauren Tanaka, two of my interns—also aspiring stylists as assistants for her. She would need lots of help. She also had her own assistant.

After committing to do the cover, she become alouf and stopped communicating with me. Ursula and Lauren had a terrible time getting in touch with her. She would ask them to do things, and then refuse to return their phone calls and emails, even though she had them calling all over kingdom come for clothing for the 8 artists who would be on the cover. She had to pull 2 looks. One was very formal, the other—Jeans and white T-Shirts.

Three days before the shoot I got a call from one of the stores she was trying to pull from. They said "Under no uncertain terms may Ms. X pull from this store. We have had problems with her in the past, and will NOT work with her".

On the day of the shoot when I arrived, I found Ursula, Lauren and the other assistant dragging clothing and accessories out of their trucks and cars, but no Ms. X. When I asked where she was, I was told by her assistant that she had food poisoning, and she wouldn't make it.

Needless to say if there had been a gun in the studio, I would be in Sing-Sing right now. But like show business, "The Show Must Go On". Ursula was my senior intern. She was reliable and had an enormous amount of calm. I put her in charge. As of June 1, 2003, I have not ever heard from Ms. X. But rest assured, that everyone on that shoot knows her name, from the photographer to some of the most powerful makeup, hair and fashion stylists in the business. One day, her name will come up, and someone will say, "Oh no, you don't want her. Let me tell you what happened...".

**BARNEY'S NEW YORK
MICHAEL SHARKEY**

wide selection of merchandise to satisfy their clothing needs, such as our Barney's private label line that is suitable for the stylist who is working with a cost-conscious client. We want them to know that everything they need is here at Barney's.

NOTES:

	FROM U.S.A	COUNTRY CODE	CITY CODE
Australia (61)			
Brisbane	011	61	7
Melbourne	011	61	3
Sydney	011	61	2
France (33)			
Monaco	011	33	No city code Required
Paris	011	33	13, 14, or 16
Germany (49)			
Berlin	011	49	30
Dresden	011	49	351
Frankfurt (East)	011	49	335
Frankfurt (West)	011	49	69
Munich	011	49	89
Hong Kong (852)			
	011	852	No city code Required
Italy (39)			
Milan	011	39	2
Rome	011	39	6
Venice	011	39	41
Japan (81)			
Osaka	011	81	6
Tokyo	011	81	3

	FROM	COUNTRY	CITY
Mexico (52)			
Mexico City	011	52	5
Netherlands (31)			
Amsterdam	011	31	20
The Hague	011	31	70
South Africa (27)			
Cape Town	011	27	21
Johannesburg	011	27	11
Spain (34)			
Barcelona	011	34	3
Madrid	011	34	1
Sweden (46)			
Stockholm	011	46	8
Switzerland (41)			
Geneva	011	41	22
Zurich	011	41	1
United Kingdom (44)			
Liverpool	011	44	151
London (inner)	011	44	207
London (outer)	011	44	208

To dial internationally from the US, dial 011 + Country Code + City Code + Local Number.

POP QUIZ

You have a photo shoot with Venice Magazine today: you're styling Jeff Goldblum. It's 2:45 PM and your call time is 3:15 PM. You're twenty minutes from the photo shoot location. You're standing in the Studio Services Department at Barney's, New York. What do you do?

1. Finish your transaction, pack up your stuff, head to your car and drive on over to the shoot

2. Finish your transaction, pack up your car and walk over to Saks Fifth Avenue and pick up another shirt you spotted yesterday that you think will look great on Jeff. Walk back to the Barney's lot and drive your car over to the shoot.

3. Ask to use the phone at Barney's, call the shoot location, speak to the photographer and/or client to let them know you are running about 15 minutes late. Walk over to Saks, pick up the shirt, return to your car and head to the shoot.

BASIC FASHION STYLIST KIT

1) Collapsable Rolling Rack	14) Spray Starch
2) Steamer	15) Scotch Guard
3) Iron	16) Wrinkle Guard
4) Good Fabric Scissors	17) Shoe Laces
5) Big Pair of Scissors (cut up anything)	18) Lots and Lots of Top Stick
6) Little Scissors for Kit Bag	19) Different Color Rit Dyes
7) Seam Ripper	20) Hanging Tags
8) Assortment of Needles and Thread	21) Sewing Machine (optional)
9) Lots of Lint Rollers (the kind with disposable tape heads)	22) Fuller's Earth
10) Tagging Gum	23) Mineral Oil
11) Variety of Shoe Polishes	24) Stain Remover
12) Tons of Safety Pins (in all sizes)	25) Calculator
13) Buttons, Snaps, Velcro	26) Shoulder Pads
	27) Bra Pads/Lit Pads

The answer, of course, is #3. Late is bad. Not calling ahead is worse and will get you canned from working with that client ever again.

THE END

Well that's it. Other than a few fabulous interviews with great industry experts—old and new, and an updated section on resources, I'm done. I hope you enjoyed reading it as much as I ALWAYS enjoy writing it. You can email me at Crystal@MakeupHairandStyling.com.

Good Luck.

Sincerely,

Crystal A. Wright

Crystal Wright

we heard...

GLOSSARY

1ST ASSISTANT: The person usually selected by the key makeup, hair, or fashion stylist as their right hand. This individual has been identified by the key as fully capable of handling some or all aspects of a job.

ACCOUNTS PAYABLE DEPARTMENT: The department in most companies that handles payment to you on your invoice.

ACCOUNTS RECEIVABLE DEPARTMENT: A friend over 6'5 who weighs 240lbs. and always gets his own way or the department in most companies that handles receiving payments on invoices sent to their customers.

AGENT: An individual connects the creative artist or their work with opportunities for exposure, negotiate deals, promote the artists name or reputation.

AGENCY: A firm that handles the business and creative works for a fee.

ART DIRECTOR: The individual at a record company or advertising agency who typically is responsible for selecting the photographer, makeup, hair, fashion stylist, prop and/or food stylist or nail tech for a photo shoot. Many art directors have final say regarding the makeup, hair and styling talent. Others have to consider the requests of the photographers, artists, the artists management, product managers, and directors of A&R.

ARTIST Often used to describe a recording artist signed to a record label. Maria Carey, Keith Sweat, k.d. lang, and Dr. Dre are considered artists. In THE makeup, hair & STYLING CAREER GUIDE, artist also refers to you, the makeup, hair and Fashion Stylist.

ARTIST MANAGER: Typically found in the entertainment business, the artist manager will often call in and/or review the books of freelancers.

BALLS: Something you should have bought right after you bought this book.

BEAT (MAKEUP)**:** Term used by professional makeup artists to describe having done a fabulous job making up a person's face.

BOOKER: Someone who schedules jobs at an agency, sends out confirmations, negotiates fees, etc.

BOOKING: A firm reservation for a job. A firm reservation to some is a handshake, to others it's a written document like a confirmation form.

BUDGET: A set of financial parameters under which the person giving out the job must adhere to and therefore you must fit into if you are going to be awarded that particular job.

CALL TIME: The time talent is required to be at the shoot. A good rule of thumb is to be at least 15 minutes early.

CHAT ROOM: A place on the internet where you can converse with other people around the world (in real time) about subjects that interest you.

CLIENT: The person or company who hired you, and/or the person or company who is paying you.

COLOR LAB: A place where film is developed and turned into transparencies, slides or prints. A color lab can enlarge and reduce photographs.

CONCEPT MEETING: A meeting where a plan is developed for creating the look and style of an artist or celebrity for their CD cover or video, film, etc. . .

COMPOSITE: (SEE PROMO CARD): Term used to describe the Promo Card or ZED Card. Usually includes a selection of photographs that represent a body of work. The card is given away to potential clients to generate business.

CONFIRMATION: A confirmation can be a familiar voice on the other end of your phone line telling you that you're booked for the job and assuring you that you'll get paid even if the job cancels at the last minute. If not however it is a written document that spells out the terms and conditions under which an artist will work, get paid, travel, etc. . .

CONTACT: A person with whom you have a business and/or personal relationship. An individual whose name, and telephone number you are privy to. Someone you call on for information or assistance.

CONTINUITY: The act of keeping track of the physical qualities and specifics of a particular shot or scene for the purpose of duplicating it a later date. Continuity is important in feature film because movies are often shot out of sequence. Artists use polaroid cameras to maintain continuity.

CONTRACT/AGREEMENT: A legally binding arrangement between two or more parties.

COSTUME DESIGNER: The person who creates costumes by designing, shopping or facilitating the production of the garments that will be worn on television, in film or on stage (in print, this person is called a fashion stylist).

CREDITS: The lines of type on a tearsheet that include a persons name, what they did (makeup, hair, styling or photography, and who represents them.

CREW: makeup, hair, Fashion Stylists, Gaffers, Grips, Cameramen, Assistants, Costumers, etc. . . are all considered CREW.

CROP: The act of adjusting or trimming a photograph, print, and/or transparency before printing.

DEAL MEMO: (SEE ALSO CONFIRMATION): A confirmation in writing that describes the terms and conditions under which an artist will work (ie: rate, overtime, per diem, mileage etc. . .).

DECISION MAKER: A person with the ability to hire talent and authorize payment. Usually refers to Photographers, Producers, Production Managers, Art Directors, Fashion Editors, Directors of Creative Services, etc. . .

DIRECTOR: The person responsible for all the creative decisions on a production. The director makes the script or treatment a reality. The person with the artistic vision.

DIRECTOR OF A & R: The person responsible for signing new acts to a record label, and/or matching existing artists up with producers and writers who can facilitate the completion of a CD project. A&R people are often very hands on with their artists and sometimes get involved in and can have the final say in the hiring of photographers, makeup, hair and fashion stylists.

DUPE: A copy of a transparency or slide.

DUPED: A thing that happens to fashion stylists who listen to the artists they are dressing instead of the client who gave them the money to shop.

EDITORIAL: Work done for a magazine. Covers, features, and spreads are considered editorial.

ENTRY LEVEL: A job in the basement. The job(s) you do to educate yourself and give yourself an opportunity for advancement in your field. In our business, Tests & Student Films.

EXECUTIVE PRODUCER: The person who is responsible for financing and overseeing a video, commercial, television or film project. The executive producer also hires the producer. The executive producer is not usually involved in the day to day production operation.

EXPENDABLE: Items such as facial tissue, sponges, safety pins, Q-Tips, etc. . . that will be used up during the course of a production.

EXPENSES: Monies given to you, and spent by you for the items that are necessary for you to complete your job as a makeup, hair or fashion stylist. Expenses include things like: mileage, wigs, special effects makeup, clothing, props, etc. . .

FASHION EDITOR: The person at a publication who handles the style and fashion department of that publication. The fashion editor usually hires hair and makeup artists, could have been a freelance fashion stylist, and writes for the magazine.

FITTING: The time a fashion stylist/costumer/costume designer uses to try clothing on models, artists, celebrities, etc.

FLAT RATE: The monetary rate talent agrees to work for, regardless of the number of hours they will have to work during the day. All inclusive. An amount agreed upon in advance. A rate that is inclusive of the fee, overtime (OT), per diem, kit rental, and agency fee.

FREELANCER: Any artist who sells his or her services to employers without a long-term commitment to any one of them, without the benefit of an agency.

GENRE: A specific class or category. Example: Action Films are a genre of movie making.

GOLDEN TIME: An overtime (OT) rate that is triple the normal hourly rate.

GREASE PENCIL: Pencil used to mark on transparencies, slides and contact sheets without damaging them. Usually comes in burgundy, yellow or orange and can be purchased at all art supply stores.

HOUSE ACCOUNT: A term used by artists and photographers to describe those clients which should remain theirs after signing with an agent. When agreed to by the agency, these accounts are non-commisionable to the agency for the fifteen percent to twenty five (photo rate) percent paid by the artist.

FIRST HOLD (ALSO *1ST HOLD* THE NEWSLETTER)**:** A term used to describe the time a client is holding on an artist. *Ex: Can I get a 1st Hold on Neeko for Teen Magazine on May 17th.*

I.A.T.S.E: (SEE CHAPTER 6: TV & FILM)**:** International Alliance of Theatrical and Stage Employees. A unionized organization.

KEY: Used to describe the person in charge of the makeup, hair or styling department on a film, television, or commercial production.

KILL FEE: (SOMETIMES CALLED CANCELLATION FEE)**:** The kill fee serves to assure payment to you in the event that a client cancels at the last minute.

KIT RENTAL (ALSO CALLED KIT FEE)**:** Usually ranges from $25-$75 a day. This amount is given to makeup and/or hair stylists to replenish the supplies in their makeup or hair kits.

LEADING QUESTION: A question requiring more than a "yes" or "no" answer. It requires the person answering the question to expound on the subject.

LIGHT BOX: Used to view transparencies and slides more effectively. It is often used with a loop (serves the same purpose as a magnifying glass).

LINE PRODUCER: The producer who is in charge of hiring and negotiation.

LISTINGS: An accurate written description of a person, place, or item. Many creative directories give free listings to makeup, hair and fashion stylists.

LOCATION: The place the job will take place. The word location is often used to describe any place outside a studio.

LOGO: A unique symbol or design used by an individual or business. Often found on business cards, stationary, promotional pieces, etc. . .

LOOP: A product that is similar to a magnifying glass. It is shaped like a mini telescope. It is used to see small photographs such as transparencies, slides, and contact sheets more clearly.

M•A•C: Makeup Artist Cosmetics. The name of a well known cosmetics company.

MASTHEAD: The pages in a magazine that list the names and titles of the important people who work at the magazine.

N.A.B.E.T (See Unions Section)**:** National Alliance of Broadcast Engineers and Technicians. N.A.B.E.T. is a union organization.

NEGATIVE FILM: Comes in one inch strips, always black & White. Cannot be viewed in its original form. Must be converted into a contact sheet for reviewing.

NFA: No Fax Available

NEPOTISM: Favoritism shown to a relative or close friend for an available position on a production.

NOTICE OF CANCELLATION: Clients have from 24 - 48 hours prior to a job to cancel the assignment without penalty. The penalty ranges from 50 percent of the original fee to 100 percent of the fee depending on the hour notice of cancellation is given.

OPEN ENDED QUESTION: A question that requires more than a simple yes or no response. Ex. of an open ended question: What do you like about my book? Ex. of a closed ended question: Do you like my book?

OVERTIME: The span of time which exceeds the regular hours talent agrees to work for a specific amount of money.

PIXEL: A grid of small squares that come together to form a picture. Used in retouching photographs.

PER DIEM: Money paid to an artist to cover the cost of meals and incidental expenses when shooting on location during overnite shoots.

PERIPHERAL VISION: The ability to see things from every angle. Can be applied both literally and figuratively.

PERIOD PIECE: A movie, television show or photo shoot that is set in a specific period in time (ie: a photo shoot set in the 1950's; the clothes, props, makeup and hair would have to reflect that time period). Ex: Dangerous Liaisons.

PERMANENT PLACEMENT: Often used when referring to a job gotten through a temporary agency or head hunter. A permanent placement can also occur when an agency places one of its artists at a magazine as a fashion editor, or staff stylist.

PHOTO EDITOR: The person at a magazine who hires photographers and decides which photographs will be used in stories.

PURCHASE ORDER NUMBER (PO#): A number often given by companies which proves that the job assignment given to you is legitimate and you will be compensated (paid) in a timely fashion once the job is completed and your invoice is submitted.

POLAROIDS: Photos taken with a Polaroid camera. Used in film and television for continuity. Used in print as a gage for lighting, mood, etc. . .before shooting final film on a subject.

POLAROID BOOK: A portfolio book is a photo album of polaroid photos taken from a photo shoot. They are sometimes kept by artists to showcase their work prior to retouching, or a tearsheet being printed.

POST-PRODUCTION: The span of time after the shooting of a production, when the fashion stylist, makeup artist, hair stylist, costume designers, prop people, etc... turn in their receipts.

PREP: The work days used to prepare for or shop prior to the actual shoot. Prep days can be billed at a dollar portion of the day rate up to the talents regular day rate. Fashion Stylists have prep days regularly.

PRINT: Anything that is printed on a piece of paper. Magazines, Advertising Layouts, CD Covers, Catalogues, etc. . . are all considered print.

> EX: You might hear someone say, "I just got a great print assignment". They could mean an CD cover, a job with a magazine, the new Guess Jeans advertising campaign, or a Victoria's Secret catalogue. It's all print.

PRODUCER: The person who is typically responsible for hiring the crew on a video, commercial, television or film project. Often called the Line Producer.

PRODUCTION ASSISTANT: The person who is available to assist in all departments and all aspects on a production.

PRODUCTION COORDINATOR: The person who is typically responsible for maintaining contact with and giving direction (per the producer) to the crew on a video, commercial, television or film project.

PRODUCTION MANAGER: The person who is in charge of managing all aspects and all departments on a production.

PROMO CARD (SOMETIMES CALLED A COMPOSITE OR ZED CARD):
A card, that displays and showcases your print work. The promotional card is also called a leave behind. It serves as a reminder to a potential client once you and/or your portfolio have left the premises.

PROP: An item such as a chair, candlestick, or book that becomes part of the shot on a still photograph or moving film production.

PROPOSAL: A plan, estimate or suggestion presented for approval.

PROSPECT: A potential client.

PUBLICIST: An individual whose job it is to promote another person, company or entity in the media (newspapers, magazines, television, radio, the internet, etc.). Publicists often work hand-in-hand with the talent (celebrities and recording artists) to assist them in making decisions about who to use for photo sessions, videos, live appearances, etc.

PULL: A word used by fashion stylists and costume designers to describe the garments and/or accessories taken from one or more stores.
Example: "What did you **PULL** for the Mariah Carey photo shoot?"

REEL: A device used to wind video tape. A video tape production of your work. A video portfolio. 1/2" reel better known as VHS; the size of the tape that is used in home video recorders. A 3/4" reel is the most popular size of video reel used in the industry.

REP (OFTEN CALLED ARTISTS REPRESENTATIVE OR AGENT)**:** Someone who solicits and secures work for talent at an agency or independently for one talent at a time.

RESTOCKING FEE: An amount charged to fashion stylists by department and specialty stores for the priviledge of removing clothing from the store on approval for an agreed upon period of time. (Usually 24 hours) The purpose of this practice is to give the stylist an opportunity to take the clothing out for fittings and/or review by the client.

RETOUCHER: An artist who can remove flaws and/or enhance a persons features in a photograph. Often used to correct imperfections in the photographs of recording artists, celebrities, and models whose looks are of major importance to their image and careers.

RETURNS: Prop and clothing items returned by a stylist at the completion of a photo session or production. Usually completed on the wrap day. However, on large productions, the returns are sometimes completed by an assistant while the production is going on.

REVIEW: The process of having your portfolio called in and looked at by art directors, artist managers, photographers, and/or designers for specific jobs.

SECOND HOLD: A second hold is a reservation of your time for an upcoming job when you are already on hold for another job. The client is en effect saying "If the first client who has you on hold ends up canceling, I want you!"

SHOOT DAY: The day and/or days the action takes place.

SHOOT CHECKLIST: A check off list of prep, shoot and post activities for a photo shoot.

SHOOT SHEET: A chart of the vendors, estimated and actual charges, film processing, printing and pickup dates, petty cash accounting.

SHOT: Usually referred to as the best images chosen from a photo session.

SIGNATURE COSTUME HOUSE: A Costume house that is affiliated with the union.

SPEC JOB: A job that a photographer or director takes on (usually without pay or very minimal pay) because he/she feels it will further their career in the long run.

STILL LIFE PHOTOGRAPHY: Photography of inanimate objects.

STUDIO: Usually refers to a photography studio. Can be owned or rented by a photographer. A place where photo shoots take place.

STUDIO DEPARTMENT: The area in many department stores that loans clothing out to stylists for photo shoots, television, and film projects.

STUDIO SERVICES ACCOUNT: A business or corporate credit account at a clothing store.

TALENT: You. The makeup, hair, fashion stylist, costume designer or prop stylist is considered talent.

TEARSHEETS: Published and/or printed material. Tearsheets consist of magazine pages, advertising pages, and/or slicks, CD covers, mobiles, POS (Point Of Sale), POP (Point Of Purchase), advertising inserts, newspaper, etc. . . Any print assignment that generates a piece of artwork is considered a tearsheet.

TESTING: A gratis photo session that is organized by a photographer, where a team of makeup, hair, fashion stylists and models collaborate to produce one or more images for their portfolios.

TRANSPARENCY FILM: Comes in rolls or slides, always color.

TRAVEL: The time it takes for an artist to get from one location to another.

TRAVEL TIME/DAY: The time and distance between point "A" and point "B".

TREATMENT: A loosley written storyline or concept used to pitch an idea for a music video.

TYPFACE (FONT)**:** A style of type. Can be used to create a logo.

UNION: A labor organization that sets standard minimum rates for pay, work conditions, benefits and so on.

VOUCHER: A two to three part form given to the client or another person of authority for signature at the end of a shoot. Once signed, the voucher serves as verification and confirmation that you were present at the shoot, gives the actual amount of time you worked on the job, and proves that the terms of a transaction have been met.

WARDROBE CREDIT SHEET: A chart of the clothing designers used, and a description of the clothing and accessories used.

WRAP (SEE RETURNS)**:** The day and/or time following a shoot. Wrap days are typically billed at a dollar portion of the artists full day rate up to the artist full day rate. Artists in the styling field have wrap days with regularity.

RESOURCES

The resource section of the Career Guide is dedicated to helping you find your way around each city's vendors, streets, policies and procedures. We hope that by providing you with a specific list of businesses who understand, respect, and service the needs of makeup, hair, fashion styling, and photography professionals, you will be able to spend your money wisely and make more informed choices.

Remember that the resource lists may not be exhaustive. As you peruse the Career Guide, bear in mind that things do change. Businesses open and close, personnel move around from place to place, and a vendor whose services were superior in 1997 can become less than stellar the following year, for many reasons. When and if this happens, we encourage you to make note of it in your book, and call to let us know about your experiences. We will research the resource, and delete or amend it in next Career Guide.

Magazines tend to have a lot of turnover. You will become aware of this as you develop new study habits, such as reading the masthead in your favorite magazines. For this reason you will find that some sections include the title of the appropriate decision-maker rather than a name. The person holding the job will change. The job title will not.

Record companies, unlike magazines, have very little movement within the art departments. You may find it relatively easy to develop and sustain long term creative relationships with art directors after working together. With that, I bid you adieu and good luck.

Art supply stores that carry an array of art products from exacto knives and paper cutters to portfolios.

ART SUPPLY STORES: ATLANTA, GEORGIA

FLAX
ATLANTA, GA
1460 Northside Drive
Atlanta, GA 30318

www.flaxart.com
(404) 352 - 7200
(FAX) 350 - 9728

ART SUPPLY STORES: CHICAGO, ILLINOIS

FLAX
CHICAGO, IL
220 South Wabash Avenue
Chicago, IL 60604

www.flaxart.com
(312) 431 - 9588

BRUNDNO'S ART SUPPLY
NEAR NORTH
601 North State Street
Chicago, IL 60610
Location: Corner of State & Ohio
RIVER NORTH
700 S. Walbash 1st Floor
Chicago, IL 60605
Location: Corner of Ontario & Orleans

(312) 751 - 7980
(FAX) 751 - 4426

(312) 394 - 4100
(FAX) 341 - 1345

ART SUPPLY STORES: LOS ANGELES

FLAX
WESTWOOD, CA
10852 Lynbrook Drive West
West Los Angeles, CA 90024
Location: Corner of Lynbrook & Glendon

www.flaxart.com
(310) 208 - 3529
(FAX) 208 - 6317

INGLEWOOD, CA
8507 South LaCienega Boulevard
Los Angeles, CA 90301
Location: Between Arbor Vitea & Manchester

(310) 216 - 6300
(FAX) 216 - 6306

HG DANIELS
MID-WILSHIRE
2543 West 6th Street
Los Angeles, CA 90057
Location: Between Vermont & Alvarado

(213) 387 - 1211
(FAX) 386 - 6840

WORLD SUPPLY
HOLLYWOOD WEST
3425 West Cahuenga Boulevard
Los Angeles, CA 90068
Location: Universal Center Drive & Barham

(323) 851 - 1350
(FAX) 851 - 1922

REX ART
CORAL GABLES
2263 SW 37th Avenue
Miami, FL 33145
Location: Coral Way & Douglas Road

(305) 445 - 1413
(FAX) 445 - 1412

ART SUPPLY STORES: NEW YORK

PEARL PAINT
www.pearlpaint.com
308 Canal Street, New York, NY

(212) 431- 7932

FLAX
425 Park Avenue
New York, NY 10022
Location: Park Avenue & 55th Street

www.flaxart.com
(212) 620 - 3060
(FAX) 644 - 0138

12 West 20th Street
New York, NY 10011
Location: Betwween 5th & 6th Avenue

(212) 620 - 3038
(FAX) 633 - 1082

ART SUPPLY STORES: PHOENIX, ARIZONA

FLAX
PHOENIX, AZ
1001 E. Jefferson
Phoenix, AZ 85034

www.flaxart.com
(602) 254 - 0840

ART SUPPLY STORES: SAN FRANCISCO

PEARL PAINT
969 Market Street
San Francisco, CA 94103

www.pearlpaint.com
(415) 357-1400
(FAX) 357-1490

Visit www.MakeupHairandStyling.com to stay informed of hot new developments, news, trends and tips. Get advice on career planning, self-promotion along with up-to-date product developments and feature stories on your favorite artists; People like Kevyn Aucoin, Sam Fine, Phillip Bloch and Oribe. We recognize freelancers for the work they do behind-the-scenes in print, video, TV, film and fashion. 323-913-3773. **MakeupHairandStyling.com.**

BEAUTY SUPPLIES ATLANTA	ATLANTA COSTUME	HOLIDAY COSTUME RENTALS	ULTA 3
Address	2089 Monroe Drive NE	1772 Tullie Circle	3495 Buckhead Loop, Ste. 120
City, State, Zip	Atlanta, GA 30324	Atlanta, GA 30329	Atlanta, GA 30326
Phone	(404) 874 - 7511	(404) 321 - 0049	(404) 266 - 9645
Fax	(404) 873 - 3524	(404) 626 - 3094	(404) 266 - 9645
Services	Mail Order & Delivery	Mail Order & Delivery	Professional Beauty Supply & Retail No delivery
Credit Cards	VISA / MC	VISA / MC / AMEX / DISCOVER	VISA / MC / AMEX / DISCOVER
Notes			

BEAUTY SUPPLIES BOSTON	E-6 APOTHOCARY	BOSTON COSTUME www.bostoncostume.com	NOTES
Address	167 Newbury Street	69 Kneeland	
City, State, Zip	Boston, MA 02116	Boston, MA 02111	
Phone	(617) 236 - 8138	(617) 482 - 1632	
Fax	(617) 236 - 8171	(617) 426 - 5509	
Services	Wholesale Distrubutor of professional beauty supplies	Wholesale Distrubutor of professional beauty supplies and special FX	
Credit Cards	VISA / MC	VISA / MC / AMEX	
Notes			

BEAUTY SUPPLIES CHICAGO	CHE SGUARDO	BROADWAY COSTUMES www.broadwaycostumes.com	FANTASY HEADQUARTERS www.fantasycostumes.com
Address	716 North Wells	1100 West Cermak	4065 N. Milwaukee Avenue
City, State, Zip	Chicago, IL 60610	Chicago, IL 60608	Chicago, IL 60641
Phone	(312) 440 - 1616	(312) 829 - 6400	(773) 777-0222
Fax	(312) 440 - 0689	(312) 829 -8621	(773) 777 - 4228
Services	Catalog Available	Makeup for Photography, TV, Commercials, Feature Film, & Special FX. Horror Techniques, Bald Caps, Body Painting, Burns, Cuts, Bruises, Hairpieces, Beards, Moustaches & Much More!	Catalog • Shipping Available See website for wide selection
Credit Cards	VISA / MC / AMEX	VISA / MC / AMEX / DISCOVER	VISA / MC / AMEX / DISCOVER
Notes			

BEAUTY SUPPLIES DALLAS	NORCOSTCO www.norcostco.com	QUEEN OF HEARTS	
Address	1231 Wycliff Avenue, Ste. 300	1032 East 15th Street	
City, State, Zip	Dallas, TX 75207	Plano, TX 75074	
Phone	(214) 630 - 4048	(972) 578 - 1969	
Fax	(214) 630 -4474	(972) 516 - 1032	
Services	Makeup for Photography, TV, Commercials, Feature Film, & Special FX. Horror Techniques, Bald Caps, Body Painting, Burns, Cuts, Bruises, Hairpieces, Beards, Moustaches & Much More!	Catalog • Shipping Available	
Credit Cards	VISA / MC / AMEX / DISCOVER	VISA / MC / AMEX / DISCOVER	
Notes			

BEAUTY SUPPLIES LAS VEGAS	EMERSON COSTUME www.emersoncostume.com	STAR COSTUME & THEATRICAL SUPPLIES	WILLIAMS COSTUME
Address	15 North Mojave Road	953 East Sahara Avenue	1226 South 3rd Street
City, State, Zip	Las Vegas, NV 89101	Las Vegas, NV 89104	Las Vegas, NV 89104
Phone	(702) 386 - 7999	(702) 731 - 5014	(702) 384 - 1384
Fax	(702) 386 - 9461	(702) 731 - 6103	(702) 386 - 3956
Services	Catalog • Shipping Available See website for wide selection	Theatrical Makeup & Supplies	Theatrical Makeup & Supplies
Credit Cards	VISA / MC / AMEX / DISCOVER	VISA / MC / AMEX / DISCOVER	VISA / MC / AMEX / DISCOVER
Notes			

BEAUTY SUPPLIES LOS ANGELES	CINEMA SECRETS www.cinemasecrets.com	COSMOPROF www.cosmoprofonline.com	FRENDS BEAUTY SUPPLY
Address	4400 Riverside Drive	Over 44 Locations in California	5270 Laurel Canyon Blvd.
City, State, Zip	Burbank, CA 91505	Call for nearest location	North Hollywood, CA 91607
Phone	(818) 846 - 0579	(800) 540 - 7752	(818) 769 - 3834
Fax	(818) 846 - 0431	N/A	(818) 769 - 8124
Services	Worldwide Mail Order Service	Wholesale Distrubutor of professional beauty supplies	Worldwide Mail Order Service
Credit Cards	VISA / MC / AMEX / DISCOVER	VISA / MC	VISA / MC
Notes			

BEAUTY SUPPLIES LOS ANGELES	IMAGE EXCLUSIVES www.imageexclusives.com	MALYS www.malys.com	NAIMIES www.naimies.com
Address	8020 Melrose Avenue	Over 20 Locations	12640 Riverside Drive
City, State, Zip	West Hollywood, CA 90046	Call for nearest locations	North Hollywood, CA 91607
Phone	(323) 651 - 5002	(800) 446 - 2597	(818) 655 - 9933
Fax	(323) 651- 1710	N/A	Not available at time of print
Services	Mail Order • Delivery	Wholesale Distrubutor of professional beauty supplies Services professionals only Not open to the public	Wholesale Distrubutor of professional beauty supplies and special FX
Credit Cards	VISA / MC / AMEX	VISA / MC / AMEX / DISCOVER	VISA / MC / AMEX / DISCOVER
Notes			

BEAUTY SUPPLIES LOS ANGELES	NAIMIES www.naimies.com	WEST COAST BEAUTY SUPPLY www.westcoastbeauty.com	NOTES
Address	1208 Victory Blvd.	Over 30 Locations	
City, State, Zip	North Hollywood, CA 91606	Call for nearest locations	
Phone	(818) 763 - 7073	(800) 233 - 3141	
Fax	Not available at time of print	N/A	
Services	Wholesale Distrubutor of professional beauty supplies and special FX	Wholesale Distrubutor of professional beauty supplies	
Credit Cards	VISA / MC / AMEX / DISCOVER	VISA / MC / AMEX	
Notes			

BEAUTY SUPPLIES MIAMI	GABLES BEAUTY SUPPLY	SOUTH BEACH MAKEUP	_____
Address	352 Analusia Avenue	439 Espanola Way	
City, State, Zip	Coral Gables, FL 33134	Miami Beach, FL 33139	
Phone	(305) 446 - 6654	(305) 538 - 0805	
Fax	(305) 454 - 4928	(305) 538 - 5588	
Services	Discount to professional makeup artists	Mail Order • Delivery	
Credit Cards	VISA / MC / AMEX	VISA / MC / AMEX	
Notes			

BEAUTY SUPPLIES MINNEAPOLIS	NORTHWESTERN COSTUME www.norcostco.com	TEENERS COSTUME	_____
Address	825 Rhode Island Avenue South	729 Hennepin Avenue	
City, State, Zip	Golden Valley, MN 55426	Minneapolis, MN 55403	
Phone	(612) 544 - 0601	(612) 339 - 2793	
Fax	(612) 525 - 8676		
Services	Theatrical Makeup & Supplies	Theatrical Makeup & Supplies	
Credit Cards	VISA / MC / AMEX	VISA / MC / AMEX	
Notes			

BEAUTY SUPPLIES NEW YORK	ALCONE	ALCONE	JIQU TRADING COMPANY
Address	5 - 49 49th Avenue	235 West 19th Street	42 West 28th Street
City, State, Zip	Long Island City, NY 11101	New York, NY 10011	New York, NY 10001
Phone	(718) 729 - 8373	(212) 633 - 0551	(212) 689 - 9738
Fax	(718) 729 - 8296	(212) 633 - 0551	
Services	Mail Order & Delivery	Mail Order & Delivery	Overnight Delivery • Catalog
Credit Cards	VISA / MC / AMEX	VISA / MC / AMEX	VISA / MC / AMEX
Notes			

BEAUTY SUPPLIES NEW YORK	RICKY'S	THE MAKEUP SHOP www.themakeupshop.com	_____
Address	Mulitiple Locations	131 West 21st Street	
City, State, Zip	Call for location near you	New York, NY 10011	
Phone	212 - 725 - 1930	(212) 807-0447	
Fax	212 - 254 - 5247	(212) 727-0975	
Services	Mail Order • Delivery • Classes Worldwide Mail Order Service	Makeup for Photography, TV, Commercials, Feature Film, & Special FX. Horror Techniques, Bald Caps, Body Painting, Burns, Cuts, Bruises, Hairpieces, Beards, Moustaches & Much More! Call for a class schedule.	
Credit Cards	VISA / MC / AMEX / DISCOVER	VISA / MC / AMEX	
Notes	6 locations in Manhattan. Top of the line cosmetics & hair care products, and are known for stocking hard to find European products.		

BEAUTY SUPPLIES SAN FRANCISCO	KRYLON	IMAGE MAKER	STAGE CRAFT STUDIOS
Address	132 9th Street	1638 Palm Avenue	1854 Alcatraz Blvd
City, State, Zip	San Francisco, CA 94103	San Mateo, CA 94402	Berkeley, CA 94703
Phone	(415) 863 - 9684	(650) 574 - 1881	(510) 653 - 4425
Fax	(415) 863 - 9059	(650) 574 - 1421	(510) 653 - 9217
Services	Theatrical Makeup • Feathers • Character Wigs • Film/TV/Stage	Theatrical Makeup & Supplies	Theatrical Makeup & Supplies
Credit Cards	VISA / MC / AMEX / DISCOVER	VISA / MC / AMEX	VISA / MC / AMEX / DISCOVER
Notes			

BEAUTY SUPPLIES WASHINGTON, DC	ARTISTIC DANCE FASHIONS, INC.	BACK STAGE, INC.	KINETIC ARTISTRY www.kineticartistry.com
Address	4915 Cordell Avenue	545 8th Street South East	7216 Carroll Avenue
City, State, Zip	Bethesda, MD 20814	Washington, DC 20003	Takoma Park, MD 20912
Phone	(301) 652 - 2323	(202) 544 - 5744	(301) 270 - 6666
Fax	(301) 652 - 9467	(202) 544 - 7023	(301) 270 - 6662
Services	Theatrical Makeup & Supplies	Theatrical Makeup • Supplies Costume Shop • Theater Books	Catalog • Shipping
Credit Cards	VISA / MC / AMEX	VISA / MC / AMEX	VISA / MC / AMEX
Notes			

BEAUTY SUPPLIES CANADA	COMPLECTIONS www.complectionsmake-up.com	HAMILTONS THEATRICAL SUPPLY	MAQUIPRO www.artistic-makeup.com
Address	85 Saint Nicholas Street	2065 Midland Avenue	2345 St. Mathieu
City, State, Zip	Toronto, Ontario M4V 1W8	Toronto, Ontario M1P 4P8	Montreal, Quebec
Phone	(416) 968 - 6739	(416) 299 - 0645	(514) 998 - 5703
Fax	(416) 968 - 7340	(416) 299 - 1671	Not Available
Services	Special FX • Beauty • Film/TV/Video Mail Order & Delivery	Complete Supplier of Special FX & Theatrical Makeup Mail Order & Delivery	Professional Cosmetics & Industry Beauty Supplies
Credit Cards	VISA / MC / AMEX	VISA / MC / AMEX / DISCOVER	VISA / MC / AMEX / DISCOVER
Notes			

BEAUTY SUPPLIES CANADA	MAVIS THEATRICAL	R. HISCOTT BEAUTY SUPPLY	STUDIO FX
Address	46 Princess Street East	435 Young Street	1055 West Georgia Street
City, State, Zip	Waterloo, Ontario	Toronto, Ontario	Van Couver, BC V6E 3P2
Phone	(519) 746 - 1484	(416) 977 - 5247	(604) 685-5509
Fax	(519) 746 - 2954	(416) 977 - 0279	Not Available
Services	Professional Beauty Supplies & Distributor of RCMA Products	Professional Beauty Supply	Professional Beauty Products & Cosmetics
Credit Cards	VISA / MC / AMEX / DISCOVER	VISA / MC / AMEX / DISCOVER	VISA / MC / AMEX / DISCOVER
Notes			

the hookup...the hookup...the hookup...the hookup...the hookup...the hookup...

makeup companies tell us how you can stock your kit on the cheap

▸ **ANASTASIA of BEVERLY HILLS.** 40% off to professional makeup artists. Present agency promo, cosmetology license, tearsheets or union card. Call 310/273-3155 or visit www.anastasia.net ▧ ▸ **BENEFIT.** 50% off to professional makeup artists on makeup line. Fax resume and a recent list of projects to 415/343-7180 or mail your business card and resume. Must go through approval process to receive discount. For a participating locations list, call 800/781-2336 or 415/781-8153.▧ ▸ **BOBBI BROWN.** 40% off to professional makeup artists on makeup and skin care line. 20% off on accessories. Discount available at Barney's NY. Go to the counter and request a form for their Makeup Artist Discount Program Card. Bring photo ID, promo (comp) card and/or proof of agency affiliation or tearsheets. ▸ **CLUB MONACO.** 40% off to professional makeup artists, stylists, cosmetology students and media. Approved applicants are issued a CMCID card that allows makeup artists to purchase up to $7,500 worth of product annually. All other industry professionals may purchase up to $1,000 worth of product. For info or to receive an application, call 888/580-5084. ▧ ▸ **DERMA BLEND.** 30% off retail. Send business or promo card to: Allen Haynes, 5557 West Washington Blvd., Los Angeles, CA, 90016. Discount not available in stores. NO credit cards accepted. Call 800/325-3724.▧ ▸ **ENGLISH IDEAS.** 40% off entire makeup line to professional makeup artists. Call 949/789-8790 and give the representative your state I.D. number and where you are registered (i.e. agency, union or school) as a professional. Once verified, you can order products. Fax union card, school diploma or cosmetol-

ogy license to 949/699-0061. ▧ ▸ **GERDA SPILLMANN.** 20% off to professional makeup artists. Fax union card, call sheet/list of recent projects or agency promo to 209/529-1844. Call 800/282-3223 for info or an order form or e-mail gerdaspillmann@msn.com. ▧ ▸ **GIRLACTIC [Virtual Storefront].** 40% off to professional makeup artists. Call 818/881-3497 for details, or visit www.girlactik.com.▧ ▸ **i.d. COSMETICS by BARE ESCENTUALS.** 30% off on all makeup and skin care products. Bring promo or union card to any approved store. For approved stores list, call 415/487-3400.▧ ▸ **LAURA MERCIER.** 40% to professional makeup artists. Fax agency resume, tearsheet or callsheet to 972/-9874, Attn: Christine. Must go through approval process to receive discount. Call 888/MERCIER.▧ ▸ **LORAC.** 40% off their entire line. Send a business card, promo or copy of union card to Jenni. Call 800/845-0705. ▧ ▸ **M.A.C.** 40% off to professional makeup artists. Show agency composite card, a portfolio with tearsheets or your union card, along with photo ID. Other acceptable documentation includes: business card, letter of employment on letterhead, crew or call list or makeup artist diploma. To have an application faxed or mailed, call 800/387-6707 or email a request to MAC at ppid@mac-cosmetics.com. ▧ ▸ **MADINA MILANO.** 40% to professional makeup artists. Must have union card, tearsheets or agency promo. Call 866/623-4626 or www.madina.it ▧ ▸ **MAKE-UP FOREVER.** 35% off entire line. Fax call sheet, tearsheets, agency promo, or union card to 212/925-9561. To order call: 877/757-5175 or 212/941-9337.▧ ▸ **NARS.** 30% off on all makeup products. Provide agency promo, union card, or tearsheets. For more info. submit a request to Nars, Attn: Makeup Artist Discount Program at 580 Broadway, Suite 901, New York, NY 10012 or call 212/941-0890 X34. For a catalogue call 888/903-NARS or www.narscosmetics. com. ▧ ▸ **ORIGINS.** 40% off on makeup, brushes, skin and hair care products. To receive application, call 212/572-6636 or 800/ORIGINS. Must have union card, agency promo, or tearsheets to receive discount. ▧ ▸ **PHILOSOPHY.** 40% off entire color cosmetic makeup line and select items from their "logic" skin care division. To enroll or request the "Coloring Club Form," call Linda Jama at 602/736-8200 or

The Hook-up is updated quarterly on www.MakeupHairandStyling.com

the hookup...the hookup...the hookup...the

fax to 602/736-0600. Must supply a sample of your work, including credits, for consideration. www.philosophy.com.■ ▸ **TRUCCO.** 50% off entire line for makeup artists **AND** hair stylists. Present cosmetology license, school diploma, union card, or agency promo to Sebastian's Eyezone store. Or call 818/704-4974. Hair stylists should present their license. For locations call 800/829-7322.■ ▸ **SENNA.** 20% off entire line. Discount does not include "Green Ticket" items. Fax union card, agency promo or copy of your cosmetology license to 661/295-1019 or call 800/-537-3662.■ ▸ **STILA.** 40% discount to professional makeup artists. Fax union card or have your agency **FAX** a resume to Nancie at 213/913-1493. **No phone calls accepted.** Include a return fax or phone number for reply.■ ▸ **SHU UEMURA.** 25% discount to professional makeup artists. Provide union or promo card, portfolio, agency promo, letter of employment on letterhead, press material with name and/or tear sheets at 800/743-8205 or fax to 310/652-6568. ■ ▸ **SMASHBOX.** 40% off entire line to professional makeup artists. Agency promo and photo id or tearsheet with your name printed on it required. Call, 888/558-1490 X257. www.smash-box.com. ■ ▸ **STAR.** 30% discount to professional makeup artists. For more info call 877/214-7827 or visit www.starbeautyspot.com. ■ ▸ **TAUT** by Leonard Engleman Cosmetics 25% off entire line. Bring union card, cosmetology license or business card to any participating store, or fax it along with your order to 818/773-9736. For a list of participating stores, call 800/438-8288.■ ▸ **THREE CUSTOM COLOR SPECIALISTS.** 30% on Ready to Wear Lip Color and custom blending service. Call 888/262-7714 for an application or e-mail: info@threecustom.com. ■ ▸ **Trish McEvoy** 40% off makeup line to professional makeup artists. 25% off brushes. Mail or fax business card, cosmetology license, promo card and letter of reference to Adele at 212/758-7790 or 800/431-4306, F: 212/308-0288. Two credentials required. Walk-ins not honored. ■ ▸ **Yves Saint Laurent Beauté** 40% discount on makeup line to professional makeup artists. To place an order or receive an order form call 212/715-7333. ■

Hook-Up List updated quarterly at
www.MakeupHairandStyling.com

COSMETICS COMPANIES IN ALPHABETICAL ORDER

BOBBI BROWN ESSENTIALS (212) 980 - 7040
505 Park Avenue (FAX) 980 - 8036
New York, NY 10022

The line is comprised of lip colors, eye shadows, face powder, blush, bronzers, lip pencils and makeup brushes.

CAROL SHAW COSMETICS (800) 845 - 0705
8539 Sunset Boulevard, Suite 137 FAX (310) 855 - 0191
Los Angeles, CA 90069

LORAC onsists of lipsticks, lip tints, foundations, translucent powder and a multi-functional blush/eye shadow. The skincare line is oil free and includes a cleanser, toner, and moisturizer. Lorac is available exclusively at the following stores: Henri Bendel, New York, NY. • Neiman Marcus, Beverly Hills, CA. • Fred Segal, Santa Monica & Los Angeles, CA.

M•A•C COSMETICS (800) 387 - 6707
233 Carlton Street FAX (416) 924 - 4498
Toronto, Ontario M5A 2L2

An industry discount is offered to professional makeup artists, at specific locations. Apply for the card at: 800-387-6707.

LOS ANGELES
 WEST LOS ANGELES (310) 854 - 0860
 133 N. Robertson
 Location: Between Melrose and Alden Drive

 BEVERLY CENTER MALL (310) 659 - 6201
 8500 Beverly Blvd., Suite 772

NEW YORK
MIDTOWN MANHATTAN (212) 373 - 6359
712 5th Avenue
New York, NY 10019
Location: nside Henri Bendel

CHICAGO
MAGNIFICENT MILE (312) 642 - 0140
900 North Michigan Avenue (EXT) 253
Chicago, IL 60611
Location: Inside Henri Bendel

FLORIDA
PALM BEACH GARDENS (407) 626 - 6787
3101 PGA Blvd., Space C-105
Palm Beach Garden, FL 33410

SHU UEMURA (800) 743 - 8205

Shu Uemura has 90 locations worldwide, they offer makeup,
brushes, cases and more. The West Hollywood store extends a
15% discount to professional makeup artists. Applications are
available through the 800# or can be picked up at the Melrose
Avenue location.

MELROSE AVENUE (310) 652 - 6230
8606 Melrose Avenue, Ste B
West Hollywood, CA 90069
Location: Between LaCienega & San Vicente

LOS ANGELES
BEVERLY HILLS (310) 276 - 4400
9570 Wilshire Boulevard
Beverly Hills, CA 90212
Location: Inside Barney's New York
SAN FRANCISCO
BAY AREA (415) 243 - 8500
865 Market Street
San Francisco, CA 94103
Location: Inside Nordstrom

NEW YORK
CHELSEA (212) 929 - 9000
106 West 17th Street
New York, NY 10011
Location: Inside Barney's New York

MID-TOWN MANHATTAN (212) 826 - 8900
660 Madison Avenue
New York, NY 10022
Location: Inside Barney's New York

CHICAGO
RUSH STREET (312) 587 - 1700
5 East Oak Street
Chicago, IL 60611
Location: Inside Barney's New York

Products & Services Offered:
Worldwide Catalogue Sales • Annual "Makeup Artists Night" offering
15 - 20% off brushes, cases, skincare items, & other accessories to pro-
fessional makeup artists.

CHICAGO PRODUCTION BIBLE (312) 664 - 5236
16 West Erie, 2nd Floor (FAX) 664 - 8425
Chicago, IL 60610 www.screenmag.com
 Market: Film, Commercial & Video Production
 Published: Annually in January of each year
 Directory: $ 55

• • • • • • • • • •

ARIZONA PRODUCTION GUIDE (480) 345 - 6464
3923 E. Thunderbird, Ste. 26-102 (602) 494 - 1826
Phoenix, AZ 85032 www.azproduction.com
 Market: Film, Theatre & Television
 Published: Annually in the fall of each year
 Directory: $20

• • • • • • • • • •

CREATIVE INDUSTRY HANDBOOK (818) 752 - 3200
10152 Riverside Drive (FAX) 752 - 3220
Toluca Lake, CA 91602 www.creativehandbook.com
 Market: Video, Commercials & Broadcast
 Published: January & June of each year
 Directory Price: Free for the Asking
To receive a free copy, write to them on your business or personal stationary and provide the following information: 1. Your Job Title 2. Some projects you are working on now or in the past 3. What products or services you might reference (be looking for) in a source book. Be sure to include a street address for UPS delivery.

DEBBIES BOOK (626) 798 - 7968
P.O. Box 40968 (FAX) 798 - 5563
Pasadena, CA 91114 www.debbiesbook.com
 Market: Entertainment Industry
 Published: Annually in July of each year
 Directory: $ 50

• • • • • • • • • •

LA 411 & NY 411 (323) 460 - 6304
7083 Hollywood Blvd. #501 (FAX) 460 - 6314
Los Angeles, CA 90028 www.la411.com
 Market: Music, Commercials & Film
 Published: Annually in January of each year
 Directory: $ 69 + tax for CA residents

• • • • • • • • • •

FASHION & PRINT 2004 (800) 332 - 6700
824 E. Atlantic Ave., Ste 7 (FAX) 999 - 8931
Delray Beach, FL 33483 www.pgdirect.com
 Market: Fashion & Advertising for Print
 Published: Annually in the Summer of each year
 Directory: $ 59.95 + tax for NY residents + $7 shipping USA

• • • • • • • • • •

MIAMI PRODUCTION GUIDE (305) 442 - 9444
P.O. Box 143913 (FAX) 446 - 5168
Coral Gables, FL 33114 - 3913 www.filmflorida.com

 Published: Annually in December of each year
 Directory: $15 (includes shipping within U.S.)

• • • • • • • • • •

THE BLU BOOK (323) 525 - 2000
5055 Wilshire 6th Floor (FAX) 525 - 2387
Los Angeles, CA 90036 www.hollywoodreporter.com

 Published: Annually in January of each year
 Directory: $ 69.95+ tax & $6 shipping

• • • • • • • • • •

SELECT AMERICA (212) 929 - 9473
153 W. 18th Street (FAX) 675 - 3905
New York, NY 10011 www.selectonline.com

 Published: 3 times each year
 Directory: $ 20 each + tax or $90 to subscribe

THE REEL DIRECTORY (707) 584 - 8083
P.O. Box 866 N/A
Cotati, CA 94931 www.reddirectory.com

Facts:
 Published: Annually in July of each year
 Directory: $ 30 includes sales tax + $5 shipping
 Shipping: $ 5
 • • • • • • • • • •

MINNESOTA PRODUCTION GUIDE (612) 332 - 6493
401 North 3rd Street, Ste. 460 (FAX) 332 - 3735
Minneapolis, MN 55401 www.mnfilm.org

Facts:
 Published: Annually in January of each year
 Directory: Free
Where To Find: Minnesota Film Commission
Get listed in the directory for $40.
 • • • • • • • • • •

NEW JERSEY PRODUCTION GUIDE (973) 648 - 6279
P.O. Box 47023 (FAX) 648 - 7350
New Jersey, NJ 07101 www.nj.com/njfilm
 Email:NJFILM@nj.com

Comprehensive guide to production related personnel, goods and services available in New Jersey. FREE.
 • • •

Inquire about their student internship programs. Open to New Jersey college students that are enrolled in media programs at New Jersey public and private colleges and universities. The internship program is sponsored by the New Jersey Motion Picture and Television Commission, a state agency within the New Jersey Commerce and Economic Growth Commission.

THE SOUTH FLORIDA PRODUCTION GUIDE (305) 655-1940
100 Lincoln Road, Ste. 1114B (305) 655-1942
Miami Beach, FL 33139 www.sfpd.com
 E-mail sfpd@sfpd.com

 Published: Annually
 Directory: $ 20 + $5 shipping
 • • • • • • • • • •

 www.FloridaFilmProductionGuide.com, www.SFPD.com,
 www.SouthFloridaProductionGuide.com,
 www.MiamiBeachProductionGuide.com,
 www.SouthFloridaProductionDirectory.com, and
 www.EntertainmentTimes.com
 • • • • • • • • • •

THE WORKBOOK (323) 856 - 0008
940 North Highland Avenue (800) 547 - 2688
Los Angeles, CA 90038 (FAX) 856 - 4368
 www.workbook.com

The Workbook is comprised of 4 volumes. Each one can be purchased separately, or combined to meet specific needs. The volumes are:

1. Listing Directory's $ 25 tax included
 •Available by region: east, west, mid-west & south
 •Includes: names, addresses & phone numbers only
2. Photo Directory $ 60 + tax
 •Full page color and black & white photos)
3. Illustration Directory $ 50 + tax
4. Calendar $ 10 + tax
 Purchase the entire set for $ 90 + tax
 Published: Annually in January of each year
 Directory & Listing: $110 Includes tax & shipping
 Special Products: Mailing Labels
 Formats: Book / Web

ALLURE　　　　　　　　　　　　　　(212) 286-2860
4 Times Square, 10th Floor
New York, NY 10036

Location: Between 6th & Broadway

H,M/U & S Decision Makers: Booking Editor • Fashion Editorial Staff

Book Review Policy:
　　Drop off book M-F @ 10am. Pick up book anytime after 10am
　　the following day.

Editorial Rates:
　　Hair　　　　　　$150
　　Makeup　　　　$150
　　Makeup & Hair　$200
　　Fashion Styling　All Styling Done In House

BAZAAR　　　　　　　　　　　　　(212) 903 - 5000
1700 Broadway, 37th Floor
New York, NY 10019

Location: Between 53rd & 54th Streets

H,M/U & S Decision Makers: Bookings Editor • Photographers

Book Review Policy:
　　Call prior to dropping off your book for review. Not frequently
　　looking at books unless the photographer or editor recom-
　　mends the artist.

Editorial Rates:
　　Hair　　　　　　$150 - $249 (cover)
　　Makeup　　　　$150 - $249 (cover)
　　Makeup & Hair　Does not usually hire one person to do both.
　　Fashion Styling　Most Styling Done In House

BLACKBOOK　　　　　　　　　　　(212) 334 - 1800
　　　　　　　　　　　　　　　　　(212) 334 - 3364
10016 Prince Street, 2nd Floor
New York, NY 10012

Location: Information unavailable at time of print

H, M/U & S Decision Makers:
　　Fashion Director • Photographer •Publisher

Book Review Policy: Reviews promo cards and based on the strength of
the artists will request to see book.

Editorial Rates:
　　Hair　　　　　　CREDIT ONLY
　　Makeup　　　　CREDIT ONLY
　　Makeup & Hair　CREDIT ONLY
　　Fashion Styling　CREDIT ONLY

DETAILS　　　　　　　　　　　　　(212) 420 - 0689
7 W. 34th Street
New York, NY 10001

Location: Corner of Broadway & Bleeker

H,M/U & S Decision Makers:
　　Fashion Director • Fashion Editor • Assistant to the Fashion Editor

Book Review Policy:
　　Call prior to dropping off your book for review. There are no
　　specific drop off days or times.

Editorial Rates:
　　Hair　　　$200　　Makeup & Hair　$300
　　Makeup　$200　　Fashion Styling　All Styling Done In House

DETOUR　　　　　　　　　　　　　　(323) 469-9444
215 South Detroit Street, 2nd Floor
Los Angeles, CA 90036

Location: Between Melrose Ave. & Santa Monica Blvd.

H, M/U & S Decision Makers:
　Decisions are usually left up to the photographer. Fashion editor does get involved, and will veto a photographer's choice when and if he feels the artist selected is not up to par.

Book Review Policy:
　Drop off Wednesday and pick up Friday during business hours.

Editorial Rates:

Hair	CREDIT ONLY
Makeup	CREDIT ONLY
Makeup & Hair	CREDIT ONLY
Fashion Styling	CREDIT ONLY

ELLE　　　　　　　　　　　　　　　(212) 767 - 5800
1632 Broadway, 44th Floor
New York, NY 10019　　　　　**Web: www.elle.com**

Location: Between 50th & 51st Streets

H, M/U & S Decision Makers: Sr. Bookings Editor

Book Review Policy: Drop off book @ 10:00am. Pick up book anytime after 4:00pm the following day. Make sure the book is marked. ATTN: SR. BOOKINGS EDITOR.

Editorial Rates: (Varies with shoot)

Hair	$150
Makeup	$150
Makeup & Hair	$250
Fashion Styling	All Styling Done In House

ENTERTAINMENT WEEKLY　　　　　(212) 522 - 5681
1675 Broadway, 29th Floor
New York, NY 10019

Location: Between 52nd & 53rd Streets

H, M/U & S Decision Makers:
　The celebrity being photographed or the photographer.

Book Review Policy: None

Editorial Rates:

Hair	$150
Makeup	$150
Makeup & Hair	$250
Fashion Styling	$125 Prep / $250 Shoot /$125 Wrap

ESQUIRE　　　　　　　　　　　　　(212) 649 - 2000
250 West 55th Street, 7th Floor
New York, NY 10019

Location: Between Broadway and 8th Avenue

H, M/U & S Decision Makers: Fashion Director & Photo Director

Book Review Policy: Books are requested and reviewed if an artist has been recommended by the Fashion or Photo Director or if the artists has worked with them before. They typically hire by word of mouth.

Editorial Rates:

Hair	$150
Makeup	$150
Makeup & Hair	$250
Fashion Styling	All Styling Done In House

ESSENCE (212) 642 - 0600
1500 Broadway, 6th Floor
New York, NY 10036
 Location: Corner of Broadway and 43rd Streets

H, M/U & S Decision Makers: Fashion Director • Beauty Director •
Fashion/Beauty Coordinator

Book Review Policy: Prefers to review comp cards first and will make a request
to review portfolio based on the strength of the artist.

Editorial Rates:
 Hair $200 Makeup $250
 Makeup & Hair Does not usually use one person for both
 Manicurist $150
 Fashion Styling $150 Prep / $350 Shoot & Wrap

FLAUNT (323) 650 - 9051
1422 N. Highland Avenue (323) 856 - 5839
Hollywood, CA 90038

H, M/U & S Decision Makers: Fashion Editor • Beauty Editor

Book Review Policy: Drop book off anytime. Allow 1 to 2 days before pick
up.

Editorial Rates:
 Hair CREDIT ONLY
 Makeup CREDIT ONLY
 Makeup & Hair CREDIT ONLY
 Fashion Styling CREDIT ONLY

GLAMOUR (212) 880 - 8800
4 Times Square, 16th Floor
New York, NY 10036

Location: Between 6th & Broadway

H, M/U & S Decision Makers: All Fashion Editors & On Staff Stylists

Book Review Policy: Call and schedule an appointment with an editorial assistant.
Your book will be presented to an editor for review. You will be contacted by some-
one in the department when your book is available for pick up.

Editorial Rates:
 Hair $150
 Makeup $150
 Makeup & Hair $250
 Fashion Styling All Styling Done In House

GQ (212) 286-2860
4 Times Square, 9th Floor
New York, NY 10036

Location: Between 6th & Broadway

H, M/U & S Decision Makers: Visual Projects Editor • Bookings Editor
 We were told that books are reviewed by these two people only.

Book Review Policy: Drop off day is Wednesday before 5pm. Pick up on
Thursday after 5pm.

Editorial Rates:
 Hair $200
 Makeup $200
 Makeup & Hair $300
 Fashion Styling All Styling Done In Hous

IN STYLE (212) 522 - 1212

1271 Avenue of the Americas (6th Avenue)
New York, NY 10020 **Web: www.instyle.com**

Location: Corner of 6th Avenue & 50th Street

H, M/U & S Decision Makers:
　All makeup, hair, & styling decisions are made by the photo
　editor or the photographer, once hired by the magazine. The
　celebrities play a big part in those decisions.

Book Review Policy: Drop off your book on Wednesday. Pick up the book
on Friday after 10:00am.

Editorial Rates:
Hair	$250
Makeup	$250
Makeup & Hair	$500
Fashion Styling	$250

LA TIMES MAGAZINE (213) 237 - 7811

145 South Spring Street, 5th Floor
Los Angeles, CA 90012

Location: Corner of Spring & 5th Street

H, M/U & S Decision Makers: Art Director • Style Editor

Book Review Policy: Drop off book Monday - Friday from 10:00 AM -
5:00 PM. Pick book up in 24 hours. We recommend calling first to ver-
ify book has been reviewed.

Editorial Rates:
Hair	$150
Makeup	$150
Makeup & Hair	$250
Prop Styling	$150
Fashion Styling	$250

LATINA (212) 642 - 0600

1500 Broadway, Suite 600
New York, NY 10036 **Web: www.essencemag.com**

Location: Corner of Broadway and 43rd Streets

H, M/U & S Decision Makers: Beauty Editor

Book Review Policy: Drop off book at 6th floor mail room. Leave for 24
hours. Call (212) 642 - 0675 before picking up.

Editorial Rates:
Hair	$150 - $200
Makeup	$150 - $200
Makeup & Hair	$200 - $250
Prop Styling	$150
Fashion Styling	All Styling Done In House

MODERN SALON (847) 634 - 2600

700 Knight Bridge Parkway
Lincolnshive, IL 60069

Location: Information unavailable at time of print

H, M/U & S Decision Makers: Editorial Director • Creative Director

Book Review Policy: Drop off book anytime and call next day to pick up.

Editorial Rates:
Hair	CREDIT ONLY
Makeup	CREDIT ONLY
Makeup & Hair	CREDIT ONLY
Fashion Styling	CREDIT ONLY

NYLON (212) 226 - 6454
394 Broadway, 2nd Floor
New York, NY 20012

Location: Between Spring & Broom

H, M/U & S Decision Makers: Project Editors choose stylists then stylists choose makeup and hair person.

Book Review Policy: Drop off Wednesday during business hours. Pick up Friday.

Editorial Rates: Information unavailable at time of print
 Hair
 Makeup
 Makeup & Hair
 Fashion Styling

PLATINUM (617) 521 - 0004
101 Tremont Street, Ste. 715
Boston, MA 02108

Location: Information unavailable at time of print

H, M/U & S Decision Makers: Fashion/Art Director

Book Review Policy: Drop off anytime and call to see if book is ready for pick up the following day

Editorial Rates:
 Hair CREDIT ONLY
 Makeup CREDIT ONLY
 Makeup & Hair CREDIT ONLY
 Fashion Styling CREDIT ONLY

ROLLING STONE (212) 484 - 1616
1290 6th Avenue, 2nd Floor
New York, NY 10104 **Web: www.rollingstone.com**

Location: Between 51st & 52nd

H, M/U & S Decision Makers: Fashion Director & Fashion Associates. RollingStone uses on-staff stylists. They book out for hair and makeup only.

Book Review Policy: No policy. Drop your book off at the message center. Plan to leave it 2-3 days. Call before picking it up. Follow-up to see if it was reviewed.

Editorial Rates:
 Hair $150 Makeup $150
 Makeup & Hair $250
 Fashion Styling All Styling Done In House

SELF (212) 286-2860
4 Times Square, 5th Floor
New York, NY 10036 **Web: www.self.com**

Location: Between 6th & Broadway

H, M/U & S Decision Makers: Bookings Editor • Creative Director

Book Review Policy:

Editorial Rates:
 Hair $150
 Makeup $150
 Makeup & Hair $250
 Fashion Styling $125 Prep /$250 Shoot /$125 Wrap

Notes:

SEVENTEEN　　　　　　　　　　(212) 407 - 9700
4 Times Square, 9th Floor
New York, NY 10036　　　　**Web: www.seventeen.com**

Location: Between 6th & Broadway

H, M/U & S Decision Makers: Model Editor • Fashion Director

Book Review Policy: Call in advance to make an appointment. Only stylists represented by agencies are hired.

Editorial Rates:
Hair	$150
Makeup	$150
Makeup & Hair	$250
Fashion Styling	Most Styling Done In House

SHAPE　　　　　　　　　　(818) 595 - 0593
21100 Erwin Street
Woodland Hills, CA 91367　　　**Web: www.shape.com**

Location: Corner of Variel & Erwin (1blk east of Canoga)

H, M/U & S Decision Makers: Art Director • Photo Editor

Book Review Policy: First week of each month. Promo materials always welcome.

Editorial Rates:
Hair	$150
Makeup	$150
Makeup & Hair	$250
Fashion Styling	$475($150 Prep/ $250 Shoot/ $75 Wrap)

SHINE MAGAZINE　　　　　　(011) 44-207-664-6564
17-18 Bernes Street
London, England WI-P3DD

Location: Not Available

H, M/U & S Decision Makers: Fashion Editor

Book Review Policy: Drop off during normal business

Editorial Rates: Information not available at time of print
Hair
Makeup
Makeup & Hair
Fashion Styling

SOMA　　　　　　　　　　(415) 558 - 8974
283 9th Street
San Francisco, CA 94103

Location: Corner of 9th Street & Folsom

H, M/U & S Decision Makers: The Photographer

Book Review Policy: None

Editorial Rates:
Hair	CREDIT ONLY
Makeup	CREDIT ONLY
Makeup & Hair	CREDIT ONLY
Fashion Styling	CREDIT ONLY

SPIN (212) 231-7400
6 West 18th Street, 11th Floor
New York, NY 10011

Location: Between 5th & 6th

H, M/U & S Decision Makers:
 Photo Editor • Assistant Photo Editor • Fashion Editor

Book Review Policy: Drop off policy: Drop off Wednesday. Pick up Friday.
Promotional Materials are always welcome.

Editorial Rates:
 Hair $150
 Makeup $150
 Makeup & Hair $300
 Fashion Styling $250

STUFF MAGAZINE (212) 372-3909
1040 6th Avenue, 17th Floor
New York, NY 10018

Location: Between 39th & 40th Street

H, M/U & S Decision Makers: Photo Editor

Book Review Policy: Drop off anytime. Call next day to make sure book
has been seen.

Editorial Rates:
 Hair $150
 Makeup $150
 Makeup & Hair $200
 Fashion Styling $150 Prep /$200 Shoot /$100 Wrap

SURFACE (415) 929 - 5100
7 Isadora Duncan Lane
San Francisco, CA 94102 **www.surfacemag.com**

Location:

H, M/U & S Decision Makers: Creative Director • Editing Director •
Production Manager

Book Review Policy: Drop off only. No Appointments. Mail, messenger or
bring your book to address above. All postage is paid by artist.

Editorial Rates:
 Hair CREDIT ONLY
 Makeup CREDIT ONLY
 Makeup & Hair CREDIT ONLY
 Fashion Styling CREDIT ONLY

US (212) 484 - 1788
1290 6th Avenue, 2nd Floor
New York, NY 10104

Location: Between 51st & 52nd Streets

H, M/U & S Decision Makers: Photographer hires his or her own team.

Book Review Policy: No specific policy.

Editorial Rates:
 Hair $150
 Makeup $150
 Makeup & Hair $300
 Fashion Styling $125 Prep / $250 Shoot / $125 Wrap

VENICE (310) 452 - 8452
P.O. BOX 261
Venice, CA 90294-0261 **Web: www.venicemag.com**

Location: Not Available

H, M/U & S Decision Makers: Executive Editor • Style Editor

Book Review Policy: No specific policy. The editors request that you send a cover letter, resume and promotional card if you have one. If interested, they will phone you to schedule an appointment.

Editorial Rates:
Hair	CREDIT ONLY
Makeup	CREDIT ONLY
Makeup & Hair	CREDIT ONLY
Fashion Styling	CREDIT ONLY

VIBE (212) 522 - 1212
205 Lexington Avenue, 3rd Floor
New York, NY 10016

Location: Between Hudson & Canal

H, M/U & S Decision Makers: Fashion Editor • Photo Editor

Book Review Policy: Books can be dropped off anytime on Wednesday. Pick up anytime on Friday.

Editorial Rates:
Hair	$150
Makeup	$150
Makeup & Hair	$200
Fashion Styling	$150

VOGUE (212) 286 - 2860
4 Times Square, 12th Floor
New York, NY 10036 **Web: www.vogue.com**

Location: Between 6th & Broadway

H, M/U & S Decision Makers: Booking Editor • Fashion Editorial Staff • Beauty Director

Book Review Policy: Books can be dropped off Monday - Friday from 9am - 11am. They should be picked up anytime the following day. They prefer to see books that are sent by an agency.

Editorial Rates:
Hair	$200
Makeup	$200
Makeup & Hair	$300
Fashion Styling	All Styling Done In House

AWARD Studio (310) 395 - 2779
1541 Westwood Blvd.
Los Angeles, CA 90024
www.MediaMakeupArtists.com

Award studio offers specialized training in media make-up and a first class portfolio. They prepare creative individuals to work in advertising and TV, as well as films, CD covers, music videos, runway shows and fashion magazines. We stress an understanding of photography and teach our students about all types of lighting and film. This enables them to apply the correct make-up for each media situation. Award Studio offers its students an opportunity to work with actors and models on actual photo shoots. This "on camera" work comprises a major part of the program and enables artists to build their portfolio as they learn. One and two week and two-day classes are availabe in both media makeup and fashion. All classes are taught by International make-up artist and photographer Amy Ward.

Owner:	Amy Ward
Years In Business:	4
Office Hours:	By Appointment
Location:	Los Angeles, CA
Average Class Size:	5
Maximum Class Size:	10
Policy & Procedures:	
Licensing:	California Bureau of Postsecondary and Vocational Education
Educational Requirements:	High School Diploma or Equivalent
Age Requirements:	Must be at least 17 years old
Tuition:	$645 - $2,685
Course Offering:	Media Makeup, Fashion Makeup.
Financial Aid:	None
Exit Credentials:	Certificate of completion

Notes:

EMPIRE Academy of Makeup (714) 438 - 2430
801 Baker Suite D (FAX) 438-2438
Costa Mesa, CA 92626
www.makeupempire.com

Empire Academy offers curriculum and several complete courses that no other school offers. As a newer school, we offer the most up to date curriculum, tools & techniques. Our focus is on Beauty through the true "Art and Science" of makeup. Courses can be taken individually based on the type of artistry students aspire to do whether it's Retail, Runway or Motion Picture. Empire puts a strong emphasis on learning "real life" industry knowledge and self-marketing skills such as how to find work, negotiating rates, and building a portfolio to prepare it's graduates for success. Our daily Instructors (not just the guest speakers) are working artists who excel in their fields of TV, Film & Print and have proven themselves to be powerful educators. Empire Academy is located in beautiful and safe Orange County California, about an hour outside of LA.

Owner:	Donna Mee
Years In Business:	5
Office Hours:	M-S 10:00am – 6:00pm
Location:	Costa Mesa, CA
Average Class Size:	8 Students
Maximum Class Size:	12 Students
Policy & Procedures:	
Licensing:	Licensed by the State of California, and California Bureau of Postsecondary and Vocational Education
Educational Requirements:	Love of Makeup
Age Requirements:	Must be at least 17 years old
Tuition:	$275 – $13,500 Depending on courses.
Course Offering:	Introduction to Makeup Artistry, Retail Artistry, Salon, Advanced, Corrective, Color Theory, Bridal, Runway, Fashion, Photography, Television, Video, Period, Film/Motion Picture, Special Effects, Old Age, Bald cap, Theatrical, Post-surgical, Camouflage, Hair Styling for the Set, Airbrush Makeup
Financial Aid:	Private Student Loans
Exit Credentials:	Diploma upon satisfactory completion of "Full Course Training."

Certificates upon satisfactory completion of individual courses.

MAKEUP DESIGNORY
129 S. San Fernando Road
Burbank, CA 91502
www.makeupschool.com

(818) 729 - 9420
(FAX) 729 - 9971

Makeup Designory is a private institution whose primary objective is to provide professional training in theatrical makeup artistry, hairstyling and wardrobe styling. Vocational training is provided to those individuals seeking employment in the entertainment and fashion industries and for those in need of continuing education in their chosen areas of expertise. While some students may choose to take all the programs we offer, others may choose to take only that course or program which relates specifically to their chosen career. The experience level of students ranges from beginner to advanced.

Owner:	Los Angeles School of Makeup, Inc.
Years In Business:	4
Student Population:	100 +
Office Hours:	M-F 8:00am - 5:00pm
	Sat & Sun Closed
Location:	
Average Class Size:	14 Students
Maximum Class Size:	18 Students
Policy & Procedures:	
Licensing:	Licensed by the State of California
Educational Requirements:	High school/GED graduate
Age Requirements:	18
Tuition:	$1,800 +, depending on course
Course Offering:	Beauty Makeup ArtistryCourse
	Character Makeup Artistry Course
	Special Makeup FX Course
	Theatrical Hairstyling Course
	Wardrobe Styling Course
	Fashion Styling Program
	Journeyman Makeup Program
	Master Makeup Program
Financial Aid:	Sallie Mae
Exit Credentials:	Certificate for Course, Program Diploma

THE MAKEUP SHOP
131 West 21st Street
New York, NY 10011
www.themakeupshop.com

(212) 807 - 0447
(FAX) 727 - 0975

The Makeup Shop is a unique combination of professional makeup store, educational center, job placement service and salon. Owner, Tobi Britton is a well known professional makeup artist. She has worked in the industry for over ten years and is a member of I.A.T.S.E. Local 798, the Makeup & Hair Union for Film and Television in NY.

The Makeup Shop is a retail operation, salon and school. The school satisfies the educational needs of aspiring and continuing professional makeup artists. The makeup shop has been featured in Vogue, Allure, Town & Country and McCalls. Take a tip from me and check it out.

Owner:	Tobi Britton
Years In Business:	10
Office Hours:	M-Sat. 10:00am - 6:00pm
Location:	Between 6th and 7th Ave.
Average Class Size:	5 Students
Maximum Class Size:	10 Students
Policy & Procedures:	
Licensing:	Licensed by the State of California
Educational Requirements:	High School Diploma and Desire
Age Requirements:	18+
Tuition:	$450 - $1,500 Depending on Courses
Course Offering:	Makeup for Photography • Television Commercials • Bridal •Runway• Feature Film & Special FX. Horrow Techniques • The Bald Cap Body Painting • Burns • Cuts • Bruises Hairpieces • Beards • Moustaches & Much More! Call for an up-to-the-minute class schedule.
Financial Aid:	Payment Plan Available
Exit Credentials:	Certificate of Completion and Attendance

STUDIO MAKEUP ACADEMY	(888) 465 - 4002
1438 N Gower St., Bldg 5 - Rm 308	(323) 465 - 4002
Hollywood, CA 90028	(FAX) 465 - 6078

www.studiomakeupacademy.com

The SMA prides itself on being the only school located inside a major Television & Film studio, and calls itself a professional school for the beauty entertainment industries.

Owner:	Doreen Malek
Years In Business:	10
Student Population:	75 per year or session
Office Hours:	M - Th 10:00am - 10:00pm
	Friday 10:00am - 4:00pm
	Sat & Sun Closed
Location:	Between Gordon & Gower
Average Class Size:	8 Students
Maximum Class Size:	12 Students

Policy & Procedures:

Licensing:	Licensed by the State of California
Educational Requirements:	High School Diploma or Equivalent
Age Requirements:	18
Other Requirements:	In Person Interview
Tuition:	$1,475 + Depending on Courses Chosen
Course Offering:	Film • Television • Special FX • Theatre Beauty
Financial Aid:	None Available
Exit Credentials:	Certificate of Completion

Notes:

WESTMORE ACADEMY	(818) 562 - 6808
OF COSMETIC ARTS	(FAX) 562 - 6617
916 W. Burbank Blvd. Suite Q • Burbank, CA 91506	

www.westmoreacademy.com

Owned by Marvin Westmore, third generation Hollywood Makeup Artist, the Westmore Academy has a curriculum which emphasizes putting the "art" back into Makeup Artist. The name Westmore is to makeup what Rolls Royce is to automobiles. The schools board of advisors include Monty and Michael Westmore. Along with resident instructors, Westmore hosts guest instructors who are working professionals from the Television and Motion Picture industry. Westmore Academy is fully approved to accept non-immigrant alien students by the Department of Justice; Immigration and Naturalization Service.

Owner:	Marvin G. Westmore
Years In Business:	14+
Student Population:	12 - 24
Office Hours:	M-F 9:00am - 6:00pm
	Sat & Sun Closed
Location:	Victory & Burbank
Average Class Size:	8 Students
Maximum Class Size:	15 Students
Policy & Procedures:	
Licensing:	Licensed by the State of California
Educational Requirements:	High School Diploma or Equivalent
Age Requirements:	Must be at least 17 years old
Tuition:	$1,500 + Depending on Courses Chosen
Course Offering:	Motion Picture • Television Photography Salon • Paramedical • Special Makeup Effects • Prosthetics • Bald Cap • Old Age
Financial Aid:	None Available
Exit Credentials:	Diploma or Certificate upon satisfactory completion of course work.

Notes:

MESSENGER SERVICES: ATLANTA, GEORGIA

BLITZ PACK, INC. (770) 489 - 2121
PO BOX 11285 (FAX) 489 - 1457
Atlanta, GA 30310
 Business Hours: M - F 7:00am - 7:00pm Service Hours: 24/7
 Primary Service Area: Atlanta
 Services Offered: Local Transportation of Merchandise & Materials

• • • • • • • • • •

EXECUTIVE COURIER, INC. (404) 249 - 9000
120 Ottley Drive (FAX) 249 - 6620
Atlanta, GA 30324 www.executivecourier.com
 Business Hours: M - F 8:00am - 5:00pm Service Hours: 24/7
 Primary Service Area: Atlanta
 Services Offered: Local Transportation of Merchandise & Materials

• • • • • • • • • •

MESSENGER SERVICES: CHICAGO, ILLINOIS

CHICAGO MESSENGER SERVICE (312) 666 - 6800
1600 South Ashland Avenue (FAX) 243 - 7136
Chicago, IL 60608 CMS Air (312) 666 - 3400
 Business Hours: M - F 8:00am - 5:00pm Service Hours: 24/7
 Primary Service Area: Chicago, surrounding communities
 Services Offered: Local Transportation of Merchandise & Materials

• • • • • • • • • •

MESSENGER SERVICES: DALLAS, TEXAS

STARFLEET COURIER (972) 960 - 0044
4440 Sigma, Suite 130 (FAX) 960 - 2862
Dallas, TX 75244
 Business Hours: M - F 8:00am - 5:00pm Service Hours: 24/7
 Location: Between Midway & Alpha
 Primary Service Area: Dallas, Ft. Worth Metroplex
 Services Offered: Local Transportation of Merchandise & Materials.

MESSENGER SERVICES: LOS ANGELES

CARDINAL EXPRESS (323) 466 - 7691
6571 Santa Monica Boulevard (FAX) 466 - 7542
Los Angeles, CA 90038 (800) 221 - 4141
 Business Hours: M - F 8:00am - 7:30pm Service Hours: 24/7
 Primary Service Area: Southern California
 Services Offered: Local Transportation of Merchandise & Materials.

• • • • • • • • • •

MUSIC EXPRESS MESSENGER SERVICE (818) 845 - 1502
2601 Empire Avenue (FAX) 845 - 5086
Burbank, CA 91504
 Business Hours: M -F 8:00am - 5:00pm Service Hours: 24/7
 Primary Service Area: Los Angeles County
 Services Offered: Local Transportation of Merchandise & Materials.

• • • • • • • • • •

MESSENGER SERVICES: MINNEAPOLIS, MINNESOTA

STREET FLEET (612) 623 - 9999
1122 16th Avenue SE (FAX) 623 - 0328
Minneapolis, MN 55414 www.streetfleet.com
 Business Hours: M - F 7:00am - 6:00pm Service Hours: 24/7
 Primary Service Area: Minnesota
 Services Offered: Local Transportation of Merchandise & Materials.

• • • • • • • • • •

MESSENGER SERVICES: MIAMI, FLORIDA

BARON MESSENGER SERVICE (305) 688 - 0074
667 North Biscayne River Drive (FAX) 688 - 4112
North Miami, FL 33169 www.baronmessenger.com
 Business Hours: M - F 8:00am - 5:00pm
 Service Hours: 24/7
 Location: Between 156th and 7th Avenue
 Primary Service Area: All Of South Florida
 Services Offered: Local Transportation of Merchandise & Materials

MESSENGER SERVICES: NEW YORK, NEW YORK

ART EXPRESS (212) 206 - 7125
236 W. 27th Avenue (800) 638 - 7258
New York, NY 10001 (FAX) 627 - 8439
 Business Hours: M - F 9:00am - 5:00pm • Closed Weekends
 Service Hours: M - F 9:00am - 5:00pm
 Primary Service Area: All five burroughs of Manhattan
 Services Offered: Local Transportation of Merchandise & Materials.

• • • • • • • • • •

CHAMPION COURIER (212) 366 - 1800
141 West 24th Street (FAX) 366 - 1806
New York, NY 10011
 Business Hours: M - F 7:00am - 9:00pm Service Hours: 24/7
 Primary Service Area: Midtown to Downtown Manhattan
 Services Offered: Local Transportation of Merchandise & Materials
 Throughout Manhattan

• • • • • • • • • •

MESSENGER SERVICES: SAN FRANCISCO

WESTERN MESSENGER SERVICE (415) 487 - 4100
75 Columbia Square (FAX) 522 - 1847
San Francisco, CA 94103
 Business Hours: 24/7 Service Hours: 24/7
 Primary Service Area: All 9 Bay Area Counties
 Services Offered: Local Transportation of Merchandise & Materials

• • • • • • • • • •

SILVER BULLET EXPRESS COURIER SERVICE (415) 777 - 5100
523 Bryant Street (FAX) 777 - 2957
San Francisco, CA 94103
 Business Hours: M - F 7AM - 10PM Sat & Sun 8AM - 5:00PM
 Service Hours: Same As Above
 Location: Between 3rd & 4th
 Primary Service Area: Greater Bay Area and beyond
 Services Offered: Local Transportation of Merchandise & Materials

FEDERAL EXPRESS (800) 238 - 5355

 Services Offered:
 Local & Worldwide Overnight Transportation of Mer-chandise
 & Materials. Corporate Accounts for businesses & individuals.

• • • • • • • • • •

AIRBORNE EXPRESS (800) 247 - 2676

 Services Offered:
 Local & Worldwide Overnight Transportation of Mer-chandise
 & Materials. Corporate Accounts for businesses & individuals.

• • • • • • • • • •

DHL (NEXT DAY DELIVERY) (800) 225 - 5345
DHL (SAME DAY DELIVERY) (800) 345 - 2727

 Services Offered:
 Local & Worldwide Overnight / Same Day Transportation of
 Merchandise & Materials • Pick Up & Delivery of Passport &
 Applications to the Proper Authorities & Return Back to You •
 24 Hour Customer Service • Saturday & Sunday Pick Up &
 Delivery • Insurance up to $25,000. Corporate Accounts for
 businesses & individuals.

• • • • • • • • • •

UNITED PARCEL SERVICE (UPS) (800) 222 - 8333

 Services Offered:
 Local & Worldwide Overnight Transportation of Mer-chandise
 & Materials. Corporate Accounts for businesses & individuals.

FedEx and DHL both have over two thousand drop off locations through-out the United States and abroad. Airborne has over 500 locations. UPS, well that's a last resort anyway when it comes to shipping your portfolio.

Please call the 800 numbers listed above for each carrier to request a current rate chart and a listing of the location nearest you.

NEWS STANDS: LOS ANGELES

MELROSE NEWS (323) 655 - 2866
647 North Martel Avenue NFA
Los Angeles, CA 90046
 Location: Corner of Melrose & Martel
 Parking: Metered Parking on Melrose, Martel & nearby streets

• • • • • • • • • •

THE DAILY PLANET (323) 957 - 0061
5931-1/2 Franklin Avenue NFA
Hollywood, CA 90065
 Location: Corner of Franklin & Tamarind
 Parking: Street Parking Where Available

• • • • • • • • • •

WORLD BOOK & NEWS (323) 465 - 4352
1652 Cahuenga Boulevard (FAX) 465 - 3892
Hollywood, CA 90028
 Location: Corner of Cahuenga & Hollywood Boulevard
 Parking: Metered Parking on Cahuenga & Hollywood Bl.

• • • • • • • • • •

NEWS STANDS: MIAMI, FLORIDA

NEWS CAFE (305) 538 - 6397
800 Ocean Drive NFA
Miami, FL 33139
 Location: Between Ocean Drive & Collins
 Parking: Valet Parking $5 - $6

• • • • • • • • • •

NEWS STANDS: NEW YORK

GLOBAL NEWS (212) 645 - 1197
22 - 8th Avenue NFA
New York, NY 10014
 Location: Between 12th & 13th Street
 Parking: Some Meters Available. Better to walk or cab It.

DINA'S MAGAZINE (212) 674 - 6595
270 Park Avenue South NFA
New York, NY 10010
 Location: Between 21st & 22nd
 Parking: None readily available. Better to walk or cab it.

• • • • • • • • • •

NEWS STANDS: SAN FRANCISCO, CA

GOOD NEWS (415) 821 - 3694
3920 24th Street NFA
San Francisco, CA 94114
 Location: Between Noe & Sanchez Streets
 Parking: Metered Parking on the Street

• • • • • • • • • •

HAROLD'S INTERNATIONAL NEWSTAND (415) 441 - 2665
524 Geary Street (FAX) 441 - 1447
San Francisco, CA 94102
 Location: Between Taylor & Jones Streets
 Parking: Metered Parking on the Street

PHOTO LABS: CHICAGO, ILLINOIS
Processing, Printing & Duplicates of Slides & Transparancies

LA SALLE PHOTO SERVICE (773) 327 - 6402
1700 West Diversey NFA
Chicago, IL
 Location: Corner of Division & Paulina (The Loop)
 Type: Black & White

• • • • • • • • • •

GAMMA PHOTO LAB (312) 337 - 0022
314 West Superior (FAX) 337 - 3753
Chicago, IL 60610
 Location: Between Franklin & Orleans (River North)
 Type: Color + Black & White, Digital

• • • • • • • • • •

PHOTO LABS: MIAMI, FLORIDA

LIB COLOR LABS (305) 538 - 5600
851 Washington Avenue (FAX) 538 - 0959
Miami Beach, FL 33139
 Location: Between 8th & 9th Streets
 Type: Color + Black & White

• • • • • • • • • •

THOMSON CHROME (305) 443 - 0669
4210 Ponce DeLeon Boulevard (FAX) 443 - 1710
Coral Gable, FL 33146 www.thomsonimaging.com
 Location: Between 40th & US1
 Type: Color + Black & White

• • • • • • • • • •

PHOTO LABS: LOS ANGELES, CALIFORNIA
Processing, Printing & Duplicates of Slides & Transparancies

ART FORM (323) 467 - 6632
906 North Vine Street (FAX) 467 - 4943
Hollywood, CA 90038
 Location: Corner of Vine & Willoughby (Next to 7-11)
 Type: Color + Black & White Lab

• • • • • • • • • •

CHROME & R COLOR LAB (323) 937 - 7337
7174 Beverly Boulevard (FAX) 937 - 2960
Los Angeles, CA 90036 www.chromeandr.com
 Location: Between LaBrea Ave & Poinsettia
 Type: Color Lab

• • • • • • • • • •

CM COLOR LAB (323) 937 - 6885
835 North LaBrea Avenue (FAX) 933 - 8063
Hollywood, CA 90038
 Location: Between Melrose & Santa Monica Boulevard
 Type: Color + Black & White

• • • • • • • • • •

ARGENTUM PHOTO LAB (323) 461 - 2775
1050 Cahuenga Boulevard (FAX) 461 - 2776
Hollywood, CA 90038
 Location: Corner of Cahuenga & Santa Monica Boulevard
 Type: Black & White

• • • • • • • • • •

PHOTO LABS: NEW YORK
Processing, Printing & Duplicates of Slides & Transparancies

COLOR EDGE (212) 633 - 6000
38 West 21st Street (FAX) 633 - 1600
New York, NY 10010
 Location: Between 5th and 6th Avenue (in Chelsea)
 Type: Color + Black & White

• • • • • • • • • •

LEXINGTON LABS (212) 645 - 6155
49 West 23rd Street, 4th Floor (FAX) 691 - 5165
New York, NY 10010 www.lexingtonlabs.com
 Location: Between 5th & 6th Avenue (In the Chelsea district)
 Type: Black & White

DUGGAL COLOR PROJECTS, INC. (212) 242 - 7000
3 West 20th (FAX) 463 - 0637
New York, NY 10011 www.duggal.com
 Location: Between 5th & 6th Avenue
 Type: Color + B&W

• • • • • • • • •

US COLOR LAB, INC. (212) 254 - 7200
65 Bleeker Street (FAX) 254 - 0473
New York, NY 10012 www.uscolor.com
 Location: Between Broadway & Lafayette (In Soho)
 Type: Color + Black & White

• • • • • • • • •

PHOTO LABS: SAN FRANCISCO
Processing, Printing & Duplicates of Slides & Transparancies

CHROMA COPY IMAGING (415) 546 - 5666
301 Brannon Street, Ste 100 (FAX) 543 - 3414
San Francisco, CA 94105 www.chroma-copy.com
 Location: Corner of 2nd & Brannon in the SOMA district
 Type: Color Lab

• • • • • • • • •

NEW LAB (415) 905 - 8555
651 Bryant (415) 905 - 8535
San Francisco, CA 94103 www.thenewlab.com
 Location: Between 4th & 5th Streets in the SOMA district.
 Type: Color Lab

• • • • • • • • •

BEST PHOTO LAB (415) 546 - 7110
450 Bryant Street (FAX) 546 - 0132
San Francisco, CA 94107
 Location: Between 2nd & 3rd Streets in the SOMA district.
 Type: Color + B&W Custom Lab

ADVERTISERS DISPLAY (323) 913 - 0500
BINDER CO., INC. (877) 913 - 0500
50 Dey Street, Bldg. 5 5th Floor (FAX) 913 - 0900
Jersey City, NJ 07030 www.StylingPortfolio.com

Advertisers Display offers the world's finest custom crafted portfolio books & products available today. They are used by some of the most prestigious agencies in the US.

Location: Corner of 14th & Washington
President: Jay Colvin
Office Mgr: Beverly

Products & Services Offered: Custom crafted portfolios, boxes, carrying cases & bags. Unique custom designs, custom Logos as well as standard type faces offered for name imprints. Fax & Phone Orders Welcome. Worldwide Shipping & Handling.

HOUSE OF PORTFOLIOS (212) 206 - 7323
52 West 21st Street (FAX) 633 - 2247
New York, NY 10010

BREWER CANTELMO (212) 244 - 4600
350 7th Street (FAX) 244 - 1640
New York, NY 10001

PROMO (COMP) CARDS: MIAMI, FLORIDA

HOT SPOT (305) 672 - 1581
506 Washington Avenue (FAX) 672 - 1582
Miami Beach, FL 33139
 Location: Corner of Washington Ave. & 5th St. (In SouthBeach)
 Products & Services Offered: Digital photo prints. Parking in the Rear

• • • • • • • • •

STUDIO LASER CASTING (305) 532 - 5911
1218 Washington (FAX) 532 - 5963
Miami Beach, FL 33139
 Location: Between 12th & 13th
 Products & Services Offered: Promo Cards • Laser Copies

• • • • • • • • •

PROMO (COMP) CARDS: LOS ANGELES

HOUR IMAGE (323) 653 - 0130
6399 Wilshire Boulevard (FAX) 653 - 1397
Los Angeles, CA 90048
 Location: Corner of Wilshire Bl. & LaJolla
 Products & Services Offered: Color laser & photographic quality color copies from prints & 35mm slides.

• • • • • • • • •

KINKO'S (323) 845 - 4501
7630 West Sunset Boulevard (FAX) 845 - 4512
Los Angeles, CA 90022
 Location: Corner of Stanley & Sunset
 Products & Services Offered: Color laser copying from prints & 35mm slides, binding, laminating, hourly Macintosh computer use.

• • • • • • • • •

PAPER CHASE PRINTING (get everything in writing) (323) 874 - 2300
7176 Sunset Boulevard (FAX) 874 - 6583
Los Angeles, CA 90046 www.paperchase.net
 Location: Corner of Sunset Blvd. & Formosa
 Products & Services Offered: Full color or B&W promo cards & posters.

SUPERSHOTS (323) 724 - 4809
971 Goodrich Boulevard (FAX) 724 - 4408
Los Angeles, CA 90022
 Location: Between Olympic & Whittier (East of Atlantic)
 Products & Services Offered: Full color and/or B&W promo cards • Special deal for agencies. Please call for quote Well known in the make up, hair & styling industry for its consistently high quality printing work on promotional cards.

• • • • • • • • •

PROMO (COMP) CARDS: NEW YORK

KINKO'S (212) 924 - 0802
24 East 12th Street (FAX) 924 - 9055
New York, NY 10003 www.kinkos.com
 Location: Located in the Photo District between 5th & University
 Products & Services Offered: Color & laser copies, business cards

• • • • • • • • •

CYBER FIELDS (212) 924 - 3456
20 East 13th Street (FAX) 255 - 9157
New York, NY 10003 www.cyberfields.com
 Location: Located in the Photo District @ 13th & University
 Products & Services Offered: Photocopying & printing, stationary & office supplies, typesetting, color laser copying from prints & slides.

• • • • • • • • •

IMPACT GRAPHICS (212) 334-4667
580 broadway, ste 210 NFA
New York, NY 10012
 Location: Between West End Avenue & A Dead End Street
 Products & Services Offered: Color and B&W promo cards & posters
 A popular source for composite's cards. They specialize in the design and production of agency books for promotion.

ON-LINE COLOUR GRAPHICS (212) 255 - 8200
134 5th Avenue, 5th Floor (FAX) 255 - 9402
New York, NY 10011 www.olcdesign.com
 Location: Between 18th & 19th
 Products & Services: Graphic & web design, agency books, printing.

ARISTA RECORDS (212)489 - 7400
6 West 57th Street
New York, NY 10019
 8370 Wilshire Boulevard (323)655 - 9222
 Beverly Hills, CA 90211
 1 Music Circle North, Suite 300 (615)780 - 9100
 Nashville, TN 37203

 Subsidiary Labels: La Face, Rowdy
 • • • • • • • • • •

ATLANTIC RECORDS (212)707 - 2000
75 Rockefeller Plaza - 4th Floor
New York, NY 10019
 9229 West Sunset Boulevard, 8th Floor (310)205 - 7450
 Los Angeles, CA 90069

 Subsidiary Labels: Third Stone, Big Beat, Modern, Rhino,
 • • • • • • • • • •

CAPITOL RECORDS (323)462 - 6252
1750 North Vine Street
Hollywood, CA 90028
 1290 Avenue of the Americas (212)603 - 8700
 New York, NY 10104

 Subsidiary Labels: Blue Note, Metro Blue
 Statistics: 100+ Albums (CD's) per year, 40 - 60 Videos per year
 • • • • • • • • • •

GEFFEN/INNERSCOPE/A&M RECORDS (310) 278 - 9010
10900 Wilshire Blvd. #1230
Los Angeles, CA 90024
 1755 Broadway, 6th Floor (212)841 - 8600
 New York, NY 10019

 Subsidiary Label: DGC Records
 Statistics: 40 Albums (CD's) per year, 80 Videos per year

LAFACE RECORDS (404)846 - 8050
3500 Parkway Lane, Suite 240 (404)848 - 8051
Atlanta, GA 30092
 Subsidiary Labels: None

ALL LAFACE RECORDS ART DEPARTMENT RESPONSIBILITIES ARE HAN-
DLED OUT OF ARISTA RECORDS IN NEW YORK.
 • • • • • • • • • •

SONY MUSIC (212)833 - 8000
550 Madison Avenue, 29th Floor
New York, NY 10019
 2100 Colorado Avenue (310)449 - 2100
 Santa Monica, CA 90404
 • • • • • • • • • •

SPARROW RECORDS (615)371 - 6800
101 Winners Circle
Brentwood, TN 37024 - 5010
 • • • • • • • • • •

WARNER BROS. (818)846 - 9090
3300 Warner Boulevard (FAX)953 - 3232
Burbank, CA 91505

 Subsidiary Labels: Giant, Sire, Maverick, Reprise, Qwest,

MARY MORENO RETOUCHING (323) 466-4079
424 North Larchmont Boulevard NFA
Los Angeles, CA 90004
 Location: Between Beverly & Melrose
 Products & Services Offered: Retouching
 Hours of Operation: M - F 10AM - 5PM
 • • • • • • • • • •

MAGIC GRAPHICS 24 Hour Service Available (212)239 - 8448
20 West 22nd Street (FAX)643 - 8614
New York, NY 10010
 Location: Corner of 9th Avenue & 33rd Street
 Products & Services Offered: Retouching
 Hours of Operation: 24 Hour Service
 Terms: Cash or Checks Only. No Credit Cards
 • • • • • • • • • •

AUNDRY (415)863 - 9678
130 Russ Street (415) 861 - 3477
San Francisco, CA 94103
 Location: Between Howard & Folsom
 Products & Services Offered: Retouching

AMERICAN RAG (323)935 - 3154
150 South Labrea Avenue (FAX)935 - 2238
Los Angeles, CA 90036

Studio Services Manager: Bruce Gilbert

Not just a vintage store, American Rag opened it's doors about
10 years ago to an unsuspecting Los Angeles fashion public.
Their competitive process and range of fashion merchandise
have created a demand for their clothing and accessories.
They have another location in San Francisco and their childrens
store is called "American Rag Youth".

Policy & Procedures
 Hours of Operation: Mon - Sat 10:00am - 10:00pm
 Sunday 12:00pm - 7:00pm
 Studio Dept. Hours: M - F 10:00am - 5:00pm
 Sat & Sun Closed
 Loan Policy: 24 Hour Approval
 Credit Requirements: VISA / MC / AMEX must be left on
 file as collateral to accomodate the
 amount of clothing removed.
 Corporate Accounts: Available to individuals & businesses.
 Finacial Obiligations: 15% restocking fee or 30% of mer-
 chandise taken out of the store must
 be purchased.
 Damage Control: Any merchandise that is returned in
 less than perfect condition must be
 purchased.

Credit Cards Accepted: VISA / MC / AMEX

BARNEYS NEW YORK (310)276 - 4400
Studio Services Department (EXT) 5705
9570 Wilshire Boulevard, 2nd Floor (FAX)777 - 5746
Beverly Hills, CA 90212

Studio Services Manager: Michael Sharkey

Cutting edge is a good way to describe Barneys New York. In 1994 Barneys opened its first California store on the famous Wilshire Boulevard, changing the face of Beverly Hills shopping forever. While other upscale department stores carry the tried and true designers, Barneys ventures into new territory by offering hot new designers along with the principle designers we all know and love.

Policy & Procedures
 Hours of Operation: M,TU,W,F & Sat 10:00am - 7:00pm
 Thursday 10:00am - 8:00pm
 Sunday 12:00pm - 6:00pm
 Studio Dept. Hours: M,TU,W,F & Sat 10:00am - 6:30pm
 Thursday 10:00am - 7:30pm
 Sunday Closed

 Loan Policy: 5 Day Approval Period
 Credit Requirements: VISA / MC / AMEX / BARNEYS with credit limit available to match the amount of clothing removed.
 Corporate Accounts: Available to businesses.
 Finacial Obiligations: 20% restocking fee
 Damage Control: Any merchandise that is returned in less than perfect condition must be purchased.

Credit Cards Accepted: BARNEY'S / VISA / MC / AMEX

BARNEYS NEW YORK (212) 826 - 8900
Studio Services Department (EXT) 2086
660 Madison Avenue (FAX) 777 - 5746
New York, NY 10021

Studio Services Director/Manager: Louise Maniscalco

Both Barneys stores in Manhattan provide the ultimate shopping experience. The eight floor monolith on Madison Avenue can provide hours of pleasure or pain depending on your budget.

Policy & Procedures
 Hours of Operation: M - F 10:00am - 7:00pm
 Saturday 10:00am - 7:00pm
 Sunday 12:00pm - 6:00pm
 Studio Dept. Hours: M - F 10:00am - 6:00pm
 Saturday By Appointment Only
 Sunday Closed
 Loan Policy: 48 hr Approval
 Credit Requirements: VISA / MC / AMEX / BARNEYS with credit limit available to match the amount of clothing removed.
 Corporate Accounts: Available to individuals & businesses.
 Financial Obligations: 20% restocking fee
 Damage Control: Any merchandise that is returned in less than perfect condition must be purchased.

Credit Cards Accepted: BARNEY'S / VISA / MC / AMEX

MACY'S (310) 854 - 6655
Studio Services Department Women: (310)
659 - 9660
8500 Beverly Boulevard (FAX) 657 - 2798
Los Angeles, CA 90048 Men: (310) 659 - 4792
In the Beverly Ctr Mall

Women's & Men's Manager: Staci Davis

Macy's carries many new and established designers in their upscale clothing departments. They maintain two studio services departments, one for men & one for women. The mens department is downstairs in the newly created "Men's Store." The Womens department is on the 2nd floor .

Policy & Procedures
 Hours of Operation: Mon - Sat 10:00am - 9:30pm
 Sunday 11:00am - 7:00pm
 Studio Dept. Hours: Mon - Fri 10:00am - 8:00pm
 Saturday 10:00am - 5:00pm
 Sunday 11:00am - 5:00pm
 Loan Policy: 5 Day Approval Period
 Credit Requirements: Excellent credit rating required to obtain Macy's Credit Card, or VISA / MC / AMEX must contain available credit limit to match the amount of merchandise removed from the store.
 Corporate Accounts: Available to businesses.
 Financial Obligations: Any merchandise kept out 5 Days is charged to the corporate credit account.
 Damage Control: Any merchandise that is returned in less than perfect condition must be purchased.

Credit Cards Accepted: MACY'S / VISA / MC / AMEX

NEIMAN MARCUS (310) 975 - 4336
Studio Services Department (FAX) 975 - 4354
9700 Wilshire Boulevard, 3rd Floor
Beverly Hills, CA 90212
Studio Services Manager: Beverly Thompson

Neiman Marcus put the "up" in upscale. Known for carrying the finest American and European designer clothing, accessories, and gift items, Neiman Marcus has been a staple in Beverly Hills and the Hollywood entertainment community for many years. Their studio services department and personnel are among the best in the business.

Policy & Procedures
 Hours of Operation: Mon - Sat 10:00am - 6:00pm
 Sunday 12:00pm - 5:00pm
 Studio Dept. Hours: Mon - Fri 10:00am - 6:00pm
 Saturday 10:00am - 6:00pm
 Sunday Closed
 Loan Policy: 5 Day Approval Period
 Credit Requirements: Excellent credit rating required to obtain Neiman Marcus account, or American Express Card must contain available credit limit to match the amount of merchandise removed from the store.
 Corporate Accounts: Available to businesses
 Financial Obligations: Any merchandise kept out 5 Days is charged to the corporate credit account.
 Damage Control: Any merchandise that is returned in less than perfect condition must be purchased.

Credit Cards Accepted: NEIMAN MARCUS / AMEX

NORDSTROM (310) 470 - 6155
WESTSIDE PAVILLION (310) 254 - 1670
10850 West Pico Boulevard, Basement (FAX) 254 - 2595
Los Angeles, CA 90064

Studio Services Manager: Debbie Hastain

Seattle based Nordstrom opened its first West Coast store some 14 years ago in Cerritos, California. Since then they have added over 20 stores in Southern and Northern California and have ventured into other western and eastern states. From childrens wear to trendy and upscale designer clothing, you can find it all at Nordstrom.

Policy & Procedures
Hours of Operation: Mon - Fri 10:00am - 9:30pm
 Saturday 10:00am - 8:00pm
 Sunday 11:00pm - 6:00pm
Studio Dept. Hours: Mon - Fri 10:00am - 9:00pm
 Saturday 10:00am - 8:00pm
 Sunday Closed
Loan Policy: 5 Day Approval Period
Credit Requirements: VISA / MC / AMEX / NORDSTROM with credit limit available to match the amount of clothing removed.
Corporate Accounts: Available to businesses.
Finacial Obiligations: Call for information
Damage Control: Any merchandise that is returned in less than perfect condition must be purchased.

Credit Cards Accepted: NORDSTROM / VISA / MC / AMEX

SAKS FIFTH AVENUE (310) 271- 6726
Studio Services Department (FAX) 275 - 4621
9600 Wilshire Boulevard
Beverly Hills, CA 90212
 Studio Services Manager: Bobbe Aiona

Both innovative and traditional, Saks offers a wide variety of ready to wear clothing and accessories for men and women. The studio services department provides knowledable assistance to freelancers who work in the entertainment, commercial and editorial marketplace.

Policy & Procedures
 Hours of Operation: M,Tu,W,F & Sat 10:00am - 6:00pm
 Thursday 10:00am - 8:00pm
 Sunday 12:00pm - 5:00pm
 Studio Dept. Hours: Mon - Fri 10:00am - 6:00pm
 Saturday 10:00am - 6:00pm
 Sunday Closed

 Loan Policy: 48 hr Approval
 Credit Requirements: VISA / MC / AMEX / SAKS with credit limit available to match the amount of clothing removed.
 Corporate Accounts: Available to individuals & businesses.
 Finacial Obiligations: 20% restocking fee
 Damage Control: Any merchandise that is returned in less than perfect condition must be purchased.

Notes:

Credit Cards Accepted: SAKS / VISA / MC / AMEX

MAKEUP ARTISTS & HAIR STYLISTS　　　　　(818)295 - 3933
I.A.T.S.E. (IA LOCAL 706)　　　　　　　　　(FAX)877 - 2776
11519 Chandler Boulevard, North Hollywood, CA 91601
　　　Requirements: 60 days per year of employment on a film for three
　　　out of five years. Must be hired within Los Angeles County.

MAKEUP ARTISTS & HAIR STYLISTS　　　　　(212)627 - 0660
I.A.T.S.E. (IA LOCAL 798)　　　　　　　　　(FAX) 627 - 0664
31 West 21st Street
New York, NY 10010

　　　Dues & Expenses　　　Makeup - $4500　Hair - $4000
　　　Dues:　　　　　　　　$50 Per Quarter
　　　Requirements: Contact the union to request information

MOTION PICTURE COSTUMERS　　　　　　　(323)851 - 0220
I.A.T.S.E. (IA LOCAL 705)　　　　　　　　　(FAX) 851 - 9062
1427 North LaBrea Avenue
Hollywood, CA 90028
　　　Dues & Expenses　　　$61 - $166 (Depends on Classification)
　　　Requirements 30 days in a signature costume house

COSTUME DESIGNERS GUILD　　　　　　　　(818)905 - 1557
I.A.T.S.E. (IA LOCAL 892)　　　　　　　　　(FAX)905 - 1560
13949 Ventura Boulevard, Suite 309
Sherman Oaks, CA 91423
　　　Dues & Expenses　　　$125 Per Quarter
　　　Requirements One Screen Credits